CHAMPIONSHIP

THE GREATEST TITLE IN SPORTS ENTERTAINMENT

Editor: Richard Jackson
Development Manager: Jo Bourne
Writers: Jeremy Brown, Ian Chaddock
and Richard Jackson
Designer: James Britnell
Proof Reader: Melanie Scott

Published by Hero Collector Books,
a division of Eaglemoss Ltd. 2021
Premier Place, 2 & A Half Devonshire
Square, EC2M 4UJ, London, UK

Eaglemoss France, 144 Avenue Charles
de Gaulle, 92200 NEUILLY-SUR-SEINE,
France.

WWE Credits
SVP, Consumer Products: Sarah Cummins
VP, Interactive Media: Ed Kiang
Manager, Global Publishing: Steve Pantaleo
**SVP Assistant General Counsel, Intellectual
Property:** Lauren Dienes-Middlen
Photo Department: Bradley Smith, Frank
Vitucci, Jamie Nelson, Josh Tottenham,
Melissa Halladay, Georgiana Dallas

Photographs on pages 8-11,
13-21, 24-31 by *Pro Wrestling
Illustrated*.
All other photos copyright
WWE.

Original Edition
ISBN 978-1-85875-991-3
PR7EN003BK

WWE Shop Edition
ISBN 978-1-80126-208-8
WWEEN001

Printed in China.

www.herocollector.com

CHAMPIONSHIP

THE GREATEST TITLE IN SPORTS ENTERTAINMENT

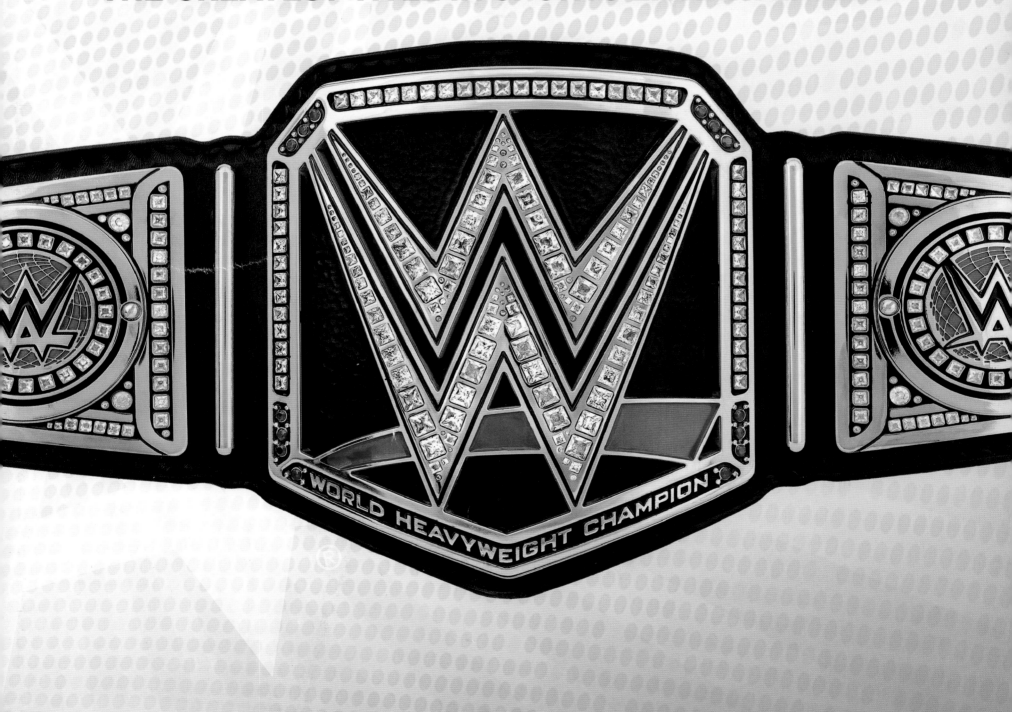

CONTENTS

Foreword

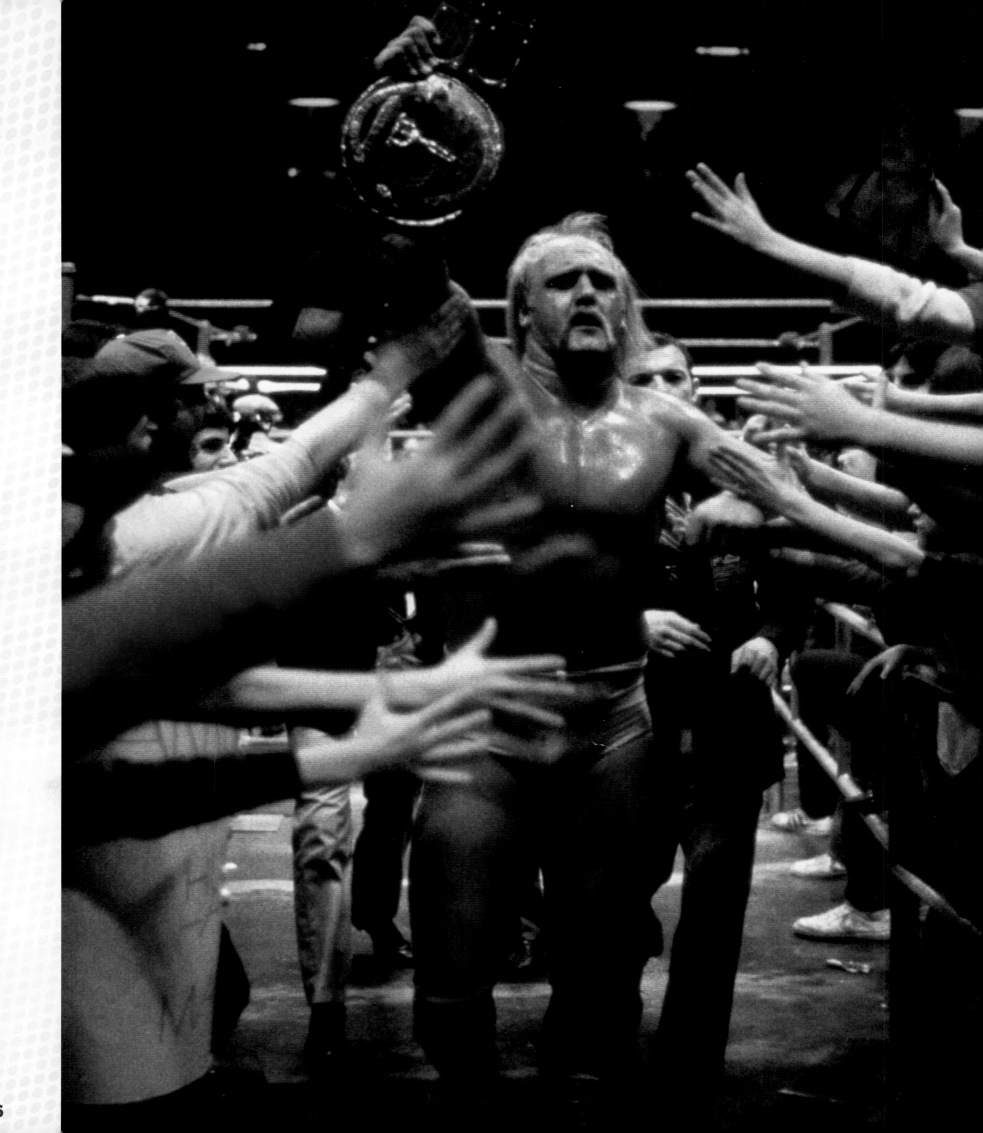

FOREWORD
BY JEREMY BROWN

I HAVE A THEORY ABOUT WWE CHAMPIONS. The champion from your childhood becomes your champion for life. Even if there are Superstars you grow to like more on the surface, whoever wore the gold during those formative years is deep down always going to be your guy. For me, confirmation of that theory came on March 29, 1987, when Hulk Hogan defeated André the Giant to retain the WWE Title. I had come to WWE fandom somewhat late, eventually being lured in by the 1985 WWE event *The War to Settle the Score* and the "Goonies R Good Enough" music video released in the same year. But once I was in, I was all in, and that night in '87 represented the culmination of two years of full-on Hulkamania. When Hogan lifted André up and slammed him to the mat as 93,000 fans roared, it was as transcendent a moment as I'd ever had in my fourteen years of life.

For years afterward, I would have sworn before a judge and jury that Hogan lifted André up over his head like the Grinch lifting his sleigh. It was only 20 years later, while working on a special issue for *WWE Magazine*, that I rewatched the match and saw that my memory and reality were slightly different. You could chalk it up to the Mandela Effect, or maybe it's just the fact that everything looks and feels bigger in a WWE Title Match. Either way, from that moment on, I was ride or die for the Hulkster. And that really has never changed. Eighteen years later, when I met him during his induction to the WWE Hall of Fame, I'll admit that I blacked out for a second when he called me "Brother."

That's the thing about WWE Champions, and the WWE Championship itself. There's an air of mystery about them. A sense of elevation. They've scaled the ladder and reached heights that only a select few Superstars have reached. They're part of an elite group who have earned the right to add their names to an incredible history that stretches back more than fifty years.

This book chronicles that history, giving you a ringside seat to the evolution of the WWE Championship. It puts you right in the thick of it with some of WWE's most iconic figures, chronicling their victories, their losses and their incredible journeys on the long, hard road to claiming WWE's highest honor. You'll learn the unbelievable true stories behind some of the greatest battles for the title ever contested. And, even more importantly, you will get to meet the Superstars who laid it all on the line for a shot at immortality. "Stone Cold", Chris Jericho, Randy Savage and Eddie Guerrero. Their WWE Championship stories are all here.

My WWE journey has been a long and interesting one, going from watching *WrestleMania* in a basement in suburban New Jersey to standing backstage and watching Hulk Hogan walk through the curtain as "Real American" thundered over the crowd. Through it all, I've never lost that sense of awe and respect for the title or the Superstars who've fought for it. Times change, Superstars rise and fall, but the WWE Championship is forever.

- Jeremy Brown

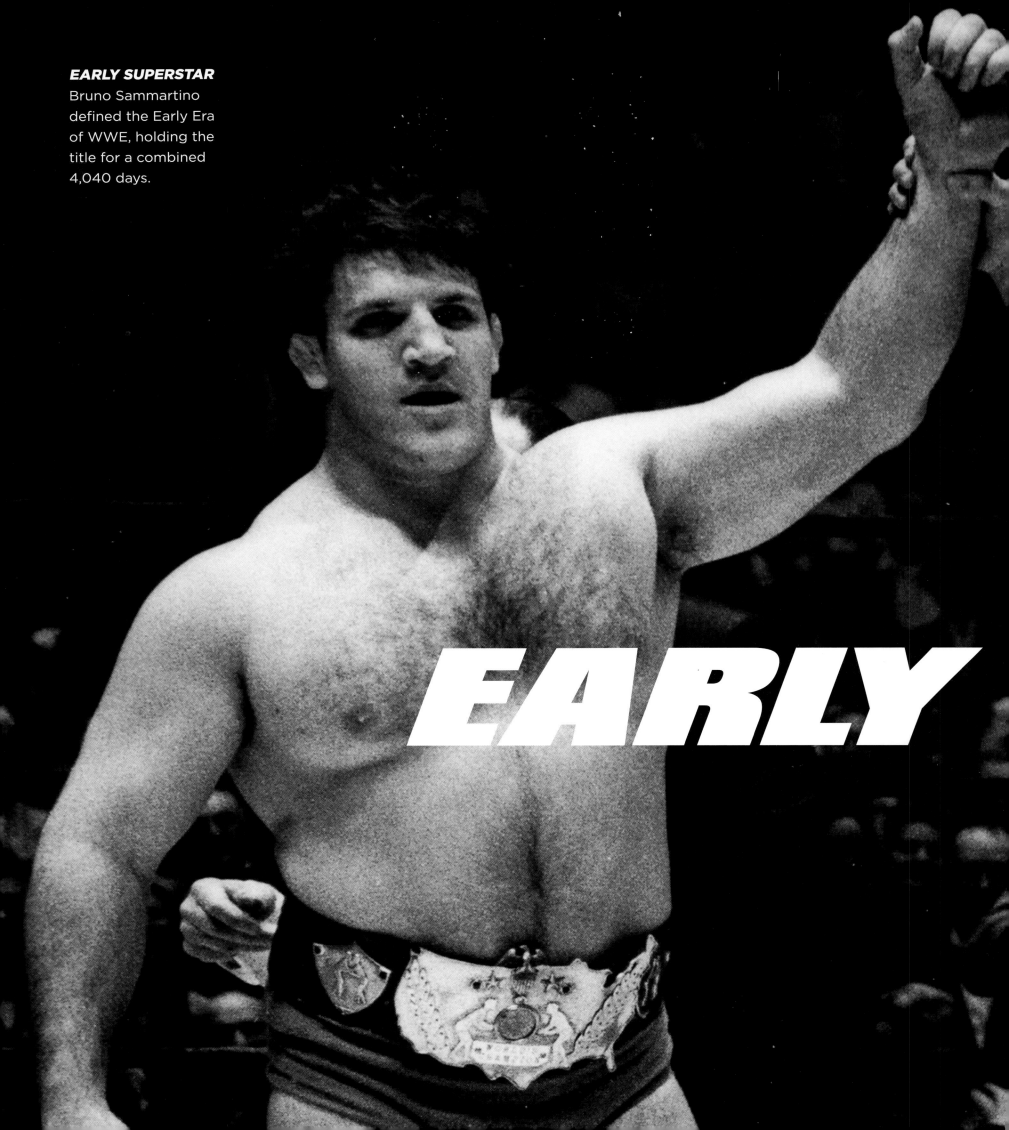

EARLY SUPERSTAR
Bruno Sammartino defined the Early Era of WWE, holding the title for a combined 4,040 days.

EARLY

YEARS
1963 - 1980s

Before Hulkamania and even predating the birth of the most Electrifying Man in Sports Entertainment, WWE was selling out arenas and creating World Champions.

EARLY YEARS

THE WWE CHAMPIONSHIP WAS BORN WHEN Vincent J. McMahon and Joseph "Toots" Mondt split from the National Wrestling Alliance and formed their own promotion. As the face of their brand, McMahon and Mondt chose "Nature Boy" Buddy Rogers, whose controversial loss of the NWA Title to Lou Thesz initiated the break. Rogers was installed as the champion of the new promotion, having won the title in a tournament in Rio De Janeiro by defeating Antonino Rocca in the finals.

Rogers was a popular Superstar, and expectations for his run as the first ever WWE Champion were high. However, not long after winning the title, Rogers was stopped short by a sudden heart attack. Rogers's medical condition all but ensured that his days with the title were numbered. And, indeed, on May 17, 1963, after a reign of less than one month, Rogers lost the Championship in 48 seconds to an up-and-coming Superstar named Bruno Sammartino.

FIRST TITLE RUN

An Italian immigrant known for his physical strength and in-ring prowess, Sammartino was a huge draw in New York, where the Italian community embraced him as their own personal hero. Bruno's popularity, combined with unparalleled talent, led him to an astounding eight-year run as WWE Champion. He was finally unseated on January 18, 1971, by the 'Russian' Superstar Ivan Koloff.

The Russian Bear held the title for just three weeks before surrendering it to Pedro Morales in a match at Madison Square Garden. Emotions were so high over Morales's defeat of Koloff that Sammartino rushed from the locker room to congratulate the new champion.

Morales quickly became a beloved champion, particularly with Puerto Rican fans in New York, who were inspired by his success. His run with the title stretched into 1973 before he lost the

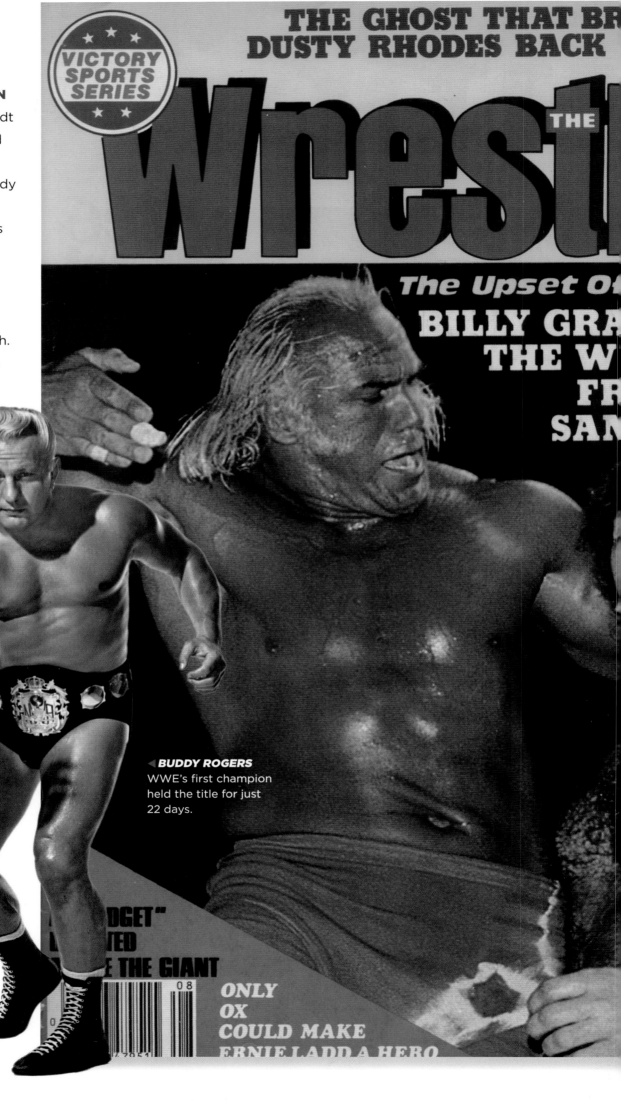

◄ BUDDY ROGERS
WWE's first champion held the title for just 22 days.

THE GHOST THAT BR
DUSTY RHODES BACK

VICTORY SPORTS SERIES

THE Wrestl

THE

The Upset Of
BILLY GRA
THE W
FR
SAN

"BUDGET"
LI TED
LE THE GIANT

ONLY
OX
COULD MAKE
ERNIE LADD A HERO

08

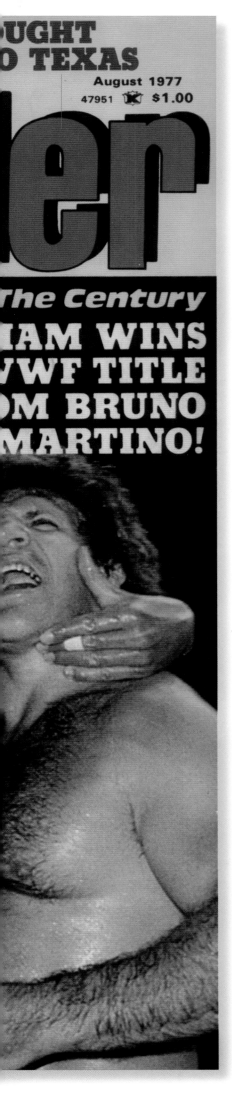

UGHT
O TEXAS
August 1977
47951 $1.00

er

The Century

AM WINS
WF TITLE
M BRUNO
ARTINO!

championship to Stan Stasiak in a shocking upset. Stasiak would not have long to celebrate, however, as it would only be nine days before the title went back to Sammartino. The Italian Superstar would embark on a lengthy title run, holding the gold for more than three years.

CREATING SUPERSTARS

By 1977, attitudes and competitors alike were beginning to change. The days of the old-school grapplers were giving way to more flamboyant Superstars whose personas spoke almost as loudly as their in-ring abilities. Leading the charge of this new wave of talent was a bleached-blond firebrand in tie-dyed ring gear who called himself "Superstar" Billy Graham. When Graham defeated Sammartino on April 30, 1977, the WWE Universe was apoplectic with rage, pelting the ring with garbage and berating Graham as he left the arena.

Graham held the title for nearly a year, winning over fans and setting attendance records with his over-the-top interviews and outrageous ring attire. The self-described "man of the hour, the man with the power, too sweet to be sour!" would eventually lose the title to Bob Backlund. Having now embraced this new type of champion, the WWE Universe was not thrilled at this turn of events, as Backlund wasn't anything like the outrageous persona of Billy Graham.

Nevertheless, the All-American Superstar was the rightful champion, and it didn't take too long for the WWE Universe to recognize his in-ring skills. Backlund found fans across the globe and managed to hold on to the gold for over four years, the longest run since Sammartino. But times were changing again as the '80s dawned, and a new era of Superstars were waiting in the wings for their shot at WWE gold.

◄ CONTROVERSIAL WIN
Bruno Sammartino's loss at the hands of Billy Graham was a huge upset back in 1977, as shown on the cover of *The Wrestler*.

"BRUNO'S UNPARALLELED TALENT LED HIM TO AN ASTOUNDING EIGHT-YEAR RUN AS WWE CHAMPION."

▼ ALL-AMERICAN CHAMPION
Bob Backlund quickly won over fans, with his in-ring skills more than compensating for his boyish demeanor.

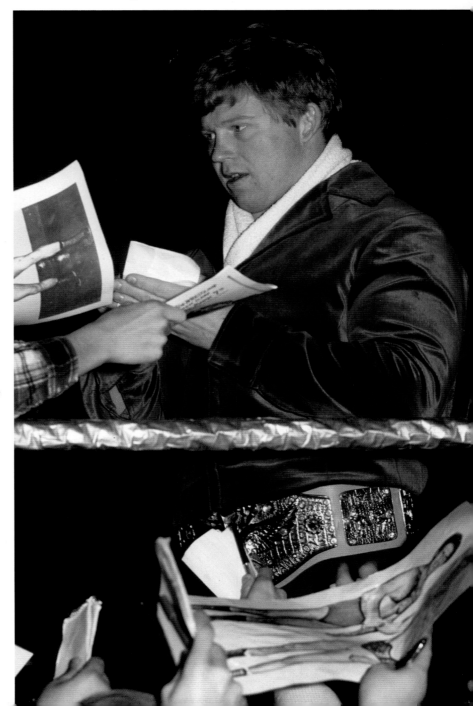

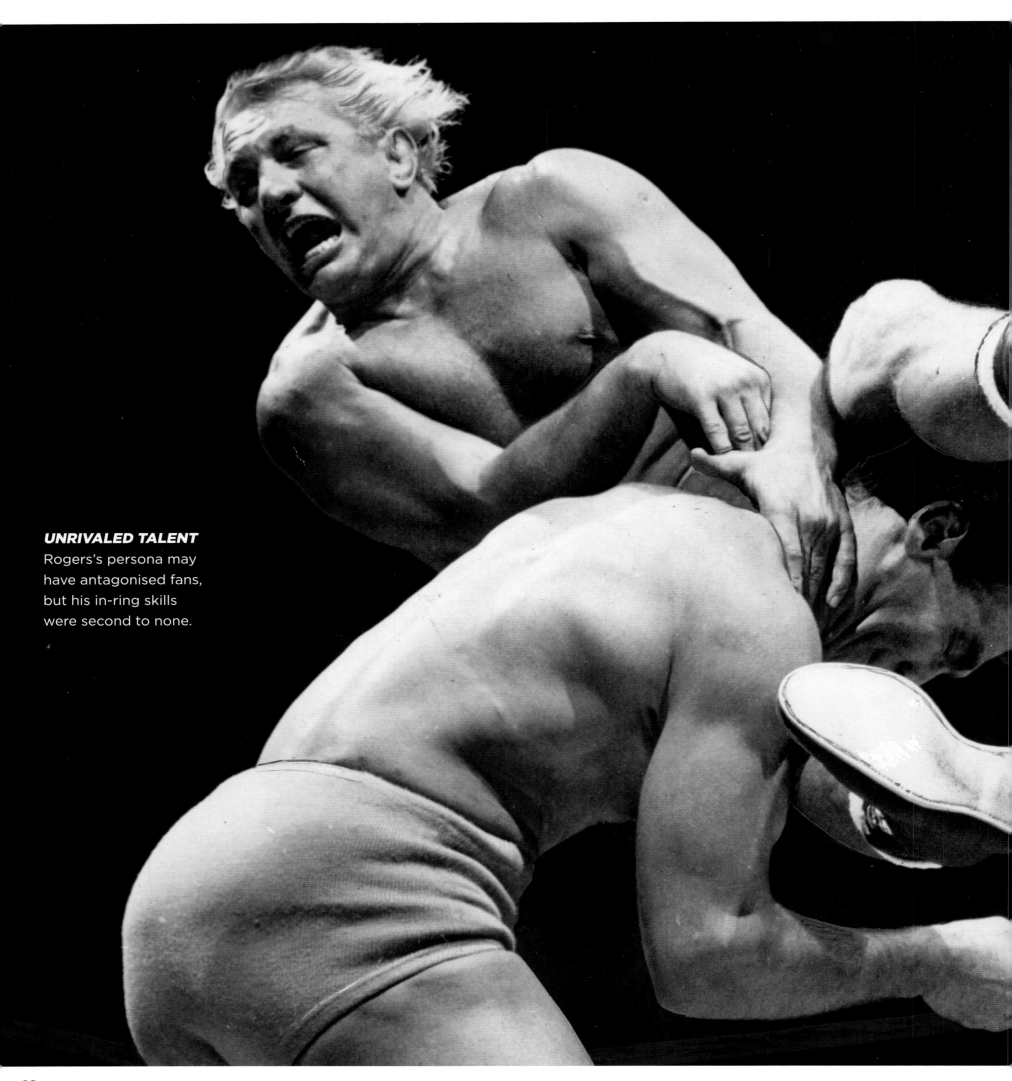

UNRIVALED TALENT
Rogers's persona may
have antagonised fans,
but his in-ring skills
were second to none.

BUDDY ROGERS

THERE HAVE BEEN MANY LEGENDARY WWE Champions, but only one man could claim to be the first. That man was Buddy Rogers. A brash, arrogant Superstar who dubbed himself "Nature Boy," Rogers was the prototype of the WWE Superstar you see today. Strutting around the ring with a shock of bleached blond hair and backing up his braggadocio with near-unrivaled talent, Rogers was a Superstar that the fans loved to despise.

Rogers's fame drew the attention of Vincent J. McMahon, who began booking him in matches for Capitol Wrestling Corporation. When Rogers lost the NWA Title to Lou Thesz in 1963, McMahon claimed that the title could only change hands in a Two-Out-of-Three Falls Match. This led to McMahon's statement that Rogers had won a tournament in Rio de Janeiro to become the first World Champion in his new promotion: WWE.

Rogers had a short title reign before health injuries sidelined him and his career. He lost the title to Bruno Sammartino a little less than a month after first winning the gold. That run would be his first and only time as WWE Champion, but he set the standard for all future champions.

"ONLY ONE CHAMPION COULD CLAIM TO BE THE FIRST."

13

BRUNO SAMMARTINO

BORN IN THE SMALL mountain town of Pizzoferrato, Italy, in 1935, Bruno Sammartino would grow up to define WWE for an entire generation.

Bruno's early life was not an easy one and when World War II broke out, Sammartino's hometown was occupied by Nazi troops, forcing his family to hide on a nearby mountain called Valla Rocca. Bruno eventually left his home in 1950, emigrating to Pittsburgh, Pennsylvania.

Settling into American life, Sammartino began working out at the Young Men's Hebrew Association and quickly took to weightlifting, almost making the 1956 Olympic team. In 1959, he set a record by bench pressing 565 pounds, a feat that drew the attention of Vincent J. McMahon. Sammartino made his professional wrestling debut in December of that year and almost immediately became a sensation.

With WWE based largely in the New York territory at that time, Sammartino was something of a local hero to fans, many of whom were blue-collar workers of Italian heritage or, like Sammartino, Italian immigrants themselves. Their fervor increased on May 17, 1963, when Sammartino defeated Buddy Rogers in a record-setting 48 seconds in Madison Square Garden to become the second Superstar to hold

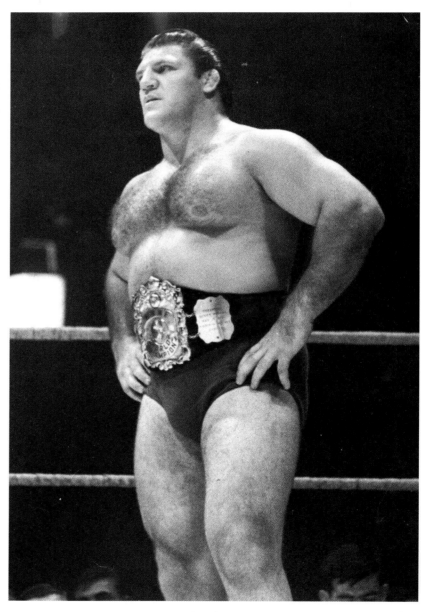

"SAMMARTINO WAS SOMETHING OF A LOCAL HERO TO FANS."

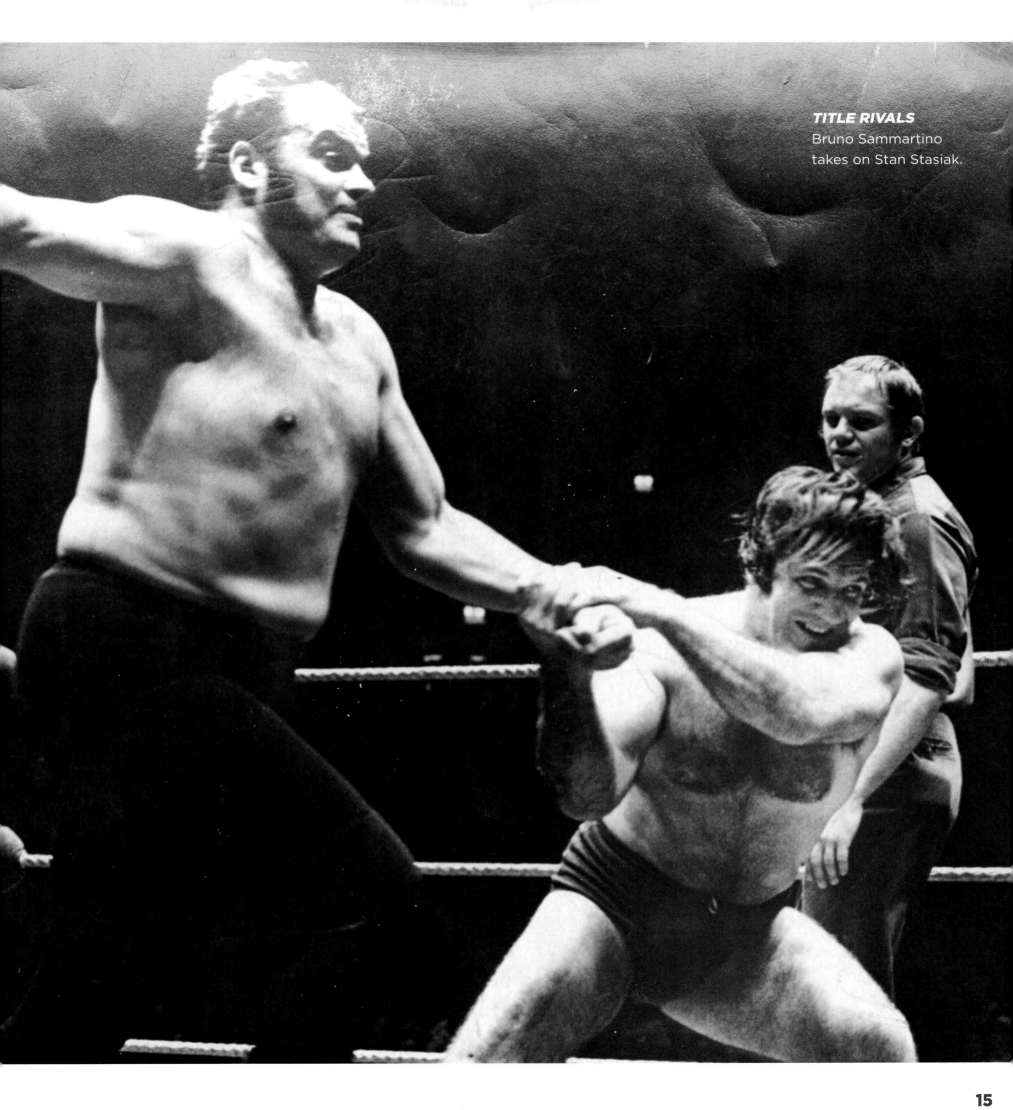

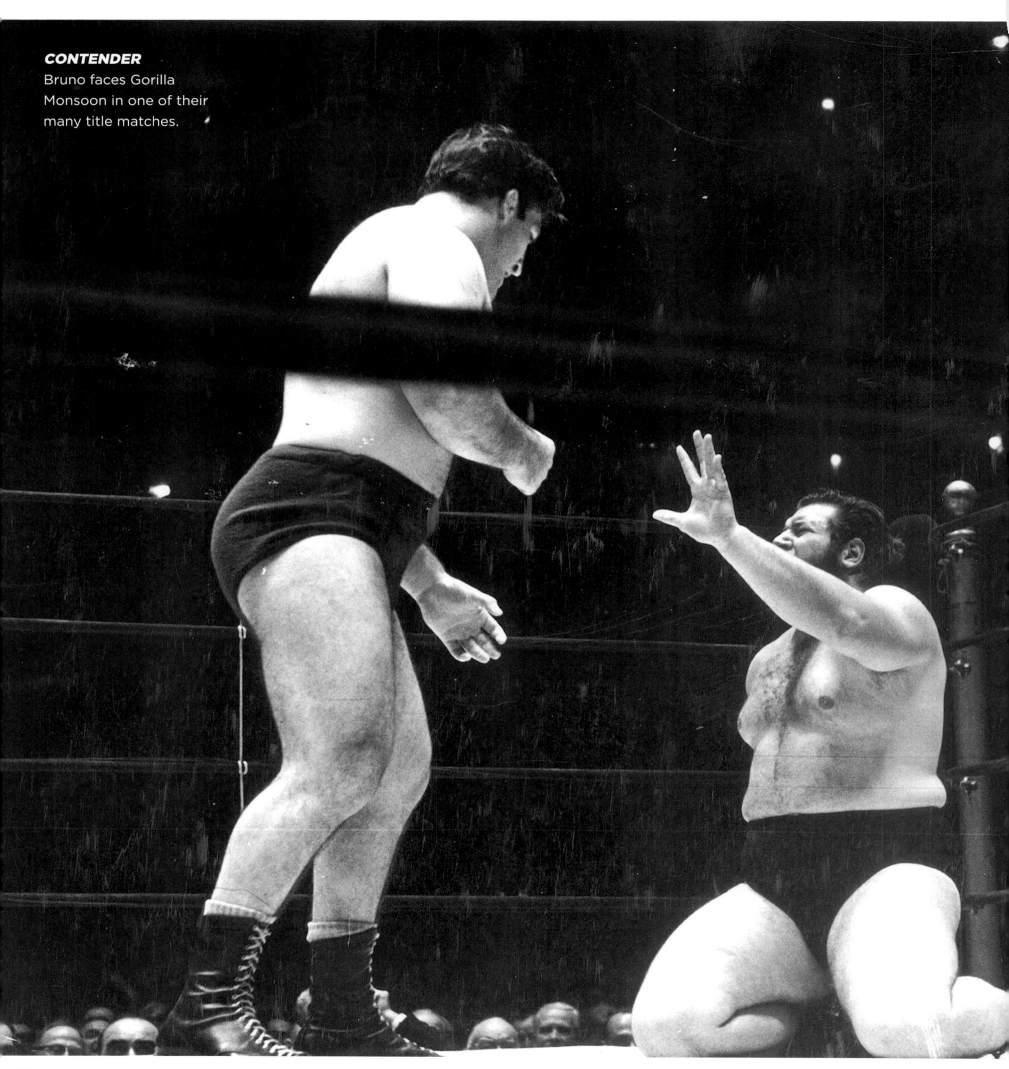

Bruno faces Gorilla Monsoon in one of their many title matches.

▼ WWE LEGEND
Bruno is inducted
into the WWE Hall
of Fame in 2013.

the WWE Championship. This win would kick off a historic seven-year run with the title, which saw Bruno battling with such legends as Gorilla Monsoon and Killer Kowalski. During this period, he sold out Madison Square Garden an unbelievable 187 times. His loss of the Championship to Ivan Koloff in 1971 was so significant it brought the Garden crowd to absolute silence. The referee, fearing a riot in the wake of Bruno's defeat, did not even hand Koloff the gold in the ring.

"A COMBINED REIGN OF OVER ELEVEN YEARS."

Two years after that heartbreaking loss, Bruno won back the title, defeating Stan Stasiak on December 10, 1973. Three years later, Bruno broke his neck in a match against Stan Hansen—this led to a rematch at Shea Stadium that became one of the biggest-drawing events of all time.

In 1977, Sammartino lost the WWE Title to an up-and-coming Superstar named, appropriately enough, "Superstar" Billy Graham. The loss marked the final time that Bruno Sammartino would hold the WWE Championship, having amassed a combined reign of 4,040 days—over eleven years!

Following his retirement from regular in-ring competition, Sammartino transitioned into a role as a commentator while also helping launch his son David's burgeoning wrestling career. He also took part in the occasional match, competing alongside his son in a match against Brutus Beefcake and Johnny Valiant, and defeated Randy Savage in a match for the WWE Light Heavyweight Championship. However, since the win was via disqualification, Sammartino could not claim the title. In 1987, Sammartino competed in his final WWE match, nearly 30 years after he made his debut, teaming with Hulk Hogan to defeat King Kong Bundy and One Man Gang.

As Sammartino, the most iconic Superstar of his era, battled alongside Hogan, the icon of his own time, it was a fitting way to bring down the curtain on a career that shaped the future of WWE itself.

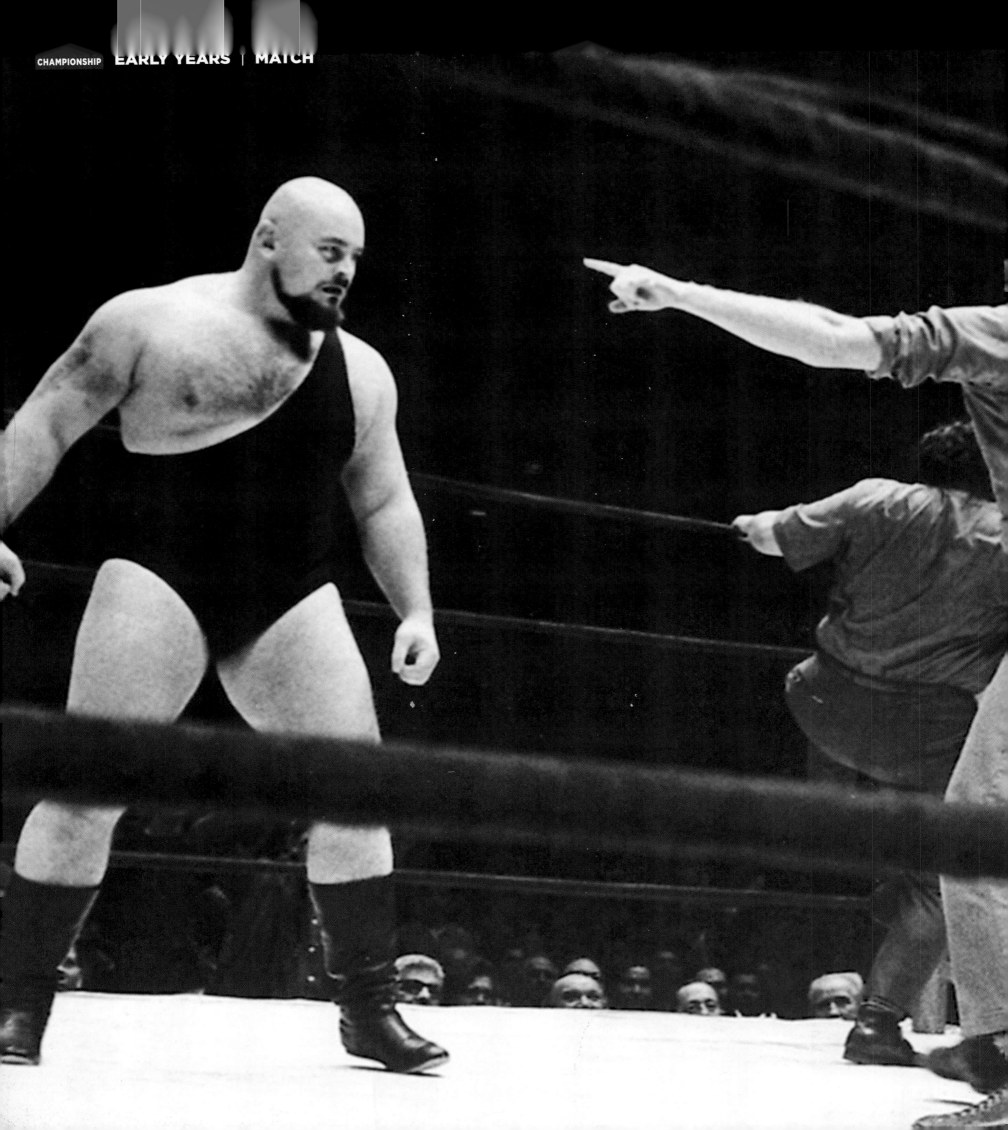

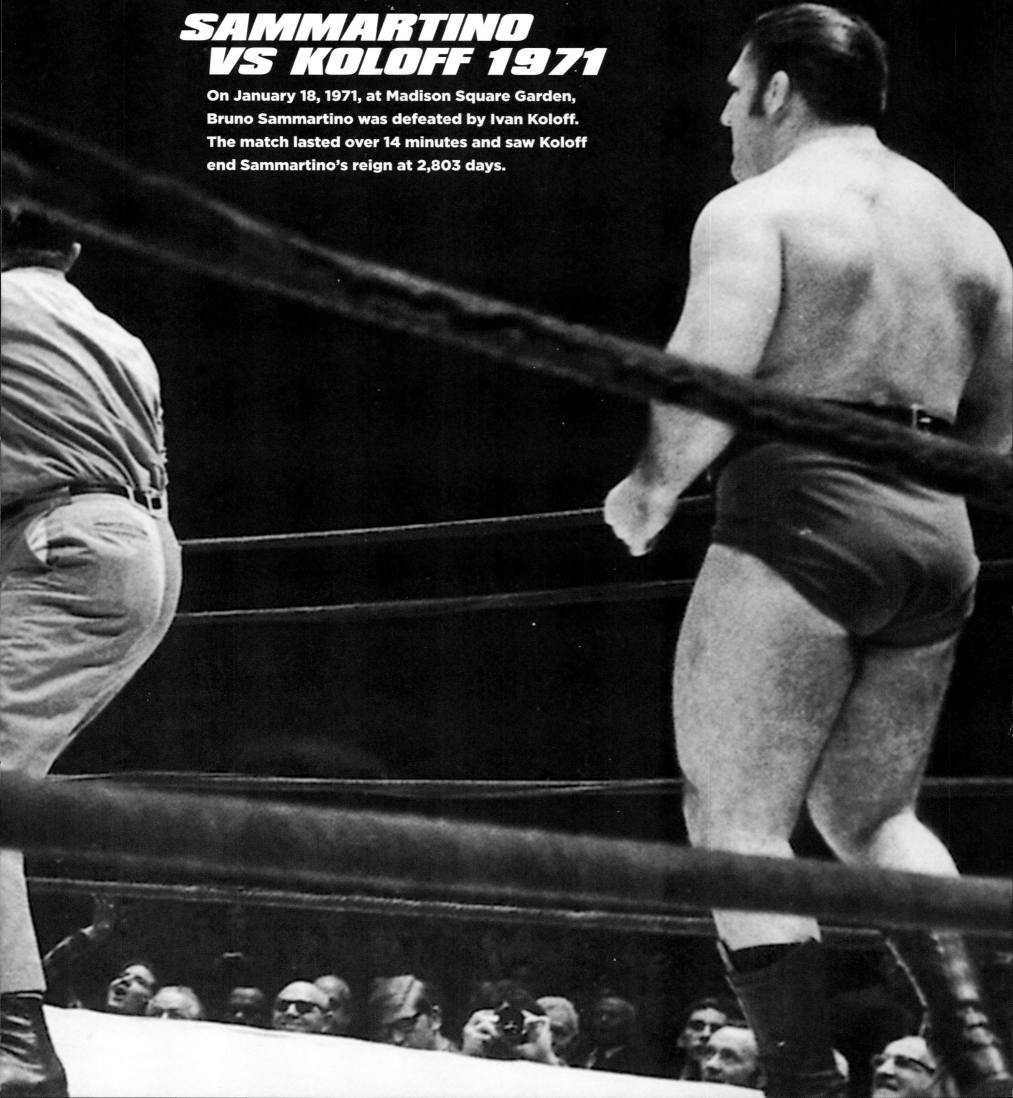

SAMMARTINO VS KOLOFF 1971

On January 18, 1971, at Madison Square Garden, Bruno Sammartino was defeated by Ivan Koloff. The match lasted over 14 minutes and saw Koloff end Sammartino's reign at 2,803 days.

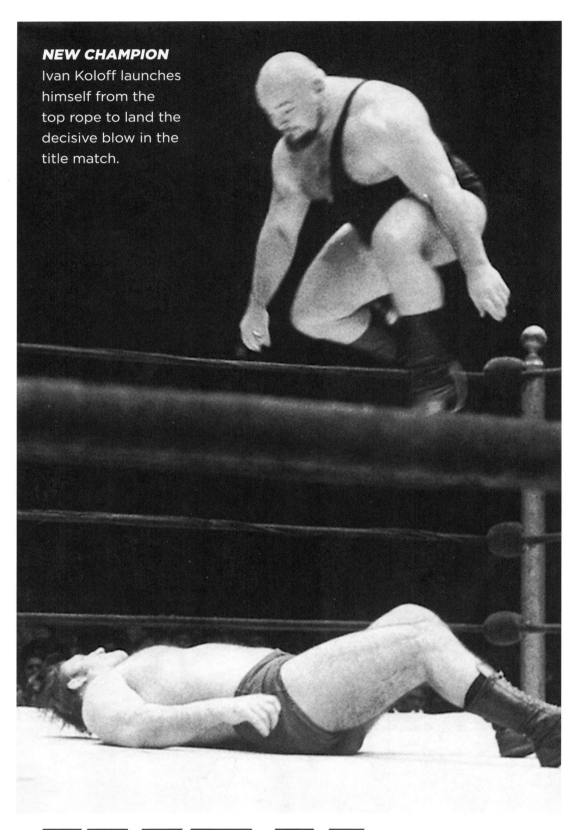

NEW CHAMPION
Ivan Koloff launches himself from the top rope to land the decisive blow in the title match.

IVAN KOLOFF

THE RUSSIAN BEAR SHOCKED THE world on January 18, 1971, when he faced the defending WWE Champion Bruno Sammartino in a title match at a sold-out Madison Square Garden. Although both Superstars were known for their crushing bear hugs, Koloff hit Sammartino with a powerful knee drop from the top rope, giving him the gold and leaving grown men in tears. At the height of the Cold War, the feared 'Soviet' had ended Bruno's almost eight-year reign. While Koloff's time at the top only lasted three weeks before he dropped the title to Pedro Morales,

"THE MAN WHO FINALLY FELLED WWE'S FIRST SUPERHERO."

he and Sammartino battled over the following decade, including the first-ever challenge for the Championship in a brutal Steel Cage Match in 1975. He also competed in unsuccessful title matches against "Superstar" Billy Graham and Bob Backlund, but he will always be remembered as the man who finally felled WWE's first superhero.

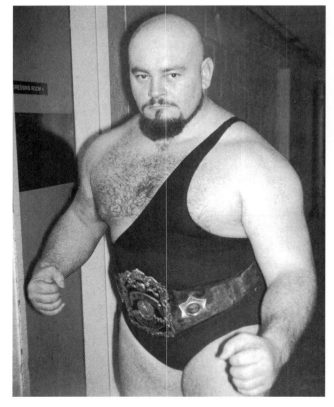

STAN STASIAK

DURING THE '70S, THE WWE Universe loved to hate the snarling Quebec native Stan "The Man" Stasiak. After several title matches between them, on December 1, 1973, Stasiak ended the almost three-year WWE Championship reign of Pedro Morales. It looked like Morales had the match won when he delivered a back suplex to Stasiak and went straight into a pin. However, the sneaky Stasiak was able to raise an arm, while both Morales's shoulders were on the mat. As the referee counted to three to give Stasiak the title, Morales and the Philadelphia crowd were left in shock. "The Man" reigned for just nine days, as Bruno Sammartino regained the WWE Championship from him at Madison Square Garden. Only the fifth man to ever hold the WWE Title, his time as WWE Champion was short-lived but showed the grit that made the menacing Stan Stasiak a Superstar.

> ## "STASIAK ENDED THE ALMOST THREE-YEAR REIGN OF PEDRO MORALES."

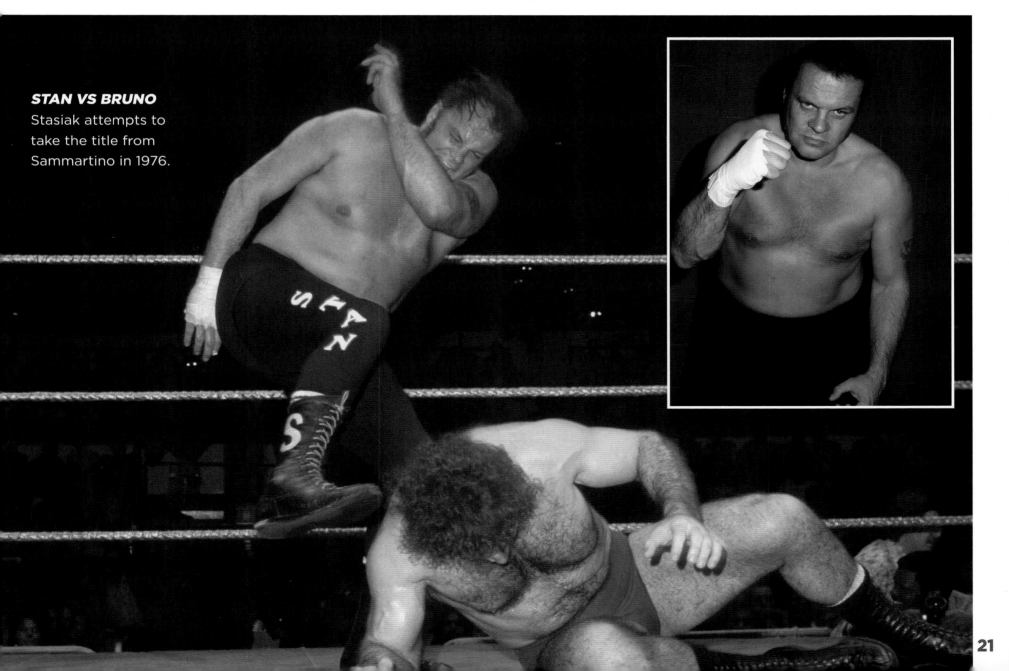

STAN VS BRUNO
Stasiak attempts to take the title from Sammartino in 1976.

21

PEDRO MORALES

HAILING FROM PUERTO RICO, PEDRO MORALES became an icon to the large Puerto Rican population of his adoptive home, New York City. In the ring he was a powerful, popular sports entertainer who often won matches by using the Boston Crab on his opponents. Joining WWE in 1971, it was less than a year later that Morales pinned "The Russian Bear" Ivan Koloff at Madison Square Garden to win the WWE Championship, avenging his friend and former WWE Champion Bruno Sammartino in the process. However, he and Sammartino faced off against each other in a legendary 75-minute draw at Shea Stadium in 1972 that later became known as "The Match of the Century." Wins over the likes of Toru Tanaka and Lonnie Mayne followed but he finally lost the Championship to Stan Stasiak in late 1973. Heading to the NWA, winning numerous regional NWA Championships, Morales returned to WWE in 1980 with more Superstar success. Claiming the World Tag Team Championship alongside then-WWE Champion Bob Backlund,

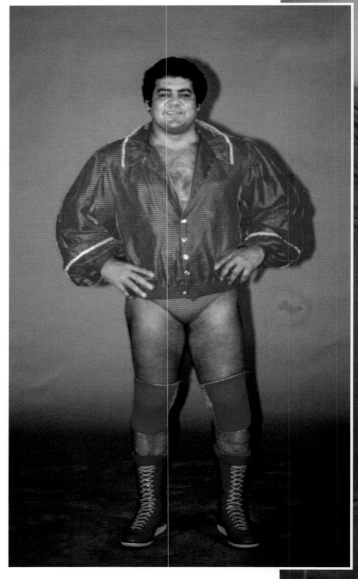

by defeating the Wild Samoans, and just four months later overcoming Ken Patera for the Intercontinental Championship, Morales made history. He became the first WWE "Triple Crown" Champion, winning the WWE, Intercontinental and World Tag Team Championships. His near thirty-year career also saw him win the United States Championship (1971) and a second Intercontinental Title (1981). After being inducted into the WWE Hall of Fame in 1995, Pedro Morales passed away in 2019 but his ground-breaking legacy will live on.

"THE FIRST WWE 'TRIPLE CROWN' CHAMPION."

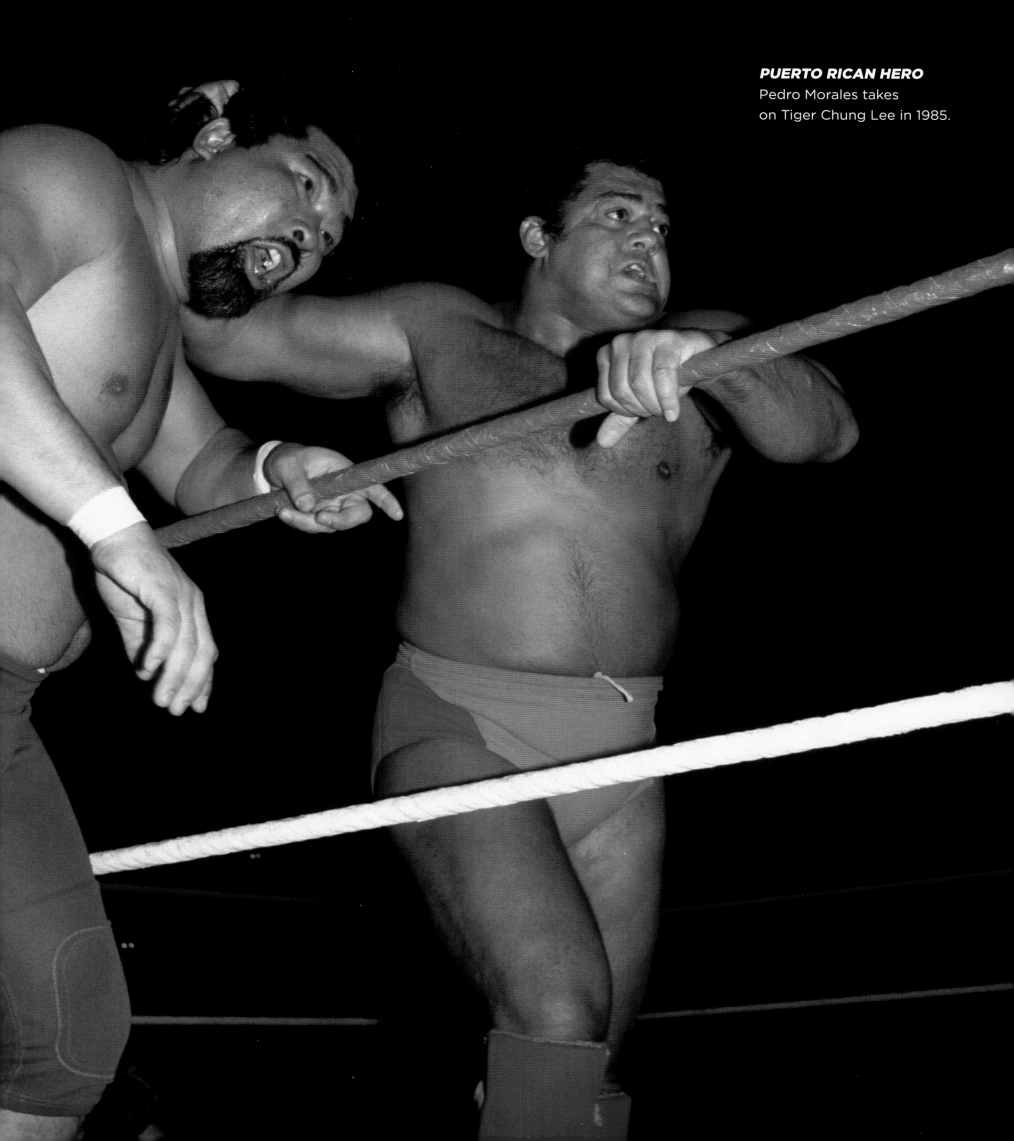

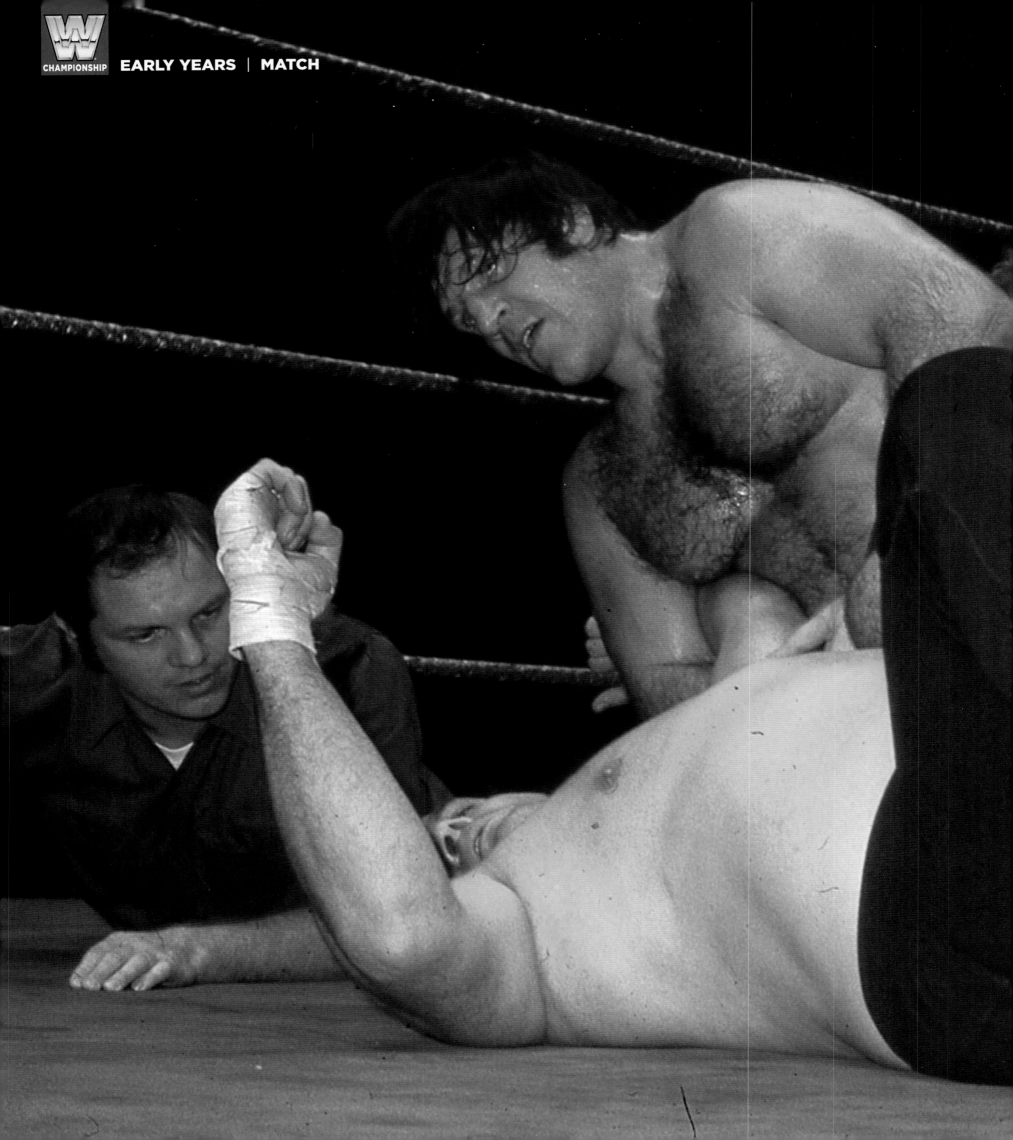

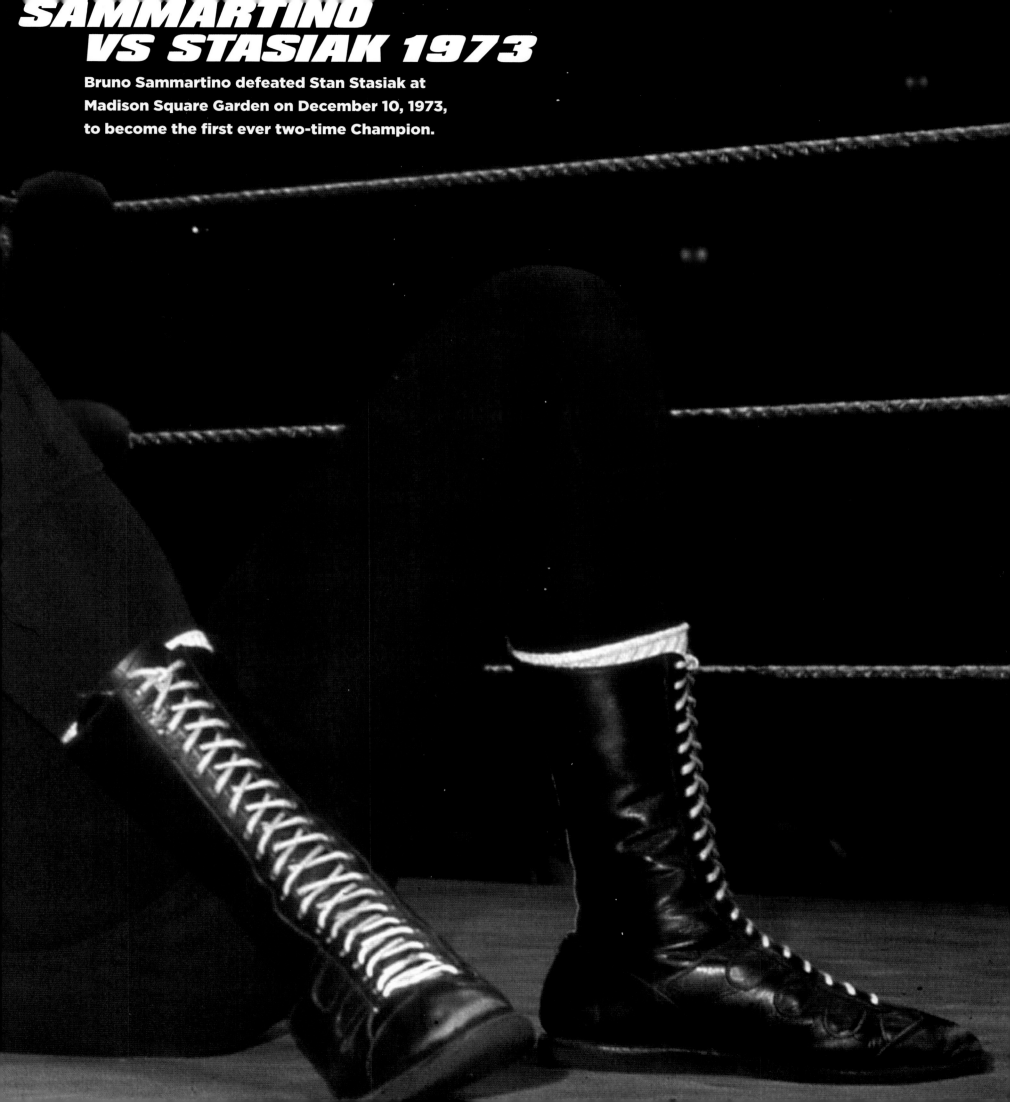

SAMMARTINO VS STASIAK 1973

Bruno Sammartino defeated Stan Stasiak at Madison Square Garden on December 10, 1973, to become the first ever two-time Champion.

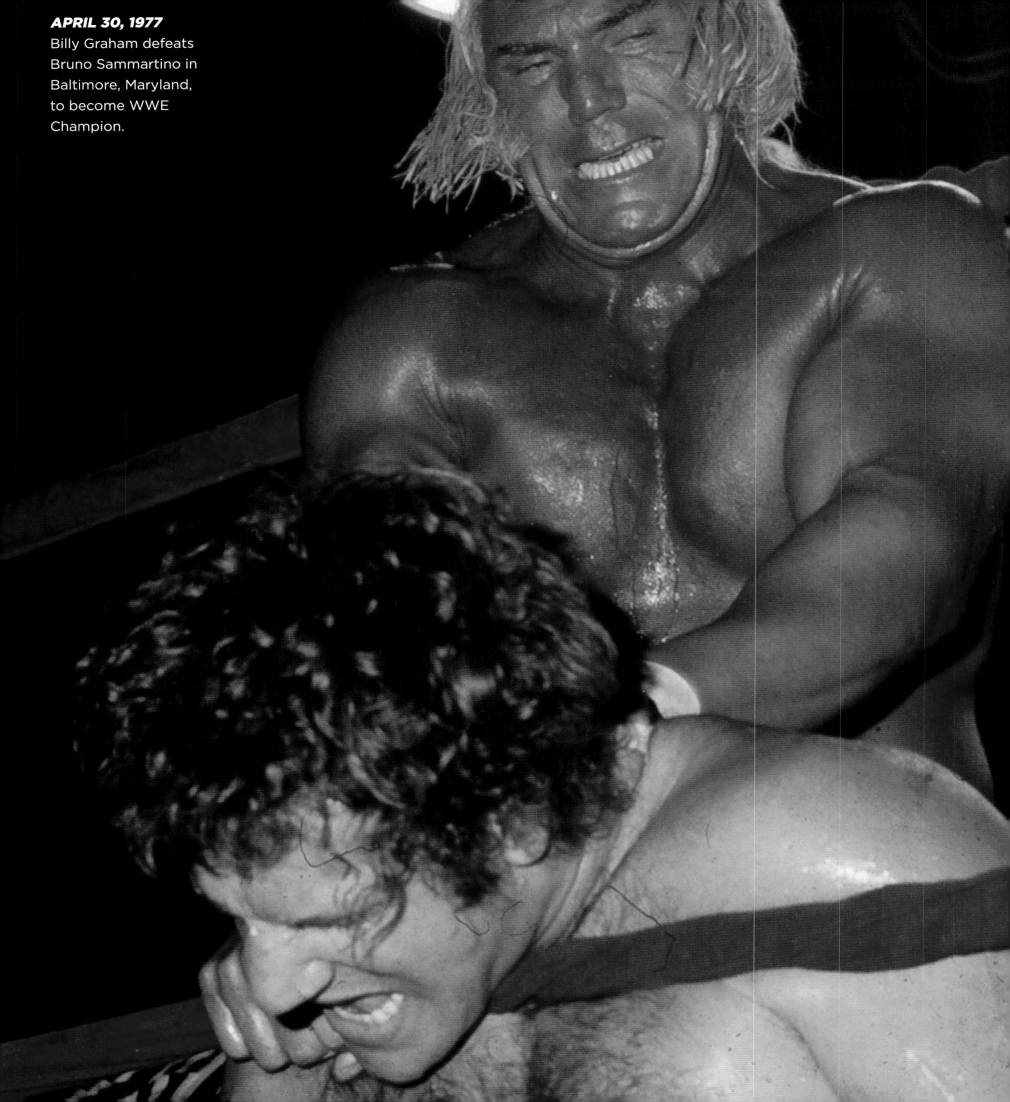

APRIL 30, 1977
Billy Graham defeats
Bruno Sammartino in
Baltimore, Maryland,
to become WWE
Champion.

"SUPERSTAR" BILLY GRAHAM

REVOLUTIONIZING SPORTS ENTERTAINMENT, "SUPERSTAR" Billy Graham changed WWE forever. From his colorful tie-dye, feathered boas and muscular physique to the interviews where he bad-mouthed his competitors and declared himself "the man of the hour, the man with the power, too sweet to be sour!", Graham was something new.

In 1977, after several unsuccessful attempts, Billy Graham finally overcame Bruno Sammartino to win the WWE Championship, celebrating alongside his equally decadent manager, the Grand Wizard of Wrestling. After that fateful night in Baltimore, he held the Championship for almost ten months, an unprecedented reign

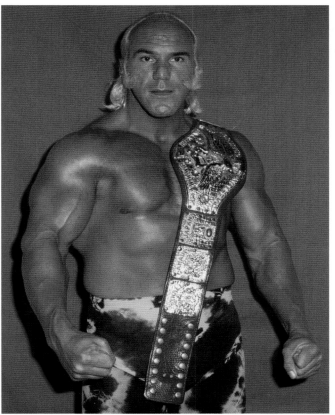

for a villain that showed "Superstar" Billy Graham's popularity with the WWE Universe. Facing challengers across the United States and Japan, including Pedro Morales, Don Muraco, Strong Kobayashi, Ivan Putski, and Gorilla Monsoon, he also battled then-NWA World Heavyweight Champion Harley Race in a grueling Unification Match in early 1978 that ended in a one-hour time-limit draw. Another rivalry during Graham's reign as Champion was with Dusty Rhodes, culminating in a Texas Bull Rope Match. Eventually, Graham lost the title to the rising Bob Backlund in early 1978. Inducted into the WWE Hall of Fame in 2004, Graham's style, look, and mic skills influenced future WWE legends like Hulk Hogan, Ric Flair, Scott Steiner, and Jesse "The Body" Ventura. A "Superstar" by both name and nature, Billy Graham paved the way for Superstars to come and declared himself "the reflection of perfection, the number-one selection."

"A 'SUPERSTAR' BY BOTH NAME AND NATURE."

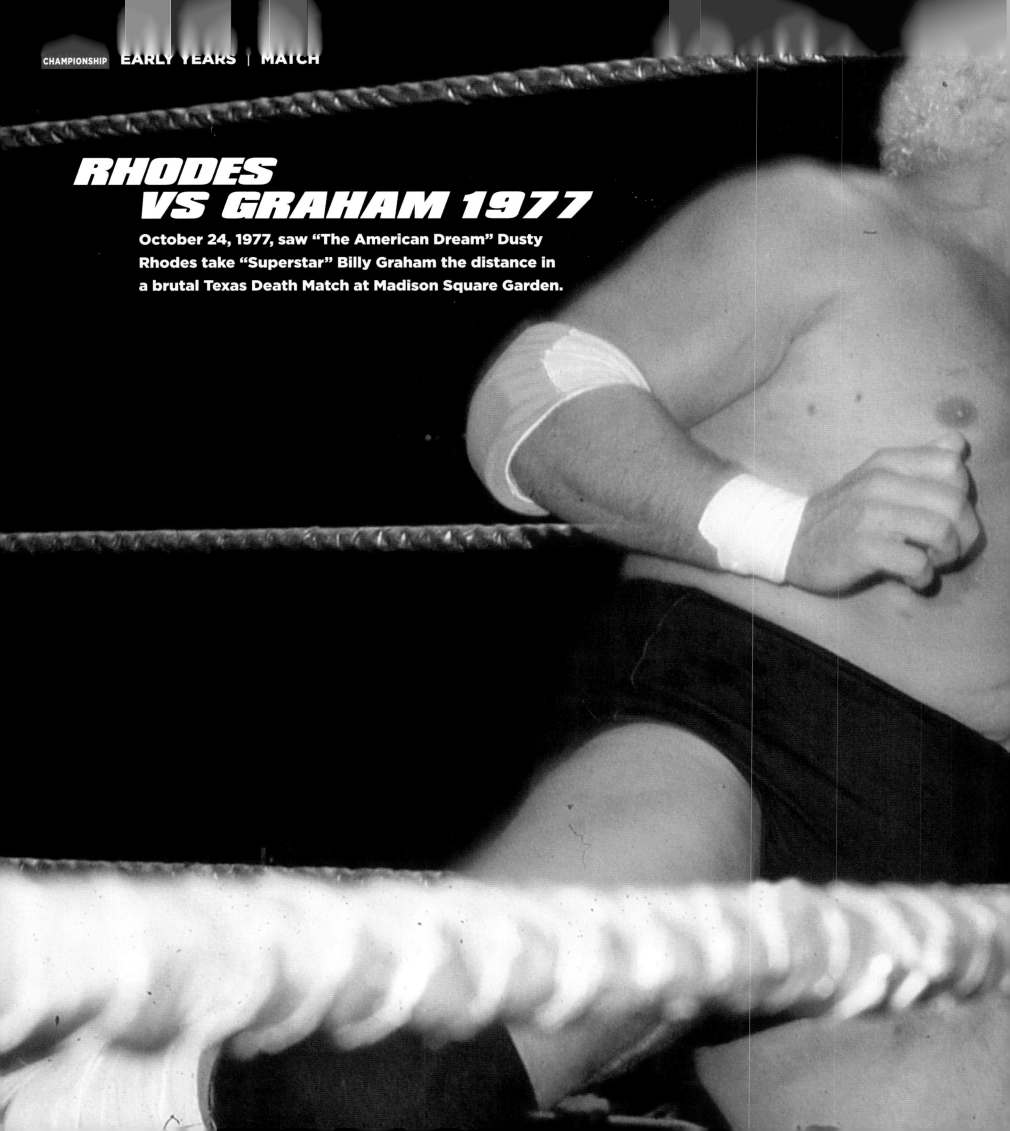

RHODES VS GRAHAM 1977

October 24, 1977, saw "The American Dream" Dusty Rhodes take "Superstar" Billy Graham the distance in a brutal Texas Death Match at Madison Square Garden.

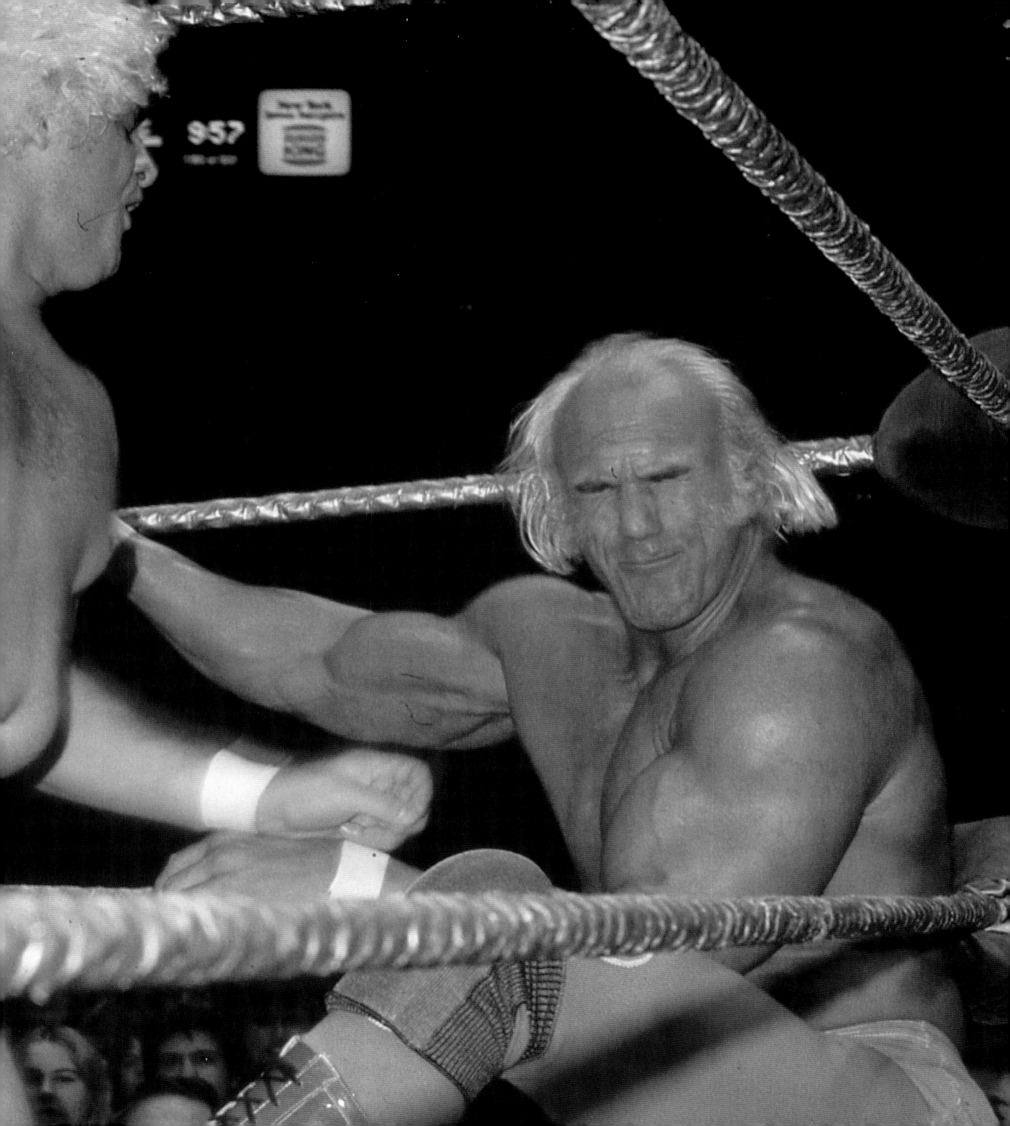

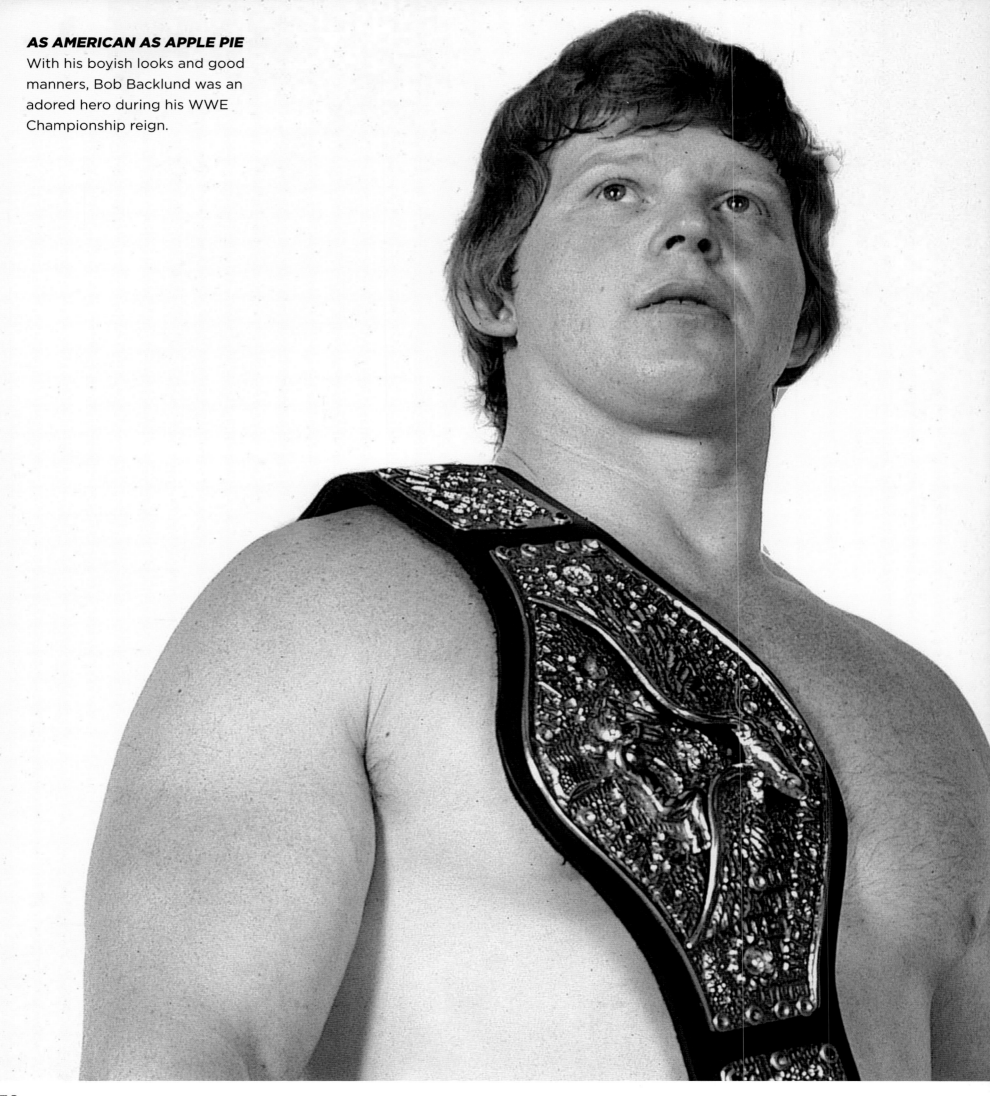

BOB BACKLUND

MINNESOTAN SUPERSTAR BOB Backlund is best known for his incredible first Championship reign, the second longest in WWE history at almost six years. He finally, and controversially, overcame his rival "Superstar" Billy Graham on February 20, 1978. Pinning him, the referee failed to see Graham get his foot on the ropes, and hit the three-count to award Backlund the title. Facing a long list of Superstars during his reign, Backlund defended the WWE Title against NWA's Harley Race and the AWA's Nick Bockwinkel. Backlund held the title until December 26, 1983, when The Iron Sheik trapped him in the Camel Clutch, leading Backlund's manager Arnold Skaaland to throw in the towel. In 1992, he made an unexpected return to WWE as the bow-tie-wearing,

unhinged Mr. Backlund. At 1994's *Survivor Series*, he faced new rival Bret Hart in a "Throw in the Towel" Match. Ironically, Backlund won his second Championship the same way he'd lost his first, locking his opponent in a submission hold, forcing Hart's mother to throw in the towel. Backlund's second reign as WWE Champion would last only three days before he dropped it against Diesel in a match that lasted around eight seconds. But as a unique Superstar and champion, Bob Backlund's first reign is nothing less than legendary.

"THE SECOND LONGEST REIGN IN WWE HISTORY."

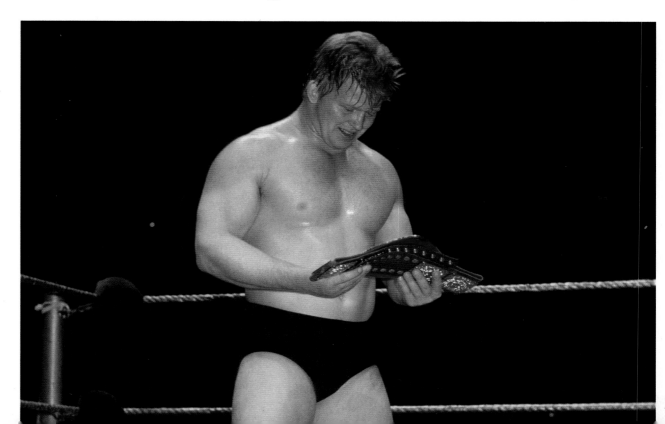

END OF AN ERA

BOB BACKLUND HAD BEEN WWE CHAMPION for nearly six years when The Iron Sheik returned to WWE and demanded a shot at the title. Backlund not only agreed to the title match but also accepted the Sheik's Persian Club Challenge: an exercise routine that involved swinging two Persian clubs (each weighing over 75lbs) around his head. Taking place just two days before their title match, the Persian Club Challenge saw The Iron Sheik attack Backlund during the routine, causing the American a serious neck injury.

When Backlund and The Iron Sheik met on December 26, 1983, at Madison Square Garden, the WWE Universe could sense something was not quite right. The champion was in pain before the bell rang and, once it did, he struggled to perform some of his signature moves. The Iron Sheik was prepared to take advantage and focused on Backlund's injured neck and shoulder throughout the bout. The match concluded with Backlund locked into the Camel Clutch. Backlund refused to submit but his manager, Arnold Skaaland, couldn't watch him suffer anymore and threw in the towel. The Iron Sheik had defeated Bob Backlund in eleven minutes and fifty seconds, and become the eighth WWE Champion, much to the disgust of virtually everyone in attendance.

This shocking turn of events not only ended Backlund's 2,135-day title reign but seemed to bookend an entire era of WWE. Soon, a new era would begin as the Sheik defended the title against a yellow-and-red-clad Superstar named Hulk Hogan.

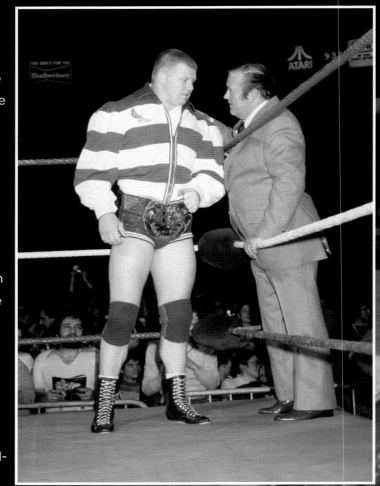

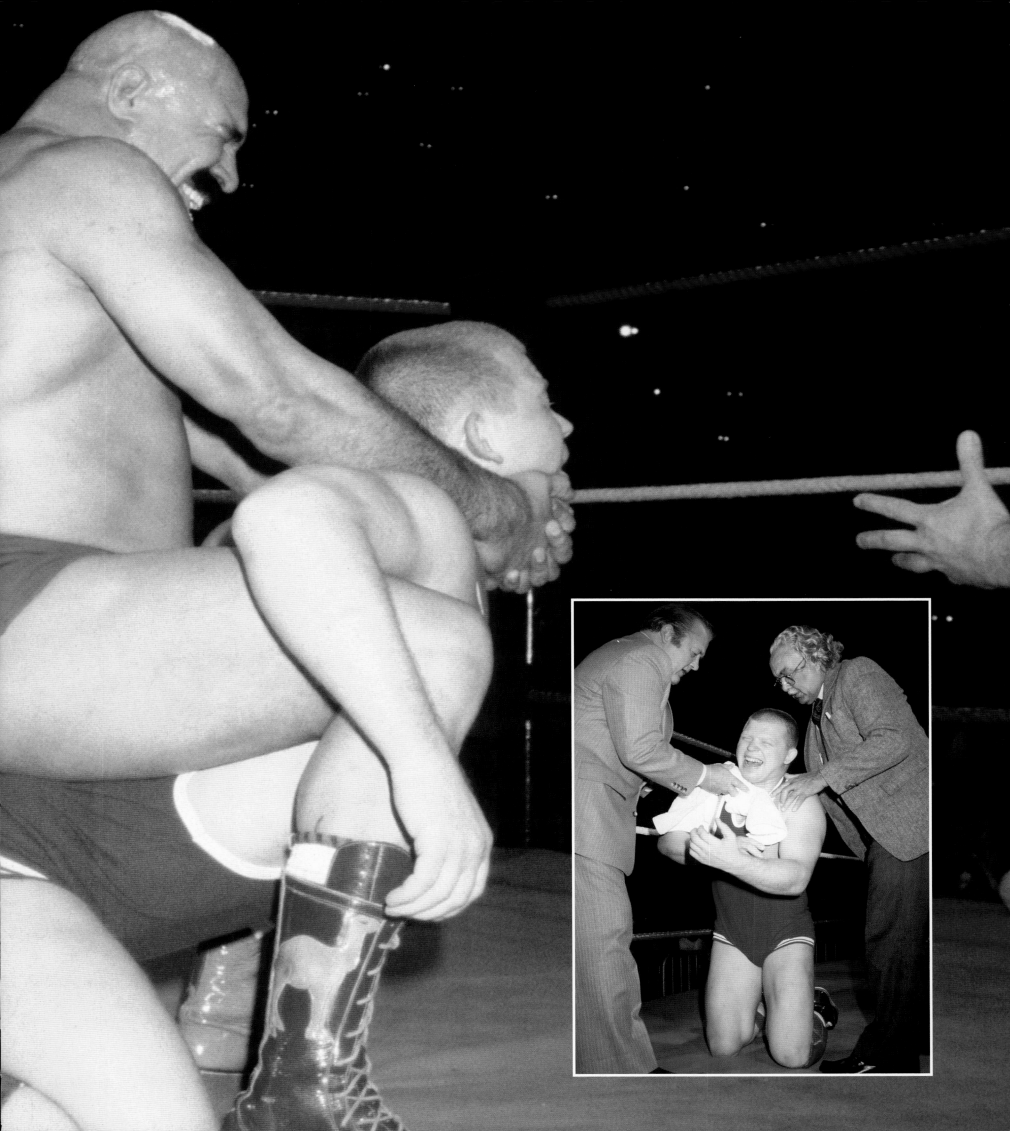

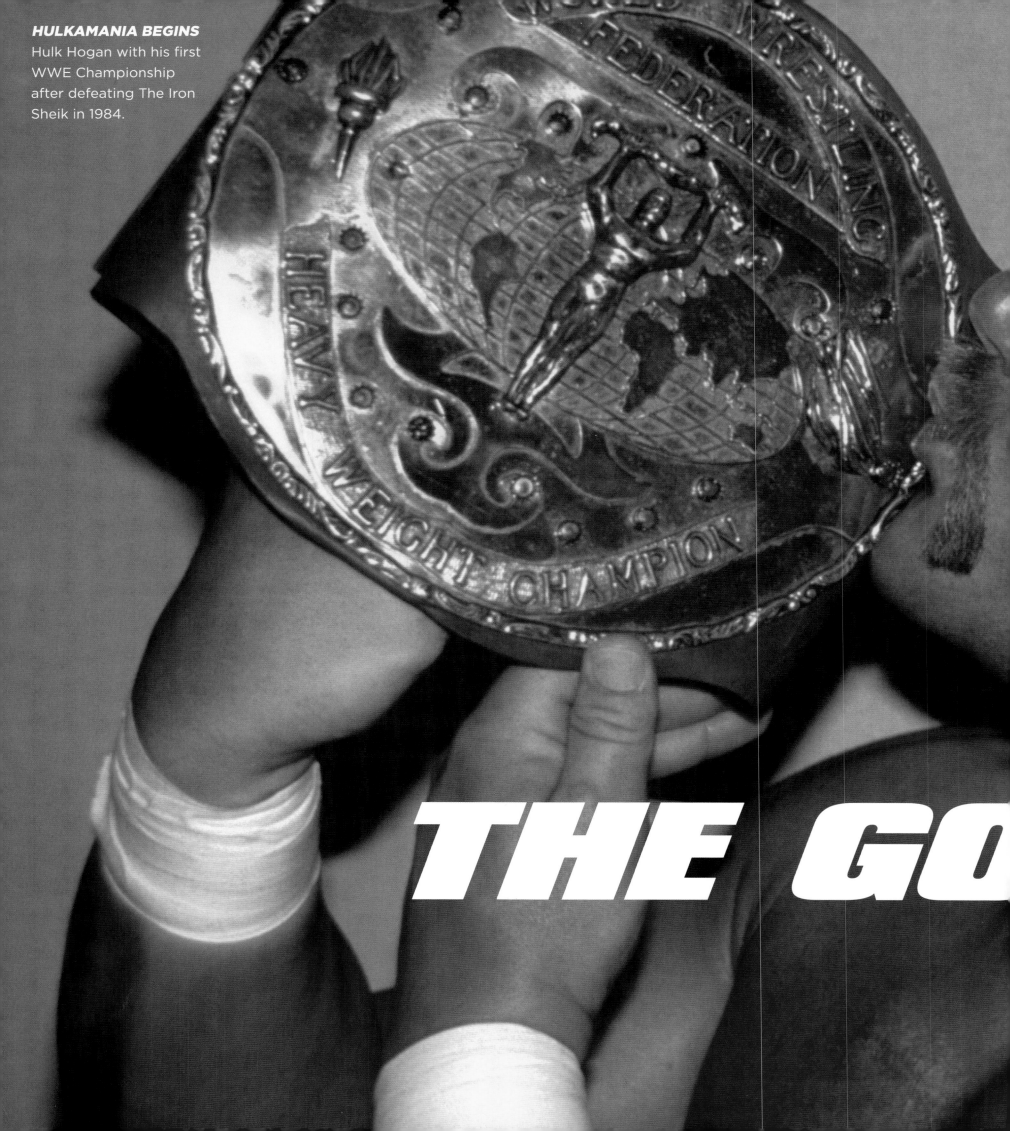

HULKAMANIA BEGINS
Hulk Hogan with his first
WWE Championship
after defeating The Iron
Sheik in 1984.

THE GO

GOLDEN ERA
1980s – EARLY 1990s

With TV networks now beaming WWE into houses across America, a changing of the guard took place in the ring as well. Colorful Superstars with larger-than-life personalities began challenging each other for the WWE Championship, Hulkamania was born and Vince McMahon introduced the world to *WrestleMania!*

AS THE '70S GAVE WAY TO THE '80S, WWE was purchased by Vincent K. McMahon, Vince Sr.'s son, who had aspirations of taking the promotion global. Part of his plan involved populating the roster with a host of larger-than-life Superstars like "Rowdy" Roddy Piper, Junkyard Dog and Jimmy Snuka.

One of the new Superstars to join was The Iron Sheik, an Iranian Superstar who combined technical mastery with flamboyant theatricality.

On December 26, 1983, Bob Backlund faced the Sheik in the ring for the WWE Championship. During the match, the Sheik locked Backlund in the Camel Clutch submission hold. Backlund refused to give in to the maneuver, until his manager, Arnold Skaaland, was forced to throw in the towel, turning the title over to The Iron Sheik and ushering in a new era for WWE.

Less than a month later, the Sheik was beaten by a rising Superstar named Hulk Hogan. With his blond hair, muscles and wild promos, Hogan was an immediate hit with the WWE Universe. During his reign, the title was revamped for the new champ, with red letters being engraved on the gold plate, and then revised again in 1986, with a massive blue globe and 3D company logo in the center and a host of international flags adorning the straps.

Hogan's ascent coincided with the launch of *WrestleMania*, the live extravaganza that remains at the peak of WWE's event calendar. Hogan's title retention against André the Giant at *WrestleMania III* stands as one of the greatest moments not only of *WrestleMania* but of WWE itself.

Hogan's first title run came to an end when "Million Dollar Man" Ted DiBiase bought off André the Giant and referee Earl Hebner to defeat Hogan at *The Main Event*. André gave the ill-gotten gold to DiBiase, but WWE President Jack Tunney opted to vacate the title. To crown a new WWE Champion, he set up a

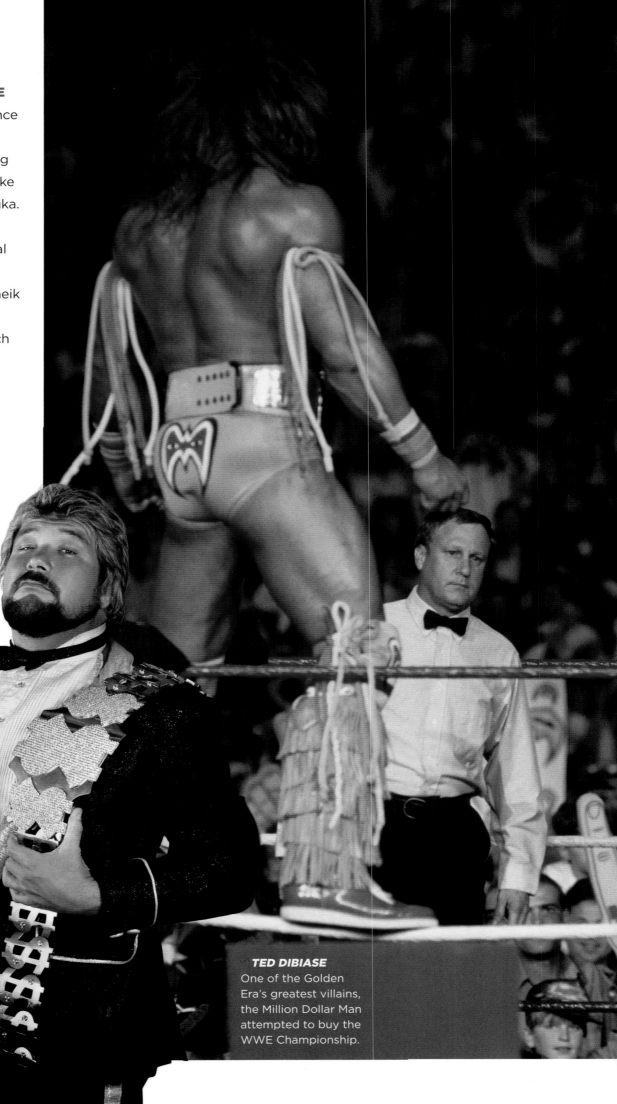

TED DIBIASE
One of the Golden Era's greatest villains, the Million Dollar Man attempted to buy the WWE Championship.

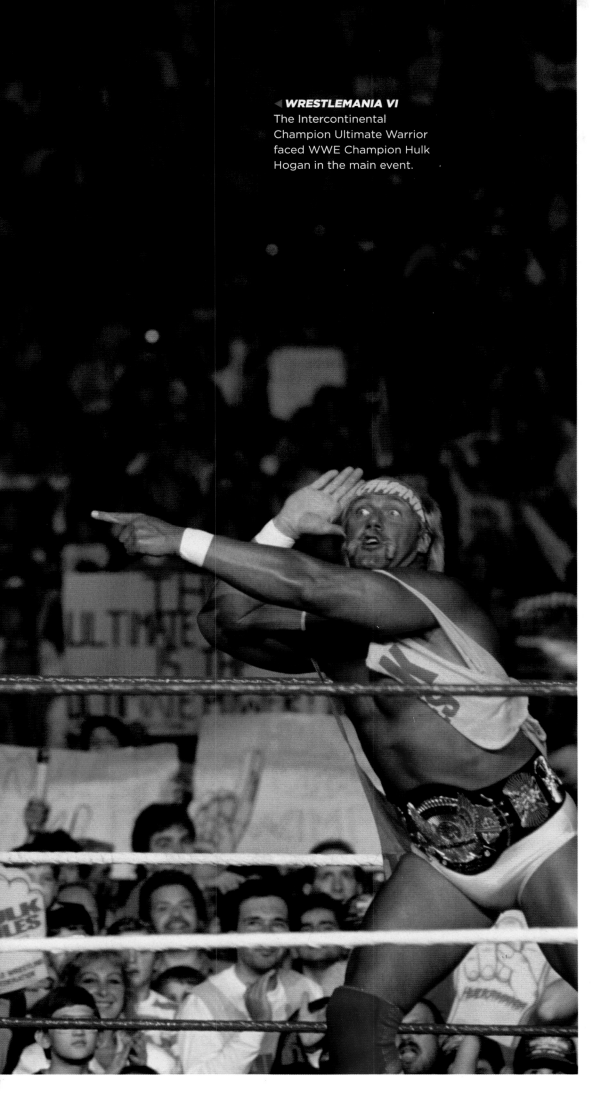

tournament at *WrestleMania IV*. Randy Savage won that tournament, defeating Ted DiBiase to win his first-ever WWE Title. This era also saw the debut of the famous "winged eagle" design, which would be one of the defining looks of the WWE Championship.

In the wake of Savage's win, Hogan and the Macho Man formed the Mega Powers tag team. However, they soon split over Miss Elizabeth, facing off at *WrestleMania V* with the title on the line. After a hard-fought battle, the Hulkster defeated Savage to win his second WWE Championship. As a result, the '80s ended with the gold around the waist of the man who had defined the era.

CHAMPIONSHIP EVENTS

In 1990, WWE broke new ground by holding *WrestleMania* outside the United States for the first time. At *WrestleMania VI*, at the SkyDome in Toronto, Canada, Hogan and the Intercontinental Champion, Ultimate Warrior, faced off with both titles on the line. After a hard-fought battle, Warrior leveled Hogan with a splash to make the three-count. The shock felt throughout the SkyDome was overwhelming.

Warrior's run with the title lasted until he came up against Sgt. Slaughter at the *Royal Rumble*. Slaughter was making enemies of the WWE Universe with his anti-American rhetoric, and his title win inspired further hatred from the crowd. The only one who could set things right was the "Real American" himself, Hulk Hogan. Hogan faced Sarge at *WrestleMania VII*, claiming the win with a boot and a leg drop.

Hogan lost the title at *Survivor Series* to a debuting Superstar known as Undertaker, before winning it back just six days later. However, due to outside interference in both title matches, the Championship was once again vacated with the title becoming the ultimate prize for the winner of 1992's Royal Rumble Match.

In January 1992, the WWE Title was won in historic fashion by Ric Flair, who took home the gold by winning the Royal Rumble Match. Flair, who had already held multiple NWA and WCW Championships, would enter a bitter rivalry with "Macho Man" Randy Savage for much of 1992. However, a "New Generation" of Superstars had begun to enter WWE and the writing was on the wall for the champions who had defined the '80s.

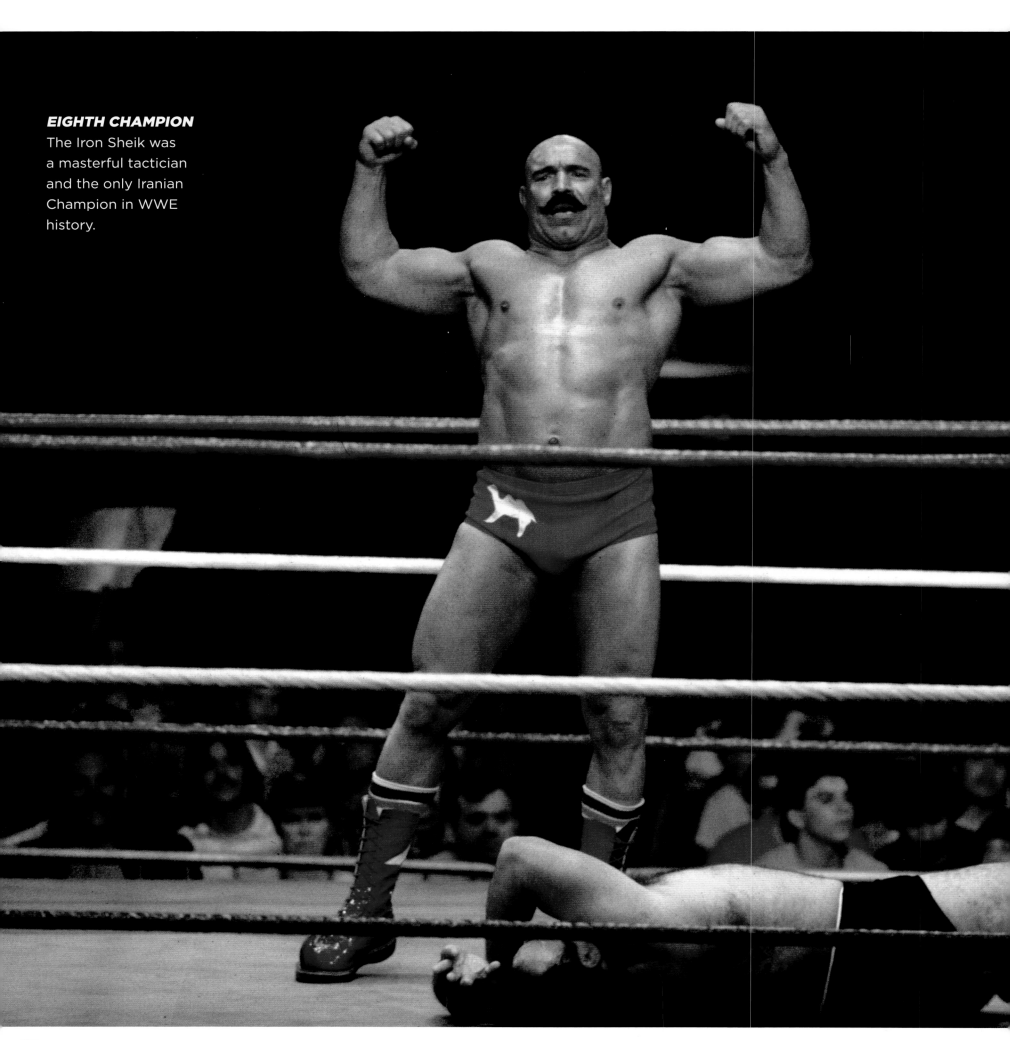

EIGHTH CHAMPION
The Iron Sheik was a masterful tactician and the only Iranian Champion in WWE history.

THE IRON SHEIK

FROM HIS AMATEUR WRESTLING DAYS IN HIS native Iran to becoming one of the most legendary villains in WWE history, The Iron Sheik was famous for nationalistic rivalries. He controversially became WWE Champion on the day after Christmas in 1983, defeating Bob Backlund with his Camel Clutch after Backlund's manager threw in the towel.

The Iron Sheik was a villain that the WWE Universe truly loved to hate, and winning the title felt like a betrayal to the very concept of the American Dream. However, The Iron Sheik's reign would last less than a month, and his loss to "Hollywood" Hogan in early 1984 proved integral in launching Hulkamania on the world.

The Iron Sheik then entered a bitter rivalry with Sgt. Slaughter, including a Boot Camp Match at Madison Square Garden. Changing focus to the Tag Team Division, The Iron Sheik teamed with Nikolai Volkoff as the Foreign Legion. This duo took on the U.S. Express (Barry Windham and Mike Rotundo) at *WrestleMania* in 1985, emerging with the WWE Tag Team Championship, after The Iron Sheik floored Windham from behind with his manager's cane. He shocked the WWE Universe by returning in '91 with a new moniker, Colonel Mustafa, and teaming up with former rival Sgt. Slaughter against Hulk Hogan and Ultimate Warrior. The Iron Sheik made another return to the ring in 2001 at *WrestleMania X-Seven,* winning a Gimmick Battle Royal that involved WWE legends famous for their outlandish personas.

A Champion against the odds, The Iron Sheik would do whatever it took to win the gold.

"A VILLAIN THE WWE UNIVERSE LOVED TO HATE."

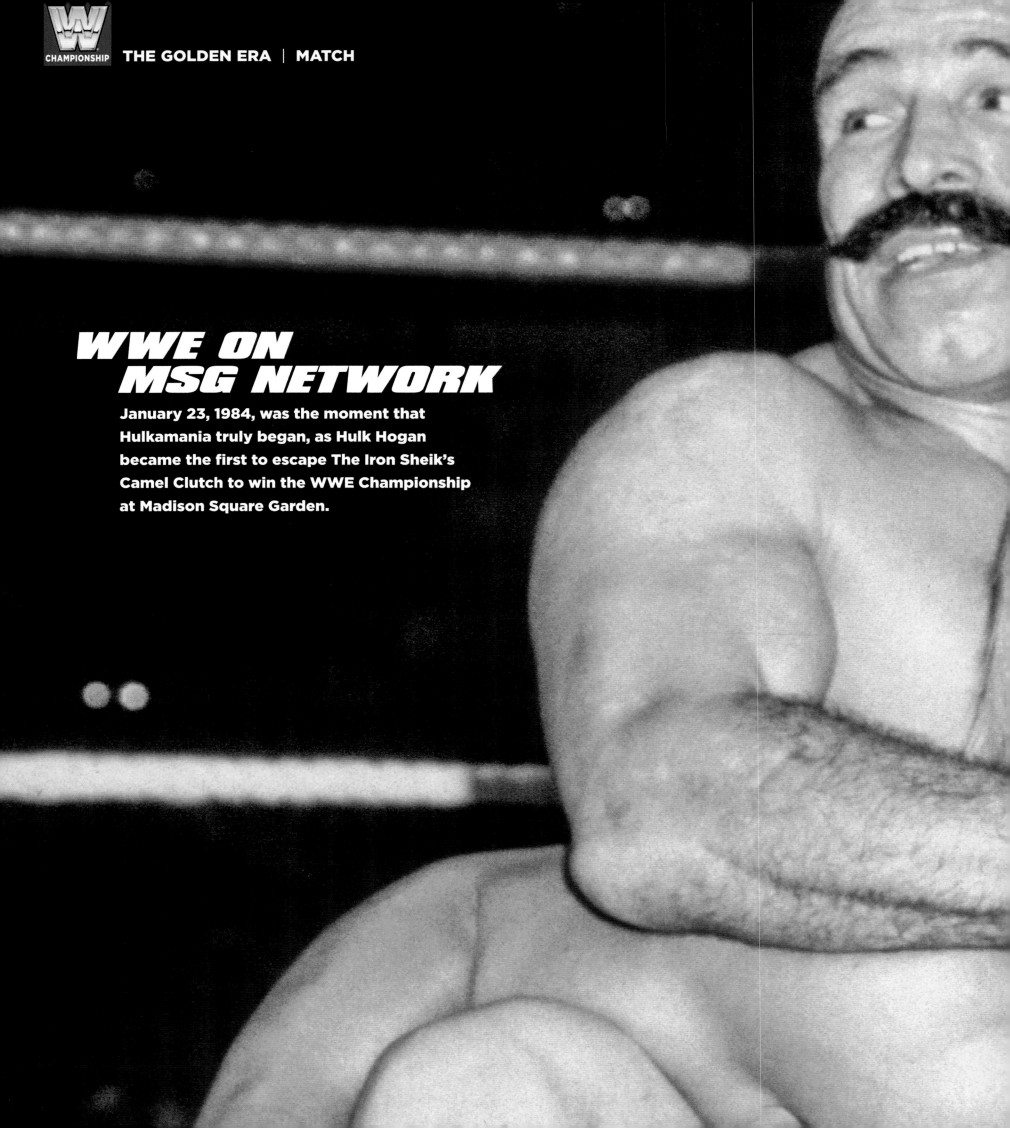

WWE ON MSG NETWORK

January 23, 1984, was the moment that Hulkamania truly began, as Hulk Hogan became the first to escape The Iron Sheik's Camel Clutch to win the WWE Championship at Madison Square Garden.

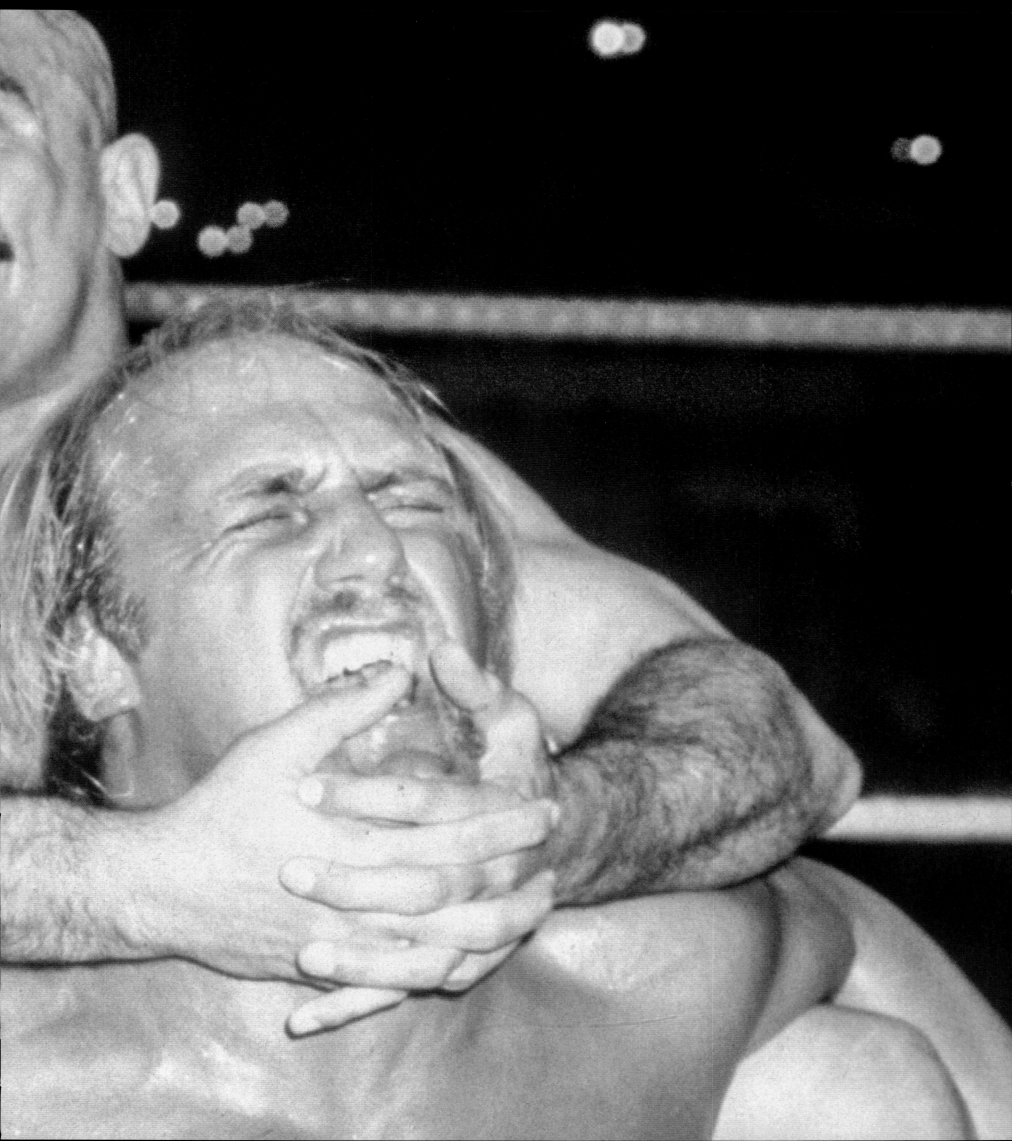

HULK HOGAN

A TRUE ICON OF SPORTS ENTERTAINMENT, Hulk Hogan changed WWE with his charisma and domination, setting the standard for all Superstars to come. The Hulkster first won the Championship in 1984 at New York City's Madison Square Garden, becoming the first Superstar to escape The Iron Sheik's Camel Clutch, overpowering him before hitting a Running Leg Drop to claim the gold. The yellow-and-red-clad hero cemented himself in WWE history, headlining the first three *WrestleManias* as WWE Champion. After teaming up with Mr. T to take on "Rowdy" Roddy Piper and "Mr. Wonderful" Paul Orndorff at the first *WrestleMania*, he successfully defended the title in a Steel Cage Match at *WrestleMania 2*. But it was against André the Giant at *WrestleMania III* that Hogan secured his place in legend, unbelievably defeating his colossal opponent with "the slam heard 'round the world" to retain the WWE Title again. André finally ended Hogan's first Championship reign in a controversial rematch on an edition of *The Main Event*, with the referee awarding the Giant the win, even though Hogan's shoulder was up. Another spectacular

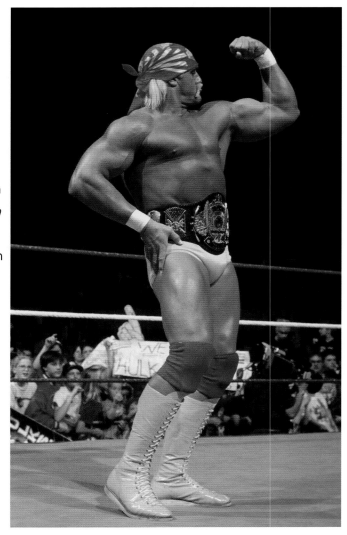

"THE FACE OF WWE DURING THE '80S & '90S."

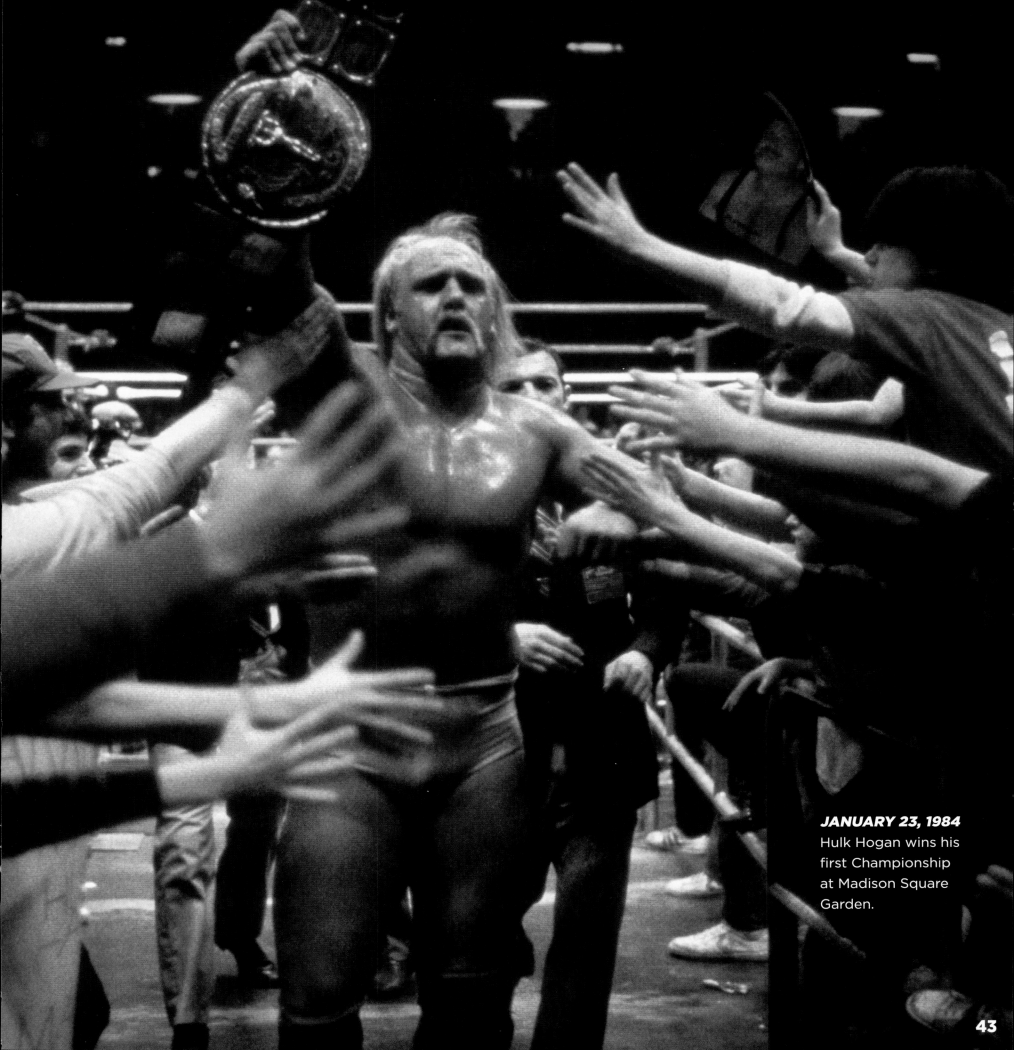

JANUARY 23, 1984
Hulk Hogan wins his
first Championship
at Madison Square
Garden.

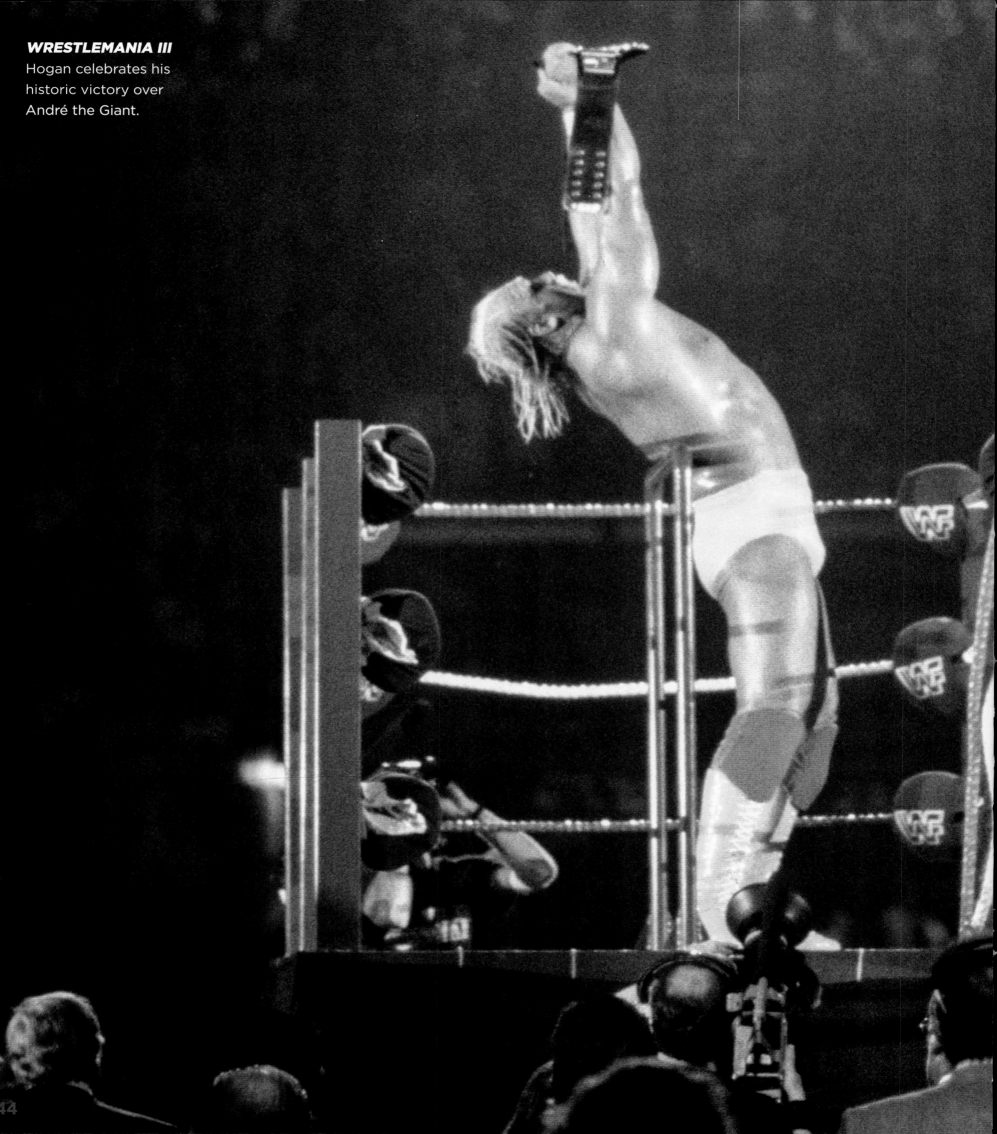

Hogan celebrates his historic victory over André the Giant.

headline match at *WrestleMania V* saw Hogan defeat his former tag-team partner "Macho Man" Randy Savage to win the Championship again. Hogan's second reign lasted 364 days, before being ended by Ultimate Warrior at *WrestleMania VI*.

Hogan won the WWE Championship a further three times in the early '90s. At *WrestleMania VII*, Hogan faced turncoat Sgt. Slaughter and reclaimed the title, before losing it to Undertaker at *Survivor Series* 1991. But at *This Tuesday in Texas* six days later, Hogan won back the WWE Championship from 'Taker. However, due to the interference of Ric Flair, the title was made vacant, with Flair claiming it at a Royal Rumble Match at *Royal Rumble*. At *WrestleMania IX*, the main event saw Yokozuna defeat Bret "Hit Man" Hart for the Championship, with Hogan coming to the ring to protest. Yokozuna's manager Mr. Fuji challenged Hogan on the spot and Hogan accepted. Fuji tried to throw salt in Hogan's eyes, but missed and hit Yokozuna instead, before Hogan hit Yokozuna with a Leg Drop to claim his fifth WWE Championship after a 22-second unscheduled match. Defending the title against Yokozuna at the first *King of the Ring* in 1993, a fireball shot into Hogan's face by a crooked photographer (actually Harvey Wippleman in disguise) resulted in Yokozuna reclaiming the title from Hogan. This was Hogan's last WWE pay-per-view event for almost a decade, with him competing in WCW in the interim. But in 2002, Hollywood Hulk Hogan returned and delighted the WWE Universe, taking down Triple H at *Backlash* to win yet another WWE Title. Hogan had returned to the top of the mountain more than 15 years after his first WWE Championship win over The Iron Sheik. He would lose it one final time at *Judgment Day* 2002 against his old rival Undertaker. A six-time champion and the face of WWE around the globe during the '80s and '90s, no wonder Hulk Hogan is known as the 'Immortal One'.

▶ *FACE OF THE '80S*
Hogan's personality helped WWE reach a global audience.

FIRST TITLE
PAY-PER-VIEW

FOLLOWING THE SUCCESS OF *WRESTLEMANIA* in March 1985, the second WWE pay-per-view event followed in November, and this time the WWE Championship was on the line. *The Wrestling Classic* at the Rosemont Horizon in Illinois consisted of a 16-man tournament, won by Junkyard Dog.

However, the real draw for the WWE Universe was a match that saw defending WWE Champion Hulk Hogan face off against his rival, "Rowdy" Roddy Piper. The two Superstars had battled at *WrestleMania* in a Tag Team Match and their rivalry had built to this title match, pitting Hogan's force against Piper's cunning. The intense bout quickly spilled out of the ring in front of the roaring 14,000-strong crowd. Back between the ropes, Hot Rod landed dirty shots to Hulk's throat before Hogan leveled Piper with a clothesline, to roars from the WWE Universe. Pummeling Piper with a suplex and elbow drops, the champion used a bear hug when Piper jumped from the ropes. Piper broke free and hit a sleeper hold, but Hogan battled back and Hulked up. As they exchanged blows, Piper hurled Hogan into the ref, knocking him down. Taking advantage of the referee's absence, Piper hit Hogan with a foreign object, but it wasn't enough and Hogan locked Piper in a sleeper hold. At this point, chaos ensued. Bob Orton entered the ring and hit Hogan with his cast, the official disqualified Piper, and Hogan retained the title.

The first PPV to feature a Championship Match, *The Wrestling Classic* laid the foundation for the events that followed.

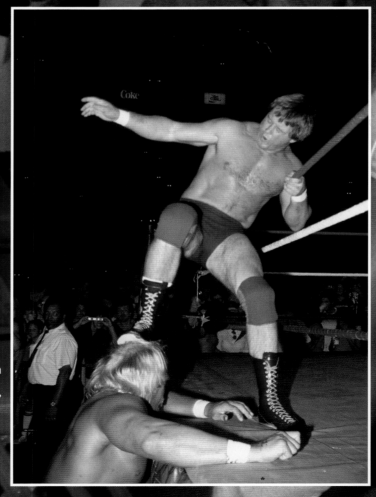

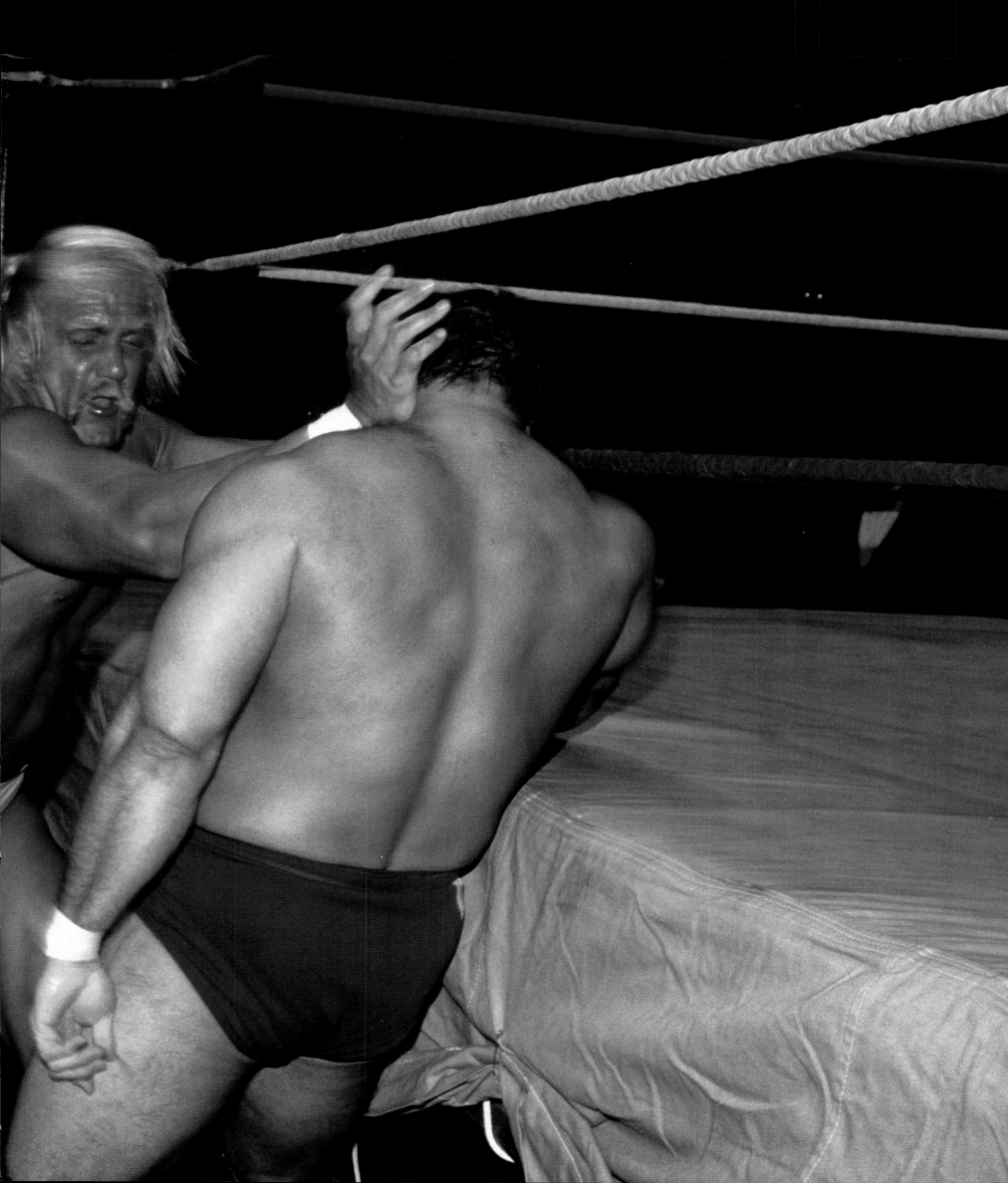

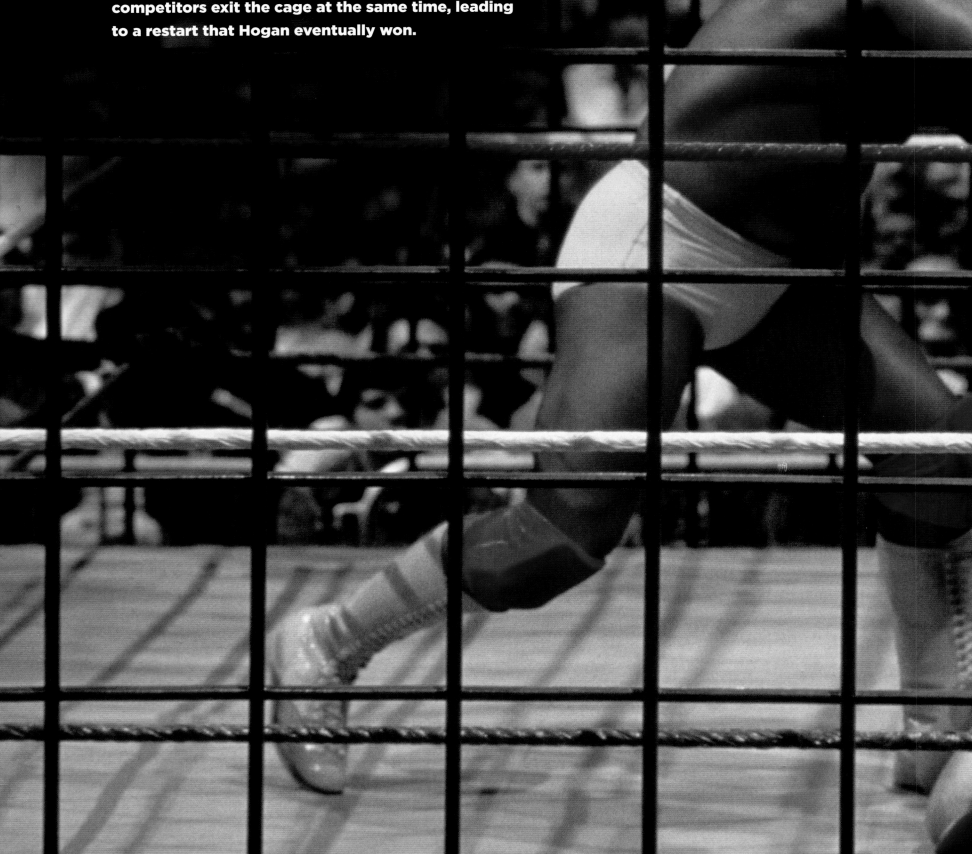

SATURDAY NIGHT MAIN EVENT 1987

On January 3, 1987, Hulk Hogan faced "Mr Wonderful" Paul Orndorff in a Steel Cage Match that saw both competitors exit the cage at the same time, leading to a restart that Hogan eventually won.

WRESTLE MANIA III

The very definition of an irresistible force meeting an immovable object, the Main Event at *WrestleMania III* saw Hulk Hogan take on André the Giant. The Hulkster would eventually lift and slam the Giant to retain the gold.

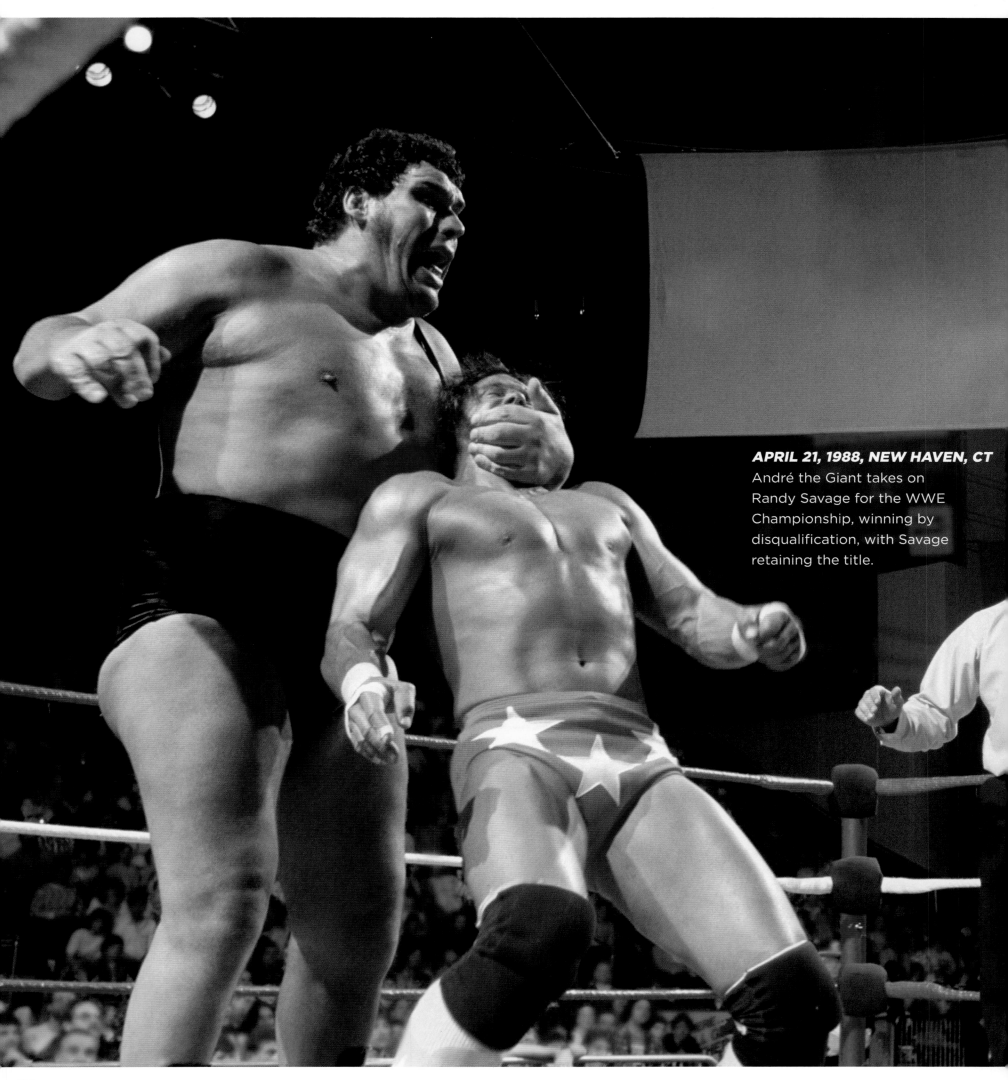

APRIL 21, 1988, NEW HAVEN, CT
André the Giant takes on Randy Savage for the WWE Championship, winning by disqualification, with Savage retaining the title.

ANDRÉ THE GIANT

BORN IN A SMALL FRENCH FISHING VILLAGE, the "Eighth Wonder of the World" André the Giant rose to the peak of WWE in the '70s and '80s. The towering seven feet, four inches, 500-plus pounds Superstar shocked the WWE Universe in 1987 when he turned on his long-time ally Hulk Hogan for his first-ever shot at the WWE Championship at *WrestleMania III*. However, Hogan successfully defended the title and ended André's 15-year winning streak by defying gravity and making history, taking down the Giant with "the slam heard 'round the world". Despite the loss, André continued to chase the WWE Title for nearly a year and finally claimed the gold in a rematch against Hogan on *The Main Event*. After the controversial win, the Giant didn't hold onto the title and instead sold it to the "Million Dollar Man" Ted DiBiase in a move declared invalid by WWE, vacating the Championship. This set the stage for the first-ever WWE Championship tournament at *WrestleMania IV*, won by Randy Savage. André enjoyed further success in WWE, winning the World Tag Team Titles with Haku in 1990, before passing away in Paris, France, in 1993. However, a year after his death the much-loved André made history again by becoming the first inductee of the newly founded WWE Hall of Fame.

From facing Hogan in one of the most famous Championship Matches ever to eventually overcoming his rival, André the Giant's massive legacy will live on.

"ANDRÉ'S MASSIVE LEGACY WILL LIVE ON."

CAN'T BUY A TITLE

DESPITE HIS LOSS AT *WRESTLEMANIA III*, André the Giant's rivalry with Hulk Hogan continued throughout 1987 as the Giant pursued the WWE Championship.

Meanwhile, another Superstar had set his sights on the WWE Title. Known as the "Million Dollar Man", Ted DiBiase believed everything and everyone had a price. However, when Hogan refused to sell the WWE Championship to him and DiBiase proved unsuccessful inside the ring, the Million Dollar Man came up with a new plan to gain the gold: pay André to win it for him.

On February 5, 1988, at *The Main Event* with Ted DiBiase in his corner, André faced Hogan for the title. André managed to pin the Hulkster and was awarded the win despite Hogan's shoulders not being down. As promised, André then surrendered the title to DiBiase. It would later be revealed that DiBiase had paid referee Dave Hebner's twin to replace the official, and to call the match in André's favor. Not long after, WWE President Jack Tunney declared the title could only be won via pinfall or submission and so André had in fact vacated the WWE Title. DiBiase's plan had failed, and the Million Dollar Man discovered the one thing his money couldn't buy.

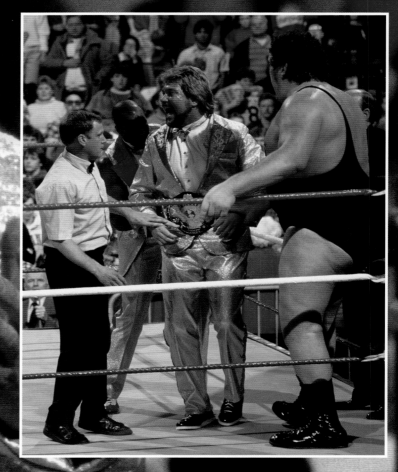

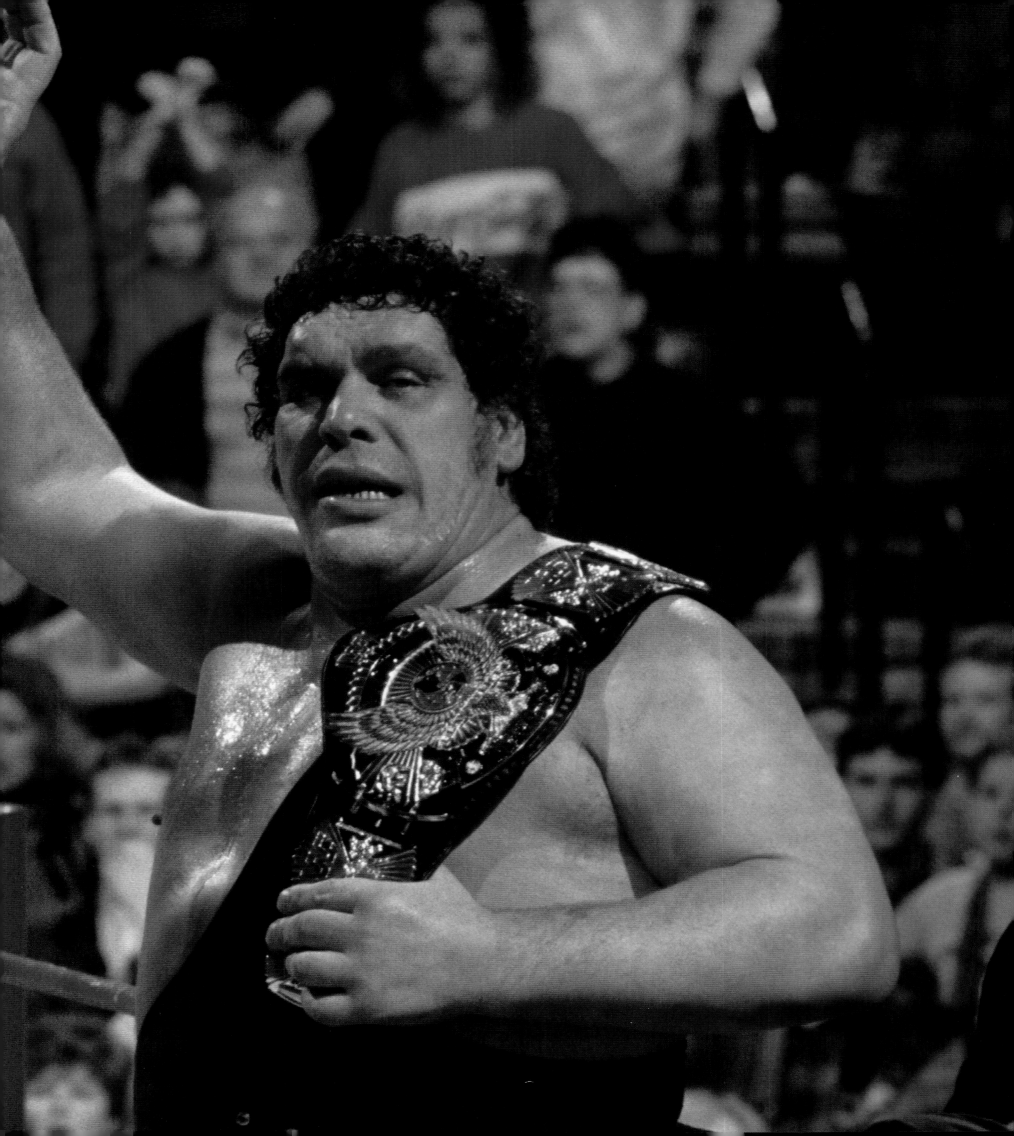

WRESTLE MANIA IV

TED DIBIASE'S CONTROVERSIAL 'WIN' ON *The Main Event* led to the title being vacated. To resolve the issue, a 14-man knockout tournament was set for *WrestleMania IV*, with the final victor taking home WWE's biggest prize.

Randy Savage made it through the first round by defeating Butch Reed, advancing to the quarter-finals, where he beat Greg "The Hammer" Valentine. By this point, the WWE Universe was beginning to suspect that the Macho Man could go all the way and were fully in his corner.

Meanwhile, Ted DiBiase was pummeling his way through opponents as well, setting up a final between Randy Savage and the Million Dollar Man. Thanks to the match between Hulk Hogan and André the Giant not having a victor, DiBiase's defeat of Don Muraco meant he advanced to the final.

After Savage defeated One Man Gang, he earned his shot against DiBiase in the final. The Million Dollar Man wasn't taking any chances, bringing André the Giant to the ring as insurance. But, thanks to some help from Miss Elizabeth, Savage also had Hulk Hogan to help keep the Giant in check.

André attempted to interfere, and was quickly admonished by the referee, giving Hogan the distraction he needed to enter the ring and clobber DiBiase. With DiBiase down, Savage had the title in his grasp. He climbed to the top rope and connected with an elbow drop and a rollup for the win. It was a moment that the Macho Man, and the WWE Universe, had been waiting for. Savage had won four matches in one day at the Show of Shows and walked away with the WWE Championship.

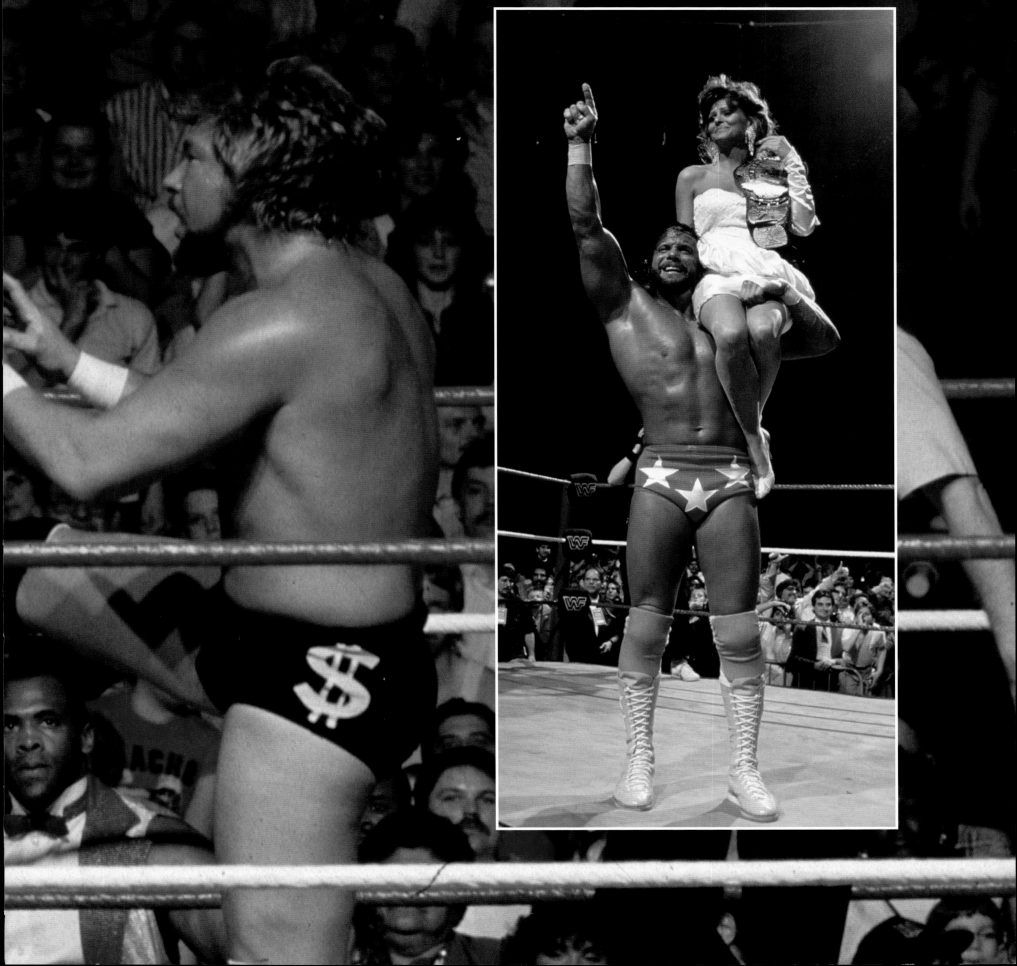

MACHO MAN

SOME WWE SUPERSTARS CAN CAPTIVATE AN ENTIRE arena with powerful, compelling and exciting promos. Other Superstars only need two words. "Macho Man" Randy Savage had the WWE Universe completely in his grip with a simple shout of "Oooooh yeaaahhhh!"

Savage joined WWE in 1985, was paired with Miss Elizabeth as his manager, and the seeds of a legendary WWE career were planted. It wasn't long before Savage defeated Tito Santana to win the Intercontinental Championship, kicking off a run with that title that culminated in a match against Ricky Steamboat at *WrestleMania III*.

At *WrestleMania IV*, Savage ascended to the top of the WWE ranks when he won a 14-man tournament to claim the vacant WWE Championship by defeating "Million Dollar Man" Ted DiBiase in the final. That title reign would last for more than a year and cement Savage's position as one of the all-time WWE greats. Eventually, at *WrestleMania V*, Savage would lose the title to Hulk Hogan, in a match that remains a high point in both Superstars' careers.

As the '90s began, Savage found himself in an intensely personal rivalry with Ric Flair over Miss Elizabeth. That rivalry exploded at *WrestleMania VIII*, when Savage defeated Flair to pick up his second WWE Championship. Following this run with the gold, Savage began to step away from in-ring competition, taking on the role of commentator before leaving WWE for good in 1994.

Even today, nearly thirty years after he left WWE, the name Randy Savage inspires excitement and awe among the WWE Universe, who will forever remember two simple words: "Oooooh yeaaahhh!

"OOOOOH YEAAAHH!"

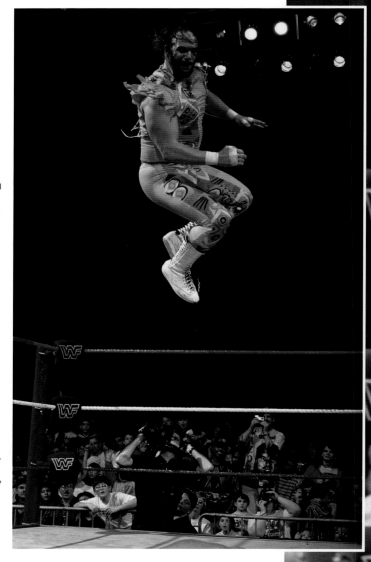

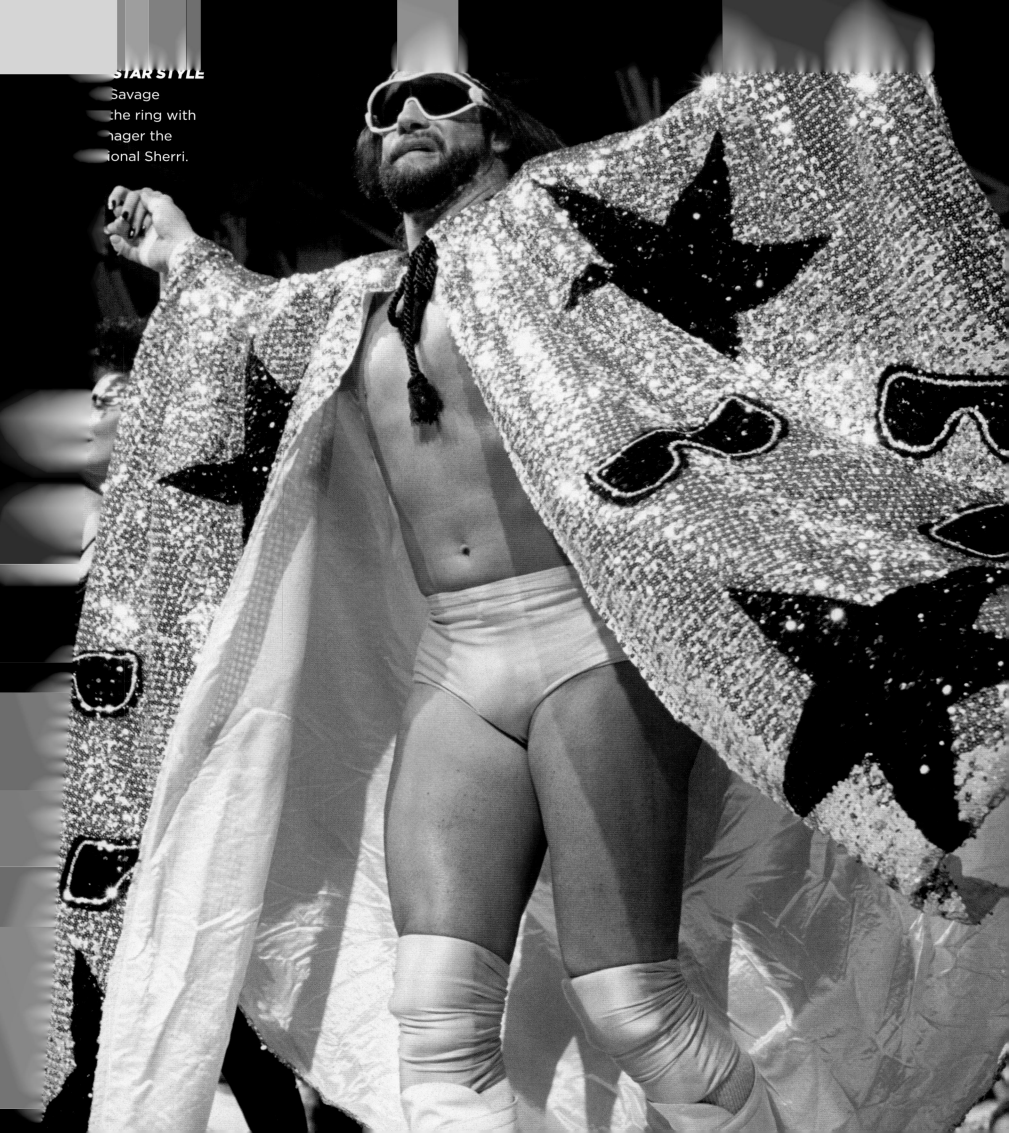

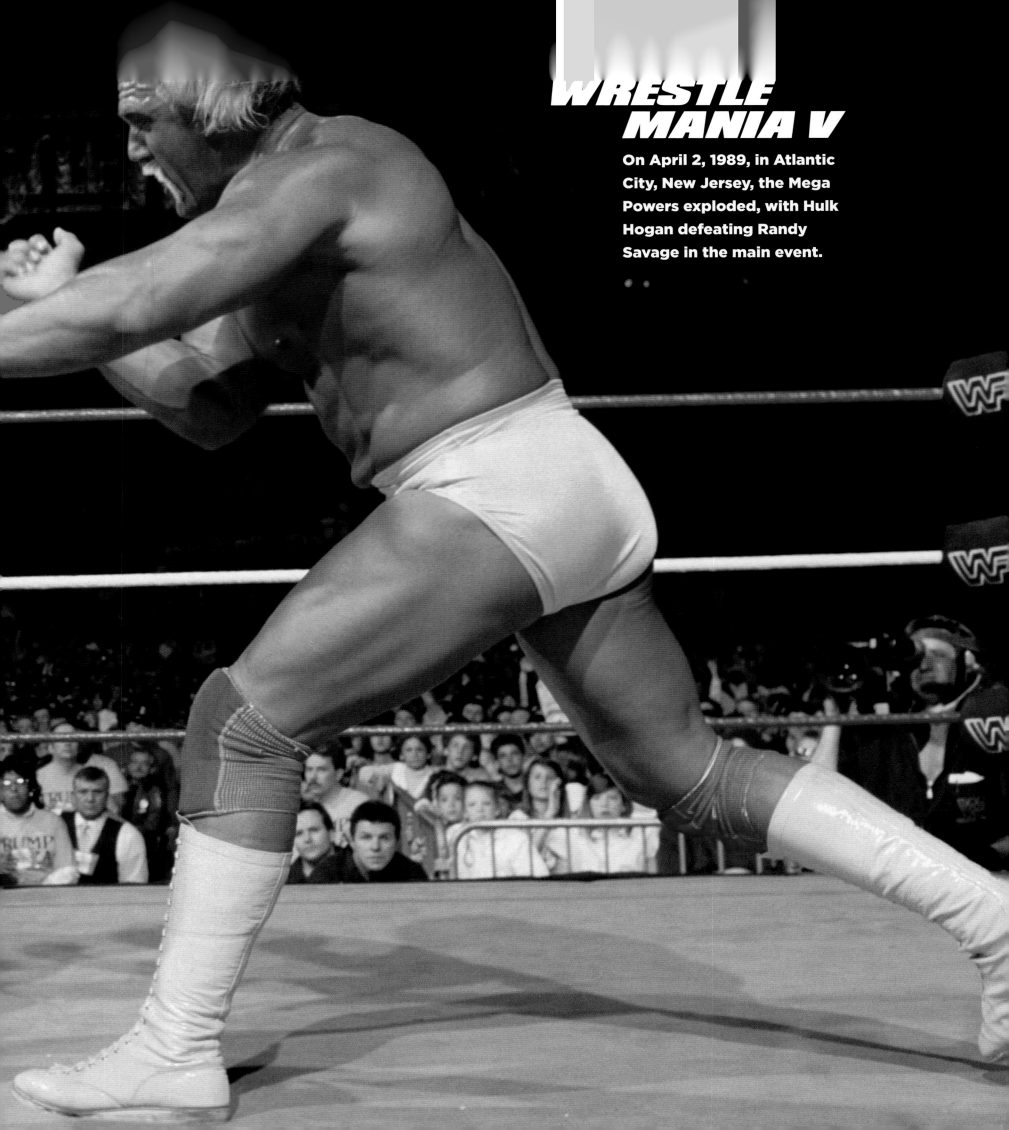

WRESTLE MANIA V

On April 2, 1989, in Atlantic City, New Jersey, the Mega Powers exploded, with Hulk Hogan defeating Randy Savage in the main event.

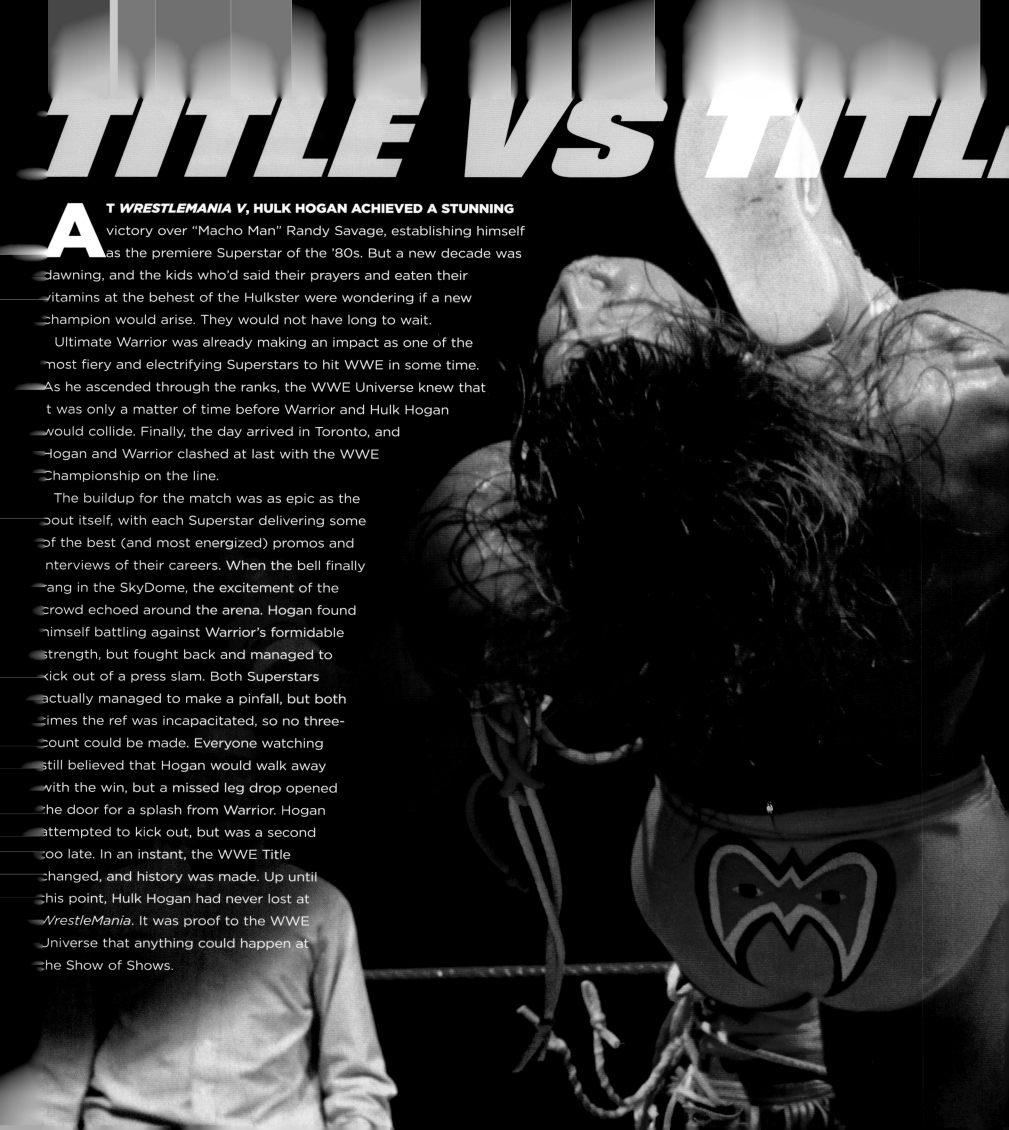

TITLE VS TITLE

AT *WRESTLEMANIA V*, HULK HOGAN ACHIEVED A STUNNING victory over "Macho Man" Randy Savage, establishing himself as the premiere Superstar of the '80s. But a new decade was dawning, and the kids who'd said their prayers and eaten their vitamins at the behest of the Hulkster were wondering if a new champion would arise. They would not have long to wait.

Ultimate Warrior was already making an impact as one of the most fiery and electrifying Superstars to hit WWE in some time. As he ascended through the ranks, the WWE Universe knew that it was only a matter of time before Warrior and Hulk Hogan would collide. Finally, the day arrived in Toronto, and Hogan and Warrior clashed at last with the WWE Championship on the line.

The buildup for the match was as epic as the bout itself, with each Superstar delivering some of the best (and most energized) promos and interviews of their careers. When the bell finally rang in the SkyDome, the excitement of the crowd echoed around the arena. Hogan found himself battling against Warrior's formidable strength, but fought back and managed to kick out of a press slam. Both Superstars actually managed to make a pinfall, but both times the ref was incapacitated, so no three-count could be made. Everyone watching still believed that Hogan would walk away with the win, but a missed leg drop opened the door for a splash from Warrior. Hogan attempted to kick out, but was a second too late. In an instant, the WWE Title changed, and history was made. Up until this point, Hulk Hogan had never lost at *WrestleMania*. It was proof to the WWE Universe that anything could happen at the Show of Shows.

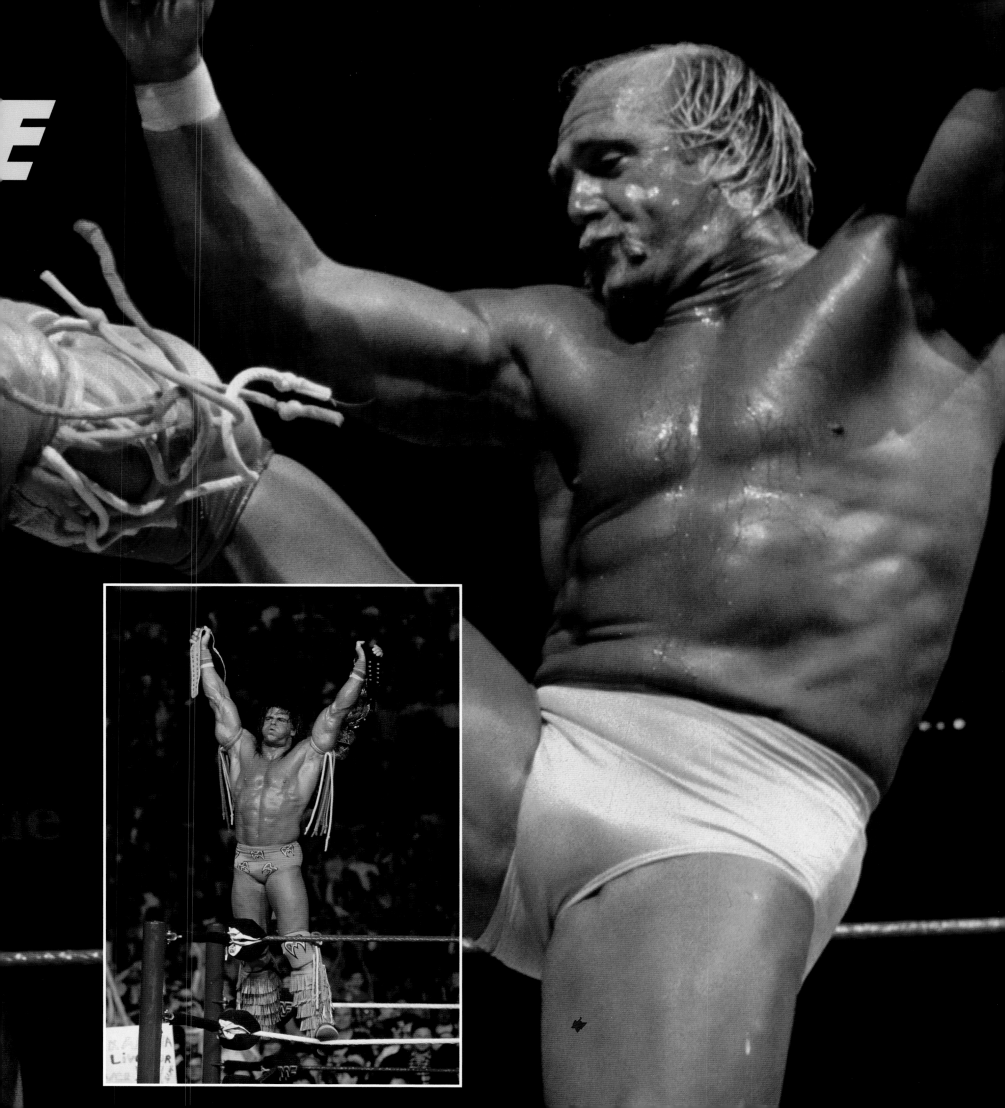

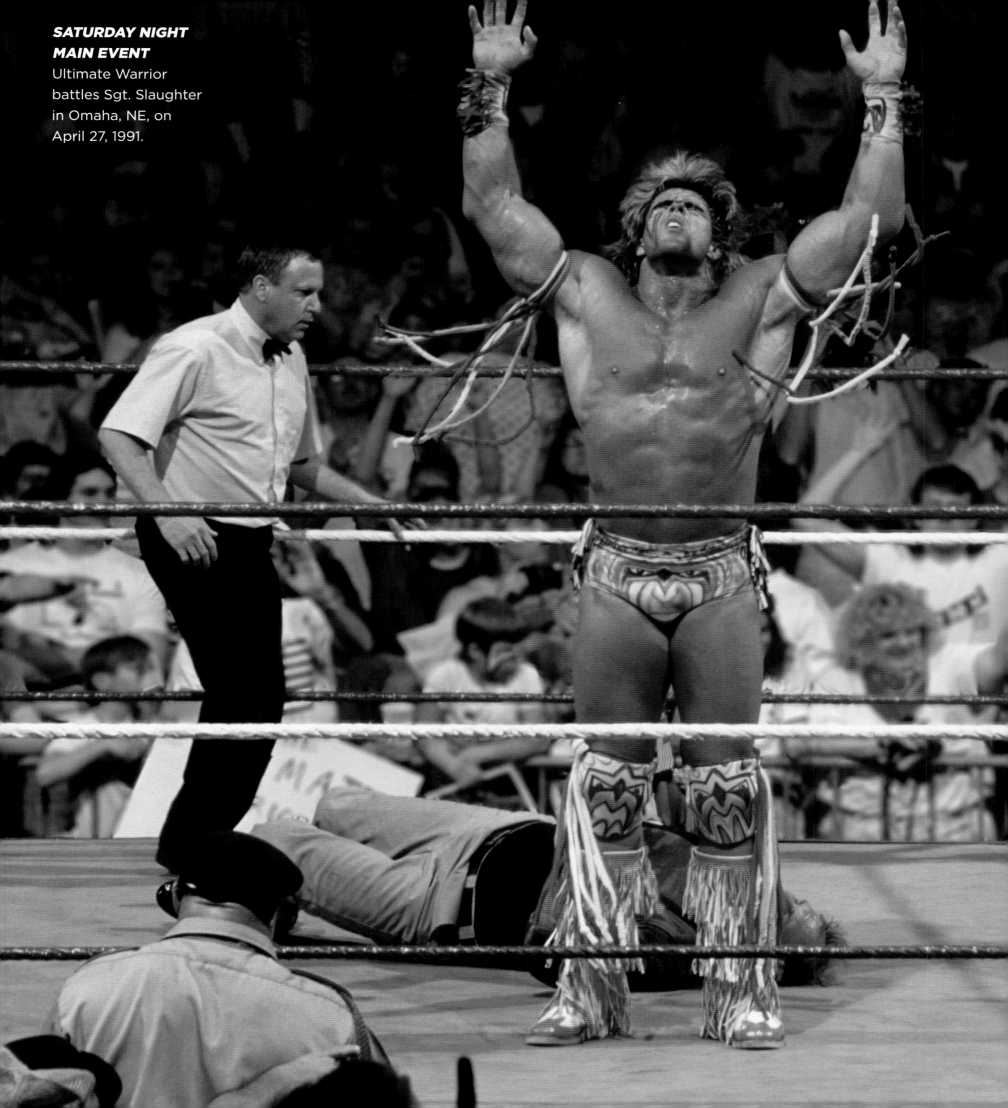

**SATURDAY NIGHT
MAIN EVENT**
Ultimate Warrior
battles Sgt. Slaughter
in Omaha, NE, on
April 27, 1991.

ULTIMATE WARRIOR

ULTIMATE WARRIOR CAME HURTLING INTO THE WWE WITH the same speed and intensity as his legendary ring entrances. Having debuted in 1987, it wasn't long before Ultimate Warrior won his first piece of WWE gold, defeating The Honky Tonk Man at *SummerSlam* 1988 to win the Intercontinental Championship. By 1990, Warrior had lost and won back the Intercontinental Title and, with his popularity growing, had become the number-one contender for the WWE Championship. Billed as the "The Ultimate Challenge", *WrestleMania VI*'s main event saw Warrior take on Hulk Hogan with both Intercontinental and WWE Championships on the line. In a match that took both competitors to their limits, Warrior managed to defeat Hogan, stunning everyone in attendance. At the time, no Superstar

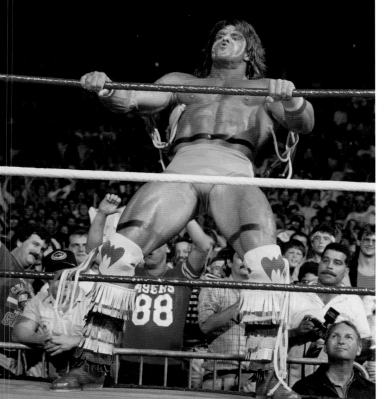

could hold more than one singles championship simultaneously, so Warrior vacated the Intercontinental Title to begin his only WWE Championship reign.

Ultimate Warrior would hold the WWE Championship for 293 days, before losing to Sgt. Slaughter at 1991's *Royal Rumble*. Following the loss of the title, Warrior would form rivalries with Undertaker and Jake "The Snake" Roberts until he left WWE in 1992. While Warrior would make sporadic appearances for WWE in 1996 and WCW in 1998, the WWE Universe didn't hear much from him until 2014, when he was inducted into the WWE Hall of Fame. Sadly, just three days after his induction, Warrior passed away. Warrior's time in WWE was short, but as he told the WWE Universe, "The spirit of Ultimate Warrior will run forever."

"THE SPIRIT OF ULTIMATE WARRIOR WILL RUN FOREVER."

SGT. SLAUGHTER

AFTER YEARS AS AN AMERICAN HERO, FACING THE likes of The Iron Sheik, the former U.S. Marine horrified the WWE Universe when he returned to WWE as an Iraqi sympathizer during the Gulf War. Sgt. Slaughter argued America had gone soft because of the end of the Cold War. Slaughter received backlash from furious Americans but wasn't deterred from battling defending WWE Champion Ultimate Warrior at *Royal Rumble* 1991. He received no mercy from Warrior, who was distracted by his manager, Sensational Sherri. Chasing her, Ultimate Warrior was ambushed by "Macho King" Randy Savage, who smashed his royal scepter over Warrior's head while the referee was distracted. Taking his chance, Slaughter pinned Ultimate Warrior to claim his only WWE Championship. After 63 days with the title, the turncoat Sarge faced the red-white-and-blue-clad "Real American" Hulk Hogan at *WrestleMania VII* in Los Angeles for the "Superstars and Stripes Forever" main event. With the Iraqi General Adnan in his corner and distracting Hogan, Slaughter even hit Hogan with his former nemesis Iron Sheik's move, the Camel Clutch. However, Hulk Hogan escaped, tore up the Iraqi flag and hit the big boot and Leg Drop to restore national pride and win his third WWE Championship. While the Sarge went on to eventually plead for the WWE Universe's forgiveness and team with "Hacksaw" Jim Duggan to battle waving the American flag, his title reign will always be tied to the time he turned on his own country.

> **"AFTER 63 DAYS WITH THE TITLE, THE TURNCOAT SARGE FACED 'REAL AMERICAN' HULK HOGAN."**

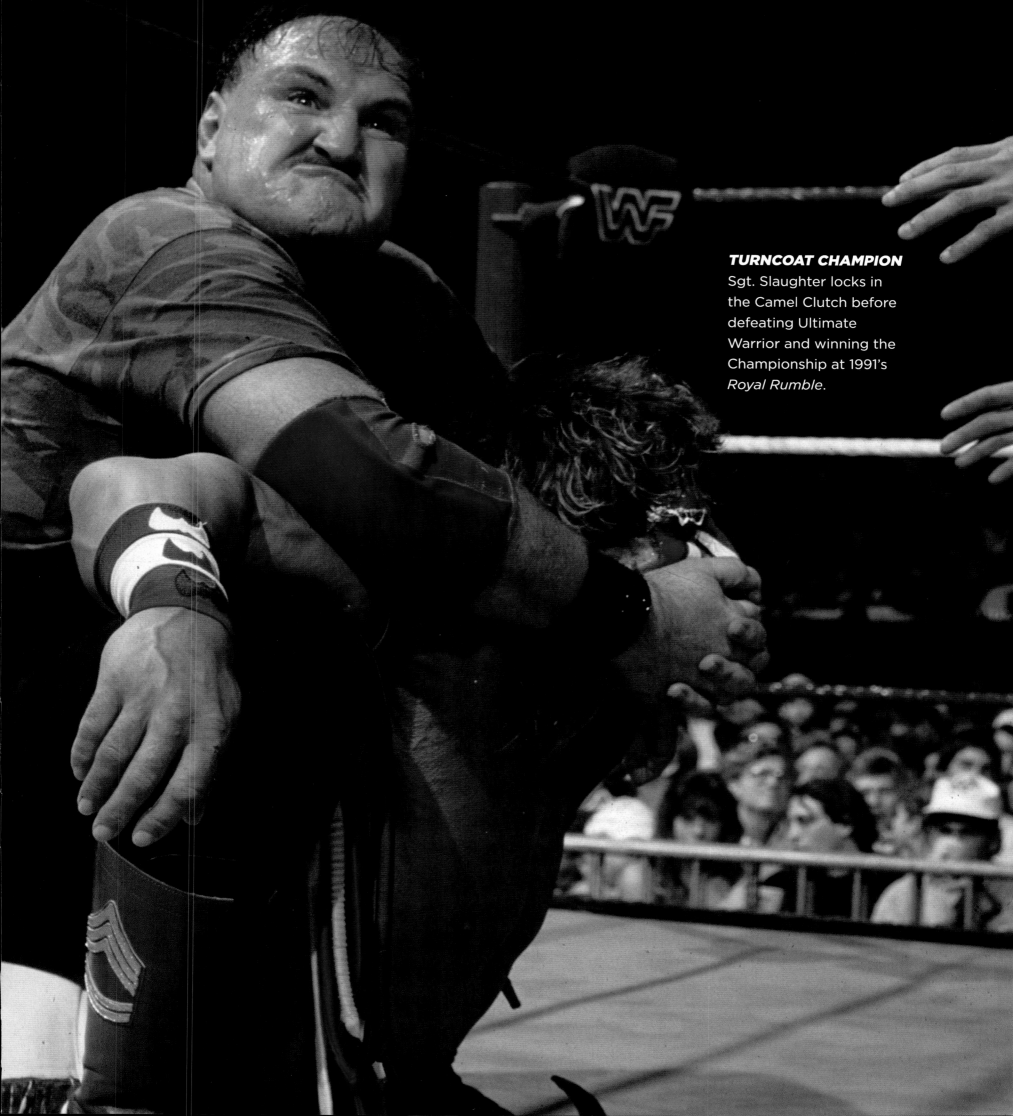

TURNCOAT CHAMPION
Sgt. Slaughter locks in the Camel Clutch before defeating Ultimate Warrior and winning the Championship at 1991's *Royal Rumble*.

UNDERTAKER

IN A CAREER THAT SPANNED FOUR decades, Undertaker rose to become a Superstar who rewrote the rules of WWE Superstardom and reshaped the reality of what a WWE Superstar could accomplish. The Deadman first made his debut at the 1990 *Survivor Series* as the mystery partner of Ted DiBiase's Million Dollar Team. Right away, the WWE Universe knew that they were witnessing something special. Undertaker was like no other Superstar they had ever seen before. Cloaked in black and towering at nearly seven feet tall, he was a truly otherworldly presence. And when he unleashed the full fury of his power, their awe turned to abject amazement.

Undertaker immediately became a fixture in WWE, taking on some of the most high-profile Superstars of the era, including Hulk Hogan, whom he defeated nearly one year to the day after his debut to win his first-ever WWE Championship at the 1991 *Survivor Series*. Hogan would reclaim the gold a month later at *This Tuesday in Texas*, sending the Deadman on a two-year chase for the title. During that time, he would come up against the likes of Randy Savage, Bret Hart, Ric Flair and Shawn Michaels.

The next time Undertaker would compete for the WWE Title would be at an event that he defined. Facing Sycho

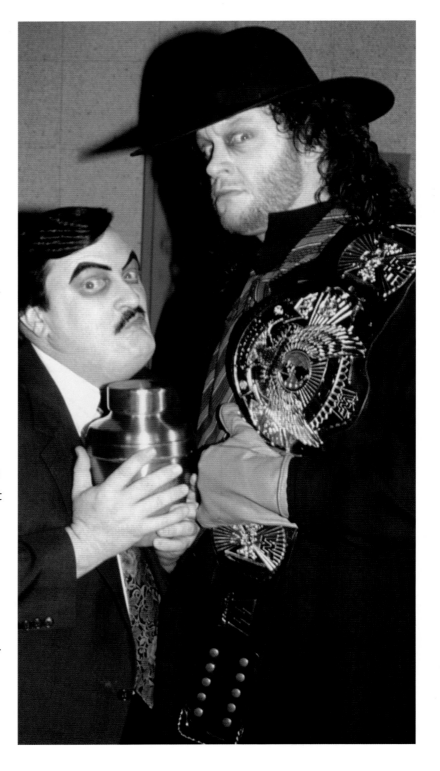

"UNDERTAKER WAS LIKE NO OTHER SUPERSTAR THEY HAD SEEN BEFORE."

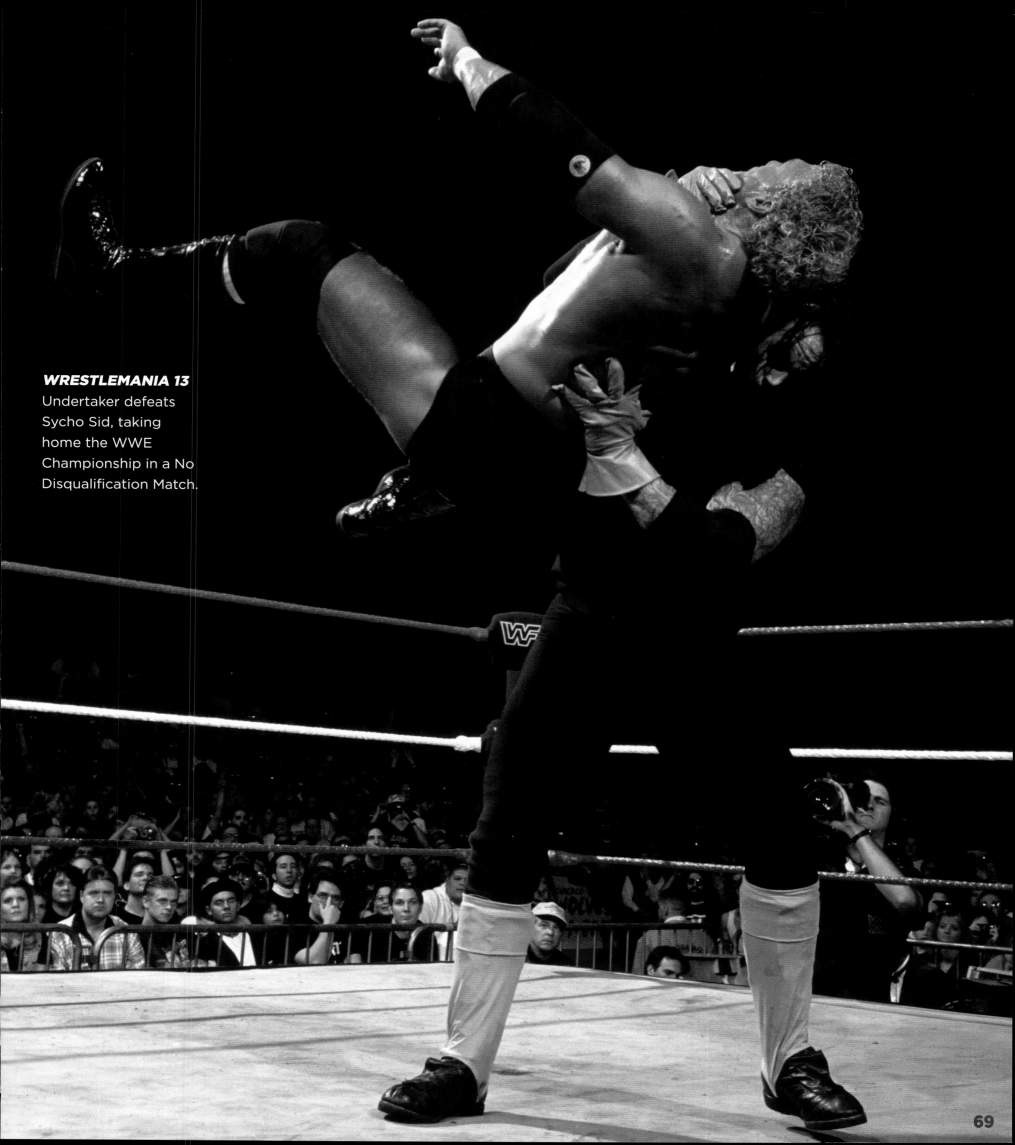

WRESTLEMANIA 13
Undertaker defeats
Sycho Sid, taking
home the WWE
Championship in a No
Disqualification Match.

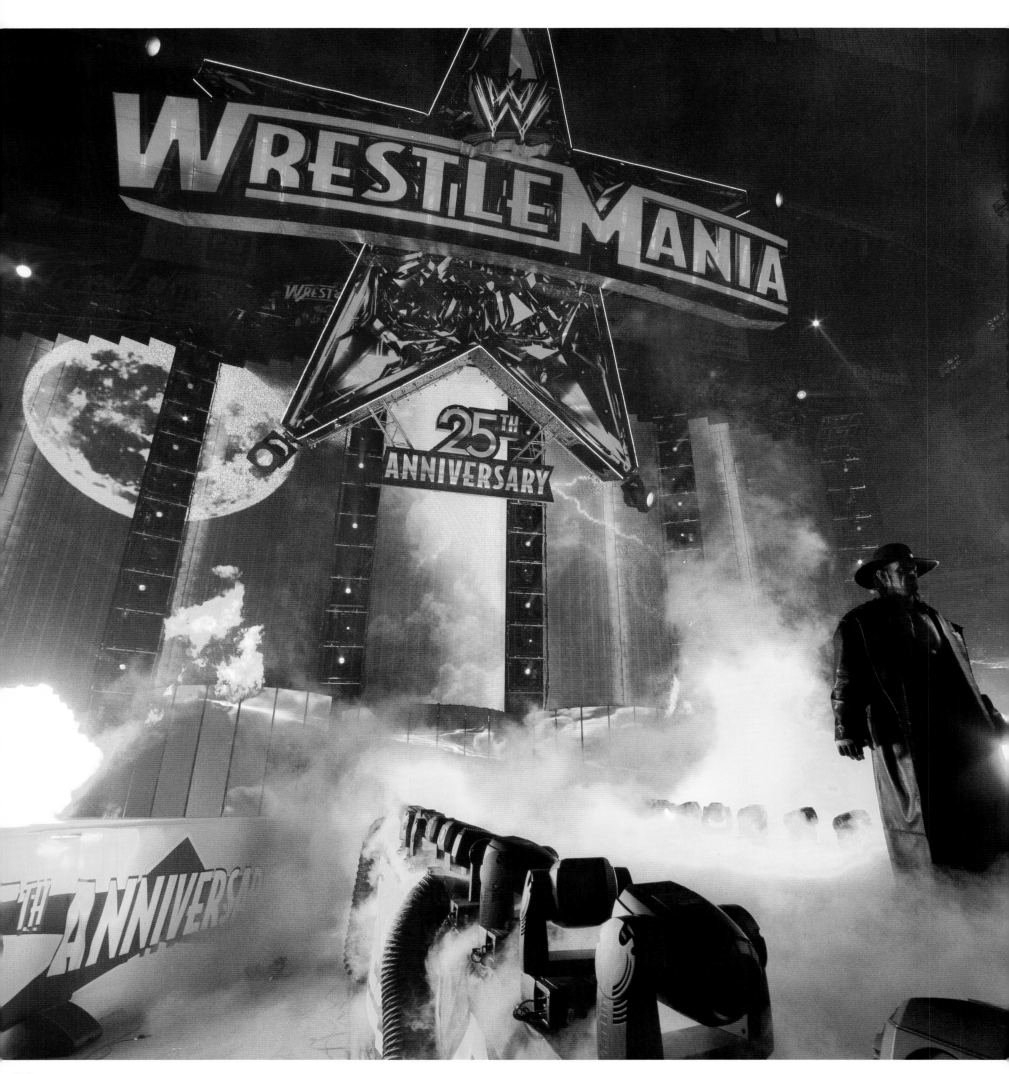

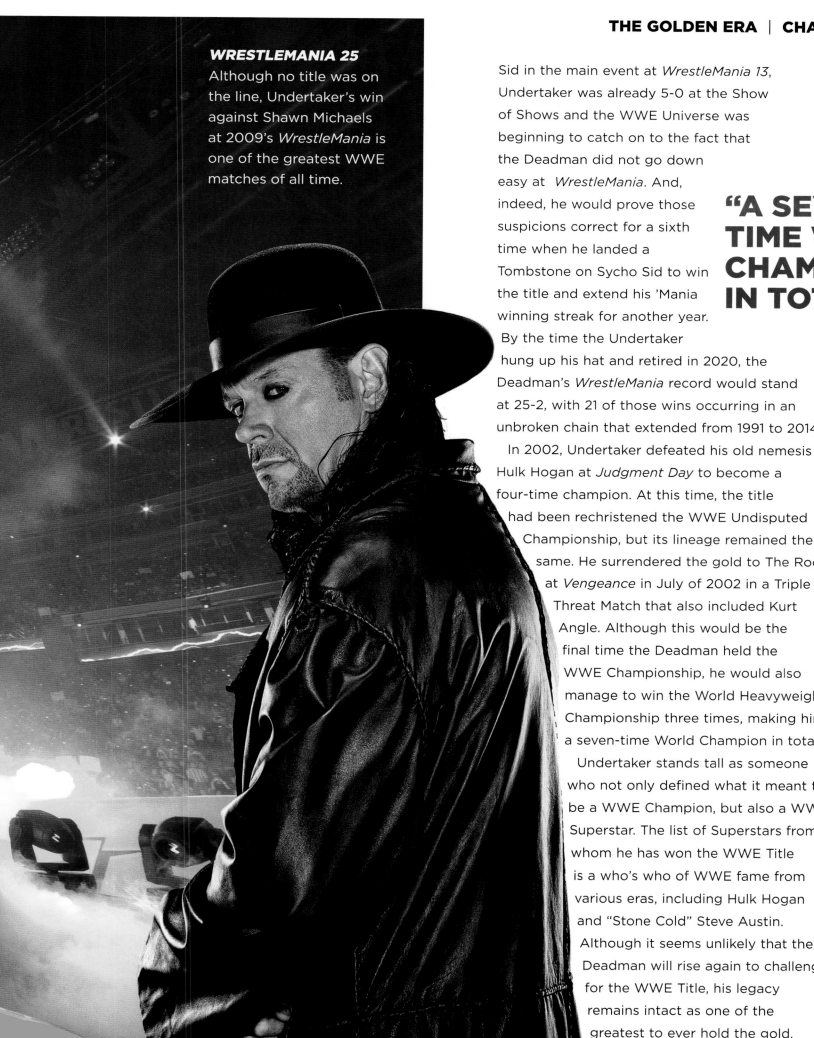

WRESTLEMANIA 25
Although no title was on the line, Undertaker's win against Shawn Michaels at 2009's *WrestleMania* is one of the greatest WWE matches of all time.

Sid in the main event at *WrestleMania 13*, Undertaker was already 5-0 at the Show of Shows and the WWE Universe was beginning to catch on to the fact that the Deadman did not go down easy at *WrestleMania*. And, indeed, he would prove those suspicions correct for a sixth time when he landed a Tombstone on Sycho Sid to win the title and extend his 'Mania winning streak for another year.

By the time the Undertaker hung up his hat and retired in 2020, the Deadman's *WrestleMania* record would stand at 25-2, with 21 of those wins occurring in an unbroken chain that extended from 1991 to 2014. In 2002, Undertaker defeated his old nemesis Hulk Hogan at *Judgment Day* to become a four-time champion. At this time, the title had been rechristened the WWE Undisputed Championship, but its lineage remained the same. He surrendered the gold to The Rock at *Vengeance* in July of 2002 in a Triple Threat Match that also included Kurt Angle. Although this would be the final time the Deadman held the WWE Championship, he would also manage to win the World Heavyweight Championship three times, making him a seven-time World Champion in total.

Undertaker stands tall as someone who not only defined what it meant to be a WWE Champion, but also a WWE Superstar. The list of Superstars from whom he has won the WWE Title is a who's who of WWE fame from various eras, including Hulk Hogan and "Stone Cold" Steve Austin. Although it seems unlikely that the Deadman will rise again to challenge for the WWE Title, his legacy remains intact as one of the greatest to ever hold the gold.

"A SEVEN-TIME WORLD CHAMPION IN TOTAL."

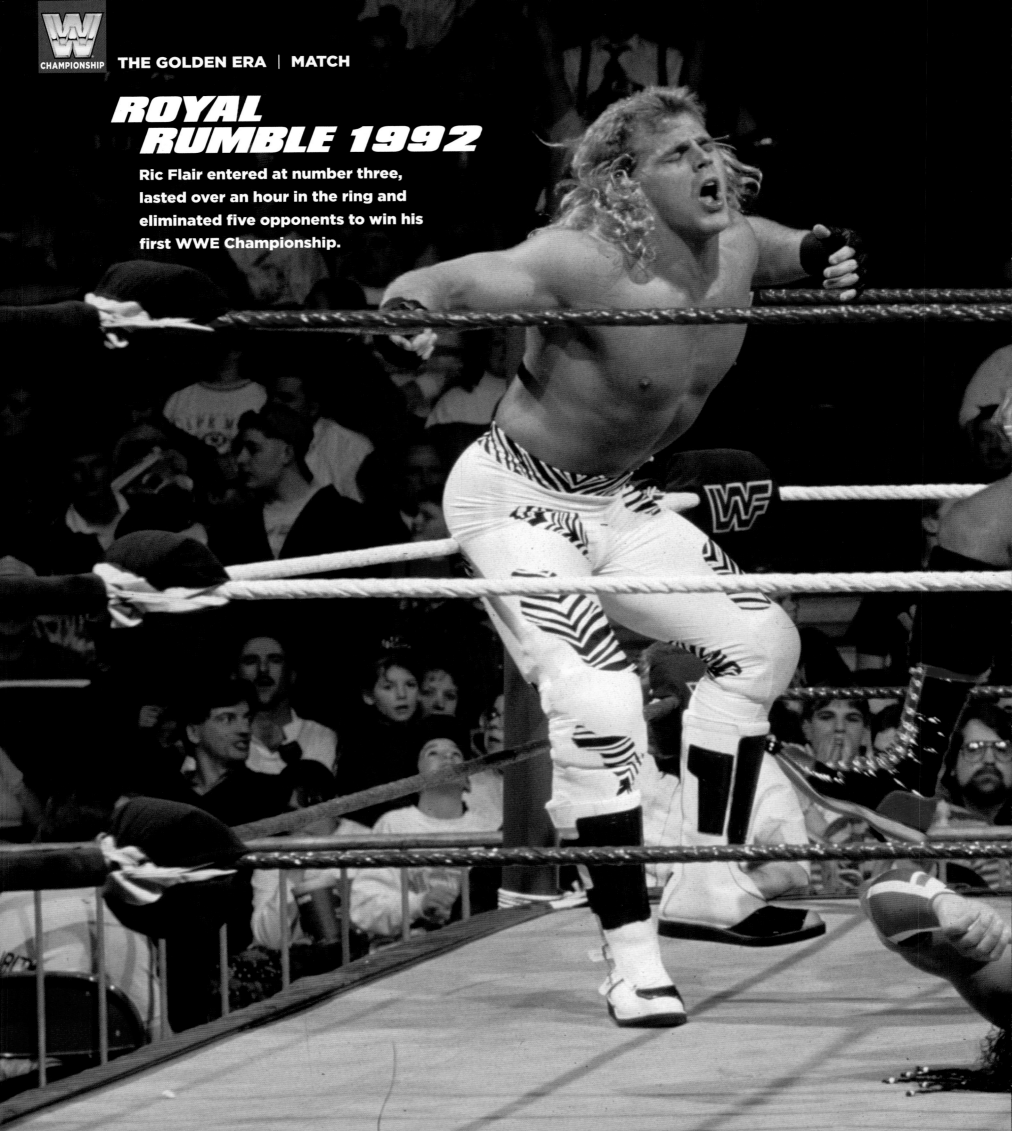

ROYAL RUMBLE 1992

Ric Flair entered at number three, lasted over an hour in the ring and eliminated five opponents to win his first WWE Championship.

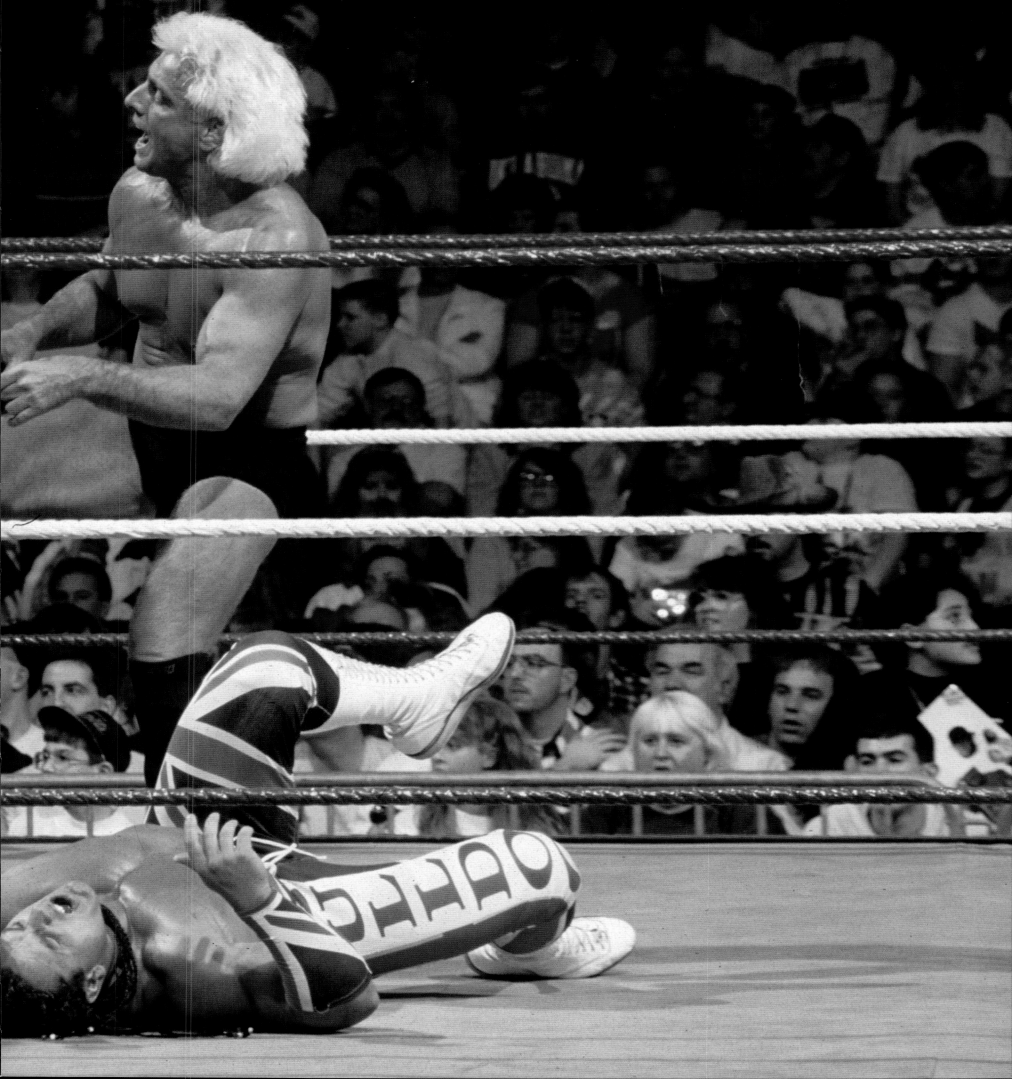

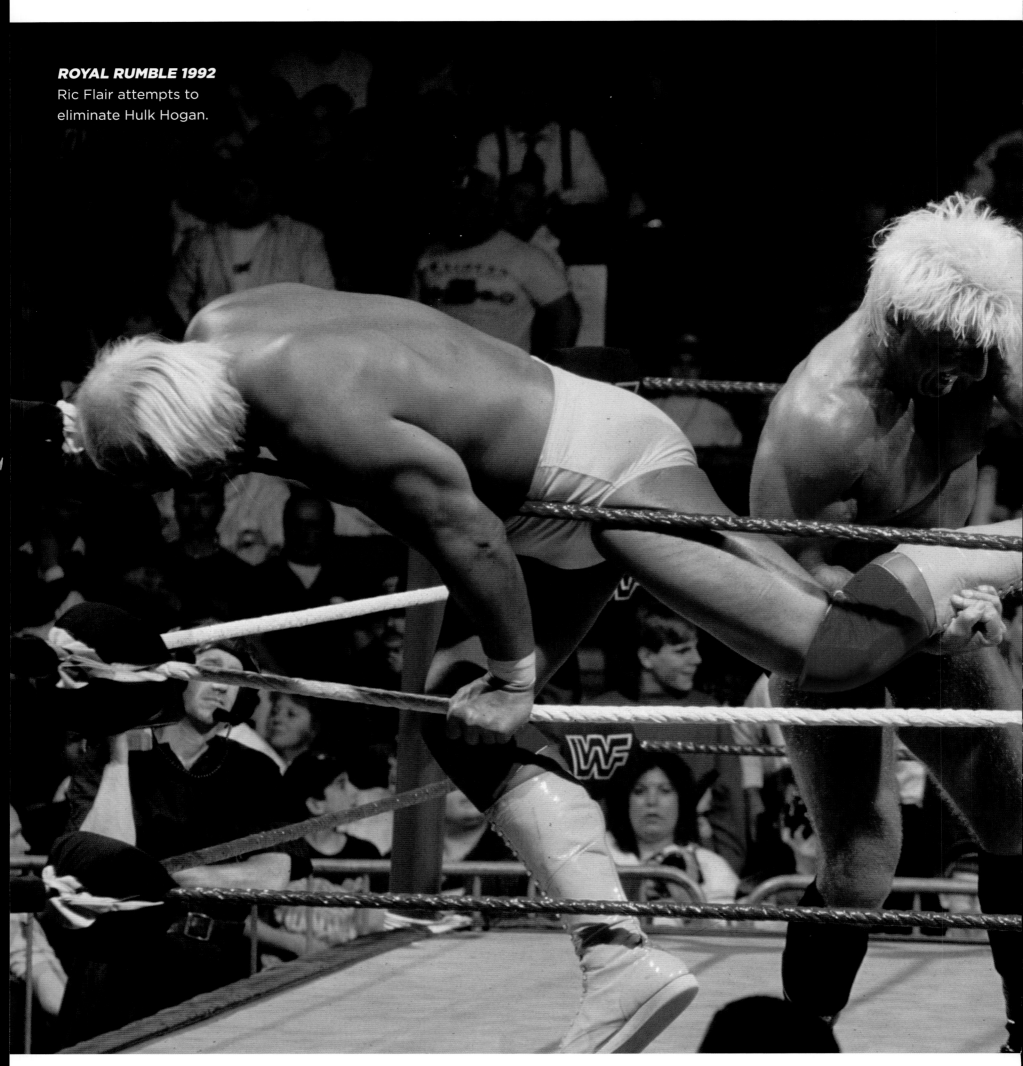

ROYAL RUMBLE 1992
Ric Flair attempts to eliminate Hulk Hogan.

RIC FLAIR

RIC FLAIR IS A 16-TIME WORLD Heavyweight Champion whose promos, usually delivered in a hysterical shout and punctuated with his signature catchphrase of "Woooooo!", were as mesmerizing to witness as his matches.

When Ric Flair joined WWE in 1991, he arrived with an impressive resume—seven -time NWA World Heavyweight Champion, five-time United States Champion, and two-time WCW World Tag Team Champion. It didn't take "The Nature Boy" long to add to this list, as he lasted over 60 minutes in 1992's Royal Rumble to win the vacant WWE Championship. Flair held the title for 77 days before losing to Randy Savage at *WrestleMania VIII*. Flair would win the WWE Championship back on *Prime Time Wrestling* in September 1992, but his second reign would be even shorter than the first, as he lost the WWE Championship to Bret Hart just 41 days later.

Flair would depart for WCW in 1993, going on to win one more NWA Championship followed by six reigns as WCW World Heavyweight Champion in total. He returned to WWE in 2001, and while Flair would not get his hands on the title again, he did find success winning the Intercontinental Title and three WWE Tag Team Championships. In a powerful, spellbinding and ultimately emotional match at *WrestleMania XXIV*, Flair lost to Shawn Michaels to bring his in-ring career to a close.

Ric Flair has had an amazing career and even today, arenas everywhere erupt with the sounds of fans calling out "Wooooooo!" whether he's there or not.

"A 16-TIME WORLD HEAVYWEIGHT CHAMPION."

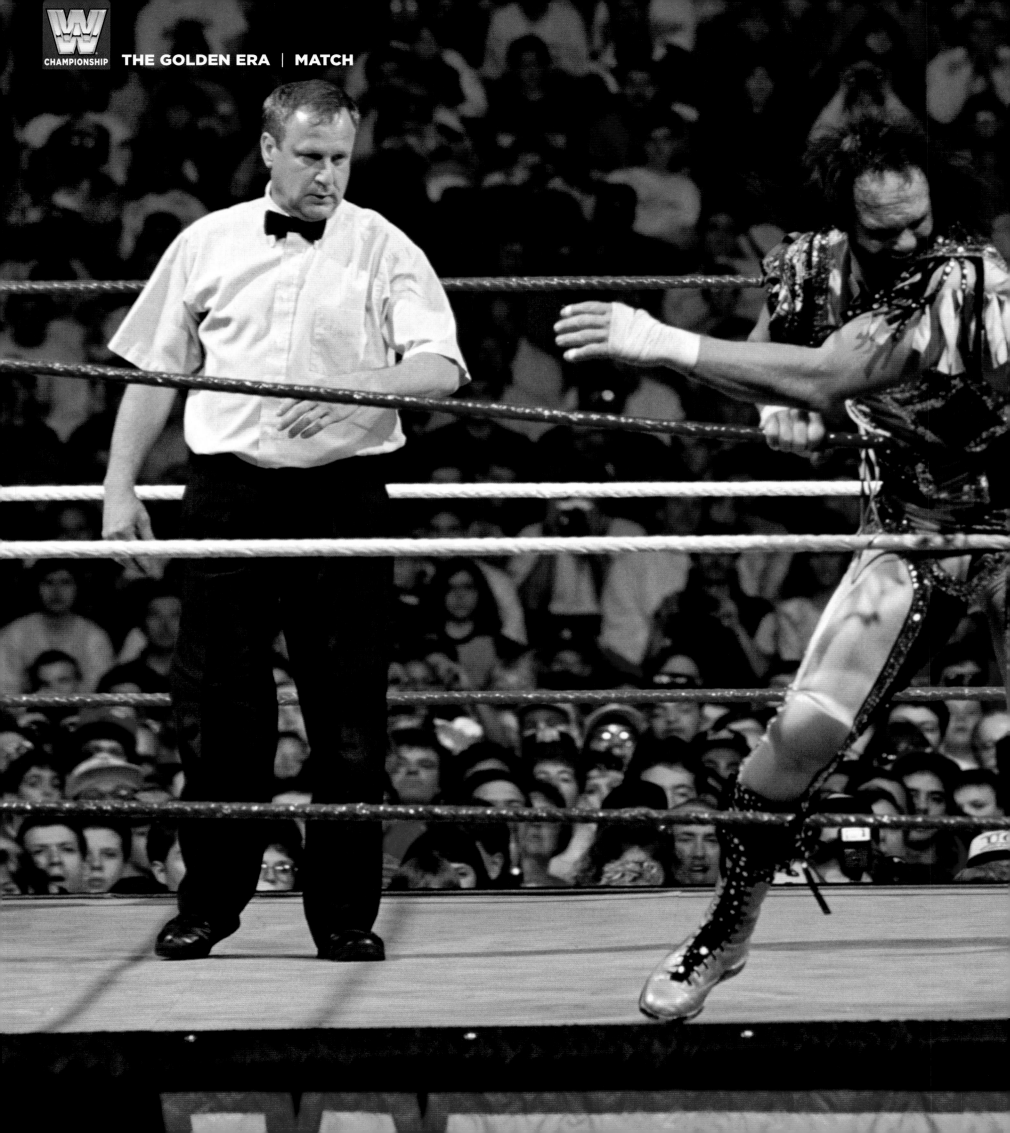

WRESTLE MANIA VIII

With Miss Elizabeth at the center of an intense rivalry, Randy Savage defeated Ric Flair at the Hoosier Dome in Indianapolis, Indiana, to win his second WWE Championship on April 5, 1992.

NEW GENERATION
EARLY '90s – MID '90s

As the '80s came to an end, the old-school musclemen who had dominated WWE began to find new, leaner, technically gifted Superstars rising through the ranks and challenging for the Greatest Title in Sports Entertainment.

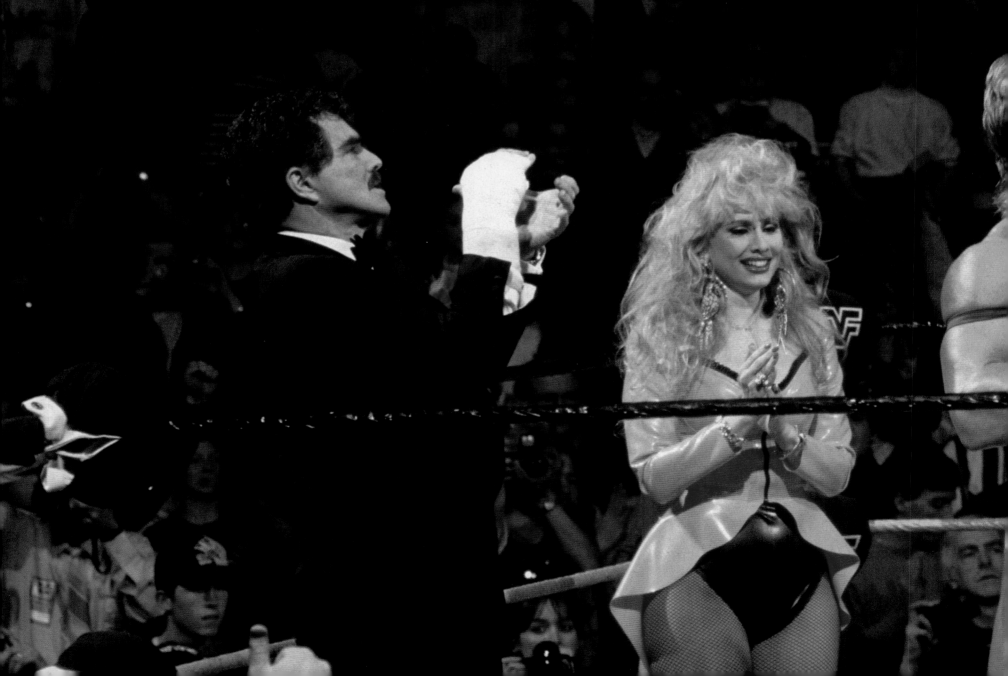

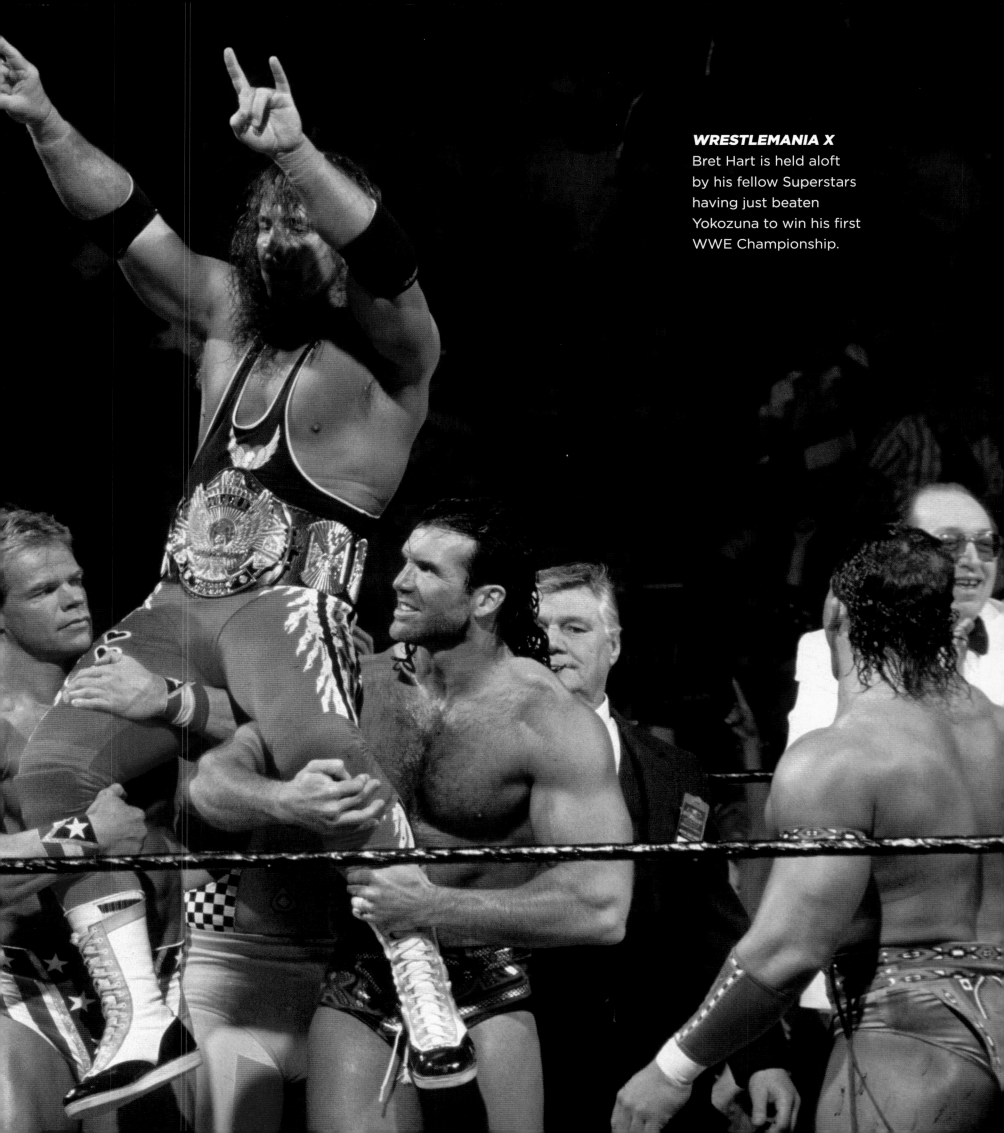

WRESTLEMANIA X
Bret Hart is held aloft by his fellow Superstars having just beaten Yokozuna to win his first WWE Championship.

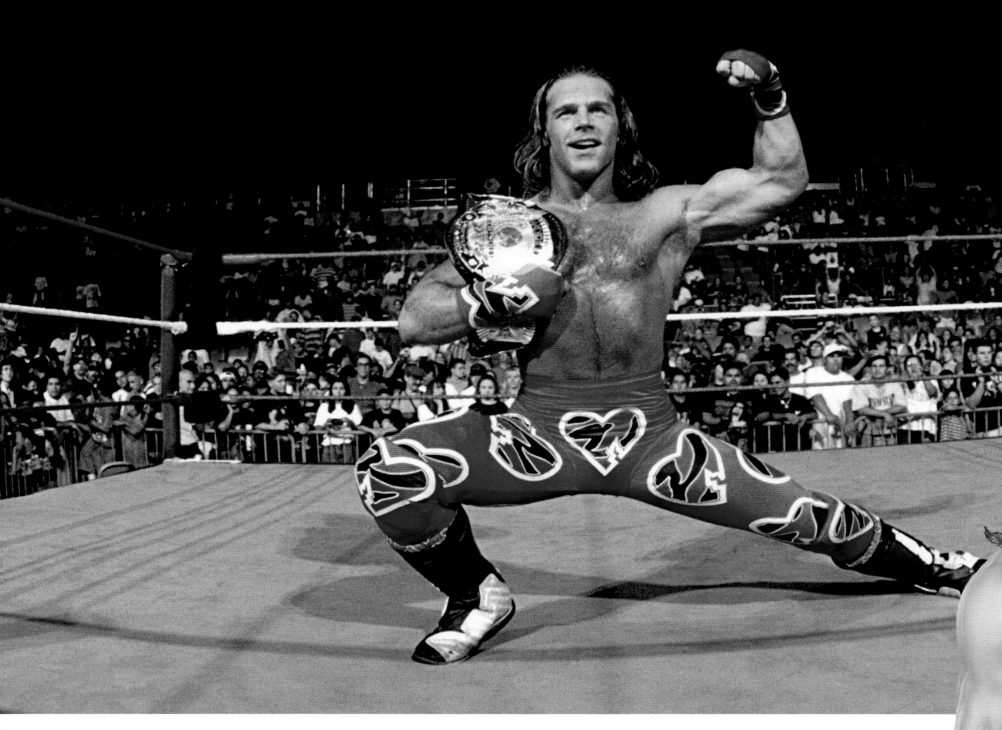

THE '90S OPENED WITH RIC FLAIR AND
"Macho Man" Randy Savage battling over the
WWE Championship, in a heated rivalry that
involved a scandal over Miss Elizabeth. The title rivalry
ended in September of 1992 with the gold around the
waist of Flair. However, a new era for the WWE
Championship, and WWE as a whole, had been
set in motion.

Lean, mean Superstars with mat training like Bret
Hart, Shawn Michaels and Sycho Sid found themselves
in the gold rush alongside the old-school
musclemen who had defined the previous
decade. It was during this era that technical
ability took a quantum leap forward in WWE,
with Superstars like Hart and Michaels delivering
fast-paced, high-flying matches that favored skill
over raw strength.

Flair's second run with the title would eventually
come to an end when he came up against Bret
"Hit Man" Hart. A Canadian Superstar who came

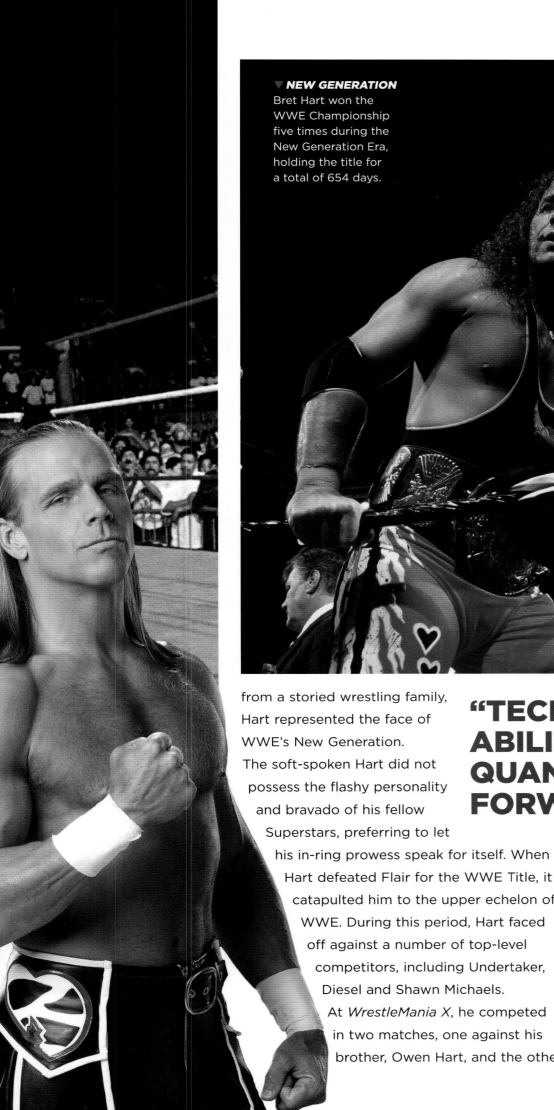

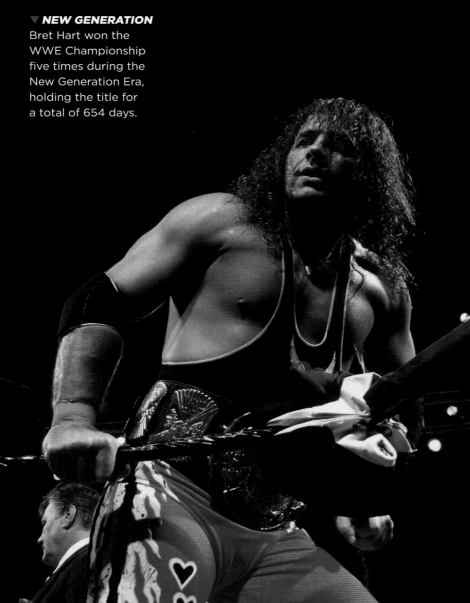

from a storied wrestling family, Hart represented the face of WWE's New Generation. The soft-spoken Hart did not possess the flashy personality and bravado of his fellow Superstars, preferring to let his in-ring prowess speak for itself. When Hart defeated Flair for the WWE Title, it catapulted him to the upper echelon of WWE. During this period, Hart faced off against a number of top-level competitors, including Undertaker, Diesel and Shawn Michaels.

At *WrestleMania X*, he competed in two matches, one against his brother, Owen Hart, and the other

"TECHNICAL ABILITY TOOK A QUANTUM LEAP FORWARD."

a title match that saw him defeat Yokozuna for the WWE Championship.

Throughout this era, Hart typified the New Generation style of sports entertainment, delivering championship matches that highlighted skill and showmanship in equal measure. One of the best examples of this came in 1996 when Hart and Michaels faced off at *WrestleMania XII* in a 60-minute Iron Man Match for the WWE Championship. After the two Superstars battled to a draw, the match went into sudden death overtime, with Michaels picking up the win to finally achieve his "boyhood dream."

By the late '90s, Bret Hart was riding high as the face of WWE and its current champion. However, Hart had received an offer to compete in rival promotion WCW. This led to a controversial match at the 1997 *Survivor Series* between Bret and Shawn Michaels that became known as the "Montreal Screwjob." During the bout, Vince McMahon ordered the ring bell rung while Hart was trapped in his own finisher, the Sharpshooter. The ending of the match led to Michaels taking the title and Bret Hart leaving WWE for more than a decade.

The fallout of Montreal led to the crowning of a new champion in Shawn Michaels. But, just as had happened in the past, the WWE Universe was craving something new. They were looking for a WWE that was rough, tough and didn't play by the rules. They wanted a WWE with attitude.

BRET HART

EVERY ERA OF WWE HAS A SUPERSTAR THAT DEFINES IT. For the Golden Era, it was Hulk Hogan. And, when WWE began a shift to what became known as the New Generation, the man who led the way was Bret Hart.

Born and raised in Calgary in Alberta, Canada, Bret "Hit Man" Hart came from a family steeped in wrestling tradition. His father, Stu Hart, ran a wrestling gym out of his basement, a place so infamous for its rigorous training that it became known as The Dungeon.

Bret Hart made a name for himself in his father's promotion, where his talents soon drew the attention of WWE, with Hart joining the company in 1984.

For the first part of his WWE career, Hart tagged with brother-in-law Jim "The Anvil" Neidhart to form the Hart Foundation. Hart and Neidhart became one of WWE's greatest units, winning two WWE Tag Team Championships. Following the team's split in 1991, Hart struck out on his own and won the Intercontinental Championship.

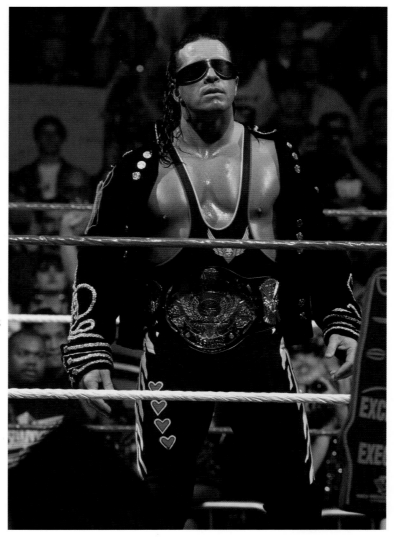

In 1992, Hart took his first step into the WWE big leagues when he defeated reigning champion Ric Flair at a non-televised event to win his first WWE Championship. He held that title from October of 1992 straight through until *WrestleMania IX,* when he came up against Yokozuna.

At *WrestleMania IX,* Hart lost

"HIS FIVE TITLE REIGNS HELPED MAKE THE NEW GENERATION ERA ONE OF WWE'S MOST EXCITING."

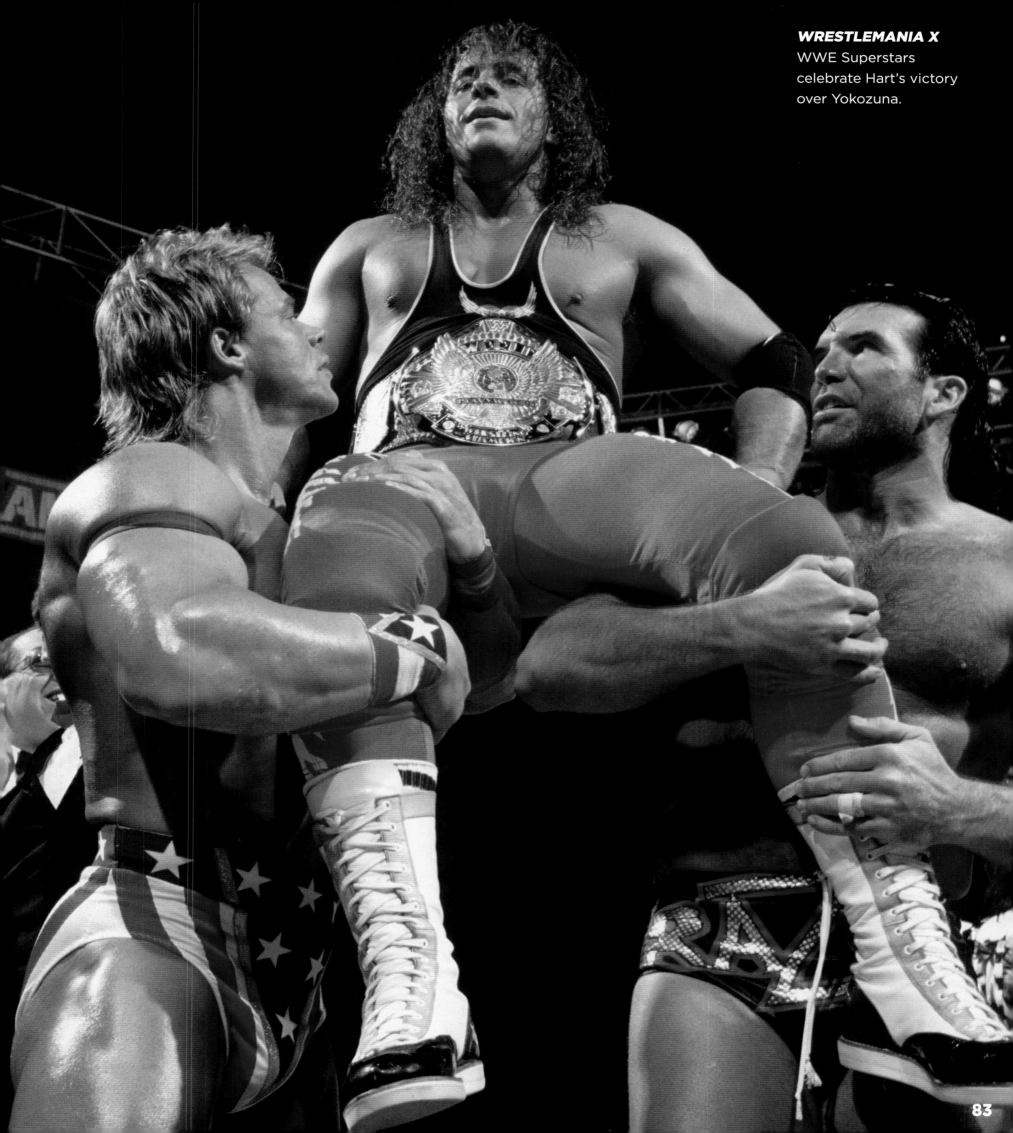

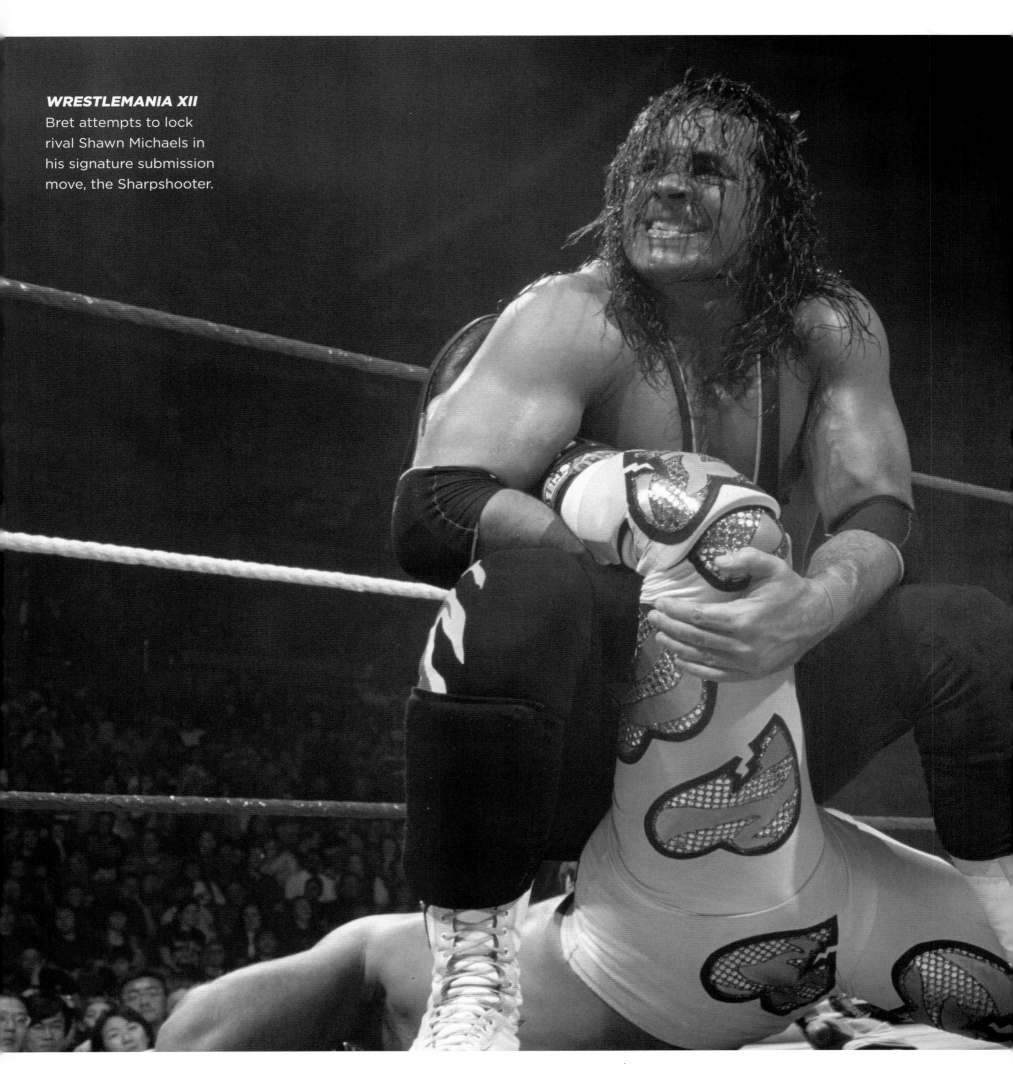

Bret attempts to lock
rival Shawn Michaels in
his signature submission
move, the Sharpshooter.

the WWE Title to Yokozuna, but the tables were turned on both Superstars when Hulk Hogan appeared, accepted Mr. Fuji's impromptu challenge for the title and left Las Vegas with the gold. Yokozuna would later defeat Hogan at the 1993 *King of the Ring* and enter *WrestleMania X* as the champion, only to find Hart waiting for him. With Roddy Piper as the guest referee, Yokozuna and Hart battled for the gold, with Hart taking the win to claim his second WWE Championship.

Hart's second title run came to an end at the 1994 *Survivor Series* in a match against Bob Backlund. It would be a year before he held the title again, kicking off his third reign by defeating Diesel at the 1995 *Survivor Series*. He would hold the title for more than 130 days before going up against his arch-rival, Shawn Michaels, in a 60-minute Iron Man Match at *WrestleMania XII*. The match would go into sudden death overtime when neither Hart or HBK could land a pinfall. Eventually, HBK hit Hart with Sweet Chin Music to take home the WWE Title.

In 1997, after Michaels suffered a knee injury during his second title reign, the WWE Championship was vacated. Hart managed to win it back at *In Your House 13: Final Four* in a Four-Way Elimination Match that included "Stone Cold" Steve Austin, Vader and Undertaker. Unfortunately for Hart, his fourth title reign was a short one, as he lost the WWE Championship a day later to Sycho Sid. He wouldn't hold the title again until later that year, when he defeated Undertaker for the gold at *SummerSlam*.

Bret Hart's fifth title run would prove to be his most controversial. Towards the end of 1997, Hart received, and accepted, an offer to join WWE's rival promotion, WCW. Fearful that Hart would take the title with him, Vince McMahon needed to ensure that Bret lost the title at *Survivor Series*, no matter what the cost. During the infamous bout against Shawn Michaels, as HBK had Hart locked in the Sharpshooter (Hart's own finisher), McMahon ordered the ref to ring the bell, ending the match. The fact that Hart had not tapped out was irrelevant. The match was over, the title went to Michaels, and the outraged and furious Hart stormed out of the ring. It would be more than a decade before he would step into a WWE ring again.

Bret Hart was not only one of WWE's greatest champions, but he was also one of the greatest Superstars to ever lace the boots. Hart's five title reigns helped make the New Generation Era one of WWE's most exciting and his legacy as "the best there is, the best there was, and the best there ever will be" will remain unchallenged for all time.

▶ **THE BEST THERE WAS**
Hart helped define the New Generation Era and became one of WWE's greatest champions.

UNSCHEDULED TITLE MATCH

WRESTLEMANIA IX WAS THE first-ever Show of Shows to be held in an outdoor venue, with Caesar's Palace in Las Vegas hosting the event. And while it's a commonly held belief that what happens in Vegas stays in Vegas, what happened at *WrestleMania IX* sent shockwaves through the WWE Universe.

The main event pitted defending WWE Champion Bret Hart against Yokozuna with the WWE Championship on the line. The matchup was an interesting one, with the smaller, technically minded Hart facing off against a gigantic, 500-pound sumo wrestler. Despite being physically outsized, Hart had all of his training in The Dungeon to fall back on.

Hit Man's skill kept Yokozuna at bay, but the massive Superstar still managed to connect with a number of power moves, including a clothesline and leg drop, that sent Hart reeling. Eventually, Bret was able to lock in the Sharpshooter, trapping Yokozuna and nearly forcing him to tap. Only a handful of salt hurled into Hart's eyes by Yokozuna's manager, Mr. Fuji, prevented a title retention. Instead, Yokozuna was freed from the Sharpshooter and able to make the pinfall to take the WWE Championship from Hart.

However, the story didn't end there. As Yokozuna was celebrating, Hulk Hogan came down to the ring to see how Hart was after the attack and to dispute the outcome with the referee.

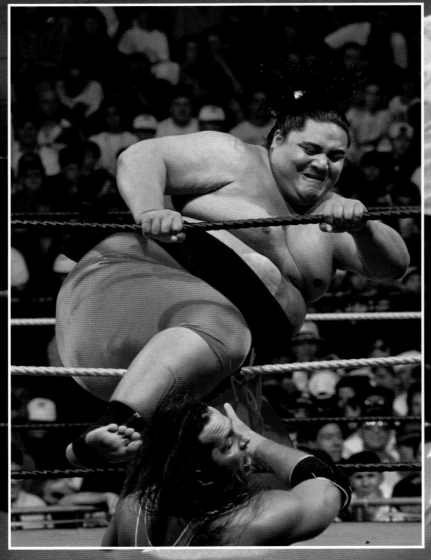

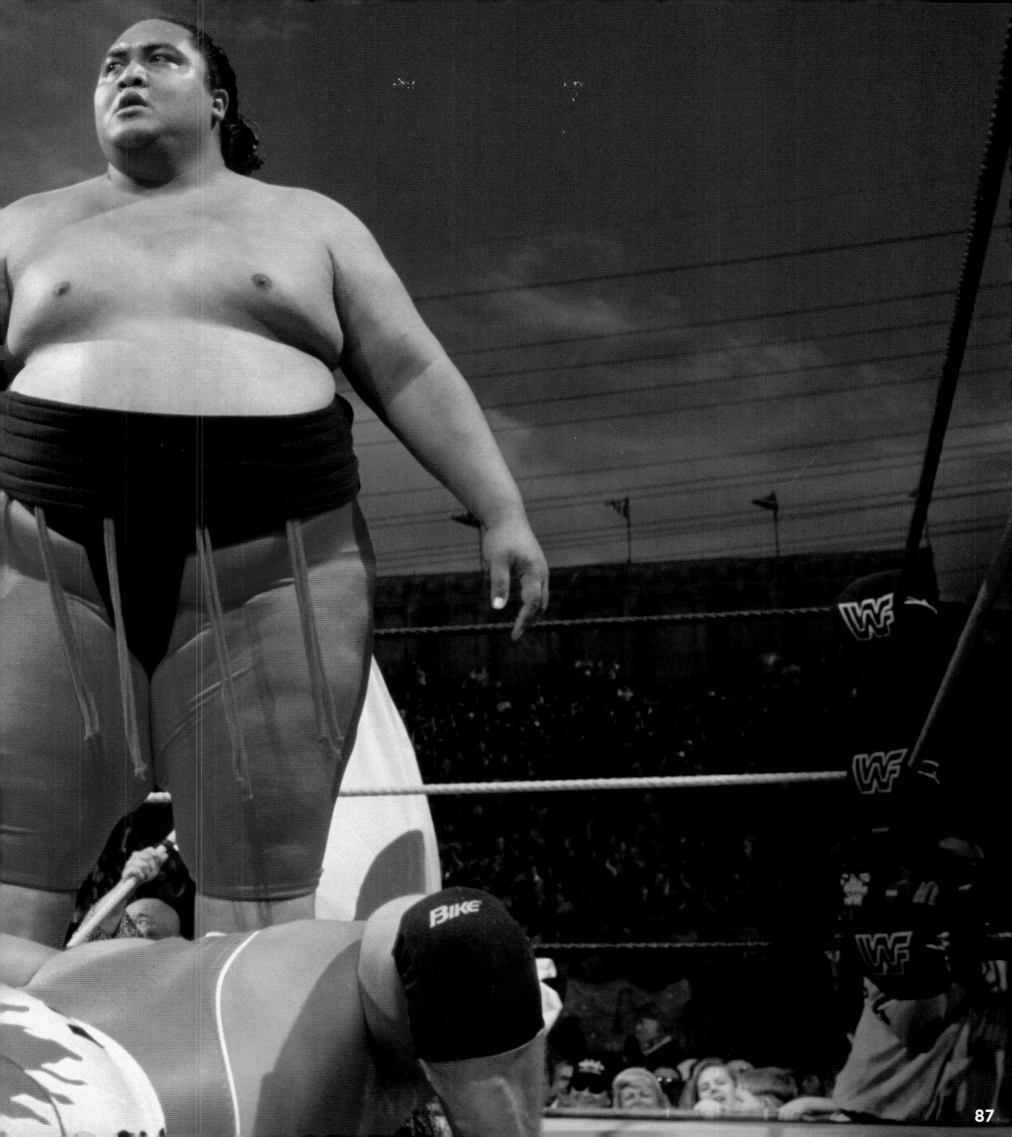

That's when Fuji issued a challenge for the title on the spot, calling Hogan a yellow-bellied coward. Never one to back down, and with the support of Bret Hart, the Hulkster accepted. As the match began, Mr. Fuji once again attempted to use salt as a means of gaining the upper hand for Yokozuna. However, in his overexcitement, Fuji missed his intended target and the salt hit Yokozuna in the eyes instead. That was all it took for Hogan to spring into action, connecting with a clothesline and a Leg Drop to make the pinfall on Yokozuna in under 30 seconds.

Seemingly out of nowhere, Hogan had picked up his fifth WWE Championship. It was a shocking moment that proved, once again, that anything goes at the Show of Shows.

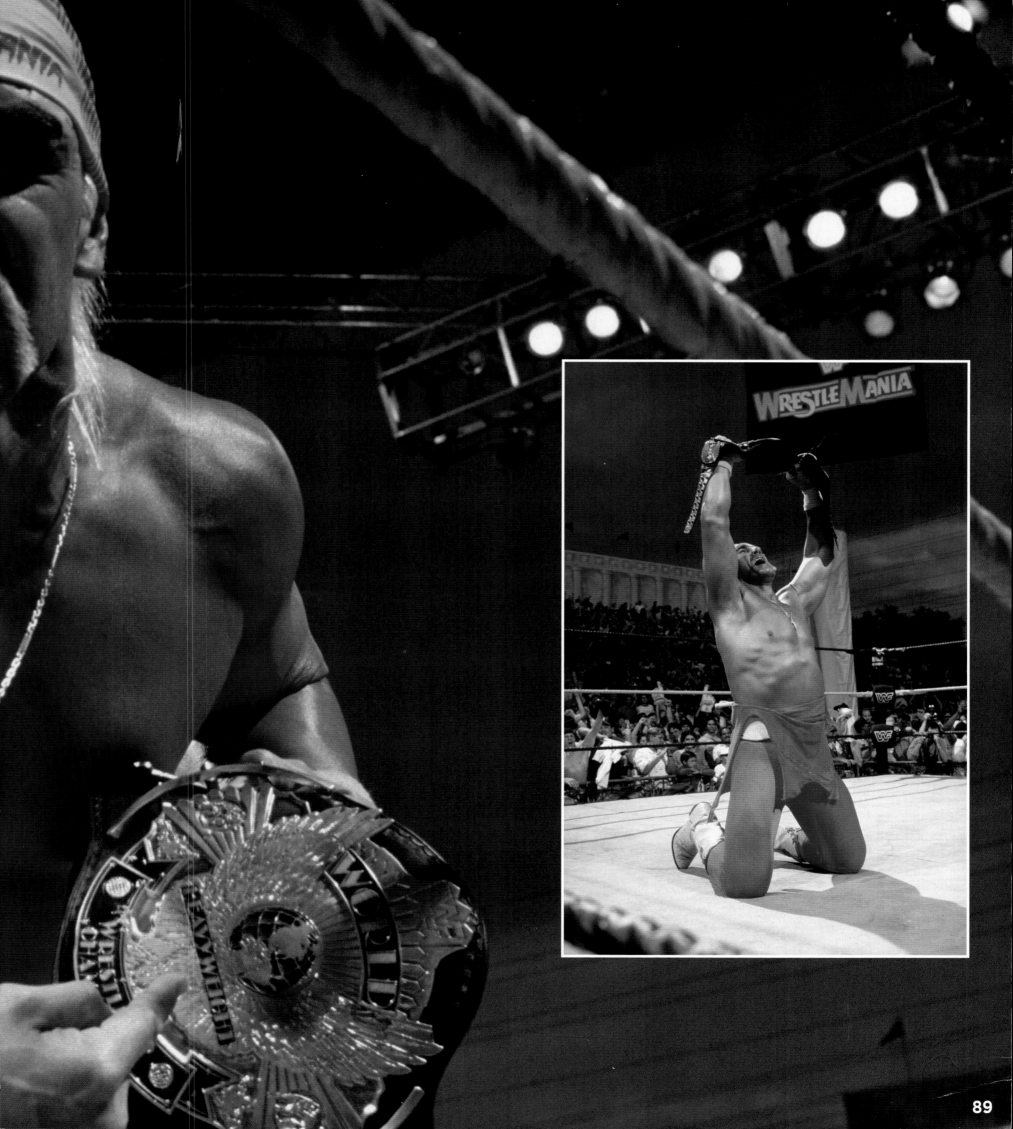

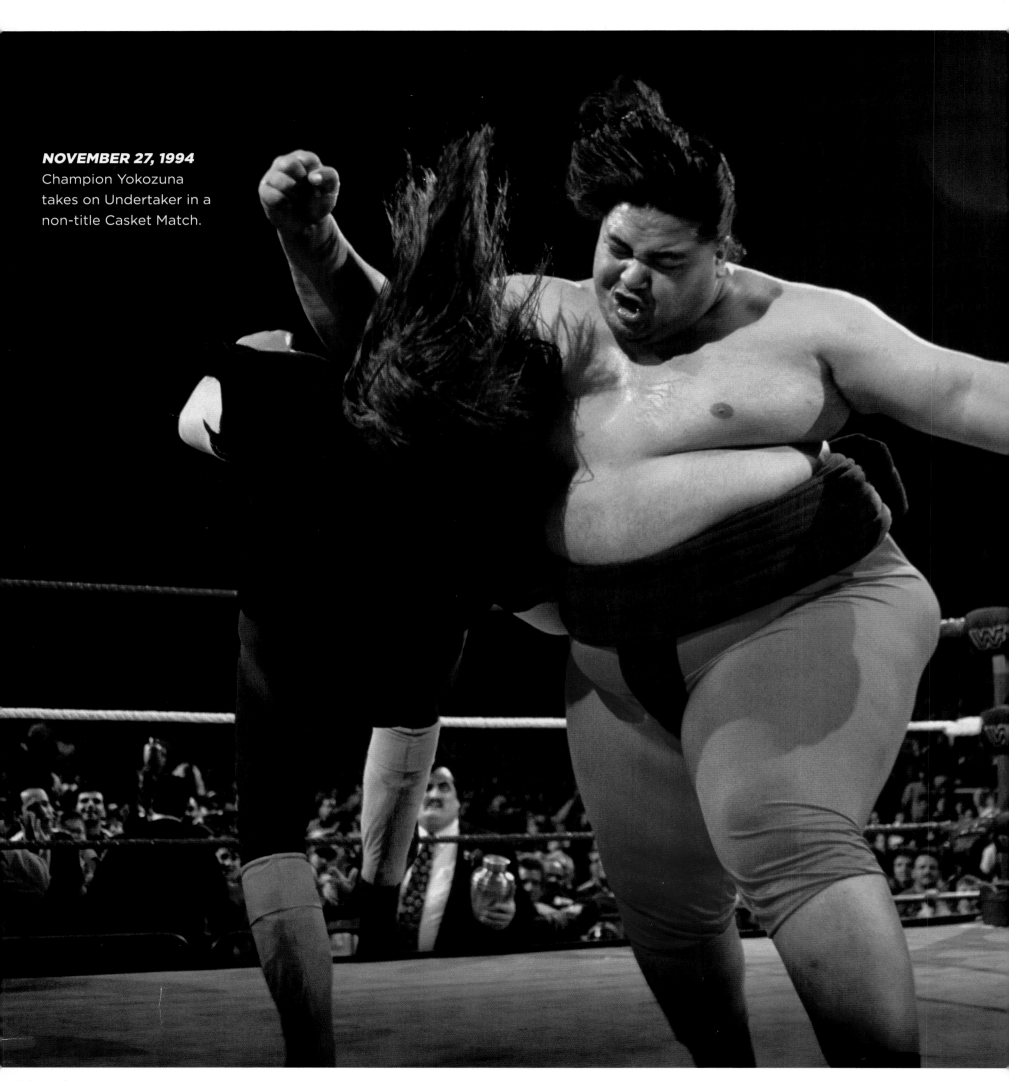

NOVEMBER 27, 1994
Champion Yokozuna
takes on Undertaker in a
non-title Casket Match.

YOKOZUNA

STANDING AT 6'4" AND WEIGHING ALMOST 600lbs, the huge Japanese Superstar, Yokozuna, could crush any rival. In 1993, Yokozuna challenged Bret "Hit Man" Hart for the title at *WrestleMania IX*. The former sumo wrestler used his massive size against the speed and technical skills of the champion, but as the match entered its final phase, Yokozuna found himself locked into the Sharpshooter. He was seemingly about to submit, when Yokozuna's manager Mr. Fuji threw salt in Hit Man's eyes, allowing Yokozuna to escape the submission move and win his first WWE Championship. Yokozuna's celebrations were short-lived as Hulk Hogan stormed to the ring and Fuji challenged him to face the new champion immediately. Fuji tried his salt trick again but accidentally hit Yokozuna, before Hogan landed a Leg Drop to end Yokozuna's title reign after just a few minutes. Yokozuna faced Hogan in a rematch at *King of the Ring* and when a 'photographer' shot a fireball from his camera into Hogan's face, Yokozuna hit Hogan with his own leg drop to become champ for a second time. Entering into rivalries with challengers Lex Luger and Undertaker, Yokozuna proved he was a colossal WWE Champion during his nine-month reign. At *WrestleMania X*, both Luger and Bret Hart were awarded title shots. Luger was disqualified but in the main event Yokozuna faced his old rival Hart. Lining up a Banzai Drop, Yokozuna lost his balance and fell from the ropes, before Hart got the pin and won the title. Tragically, Yokozuna died in 2000, aged just 34, but the two-time WWE Champion will live on in the hearts of the WWE Universe.

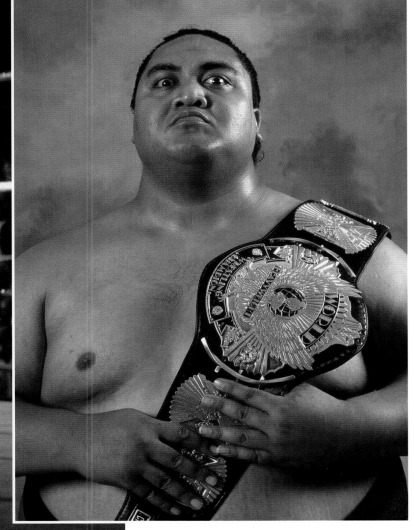

"YOKOZUNA PROVED HE WAS A COLOSSAL CHAMPION."

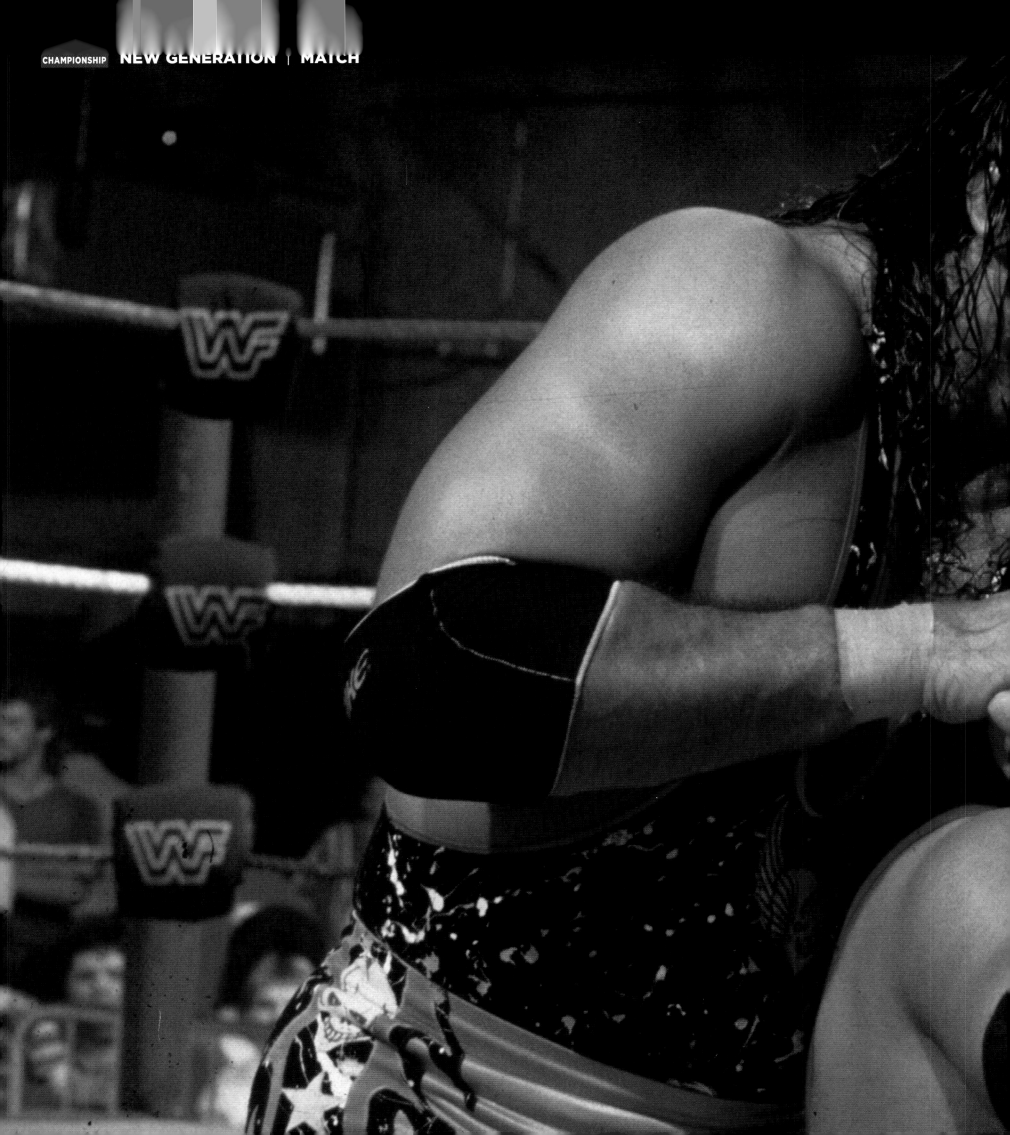

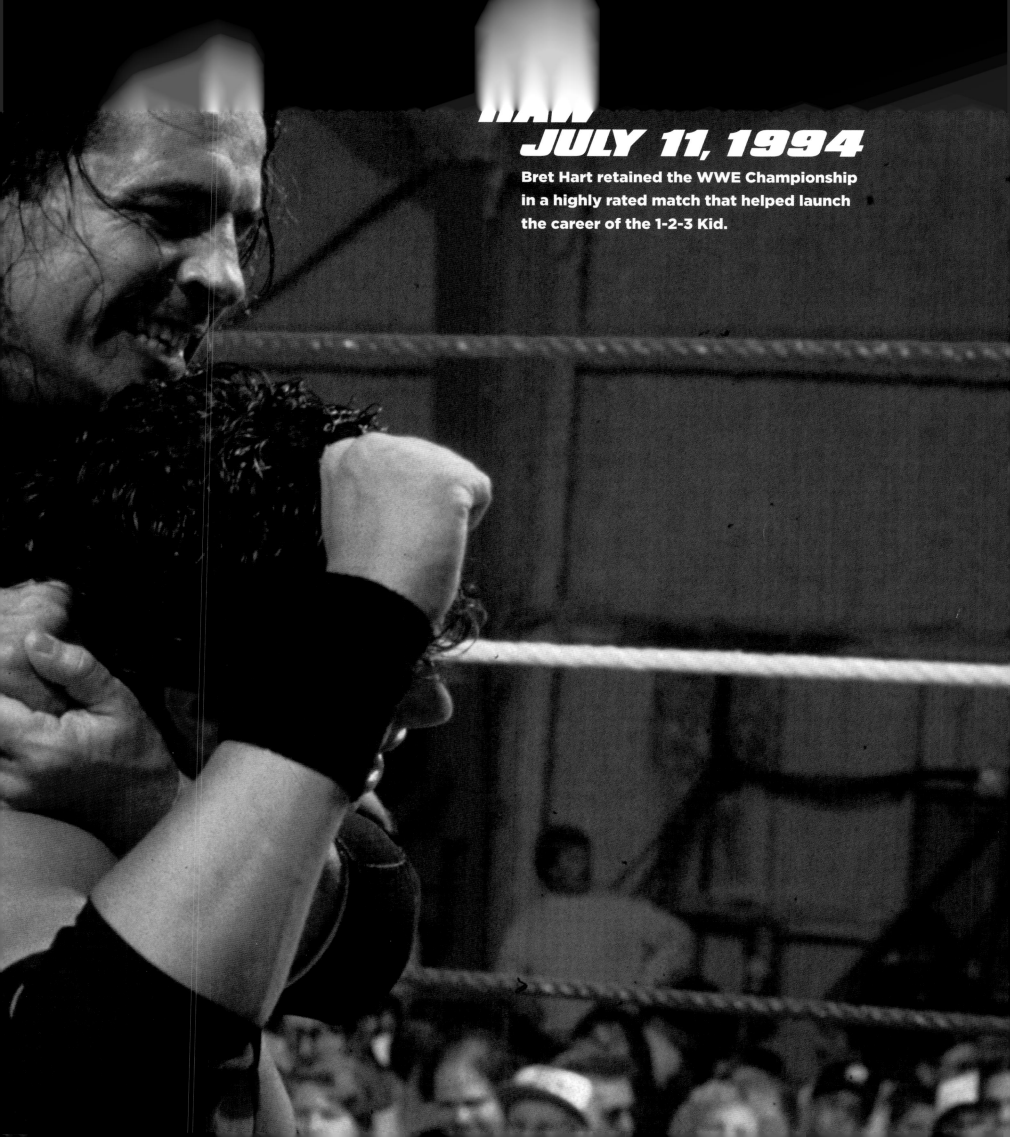

JULY 11, 1994

Bret Hart retained the WWE Championship in a highly rated match that helped launch the career of the 1-2-3 Kid.

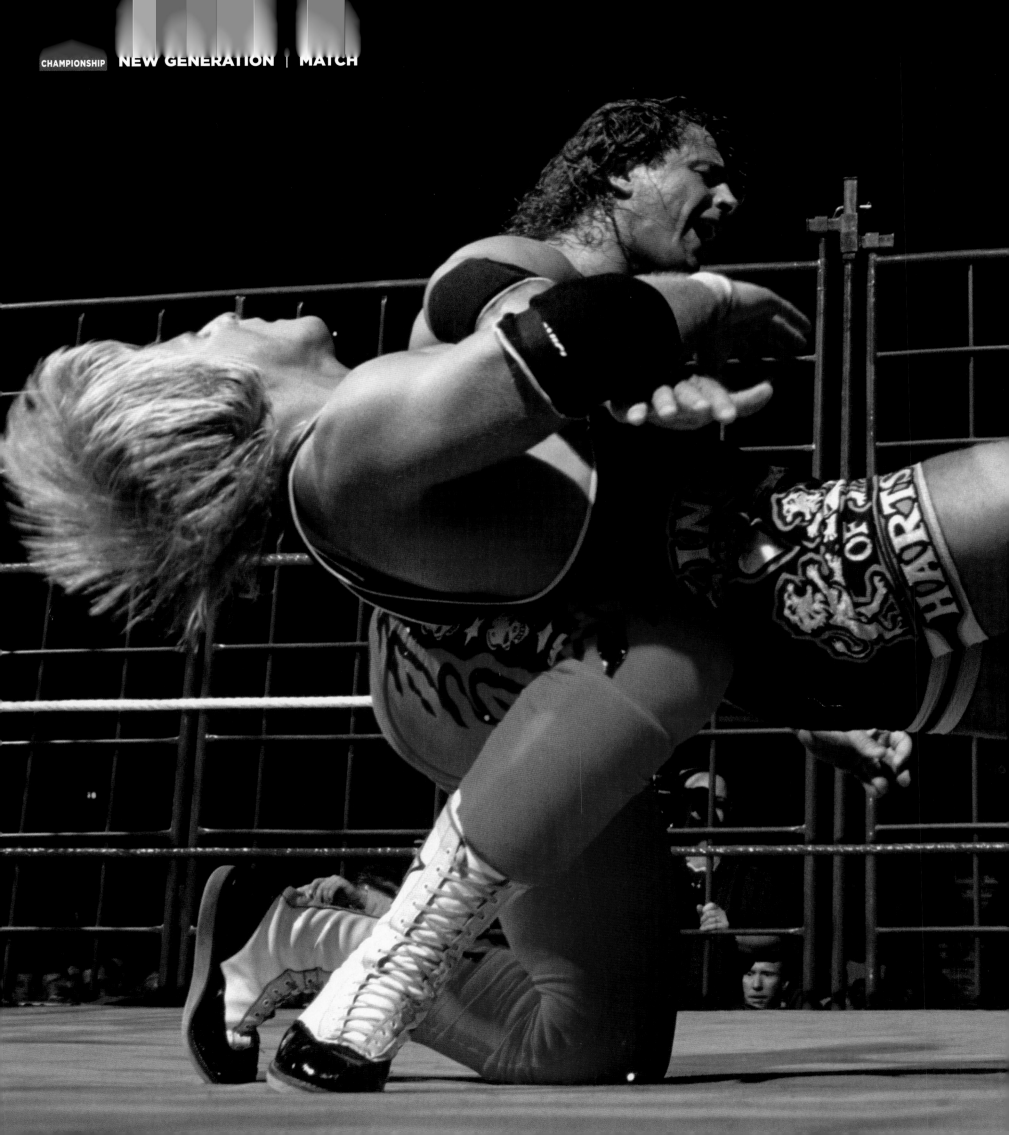

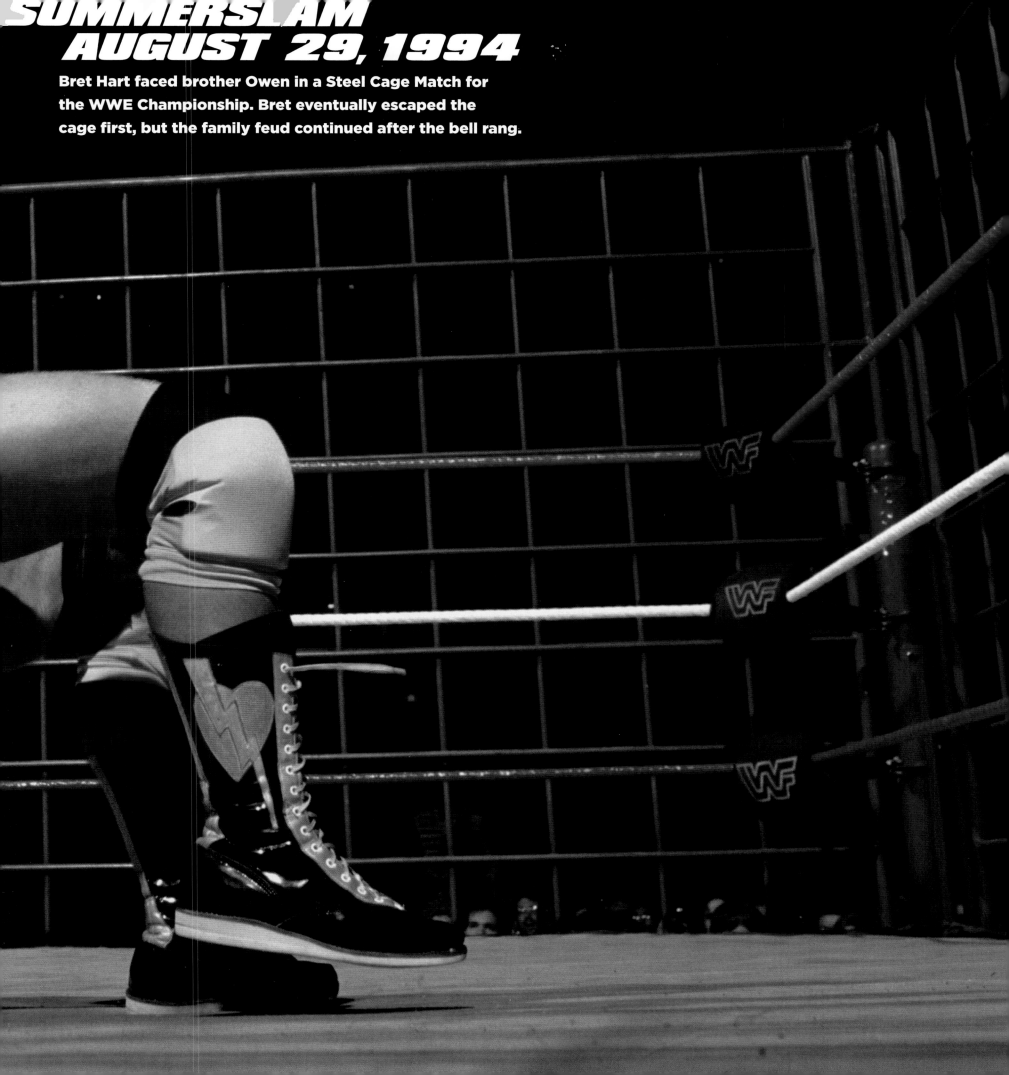

SUMMERSLAM
AUGUST 29, 1994

Bret Hart faced brother Owen in a Steel Cage Match for
the WWE Championship. Bret eventually escaped the
cage first, but the family feud continued after the bell rang.

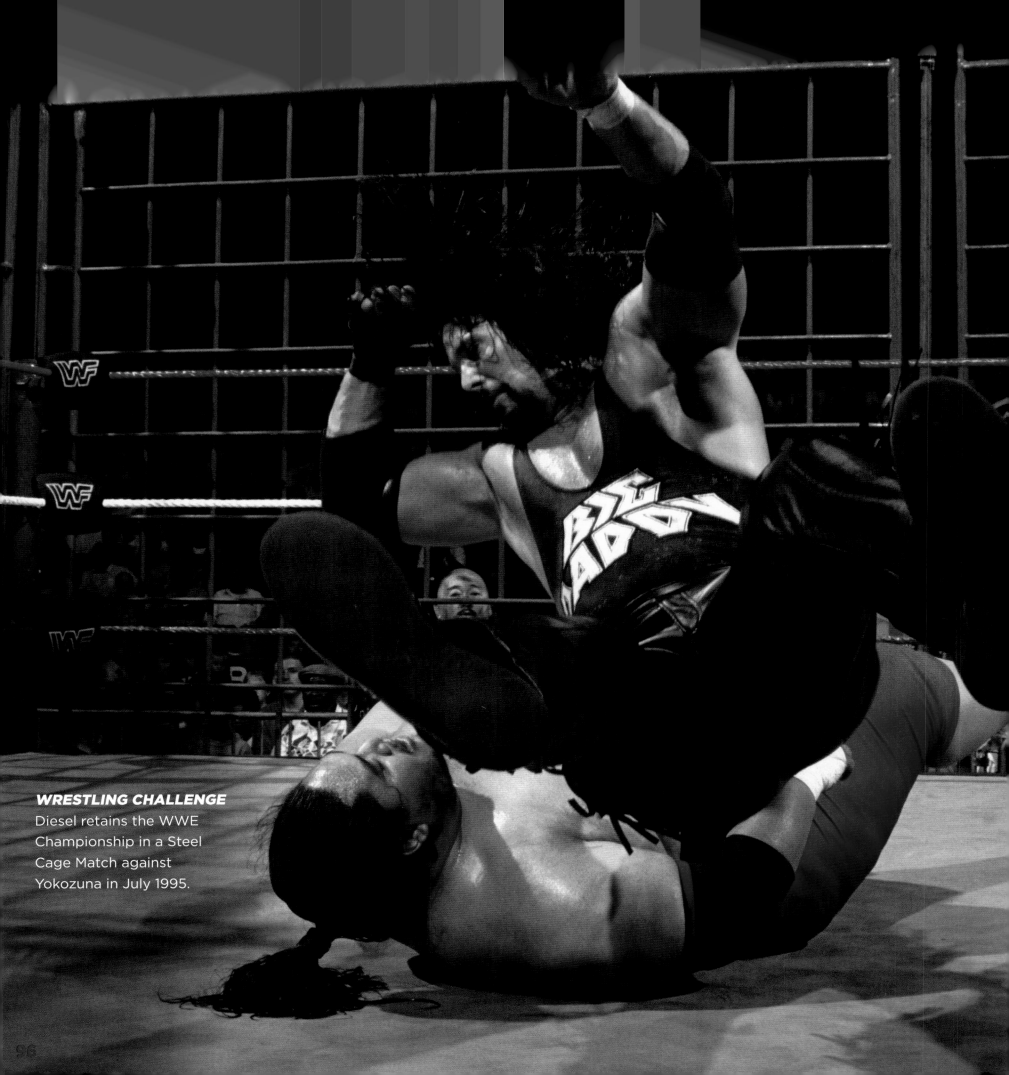

WRESTLING CHALLENGE
Diesel retains the WWE
Championship in a Steel
Cage Match against
Yokozuna in July 1995.

DIESEL

STANDING MORE THAN SEVEN FEET TALL AND WEIGHING in at 300-plus pounds, Diesel was the embodiment of raw, unbridled power. He first arrived in WWE in the early '90s, working as a bodyguard and enforcer for Shawn Michaels.

Unfortunately for HBK, Diesel had larger ambitions. On November 26, 1994, Diesel took just eight seconds to win the WWE Championship, defeating Bob Backlund in New York City. The win began a title reign that lasted nearly a year and saw Diesel defeat the best of the New Generation. His first major title defense came at the 1995 *Royal Rumble* against Bret Hart. Thanks to interference from a number of Superstars, that match ended in a draw, allowing Diesel to retain.

That same night, Michaels won the Royal Rumble Match and

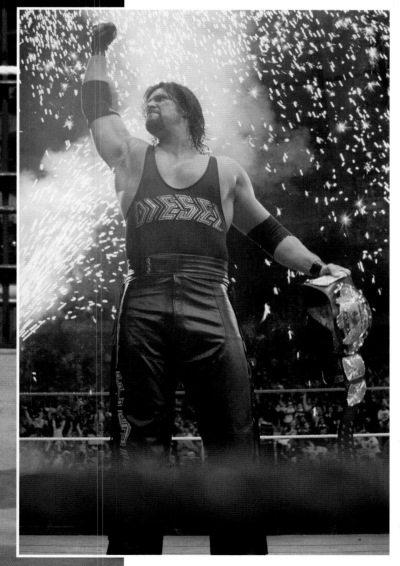

earned a shot against Diesel at *WrestleMania XI*. At the Show of Shows, Diesel and Michaels each came to the ring accompanied by a beautiful star, Jenny McCarthy with Michaels and *Baywatch*'s Pamela Anderson with Diesel.

"DIESEL TOOK JUST EIGHT SECONDS TO WIN THE WWE CHAMPIONSHIP."

The bout ended with Diesel hitting a brutal powerbomb on HBK to retain the title. Adding insult to injury, Diesel then left with both beauties on his arm.

Diesel and HBK repaired their fractured friendship, and in September 1995, with Michaels now the Intercontinental Champion, they partnered up in a "Winner Take All" Tag Match against Owen Hart and Yokozuna at *In Your House 3*. When the duo won the match, it meant that Diesel and Michaels held all three major titles in WWE.

Diesel's title reign came to an end at 1995's *Survivor Series* when he lost to Bret Hart. Although he did not compete for the title again, Diesel's WWE Title run was marked by strong victories against some of the best Superstars WWE could throw at him. That's why, even today, nearly three decades after his first title win, he is considered one of the all-time greats.

WRESTLE MANIA XII

BRET HART AND SHAWN MICHAELS WERE the rivals who pretty much defined the New Generation Era in WWE. Once Hart won the WWE Championship from Diesel at the 1995 *Survivor Series*, it was only a matter of time before Michaels and Hit Man met in the ring to settle the score. When word came down that HBK and Hart would face off in an Iron Man Match for the WWE Championship at *WrestleMania XII*, anticipation was high for what was expected to be the match of the year.

Right out of the gate, the bout kicked off in spectacular fashion with a show-stopping zipline entrance from Shawn Michaels. Both Hart and Michaels battled hard, each Superstar refusing to give any ground to the other. But, when the clock ran out, neither Hart nor Michaels had scored a fall. Hart, assuming he had retained by default, prepared to leave the ring. That's when WWE President Gorilla Monsoon shocked everyone by ordering the match into sudden-death overtime. Energized at being given another shot to grab the WWE Title, HBK nailed Hit Man with Sweet Chin Music, knocking Hart for a loop, but it was not enough to put him down for the count. Still slightly dazed, Hart charged HBK but was leveled by a second shot of Sweet Chin Music. That hit was enough for Michaels to make the cover. The victory was celebrated as the achievement of Shawn's "boyhood dream," the goal of coming to WWE as a comparatively smaller Superstar and winning the promotion's most coveted prize. It was a high point for HBK and a high point for the New Generation years.

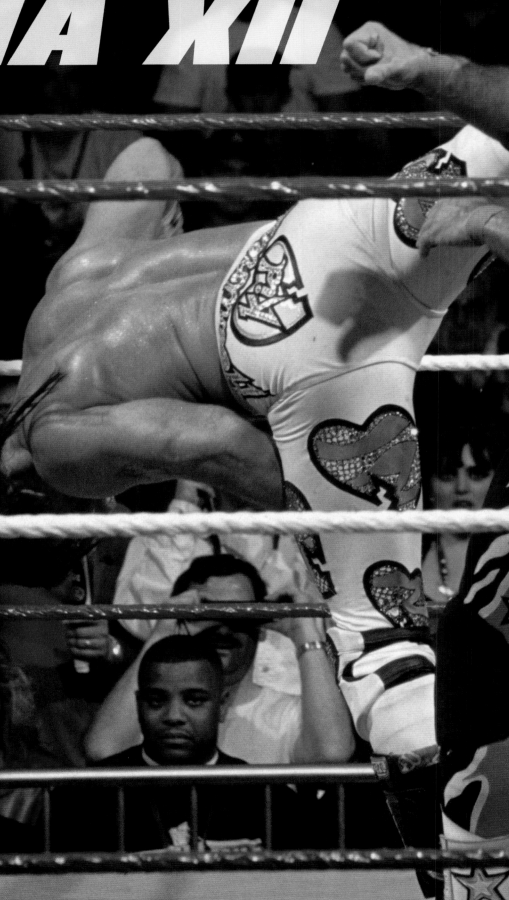

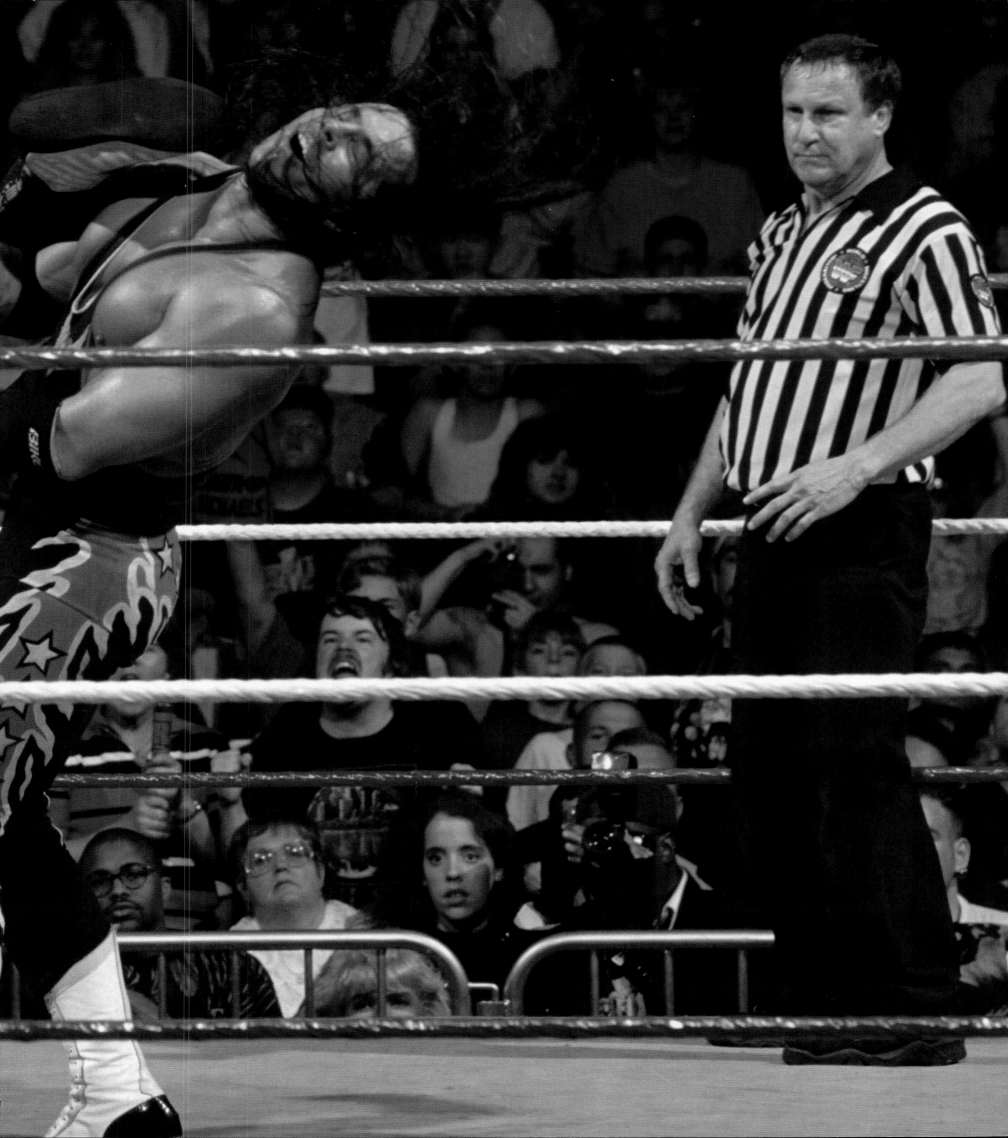

SHAWN MICHAELS

SHAWN MICHAELS HAS GONE BY A NUMBER OF different nicknames in his career, from "The Heartbreak Kid" to "Mr. *WrestleMania*." But perhaps the one that best applies is "The Showstopper," because no matter who he was facing, no matter where he was competing, no matter what was on the line, when Shawn Michaels stepped between the ropes, every single person watching had their eyes on him.

Although a Superstar who rose to the absolute height of singles greatness, Shawn Michaels got his start as part of a tag team. He debuted in WWE in 1988 alongside Marty Jannetty as one half of the Rockers, a hard-charging and hard-hitting tag team. However, all good things must come to an end, and in 1992, the Rockers suffered an acrimonious split when Michaels tossed Jannetty through a window on Brutus Beefcake's "Barbershop" talk segment.

As a singles competitor, Shawn Michaels rocketed to the top of the ladder, putting on spectacular, electrifying matches that, in some instances, changed the game in WWE forever. For everyone watching, it was only a matter of time before HBK became WWE Champion.

Since splitting from Jannetty, Michaels had had a few shots at the title, such as a match against Bret Hart at the 1992 *Survivor Series* and a title match against Diesel at *WrestleMania XI*, but at *WrestleMania XII*, the title seemed to be within his grasp. His star had never been higher and his rivalry with then-champion Bret Hart had never been hotter. At the Show of Shows in Anaheim, Michaels faced Hart in a 60-minute Iron Man Match, with neither Superstar giving any quarter.

"HE ACHIEVED HIS FABLED 'BOYHOOD DREAM' TO WIN THE WWE CHAMPIONSHIP."

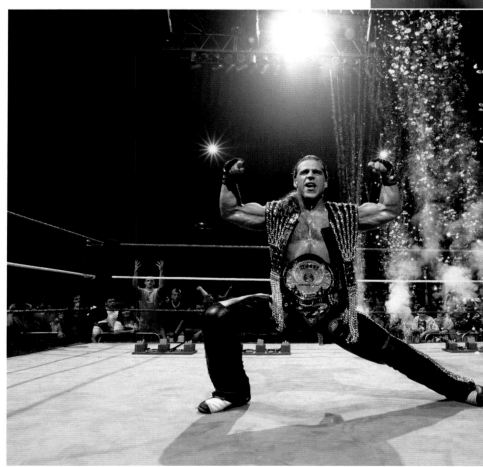

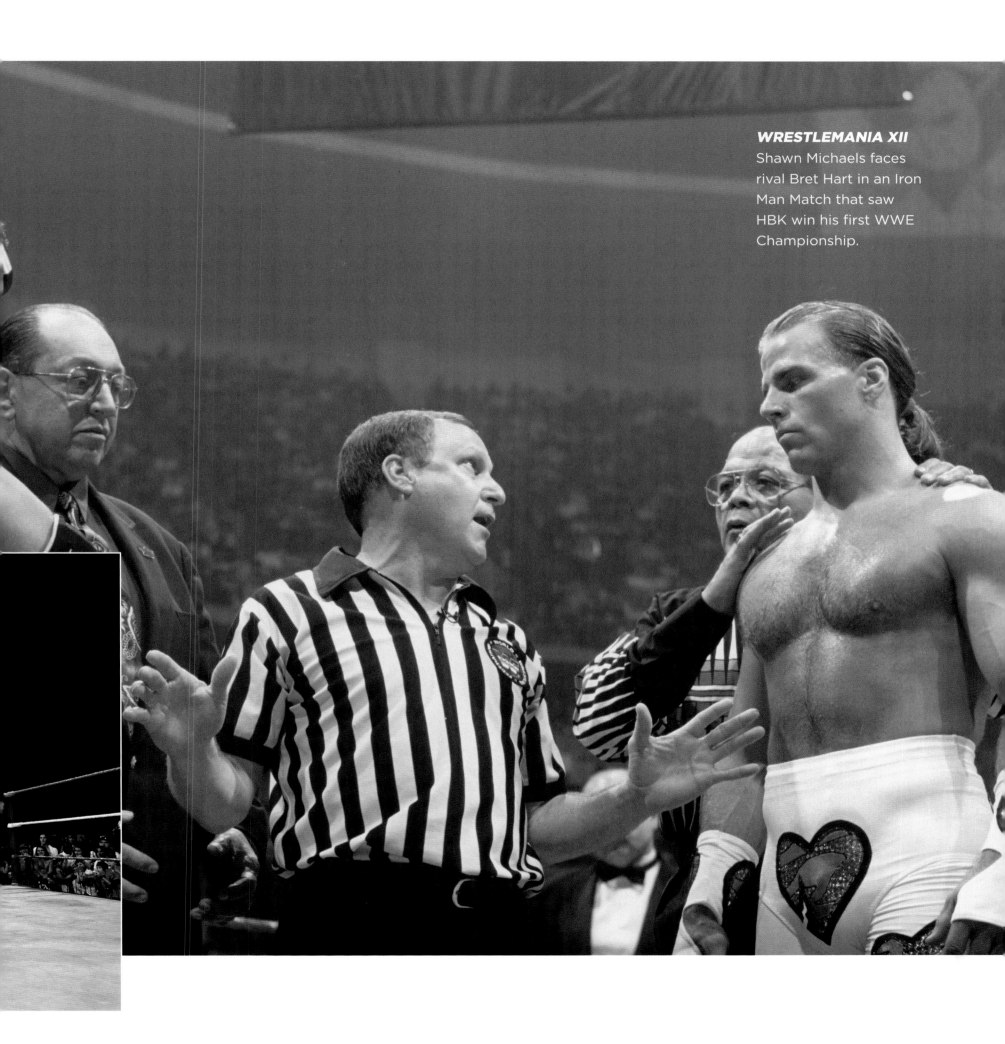

WRESTLEMANIA XII
Shawn Michaels faces rival Bret Hart in an Iron Man Match that saw HBK win his first WWE Championship.

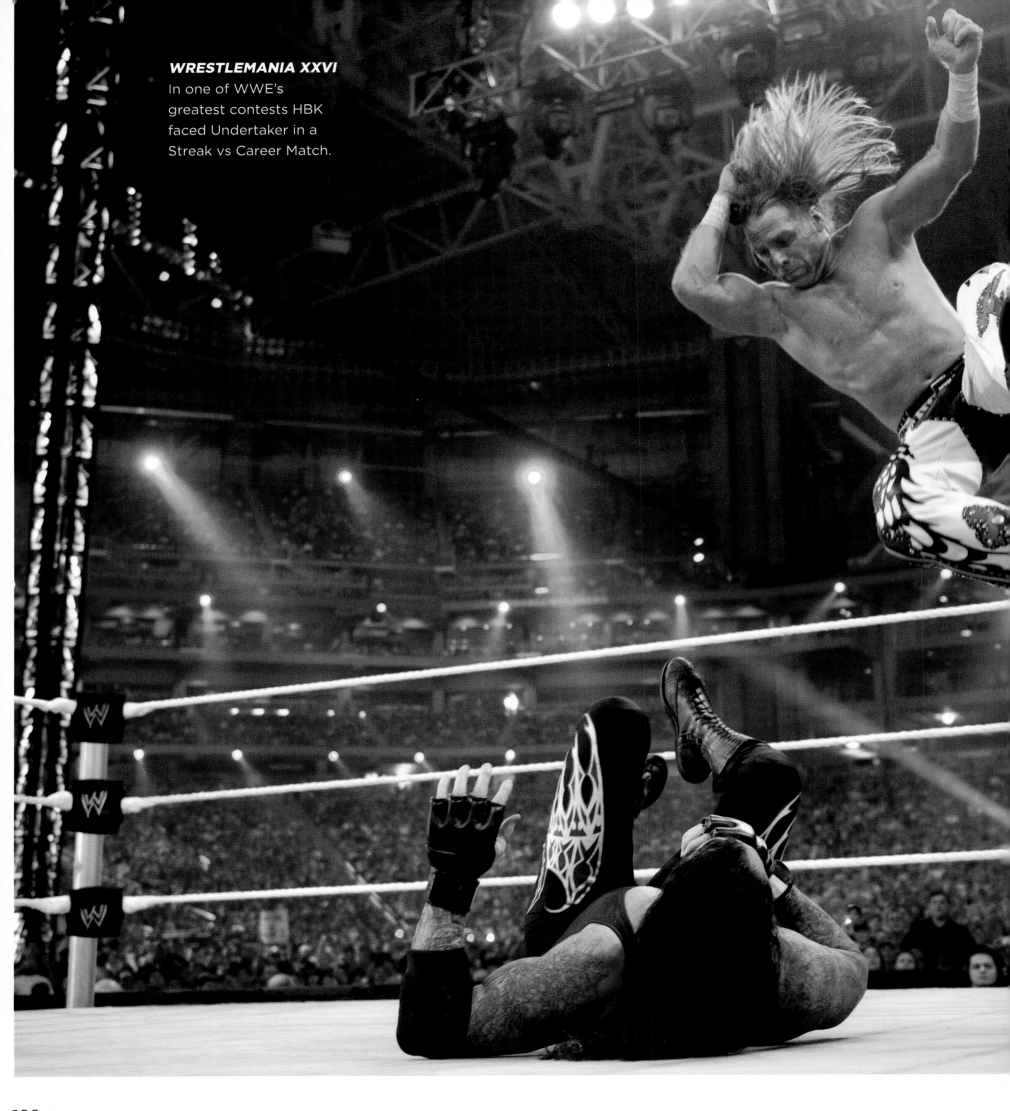

WRESTLEMANIA XXVI
In one of WWE's greatest contests HBK faced Undertaker in a Streak vs Career Match.

When the match went into sudden-death overtime, it was Michaels who landed Sweet Chin Music on Hart to pick up the three-count and achieve his fabled "Boyhood Dream" to win the WWE Championship.

HBK held the title for more than 230 days, his longest run with the WWE Championship, before losing it to Sycho Sid at *Survivor Series* in November of 1996. At the 1997 *Royal Rumble*, he managed to win the title back, but vacated it just 25 days later. In an emotional speech on *Raw*, Michaels told the WWE Universe that he had to step away from the ring for a time due to a knee injury and the overall feeling that he needed to reevaluate where his career was going.

"EVERY PERSON HAD THEIR EYES ON HIM."

HBK was away for much of the first half of 1997, returning in the late spring to briefly hold the WWE Tag Team Championship with "Stone Cold" Steve Austin. After that, he went back on the hunt for the WWE Title in earnest. It all came to a head in Montreal, Canada, at the 1997 *Survivor Series* when he faced off against his longtime rival, Bret Hart, for the title. Despite the controversial ending of that match, HBK's win ignited a third title reign that extended all the way to *WrestleMania XIV*. In that match, Michaels faced off against "Stone Cold" Steve Austin for the title. Stone Cold won that bout, paving the way for the Attitude Era to begin in WWE.

In every era that he has competed, Shawn Michaels has set a new standard for what a WWE Superstar can accomplish. Each of his title runs marked a significant turning point in both his career and the trajectory of the company itself. Whatever he accomplishes next in his career, he leaves behind an unmatched legacy and a bar raised so high that only the greatest Superstars can hope to reach it.

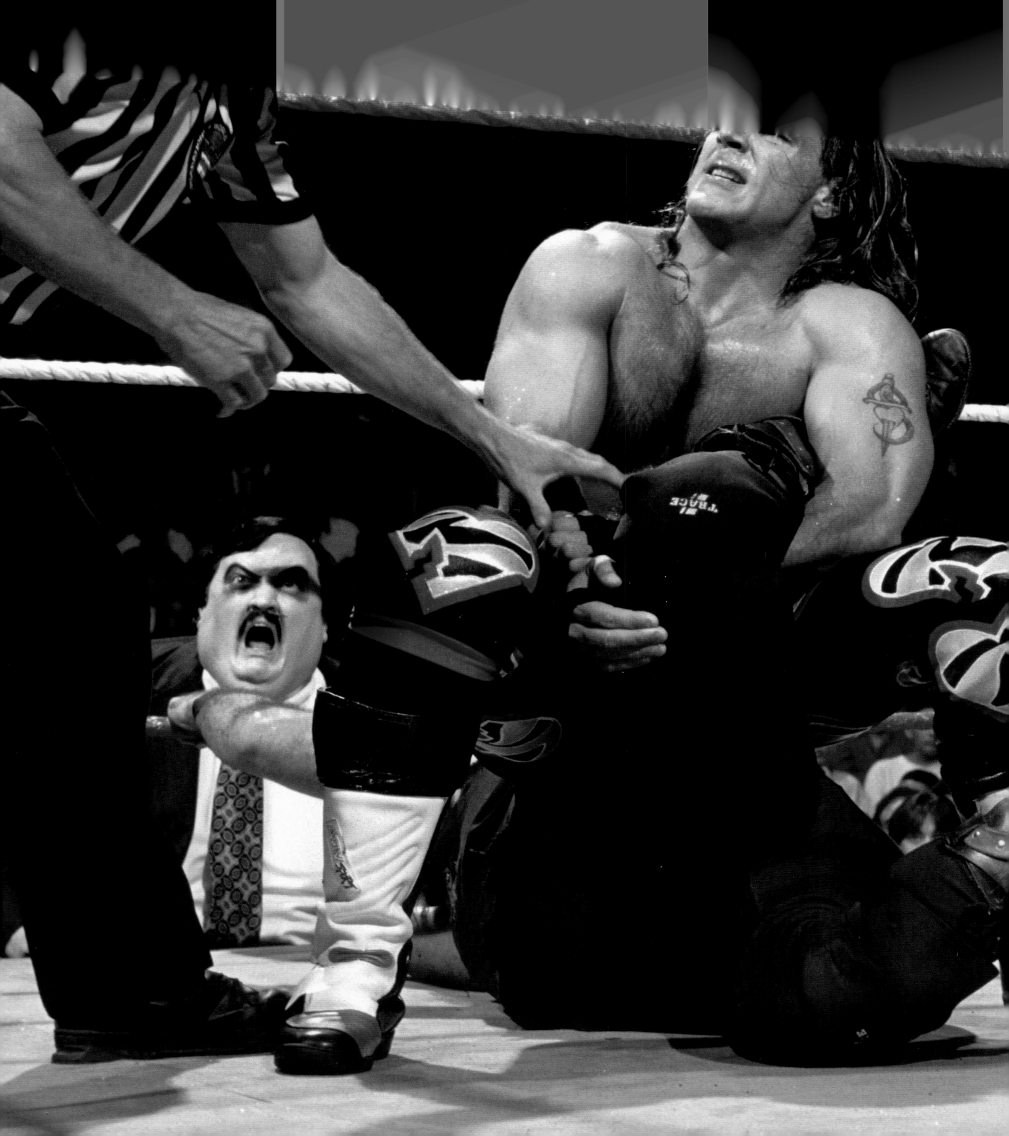

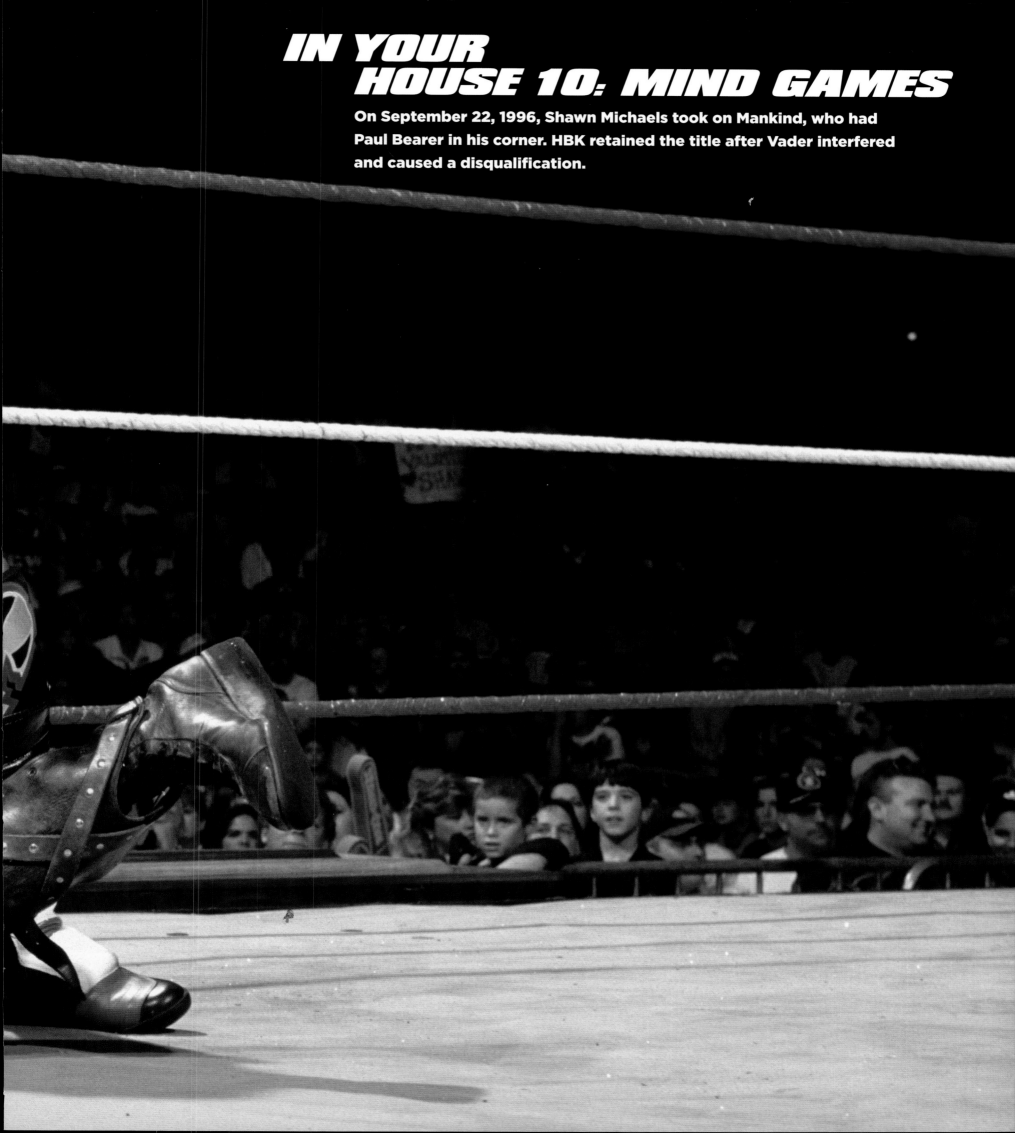

IN YOUR HOUSE 10: MIND GAMES

On September 22, 1996, Shawn Michaels took on Mankind, who had Paul Bearer in his corner. HBK retained the title after Vader interfered and caused a disqualification.

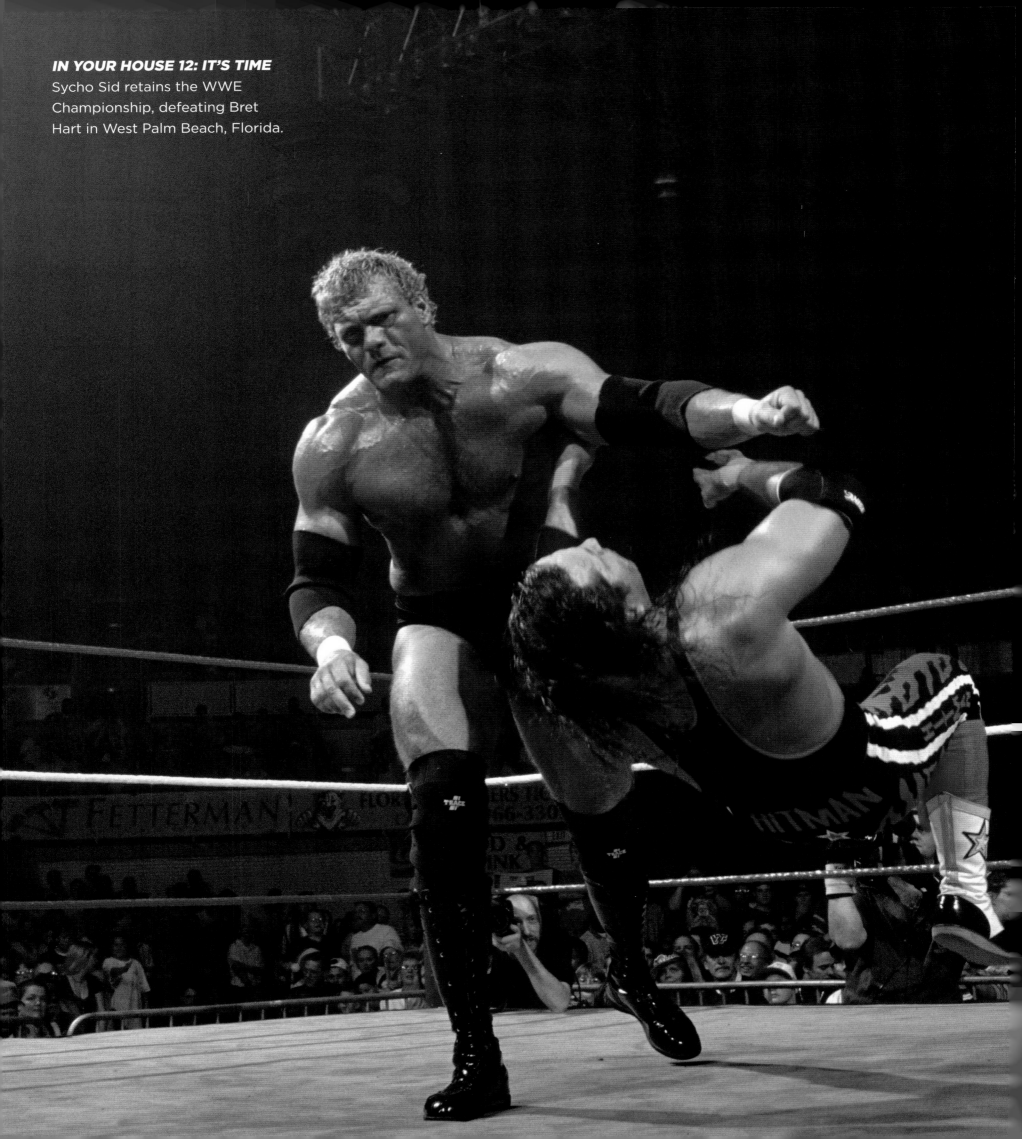

IN YOUR HOUSE 12: IT'S TIME
Sycho Sid retains the WWE Championship, defeating Bret Hart in West Palm Beach, Florida.

SYCHO SID

CALLING HIMSELF "SYCHO" WAS NOT just a nickname to inspire fear in his opponents. Intense, brutal and sadistic, Sid was indeed one of the most psychotic Superstars ever to stalk the ring.

After working his way through the roster, facing Superstars like Diesel, Razor Ramon and the British Bulldog, Sycho Sid earned a shot at the WWE Title against Shawn Michaels at the 1996 *Survivor Series*. HBK seemed to have the match locked up when he took down Sid with Sweet Chin Music. But, instead of going for the fall, Michaels took a moment to check on his manager, José Lothario, whom Sid had attacked earlier. This lapse in judgment allowed Sid to get back to his feet and hit Michaels with a camera, before following up with a powerbomb to win the WWE Championship.

Sid's first major title defense came at *In Your House 12: It's Time* when he faced Bret Hart for both the title and a match against Shawn Michaels at the *Royal Rumble*. Hart locked Sid in the Sharpshooter, forcing him to tap, but an unconscious ref meant the title couldn't change hands. Instead, Sid was able to hit a powerbomb and walk away with the gold.

At the *Royal Rumble*, Michaels managed to defeat Sid for the Championship but soon had to vacate the title due to injury. When Bret Hart won the vacant Championship at *In Your House 13: Final Four*, Sid got a title match against Hart the following night on *Raw*. Sid was nearly taken out with a Sharpshooter, but an attack by Steve Austin on Hart allowed Sid to make the pinfall and become a two-time WWE Champion. He kept the title until *WrestleMania 13*, when he lost it to Undertaker.

More than two decades after his last reign as WWE Champion, Sid remains a larger-than-life figure who looms tall over the WWE landscape.

"SID WAS ONE OF THE MOST PSYCHOTIC SUPERSTARS EVER TO STALK THE RING."

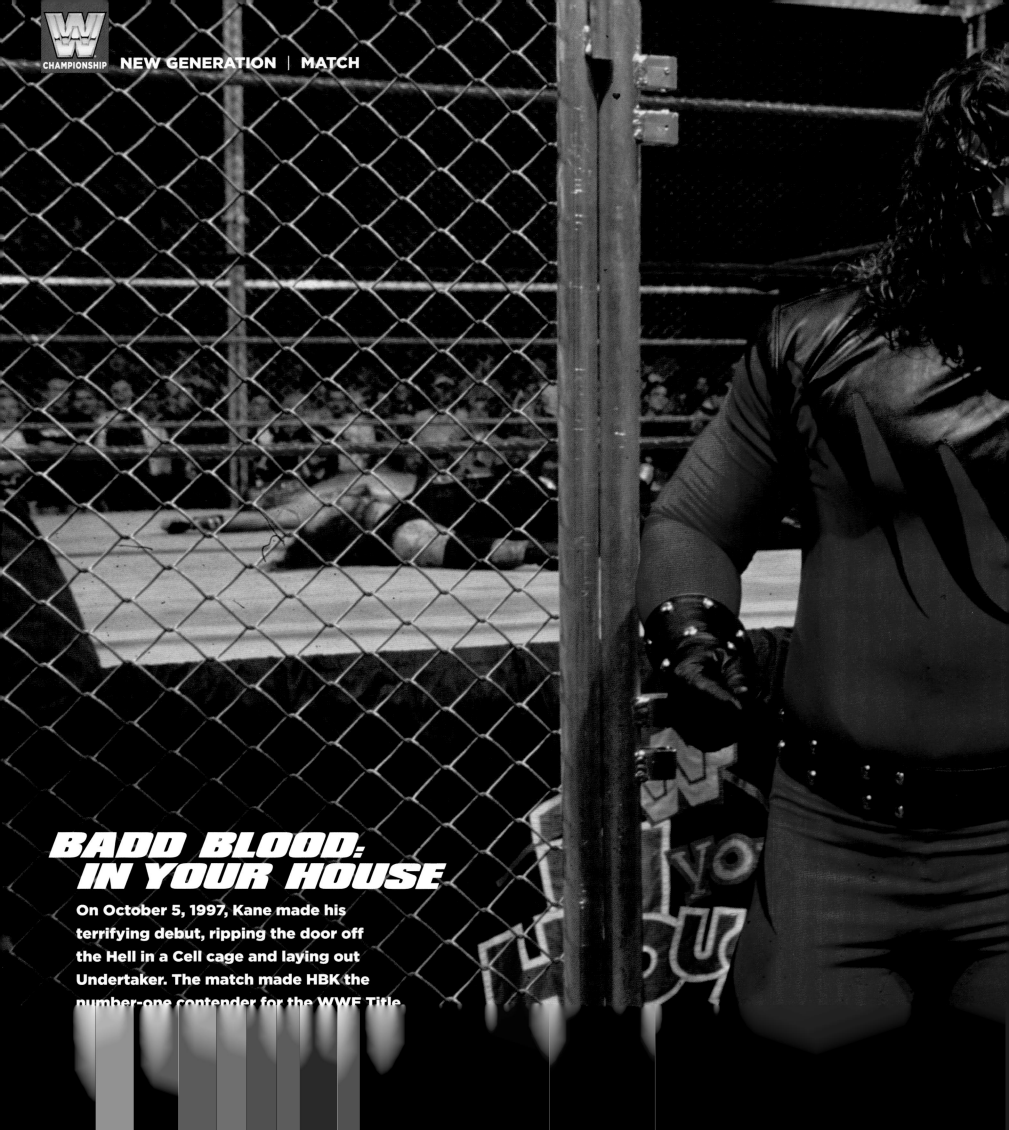

BADD BLOOD: IN YOUR HOUSE

On October 5, 1997, Kane made his terrifying debut, ripping the door off the Hell in a Cell cage and laying out Undertaker. The match made HBK the number-one contender for the WWF Title.

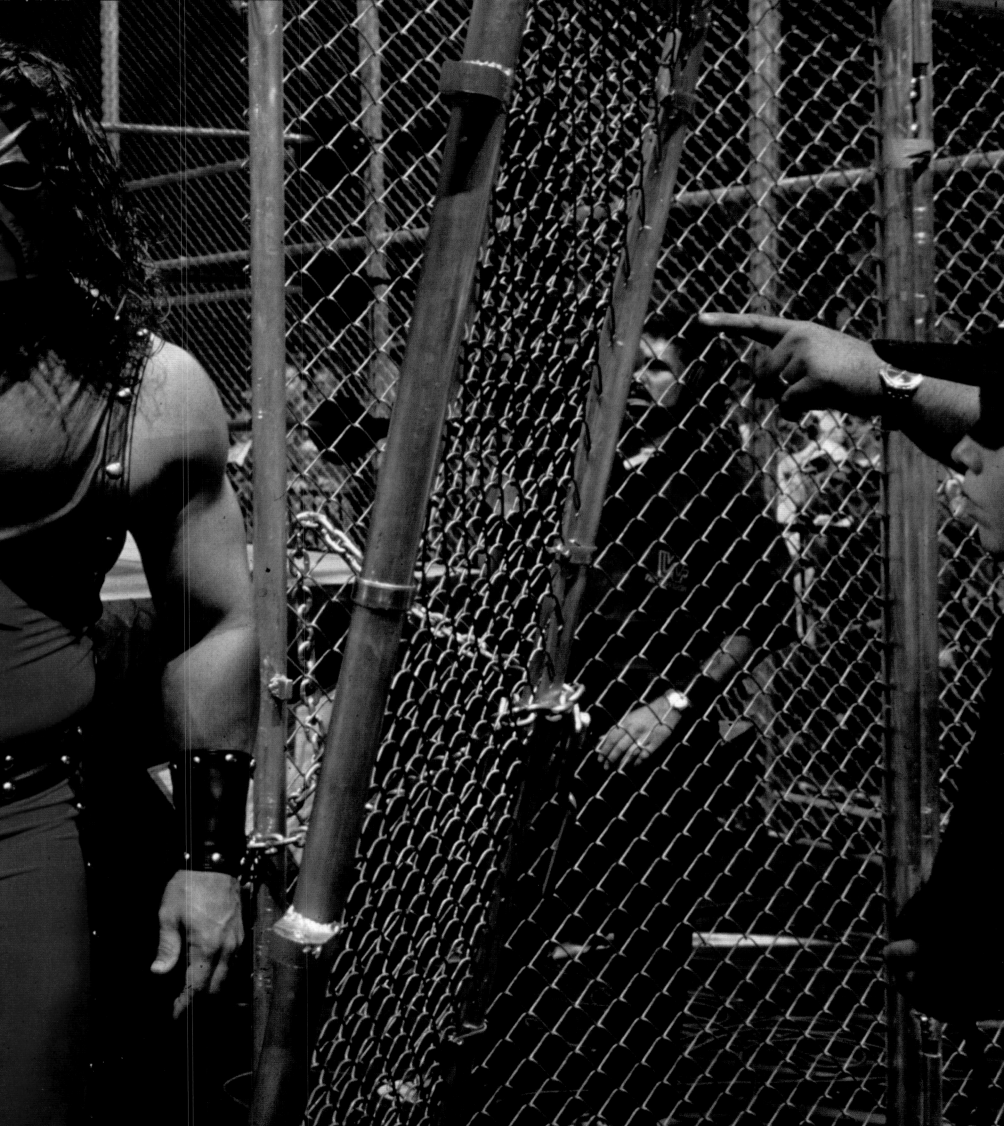

MONTREAL SCREW JOB

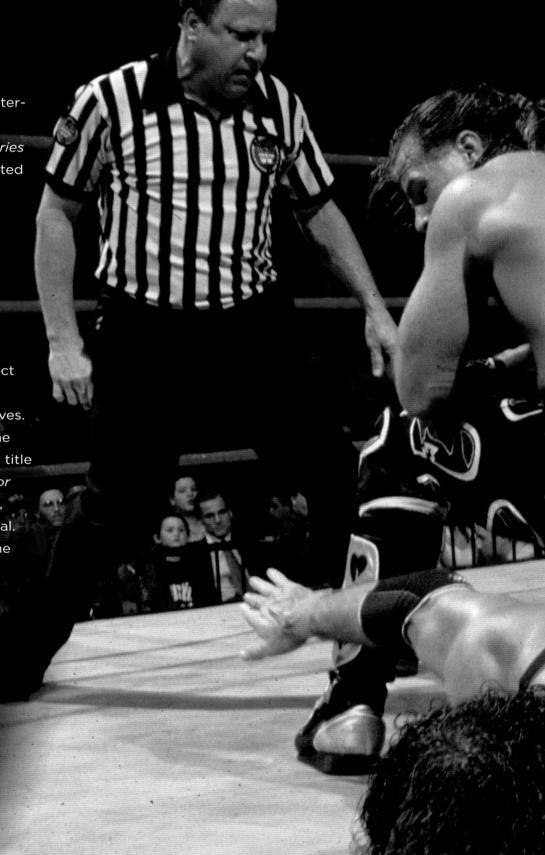

IN THE LONG HISTORY OF WWE, this moment ranks as its most infamous. It had all the elements of great drama: personal rivalry, grudges and, ultimately, betrayal. Even now, nearly a quarter-century later, the match between Bret Hart and Shawn Michaels at the 1997 *Survivor Series* stands out as probably the most hotly debated title change of all time.

In late 1997, Bret Hart, who had been one of WWE's top Superstars for more than a decade, was offered a contract with then-rival promotion WCW, which he accepted. The only issue was, Hart was the WWE Champion at the time. Mr. McMahon had seen other former WWE Superstars. such as Women's Champion Alundra Blayze, defect to WCW with their championships, only to disrespect and defile them on WCW's airwaves. Not wanting the same thing to happen to the WWE Championship, McMahon scheduled a title match between Hart and Michaels at *Survivor Series*. Hart was not thrilled at this prospect, as the event was going to be held in Montreal. Hart did not want to run the risk of losing the title in his native Canada, especially to his hated rival, Shawn Michaels. Nevertheless, the match was made and Bret Hart would be forced to defend the title in his home country.

During the bout, Michaels trapped Hart in Hit Man's own finisher, the Sharpshooter. Before Hart could break

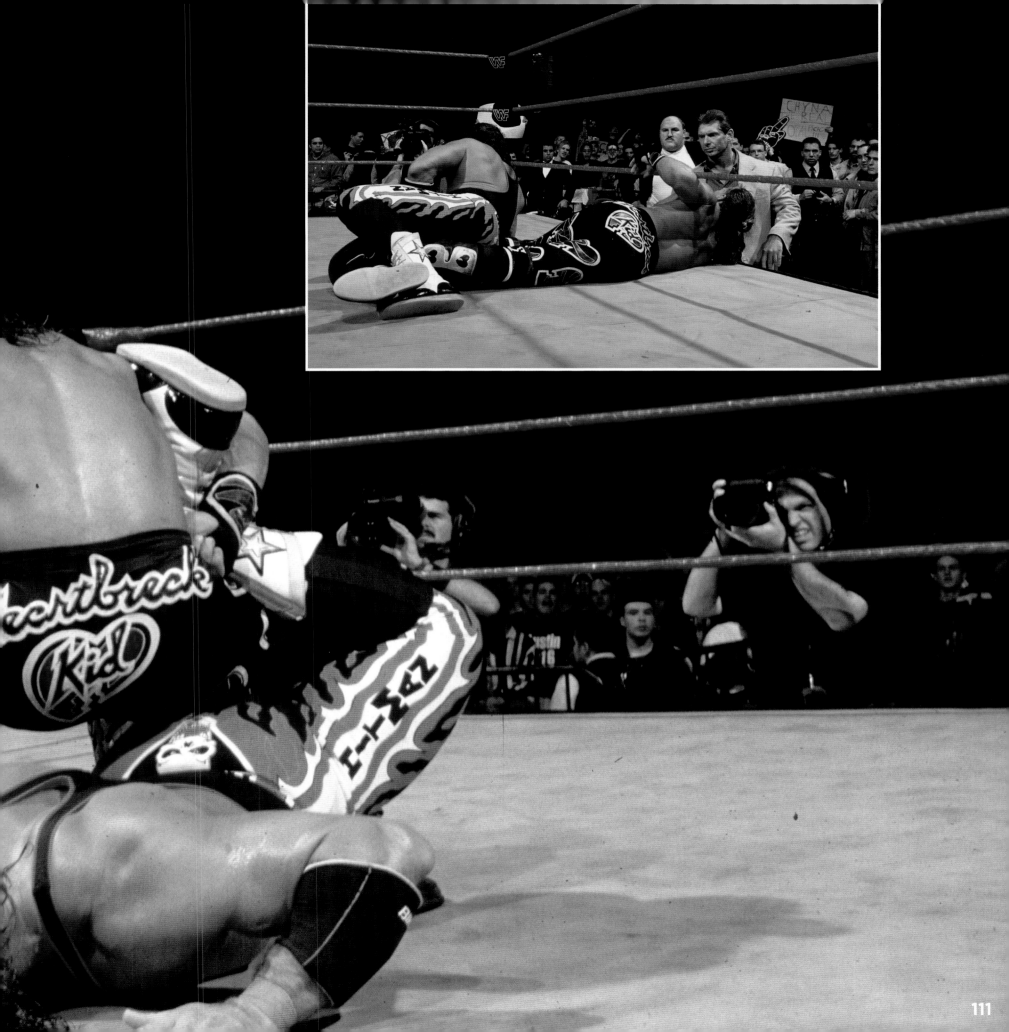

the hold, McMahon ordered the referee to end the match, despite Hart not submitting, making Michaels the winner. Hart was outraged and walked out of WWE seemingly for good. He would not be seen in a WWE ring again for twelve years.

Even today, what happened at Montreal, becoming known as the "Montreal Screwjob", is not fully known. Had McMahon always planned on ringing the bell prematurely or was it a decision made in the heat of the moment? Did anyone else know? The full truth may never come out, but no matter the circumstances, the events of Montreal prove that, just when the WWE Universe thinks it has seen everything, there are always more big surprises waiting in the wings.

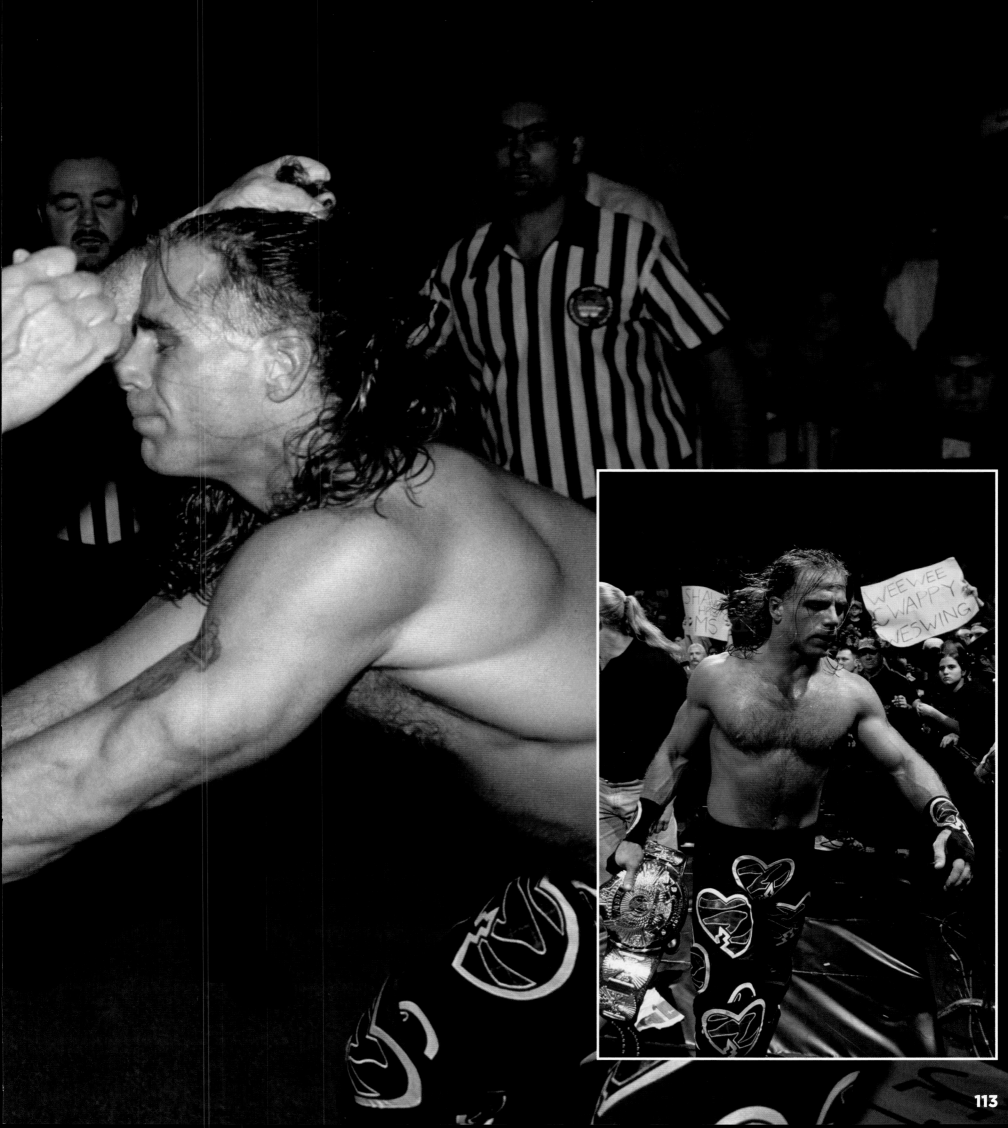

E RA
RA

MID '90s - 2002

For the first time in a long while, WWE found it had serious competition in WCW and ECW. The Monday Night Wars raged across the world of sports entertainment, ushering in a new era where brash, rebellious Superstars clashed with corporate champions and no one knew what was going to happen next.

ATTITUDE ERA

THE EVENTS OF MONTREAL IN 1997 SENT shockwaves through the world of WWE, changing it irrevocably. For starters, Vince McMahon, known primarily to the WWE Universe as a color commentator, stepped out from behind the scenes to become Mr. McMahon, the scheming, conniving owner of WWE who valued money and success above all else. Standing in direct opposition to McMahon's reign of greed and avarice was "Stone Cold" Steve Austin.

A bald-headed, beer-swilling Superstar clad in a leather vest and a tendency to express himself by waving his middle fingers in the face of anyone who defied him, Austin was the anti-Superstar. He was also imbued with a healthy disregard for authority figures, and had a simple solution for dealing with them. Should someone tell him what to do, he would just drop them to the mat with a Stone Cold Stunner.

Mr. McMahon did all he could to hold Austin down, but Stone Cold was like a force of nature that could not be repressed. He won the 1998 Royal Rumble Match, which set him on the track to face Shawn Michaels at *WrestleMania XIV* for the WWE Title. With Mike Tyson as a "guest enforcer," HBK and Stone Cold squared off in Boston for the gold. Although struggling with a nagging back injury, Michaels fought hard to take the Rattlesnake down, almost sealing the deal with Sweet Chin Music. But Stone Cold was ready for the move and countered with a Stunner, allowing Tyson, who had taken over as referee, to make the three-count. As commentator Jim Ross observed in the moment, the Austin Era had begun.

Austin's ascendancy coincided with another sea change in WWE. With rival promotions like WCW and the Philly-based ECW presenting sports entertainment with a harder and more extreme edge, with more stipulation matches and high-flying cruiserweights, the time had come for WWE to shift the promotion into a higher gear as well. Thus began the so-called Attitude Era.

To take Austin down, McMahon commissioned Kane, who defeated Austin for the title at the 1998 *King of the Ring*. However, the next night on *Raw*, Austin swiftly won it back. In celebration of his second title

reign, Austin had his own title commissioned, emblazoned with his own personal logo and known as the "Smoking Skull" Championship.

After Austin was simultaneously pinned by both Undertaker and Kane at *Breakdown: In Your House*, the WWE Title was vacated, clearing a path for a new champion to arise. That champion took home the gold at the 1998 *Survivor Series*, exactly two years after his debut. When he debuted, he was known as Rocky Maivia, but on

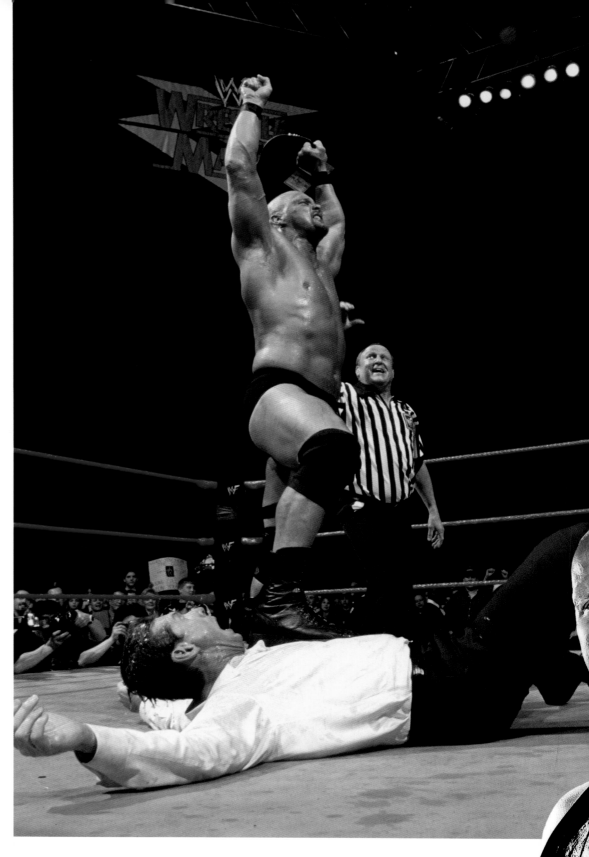

▲ **WRESTLEMANIA XV**
Austin celebrates winning his third WWE Championship, defeating the combined might of The Rock and Mr. McMahon.

▶ **STONE COLD**
Austin's disregard for authority drove his popularity and led to six title reigns during the Attitude Era.

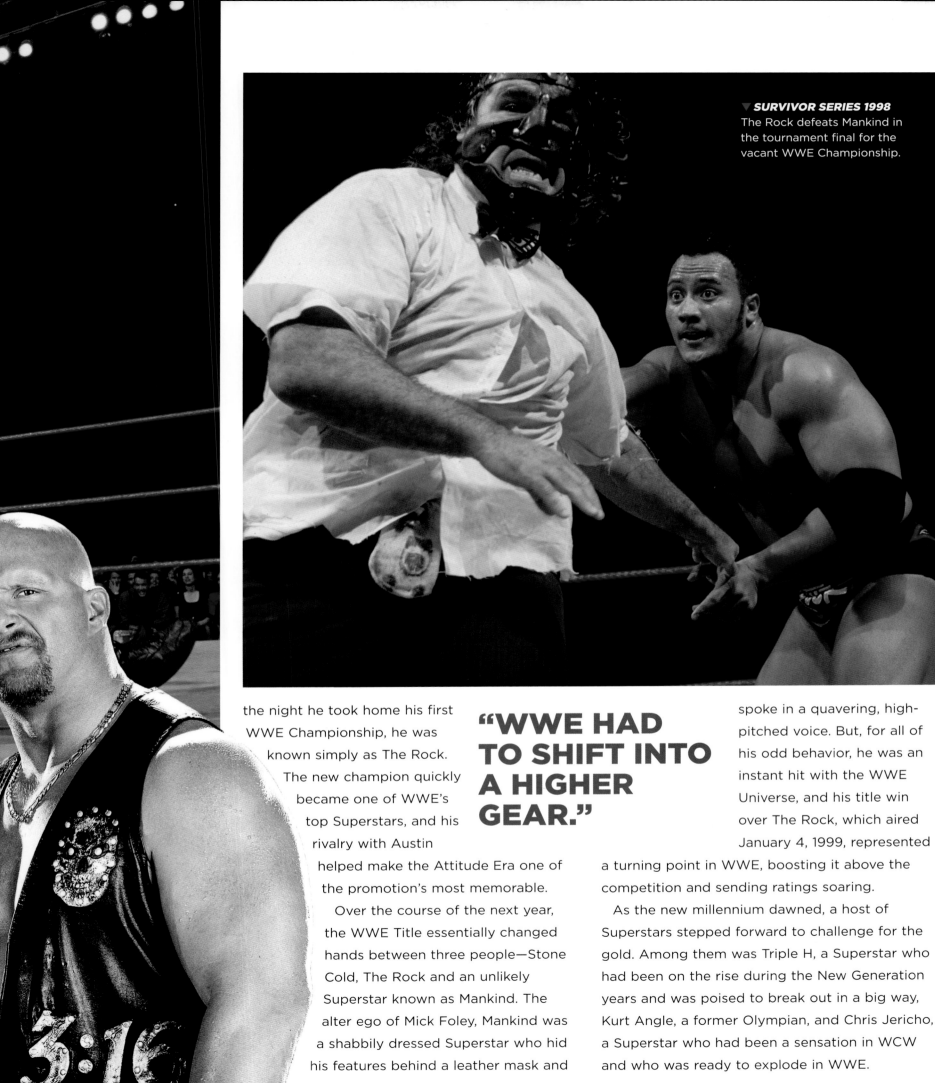

"WWE HAD TO SHIFT INTO A HIGHER GEAR."

the night he took home his first WWE Championship, he was known simply as The Rock. The new champion quickly became one of WWE's top Superstars, and his rivalry with Austin helped make the Attitude Era one of the promotion's most memorable.

Over the course of the next year, the WWE Title essentially changed hands between three people—Stone Cold, The Rock and an unlikely Superstar known as Mankind. The alter ego of Mick Foley, Mankind was a shabbily dressed Superstar who hid his features behind a leather mask and spoke in a quavering, high-pitched voice. But, for all of his odd behavior, he was an instant hit with the WWE Universe, and his title win over The Rock, which aired January 4, 1999, represented a turning point in WWE, boosting it above the competition and sending ratings soaring.

As the new millennium dawned, a host of Superstars stepped forward to challenge for the gold. Among them was Triple H, a Superstar who had been on the rise during the New Generation years and was poised to break out in a big way, Kurt Angle, a former Olympian, and Chris Jericho, a Superstar who had been a sensation in WCW and who was ready to explode in WWE.

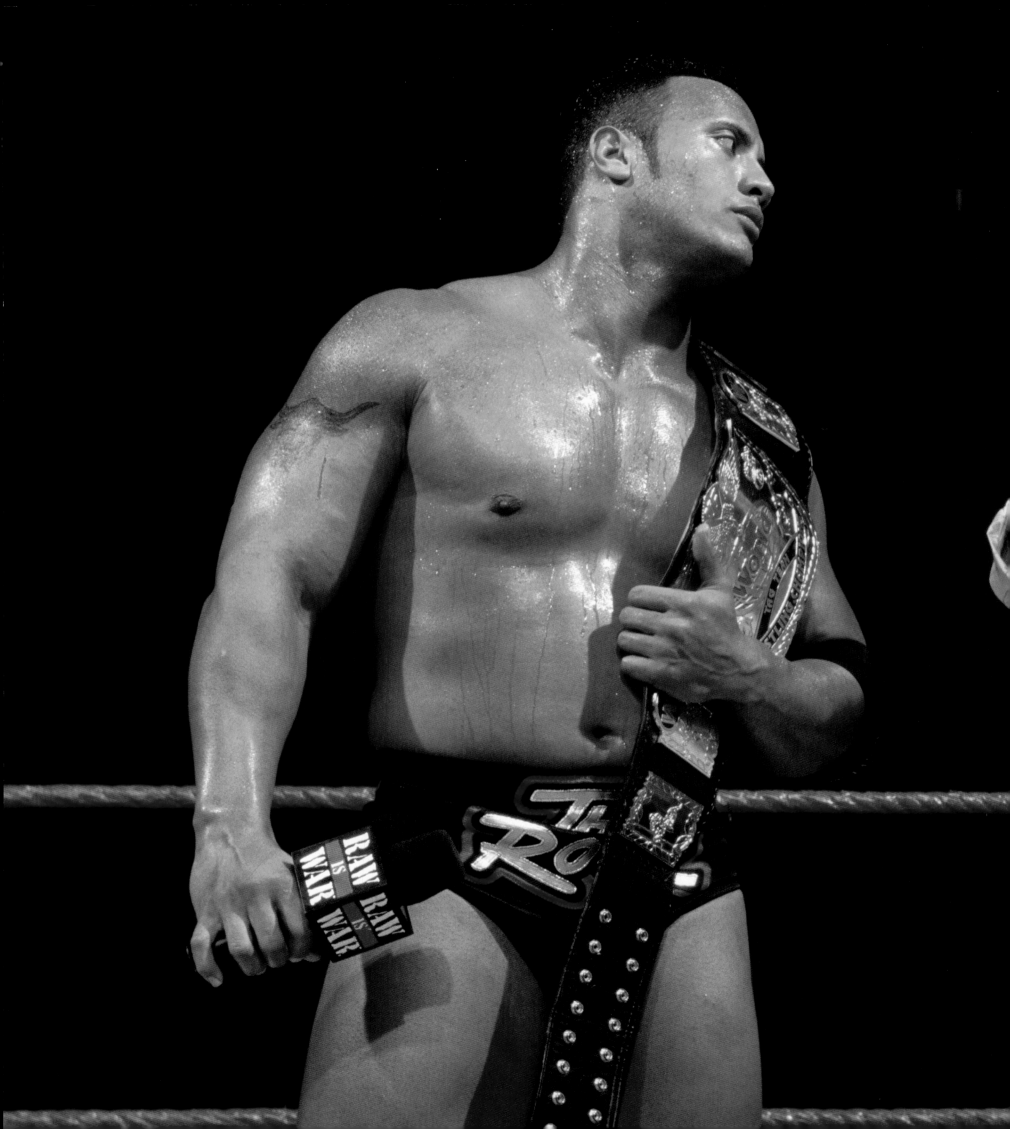

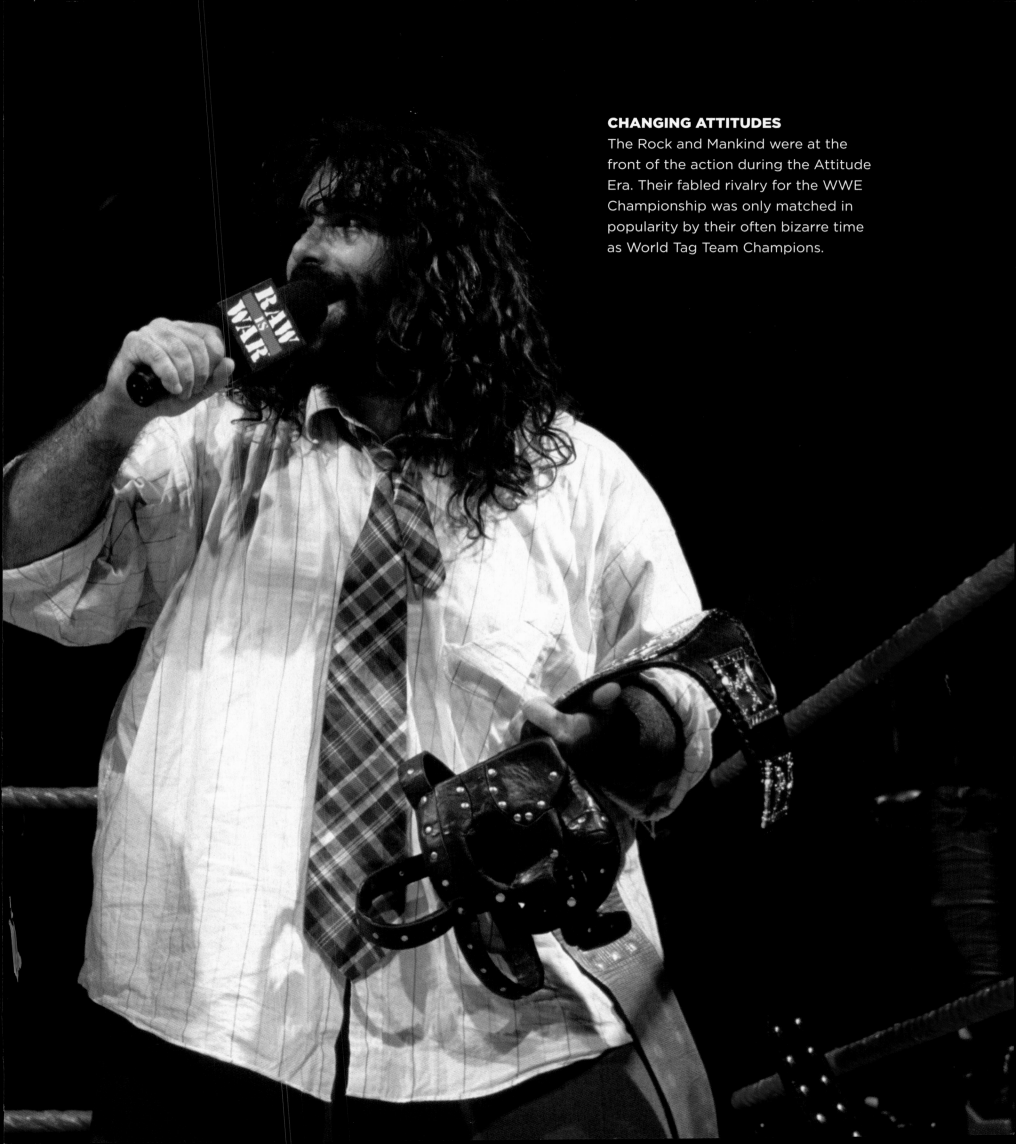

CHANGING ATTITUDES
The Rock and Mankind were at the front of the action during the Attitude Era. Their fabled rivalry for the WWE Championship was only matched in popularity by their often bizarre time as World Tag Team Champions.

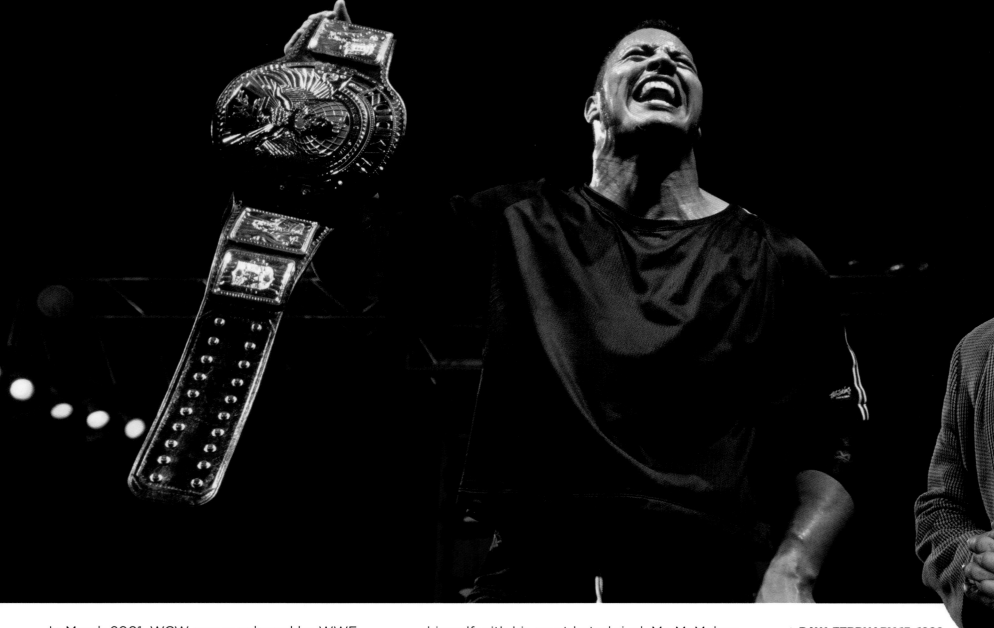

In March 2001, WCW was purchased by WWE, ending the Monday Night Wars and bringing in a whole new roster of talent. Each of the new Superstars were eager to earn a shot at WWE's biggest prize. Everywhere throughout the promotion, there was a sense that things were going to be different.

At *WrestleMania X-7*, Stone Cold faced The Rock for the WWE Title and, after defeating the People's Champ, shocked the WWE Universe by aligning himself with his most hated rival, Mr. McMahon. This surprising partnership thrust Austin and McMahon into a battle for WWE itself when McMahon's son Shane revealed that he was the rightful owner of WCW and was forming an Alliance of Superstars to take back the promotion. That Alliance was strengthened when ECW was also purchased by WWE, adding another host of Superstars to the roster.

While still WWE Champion, Stone Cold

▲ **RAW, FEBRUARY 15, 1999**
The Rock defeats Mankind in a Ladder Match to win his third WWE Championship, setting up a match with Steve Austin at *WrestleMania XV*.

▶ **OLYMPIC SUPERSTAR**
An Olympic gold medalist, Kurt Angle quickly rose to the top in WWE, winning the WWE Championship four times.

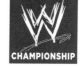

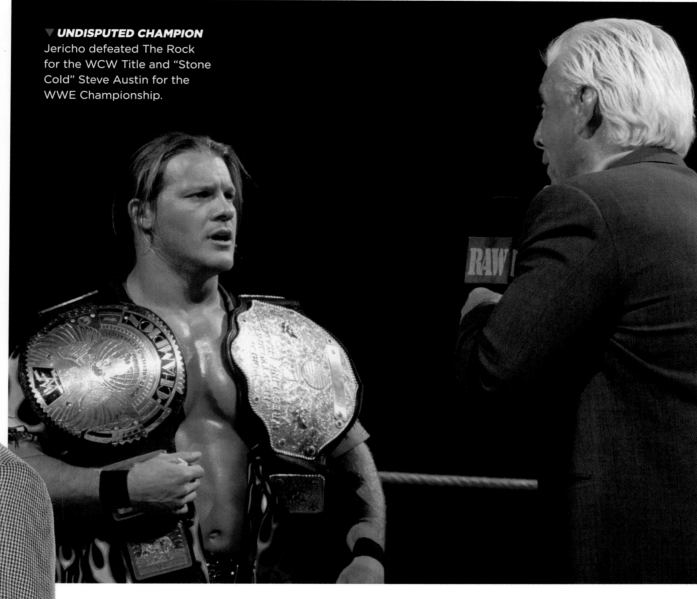

▼ UNDISPUTED CHAMPION
Jericho defeated The Rock for the WCW Title and "Stone Cold" Steve Austin for the WWE Championship.

defected from McMahon and joined the Alliance, forcing McMahon to activate Olympic gold medalist Kurt Angle to take down the Rattlesnake once and for all. Angle defeated Austin at *Unforgiven* in 2001 to pry the gold from the Alliance's hands, but Austin won it back two weeks later on *Raw*. The situation was further compounded by The Rock, who was at the time holding the WCW Championship. To resolve the dispute, matches were made at *Vengeance* between Austin and Angle, and The Rock and Chris Jericho. The winners of those matches would face off in the main event in a bout that would

"IN MARCH 2001, WCW WAS BOUGHT BY WWE."

unify the titles to create the first-ever Undisputed Champion.

The WWE Universe believed that the final match of the night would come down to The Rock against Austin, but they were stunned when Chris Jericho beat The Rock, leading to a Y2J/Austin showdown in the main event. In an even more shocking development, Jericho managed to beat Austin to become WWE's first-ever Undisputed Champion.

With so many Superstars ready to compete for the WWE Championship, it was once again time for WWE to evolve and leave behind the Attitude Era.

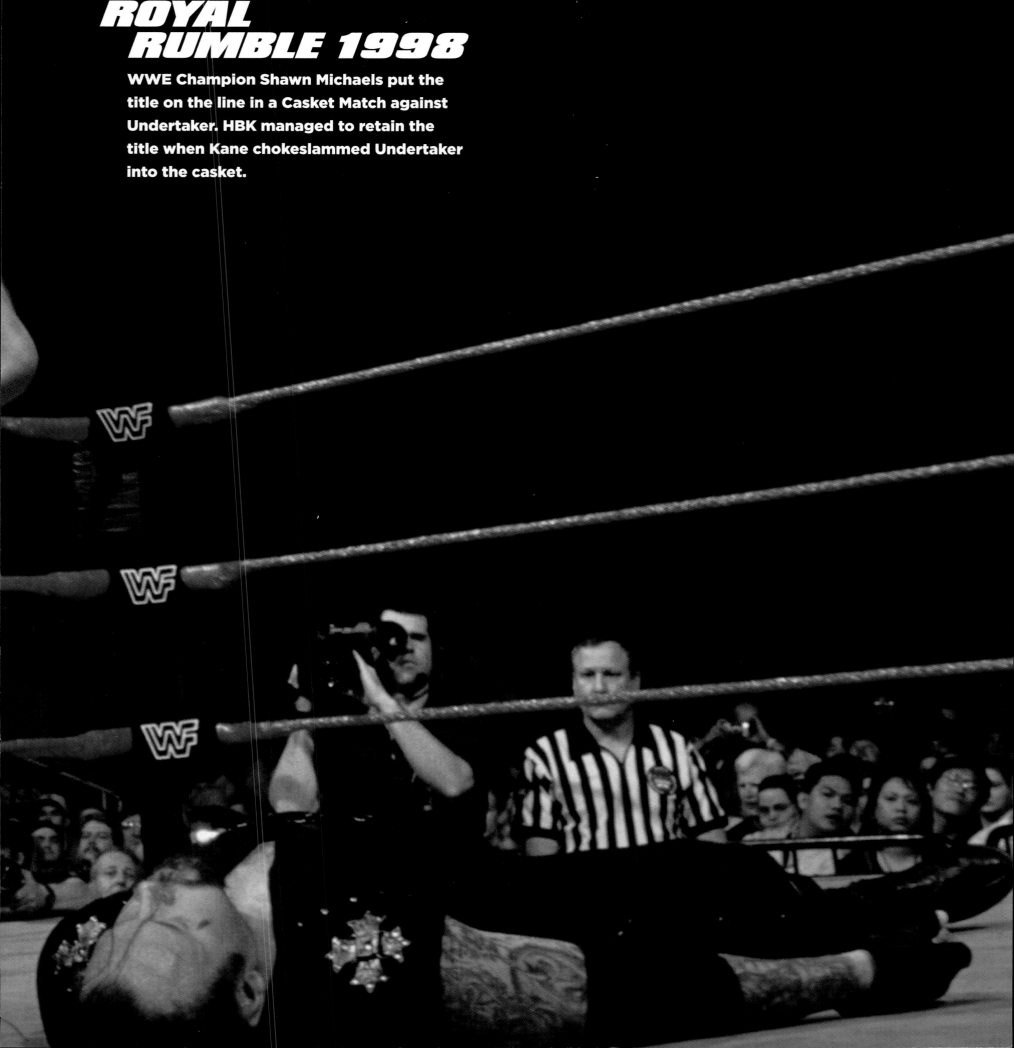

ROYAL RUMBLE 1998

WWE Champion Shawn Michaels put the title on the line in a Casket Match against Undertaker. HBK managed to retain the title when Kane chokeslammed Undertaker into the casket.

WRESTLE MANIA XIV

"STONE COLD" STEVE AUSTIN VS. SHAWN MICHAELS

IN 1998, THE ATTITUDE ERA WAS WELL UNDER WAY, with WWE embracing a harder-edged style where just about anything went. And with the rise of a new era in WWE came the call for a new champion. Shawn Michaels was the current title holder, but everyone could sense that "Stone Cold" Steve Austin's time was at hand. The beer-drinking rebel had been raising hell all over WWE and gathering supportive legions of the WWE Universe in the process.

When it was revealed that Stone Cold and HBK would face off for the WWE Title, the intensity going into this match could be felt across the WWE Universe. Mike Tyson was announced as the special guest enforcer, which added an element of danger to the bout. When the announcement took place on *Raw*, Austin stepped out and confronted Tyson, leading to a heated confrontation that turned into a full-on melee. In that moment, the WWE Universe knew that the Main Event showdown was going to be one for the history books.

At *WrestleMania XIV*, Austin and Michaels traded blows, with Michaels trying to gain the upper hand however he could. This included relying on a little help from Triple H and Chyna, who were standing at ringside. However, Austin was determined to leave the Show of Shows with the gold and rained down punch after punch on the Showstopper. HBK managed to fight his way back and took Austin down with a flying elbow drop that seemed to wrap it up for Michaels. But the Rattlesnake managed to duck Sweet Chin Music and hit a Stunner for the three-count. Adding insult to injury, Tyson then revealed his alignment with Stone Cold, holding up an "Austin 3:16" shirt and then coldcocking HBK with a right hand. If anyone had any doubts, there could no longer be any mistaking it: the Austin Era had begun.

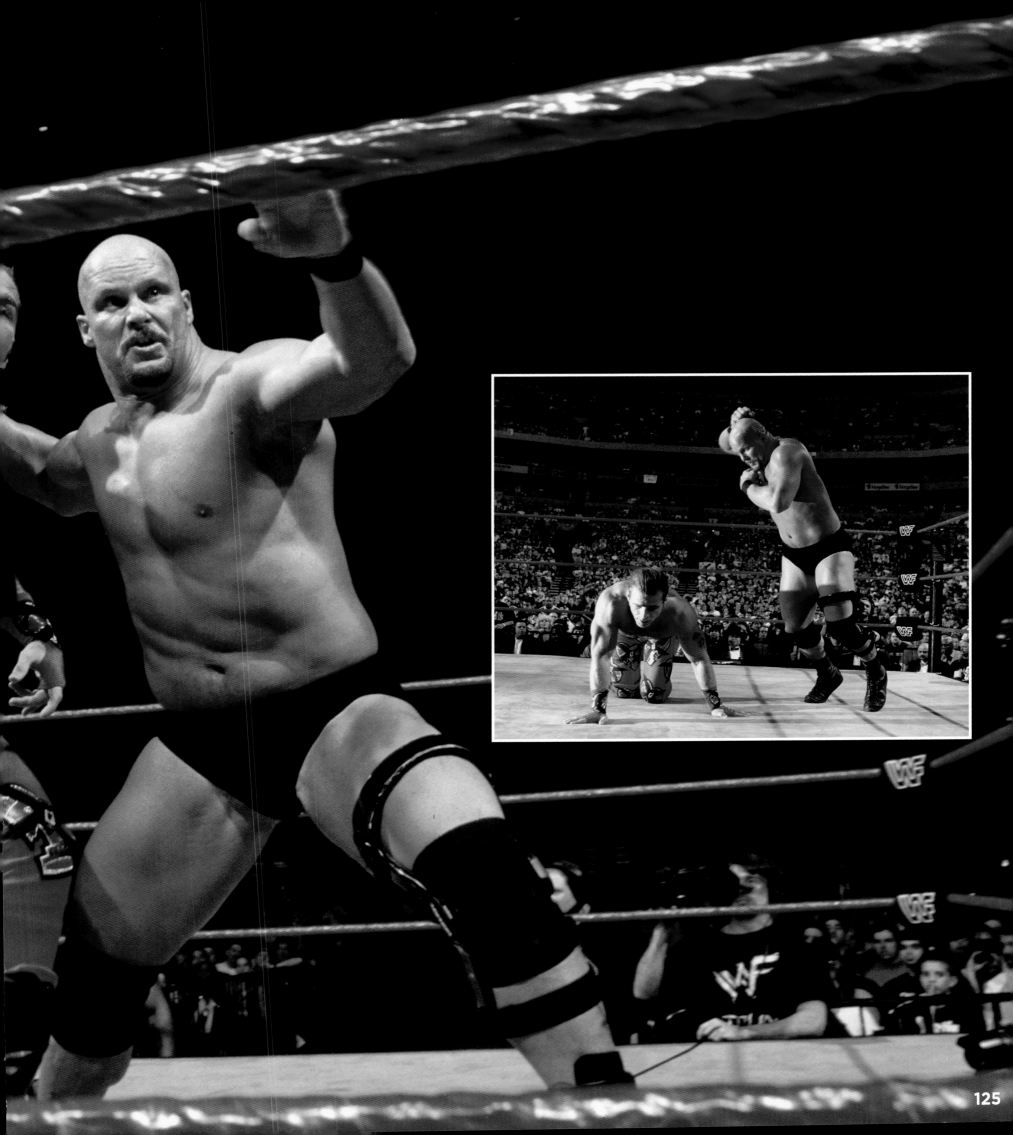

"STONE COLD" STEVE AUSTIN

SWILLING BEER, BREAKING RULES AND RAISING ALL KINDS of hell, "Stone Cold" Steve Austin didn't just define the Attitude Era, he *was* the Attitude Era. His clashes with Mr. McMahon, defiance of authority and refusal to take anything from anyone captivated the WWE Universe and catapulted Austin to the upper ranks of WWE stardom.

In Austin, the WWE Universe saw a reflection of themselves, or at least the person they wished that they could be. Austin was the blue-collar rebel who had no problem telling his boss off and giving a brash middle finger to anyone who tried to get him to bend to their rules. As such, it was no surprise that he quickly became one of WWE's greatest all-time champions.

At the 1996 *King of the Ring*, Austin famously defeated Jake "The Snake" Roberts and mocked his opponent's propensity for quoting the John 3:16 Bible verse by saying, "Austin 3:16 says I just whooped your ass!" Just like that, a new sensation was born.

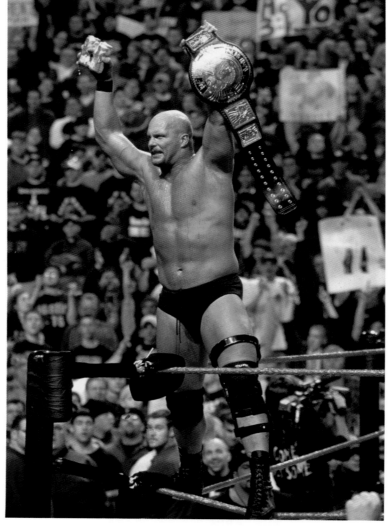

Within two years, Stone Cold had become the top draw in WWE, competing against some of the era's biggest names and winning over legions of the WWE Universe, all of whom showed up to live events wearing "Austin 3:16" t-shirts. By 1998, Austin was primed for a major breakthrough.

> **"AUSTIN PROVED YOU DIDN'T NEED TO PLAY BY THE RULES TO HOLD WWE'S GREATEST PRIZE."**

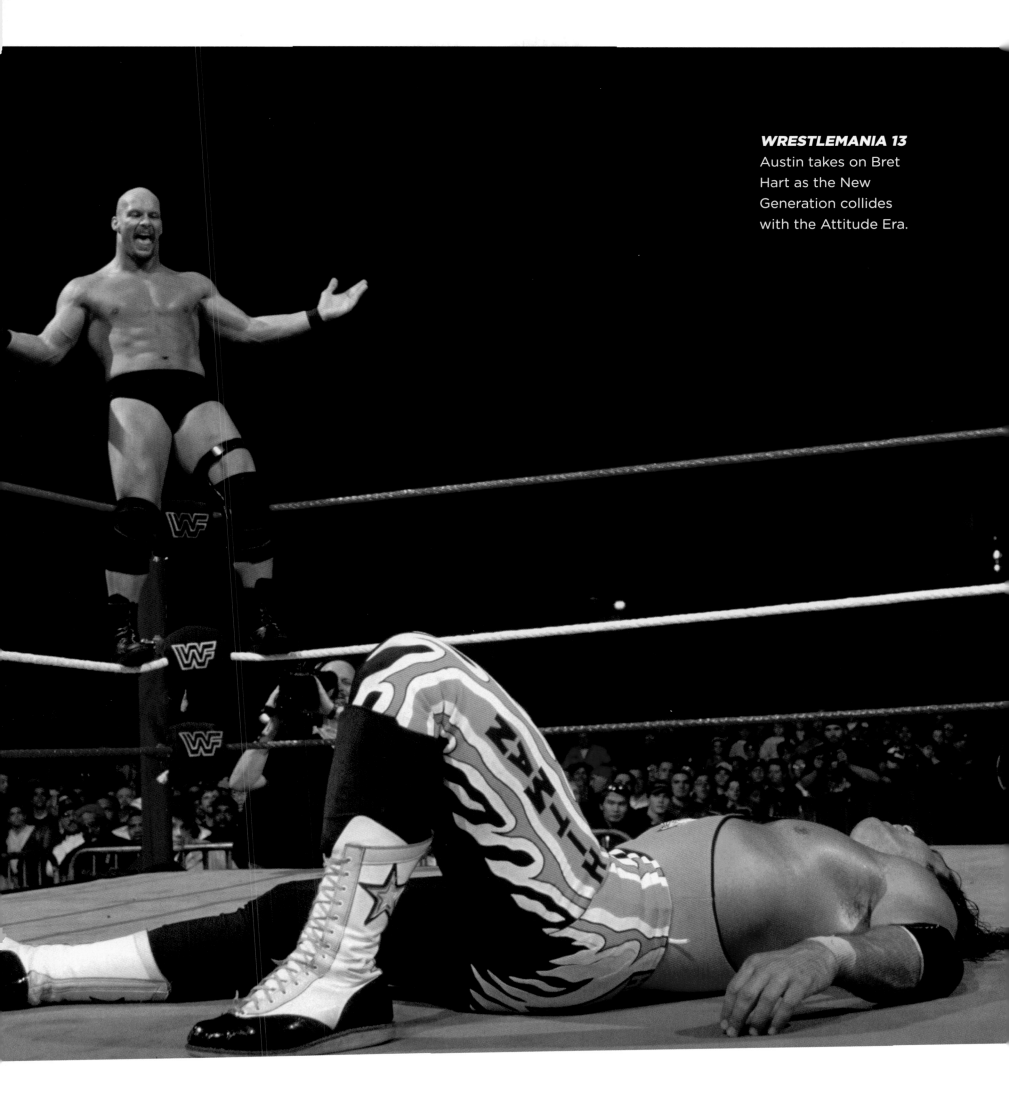

WRESTLEMANIA 13
Austin takes on Bret
Hart as the New
Generation collides
with the Attitude Era.

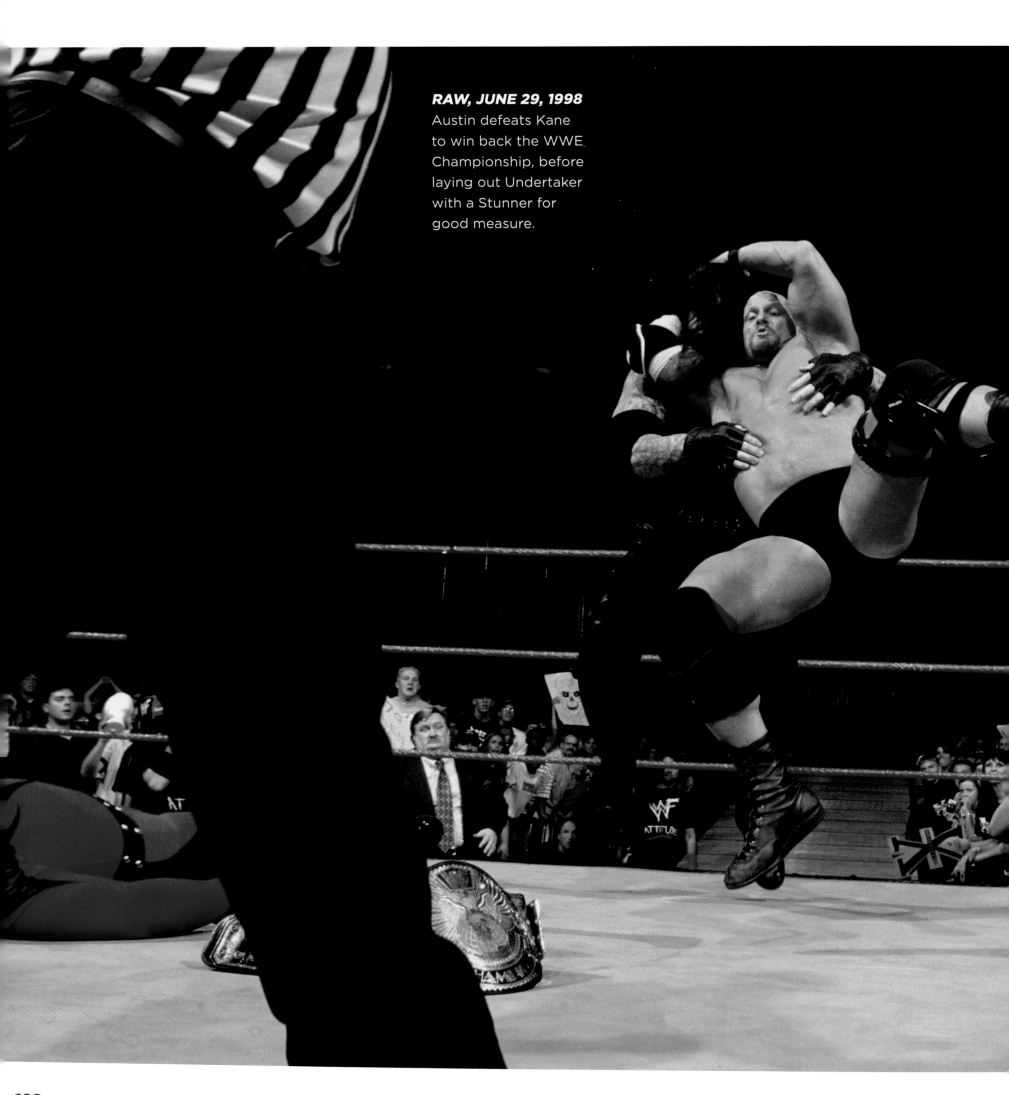

RAW, JUNE 29, 1998
Austin defeats Kane to win back the WWE Championship, before laying out Undertaker with a Stunner for good measure.

That came at *WrestleMania XIV*, when, in a passing of the torch moment as impactful as Hogan vs. André, Austin defeated Shawn Michaels, gained the WWE Championship and kicked off a new era for WWE.

Austin's first title reign was cut short by Kane, who defeated him for the gold at the 1998 *King of the Ring*. However, Austin turned around and ended Kane's reign the very next night on *Raw*. During this time, he unveiled a new version of the WWE Championship, known as the Smoking Skull, which became an immediate hit with the WWE Universe.

Austin managed to hold onto the title for 90 days before the outcome of a Triple Threat Match against Kane and Undertaker at *Breakdown: In Your House* led to the title being vacated. It would be nearly six months before Austin reclaimed the title by defeating his arch-nemesis The Rock at *WrestleMania XV*.

That win put Austin directly in the crosshairs of Undertaker, who took the title from Austin at *Over the Edge* before Stone Cold reclaimed it on *Raw* in a match where, should the Deadman have been disqualified, he would have lost the title. At *SummerSlam*, Austin would drop the title again, this time to Mankind.

The Rattlesnake's fifth run with the WWE Championship would begin in controversial fashion in a match against The Rock at *WrestleMania X-Seven*. In a brutal No Disqualification Match, Austin and The Rock viciously pounded each other both inside and outside the ring. When The Rock kicked out of a Stunner, Austin was handed a foreign object by none other than his most hated rival, Mr. McMahon. Austin shocked the WWE Universe when he struck The Rock with it repeatedly before making the pinfall and claiming the WWE Title. Later that year, after briefly losing the title to Kurt Angle, Austin saw his sixth, and final, title reign come to an end when he lost to Chris Jericho at *Vengeance*. Jericho's win led to the unification of the WCW World Championship and the WWE Championship into the Undisputed WWE Championship.

The Attitude Era demanded a new kind of Superstar and a new kind of WWE Champion, and "Stone Cold" Steve Austin was able to be both. Just like the shattering glass that marked his entrance, Austin proved he didn't need to play by the rules or fit into a certain mold to hold WWE's greatest prize.

▶ **REAL ATTITUDE**
Austin won the title six times for a total reign of 529 days.

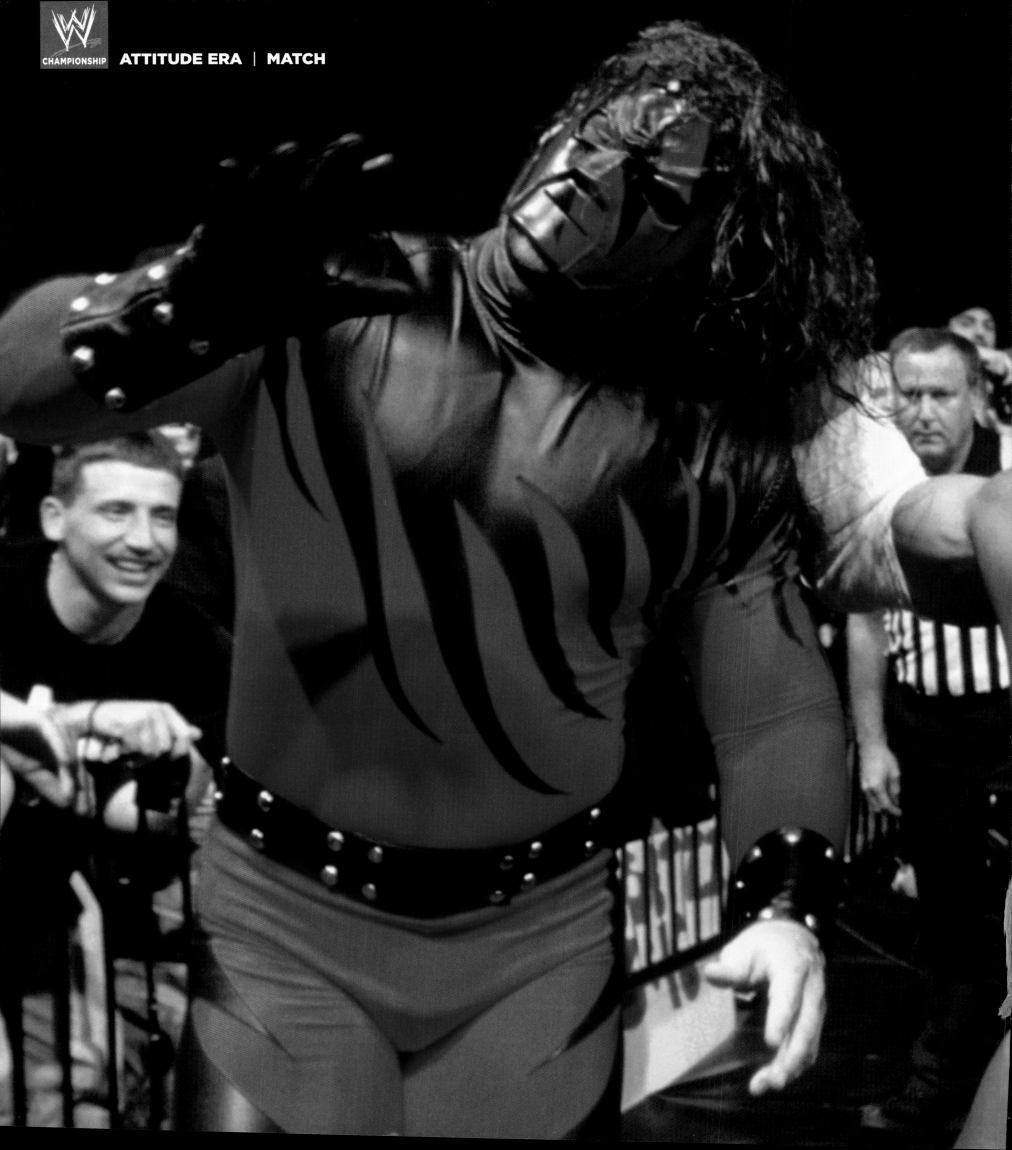

KING OF THE RING 1998

Kane defeats Steve Austin to win his only WWE Championship on June 28, 1998, in a First Blood Match that would have seen the Big Red Monster set himself on fire if he lost.

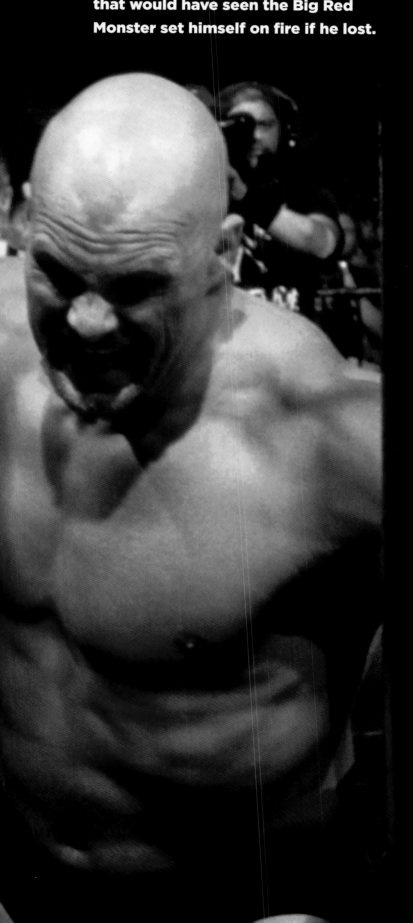

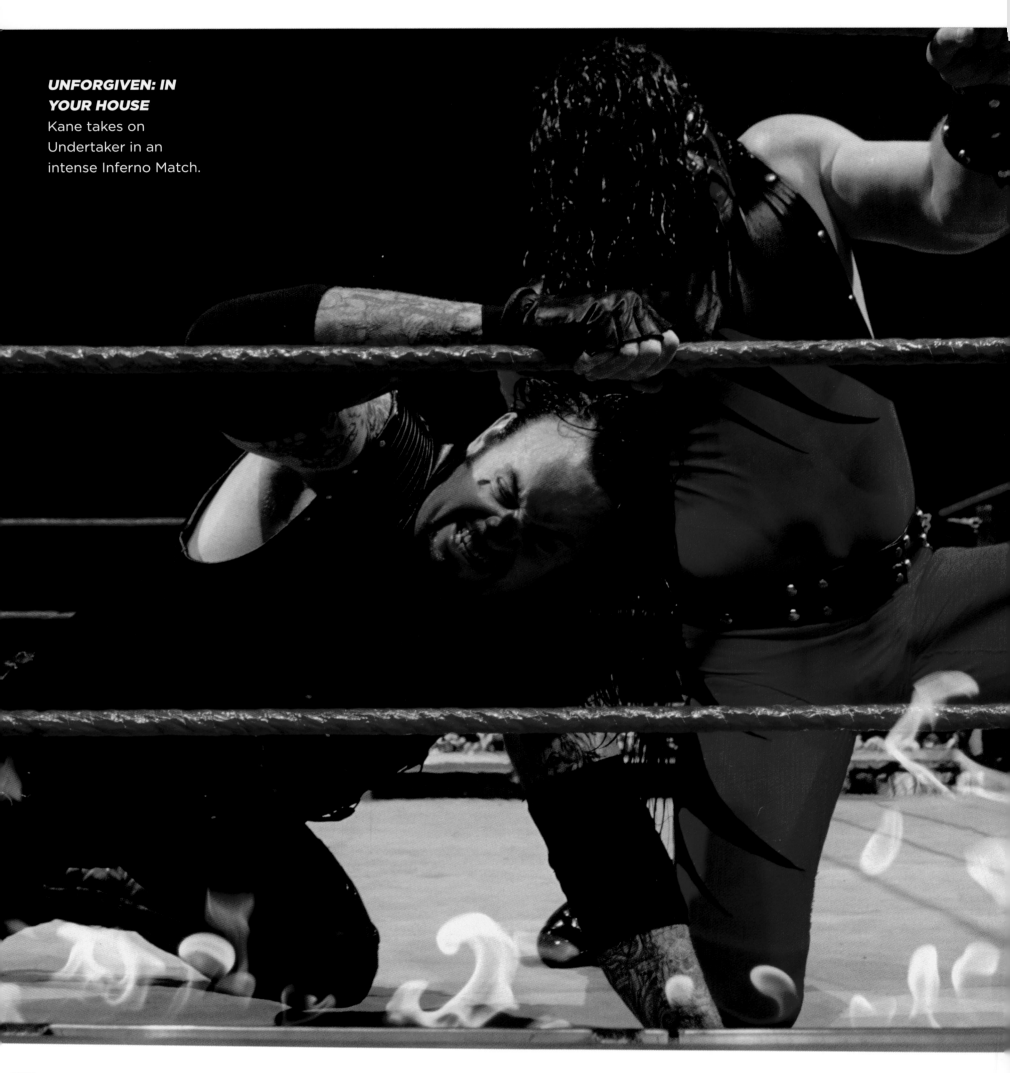

UNFORGIVEN: IN YOUR HOUSE
Kane takes on Undertaker in an intense Inferno Match.

KANE

"A (BIG RED) MONSTER OF A WWE CHAMPION."

HE EMERGED AS UNDERTAKER'S LONG-LOST BROTHER, clad in red and black and wearing a mask to conceal the burns from a fire started by the Deadman. The twisted Superstar Kane would go on to great success in WWE. Having defeated Undertaker to become the number-one contender to the WWE Championship, he faced "Stone Cold" Steve Austin for the title at the 1998 *King of the Ring*. Before their First Blood Match, Kane had declared that if he lost, he would set himself on fire. When Mankind interfered in the match on Kane's behalf, Undertaker also got involved. While

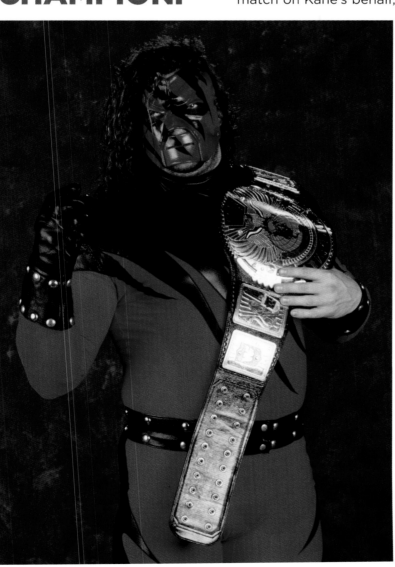

attempting to hit Mankind with a foreign object, 'Taker accidentally struck Austin, leading to Kane controversially claiming the win and the WWE Title. Not only was it a huge upset, but it was Kane's first pay-per-view main event. However, Kane didn't have long to enjoy the title, as Stone Cold defeated him to regain the championship on *Raw* the following night. Kane's other title wins included the World Heavyweight Championship, defeating Rey Mysterio at *Money in the Bank* 2010, the Hardcore Championship, two Intercontinental Championships, the ECW Championship, and even the 24/7 Title. Kane also claimed numerous WWE and WCW tag team titles with the likes of Mankind, X-Pac and Big Show, as well as alongside his sibling Undertaker as the Brothers of Destruction. His time holding the WWE Title may have been brief but Kane was a (Big Red) Monster of a WWE Champion.

THE ROCK

KNOWN AS THE PEOPLE'S CHAMPION, THE ROCK is an eight-time WWE Champion who has thrilled the WWE Universe like no other, as he layeth the smacketh down. The first third-generation Superstar in WWE history, he was destined to become the Great One.

Two years after debuting in 1996, The Rock took a huge step forward at *Survivor Series*, winning a 14-man tournament to claim his first WWE Championship, controversially defeating Mankind in the finals despite a lack of submission. With Mr. McMahon backing him, The Rock had become the Corporate Champion and entered into a heated rivalry against Mankind and "Stone Cold" Steve Austin. The WWE Title changed hands between The Rock and Mankind multiple times in early 1999, with The Rock emerging victorious from a relentless "I Quit" Match at *Royal Rumble* for his second title. He won again in a Ladder Match on *Raw*, the night after his loss to Mankind at the *St. Valentine's Day Massacre*, for a third. The Rock faced Austin 40 days later at *WrestleMania XV*. Despite the loss to Stone Cold, it was the first time these two mighty rivals collided on the Grandest Stage of Them All—and it wouldn't be the last.

With his huge charisma leading him to become one of the WWE Universe's favored Superstars, The Rock turned on Triple H and defeated him at 2000's *Backlash* in Washington, D.C. to claim his fourth WWE Championship. With a reign

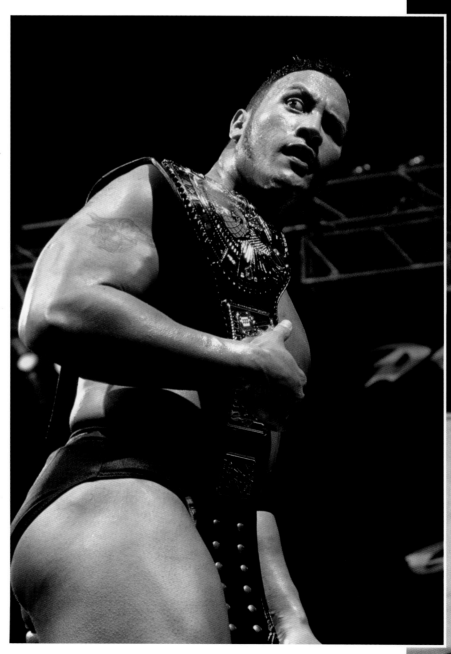

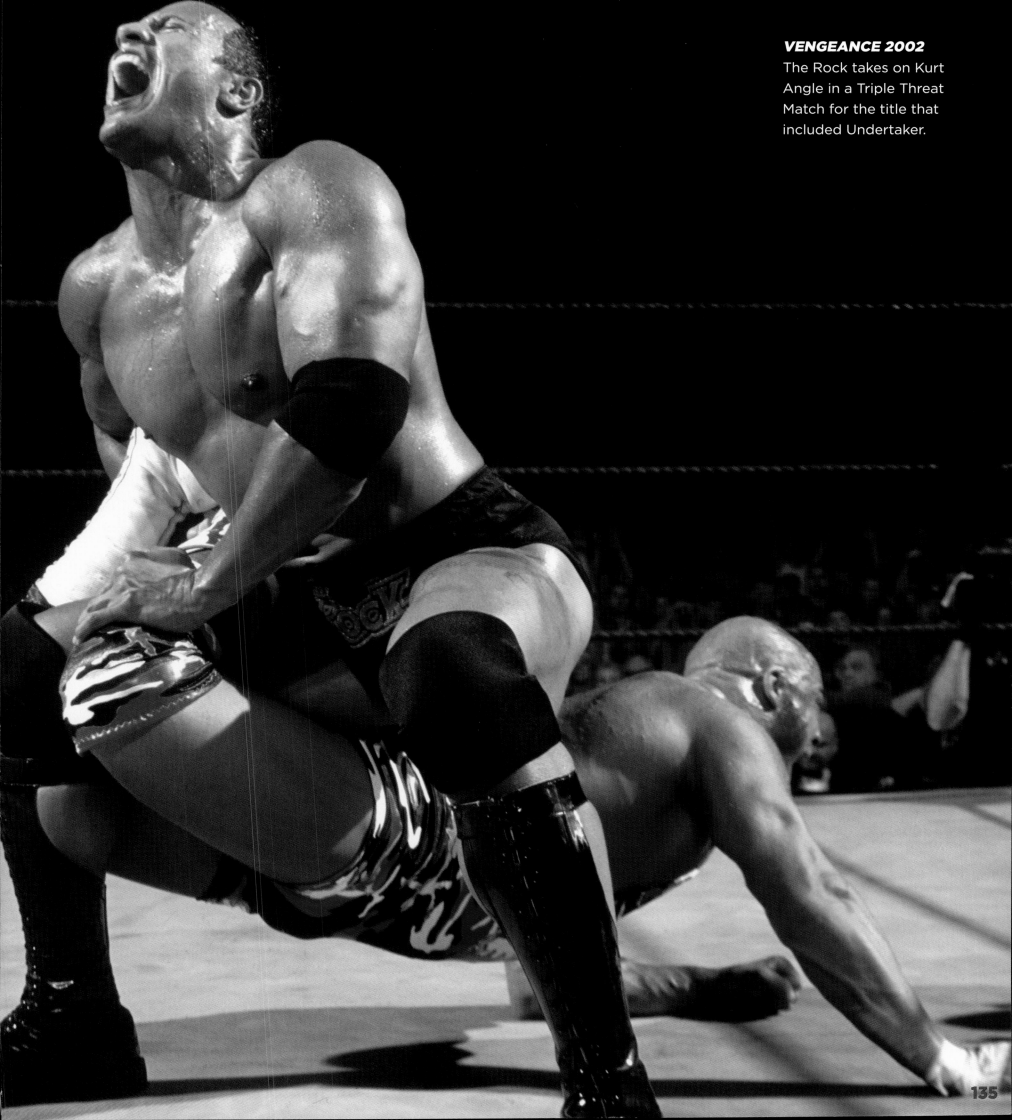

VENGEANCE 2002
The Rock takes on Kurt
Angle in a Triple Threat
Match for the title that
included Undertaker.

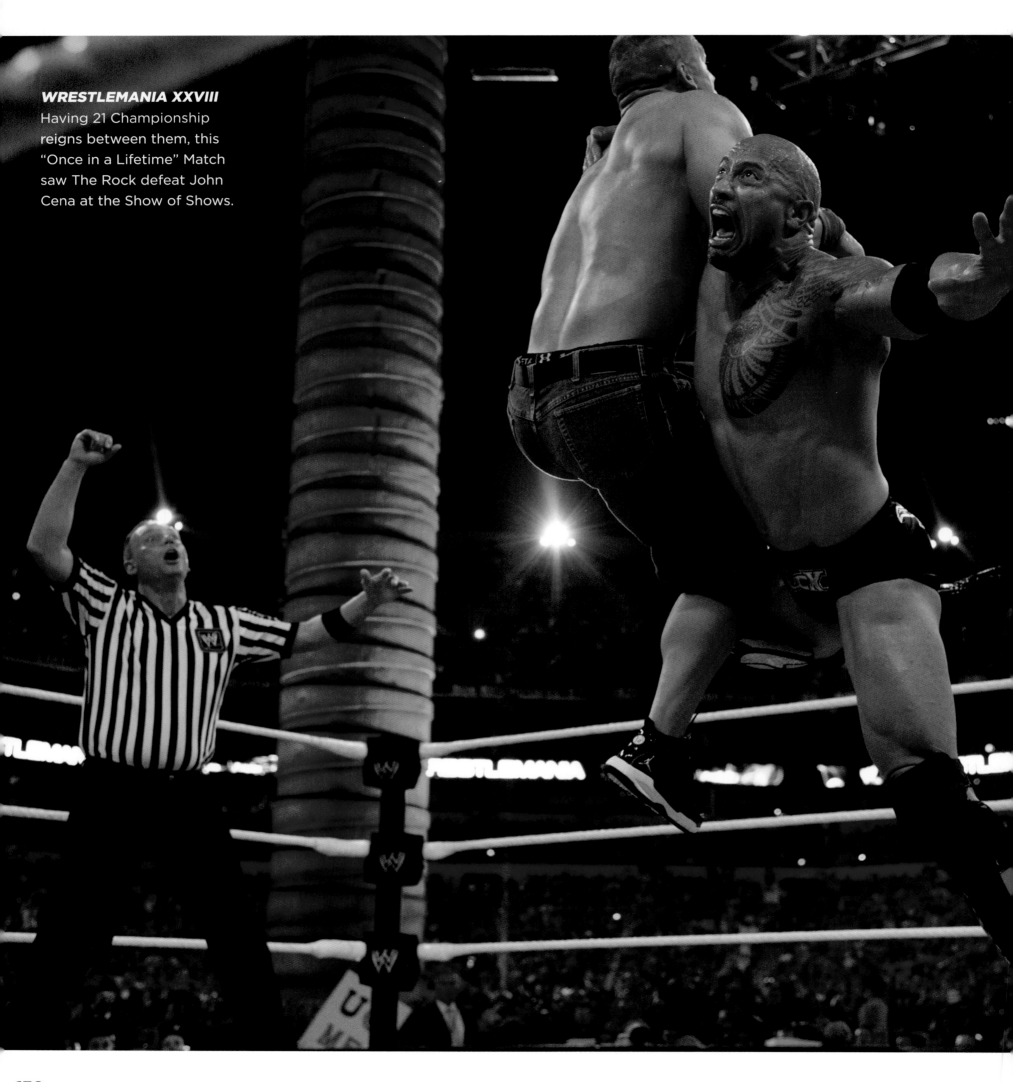

WRESTLEMANIA XXVIII
Having 21 Championship reigns between them, this "Once in a Lifetime" Match saw The Rock defeat John Cena at the Show of Shows.

that lasted three weeks, he lost the title to Triple H before reclaiming it from him for a fifth WWE Title at *King of the Ring*. At that event, during a six-man Tag Team Match where the champion did not have to be pinned to lose the title, The Rock won by pinning Mr. McMahon, Triple H's teammate. This time the People's Champion reigned for just short of four months, retaining at multiple pay-per-view events, before surrendering the title to Kurt Angle at *No Mercy*. At *No Way Out* 2001, The Rock claimed the gold in Las Vegas by defeating Angle. This sixth title reign came to a close a month later inside a packed Houston Astrodome. The reignited rivalry between The Rock and "Stone Cold" Steve Austin led to what many consider the greatest pay-per-view event of all-time, *WrestleMania X-Seven*. Austin shocked the WWE Universe by allying with Mr. McMahon to defeat The Rock for the title.

Vengeance 2002 in Detroit saw the Great One outlast both Kurt Angle and then-champion Undertaker in a Triple Threat Match to win his seventh WWE Championship. Surrendering it to "The Next Big Thing" Brock Lesnar a month later, The Rock left WWE to pursue an acting career. With occasional appearances, including finally defeating Austin at the Show of Shows at *WrestleMania XIX*, The Rock waited over a decade before becoming WWE Champion for an eighth time. At *Royal Rumble* 2013, the WWE Universe went wild as the Most Electrifying Man in All Entertainment returned to defeat CM Punk by landing a People's Elbow to claim the gold. Just bring it!

> "THE PEOPLE'S CHAMPION IS AN EIGHT-TIME WWE CHAMPION WHO HAS THRILLED THE WWE UNIVERSE LIKE NO OTHER."

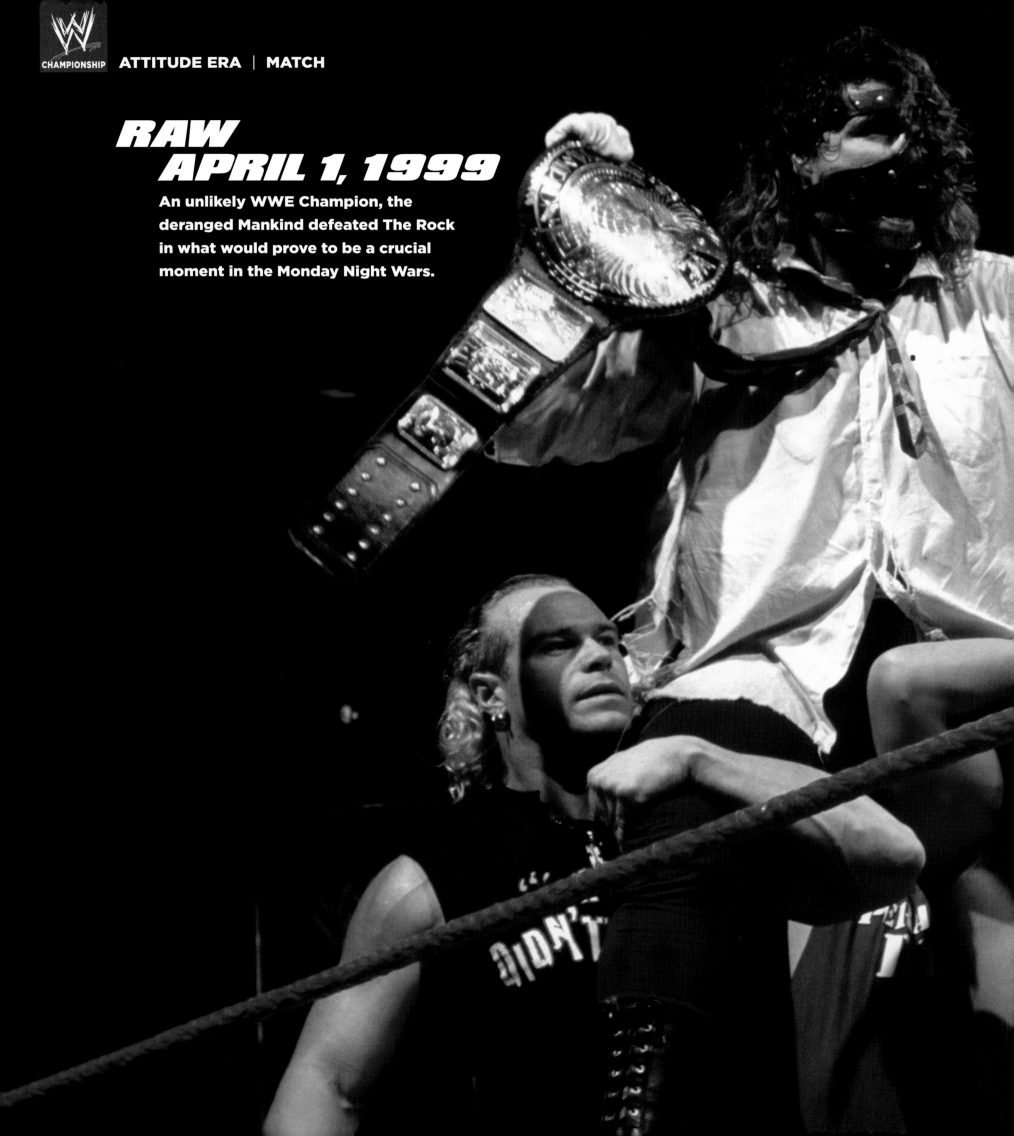

RAW
APRIL 1, 1999

An unlikely WWE Champion, the deranged Mankind defeated The Rock in what would prove to be a crucial moment in the Monday Night Wars.

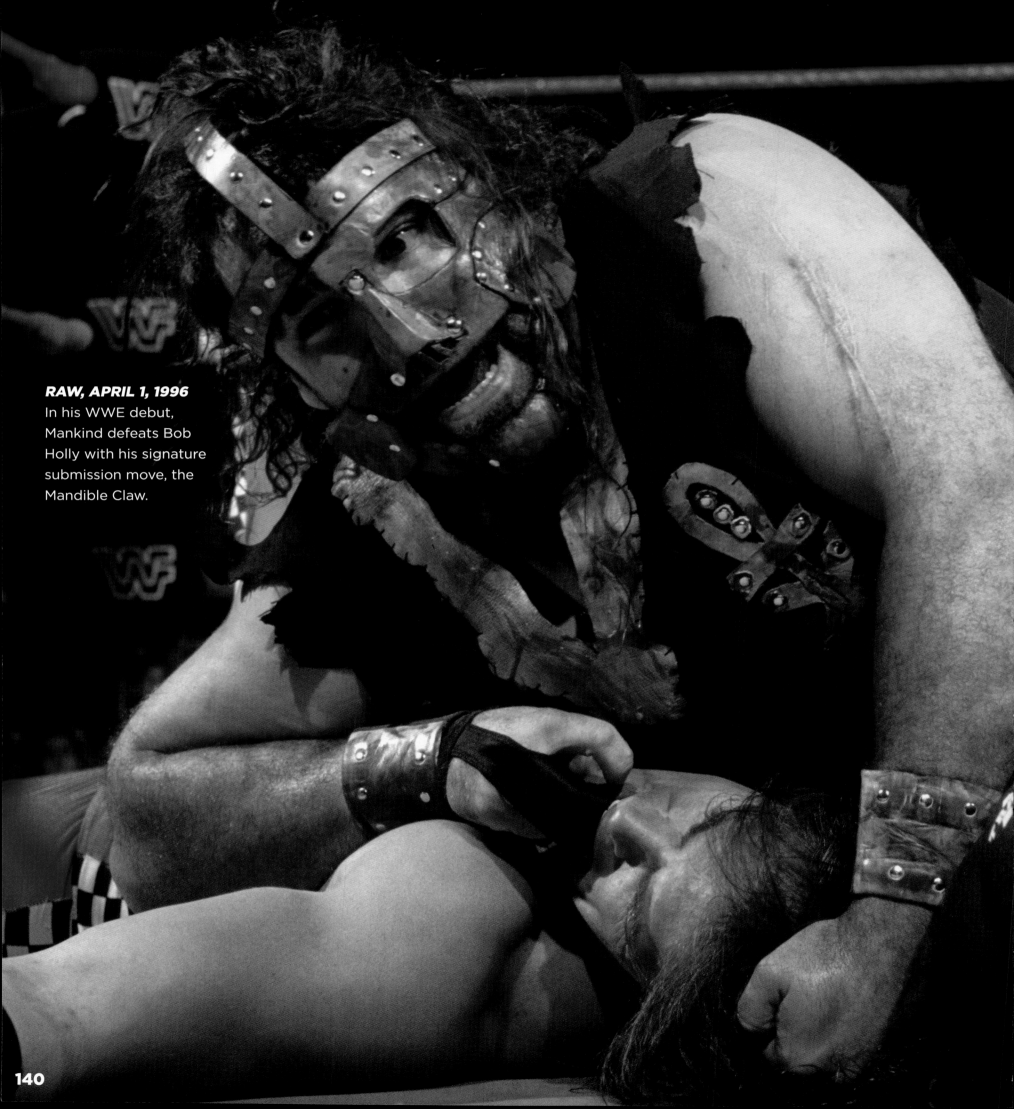

RAW, APRIL 1, 1996
In his WWE debut, Mankind defeats Bob Holly with his signature submission move, the Mandible Claw.

MANKIND

A **SUPERSTAR OF MANY** faces, Mick Foley reached the peak of the WWE mountain with his strangest persona of all, the masked maniac known as Mankind.

Foley joined WWE in 1996, making his debut on an episode of *Raw* the night after *WrestleMania XII*. Appearing as a disheveled lunatic who wore a sock on his hand and spoke in a quivering, high-pitched voice, Mankind was an instant hit. His intense in-ring style saw him awarded with a new title, the WWE Hardcore Championship, in 1998.

During his time in WWE, Foley would often compete as one of his other personas, such as the groovy hippy Dude Love or his beloved brawler, Cactus Jack, both of whom won WWE Tag Team Championships. However, it was during Foley's time as Mankind that he won his first WWE Championship, defeating The Rock on January 4, 1999's episode of *Raw*. Mankind held the title for 20 days, before losing in a controversial "I Quit" Match at 1999's *Royal Rumble*.

Mankind won the WWE Title back from The Rock two days later at *Halftime Heat*, but, just 15 days later, lost the championship again to The Rock.

Mankind would go on to win the WWE Championship for a third and final time at *SummerSlam 1999*, pinning then-champion "Stone Cold" Steve Austin in a Triple Threat Match that also included Triple H. This reign would be Mankind's shortest yet, as the next night on *Raw* he was defeated by Triple H. Following the loss of the title, Mankind teamed up with his former rival The Rock to win three more WWE Tag Team Championships—he would end up with eight in total. As Cactus Jack, Foley would challenge Triple H for the title a number of times, culminating in the main event at *WrestleMania 2000*. This losing effort would be Foley's last WWE match for a number of years.

Foley returned to WWE in 2003, appearing as a guest referee and making his final in-ring appearance as Mankind in 2005. He retired from in-ring action in 2012, leaving behind a legacy of intense Hardcore Matches that will live long in the memory of the WWE Universe.

"AN INSTANT HIT WITH HIS INTENSE IN-RING STYLE."

"I QUIT!"

BY THE TIME THIS MATCH ROLLED AROUND, everyone knew that The Rock could be as mean and nasty as they come inside the ring. The WWE Universe had also discovered just how much punishment Mankind could take and give out. However, absolutely no one expected the torrent of brutality unleashed when the two faced off for the WWE Championship at 1999's *Royal Rumble*.

The bout was an "I Quit" Match, meaning the only way either competitor could walk away with the title was to force their opponent to say the words "I Quit." This stipulation meant there was no disqualification and so the action quickly spilled outside the ring, with both Superstars using anything they could get their hands on to win. Announce tables were shattered, the fight went through the crowd and at one point Mankind was launched into the electrical hub of the arena, causing sparks to fly.

Gaining the upper hand, The Rock cuffed his opponent's hands behind his back, and then blasted Mankind with chair shot after chair shot. Eventually, Mankind couldn't withstand the onslaught and hit the deck. It was then that The Rock held a microphone to his opponent's mouth and the WWE Universe heard the words "I quit" echo through the arena, words later revealed to be a recording. The match was proof that The Rock was willing to win at all costs.

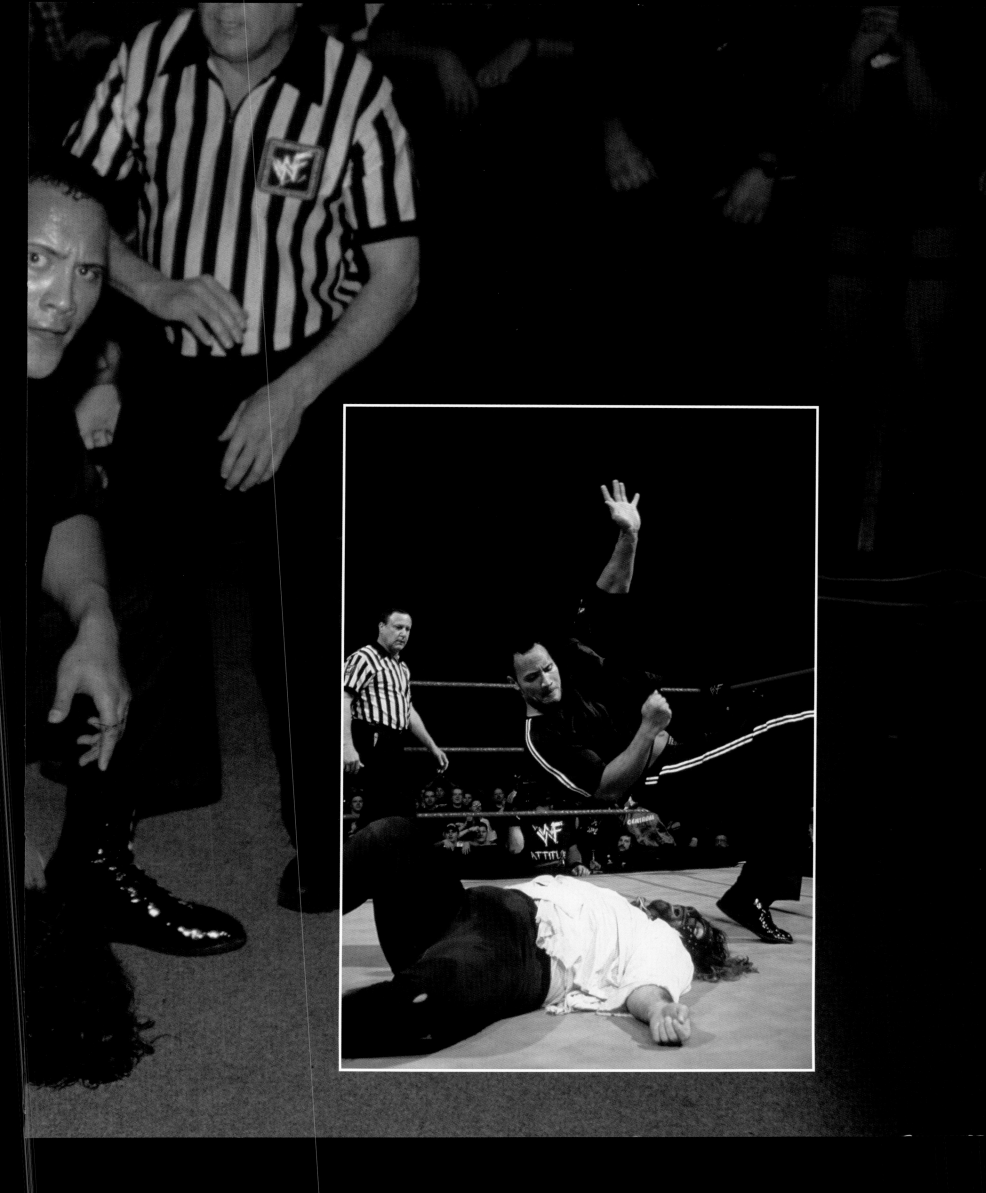

CORPORATE CHAMP

BY THE LATE '90S, STEVE AUSTIN was one of the company's top Superstars. Meanwhile, Mr. McMahon began playing a larger and larger role on TV, taking on the persona of a greedy chairman who used his employees as pawns. When McMahon announced Mike Tyson as the guest referee for the main event of *WrestleMania XIV*, Austin came out and disrupted the entire segment, embarrassing McMahon.

When Austin won the Championship at *WrestleMania XIV*, he made it clear he wasn't going to be McMahon's stooge when he assaulted the Chairman the next night on *Raw*. Over the next few weeks, Austin beat Mr. McMahon with foreign objects, poured concrete into his Corvette and assaulted him in the hospital, thrilling the WWE Universe with every one of his antics.

A furious Mr. McMahon did not take this lying down and quickly formed an alliance with Undertaker and Kane, whereby each of them would get a shot at the title for protecting Vince from Austin. Although Kane briefly took the title away from Austin, The Rattlesnake soon gained it back, leading to a Triple Threat Match between the three Superstars at *Breakdown: In Your House*. When Undertaker and Kane pinned Austin simultaneously, it was decided the WWE Championship would be vacated and a new champion crowned at *Judgment Day: In Your House*. Thinking he had finally put one over Austin, Vince set the Title Match between Undertaker and Kane, with Austin acting as guest referee. When, on the night, Austin refused to award the win to either man, Vince finally snapped and fired Steve Austin. With the Championship still vacated, a tournament was arranged for 1998's *Survivor Series*.

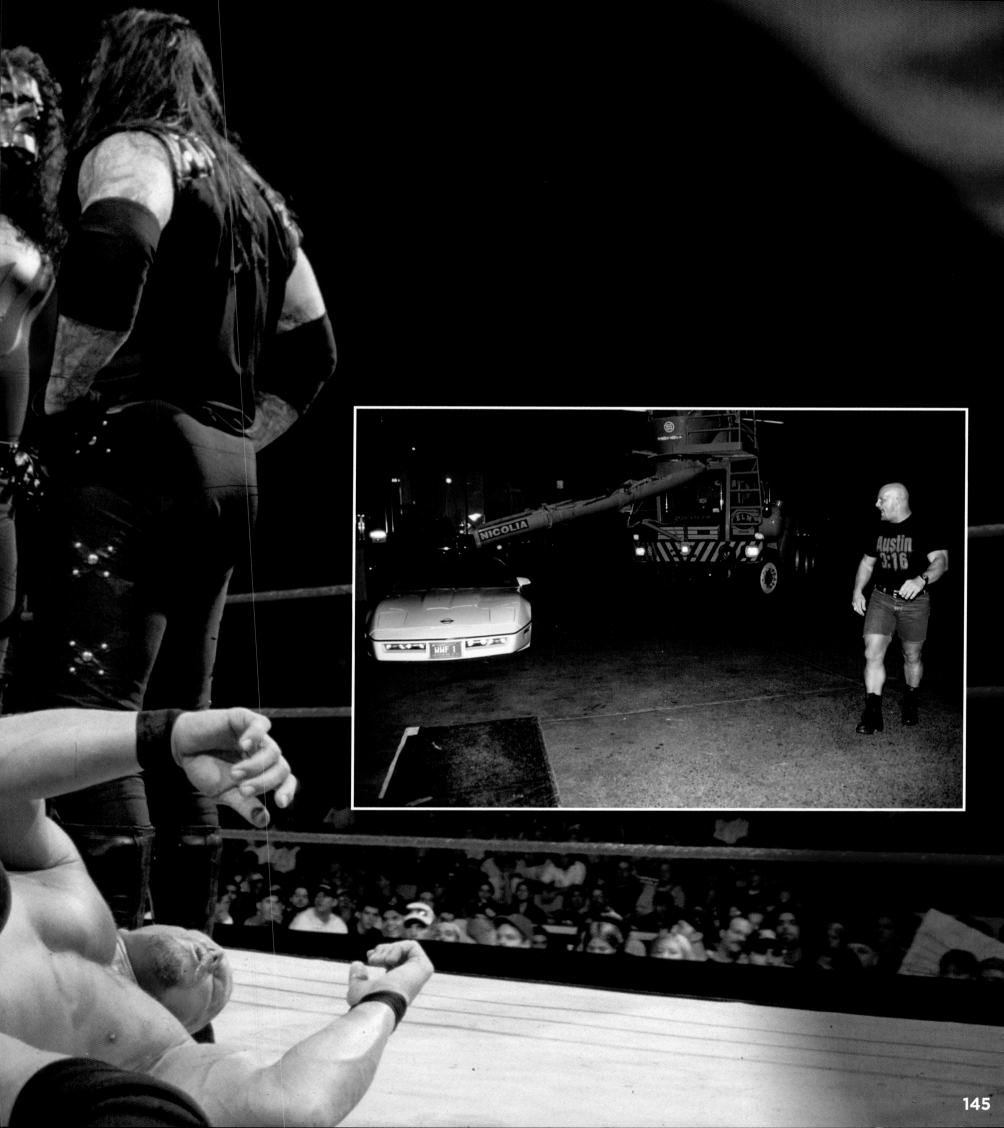

In the buildup to *Survivor Series*, Mr. McMahon had been laying the foundations for one of WWE's most shocking twists. Vince had spent weeks berating The Rock and setting The People's Champion seemingly insurmountable challenges to enter the *Survivor Series* title tournament. At the same time, Vince had taken Mankind under his wing, giving the scruffy Superstar a makeover and awarding him the Hardcore Championship. It seemed Vince had finally found a Superstar who would pay him the respect he demanded.

Meanwhile, Austin was re-signed to WWE by Shane McMahon and so at *Survivor Series*, Austin faced Mankind in the semi-finals of the tournament. Austin seemed to have the win until interference from Gerald Bisco, Sgt. Slaughter and Shane McMahon led to Mankind advancing to the finals to face The Rock. With Vince seemingly backing Mankind, the WWE Universe was shocked when The Rock applied the Sharpshooter and Mr. McMahon ordered the referee to ring the bell without Mankind submitting.

It was at this point that The Rock revealed he'd been working with Vince and Shane the whole time and was without a doubt the corporate champion. Mr. McMahon had got his revenge and successfully screwed Steve Austin, Mankind and the people.

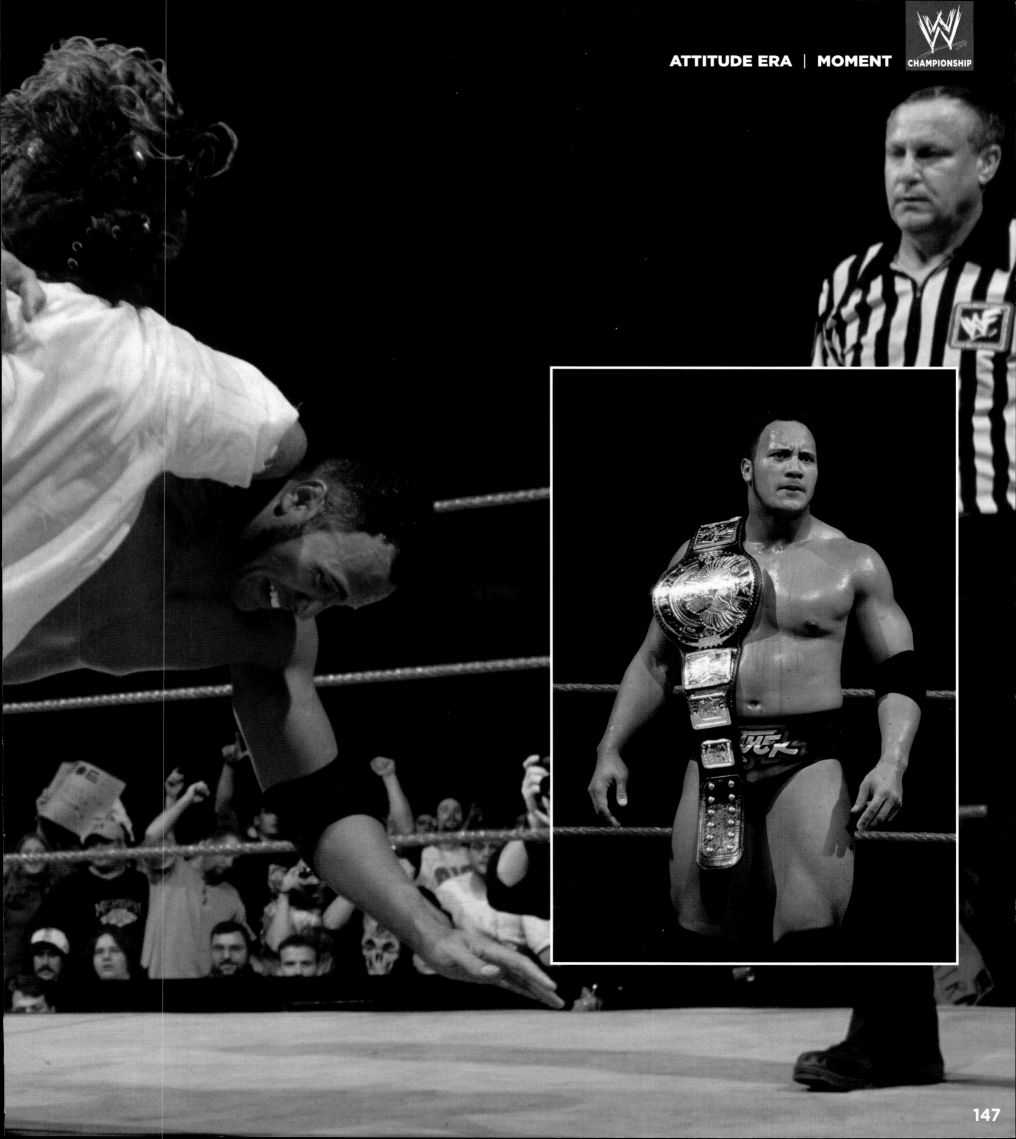

TRIPLE H

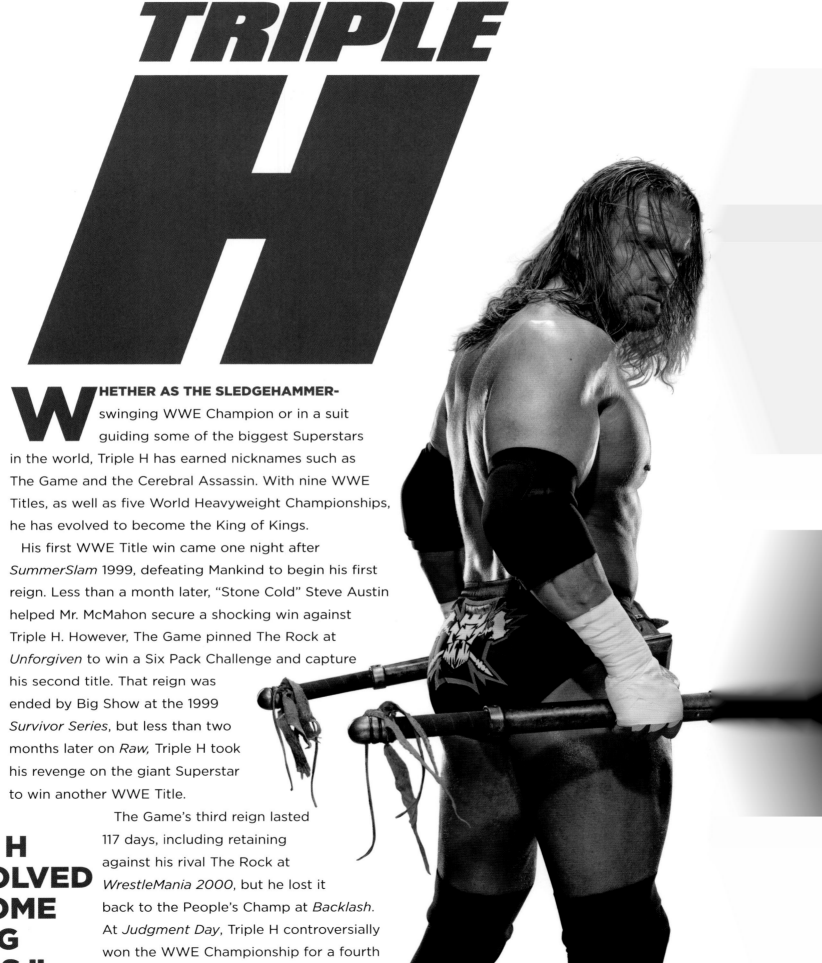

WHETHER AS THE SLEDGEHAMMER-swinging WWE Champion or in a suit guiding some of the biggest Superstars in the world, Triple H has earned nicknames such as The Game and the Cerebral Assassin. With nine WWE Titles, as well as five World Heavyweight Championships, he has evolved to become the King of Kings.

His first WWE Title win came one night after *SummerSlam* 1999, defeating Mankind to begin his first reign. Less than a month later, "Stone Cold" Steve Austin helped Mr. McMahon secure a shocking win against Triple H. However, The Game pinned The Rock at *Unforgiven* to win a Six Pack Challenge and capture his second title. That reign was ended by Big Show at the 1999 *Survivor Series*, but less than two months later on *Raw*, Triple H took his revenge on the giant Superstar to win another WWE Title.

The Game's third reign lasted 117 days, including retaining against his rival The Rock at *WrestleMania 2000*, but he lost it back to the People's Champ at *Backlash*. At *Judgment Day*, Triple H controversially won the WWE Championship for a fourth reign in an Iron Man Match, after chaotic

"TRIPLE H HAS EVOLVED TO BECOME THE KING OF KINGS."

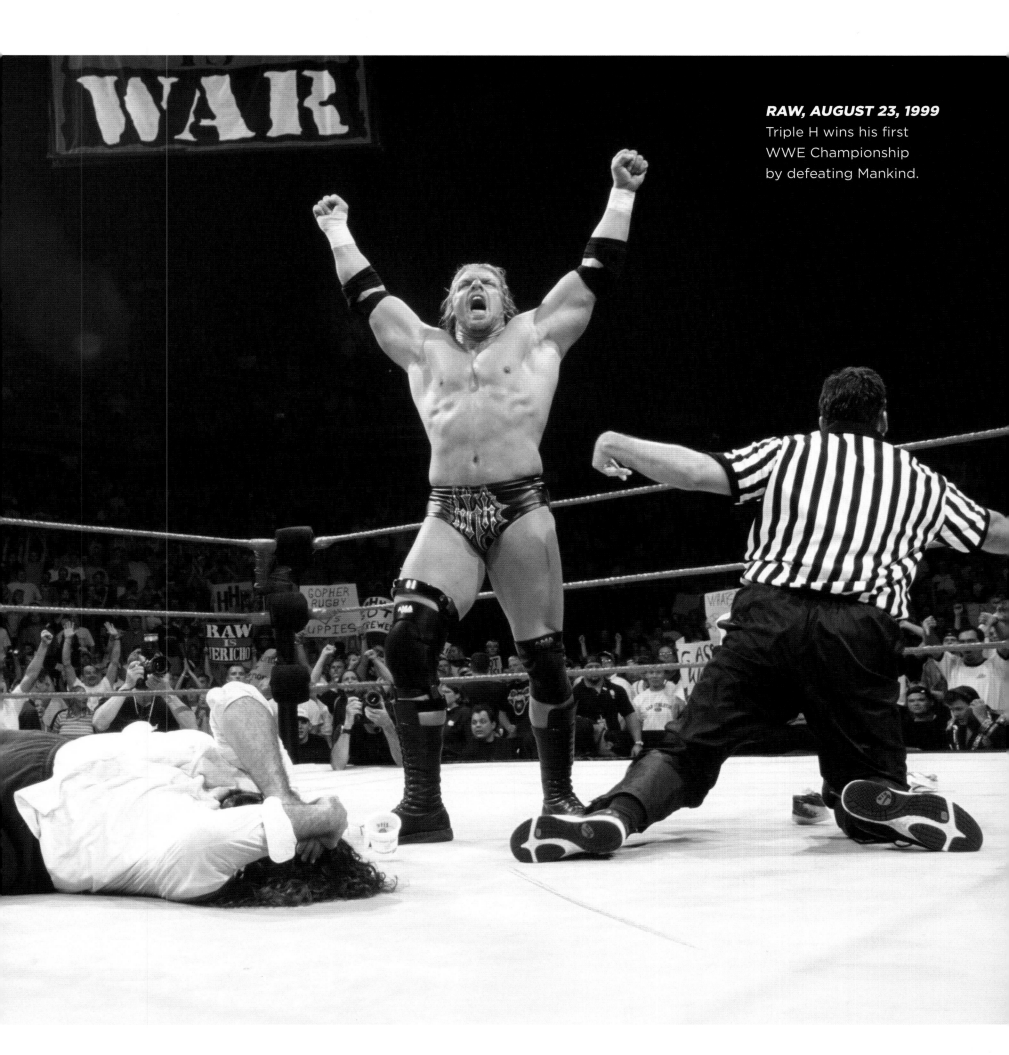

RAW, AUGUST 23, 1999
Triple H wins his first
WWE Championship
by defeating Mankind.

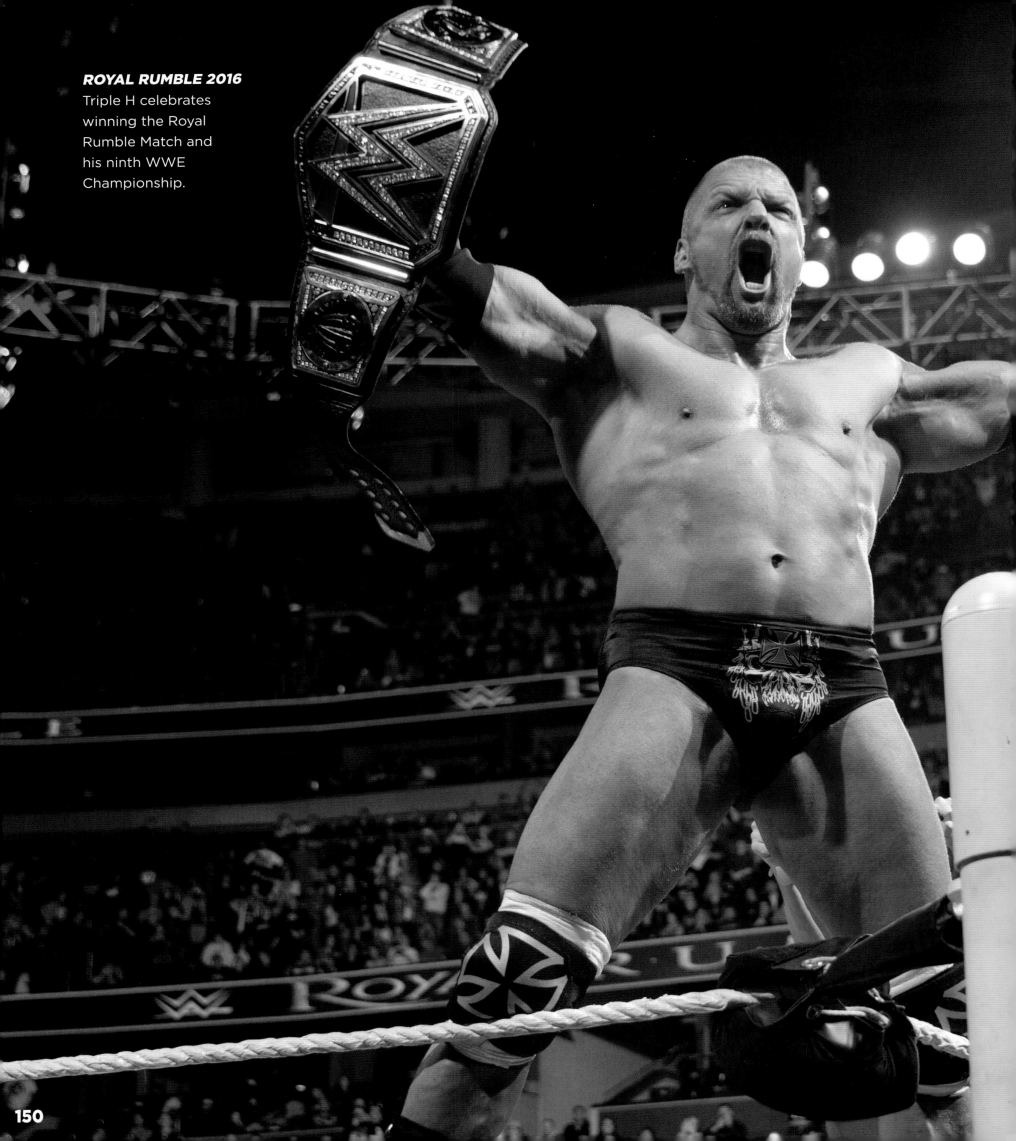

Triple H celebrates winning the Royal Rumble Match and his ninth WWE Championship.

interference from Undertaker resulted in the disqualification of The Rock. A month later their rivalry ended with a loss to The Rock at *King of the Ring*.

Triple H became a five-time WWE Champion at *WrestleMania X8*, defeating Chris Jericho by hitting him with a Pedigree at the Show of Shows. The Game surrendered the title to "Hollywood" Hulk Hogan at *Backlash 2002*. Having formed the powerful stable Evolution and won the World Heavyweight Championship, Triple H battled in losing WWE Championship matches at *WrestleMania 22* and *Backlash 2006*, before reclaiming the gold for a sixth time at *No Mercy* 2007. When Mr. McMahon awarded Randy Orton the title, Triple H reignited his rivalry with the Viper and defeated him in an intense match to briefly hold the title. After retaining against Umaga, the night still wasn't over as Mr. McMahon granted Orton a Last Man Standing Match against Triple H (his third bout of the night) that Orton emerged from with the gold.

After that wild event, *Backlash* 2008 saw The Game defeat Orton, JBL and John Cena in a Fatal 4-Way Elimination Match to begin his seventh WWE Title reign. Retaining in title matches against Cena, Edge, the Great Khali and Jeff Hardy, the reign eventually came to an end after 209 days. Edge toppled The Game, with assistance from Jeff Hardy, at *Survivor Series*. *No Way Out* saw Triple H survive an Elimination Chamber Match against five opponents to claim an eighth WWE Championship. The Game made a triumphant return in the 2016 *Royal Rumble*, outlasting all Superstars, eliminating the reigning champion Roman Reigns and finally Dean Ambrose to win his second Royal Rumble Match and the gold for the ninth time.

With his many WWE Championship reigns and his current role as Executive Vice President of Global Talent Strategy & Development for WWE, no matter who's playing, it's by The Game's rules.

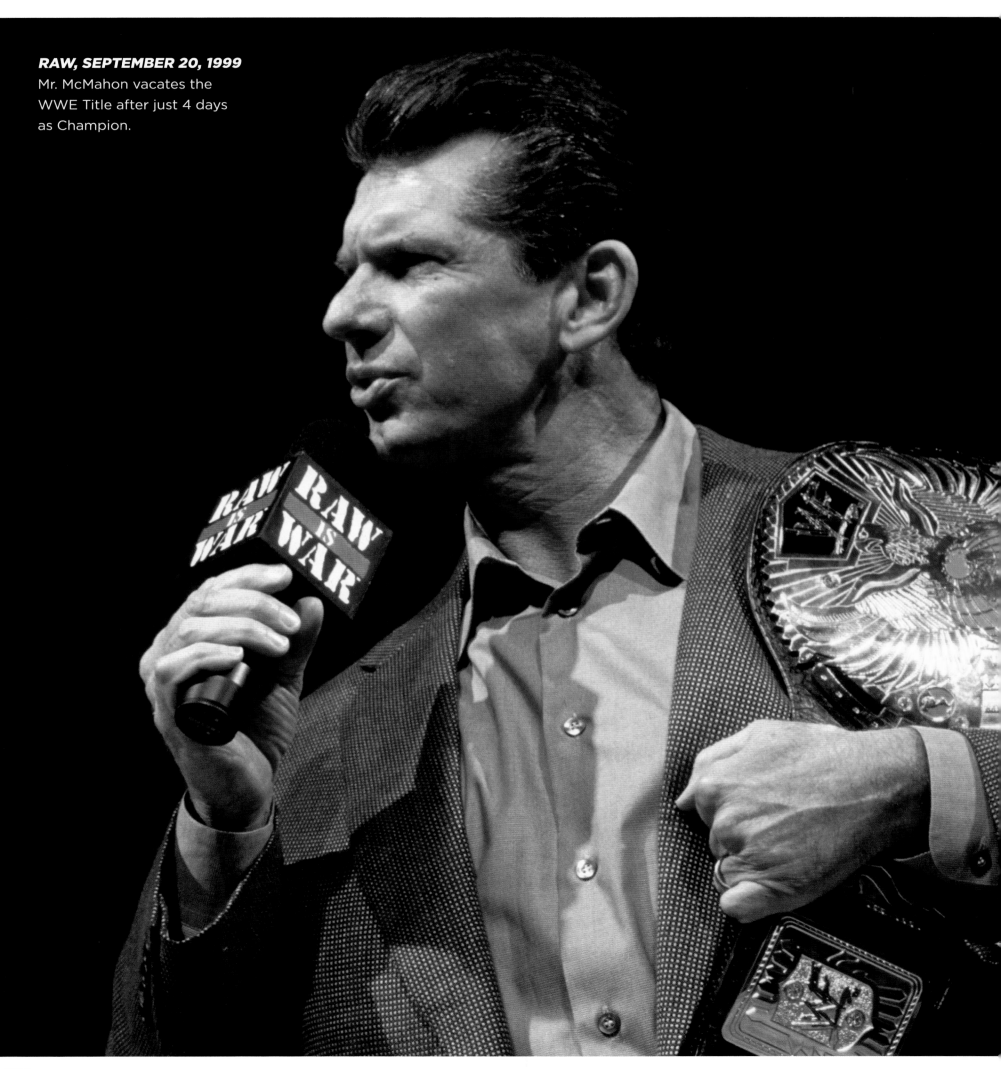

RAW, SEPTEMBER 20, 1999
Mr. McMahon vacates the
WWE Title after just 4 days
as Champion.

MR. MCMAHON

FOR YEARS, HE WAS JUST SEEN BY THE WWE UNIVERSE AS a commentator, calling the action alongside Superstars like Jesse Ventura and Bobby Heenan. But, as the New Generation gave way to the Attitude Era, Mr. McMahon revealed his true face. The seemingly innocent, playful color commentator was unveiled as a scheming, manipulative corporate snake in the grass who placed wealth and power ahead of everything else.

Mr. McMahon's evil machinations put him at odds with much of the roster, most notably the rebellious "Stone Cold" Steve Austin, who devoted his entire existence to making Mr. McMahon's life a living hell. But his rivalry with the Rattlesnake aside, there could

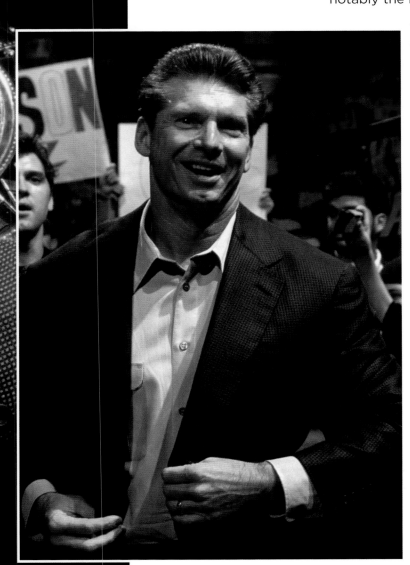

"HE SOUGHT TO RULE WWE FROM WITHIN THE RING AS WELL."

be no denying that Mr. McMahon had a plan for total domination. It wasn't enough that he ruled WWE from the company's corporate offices, he also sought to rule it from within the ring as well.

In January 1999, he shocked the WWE Universe when he outlasted 29 other Superstars to win the Royal Rumble Match. Just a month later, he pulled off another seemingly impossible feat when he defeated Stone Cold in a Gauntlet Match on *Raw*. But the real game changer came in September 1999, when he defeated Triple H on *SmackDown* to win the WWE Championship. Some deemed the title win to be controversial, particularly given the fact that Mr. McMahon's son, Shane, was the one who made the three-count. Nevertheless, it was on the record books for all time: Mr. McMahon was WWE Champion. The title was vacated only a few days later, ultimately being won back by Triple H at *Unforgiven*. However, the victory proved that Mr. McMahon was more than just a corporate powerhouse. He was a fighter, a contender. And, above all, a champion.

BIG SHOW

FOLLOWING IN THE MASSIVE FOOTSTEPS OF ANDRÉ THE Giant, the 7-feet tall, 383-pound goliath Big Show stomped into WWE to claim the gold and became the first Superstar to win the WWE, WCW and ECW Championships.

After being introduced to Hulk Hogan, Show signed up with WCW and made his in-ring debut in 1995, originally billed as the "son of André the Giant" and using the name The Giant. He surprised the crowd by winning the WCW World Championship from Hogan. Already making huge impacts, he joined WWE in 1999 and continued to dominate.

After debuting as Mr. McMahon's enforcer and competing in explosive matches against Superstars like Mankind and Undertaker, Big Show shocked the WWE Universe at *Survivor Series* 1999. Replacing "Stone Cold" Steve Austin, who had been hit by a car outside the arena, he emerged victorious to claim his first WWE Championship in a Triple Threat Match against The Rock and Triple H. Holding the gold for 49 days, Show was towering high.

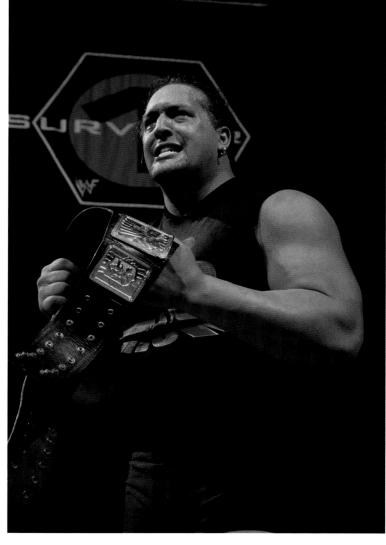

Show won his second WWE Championship in 2002, at the same event he'd won his first, *Survivor Series*. The World's Largest Athlete felled Brock Lesnar at Madison Square Garden to claim the title. A two-time WWE Champion and winner of multiple titles, Big Show's legend will be as massive as the man himself.

"THE 7-FEET, 383-POUND GOLIATH STOMPED INTO WWE TO CLAIM THE GOLD."

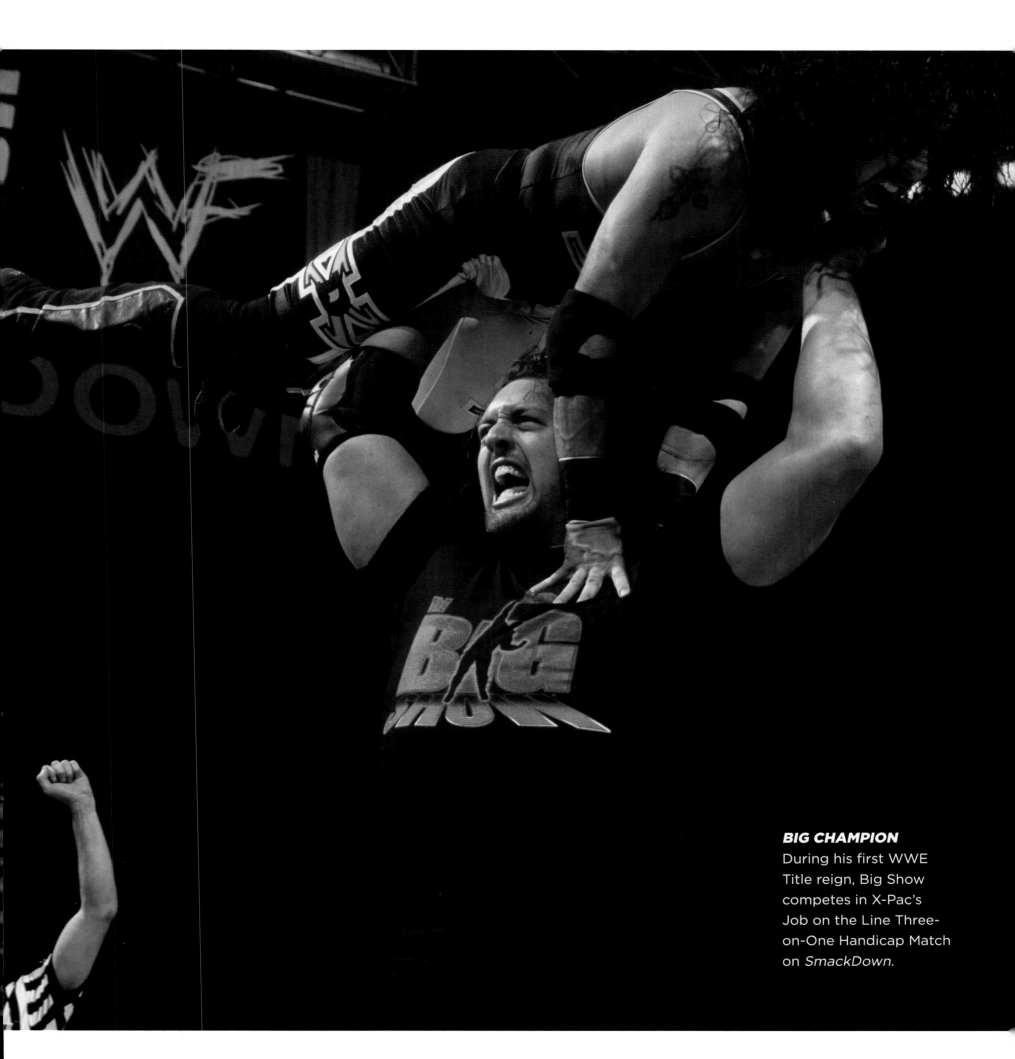

BIG CHAMPION
During his first WWE Title reign, Big Show competes in X-Pac's Job on the Line Three-on-One Handicap Match on *SmackDown*.

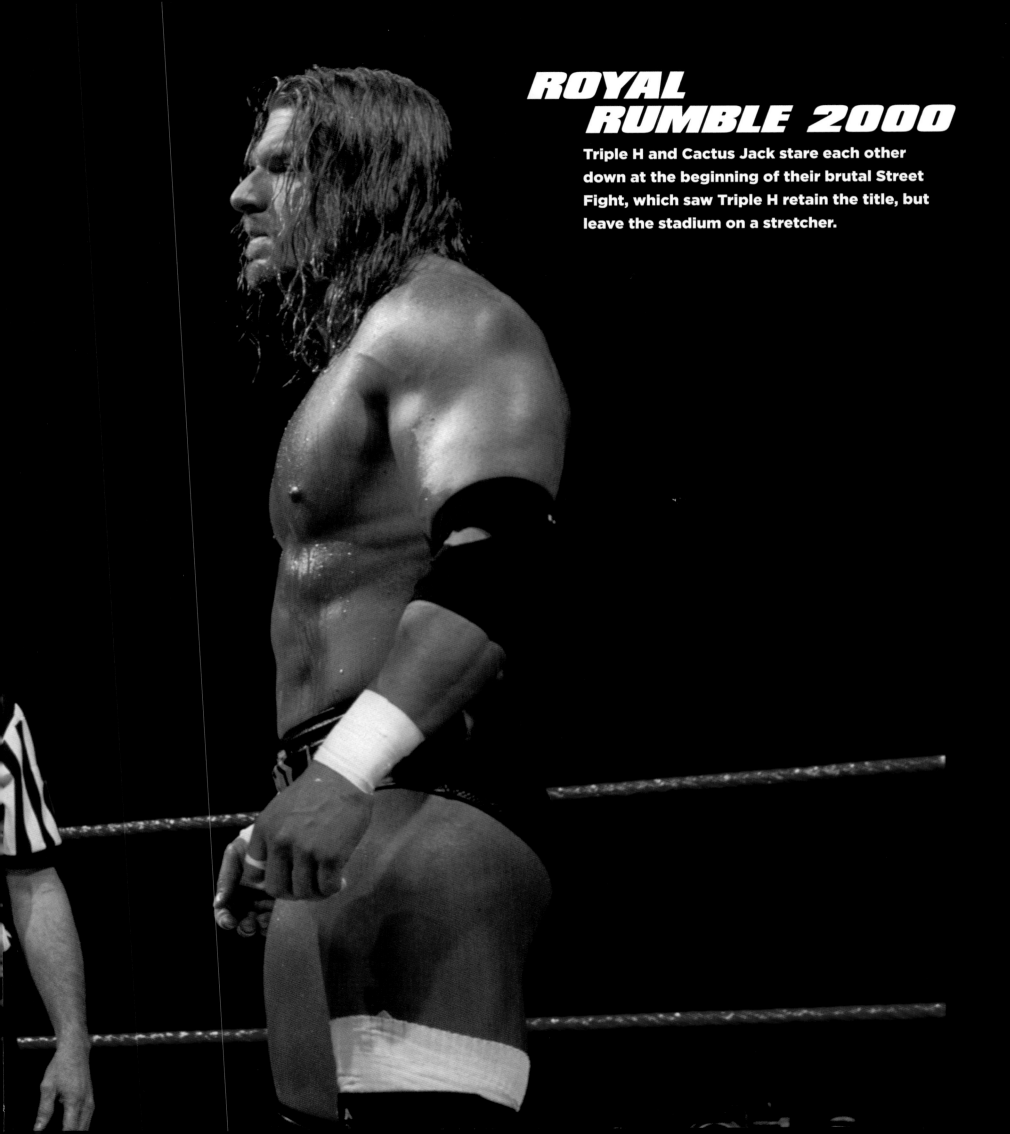

ROYAL RUMBLE 2000

Triple H and Cactus Jack stare each other down at the beginning of their brutal Street Fight, which saw Triple H retain the title, but leave the stadium on a stretcher.

ATTITUDE ERA | CHAMPION

KURT ANGLE

ONE OF THE MOST TECHNICALLY GIFTED Superstars to have ever stepped between the ropes, Kurt Angle had already won Olympic gold in the 220-pound freestyle wrestling competition at 1996's Olympic Games in Atlanta, before entering WWE four years later.

Having already won the European and Intercontinental Championships in early 2000, before dropping them at *WrestleMania 2000*, his attention turned to the WWE Championship. In a No Disqualification Match at *No Mercy*, Angle shocked the WWE Universe by capitalizing on a botched interference from Rikishi to hit The Rock with an Angle Slam and win his first WWE Title. Angle became the first Superstar to have won both an Olympic gold medal and the WWE Championship. During four months holding the title, he defeated Undertaker at *Survivor Series* and won a Six-Man Hell in a Cell Match at *Armageddon*, as well as overcoming Triple H at *Royal Rumble*. But it was The Rock who finally ended his 125-day first reign at *No Way Out* 2001.

After winning a couple of other titles, the red-white-and-blue-clad grappler claimed the WWE Championship for a second time at *Unforgiven* 2001. Angle defeated "Stone Cold" Steve Austin by making him submit with an Ankle Lock, before being congratulated by his family and the WWE roster for one of the best wins of his career. Just two weeks later, Angle controversially dropped the title back to Austin, with William Regal's interference

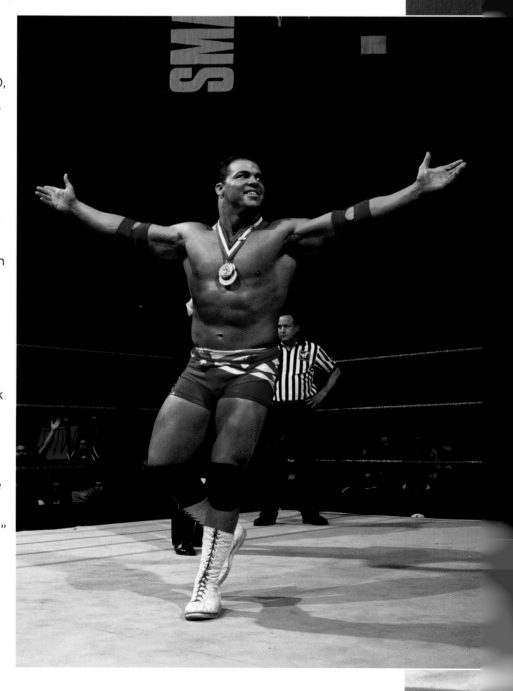

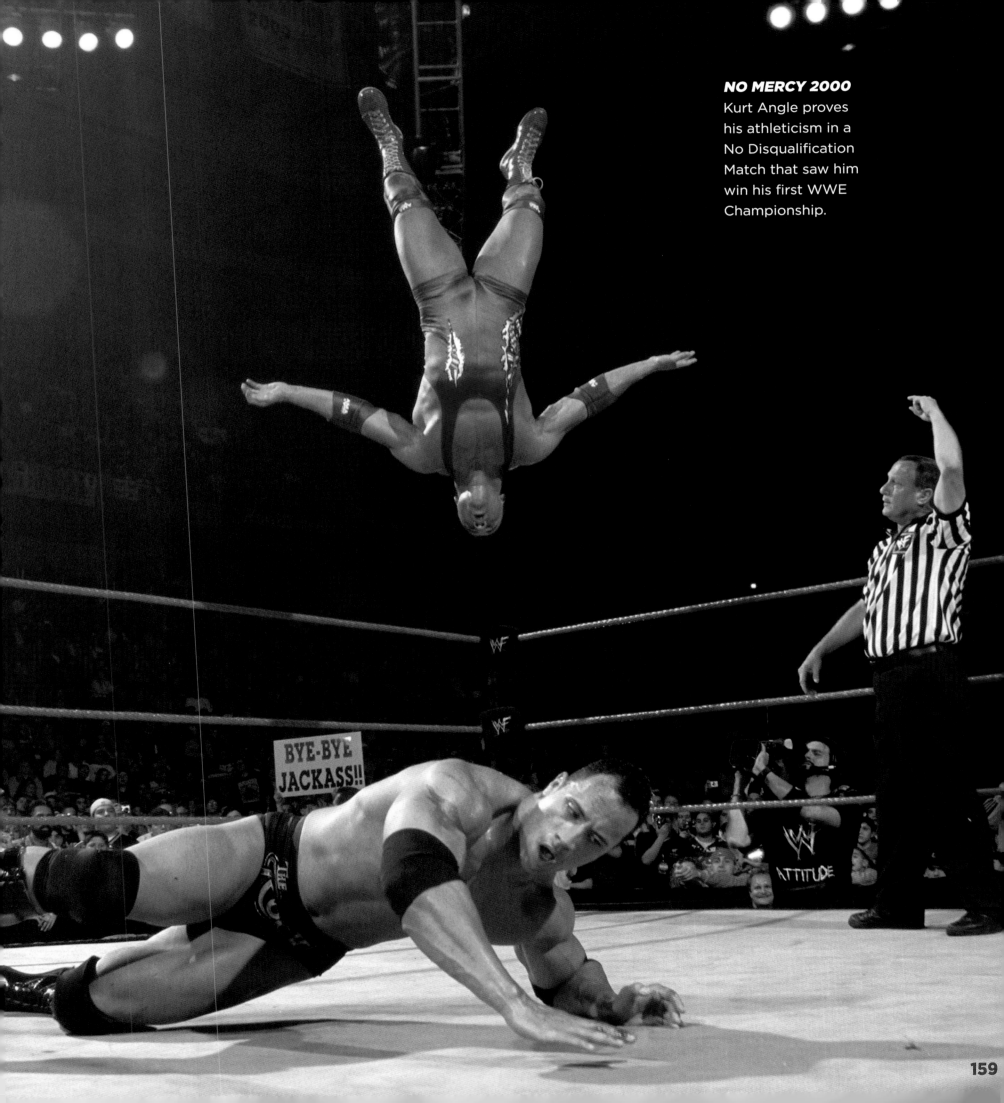

NO MERCY 2000
Kurt Angle proves his athleticism in a No Disqualification Match that saw him win his first WWE Championship.

BYE-BYE JACKASS!!

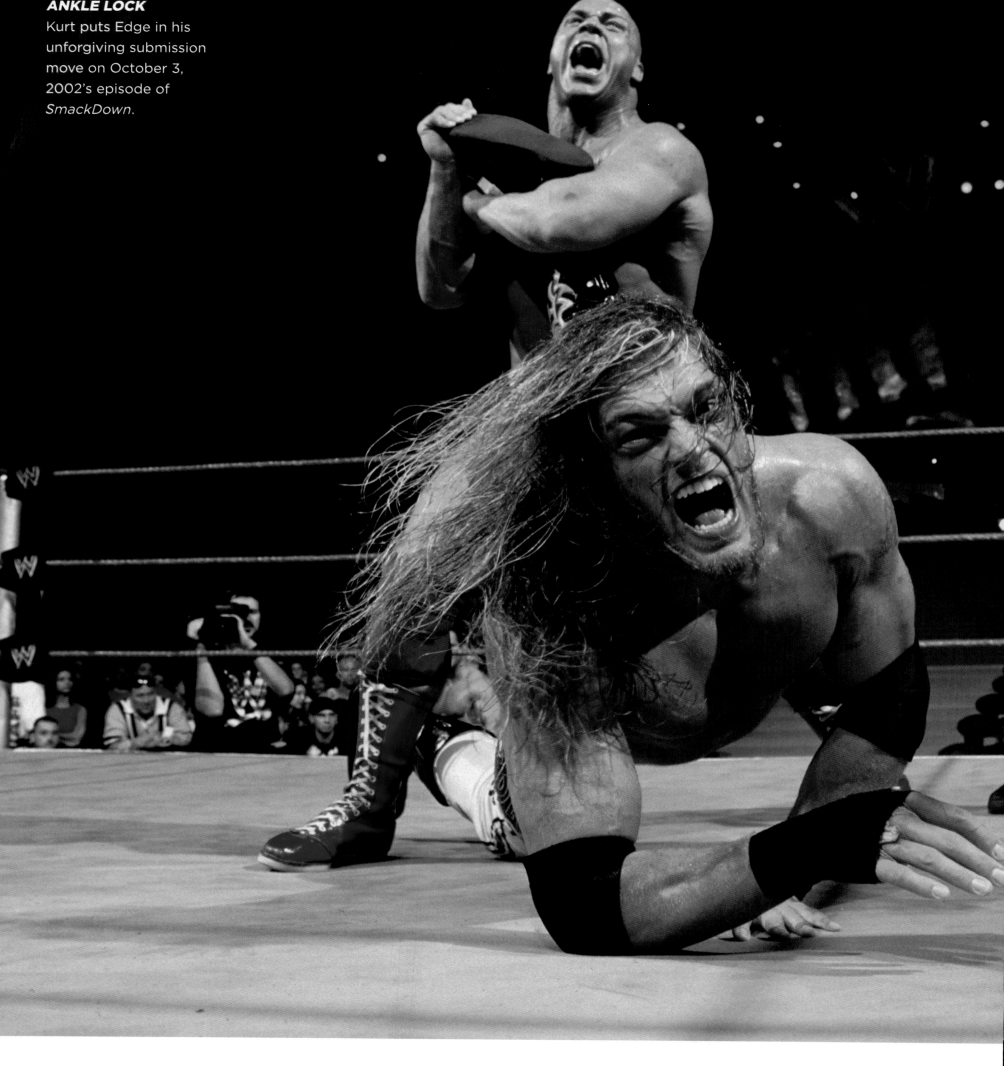

ANKLE LOCK
Kurt puts Edge in his
unforgiving submission
move on October 3,
2002's episode of
SmackDown.

allowing the Texas Rattlesnake to get the Win. 2002's *Armageddon* saw Angle face off against the massive Big Show, who was assisted by Paul Heyman and A-Train. But Brock Lesnar entered the ring to hit Big Show with an F5, allowing Angle to get the cover and become WWE Champion again.

"THE FIRST SUPERSTAR TO HAVE WON BOTH AN OLYMPIC GOLD MEDAL AND THE WWE CHAMPIONSHIP."

After 104 days his third title reign came to an end, following the collapse of his alliance with Lesnar. At the main event on the Grandest Stage of Them All, Angle faced Lesnar at *WrestleMania XIX*. The Wrestling Machine showed amazing athleticism but could not overcome Lesnar, who won after a third F5. However, after the thrilling match, Angle and Lesnar shook hands and embraced. *Vengeance* 2003 featured a Triple Threat Match in which Angle faced off against both Lesnar and Big Show. The intense bout came to an end when Angle delivered Angle Slams to first Big Show then Lesnar, covering him for the pinfall and winning his fourth WWE Title.

He retained the title against Lesnar at *SummerSlam* but dropped the WWE Championship short of the two-month mark to Lesnar in a 60-Minute Iron Man Match on *SmackDown* in September 2003. Although he left WWE three years later, his matches and title reigns have become legendary. Angle preached and lived up to the virtues of the three I's (Intensity, Integrity and Intelligence), proving himself a true WWE Champion. Returning to WWE competition in 2017, the Olympic Hero retired two years later with a farewell match against Baron Corbin at *WrestleMania 35*, thanking the WWE Universe for an incredible career.

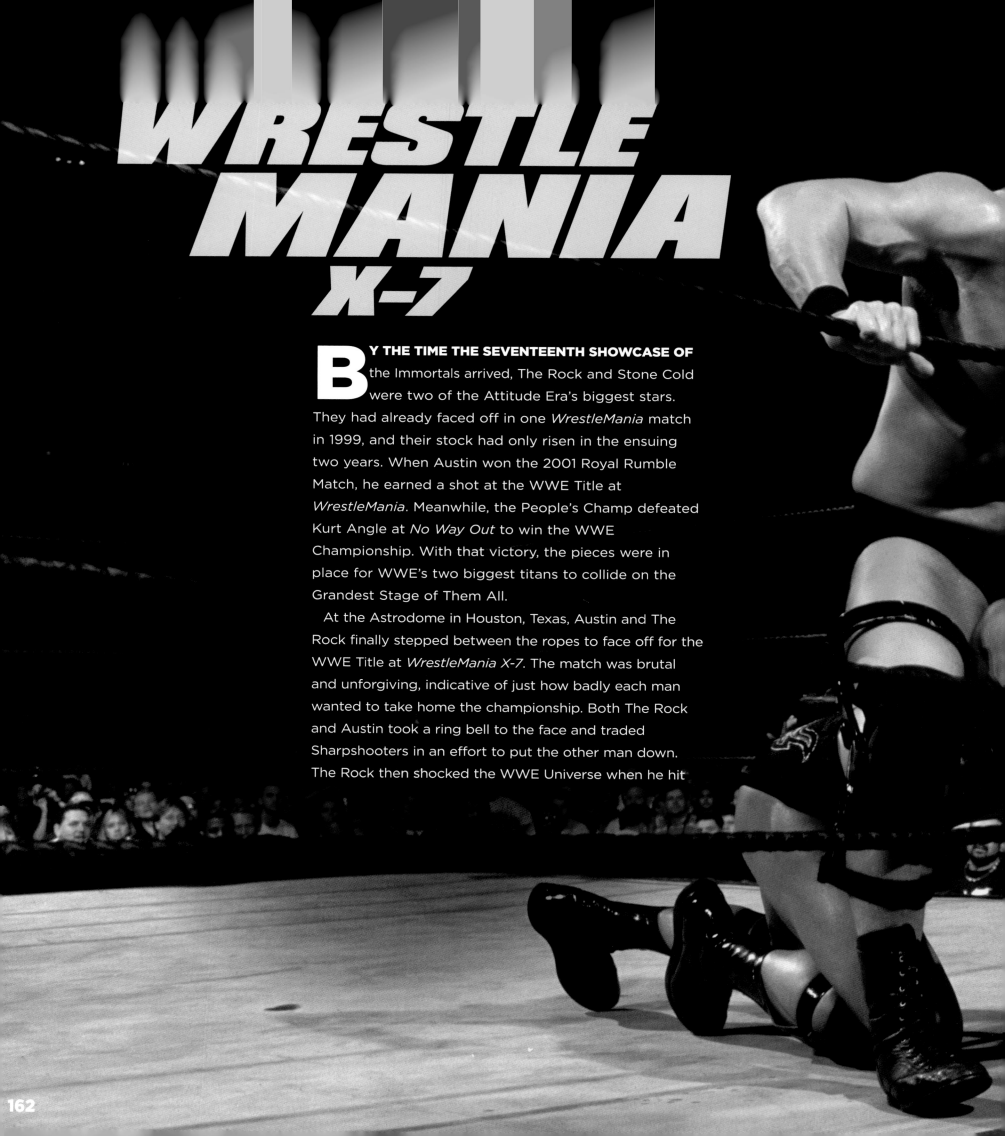

WRESTLE MANIA X-7

BY THE TIME THE SEVENTEENTH SHOWCASE OF the Immortals arrived, The Rock and Stone Cold were two of the Attitude Era's biggest stars. They had already faced off in one *WrestleMania* match in 1999, and their stock had only risen in the ensuing two years. When Austin won the 2001 Royal Rumble Match, he earned a shot at the WWE Title at *WrestleMania*. Meanwhile, the People's Champ defeated Kurt Angle at *No Way Out* to win the WWE Championship. With that victory, the pieces were in place for WWE's two biggest titans to collide on the Grandest Stage of Them All.

At the Astrodome in Houston, Texas, Austin and The Rock finally stepped between the ropes to face off for the WWE Title at *WrestleMania X-7*. The match was brutal and unforgiving, indicative of just how badly each man wanted to take home the championship. Both The Rock and Austin took a ring bell to the face and traded Sharpshooters in an effort to put the other man down. The Rock then shocked the WWE Universe when he hit

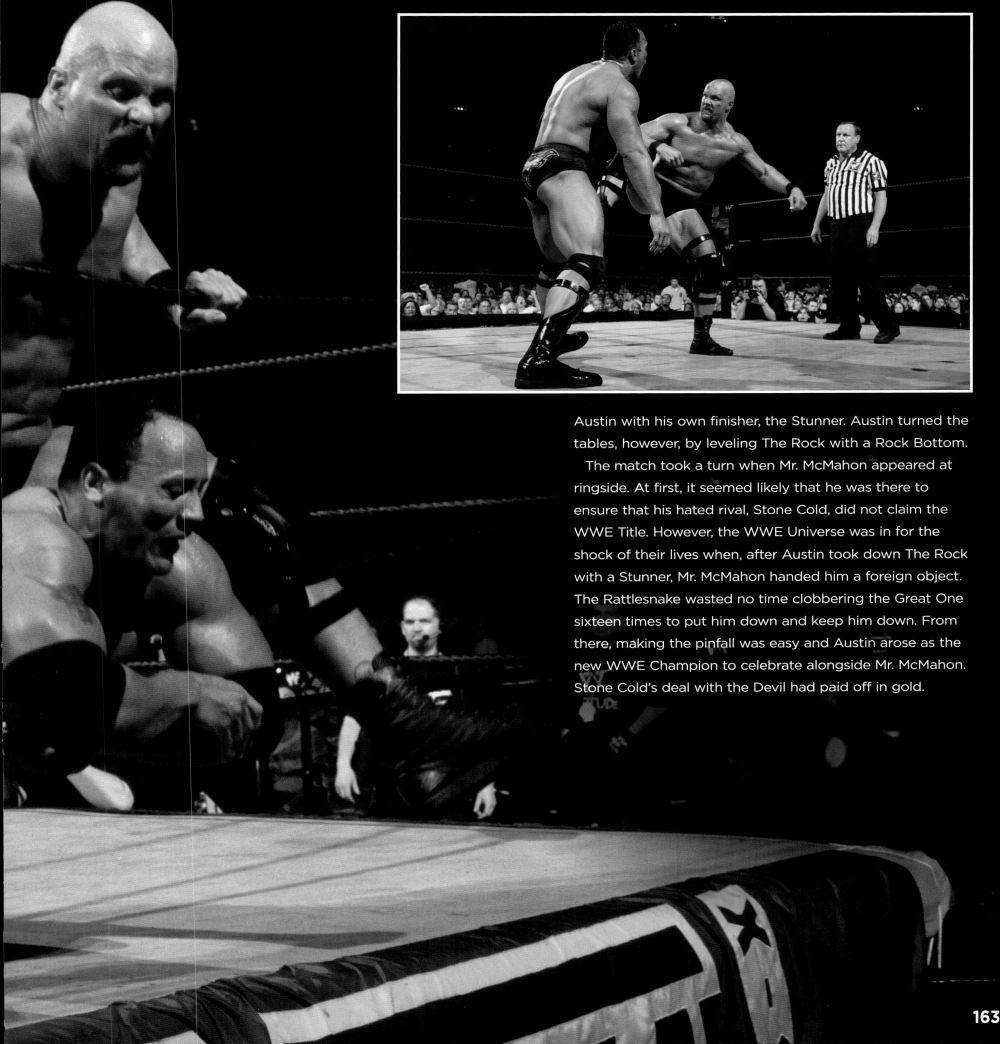

Austin with his own finisher, the Stunner. Austin turned the tables, however, by leveling The Rock with a Rock Bottom.

The match took a turn when Mr. McMahon appeared at ringside. At first, it seemed likely that he was there to ensure that his hated rival, Stone Cold, did not claim the WWE Title. However, the WWE Universe was in for the shock of their lives when, after Austin took down The Rock with a Stunner, Mr. McMahon handed him a foreign object. The Rattlesnake wasted no time clobbering the Great One sixteen times to put him down and keep him down. From there, making the pinfall was easy and Austin arose as the new WWE Champion to celebrate alongside Mr. McMahon. Stone Cold's deal with the Devil had paid off in gold.

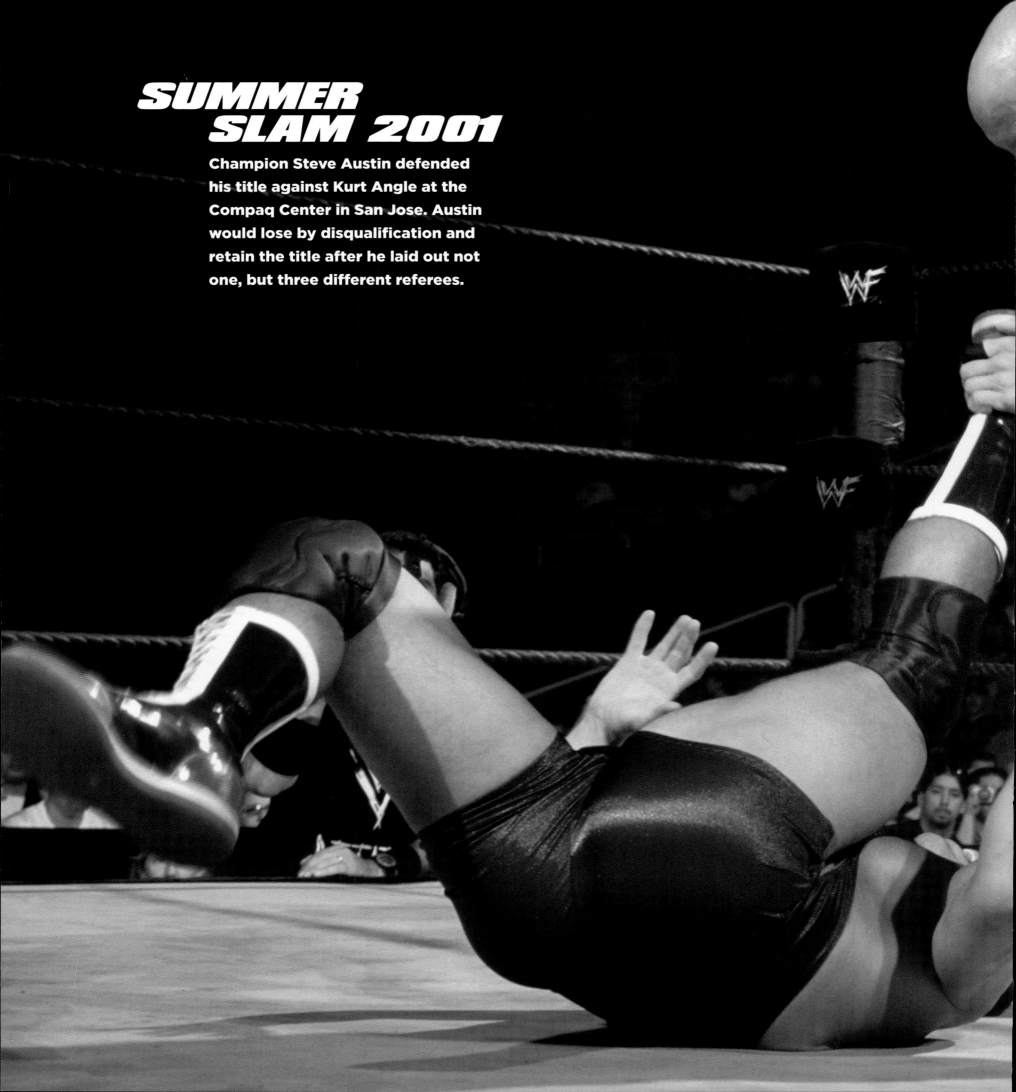

SUMMER SLAM 2001

Champion Steve Austin defended his title against Kurt Angle at the Compaq Center in San Jose. Austin would lose by disqualification and retain the title after he laid out not one, but three different referees.

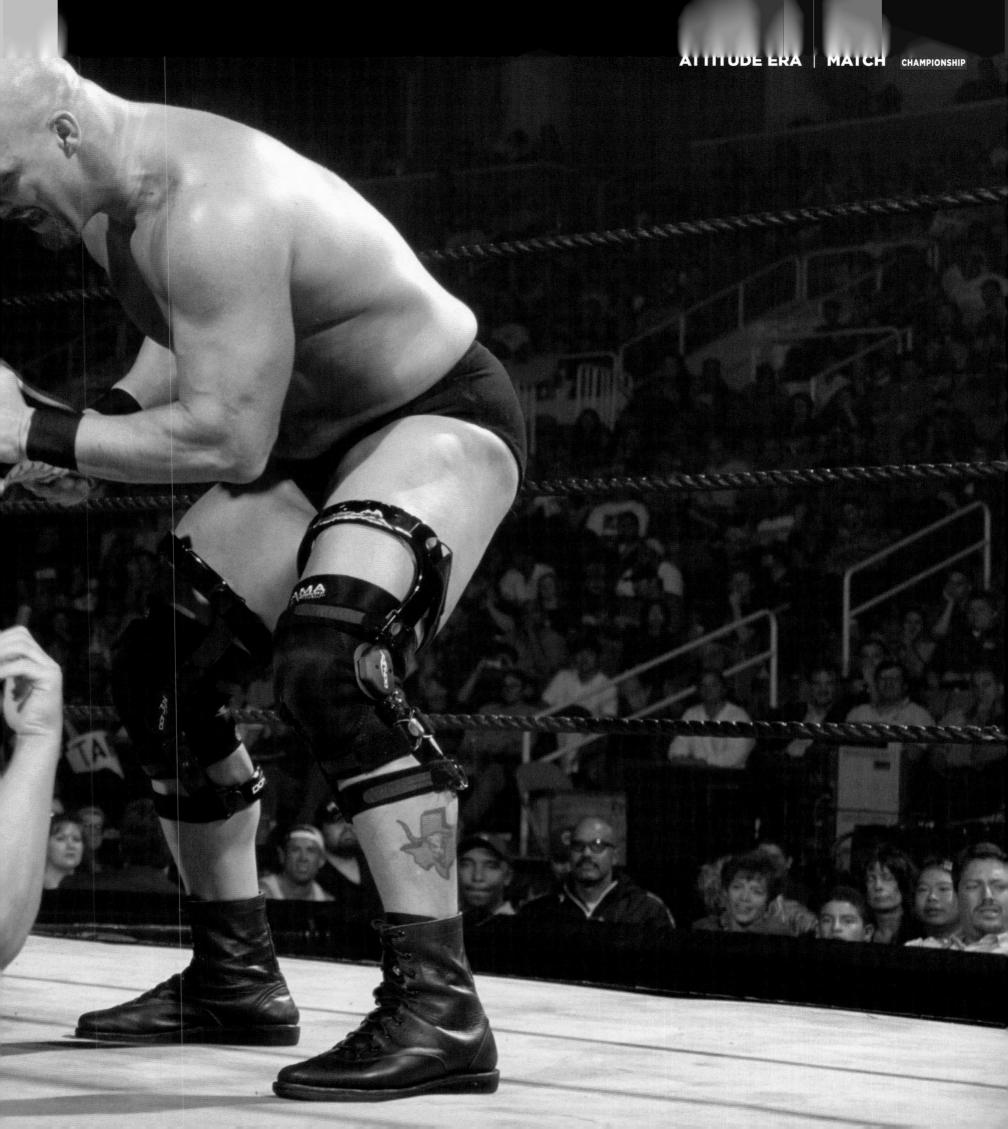

UNDISPUTED CHAMPION

AT THE *VENGEANCE* PAY-PER-VIEW EVENT, Chris Jericho found himself facing The Rock in a match for the WCW World Championship. Against all odds, Jericho defeated The People's Champion, winning the WCW World Championship and earning him a spot in the main event. That match saw Jericho take on WWE Champion "Stone Cold" Steve Austin, who had earlier that night defended the WWE Championship in a match against Kurt Angle. The main event at *Vengeance 2001* would be an historical bout that would unify the WCW World Championship and the WWE Championship.

Jericho took the battle to the Rattlesnake, locking in the Walls of Jericho and even hitting Austin with his own finisher, the Stone Cold Stunner. Austin turned the tables by slapping on his own Walls of Jericho, forcing Y2J to tap. But, with the referee having been accidentally knocked out moments earlier, there was no one in ring to make the call and Jericho still had a chance. That's when Booker T ran out and nailed the Rattlesnake with the WWE Title. With the referee recovered, Jericho capitalized on the distraction by making the pinfall to become WWE's first-ever Undisputed Champion.

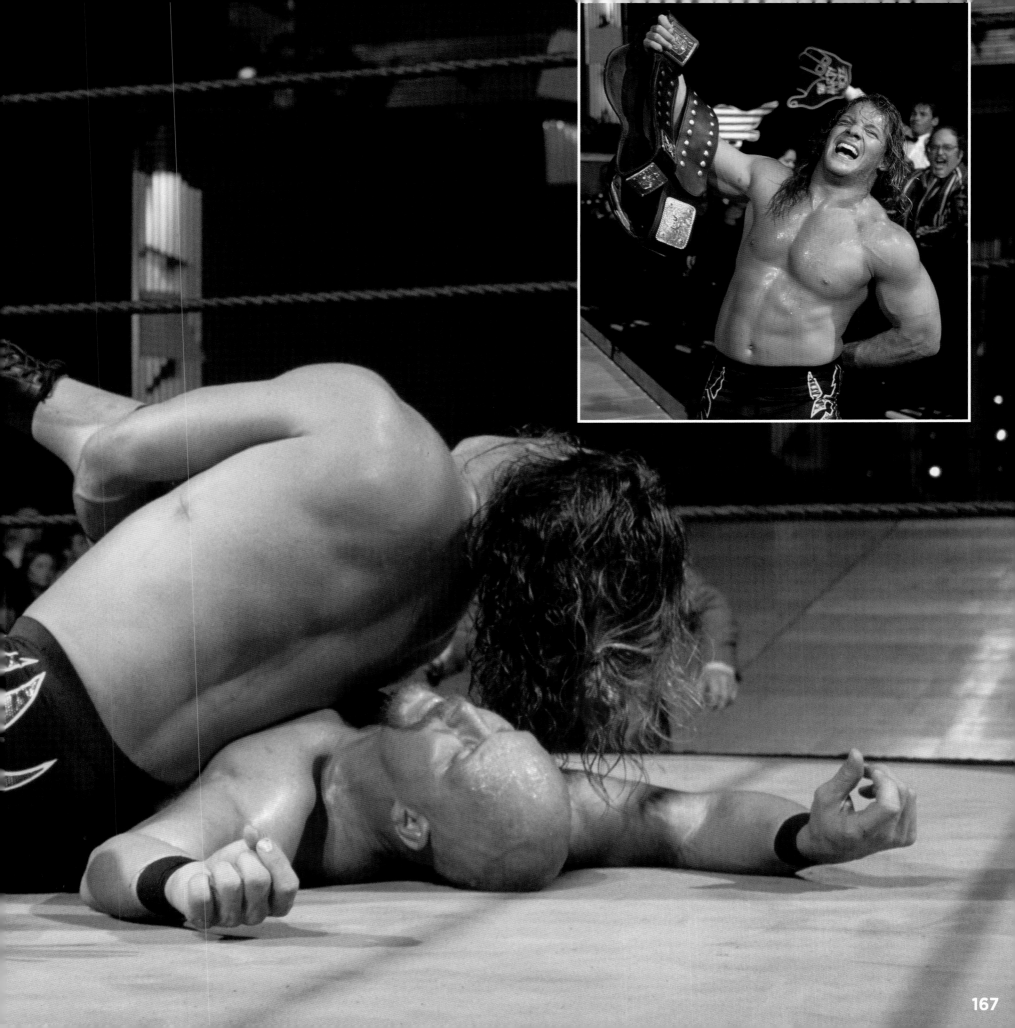

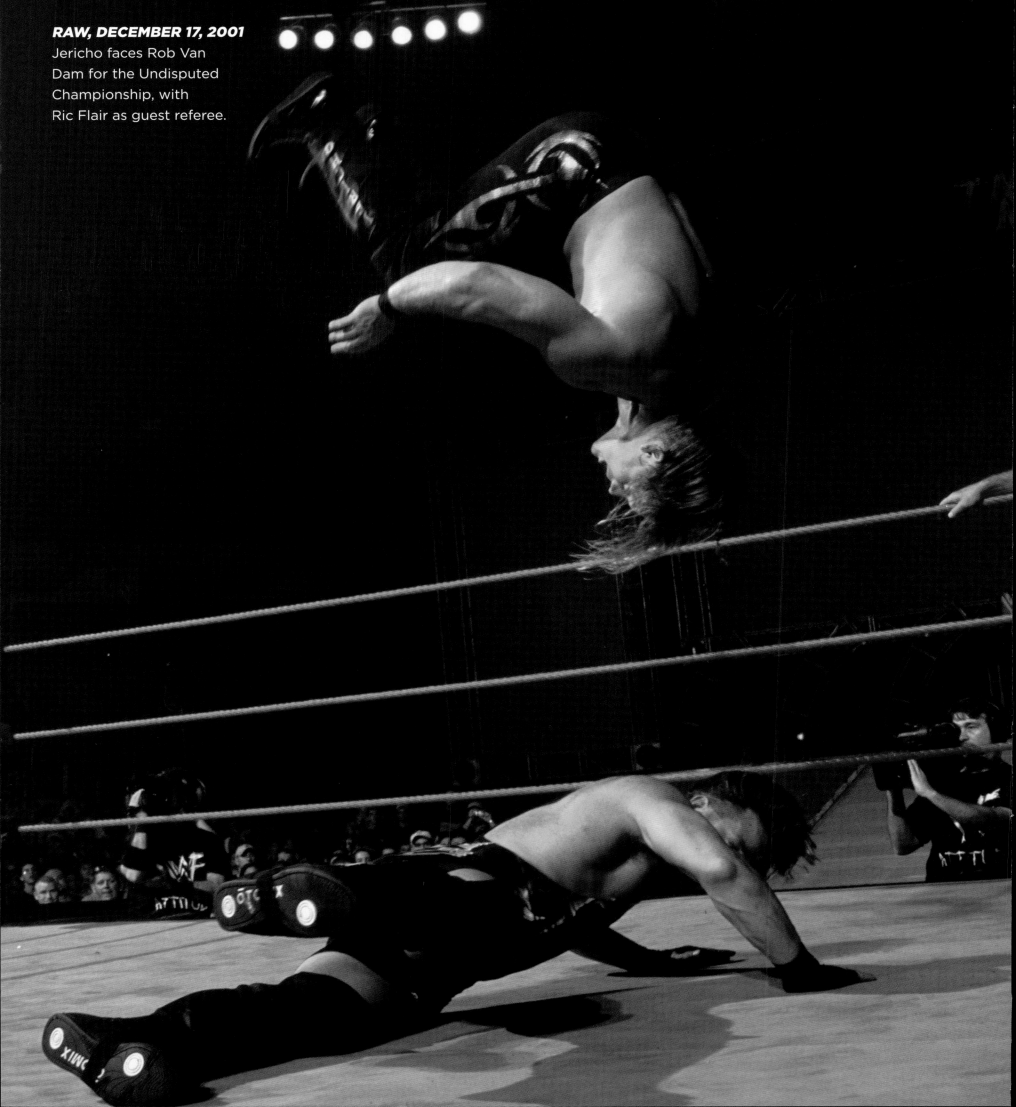

RAW, DECEMBER 17, 2001
Jericho faces Rob Van
Dam for the Undisputed
Championship, with
Ric Flair as guest referee.

CHRIS JERICHO

FLAMBOYANT, BRASH, OUTSPOKEN and talented, Chris Jericho was a Superstar who was born to be a champion. From the moment he debuted in the summer of 1999, brazenly challenging The Rock right out of the gate, Jericho let the WWE Universe know that he meant business.

Raised in Winnipeg, Canada, Jericho trained briefly in the infamous Hart Dungeon before sharpening his skills on the independent circuit.

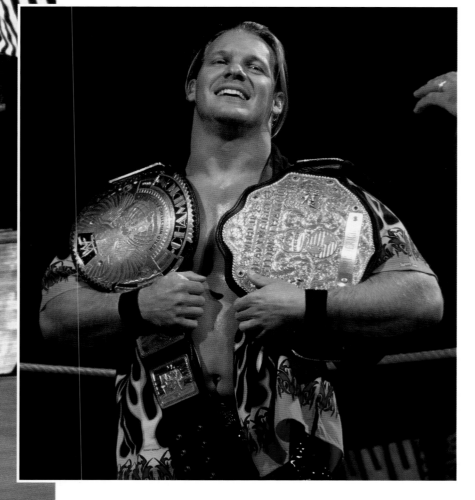

Following a successful run in WCW, Jericho was courted by WWE and, following his audacious debut, went on to defeat Chyna for the Intercontinental Championship at the first *Armageddon* in 1999. A mix-up with the refs led to both Superstars becoming co-champions, until Jericho took sole ownership of the title at 2000's *Royal Rumble*.

Jericho quickly became one of WWE's most electrifying personalities, defeating opponent after opponent and thrilling the WWE Universe with his epic promos and rockstar swagger. By the end of 2001, Jericho was a bona fide Superstar, but his biggest breakthrough was about to come.

At the *Vengeance* pay-per-view event, Jericho first defeated The Rock to win the WCW World Championship before taking on Steve Austin in the main event to win the WWE Championship, unifying the two titles. As WWE's first-ever Undisputed Champion, Jericho defeated The Rock at 2002's *Royal Rumble* and Austin at *No Way Out* before losing the title to Triple H at *WrestleMania X8*.

Jericho would go on to win a number of other titles, including the Intercontinental and Tag Team Championships. His 98-day reign as Undisputed Champion may have been Jericho's only time with that title, but the manner in which he won the WWE Championship stands for all time as one of the greatest and most historic title wins WWE has ever seen.

"JERICHO QUICKLY BECAME ONE OF WWE'S MOST ELECTRIFYING PERSONALITIES."

JUDGMENT DAY 2005
John Cena holds up the
"spinner" design of the
WWE Championship
before defeating JBL
in an "I Quit" Match.

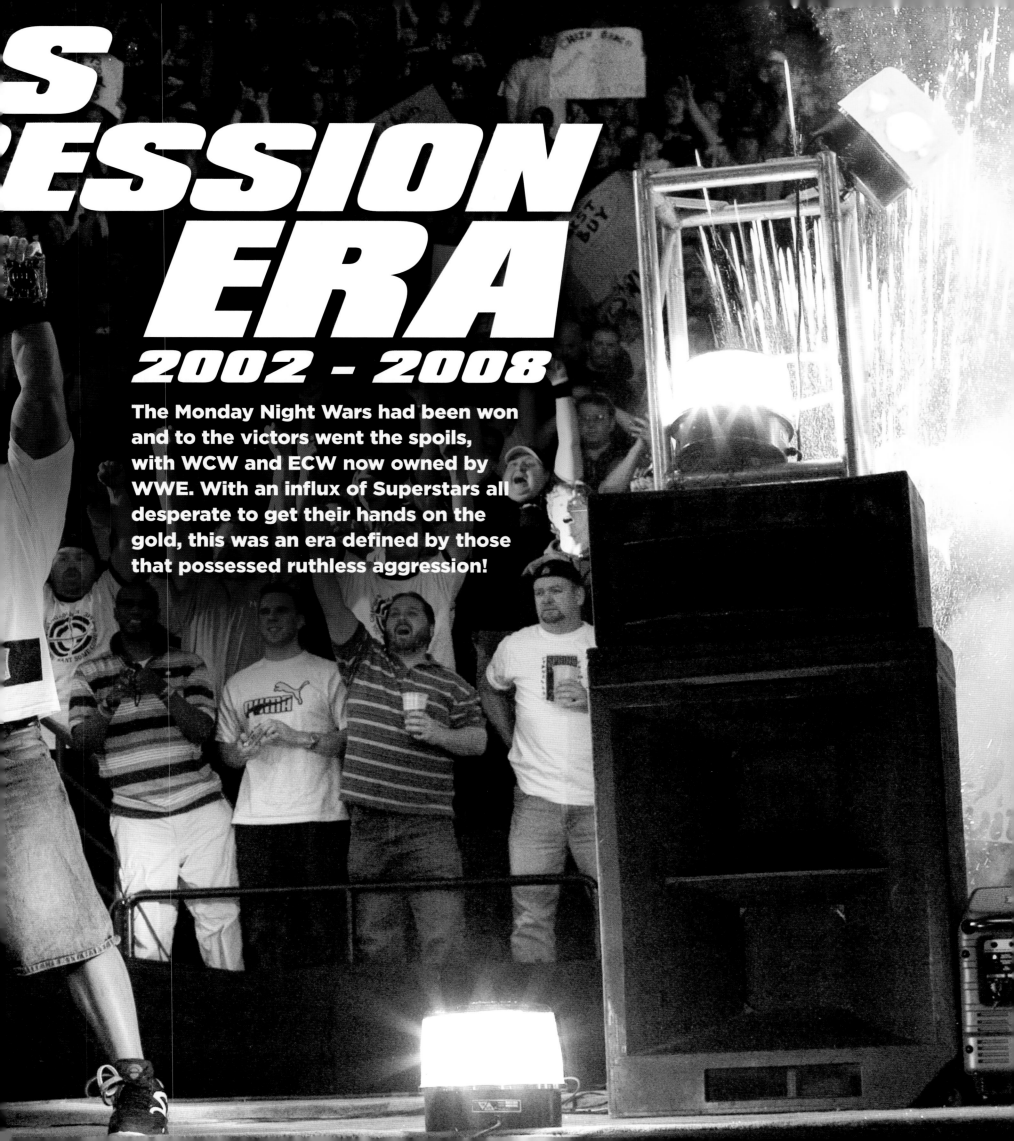

S ESSION ERA

2002 - 2008

The Monday Night Wars had been won and to the victors went the spoils, with WCW and ECW now owned by WWE. With an influx of Superstars all desperate to get their hands on the gold, this was an era defined by those that possessed ruthless aggression!

BY 2002, WWE HAD SEEN OFF ITS strongest rivals, purchasing both WCW and ECW. To handle the sheer volume of new Superstars, Vince McMahon initiated a Brand Extension, splitting the roster in two, with half appearing on *Raw* and half on *SmackDown*. This was the beginning of the era that came to be known as "Ruthless Aggression," an era that focused less on the salacious content of the Attitude years and more on hardcore, no-holds-barred sports entertainment.

In 2002, *WrestleMania* returned to Toronto for the second time and Chris Jericho put up his WWE Title against a returning Triple H, who had spent months sidelined with a quadriceps injury. The Game was back in fighting shape and managed to take down Y2J with a Pedigree to become WWE Champion. Sadly for the Cerebral Assassin, he lost the title to Hulk Hogan at *Backlash* just a month later. Later that summer, the title was won by Brock Lesnar, who became the youngest Superstar ever to hold the WWE Title.

With Lesnar signing a deal to exclusively appear on *SmackDown,* the WWE Undisputed Championship also became exclusive and a rival World Heavyweight Championship was created for *Raw*. Shortly after this, the WWE Undisputed Championship was renamed, once again becoming the WWE Championship.

After a vicious title rivalry between Brock Lesnar and Kurt Angle and a celebrated reign by fan favorite Eddie Guerrero, the WWE Championship was won by John "Bradshaw" Layfield aka JBL, an arrogant businessman with a love of money and power. He was the perfect foil for a hardscrabble Superstar from Massachusetts named John Cena. Cena was to the Ruthless Aggression Era what Stone Cold was to the Attitude days, a star whose tenacity was rivaled only by his in-ring ability. Cena's victory at *WrestleMania 21* in 2005 cemented his status as WWE's top rising Superstar.

Cena quickly ascended to the upper ranks of the WWE stratosphere, taking on a host of challengers and retaining the title for 280 days. He eventually lost it to Edge when the Rated-R Superstar cashed in his Money in the Bank title opportunity against a bloodied John Cena following an Elimination Chamber Match at the 2006 *New Year's Revolution*. This led to a heated

rivalry between the two that would see both Superstars chase the gold for much of 2006. Rob Van Dam would briefly step in the middle of Cena and Edge's rivalry in June 2006, winning the WWE Championship. RVD's reign was short but it helped usher in a new version of ECW and brought about the creation of the ECW World Heavyweight Championship.

Another Superstar, who came up at the same time as Cena, entered the WWE Championship

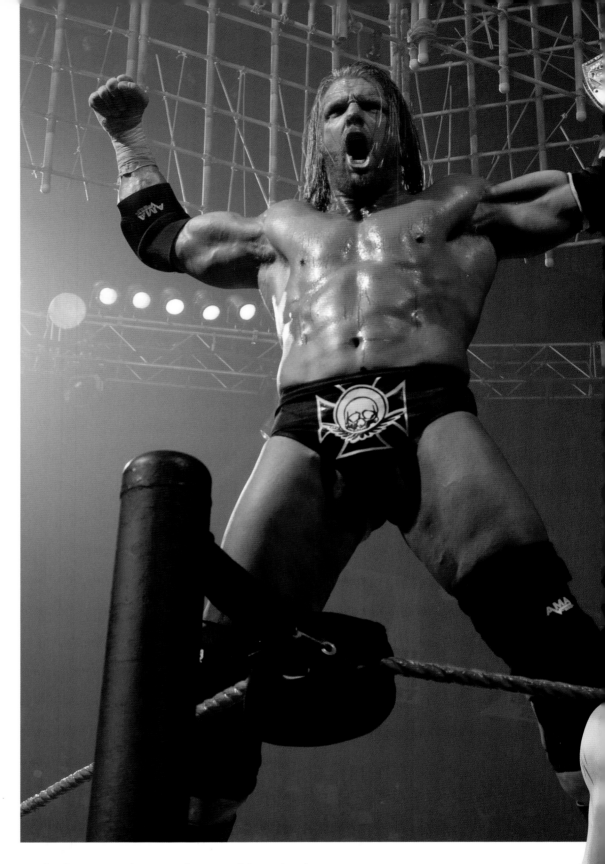

▲ NO MERCY 2007
Triple H celebrates his sixth WWE Championship on a night that would see him battle in three separate title matches.

▶ THE VIPER
Randy Orton won his first and second WWE Titles on the same night. The Legend Killer would hold the title for over 200 days during this era of WWE.

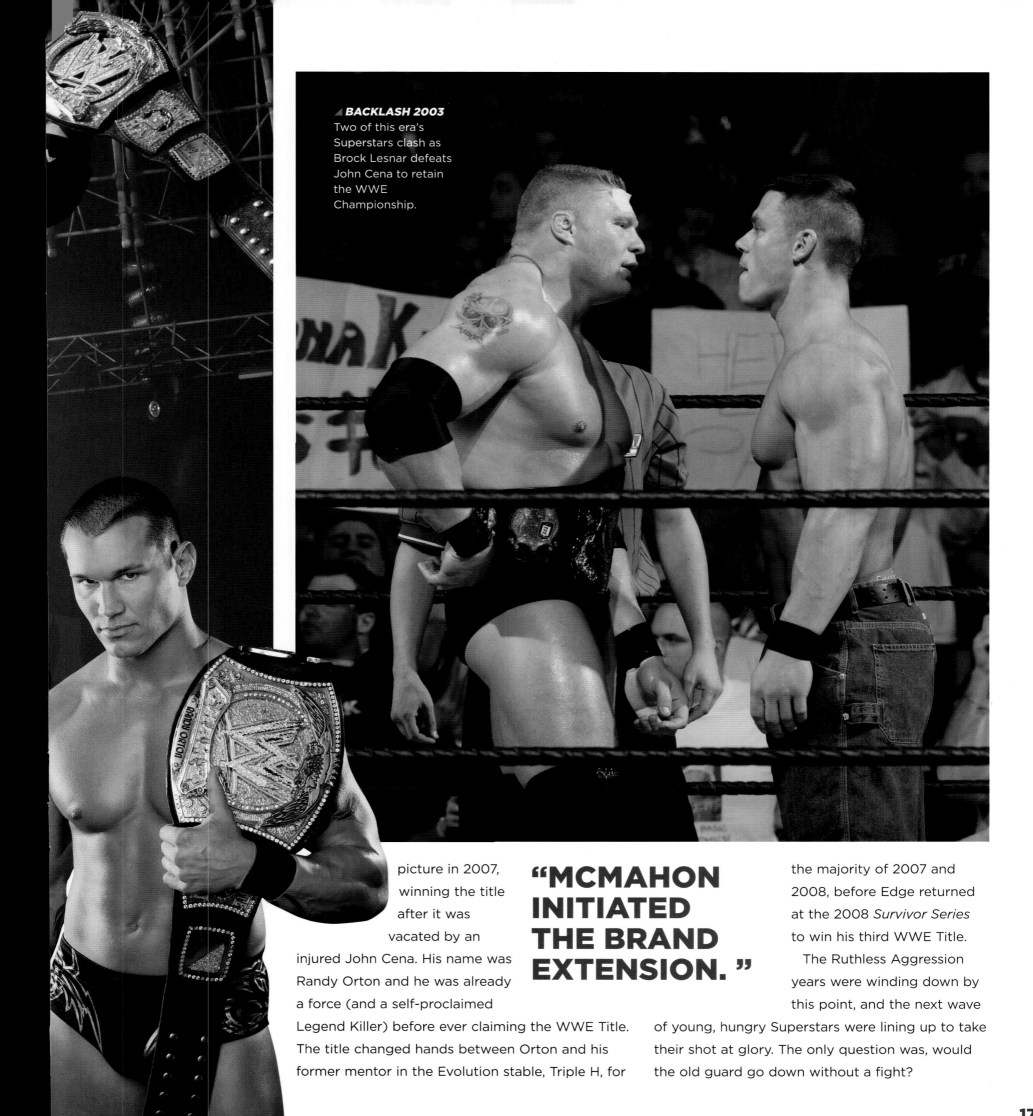

◢ **BACKLASH 2003**
Two of this era's
Superstars clash as
Brock Lesnar defeats
John Cena to retain
the WWE
Championship.

picture in 2007,
winning the title
after it was
vacated by an
injured John Cena. His name was
Randy Orton and he was already
a force (and a self-proclaimed
Legend Killer) before ever claiming the WWE Title.
The title changed hands between Orton and his
former mentor in the Evolution stable, Triple H, for

"MCMAHON INITIATED THE BRAND EXTENSION. "

the majority of 2007 and
2008, before Edge returned
at the 2008 *Survivor Series*
to win his third WWE Title.

The Ruthless Aggression
years were winding down by
this point, and the next wave
of young, hungry Superstars were lining up to take
their shot at glory. The only question was, would
the old guard go down without a fight?

173

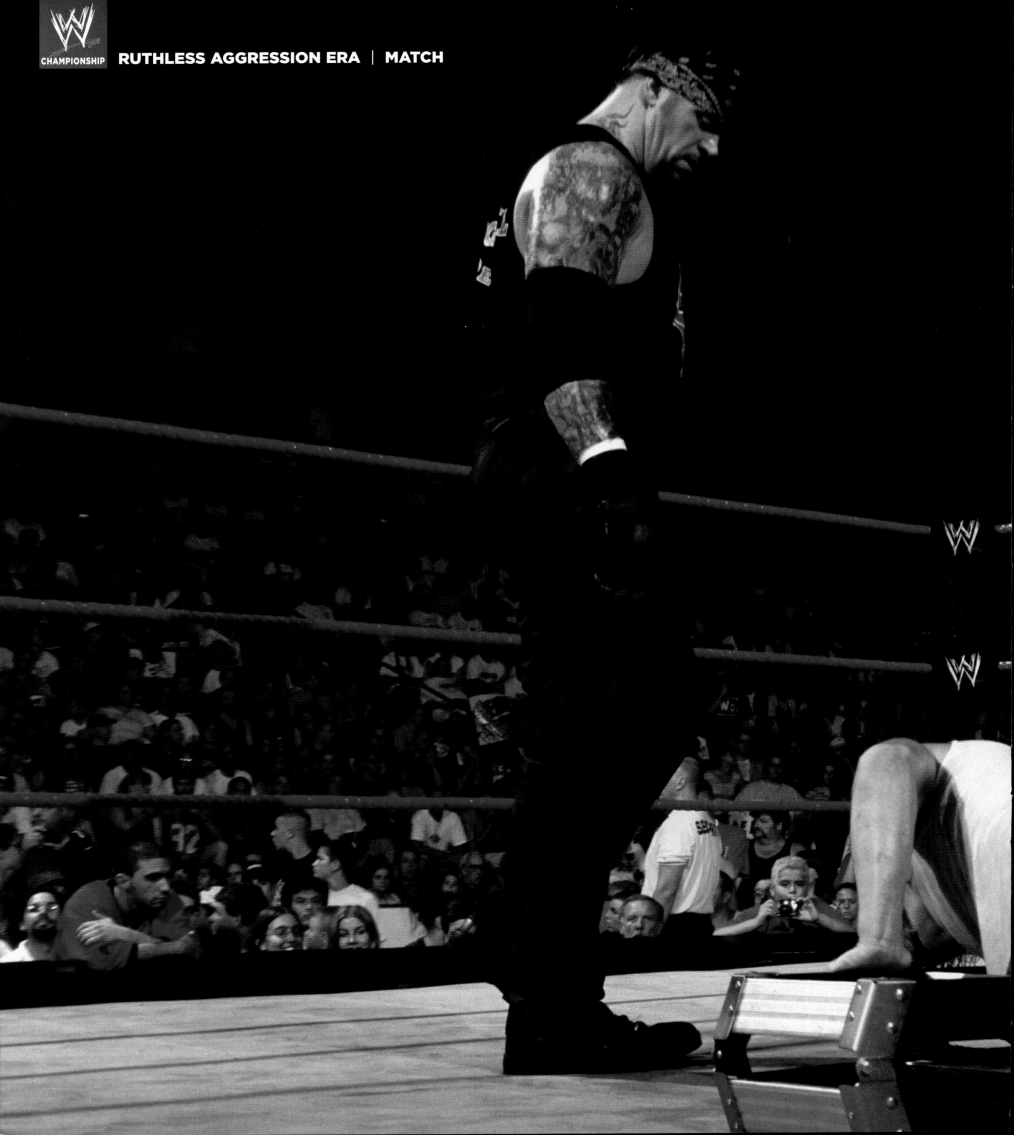

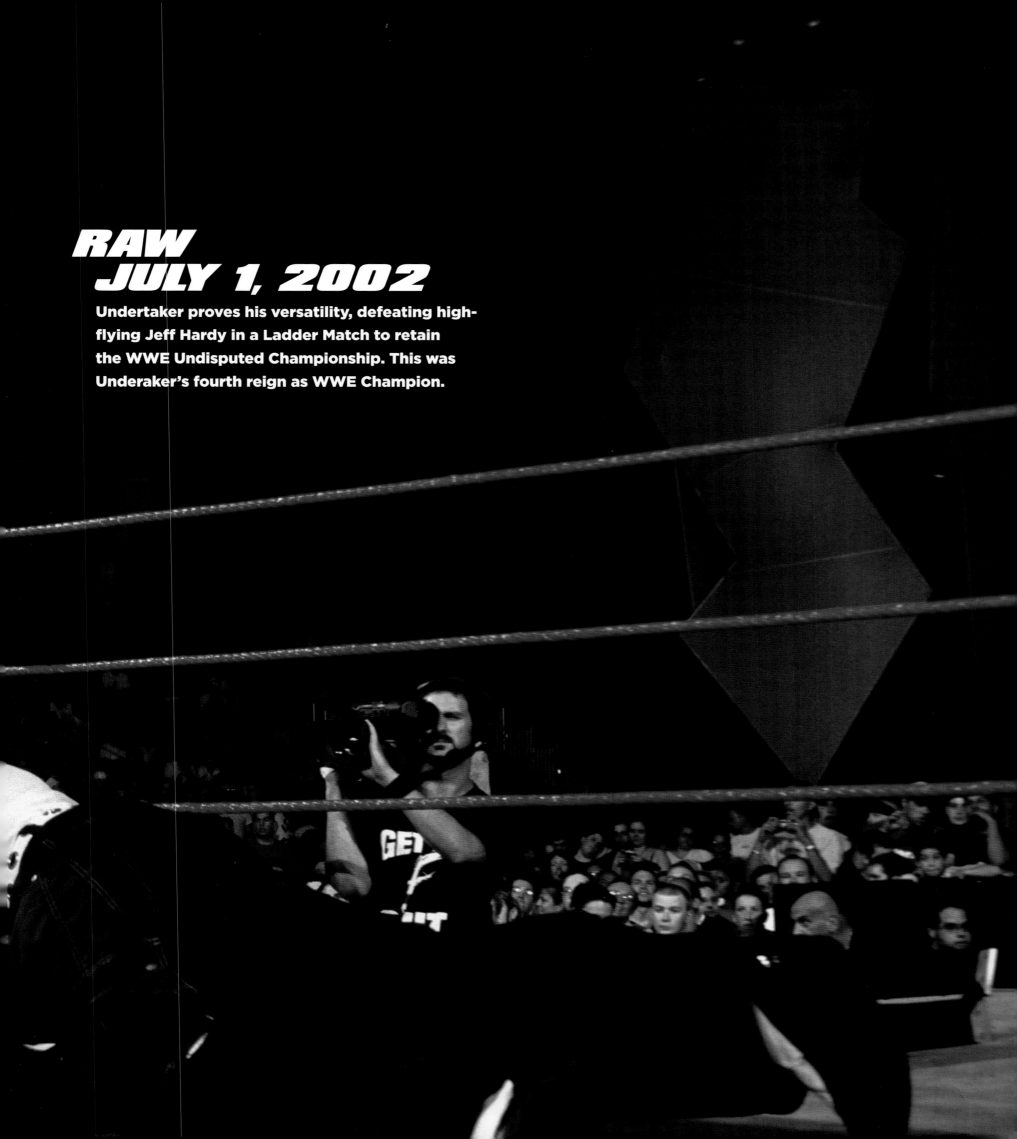

RAW
JULY 1, 2002

Undertaker proves his versatility, defeating high-flying Jeff Hardy in a Ladder Match to retain the WWE Undisputed Championship. This was Underaker's fourth reign as WWE Champion.

VENGEANCE

THE ROCK VS. KURT ANGLE VS. UNDERTAKER

COMING INTO THIS EVENT, ALL THREE SUPERSTARS were riding waves of popularity with the WWE Universe. Undertaker, in full-on Big Evil mode, was standing tall as the WWE Champion, having won the title from Hulk Hogan at *Judgment Day 2002*. The Rock had nearly cost 'Taker the title at *King of the Ring* when he interfered during Undertaker's match against Triple H. Eager for revenge, 'Taker demanded a rematch, which was scheduled for *Vengeance*. Angle was added to the match after he and Undertaker faced off on *SmackDown* and 'Taker made the pinfall while also tapping out to the Ankle Lock.

The match itself was exactly what the WWE Universe would have expected, with three titans of WWE battling their hardest to claim the promotion's biggest prize. The Rock decided to assert his dominance by using his opponents' finishers against them, hitting a Chokeslam on the Deadman and slapping the Ankle Lock on Angle. But Angle decided that turnabout was fair play and delivered a Rock Bottom back to the People's Champ. 'Taker decided to take The Rock out with a DDT for a near-fall, but was undone by a shot to the face with a foreign object from Angle. He failed to make the cover, however, and the Deadman surged back to clock the People's Champ with a boot and a Last Ride for two. Angle swooped in at the last minute to lock in another Ankle Lock. By this point, the WWE Universe was in an absolute frenzy, realizing that this match could go in any direction. In the end, Angle hit the Angle Slam on Undertaker and seemed poised to take the gold. But The Rock sprang off the ropes and hit a Rock Bottom on Angle to make the three-count and win the WWE Championship. The victory made The Rock a seven-time WWE Champion, which was a record at the time. It would be nearly a decade before the Great One would win the WWE Title again.

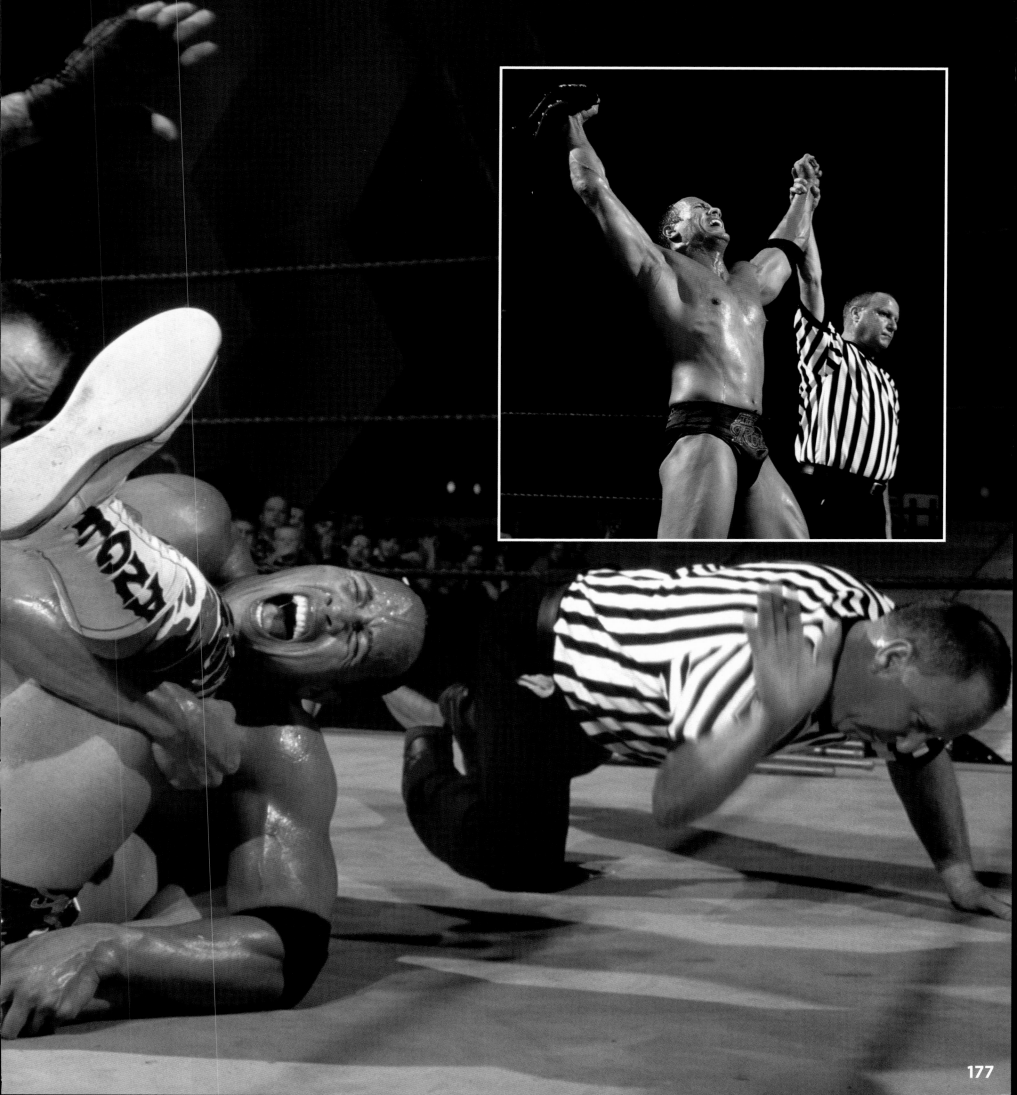

BROCK LESNAR

BROCK LESNAR IS A WWE SUPERSTAR THAT IS THE embodiment of raw power, inimitable talent and pure, unbridled fury. Since first making his debut at 24 years old, Lesnar has cut a wide swath through the WWE roster, facing—and defeating—some of the greatest names in the business. In addition to being a five-time WWE Champion, Lesnar has a number of accomplishments to his name, including the defeat of Undertaker at *WrestleMania 30* to end the Deadman's winning streak. Lesnar was born to conquer and, from day one, that is exactly what he has done. When others refer to him as the Beast, one thing is clear: they're not exaggerating.

Brock Lesnar debuted on *Raw* in March 2002 and made a swift ascent through the ranks. By August of that year, he was facing off against The Rock at *SummerSlam* with the WWE Championship on the line. To the shock of the WWE Universe, Lesnar managed to pin the People's Champ to become the youngest WWE Champion of all time at 25 years old, a record that still stands today.

Lesnar's first title run extended into November of 2002, when he lost the gold to Big Show at *Survivor Series*. He wouldn't win it back until the following year, facing off against Kurt Angle at *WrestleMania XIX*. That match is best remembered not only for

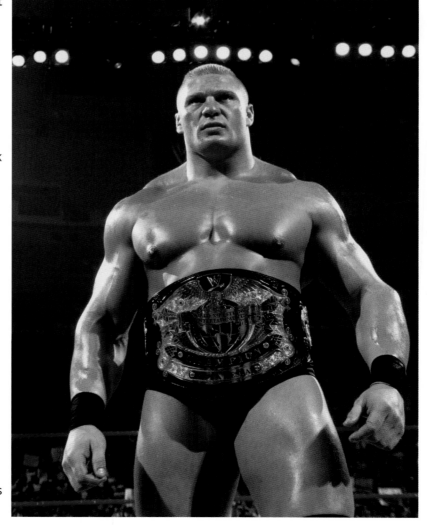

"THE YOUNGEST WWE CHAMPION OF ALL TIME AT 25 YEARS OLD."

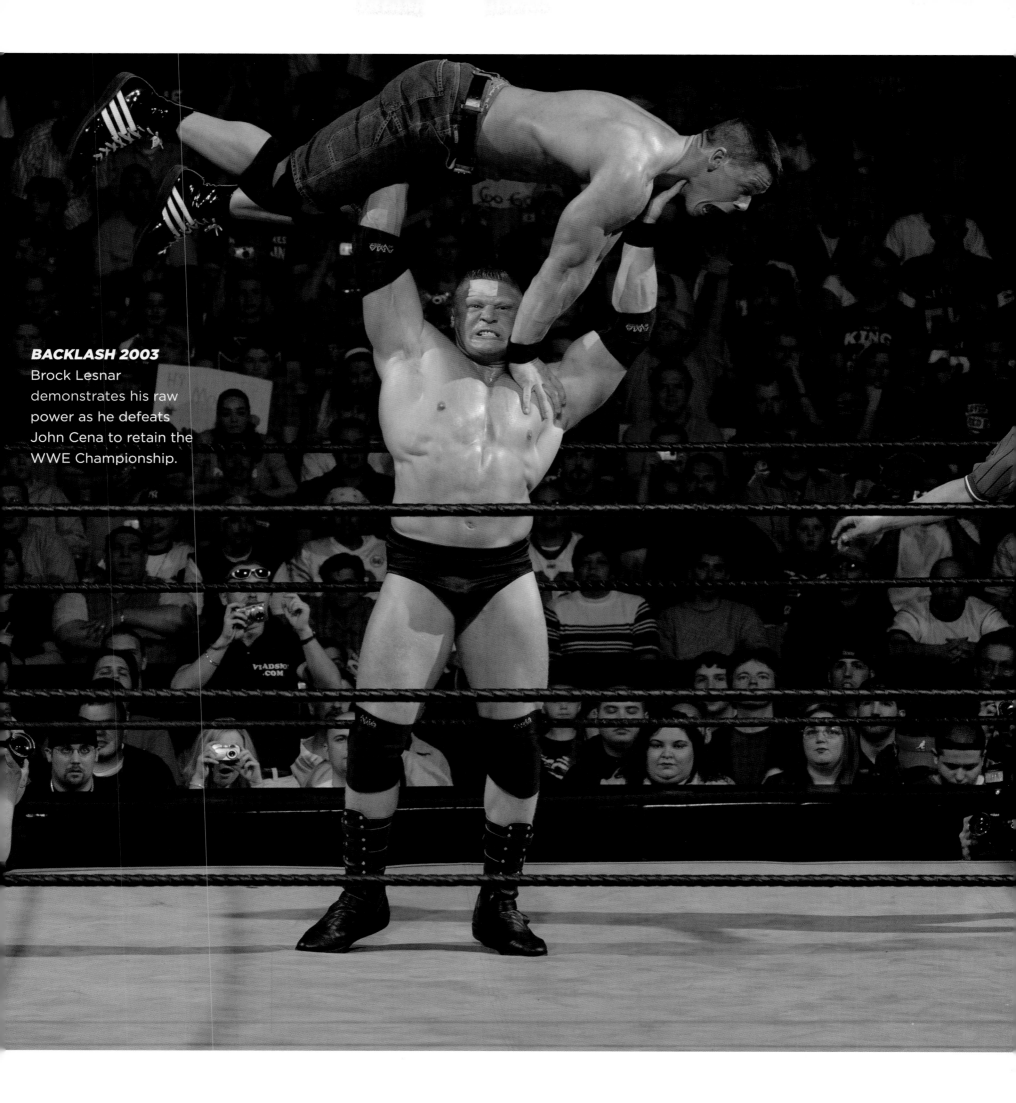

BACKLASH 2003
Brock Lesnar demonstrates his raw power as he defeats John Cena to retain the WWE Championship.

179

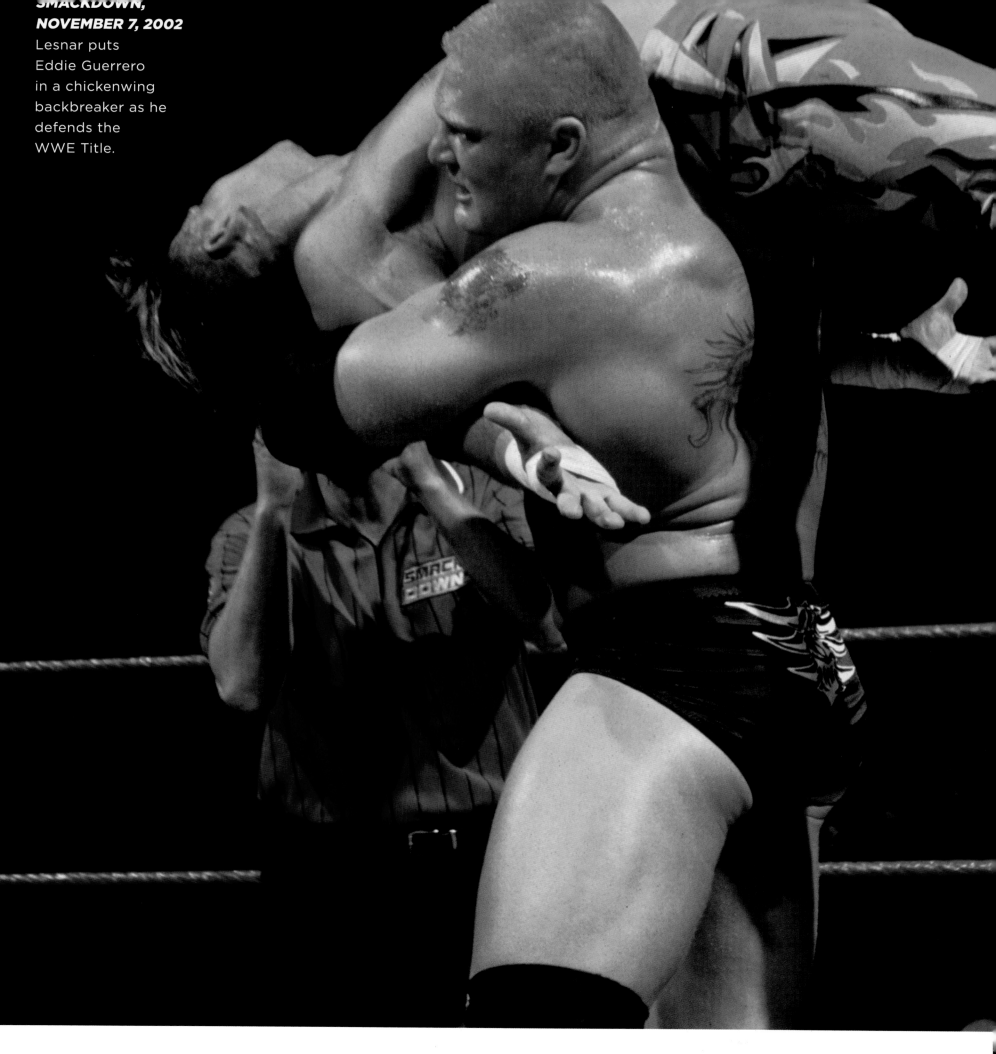

Lesnar puts Eddie Guerrero in a chickenwing backbreaker as he defends the WWE Title.

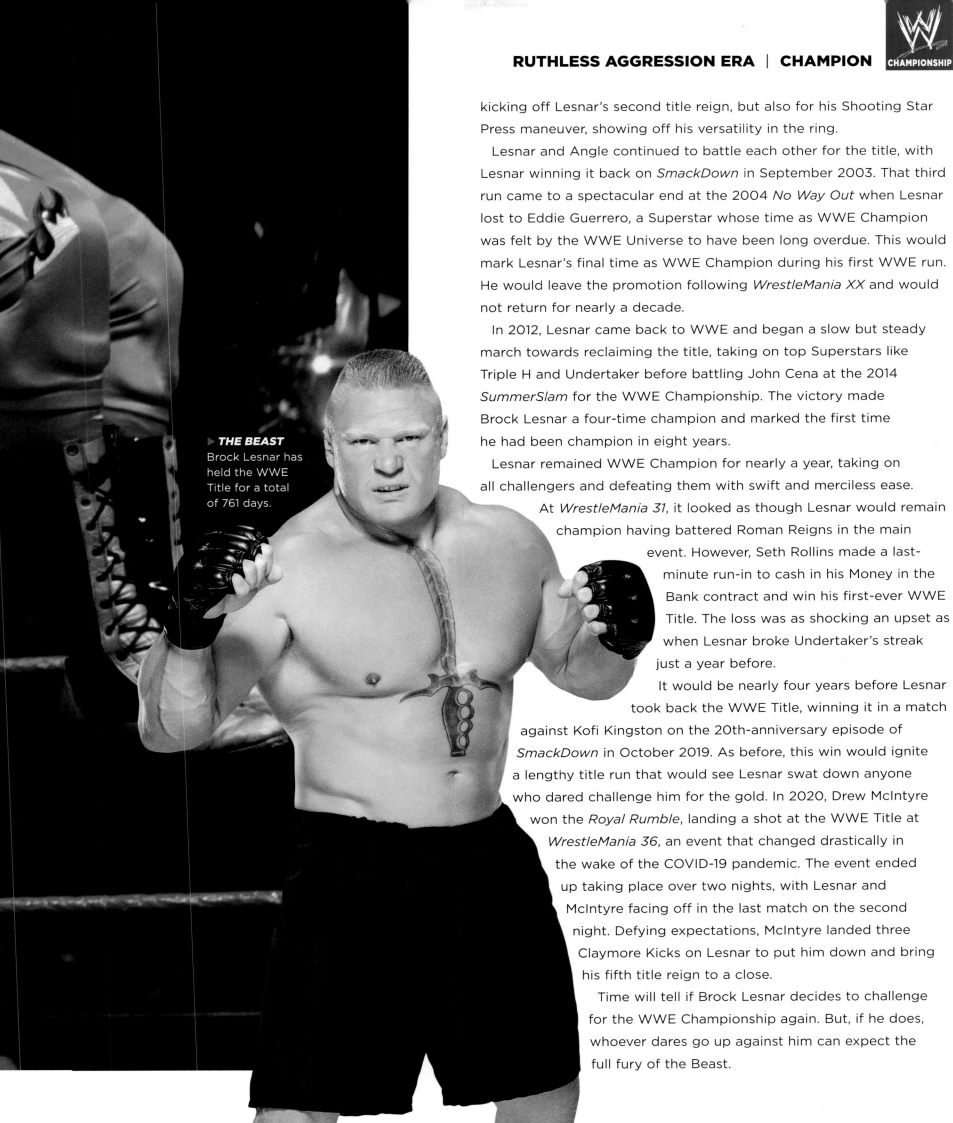

kicking off Lesnar's second title reign, but also for his Shooting Star Press maneuver, showing off his versatility in the ring.

Lesnar and Angle continued to battle each other for the title, with Lesnar winning it back on *SmackDown* in September 2003. That third run came to a spectacular end at the 2004 *No Way Out* when Lesnar lost to Eddie Guerrero, a Superstar whose time as WWE Champion was felt by the WWE Universe to have been long overdue. This would mark Lesnar's final time as WWE Champion during his first WWE run. He would leave the promotion following *WrestleMania XX* and would not return for nearly a decade.

In 2012, Lesnar came back to WWE and began a slow but steady march towards reclaiming the title, taking on top Superstars like Triple H and Undertaker before battling John Cena at the 2014 *SummerSlam* for the WWE Championship. The victory made Brock Lesnar a four-time champion and marked the first time he had been champion in eight years.

Lesnar remained WWE Champion for nearly a year, taking on all challengers and defeating them with swift and merciless ease. At *WrestleMania 31*, it looked as though Lesnar would remain champion having battered Roman Reigns in the main event. However, Seth Rollins made a last-minute run-in to cash in his Money in the Bank contract and win his first-ever WWE Title. The loss was as shocking an upset as when Lesnar broke Undertaker's streak just a year before.

It would be nearly four years before Lesnar took back the WWE Title, winning it in a match against Kofi Kingston on the 20th-anniversary episode of *SmackDown* in October 2019. As before, this win would ignite a lengthy title run that would see Lesnar swat down anyone who dared challenge him for the gold. In 2020, Drew McIntyre won the *Royal Rumble*, landing a shot at the WWE Title at *WrestleMania 36*, an event that changed drastically in the wake of the COVID-19 pandemic. The event ended up taking place over two nights, with Lesnar and McIntyre facing off in the last match on the second night. Defying expectations, McIntyre landed three Claymore Kicks on Lesnar to put him down and bring his fifth title reign to a close.

Time will tell if Brock Lesnar decides to challenge for the WWE Championship again. But, if he does, whoever dares go up against him can expect the full fury of the Beast.

▶ *THE BEAST*
Brock Lesnar has held the WWE Title for a total of 761 days.

SMACKDOWN
EXCLUSIVE

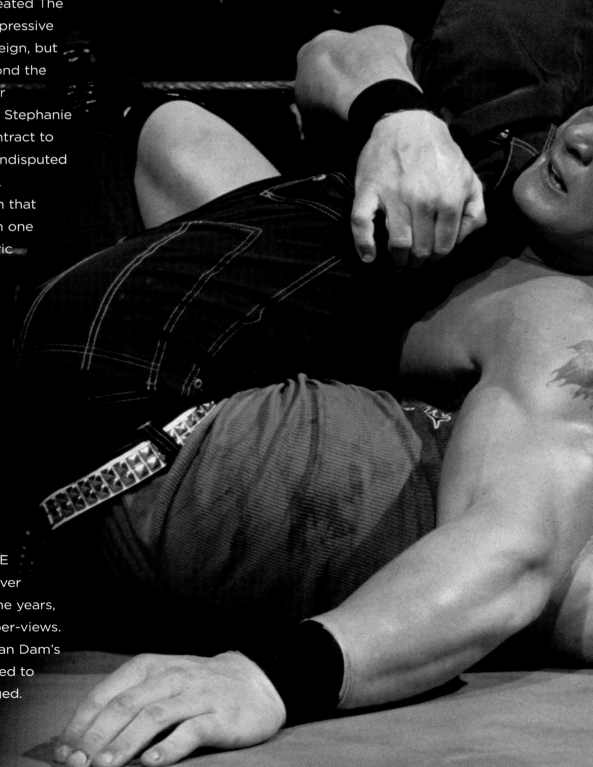

BROCK LESNAR BECAME THE YOUNGEST WWE Champion at the age of 25 when he defeated The Rock at 2003's *SummerSlam*. Brock's impressive victory not only ended The Rock's seventh title reign, but would also have far-reaching consequences beyond the usual Championship exchange. Just one day after *SummerSlam*, Brock appeared on *Raw* alongside Stephanie McMahon. It was announced he had signed a contract to appear exclusively on *SmackDown*—taking the Undisputed WWE Championship to the so-called blue brand.

This was the first time since the brand extension that a WWE Champion had decided not to appear on one of the shows, and it left *Raw* General Manager Eric Bischoff with something of a problem. *Raw* had the number-one contender for the WWE Championship in Triple H, but it no longer had a means to challenge the title holder.

While Brock would appear on *SmackDown* two days later and successfully defend the title against Jeff Hardy, the wheels had been set in motion for a new World Heavyweight Championship to be created for the *Raw* brand. The new title debuted on September 2, 2002, and was awarded to Triple H. The fact that *Raw* now had its own World Title meant that the "Undisputed" part of the WWE Championship was dropped. The WWE Championship would remain exclusive to whichever brand the champion belonged to for the next nine years, with the title only able to switch brands at pay-per-views. The one exception to this rule was during Rob Van Dam's 22-day reign, when the extreme Superstar decided to defend the WWE Title wherever he was challenged.

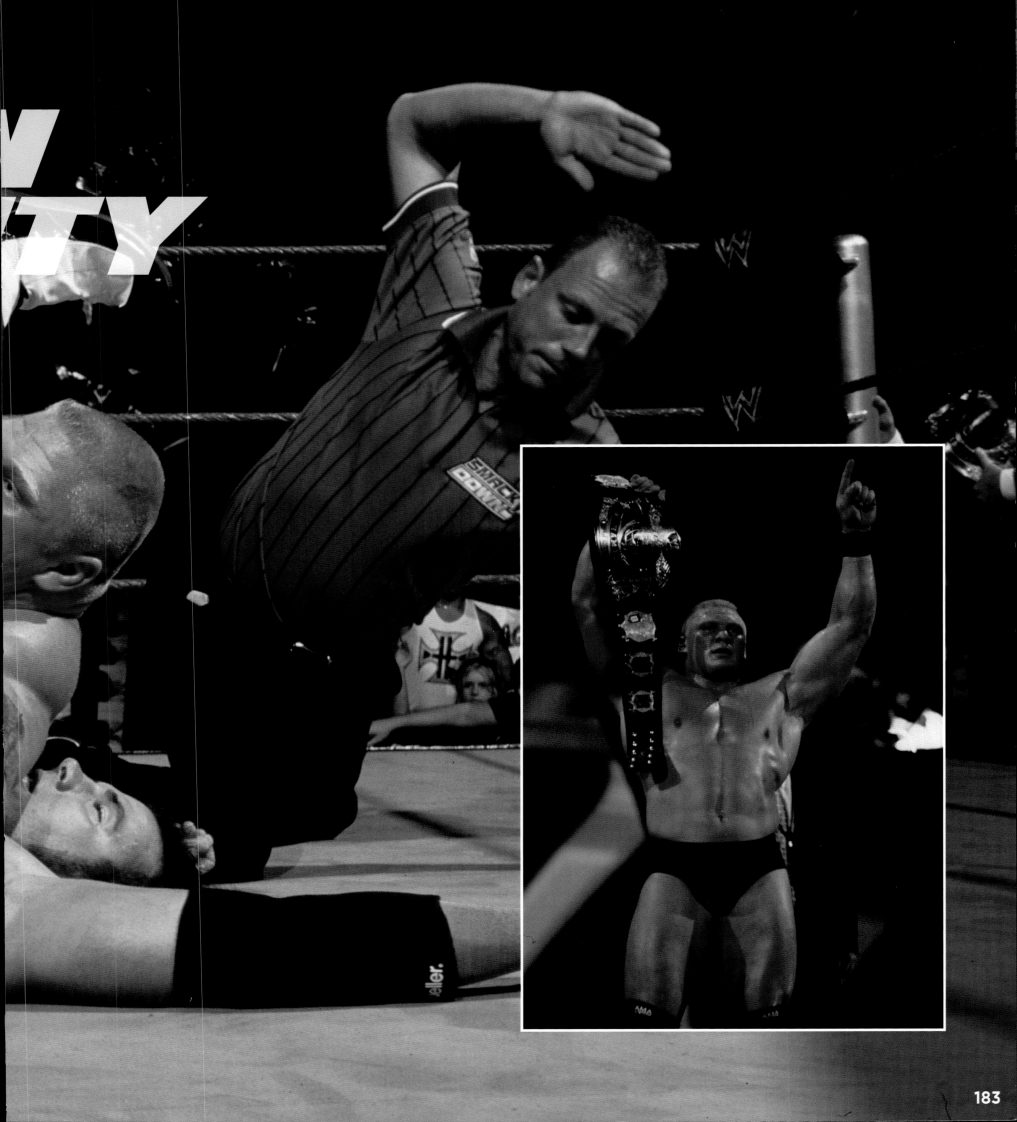

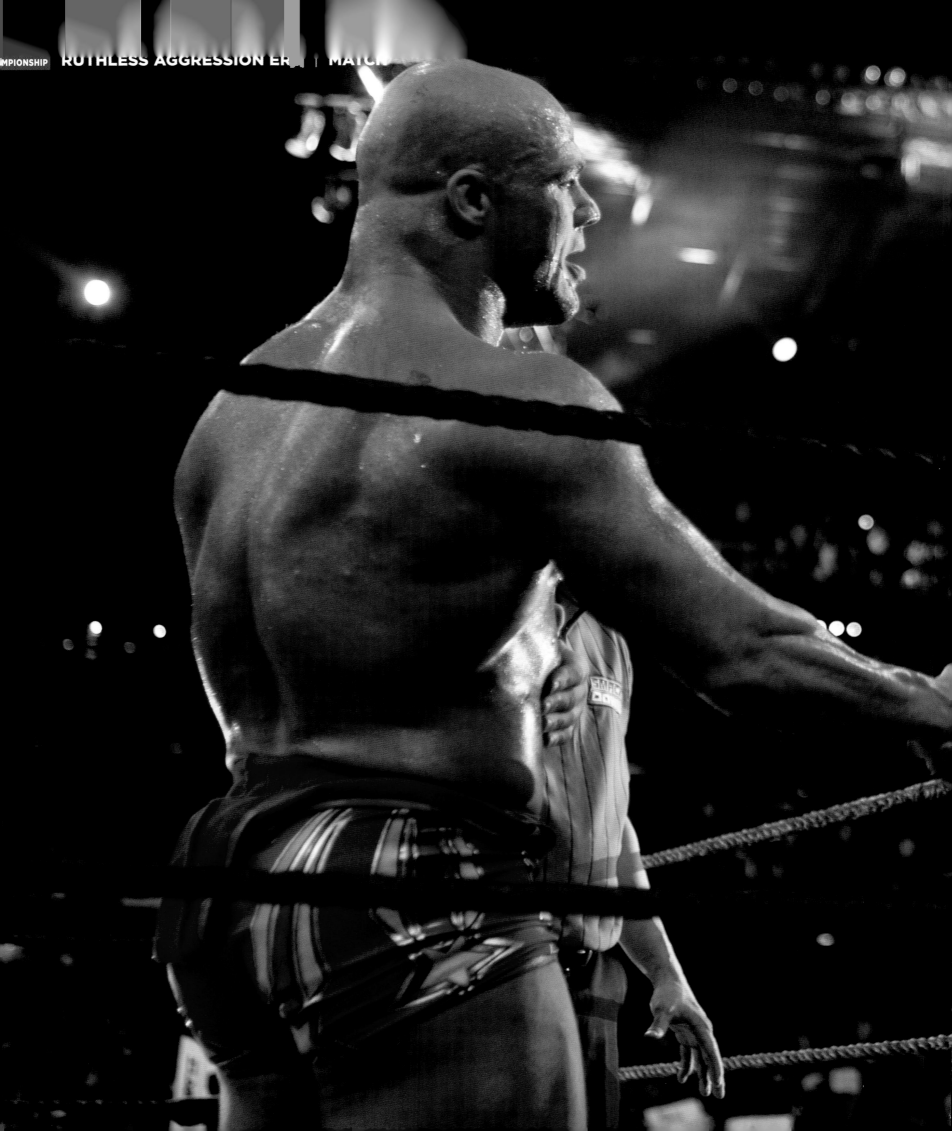

Brock Lesnar and Kurt Angle shake hands after an intense main event that saw Lesnar win his second WWE Championship.

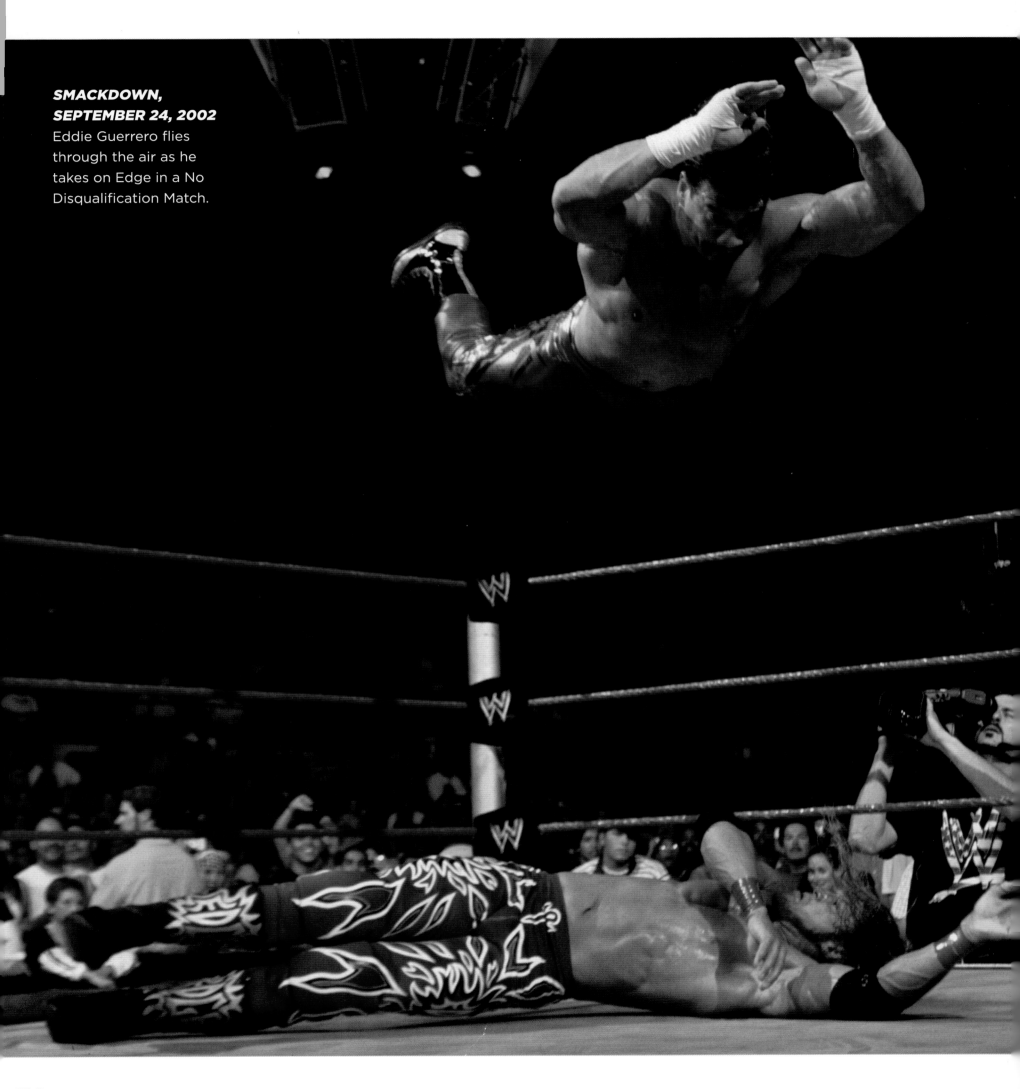

Eddie Guerrero flies
through the air as he
takes on Edge in a No
Disqualification Match.

EDDIE GUERRERO

"THE CELEBRATION FOLLOWING GUERRERO'S WWE TITLE WIN WAS EUPHORIC."

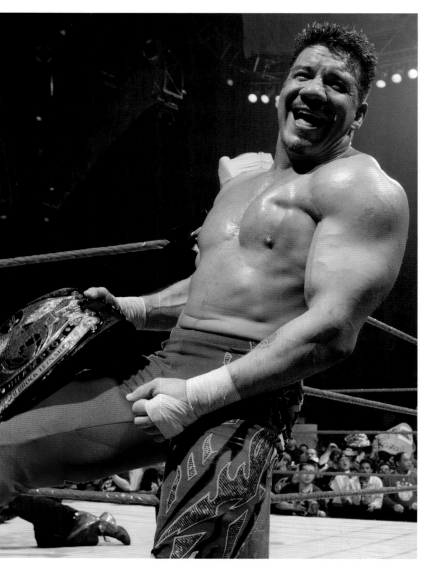

HOW MANY SUPERSTARS DO YOU KNOW WHO CAN LIE, CHEAT AND steal their way to the top and have the WWE Universe love them for it? Eddie Guerrero made a career out of using underhand tactics, but he did it with wit, humor and that signature grin that made him a favorite from day one.

Growing up in El Paso, Texas, Guerrero learned about the wrestling business from his father, Gory Guerrero, one of the top Mexican-American wrestlers. Before too long, Eddie was working his way through promotions in Mexico and Japan before coming to the States and competing in first ECW and then WCW.

His success in WCW led to Eddie joining WWE, where he quickly won fans' hearts. A phenomenally talented in-ring performer, Guerrero was also gifted with considerable charisma. However, despite his enormous popularity with the WWE Universe, claiming the WWE Championship proved to be a difficult task. His shot at the gold finally came at *No Way Out 2004*, where he faced Brock Lesnar and, in classic Guerrero fashion, managed to win the WWE Championship through devious means. With the referee unconscious, Eddie nailed Lesnar with a DDT onto the title, then landed a frog splash in time for the ref to make the three-count and give Guerrero the victory. The celebration following Guerrero's WWE Title win was euphoric, both amongst the WWE Universe and in the ring.

At *WrestleMania XX*, Eddie faced Kurt Angle with the title on the line. Angle tried to force Guerrero to submit with an Ankle Lock, but Eddie managed to escape the move, and while Angle was outside the ring, Eddie loosened his boot. When Angle returned and went for the lock again, the boot came loose, allowing Eddie to capitalize on Angle's confusion to make the pinfall and retain the championship.

Eddie would lose the title to JBL at *The Great American Bash*, ending his reign at 133 days. It would be Eddie's only run with the WWE Championship, but it stands out as a high point in the title's history.

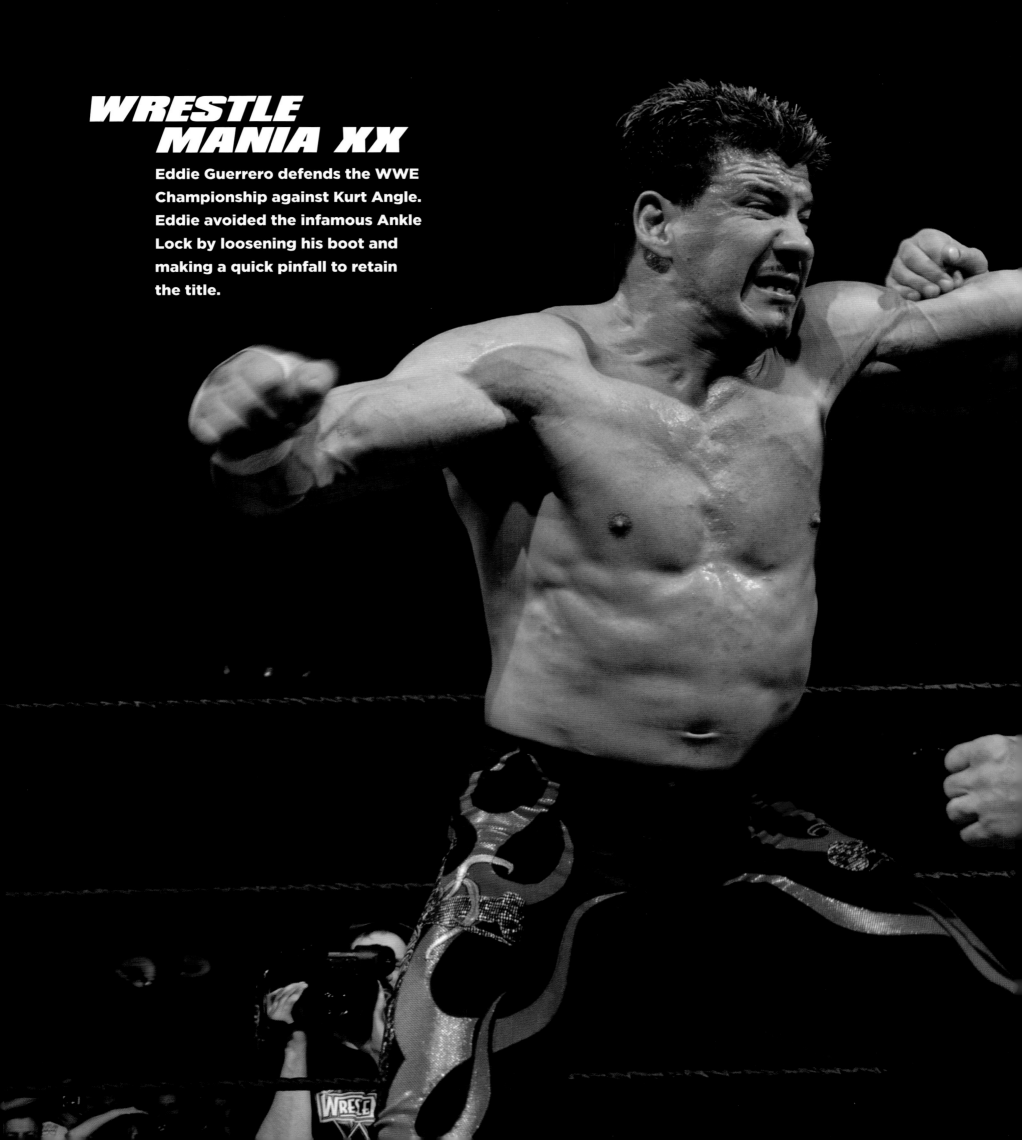

WRESTLE MANIA XX

Eddie Guerrero defends the WWE Championship against Kurt Angle. Eddie avoided the infamous Ankle Lock by loosening his boot and making a quick pinfall to retain the title.

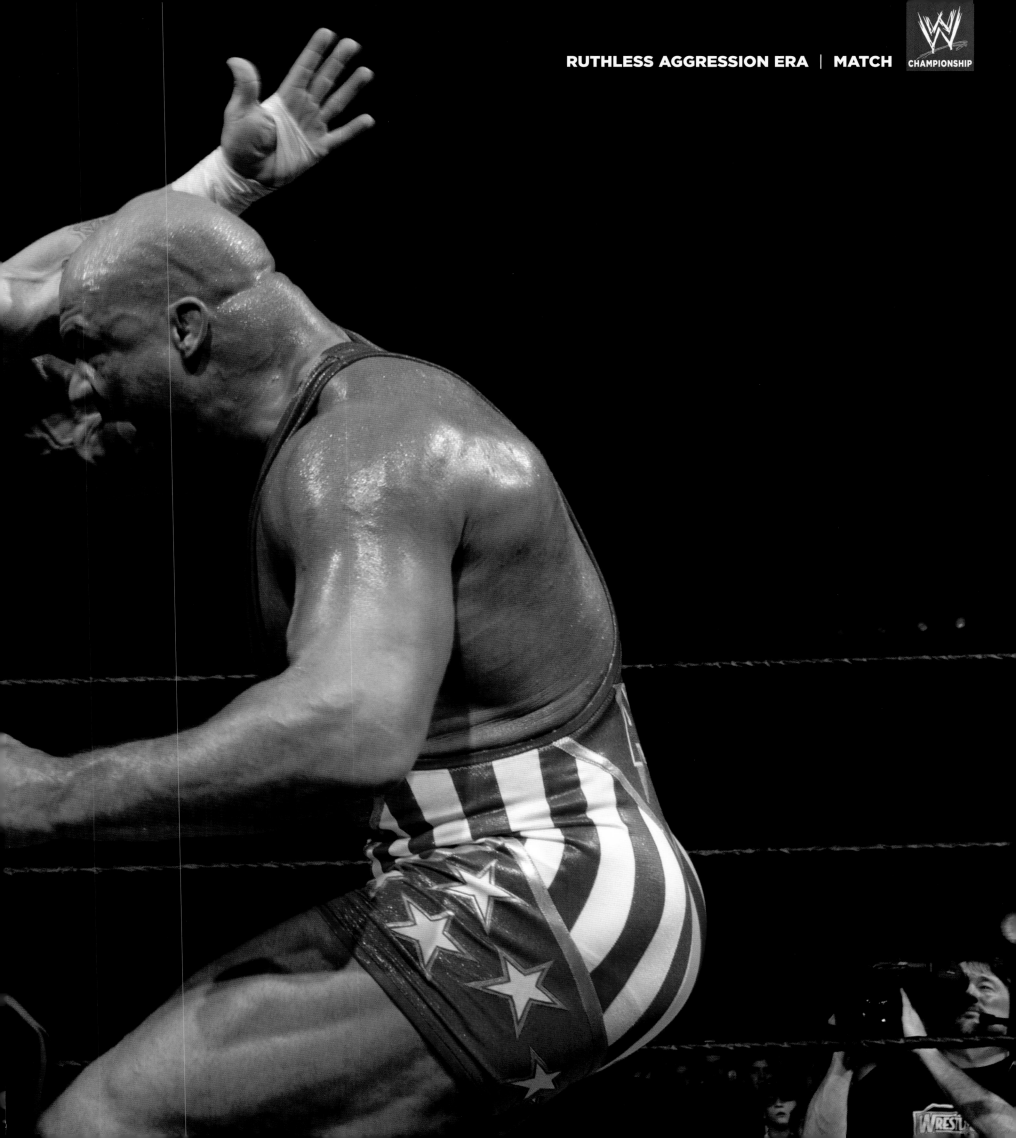

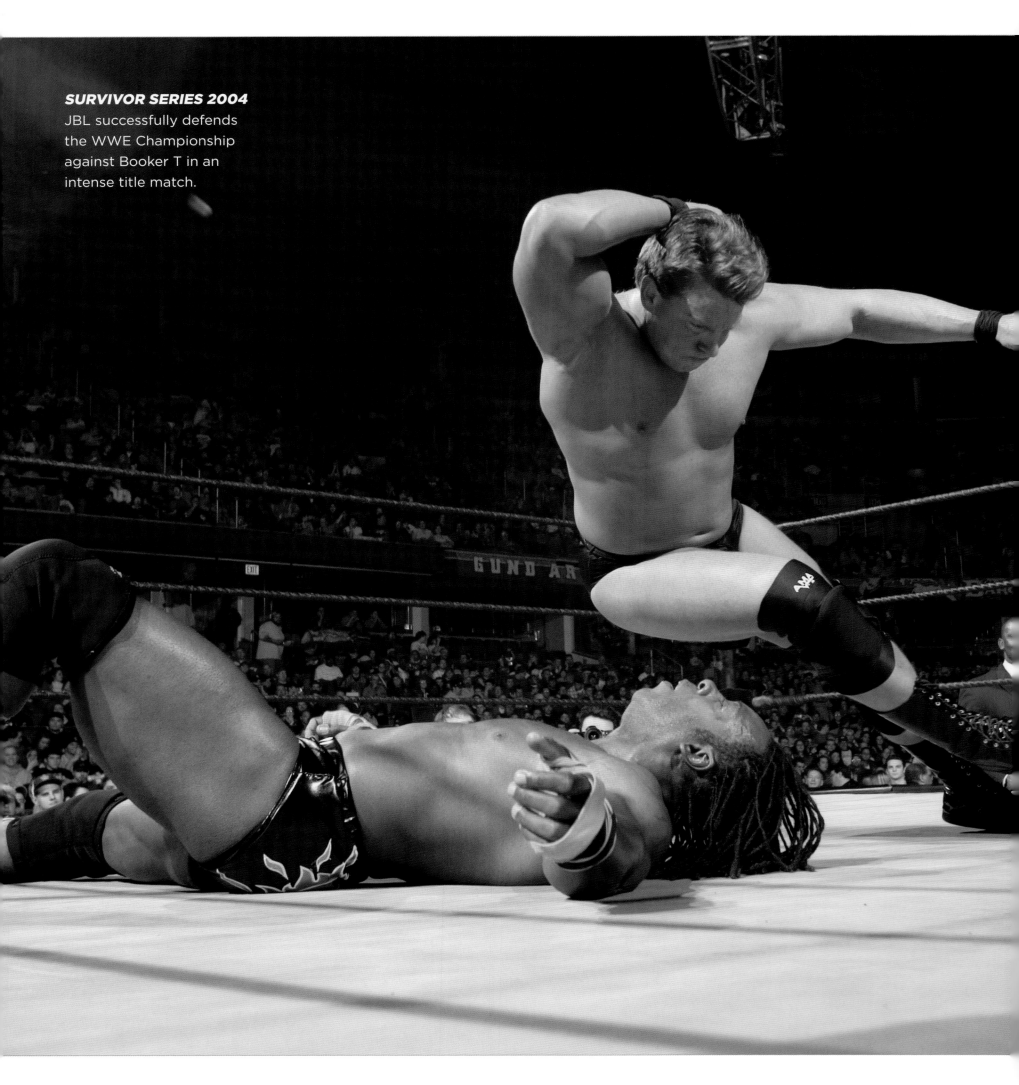

SURVIVOR SERIES 2004
JBL successfully defends
the WWE Championship
against Booker T in an
intense title match.

JBL

GIFTED WITH BOTH BRAINS and brawn, John "Bradshaw" Layfield was a Superstar who could defeat you with his wits as easily as he could his fists. He began his career as a hard-charging and hard-battling grappler, first as a member of the New Blackjacks and then alongside Ron Simmons as the APA.

In 2004, JBL reinvented himself as a financially savvy millionaire who wore expensive suits, rode in limousines and proclaimed himself to be a "Wrestling God." Those claims proved to be more than just hyperbole when he defeated Eddie Guerrero for the WWE Championship in a Texas Bull Rope Match at *The Great American Bash*. Although the win was a shocking upset to Guerrero and the WWE Universe, it sent a very clear message: John "Bradshaw" Layfield meant business.

The win at *The Great American Bash* marked the start of a title run that lasted nearly a year, the longest unbroken run since Diesel's 358-day run ten years earlier. During that time, JBL plowed his way through a host of challengers, including Undertaker, Booker T and Big Show. He also surrounded himself with a host of Superstars, dubbed "The Cabinet," who did whatever was necessary to keep the gold right where it belonged.

In 2005, JBL came up against John Cena, who was then the United States Champion. Cena's street-hardened attitude was a perfect foil to JBL's money, power and status. It was a rivalry that reminded the WWE Universe of the heyday of Stone Cold versus Mr. McMahon. It all came to a head at *WrestleMania 21* when Cena and JBL faced off for the WWE Championship. JBL went after Cena with a vengeance, determined to hang onto the title for at least another day. But Cena's time had come, and he managed to hit an Attitude Adjustment to take home the gold.

JBL only held the WWE Title one time, but his reign stands as one of the most memorable title runs of the 2000s. From delivering hard-hitting matches to electrifying promos, JBL always commanded attention from the WWE Universe.

"A SAVVY MILLIONAIRE WHO PROCLAIMED HIMSELF TO BE A 'WRESTLING GOD'."

JOHN CENA

AS A 16-TIME WORLD CHAMPION, WITH A RECORD-holding 13 WWE Championships, John Cena is one of the greatest Superstars to have ever stepped between the ropes.

From the moment he entered a WWE ring, John Cena made an impact. On the June 27, 2002, episode of *SmackDown*, Cena answered an open challenge from Kurt Angle, declaring that he had the necessary "ruthless aggression" to make it in WWE. Although he lost the match, Cena's gutsy performance earned him the respect of the WWE Universe and the entire roster.

Having won the United States Championship in 2004, The Doctor of Thuganomics entered a rivalry with John "Bradshaw" Layfield. On the Grandest Stage of Them All at *WrestleMania 21*, Cena overcame JBL to win his first WWE Championship and had a new, customized spinner WWE Title made. Holding the original title, JBL claimed he was still the champion, so Cena beat him again at an "I Quit" Match at *Judgment Day* 2005.

Cena won a brutal Elimination Chamber Match at *New Year's Revolution 2006*, 279 days after winning the championship, but then Edge finally cashed in his Money in the Bank contract and ended Cena's reign. However, the Cenation Leader reclaimed the title three weeks later at the *Royal Rumble* and retained at *WrestleMania 22* against Triple H. His second reign ended at ECW's *One Night Stand* to an opportunistic Rob Van Dam. Cena defeated Edge in an intense Tables, Ladders, and Chairs Match at *Unforgiven*, driving his

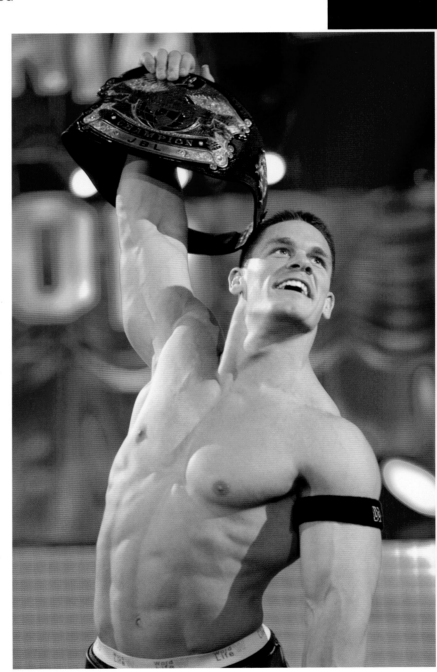

"A RECORD-HOLDING 13 WWE CHAMPIONSHIPS"

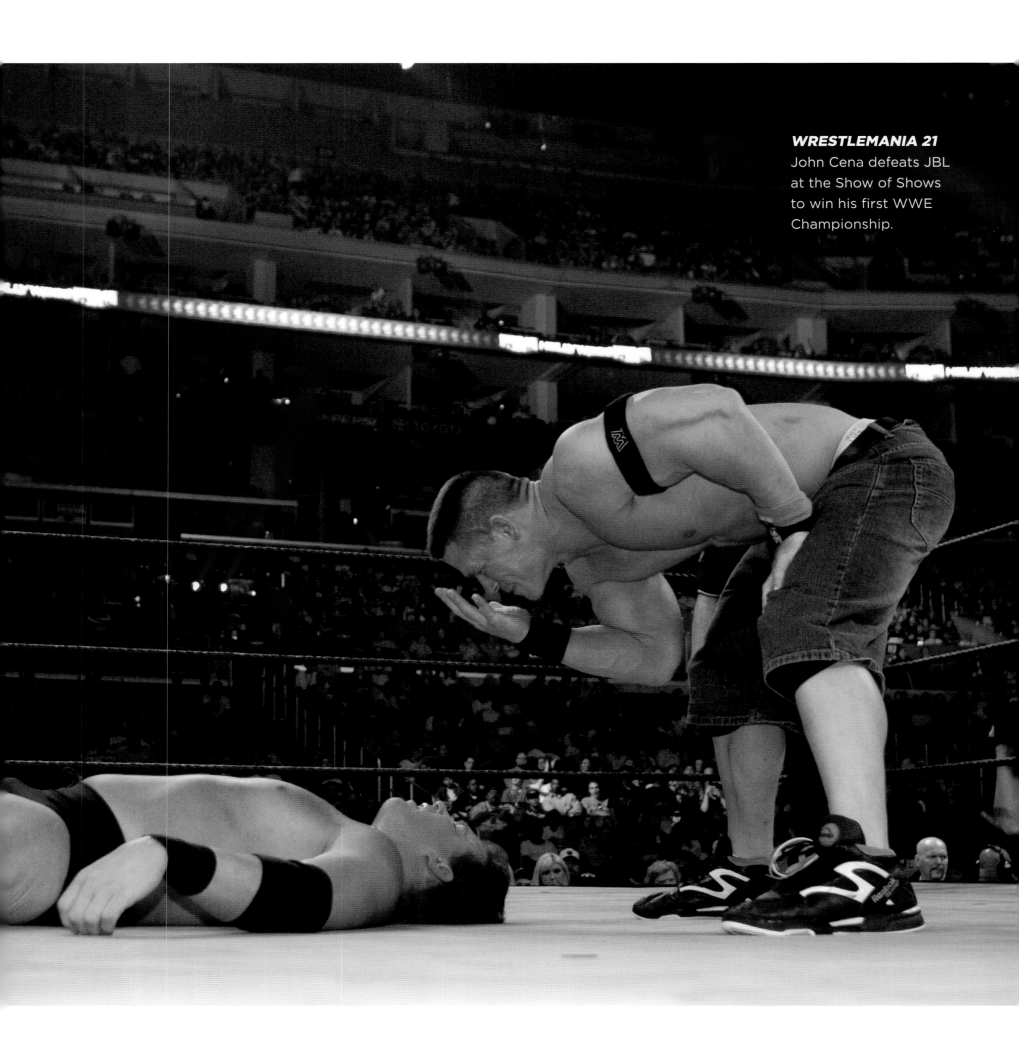

WRESTLEMANIA 21
John Cena defeats JBL
at the Show of Shows
to win his first WWE
Championship.

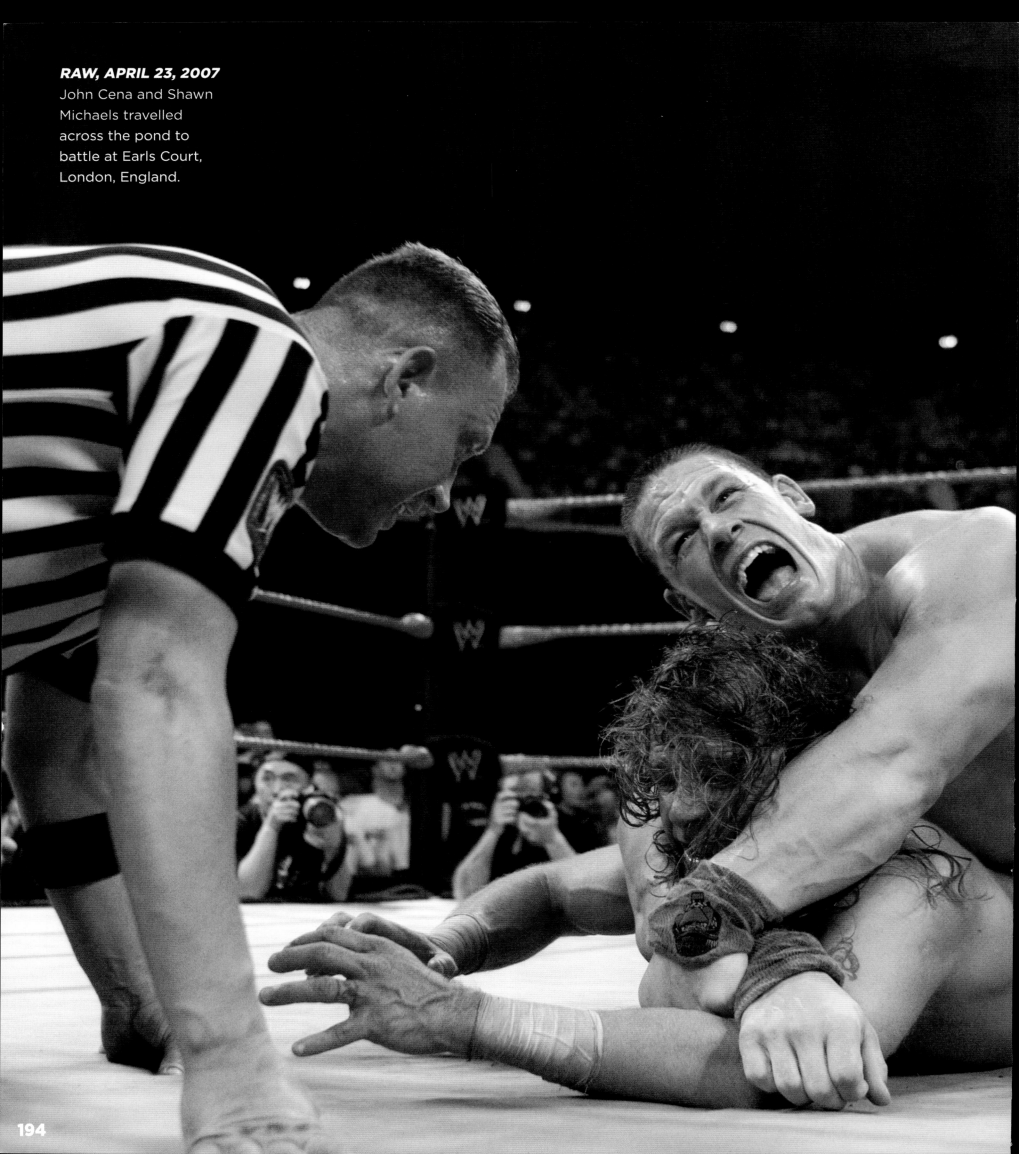

RAW, APRIL 23, 2007
John Cena and Shawn
Michaels travelled
across the pond to
battle at Earls Court,
London, England.

rival through two stacked tables with an Attitude Adjustment to capture his third WWE Championship.

Rivalries with Umaga, Shawn Michaels, and the Great Khali followed, and Cena successfully defended the title against Michaels at *WrestleMania 23*. At 380 days, Randy Orton's ambush of Cena ended the longest WWE Championship reign in over 19 years. Months of chasing Orton followed, before Cena finally caught the Viper at 2009's *Breaking Point*, forcing him to submit to the STF in an intense "I Quit" Match and winning his fourth WWE Title. Winning championships again against Orton in a grueling One Hour, Anything Goes Iron Man Match at *Bragging Rights*, Cena briefly won another title at the 2010 *Elimination Chamber*, before being forced to face Batista immediately after. At *WrestleMania XXVI*, Cena overcame his bitter rival Batista to win the WWE Championship for a seventh time.

An eighth title win came when Cena defeated titleholder The Miz and John Morrison in a Triple Threat Steel Cage Match at *Extreme Rules 2011*, with a spectacular Attitude Adjustment from the top rope. He went on to win his ninth WWE Championship against Rey Mysterio and his tenth by defeating Alberto Del Rio at *Night of Champions*. Cena faced The Rock at *WrestleMania 29*, countering a Rock Bottom attempt with an Attitude Adjustment to claim a record eleventh WWE Title and respect from The Rock. This 132-day reign was ended by Daniel Bryan at *SummerSlam 2013*, but the following year Cena had his revenge at *Money in the Bank* in his hometown of Boston, winning the WWE Title in a chaotic Ladder Match. Eventually, at *Royal Rumble 2017*, the Champ beat AJ Styles to win his thirteenth WWE Championship. Capturing his sixteenth world title, tying Ric Flair for the most in sports entertainment history, John Cena is nothing less than a living legend.

MONEY IN THE BANK

TODAY IT'S BECOME ONE OF THE MOST famous stipulations in WWE, even garnering its own pay-per-view event. But, back in 2005, it was a novelty, perhaps even a one-off for *WrestleMania*. The concept was a simple one, a Ladder Match with anywhere from five to ten Superstars, all competing to reach a briefcase suspended above the ring. Inside the case was a contract guaranteeing the winner a WWE Title match at the time of his or her choosing. It was an enticing prospect that had the whole roster eager to compete.

The first Money in the Bank Ladder Match took place at *WrestleMania 21* and featured six Superstars, including Edge, Kane, Christian, Shelton Benjamin, and Chris Jericho. Jericho was actually the Superstar who initially pitched the idea to Eric Bischoff, and was favored by many to be the one to win it all.

The match itself was a human demolition derby, with Superstars flying off and onto ladders at breakneck speed. Edge found himself sailing face-first into a ladder when Shelton Benjamin dodged a spear attempt, while Benjamin managed to use a ladder as a ramp to launch a clothesline at Jericho. However, for all of the heroic efforts put forth by the other competitors, it was Edge who managed to win the contract through devious means, using a foreign object to swat down the competition and scale the ladder.

After Edge won the title shot, the WWE Universe began to speculate how long it would be before he decided to cash in. The Rated-R Superstar made them wait until January, when he sprung a surprise cash-in on John Cena following the Elimination Chamber Match at the 2006 *New Year's Revolution*. Following a brutal match that left Cena exhausted, Edge sprang into action and landed a pair of Spears to take out Cena and win his first WWE Title.

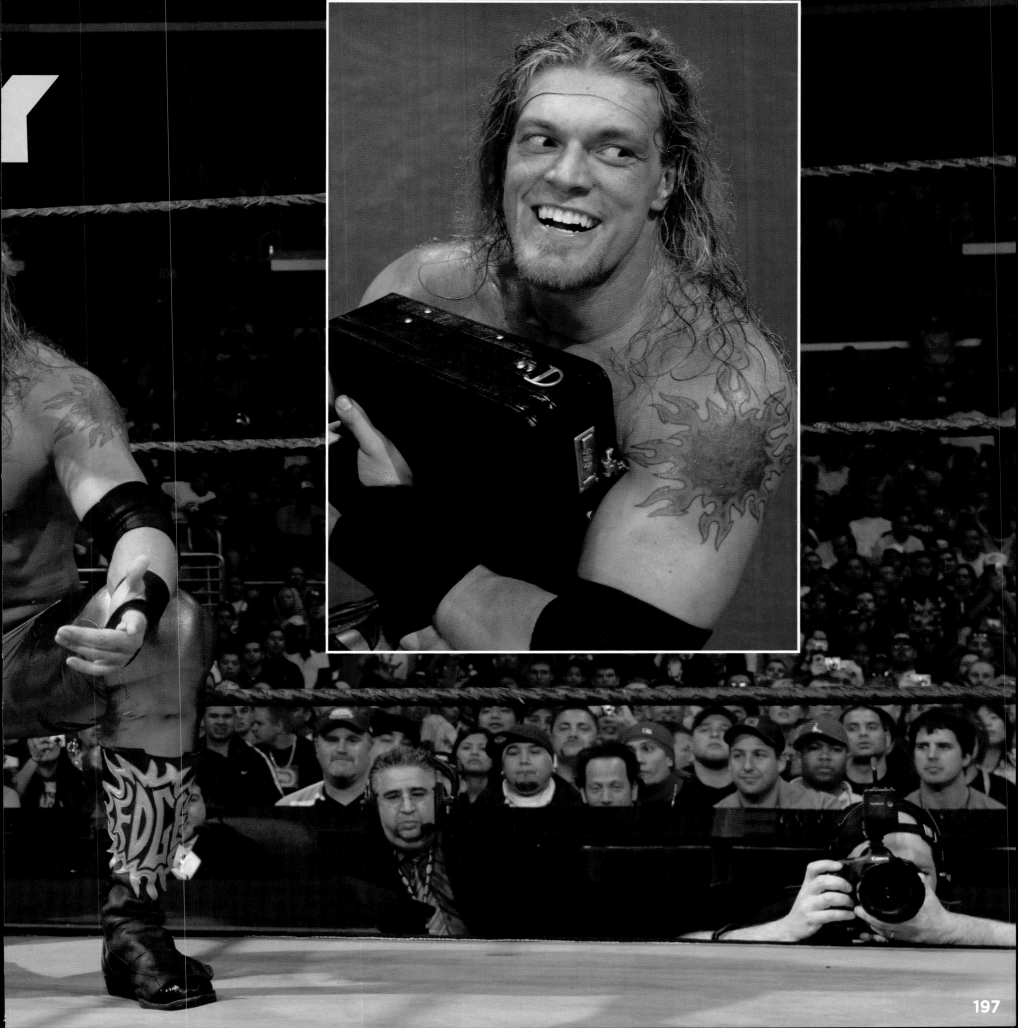

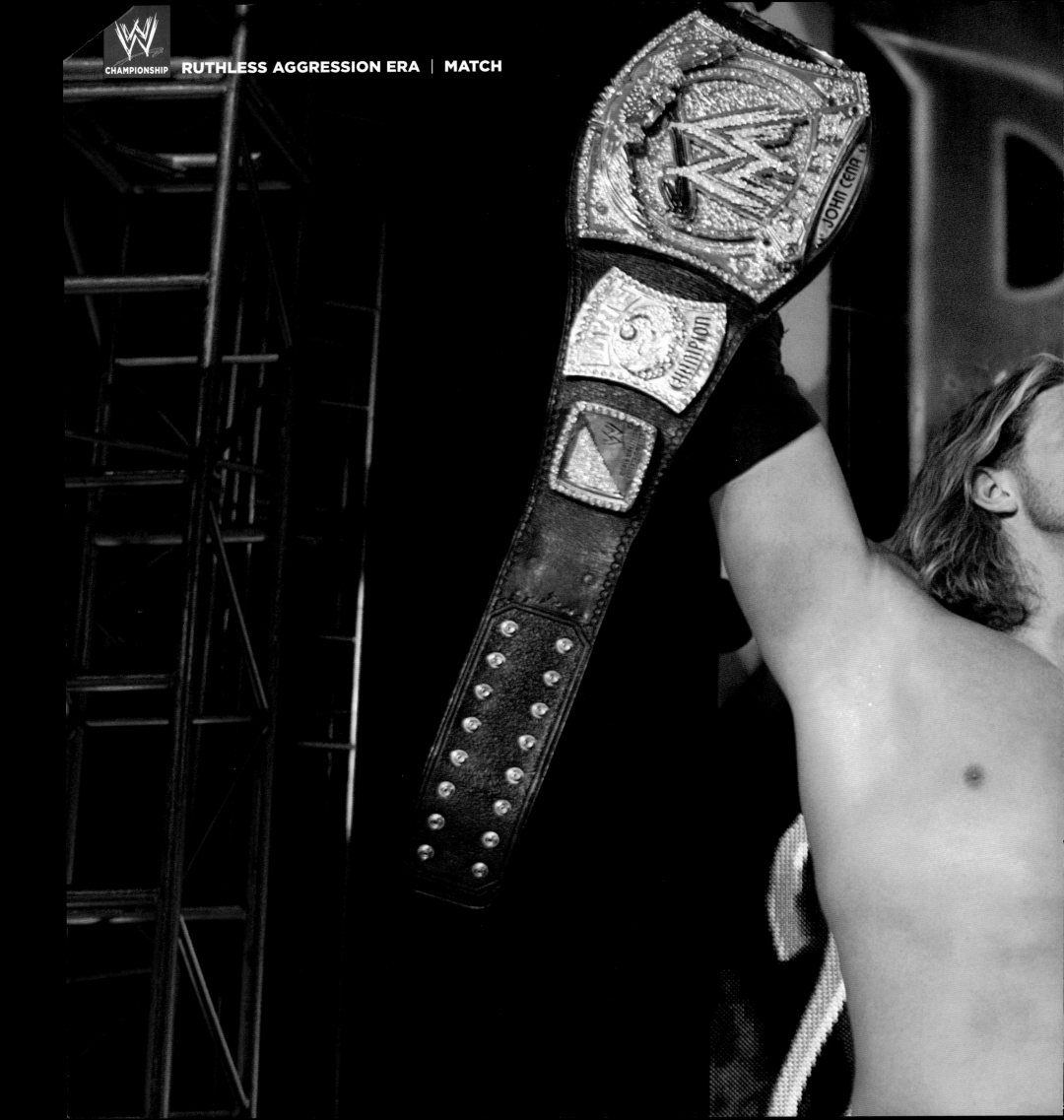

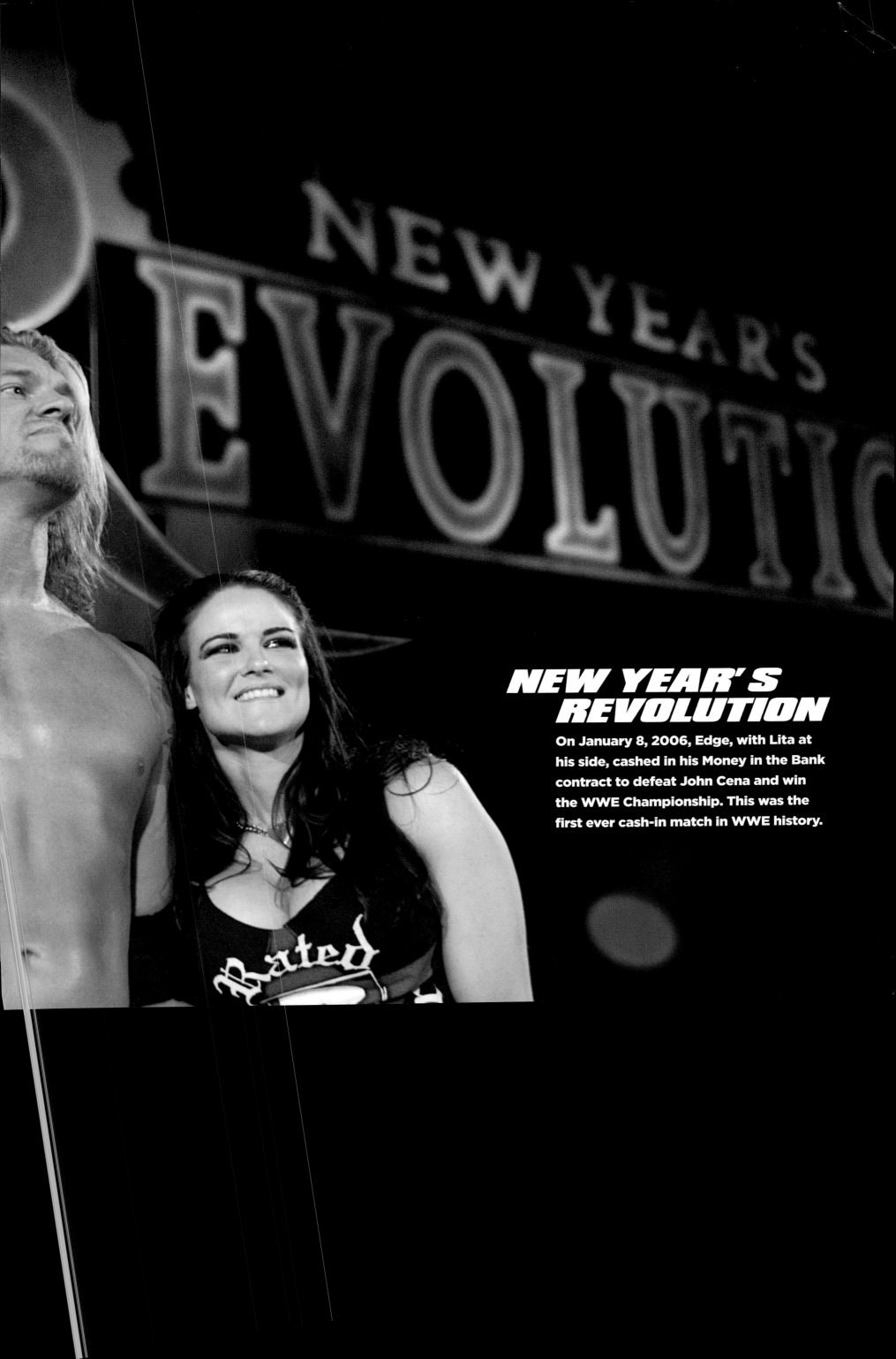

NEW YEAR'S REVOLUTION

On January 8, 2006, Edge, with Lita at his side, cashed in his Money in the Bank contract to defeat John Cena and win the WWE Championship. This was the first ever cash-in match in WWE history.

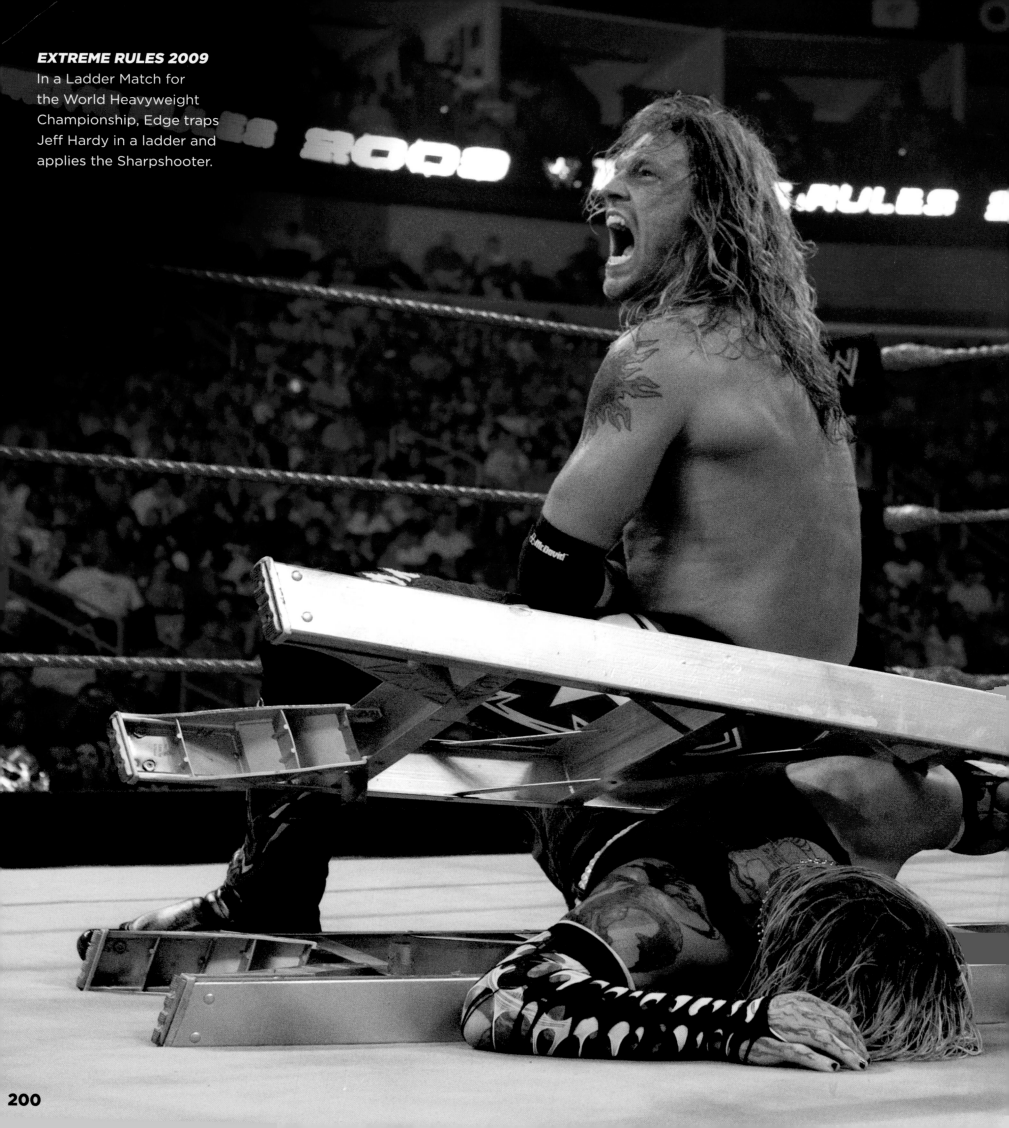

EXTREME RULES 2009
In a Ladder Match for the World Heavyweight Championship, Edge traps Jeff Hardy in a ladder and applies the Sharpshooter.

EDGE

WITH A ROCK STAR IMAGE AND attitude, Edge's explosive energy and intensity made him WWE's Rated-R Superstar. It seems that path was his destiny—his classmates in his small Canadian hometown voted him "Most Likely to be WWE Champion."

Signed to WWE in 1997, Edge and his tag partner Christian made their mark in the tag team division, winning the World Tag Team Championship seven times. When Edge decided to turn his attention to singles competition, the Rated-R Superstar did so in spectacular fashion. Having won a Money in the Bank Match at *WrestleMania 21*, he finally made his move at *New Year's Revolution 2006*. After John Cena survived an Elimination Chamber Match, Edge cashed in to defeat his exhausted opponent and secure his first WWE Title. After Cena and then Rob Van Dam had claimed the title, Edge defeated them both in a Triple Threat Match on *Raw* in July 2006, leveling Cena with the title to win the gold.

> ## "HIS CLASS-MATES VOTED HIM 'MOST LIKELY TO BE WWE CHAMPION'."

Edge's third WWE Championship reign began at *Survivor Series 2008*, shocking the WWE Universe when he joined a bout between Triple H and Vladimir Kozlov late to win the Triple Threat Match. A fourth title run saw him live up to his moniker, "the Ultimate Opportunist." Edge used Matt Hardy's betrayal to defeat Jeff Hardy and claim the gold again. As well as his four WWE Championships, Edge has won seven World Heavyweight Championships, and continues to thrill the legions of Edge heads everywhere. It's all for the benefit of those with flash photography!

ROB VAN DAM

DRESSED IN AN AIRBRUSHED SINGLET, WITH HIS BLOND HAIR pulled back into a ponytail, Rob Van Dam conveyed a sense of laidback California cool. But, when the bell rang, he transformed into the high-flying, heavy-hitting brawler from Battle Creek, Michigan.

After a short run in WCW, Van Dam went to ECW, where he partnered with Sabu to become one of the most feared tag teams in sports entertainment. In 2001, RVD came to WWE as a full-time member of the roster and quickly began gathering titles, from the Intercontinental Championship to the WWE Tag Titles with Rey Mysterio. But his biggest moment came at *WrestleMania 22* when he outlasted

Bobby Lashley, Finlay, Matt Hardy, Ric Flair and Shelton Benjamin to win the Money in the Bank Ladder Match. The victory earned him a shot at the WWE Championship, and RVD decided to take that shot in the most ECW way possible.

Rather than opting for the usual last-minute cash-in, Van Dam announced that he would challenge for the title in a match against John Cena at 2006's *ECW: One Night Stand*. The night was a supercharged event, with ECW fans cheering on RVD. When RVD hit a Five-Star Frog Splash to win the title, the ovation inside the Hammerstein Ballroom, a longtime ECW stronghold, was insane as they cheered for an original ECW hero who had finally arrived at the top.

Van Dam lost the title that July to Edge, but the impact he made created a moment of WWE history that will resonate through the ages.

"RVD TOOK A SHOT AT THE WWE TITLE IN THE MOST ECW WAY POSSIBLE."

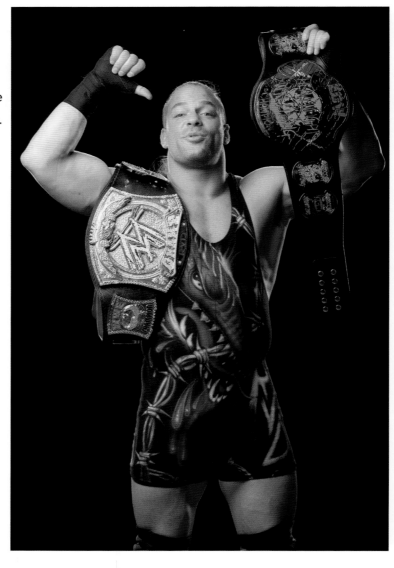

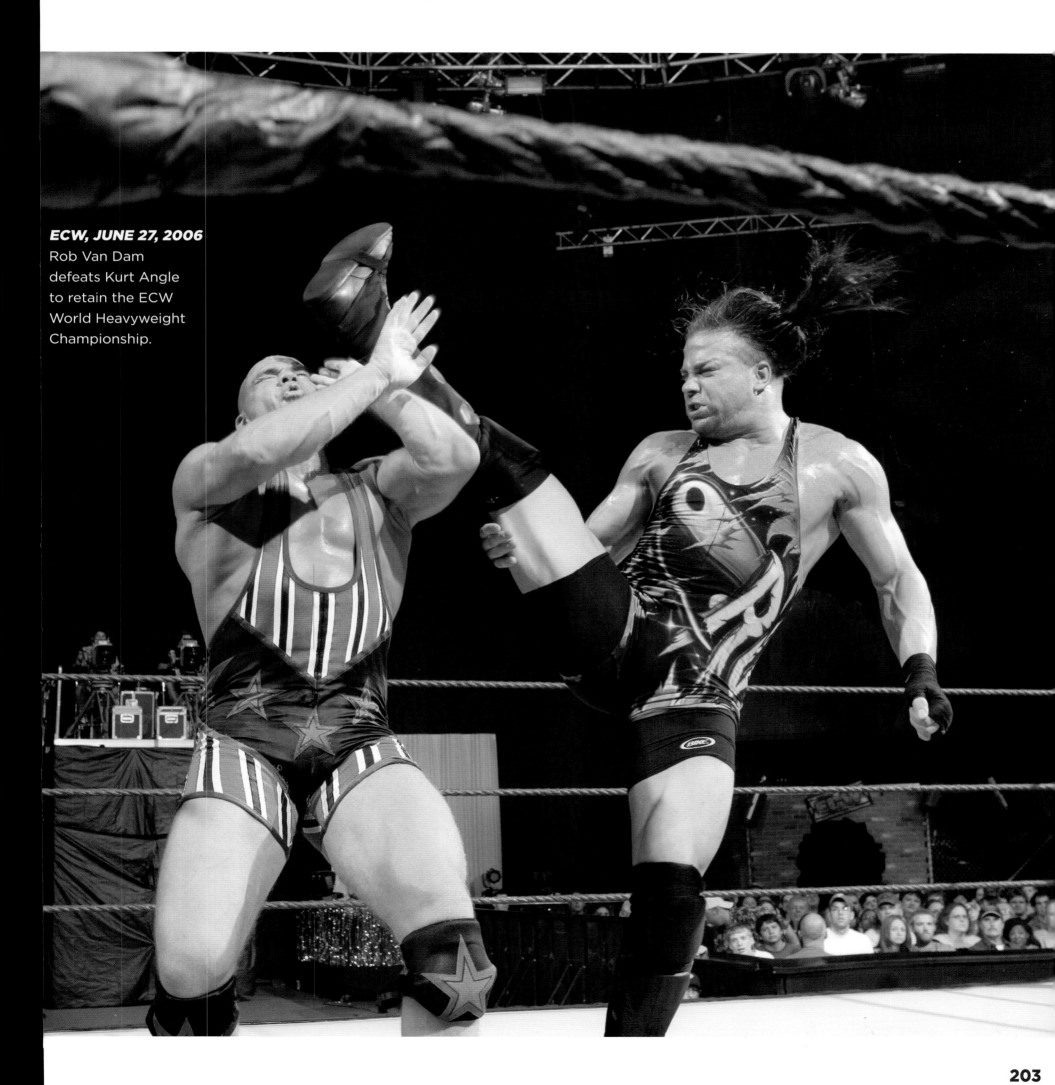

Rob Van Dam defeats Kurt Angle to retain the ECW World Heavyweight Championship.

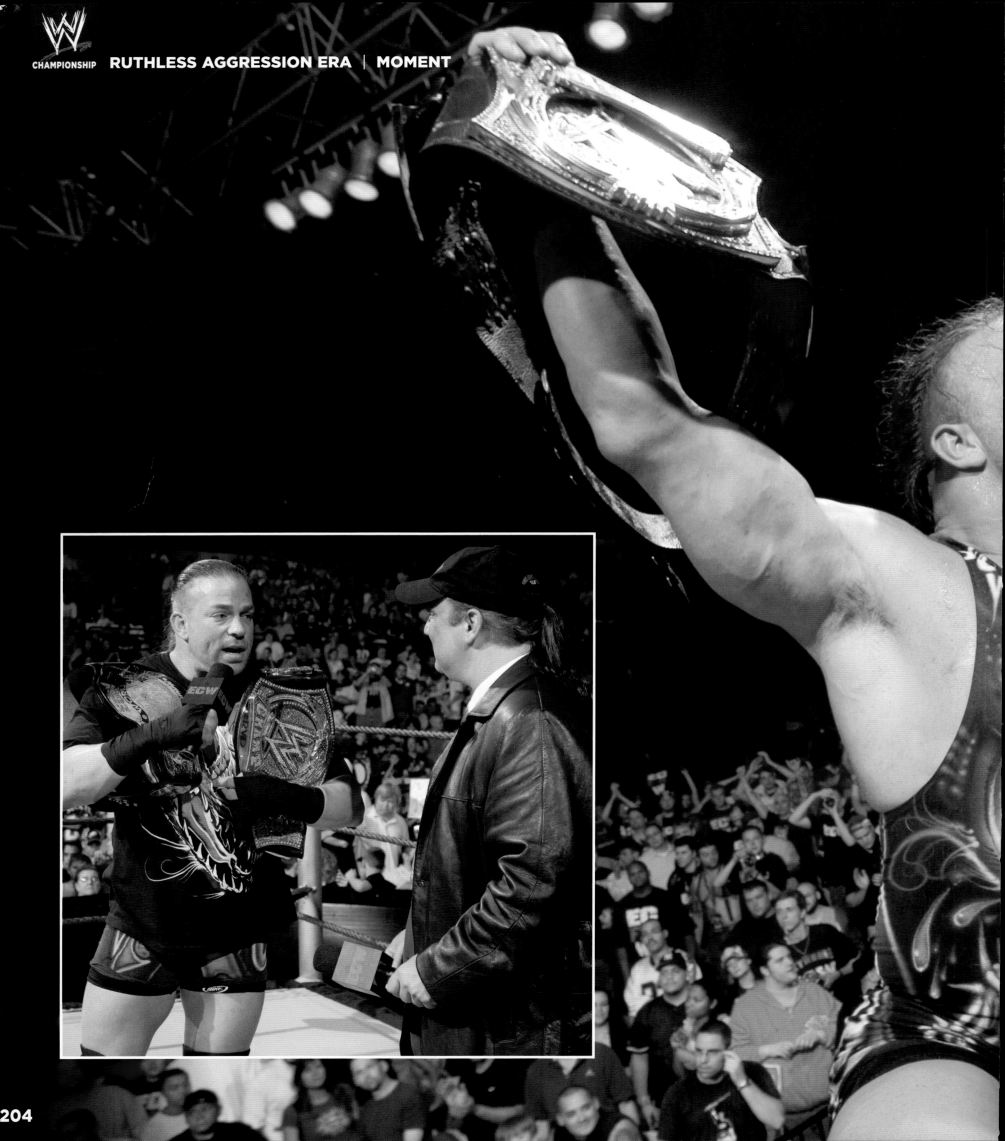

EXTREME CHAMPION

WHEN ROB VAN DAM WON THE MONEY IN the Bank Match and declared his intention to battle John Cena at *ECW: One Night Stand,* both ECW fans and the WWE Universe knew they were in for something special. The match was an unbelievable battle, with two referees going down and Edge making a sudden run-in to spear Cena through a table. With the champ down, RVD seized the opportunity to hit a Five-Star Frog Splash to win the title. The win not only made RVD the WWE Champion, but two nights later led to the reactivation of the ECW World Heavyweight Championship.

Following the success of 2006's *ECW: One Night Stand*, WWE relaunched ECW as a third brand alongside *Raw* and *SmackDown*. When the new incarnation of *ECW* debuted on June 6, Paul Heyman reactivated the ECW World Heavyweight Championship and awarded the title to Rob Van Dam.

In typical fashion for a Superstar as extreme as RVD, the dual champion declared he would defend both titles separately and simultaneously. This decision led to RVD successfully defending the WWE Championship against Edge at *Vengeance 2006* and then, just two days later, winning a hard-fought match against Kurt Angle on *ECW* to retain the ECW Title. With Superstars from both WWE and ECW after him, RVD's championship reign burnt twice as bright, but perhaps half as long as it could have. Just 22 days after winning the WWE Championship, RVD lost the title to Edge on *Raw,* and then the very next night on *ECW*, he lost his second title to Big Show.

ECW and the ECW World Heavyweight Championship would be discontinued in 2010, but to this day Rob Van Dam is one of very few Superstars to hold the WWE Championship and another world title simultaneously. His win at *One Night Stand* helped relaunch ECW, and the manner in which he defended both titles showed the WWE Universe what it meant to be an extreme champion.

RATED-R TITLE

WHEN EDGE WON HIS SECOND WWE Championship, the Rated-R Superstar declared the era of John Cena was officially over. And to make a point, Edge was willing to do the unthinkable. Appearing on *Raw* one night after retaining the WWE Championship at *SummerSlam* with a victory over Cena, Edge arrived with the WWE Title conspicuously missing. The WWE Universe was shocked when Lita appeared on the big screen, standing next to Long Island Sound with the WWE Title in hand. Upon Edge's command, Lita tossed it straight into the water, as Edge put it, "removing the last remnants of John Cena with a beautiful burial at sea."

Claiming to usher in a new era of WWE, a Rated-R era, Edge then revealed the new-look WWE Championship. The title retained the central spinner component, but where the WWE logo once stood, there was instead the Rated-R Superstar logo. Despite Edge proclaiming an end to the Edge and Cena rivalry, the Ultimate Opportunist did actually lose the WWE Championship to Cena at *Unforgiven* on September 17, 2006.

The Rated-R Superstar design may have only lasted a few weeks, but the shock of seeing the WWE Championship so brazenly discarded proved that in this era of WWE you had to be ruthless to succeed.

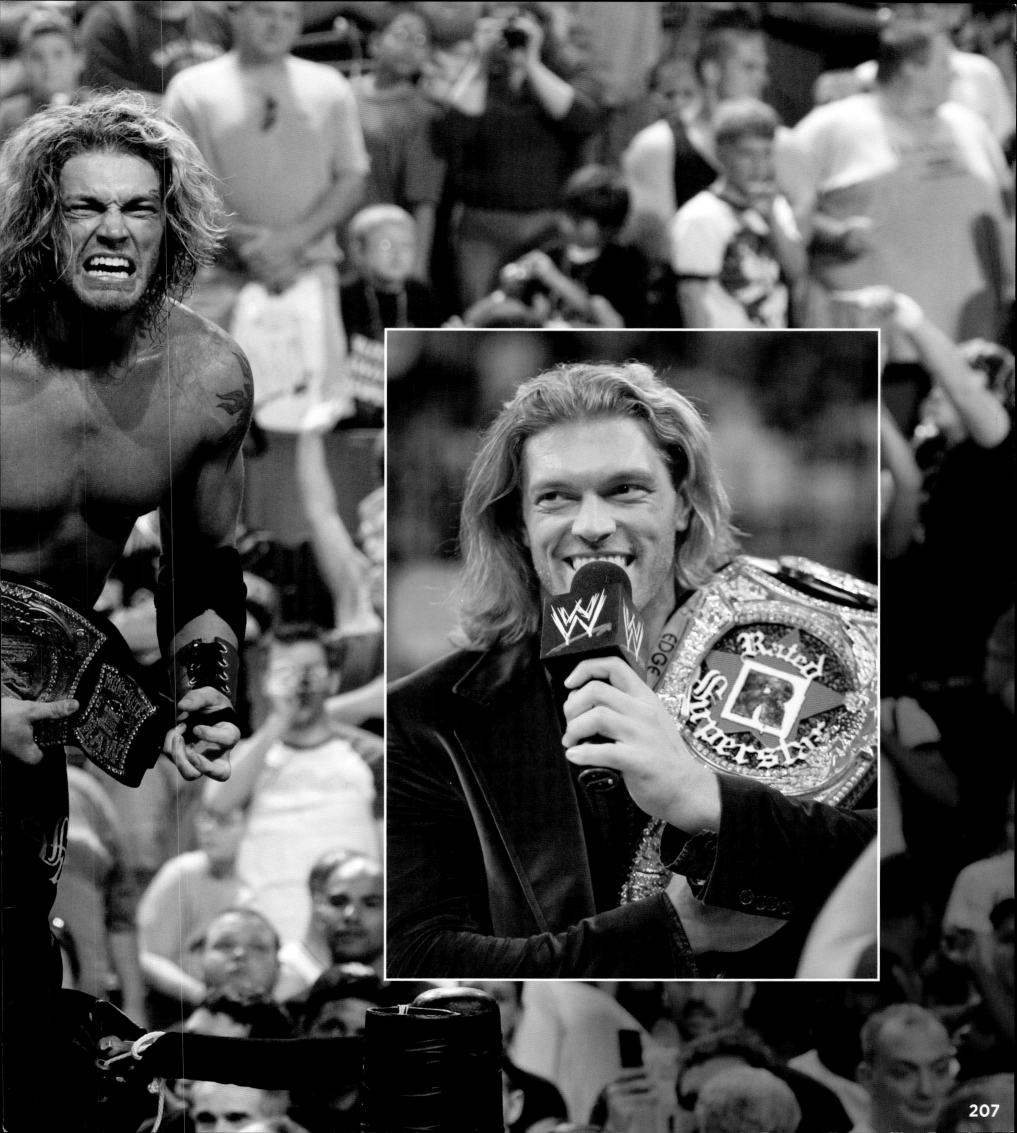

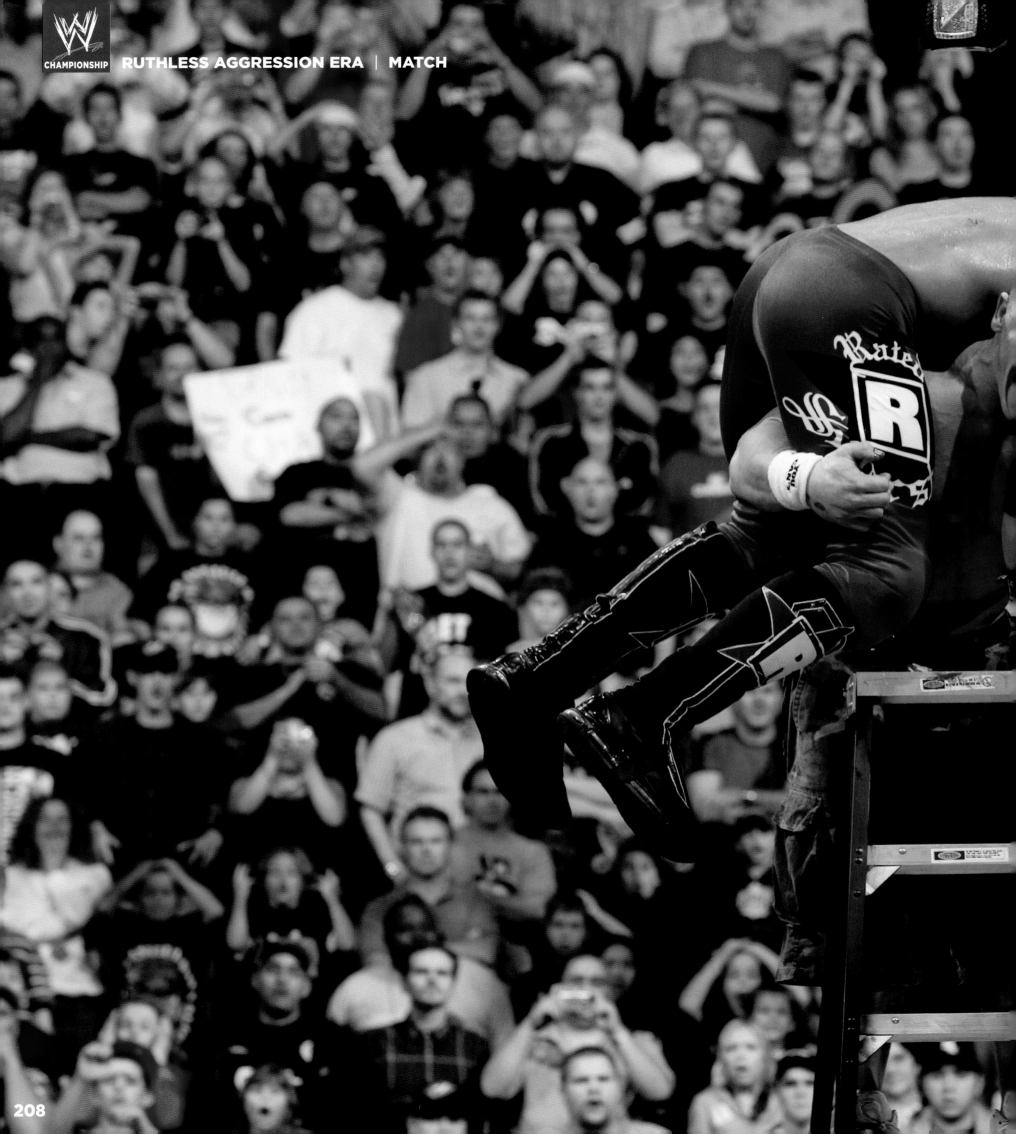

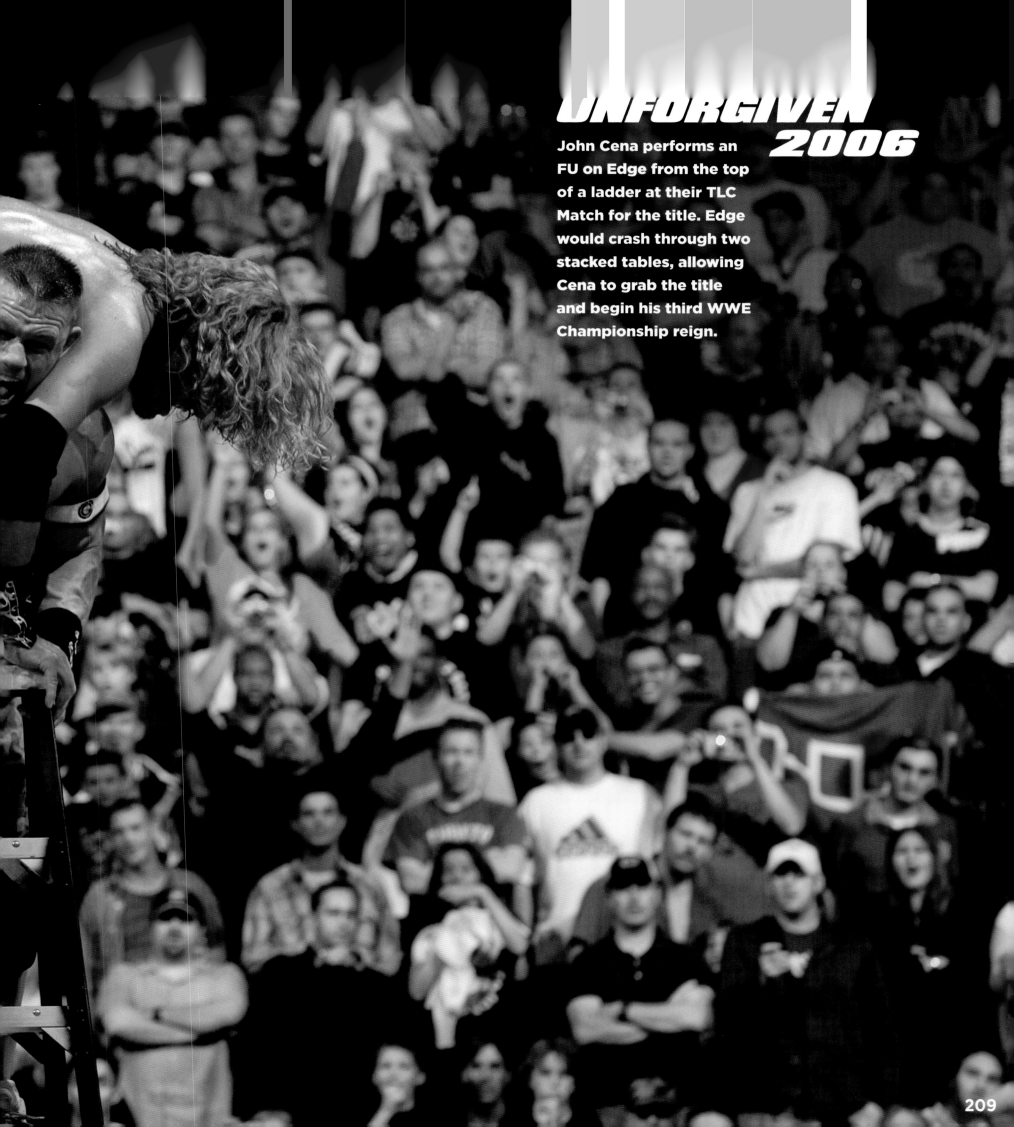

John Cena performs an FU on Edge from the top of a ladder at their TLC Match for the title. Edge would crash through two stacked tables, allowing Cena to grab the title and begin his third WWE Championship reign.

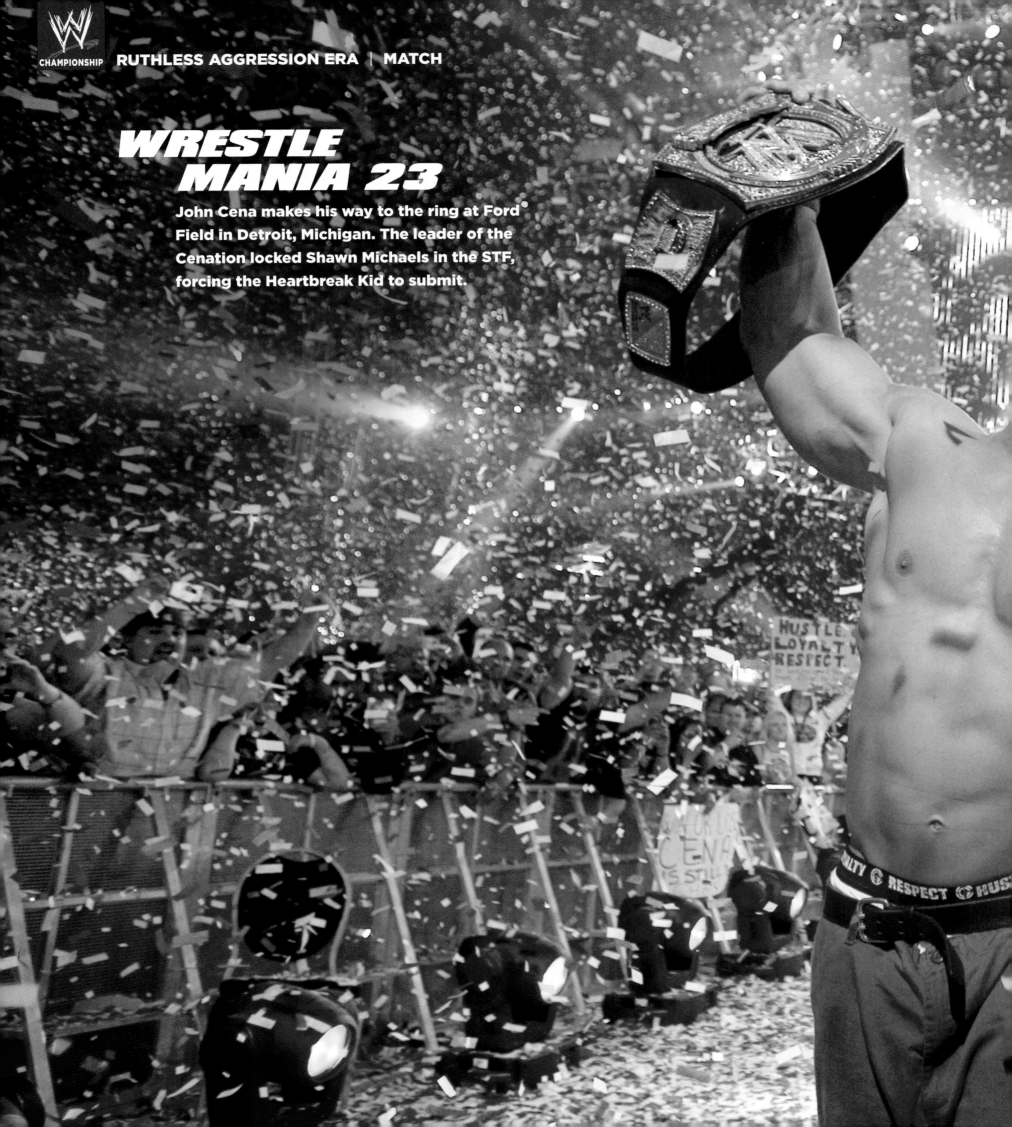

WRESTLE MANIA 23

John Cena makes his way to the ring at Ford Field in Detroit, Michigan. The leader of the Cenation locked Shawn Michaels in the STF, forcing the Heartbreak Kid to submit.

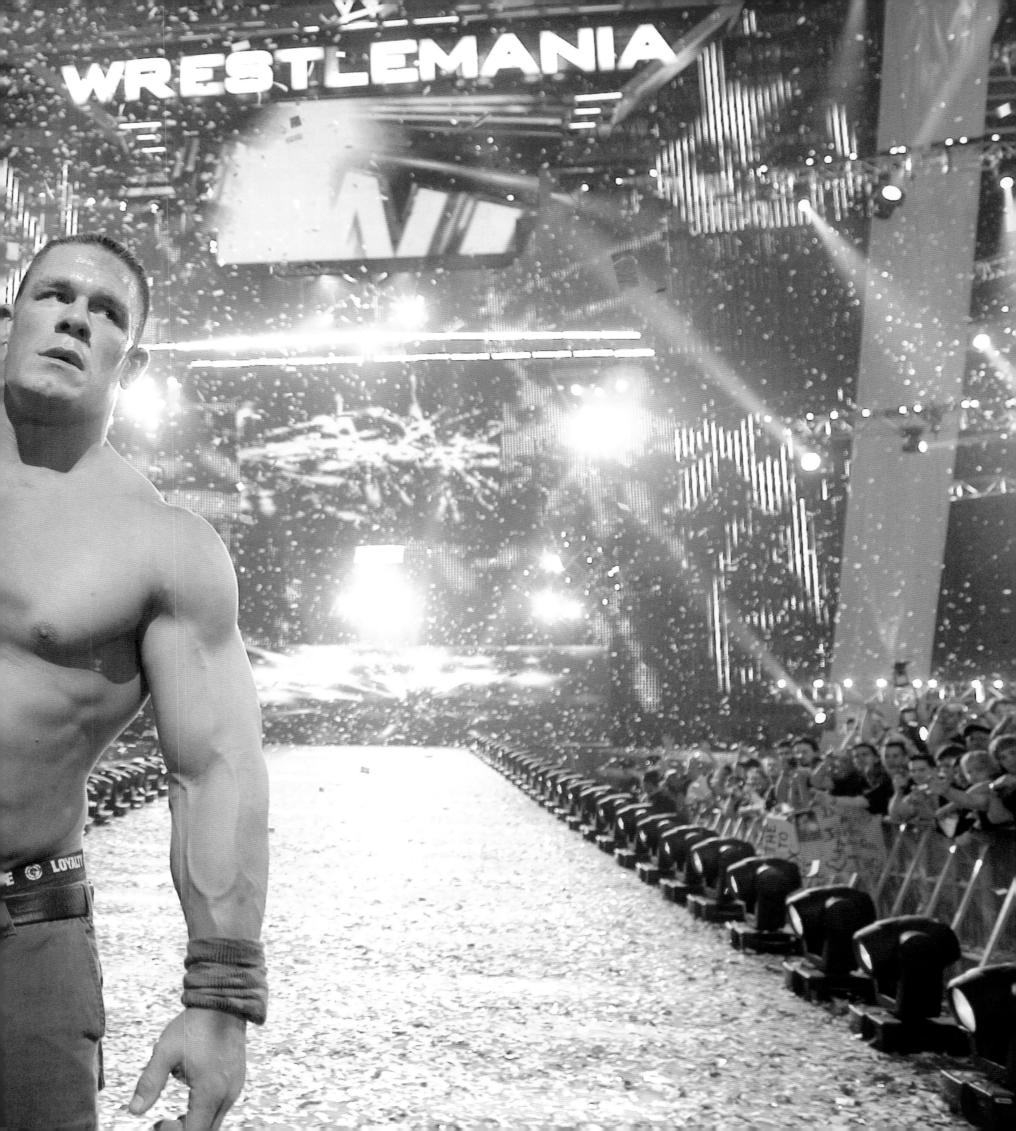

ONE NIGHT TWO CHAMP

GOING INTO 2007'S *NO MERCY*, defending WWE Champion John Cena and Randy Orton were scheduled to meet in a Last Man Standing Match for the WWE Title. However, just days before the bout, Cena tore his pectoral muscle and was forced to vacate the title. What followed ended up being a far more bizarre and historical series of events.

Mr. McMahon awarded the title to Randy Orton at the start of the event, with the stipulation that he would have to defend it that night. On cue, Triple H stepped out and challenged Orton for the WWE Championship. Although Orton battled, he was overpowered by The Game, who scored a pinfall victory to win the WWE Title.

Originally, Triple H had already been on the

card and scheduled to face Umaga. Following his victory against Orton, The Game was told that he would still be taking on Umaga, only now the title would be on the line as well. Triple H was not about to let his newly won title go so easily and landed a Pedigree on Umaga to retain.

The Cerebral Assassin barely had time to celebrate, however, when Orton invoked his rematch clause, forcing Triple H to compete in his third match of the night. Triple H looked like he was about to retain when he set up Orton for a Pedigree through the announce table. But the Legend Killer was ready for him and reversed the finisher into an RKO. The move was severe enough to keep Triple H from answering the ten-count, sending the WWE Championship back to Orton after only a few hours.

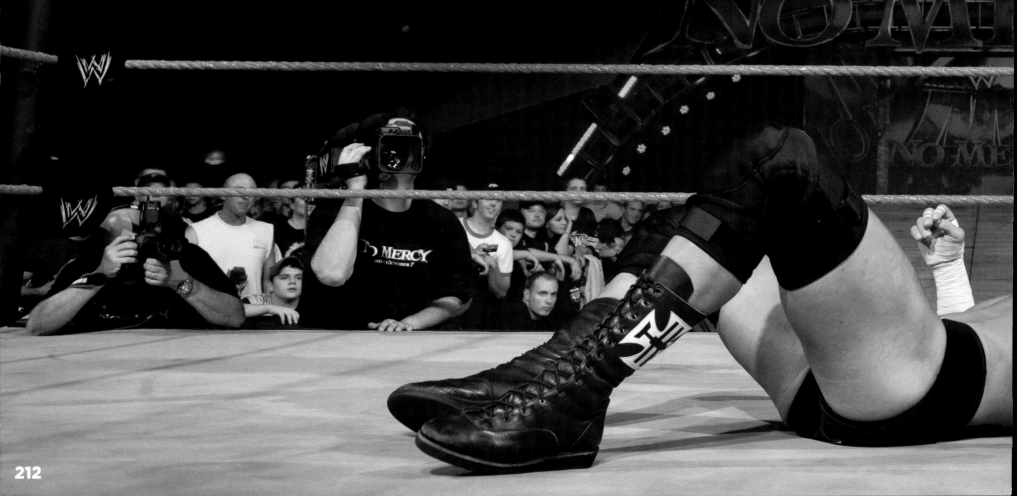

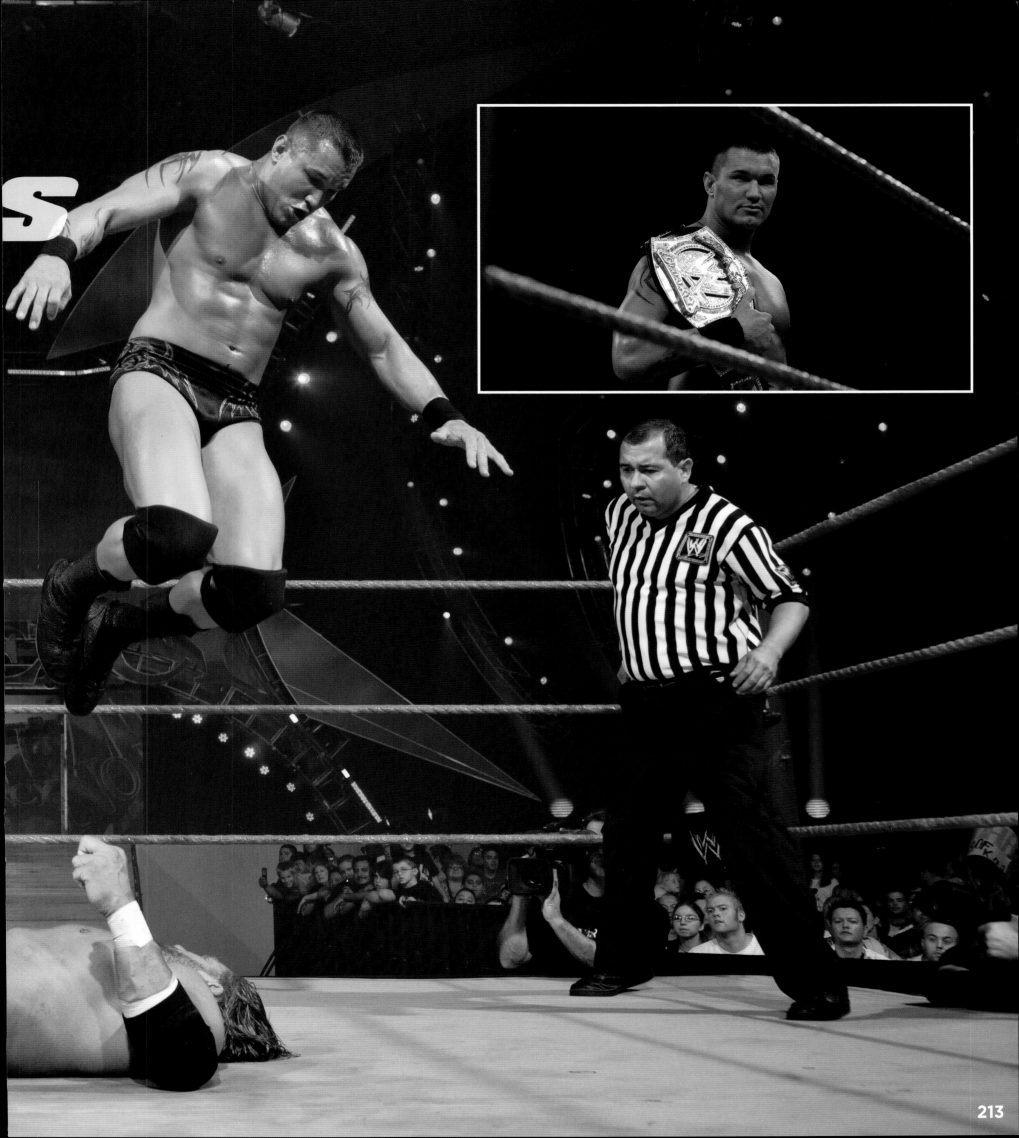

RANDY ORTON

BORN INTO A SPORTS ENTERTAINMENT FAMILY, Randy Orton is to date a 14-time World Champion, making him one of the most decorated Superstars in WWE history. That stunning achievement (ten WWE Championships and four World Heavyweight Championships) shows exactly why Orton has earned monikers including WWE's Apex Predator, the Viper, and the Legend Killer.

Under the guidance of Triple H and Ric Flair as part of the Evolution stable, Orton became the youngest World Heavyweight Champion, aged 24. However, after Evolution turned on him, he battled his former stablemates. At *No Mercy* 2007, after an intense rivalry with WWE Champion John Cena, Orton was crowned champion due to Cena suffering an injury that meant he couldn't compete. However, Mr. McMahon told Orton he would have to defend the title that same night. Defeated early on by his former mentor Triple H and losing the title, Orton's roller-coaster night ended with a Last Man Standing Match between the two Superstars. This time the Legend Killer outlasted Triple H to recapture the WWE Championship and become the second youngest two-time WWE Champion, at 27 years old. 209 days later, Triple H defeated Orton in a Fatal 4-Way Elimination Match at *Backlash* to end his second reign.

In 2009, the Viper viciously struck again and again to reclaim the title on *Raw* in a Fatal 4-Way Match, and by brutally punting John Cena to end a Hell in a Cell Match at *Hell in a Cell*. The following year he won the WWE

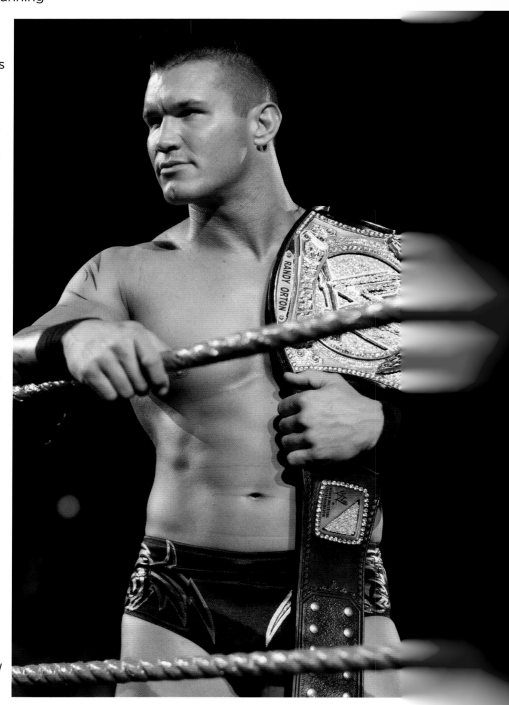

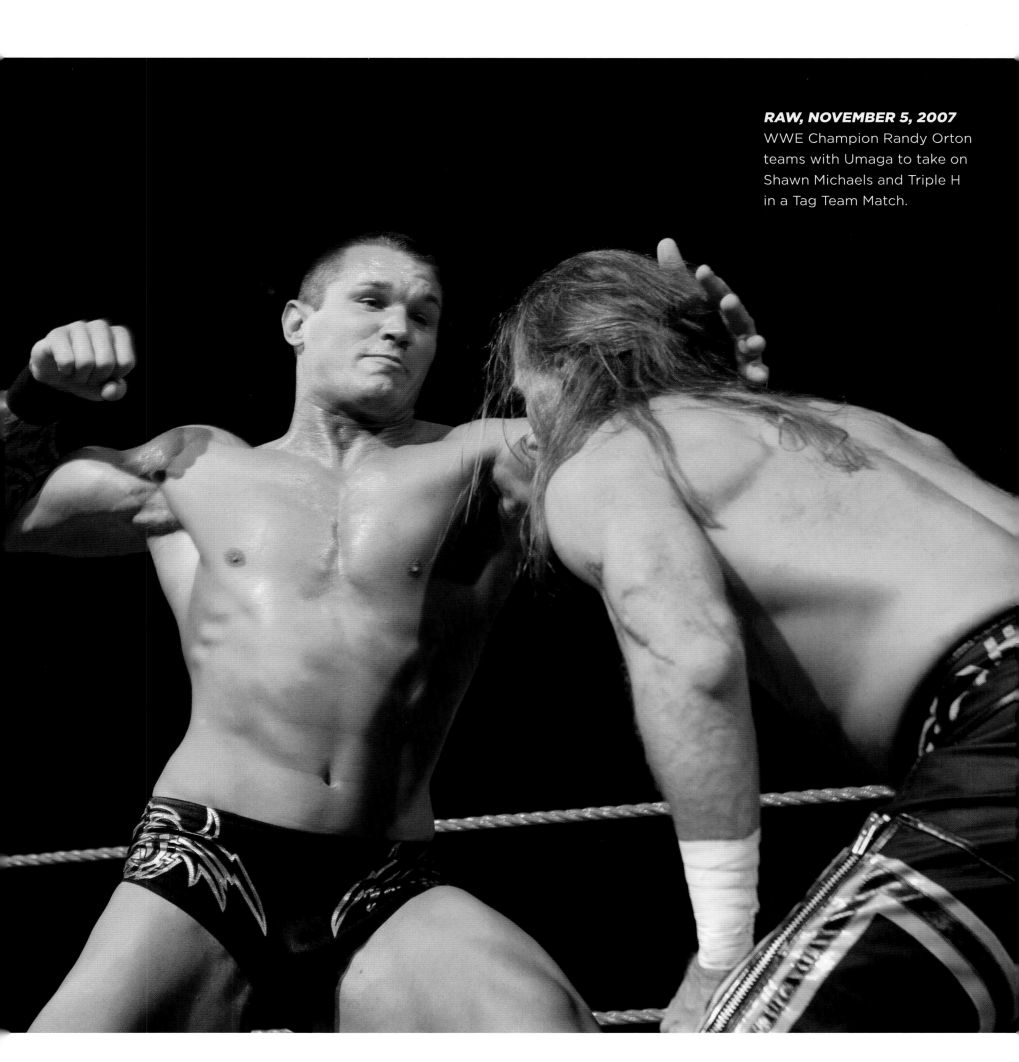

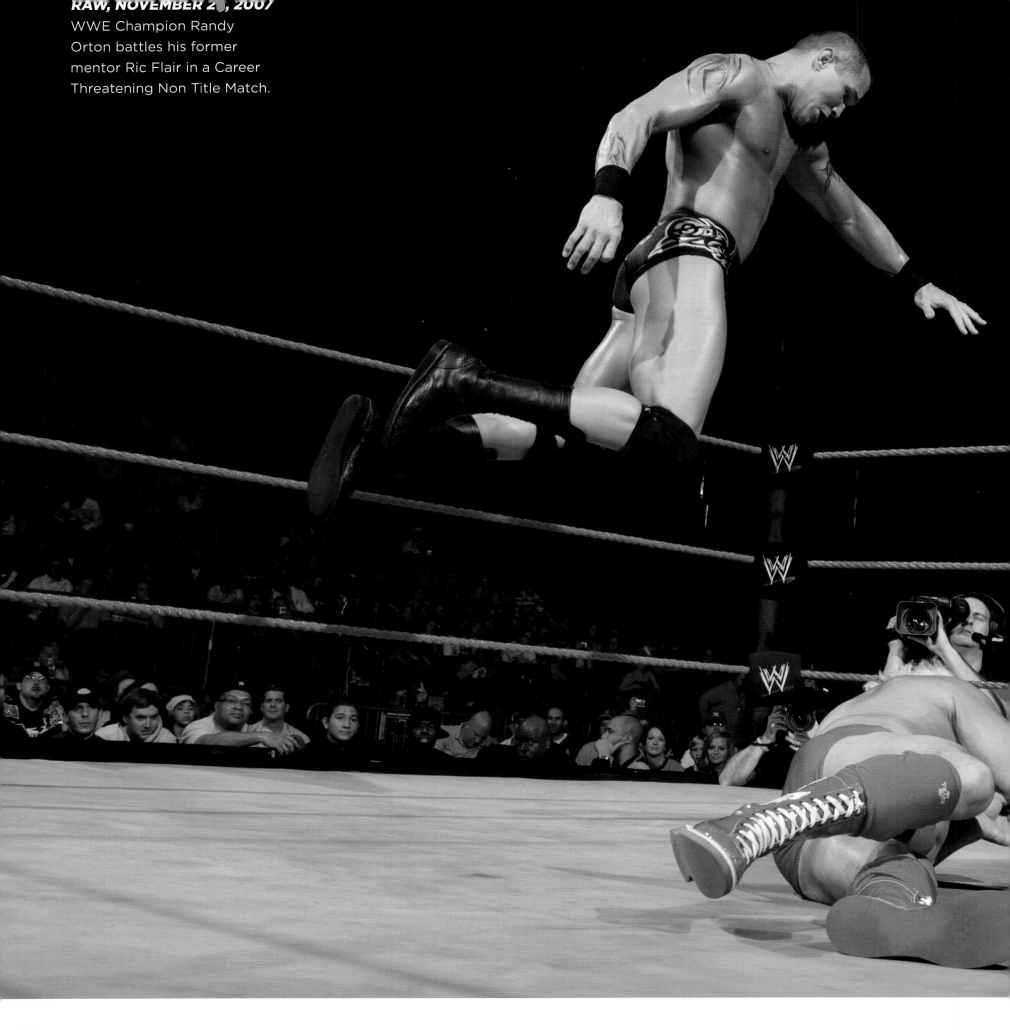

WWE Champion Randy Orton battles his former mentor Ric Flair in a Career Threatening Non Title Match.

Championship at *Night of Champions*, in a Six Pack Elimination Challenge Match. *SummerSlam 2013* saw Orton cash in his Money in the Bank WWE Championship contract to instantly pin Daniel Bryan and win the title, straight after Bryan had defeated Cena. After losing the championship to Bryan at *Night of Champions* a month later, the Viper faced him again in another Hell in a Cell Match at *Hell in a Cell* to reclaim the gold. Orton also battled Cena in a brutal Tables, Ladders, and Chairs Match at 2013's *TLC: Tables, Ladders & Chairs*, defeating the World Heavyweight Champion to unite both titles and become the first-ever WWE World Heavyweight Champion.

"HE SAVAGELY STRUCK DOWN HIS RIVALS TO BECOME A 14-TIME WORLD CHAMPION."

However, *WrestleMania 30* saw Orton and Batista lose to Bryan in a Triple Threat Match, ending Orton's 160-day title reign. Three years later, WWE's Apex Predator again competed on the Grandest Stage of Them All. After a twisted rivalry with Bray Wyatt, the two ruthless Superstars faced off at *WrestleMania 33*. Eventually, Orton hit Wyatt with an RKO to claim the WWE Championship—his first title win at *WrestleMania*. He would later lose the title to Jinder Mahal. At *Hell in a Cell* 2020, Orton challenged the "Scottish Warrior" Drew McIntyre for the title. A full-on war ensued inside, outside and on top of the cage, before the Viper finally countered a Claymore Kick with a brutal RKO to claim his tenth WWE Championship. Vicious and driven, Randy Orton is always hunting his next WWE Title.

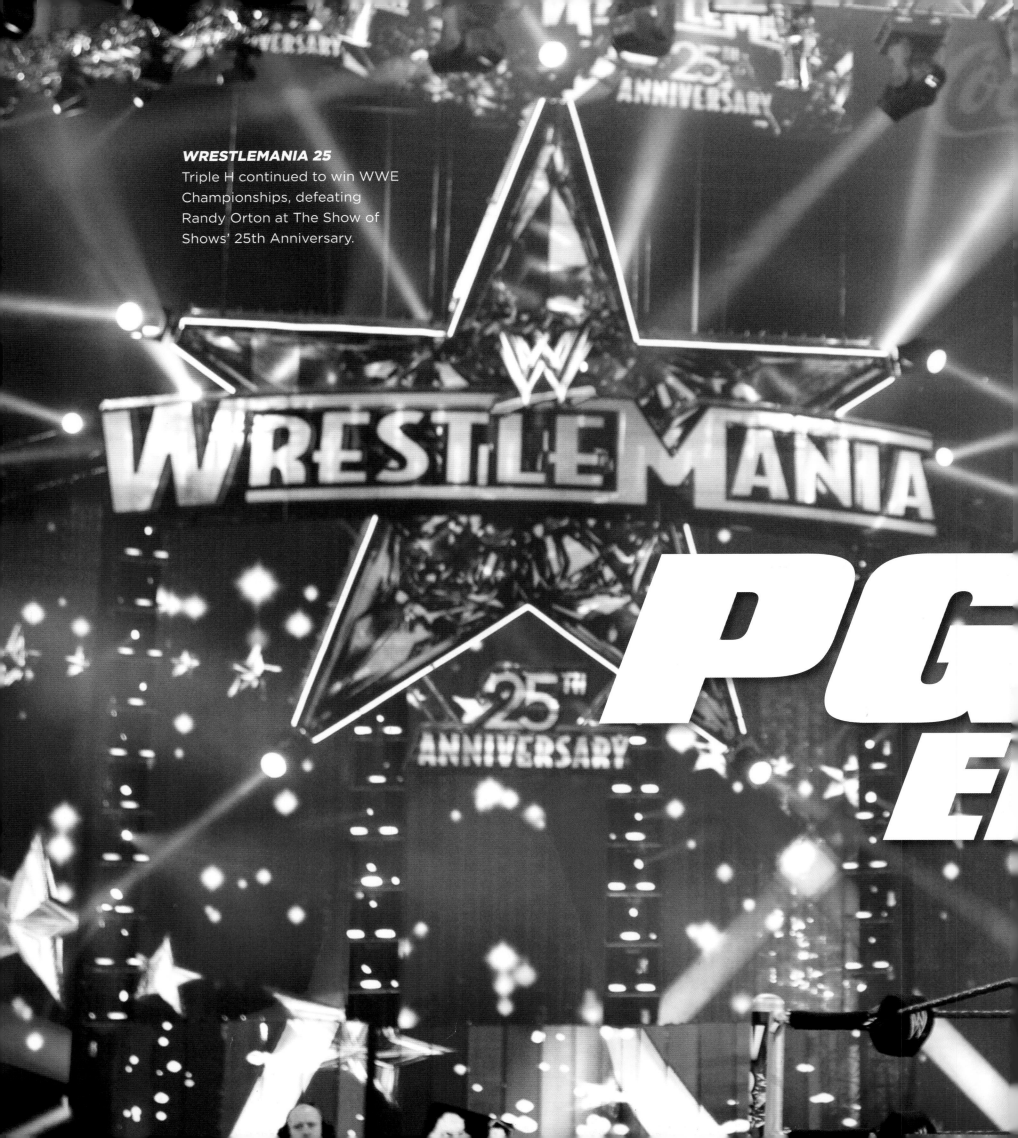

WRESTLEMANIA 25
Triple H continued to win WWE Championships, defeating Randy Orton at The Show of Shows' 25th Anniversary.

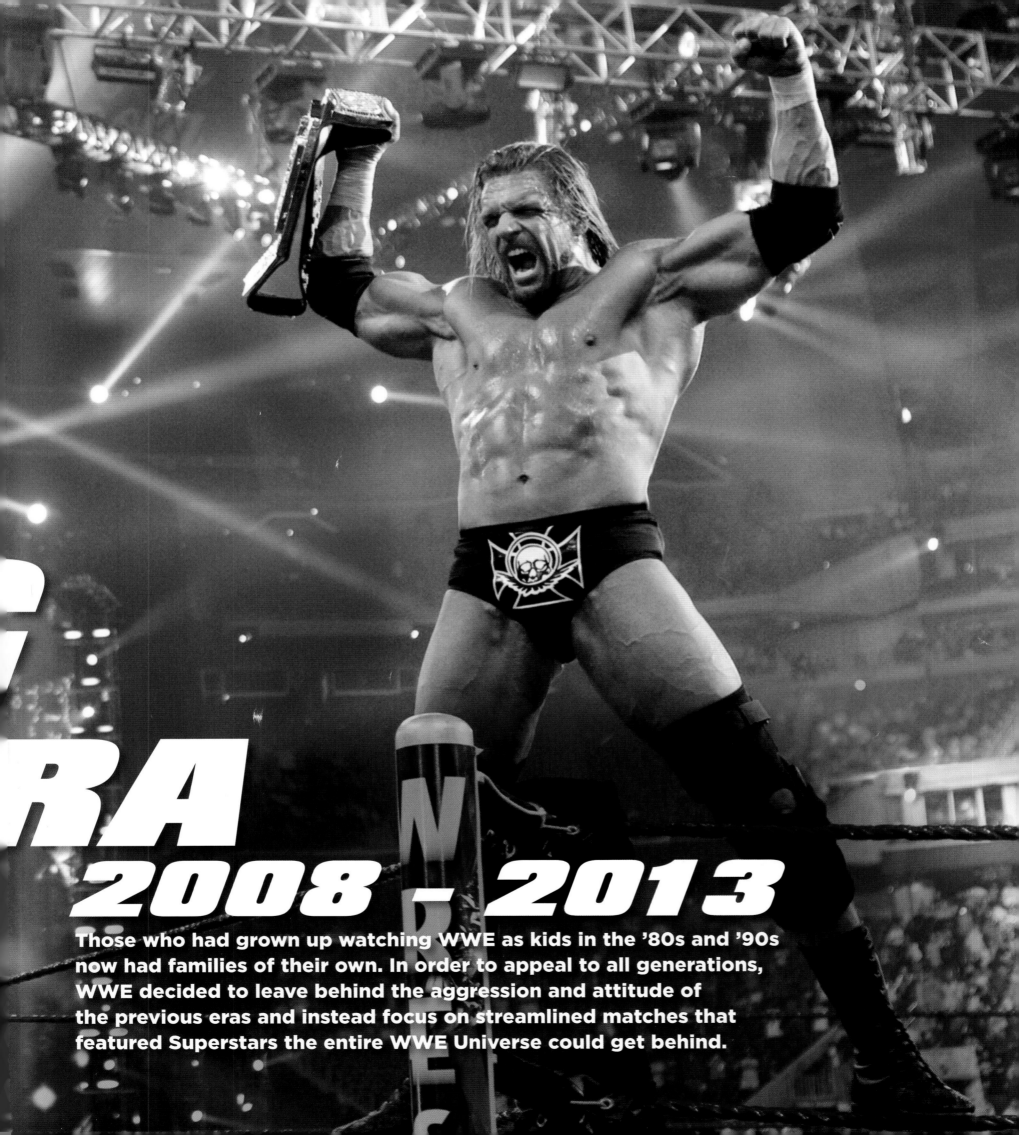

RA
2008 - 2013

Those who had grown up watching WWE as kids in the '80s and '90s now had families of their own. In order to appeal to all generations, WWE decided to leave behind the aggression and attitude of the previous eras and instead focus on streamlined matches that featured Superstars the entire WWE Universe could get behind.

AFTER DECADES AT THE TOP OF THE WORLD of sports entertainment, WWE had proven that the promotion knew how to stay relevant. And, as the pop culture landscape began to shift, WWE also looked to revamp the product for a dawning new decade. Aware that a lot of viewers who had grown up with the product now had families of their own, the company looked to find a way to bridge the generation gap. Starting in 2008, WWE began tailoring its programming to deliver a more streamlined product that would appeal to older and younger fans equally.

One of the first new WWE Champions of this era was a Superstar who had been paying his dues as a tag competitor for nearly a decade. Starting in WWE in the late '90s as one half of the Hardy Boyz, Jeff Hardy was an electrifying, colorful and larger-than-life Superstar. After some time away from the promotion, he had made his return in 2006 and was welcomed by the old school, who had thrilled to his daredevil ways back in the '90s, as well as new members of the WWE Universe, who were excited to see what he could do.

At the 2008 *Armageddon*, Hardy went up against Edge and Triple H in a Triple Threat Match for the WWE Championship. Although both Edge and The Game were top-tier competitors with multiple WWE Title reigns to their names, Jeff Hardy managed to knock Triple H out of the ring and make the three-count on Edge for the win.

Hardy's title reign came to an abrupt end at the 2009 *Royal Rumble*, when a betrayal from his own brother gave Edge the opening he needed to make the pinfall. Just a few weeks later, Edge also surrendered the title when he lost to Triple H in an Elimination Chamber Match at *No Way Out*.

Randy Orton also made several bids for the title, entering into rivalries with both Triple H and John Cena, the latter of whom became one of this era's most famous faces and most decorated champions. During this period, Cena won the WWE Title five times, bringing his total number of reigns to eleven.

One of the biggest names to rise up during this era was CM Punk. Although he had been a part of WWE since 2006, Punk finally entered the title picture in

2011, solidifying his popularity with the WWE Universe on the June 27, 2011, edition of *Raw*. During that episode, Punk delivered a scathing promo against the company, which came to be known as the "Pipe Bomb." That promo catapulted him right into the title picture, and at *Money in the Bank* the following month, Punk pinned John Cena to win the WWE Championship. That night, he left WWE and absconded with the gold, leading to the title

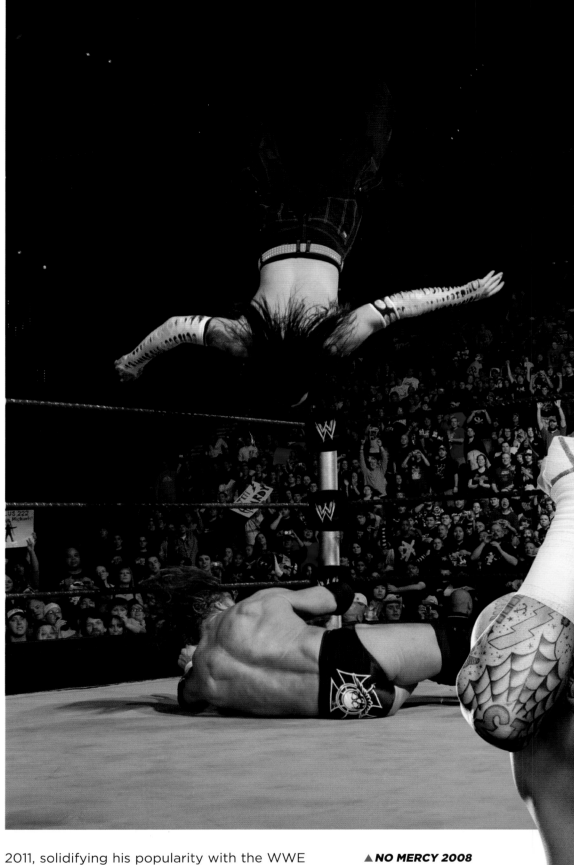

▲ **NO MERCY 2008**
Jeff Hardy performs a Swanton Bomb on Triple H for a near-pinfall. Triple H would counter with a roll-up to retain the WWE Title.

▶ **STRAIGHT EDGE SUPERSTAR**
CM Punk gave the WWE Universe a voice with his strong opinions on the state of the company.

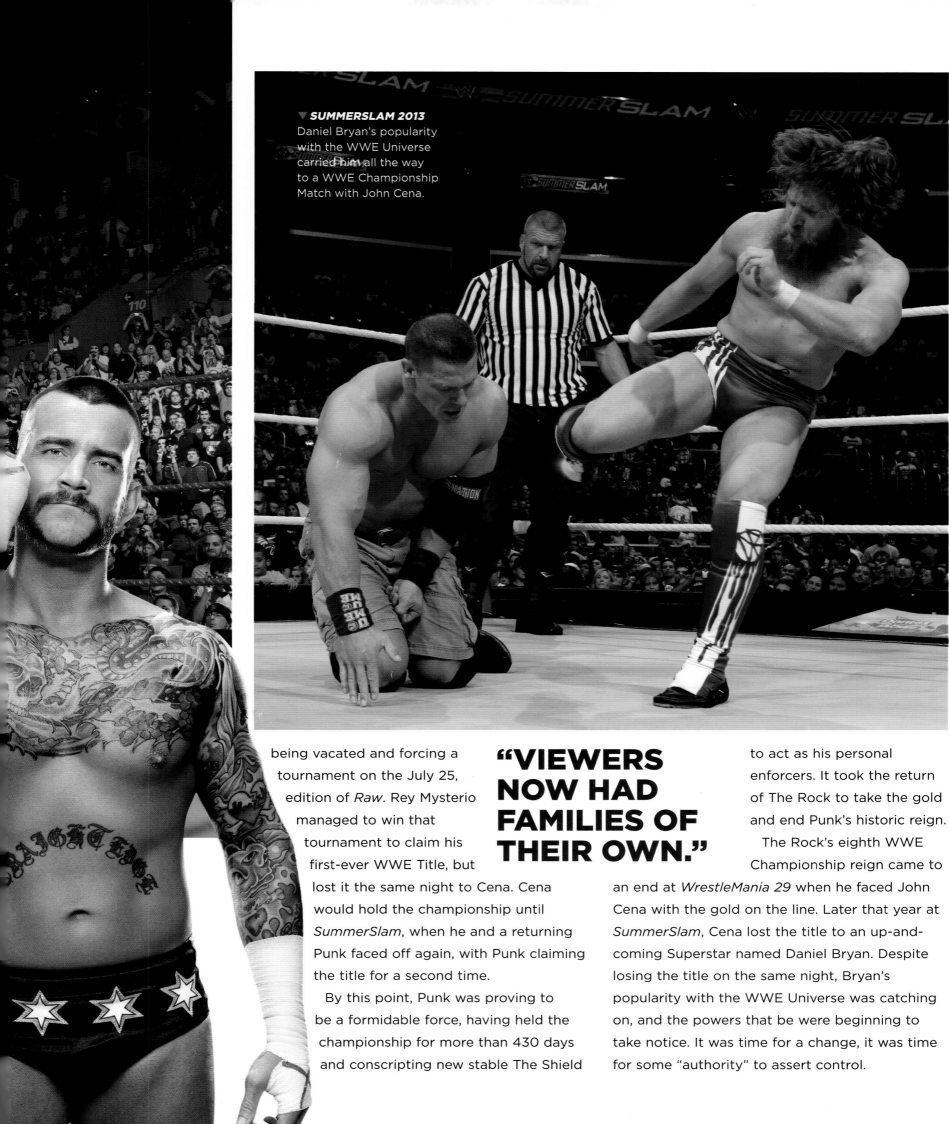

Daniel Bryan's popularity with the WWE Universe carried him all the way to a WWE Championship Match with John Cena.

being vacated and forcing a tournament on the July 25, edition of *Raw*. Rey Mysterio managed to win that tournament to claim his first-ever WWE Title, but lost it the same night to Cena. Cena would hold the championship until *SummerSlam*, when he and a returning Punk faced off again, with Punk claiming the title for a second time.

By this point, Punk was proving to be a formidable force, having held the championship for more than 430 days and conscripting new stable The Shield

"VIEWERS NOW HAD FAMILIES OF THEIR OWN."

to act as his personal enforcers. It took the return of The Rock to take the gold and end Punk's historic reign.

The Rock's eighth WWE Championship reign came to an end at *WrestleMania 29* when he faced John Cena with the gold on the line. Later that year at *SummerSlam*, Cena lost the title to an up-and-coming Superstar named Daniel Bryan. Despite losing the title on the same night, Bryan's popularity with the WWE Universe was catching on, and the powers that be were beginning to take notice. It was time for a change, it was time for some "authority" to assert control.

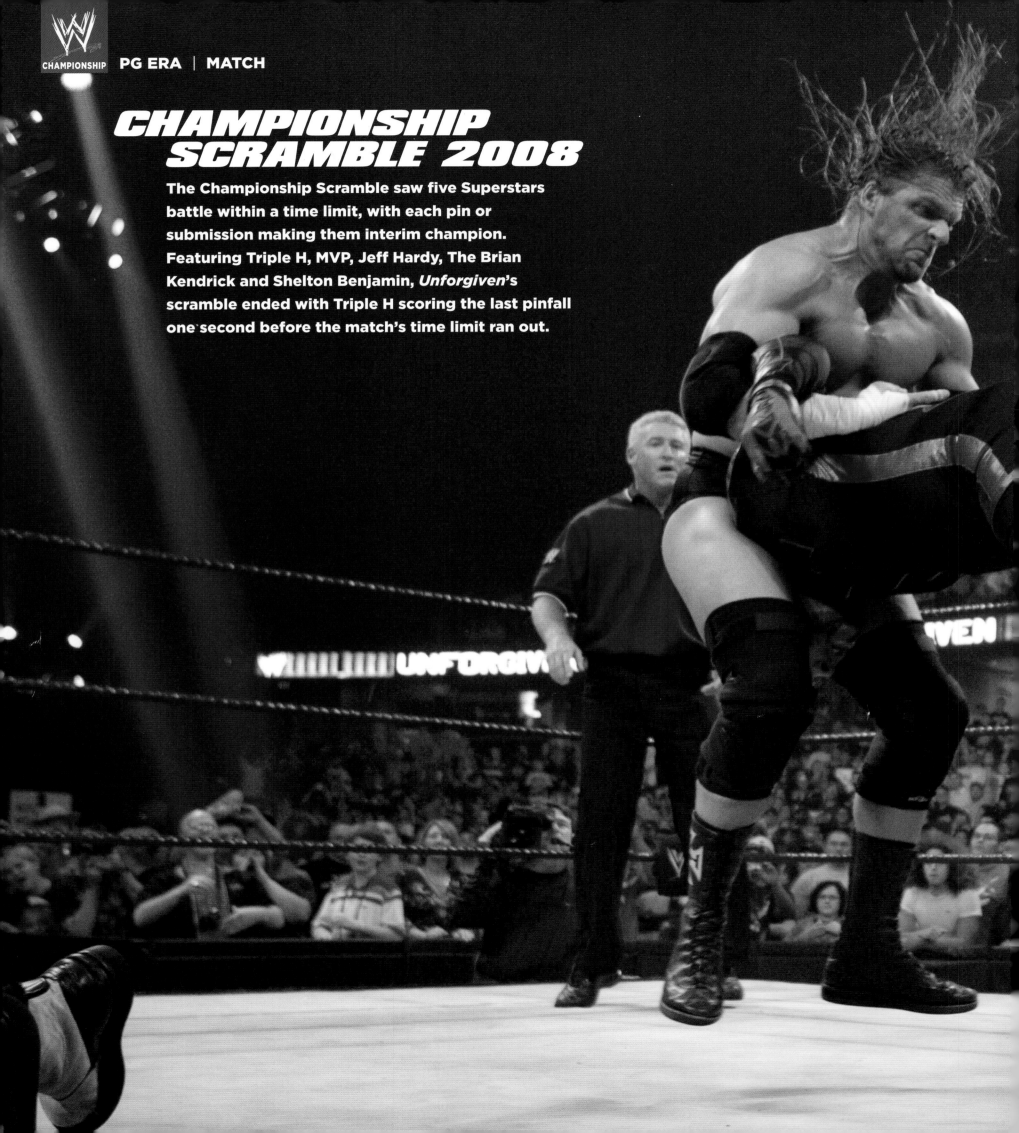

CHAMPIONSHIP SCRAMBLE 2008

The Championship Scramble saw five Superstars battle within a time limit, with each pin or submission making them interim champion. Featuring Triple H, MVP, Jeff Hardy, The Brian Kendrick and Shelton Benjamin, *Unforgiven*'s scramble ended with Triple H scoring the last pinfall one second before the match's time limit ran out.

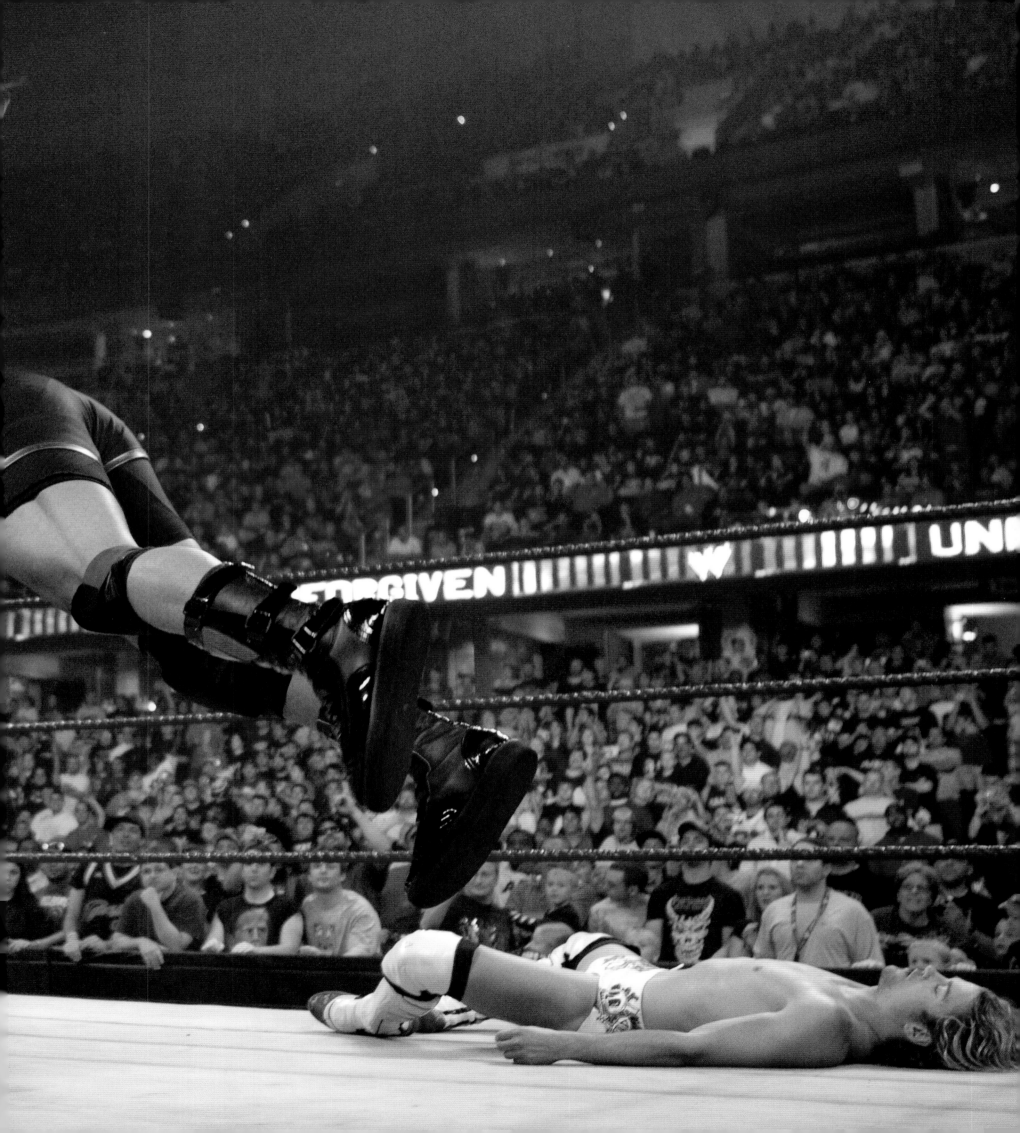

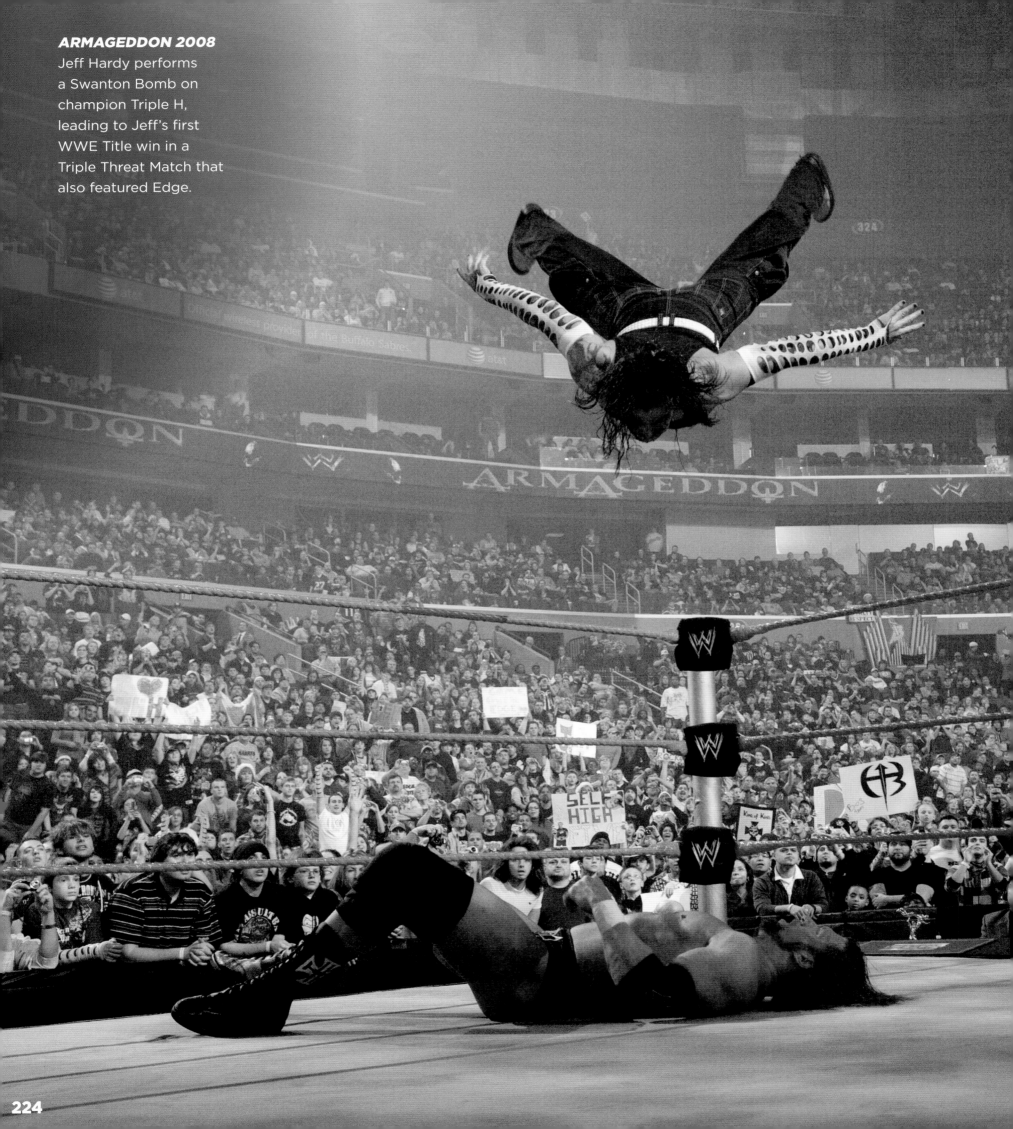

Jeff Hardy performs a Swanton Bomb on champion Triple H, leading to Jeff's first WWE Title win in a Triple Threat Match that also featured Edge.

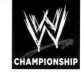

JEFF HARDY

EVEN IF JEFF HARDY HAD NEVER HELD THE WWE Championship, he would still belong in the conversation of the all-time WWE greats. Kicking off his WWE career alongside his brother, Matt, Jeff rewrote the tag competition playbook page by page. As the Hardy Boyz, Matt and Jeff put on daredevil matches that defied both description and the expectations of the WWE Universe. The Hardy Boyz quickly became sensations in WWE and both Matt and Jeff rose to the level of Attitude Era royalty.

After some time away from WWE, Jeff Hardy returned in 2006 and began a climb to singles success. He first won the Intercontinental Championship from Johnny Nitro and eventually found himself in contention for the WWE Championship. After defeating Triple H at the 2007 *Armageddon*, Hardy earned a chance to face Randy Orton for the title at the 2008 *Royal Rumble* event. Although he lost that bout, he continued to challenge for the championship at *Unforgiven*, *No Mercy* and *Cyber Sunday*. Eventually, nearly a year after earning his first title opportunity, Jeff Hardy finally won the WWE Championship at the 2008 *Armageddon*, defeating Edge and Triple H in a Triple Threat Match.

A month after winning the title, Hardy lost the gold to Edge in a No Disqualification Match when his brother and former tag partner, Matt, interfered to cost him the bout. This led to a bitter rivalry that pit brother against brother in a series of brutal matches, including an Extreme Rules Match at *WrestleMania 25*.

Jeff Hardy has only held the WWE Championship one time, but his reign at the top proved that he had what it took to go toe-to-toe with WWE's heavy hitters and come out holding gold.

"JEFF HARDY PUT ON DAREDEVIL MATCHES THAT DEFIED DESCRIPTION AND EXPECTATION."

BATISTA

BATISTA DEBUTED IN 2002 AND MADE A SWIFT RISE WHEN he was hand-picked to join Triple H's stable, Evolution. There, alongside The Game, Ric Flair and Randy Orton, Batista ruled the ring and ran roughshod over anyone who stood in the group's way.

In 2005, Batista won the Royal Rumble, which earned him a shot in the main event of *WrestleMania 21* and the world title of his choice. Batista decided to compete for the World Heavyweight Championship, defeating his former mentor, Triple H, at the event to claim his first world title in WWE.

The Animal would go on to hold the World Heavyweight Title three more times between 2005 and 2008, before setting his sights on the WWE Championship. He eventually won the title in a Steel Cage Match against Randy Orton at the 2009 *Extreme Rules*. Unfortunately, he was forced to vacate the title only a few days later, when an attack from Orton put him out of commission. The following year, Batista went back on the hunt for the WWE Championship, aligning himself with Mr. McMahon and going as far as attacking Bret Hart to earn the Chairman's respect. Out of gratitude, Mr. McMahon allowed Batista to challenge for the title at *Elimination Chamber* 2010. The match was held immediately following Cena's title win against Randy Orton, Triple H, Ted DiBiase, Kofi Kingston and defending champion Sheamus in the chamber. The Chairman announced that the new WWE Champion would be forced to defend his title against Batista immediately. Cena was in no condition to withstand an onslaught from the Animal, and a spear and powerbomb ended the match quickly, earning Batista his second WWE Championship. This led to a contentious rivalry with Cena that saw the two face off at *WrestleMania XXVI*, with Cena taking back the gold.

Batista has since conquered the movie business with the same ferocity as in the ring. There is always the chance that he could return to WWE and try for a third WWE Championship. After all, Hollywood loves a trilogy.

"BATISTA RULED THE RING AND RAN ROUGHSHOD OVER ANYONE WHO STOOD IN THE WAY."

Batista shows off the WWE Championship on *Raw*, having transferred to the red brand upon becoming champion.

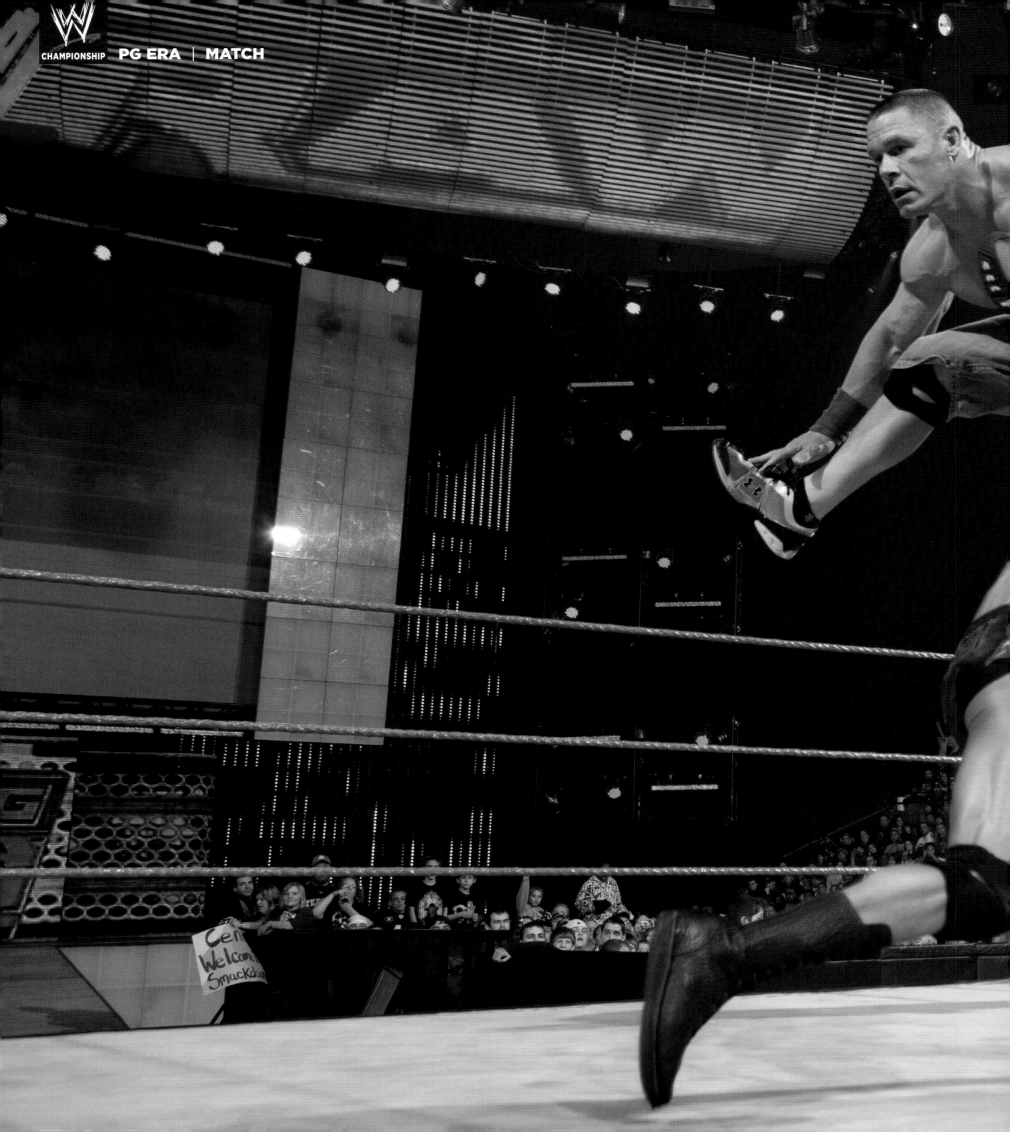

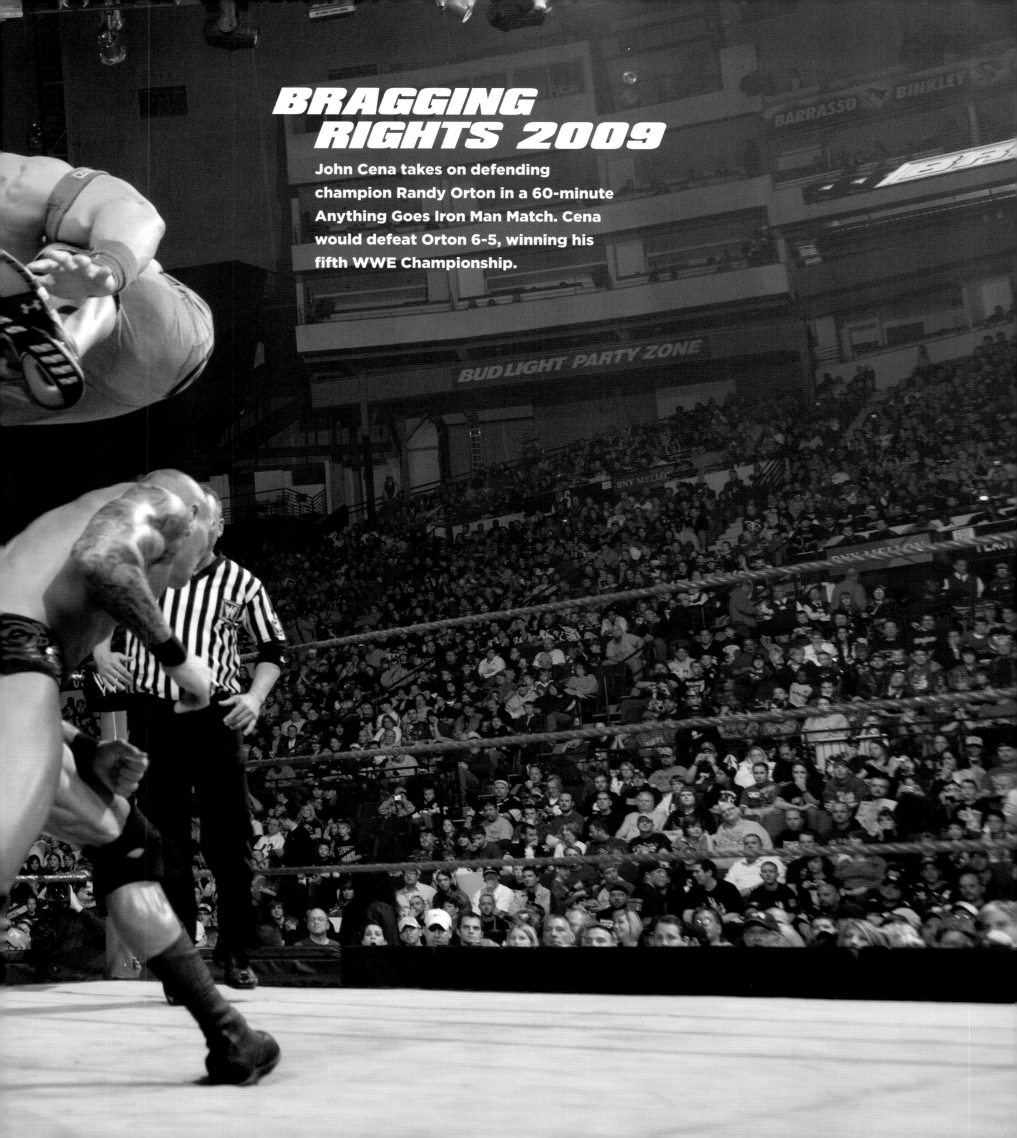

BRAGGING RIGHTS 2009

John Cena takes on defending champion Randy Orton in a 60-minute Anything Goes Iron Man Match. Cena would defeat Orton 6-5, winning his fifth WWE Championship.

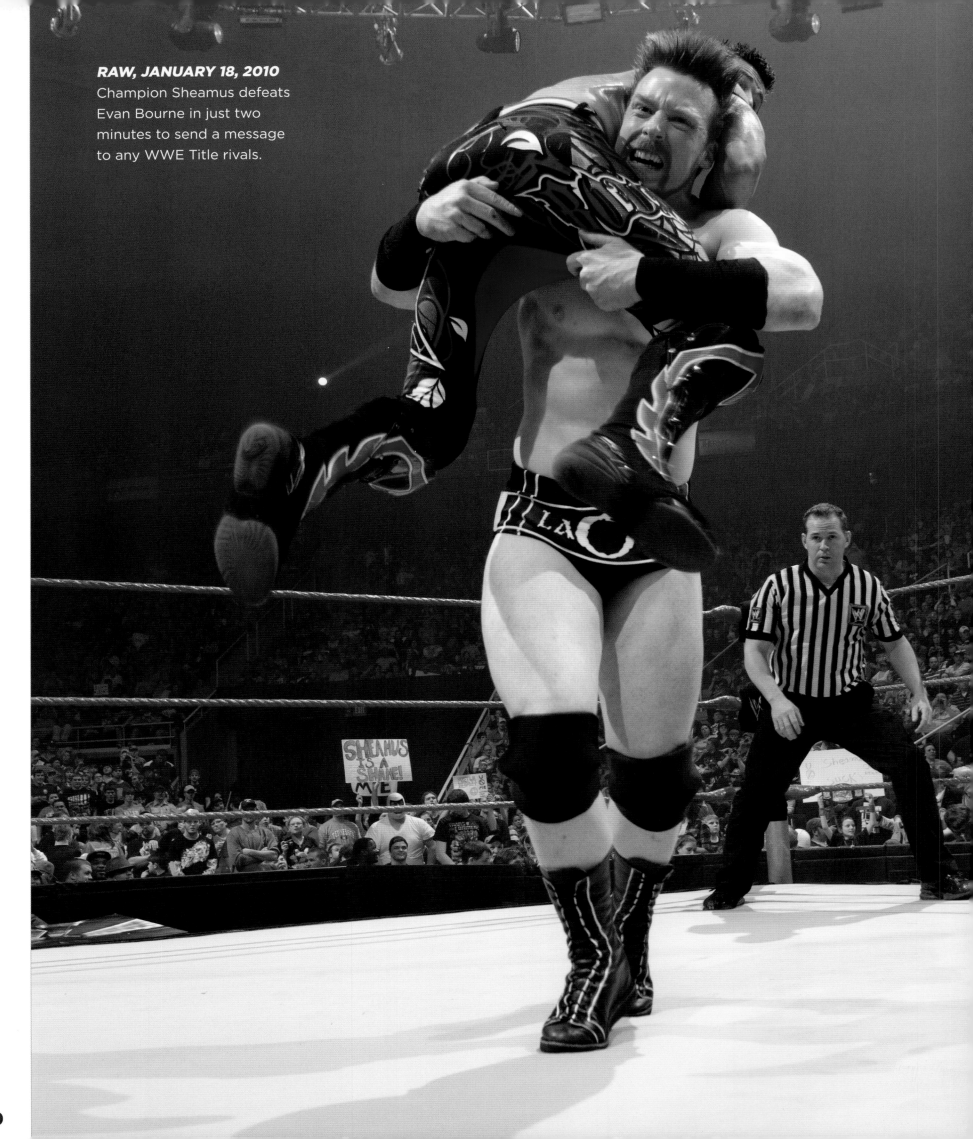

SHEAMUS

"SHEAMUS DEFEATED JOHN CENA TO WIN THE TITLE JUST SIX MONTHS AFTER HIS WWE DEBUT."

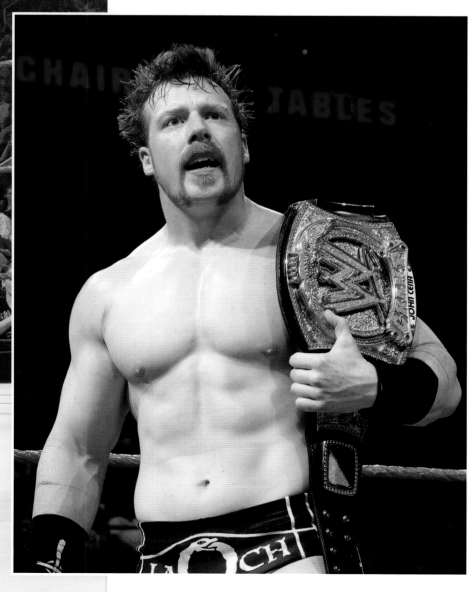

AN IRISH BRAWLER WITH a mean streak as thick as his brogue, Sheamus established himself as one of WWE's heaviest hitters right out of the gate. From the time he debuted on *ECW* in June 2009, Sheamus was seen as a force to be reckoned with. His rivalries with Goldust and Shelton Benjamin demonstrated to the WWE Universe his raw power and refusal to go down without a fight. They also showcased his brutal finishers, the Brogue Kick and the Celtic Cross.

Sheamus's fast ascent continued when he arrived on *Raw* and won a Battle Royal Match to become the number-one contender for the WWE Title. At *TLC: Tables, Ladders & Chairs 2009*, Sheamus defeated John Cena to win the title just six months after his WWE debut. He managed to hold on to the WWE Title until 2010's *Elimination*

Chamber, when he was eliminated from the chamber by Triple H. It took him until June to regain it, defeating John Cena in a Fatal 4-Way Match, which also included Edge and Randy Orton.

In September 2010, Sheamus faced off against Randy Orton, Wade Barrett, John Cena, Edge and Chris Jericho in a Six-Pack Elimination Challenge for the title. Orton won that bout, ending Sheamus's second reign at 91 days. It would be five years before he held the title again.

At the 2015 *Survivor Series*, Sheamus became a three-time WWE Champion when he cashed in his Money in the Bank contract to challenge Roman Reigns, who had just won the vacant title by pinning Dean Ambrose. All it took was a pair of Brogue Kicks on an exhausted Reigns, and Sheamus was champion again. However, Reigns wasn't about to take the loss lying down, and challenged Sheamus to a Title Versus Career Match on *Raw*. This time, Reigns walked away with the victory, bringing Sheamus's third reign to a close.

Sheamus is still very much a force in the promotion, so a fourth WWE Championship reign and beyond is most definitely not out of the question. All it will take is one well-placed Brogue Kick and the gold goes back to the Irish once again.

THE MIZ

"THE MIZ CASHED IN HIS MONEY IN THE BANK CONTRACT TO BEGIN HIS TITLE REIGN."

FROM REALITY TV TO TWO-TIME WWE CHAMPION, The Miz made his dreams come true and defied the doubters to become the A-Lister. Or as he'd put it, he's awesome.

First finding fame on the reality show *The Real World: Back to New York*, his path to the ring was an unusual one. Making his in-ring WWE debut in 2006, he teamed with John Morrison and went on to win the Tag Team Championship before claiming the United States Title. Winning the Money in the Bank Ladder Match in 2010 enabled him to set his sights on the WWE Championship.

Four months later, Randy Orton had defended the WWE Championship at *Survivor Series* and again the night after on *Raw*, both against Wade Barrett, but The Nexus unleashed a beating on him. Seizing the opportunity, The Miz finally cashed in his Money in the Bank contract to defeat Orton and begin a 160-day title reign.

The Miz lost the WWE Title to John Cena at the 2011 *Extreme Rules* and, despite other title wins, The Miz had to wait a decade to reclaim the WWE Championship. At *Elimination Chamber 2021*, after defending champion Drew McIntyre had been worn down by Bobby Lashley, The Miz again cashed in the Money in the Bank contract. He performed a Skull Crushing Finale on McIntyre to begin his second WWE Championship reign, although it lasted only eight days. However, the A-Lister is sure to be planning his route back to the top.

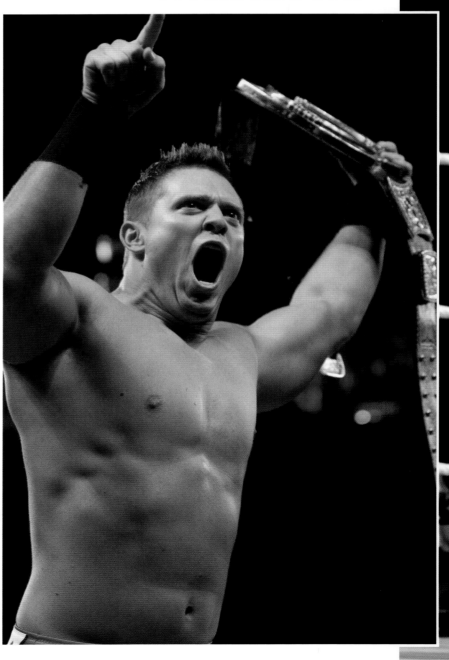

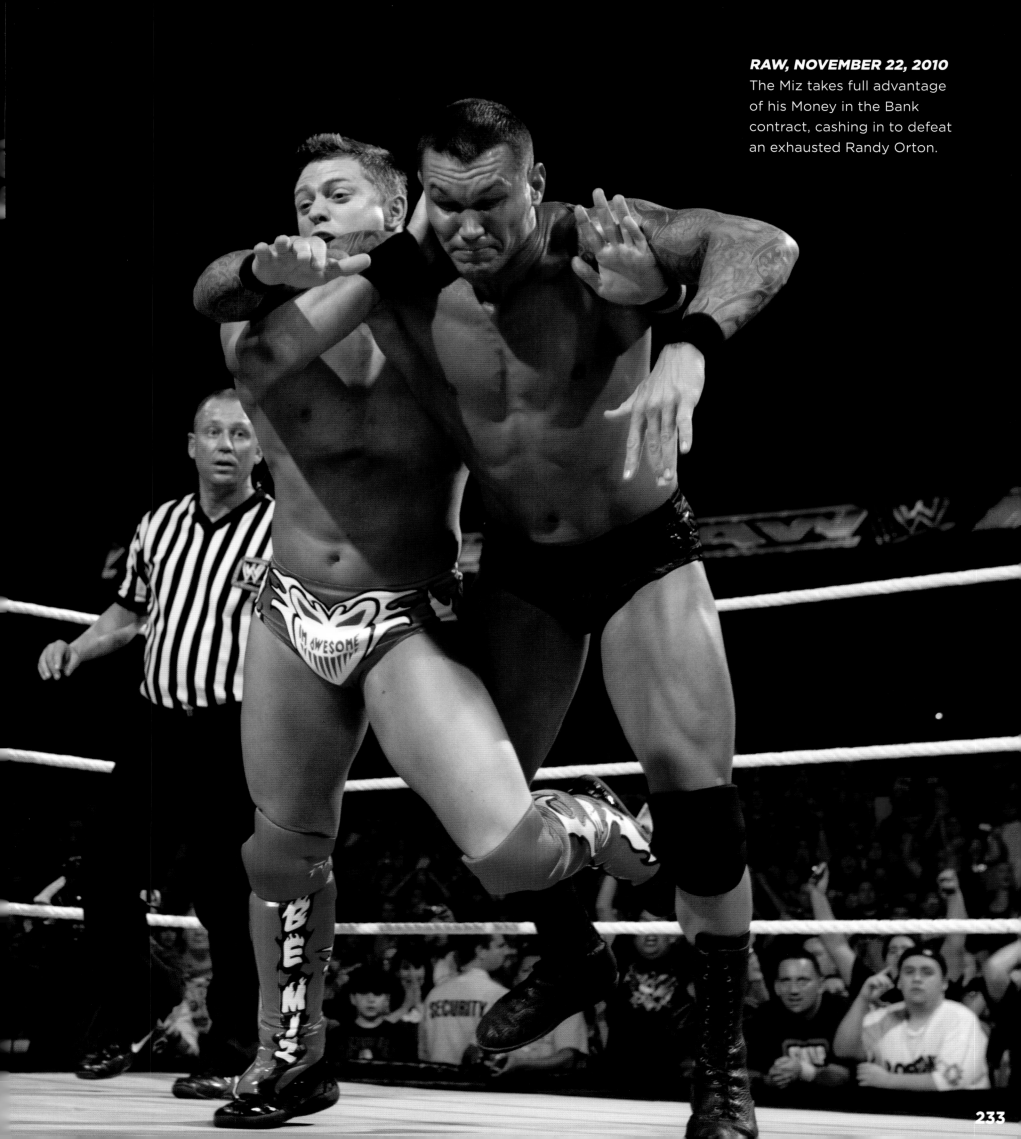

RAW, NOVEMBER 22, 2010
The Miz takes full advantage of his Money in the Bank contract, cashing in to defeat an exhausted Randy Orton.

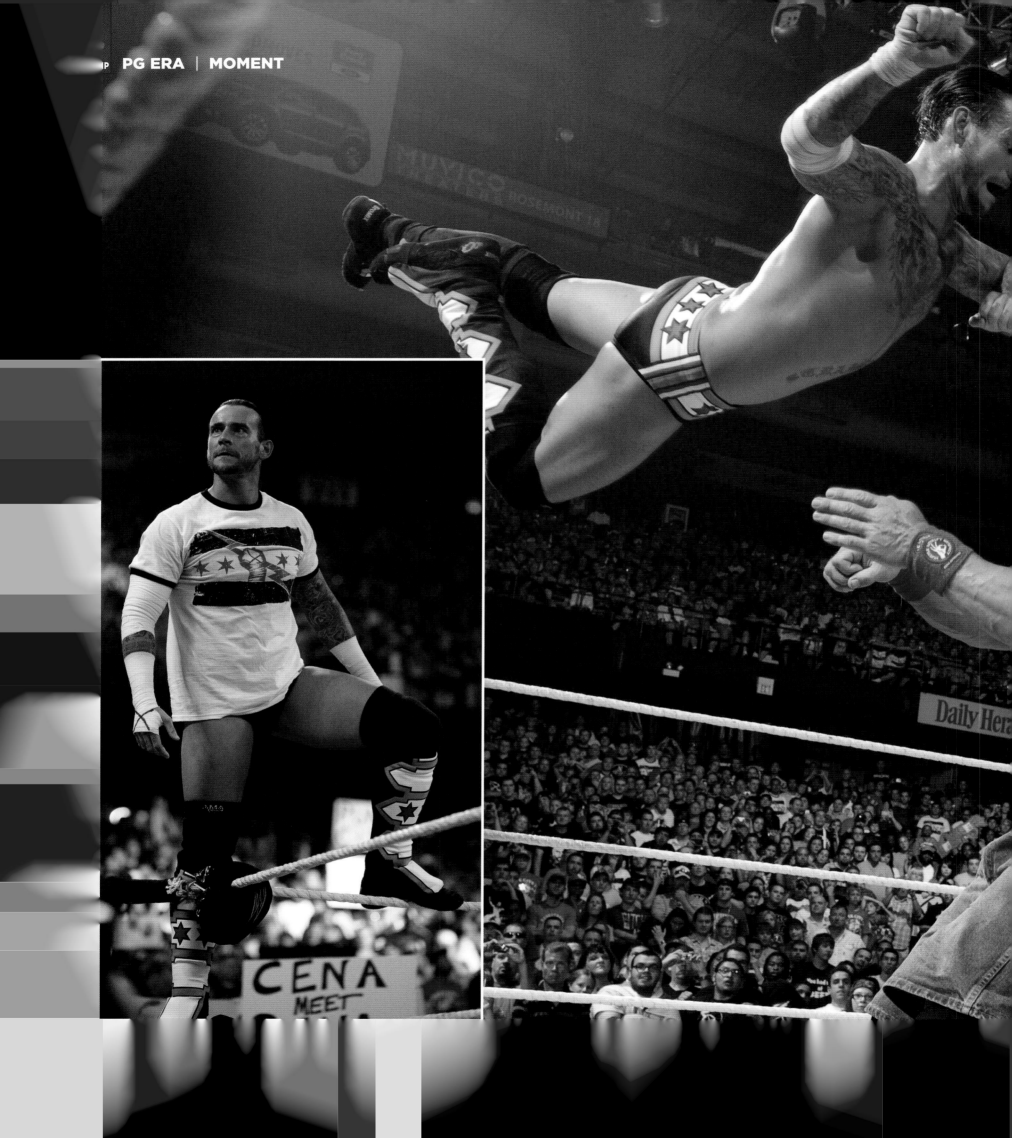

WHEN PUNK WENT ROGUE

IN JUNE 2011, CM PUNK WAS DRAWING closer and closer to the top of the ladder in WWE. In one week, he managed to pin Rey Mysterio, WWE Champion John Cena and Alberto Del Rio to become the number-one contender for the title. Not long after, he appeared on *Raw*, where he delivered his infamous "Pipe Bomb" promo. In a blistering tirade, he called out everyone in WWE management for their backstage politics, manipulative tactics, and for pushing certain Superstars while allowing others to languish in obscurity. Announcing that his WWE contract expired on the same day as the 2011 *Money in the Bank* event, Punk revealed his intention to win the WWE Championship and leave WWE with the title in hand. He also threatened to take the title to other promotions and defend it, a claim which led to his removal from the title match at *Money in the Bank*.

Cena protested Punk's ejection from the match, threatening to quit unless he was reinstated. Mr. McMahon eventually acquiesced to Cena's demand, with the proviso that, if he lost, Cena would be fired. Cena agreed to the condition and the match was on.

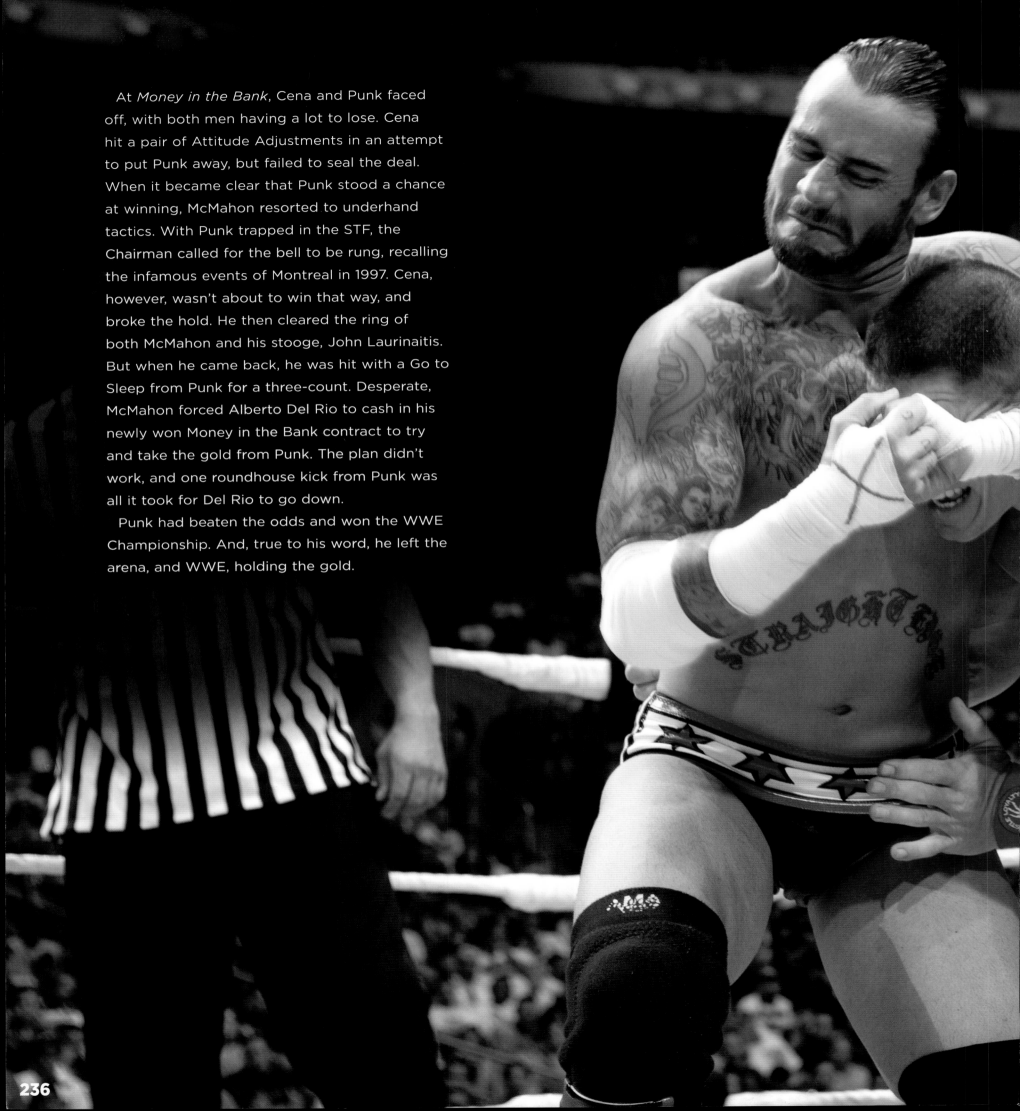

At *Money in the Bank*, Cena and Punk faced off, with both men having a lot to lose. Cena hit a pair of Attitude Adjustments in an attempt to put Punk away, but failed to seal the deal. When it became clear that Punk stood a chance at winning, McMahon resorted to underhand tactics. With Punk trapped in the STF, the Chairman called for the bell to be rung, recalling the infamous events of Montreal in 1997. Cena, however, wasn't about to win that way, and broke the hold. He then cleared the ring of both McMahon and his stooge, John Laurinaitis. But when he came back, he was hit with a Go to Sleep from Punk for a three-count. Desperate, McMahon forced Alberto Del Rio to cash in his newly won Money in the Bank contract to try and take the gold from Punk. The plan didn't work, and one roundhouse kick from Punk was all it took for Del Rio to go down.

Punk had beaten the odds and won the WWE Championship. And, true to his word, he left the arena, and WWE, holding the gold.

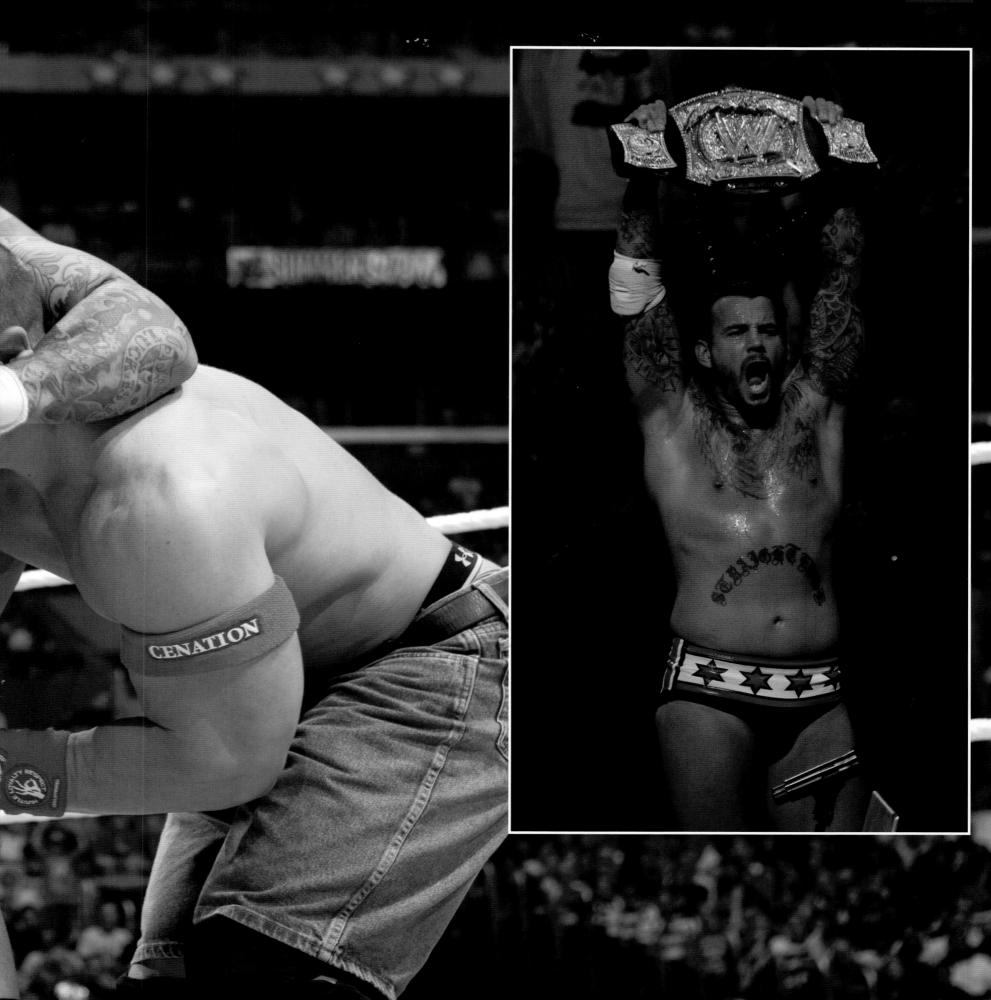

CM PUNK

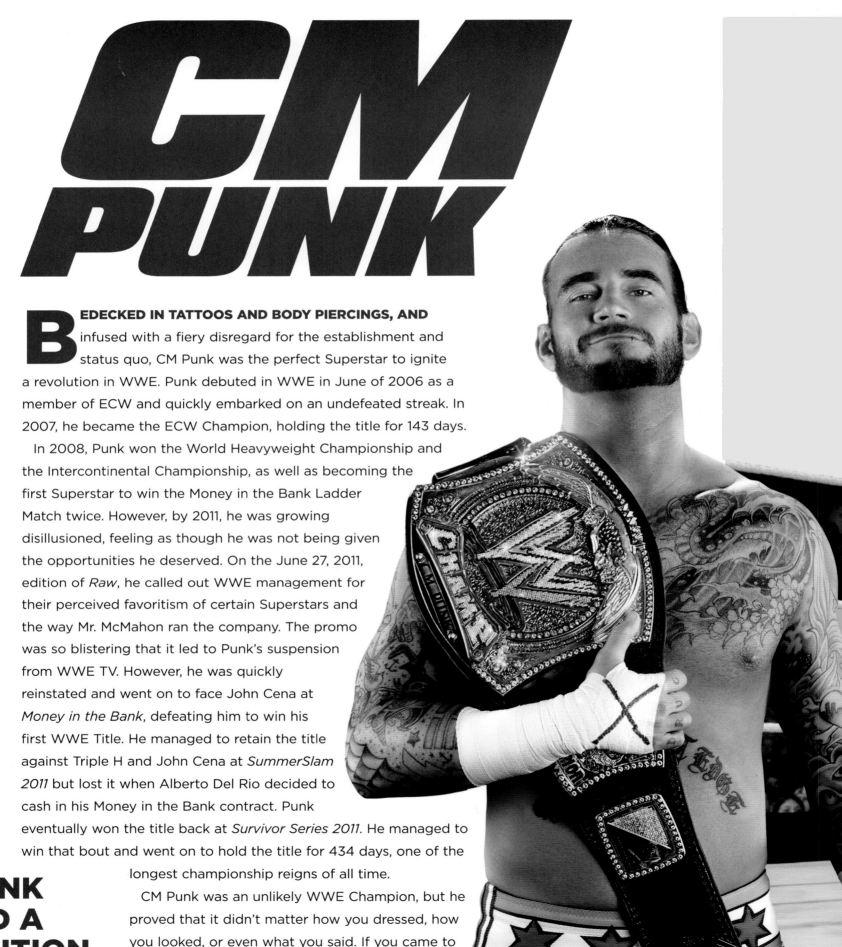

BEDECKED IN TATTOOS AND BODY PIERCINGS, AND infused with a fiery disregard for the establishment and status quo, CM Punk was the perfect Superstar to ignite a revolution in WWE. Punk debuted in WWE in June of 2006 as a member of ECW and quickly embarked on an undefeated streak. In 2007, he became the ECW Champion, holding the title for 143 days.

In 2008, Punk won the World Heavyweight Championship and the Intercontinental Championship, as well as becoming the first Superstar to win the Money in the Bank Ladder Match twice. However, by 2011, he was growing disillusioned, feeling as though he was not being given the opportunities he deserved. On the June 27, 2011, edition of *Raw*, he called out WWE management for their perceived favoritism of certain Superstars and the way Mr. McMahon ran the company. The promo was so blistering that it led to Punk's suspension from WWE TV. However, he was quickly reinstated and went on to face John Cena at *Money in the Bank*, defeating him to win his first WWE Title. He managed to retain the title against Triple H and John Cena at *SummerSlam 2011* but lost it when Alberto Del Rio decided to cash in his Money in the Bank contract. Punk eventually won the title back at *Survivor Series 2011*. He managed to win that bout and went on to hold the title for 434 days, one of the longest championship reigns of all time.

CM Punk was an unlikely WWE Champion, but he proved that it didn't matter how you dressed, how you looked, or even what you said. If you came to every match with the will of a champion, nothing could keep you from grabbing the gold.

"CM PUNK IGNITED A REVOLUTION IN WWE."

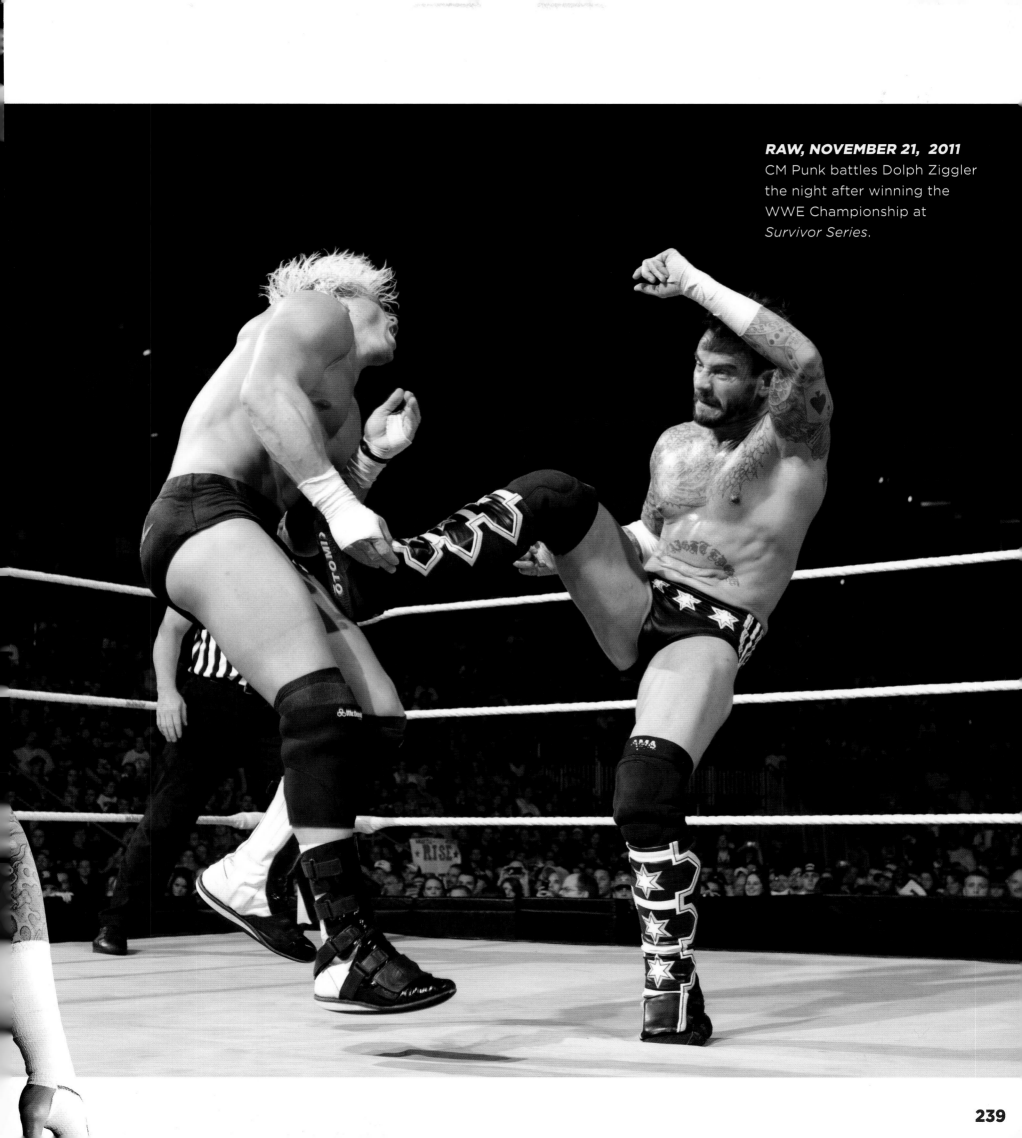

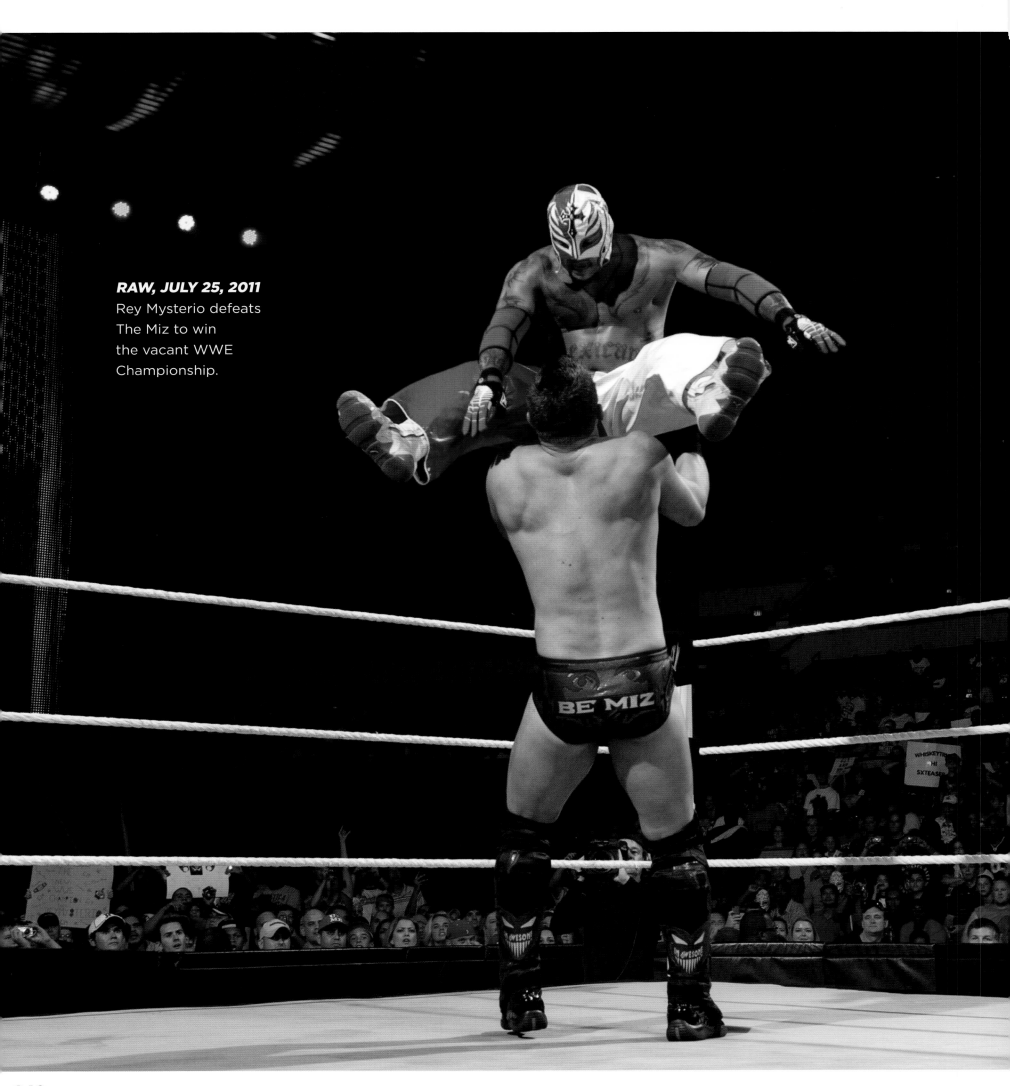

RAW, JULY 25, 2011
Rey Mysterio defeats The Miz to win the vacant WWE Championship.

REY MYSTERIO

FLYING THROUGH THE AIR, SWINGING THROUGH THE ropes and taking down Superstars with lightning speed, the masked Rey Mysterio is WWE's own superhero. Following a stint in ECW, Mysterio went to WCW, where he continued to dazzle audiences with his aerial style and spring-like leaps into and out of the ring. His match against Eddie Guerrero at the 1997 *Halloween Havoc* still ranks among WCW's all-time best.

In 2002, following the dissolution of WCW, Mysterio came to WWE, where he immediately became one of the promotion's top Superstars. His colorful costumes, elaborately decorated masks and aerial acrobatics made him popular with old and young members of the WWE Universe alike. In 2006, he shocked the world when he defeated both Randy Orton and Kurt Angle at *WrestleMania 22* to win the World Heavyweight Championship. He would go on to win the title a second time in 2010 when he won a Fatal 4-Way Match at *Fatal 4-Way* in Uniondale, New York.

Still, for all of his achievements, Rey had yet to claim the WWE Championship. He finally landed his opportunity on *Raw* in 2011 when he defeated The Miz in the finals of a tournament to crown a new champion. Unfortunately for Mysterio, his reign was short, as he lost the title to John Cena that night.

Being only a one-time WWE Champion, however, does not exclude Rey Mysterio from the list of all-time greats. And, with his run in WWE still ongoing, there's always a chance that the gold will find its way back to the Ultimate Underdog before long.

> **"FLYING THROUGH THE AIR, THE MASKED REY MYSTERIO IS WWE'S OWN SUPERHERO."**

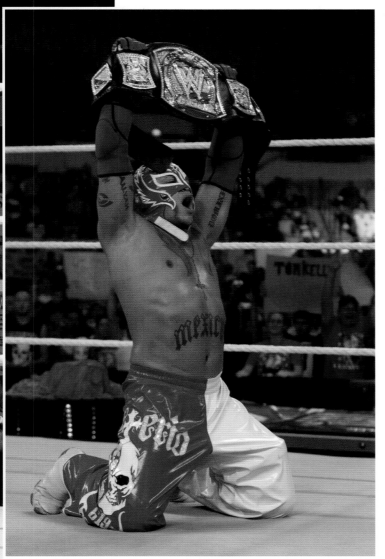

ALBERTO DEL RIO

HAILING FROM SAN LUIS POTOSI, MEXICO, Alberto Del Rio is the son of legendary luchador Dos Caras. After competing in various promotions in Mexico and Japan, Del Rio made his WWE television debut in 2010, competing unmasked as a wealthy aristocrat. He defeated Rey Mysterio in the main event of the *SmackDown* edition, with his signature submission move, the Cross Armbreaker. The following year his pursuit of the greatest title in WWE began. After defeating seven other Superstars at *Money in the Bank* for a shot at the WWE Title any time in the next year, he tried to cash in his contract that same night against CM Punk but was taken down before he had the chance. At *SummerSlam 2011*, he eventually cashed in his contract and quickly secured a pinfall of CM Punk, to win his first WWE

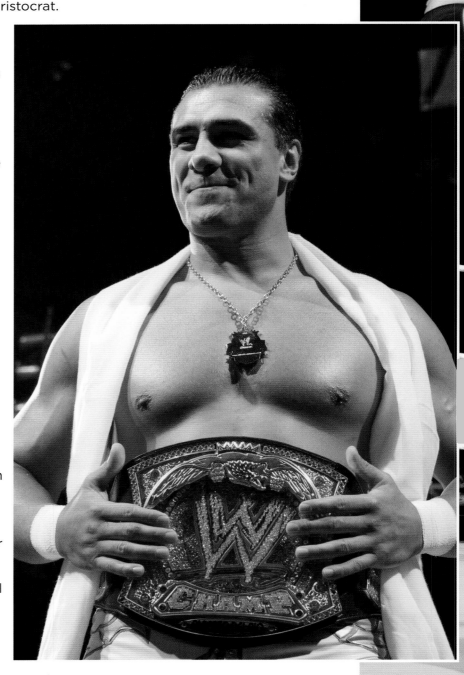

"DEL RIO MADE HISTORY BY BECOMING THE FIRST EVER MEXICAN-BORN WWE CHAMPION."

Title. Del Rio made history by becoming the first ever Mexican-born WWE Champion. He successfully defended the title against Rey Mysterio the following night on *Raw* but was overcome by John Cena at 2011's *Night of Champions*.

In early October 2011 he reclaimed the championship from Cena at *Hell in a Cell*, before successfully retaining in a challenge from Cena at *Vengeance*. His second title reign ended at *Survivor Series* in November when he dropped the title to Punk. A pioneer and a technical master, Alberto Del Rio reached the peak of the mountain twice and overcame his rivals in the ring, earning the moniker of the Essence of Excellence.

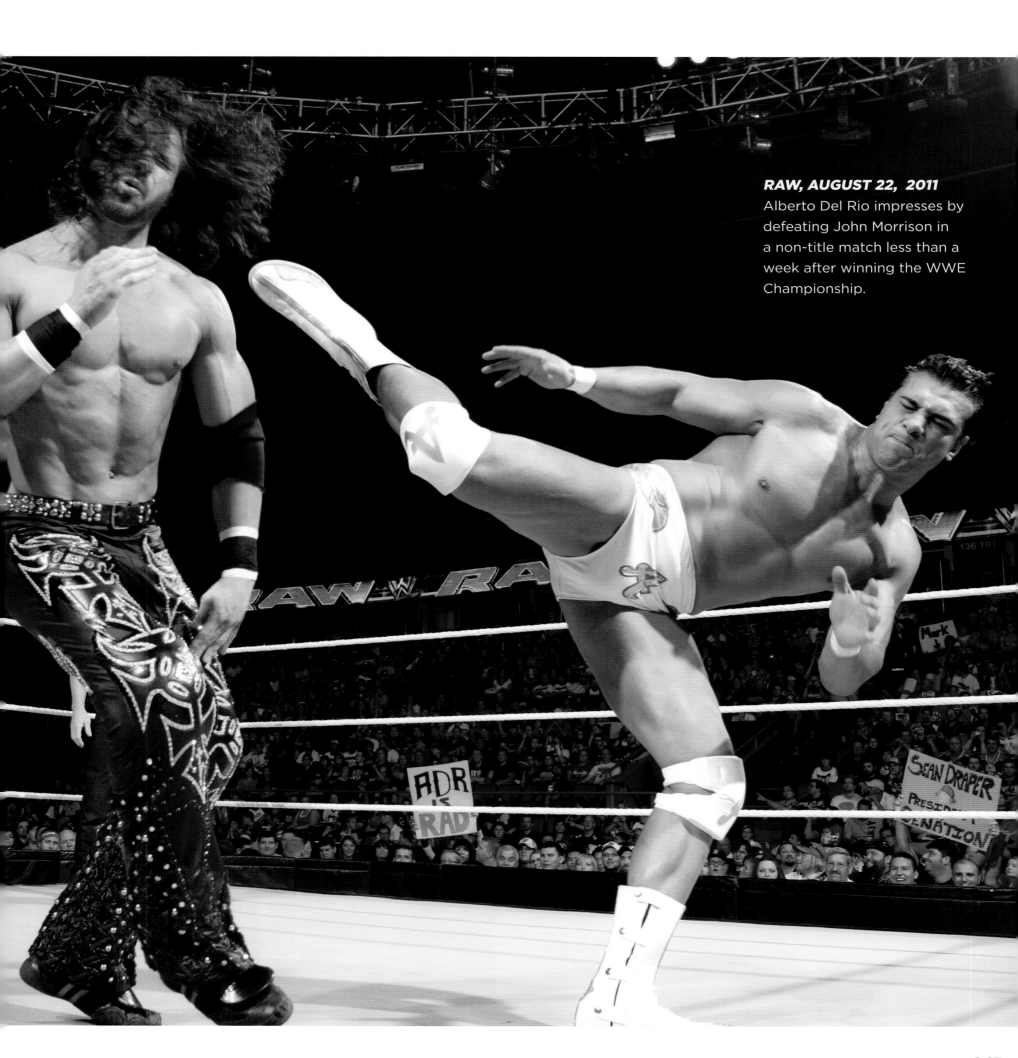

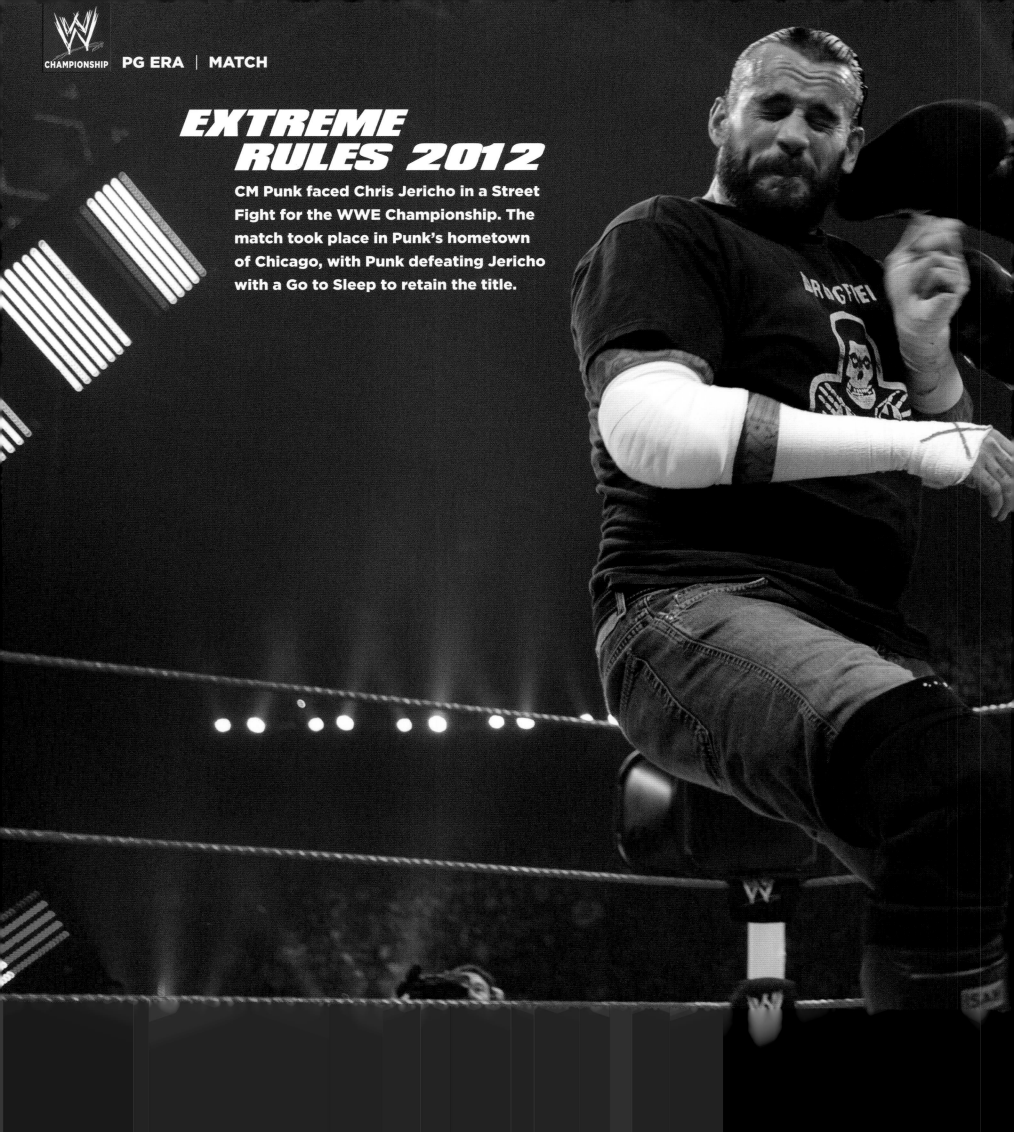

EXTREME RULES 2012

CM Punk faced Chris Jericho in a Street Fight for the WWE Championship. The match took place in Punk's hometown of Chicago, with Punk defeating Jericho with a Go to Sleep to retain the title.

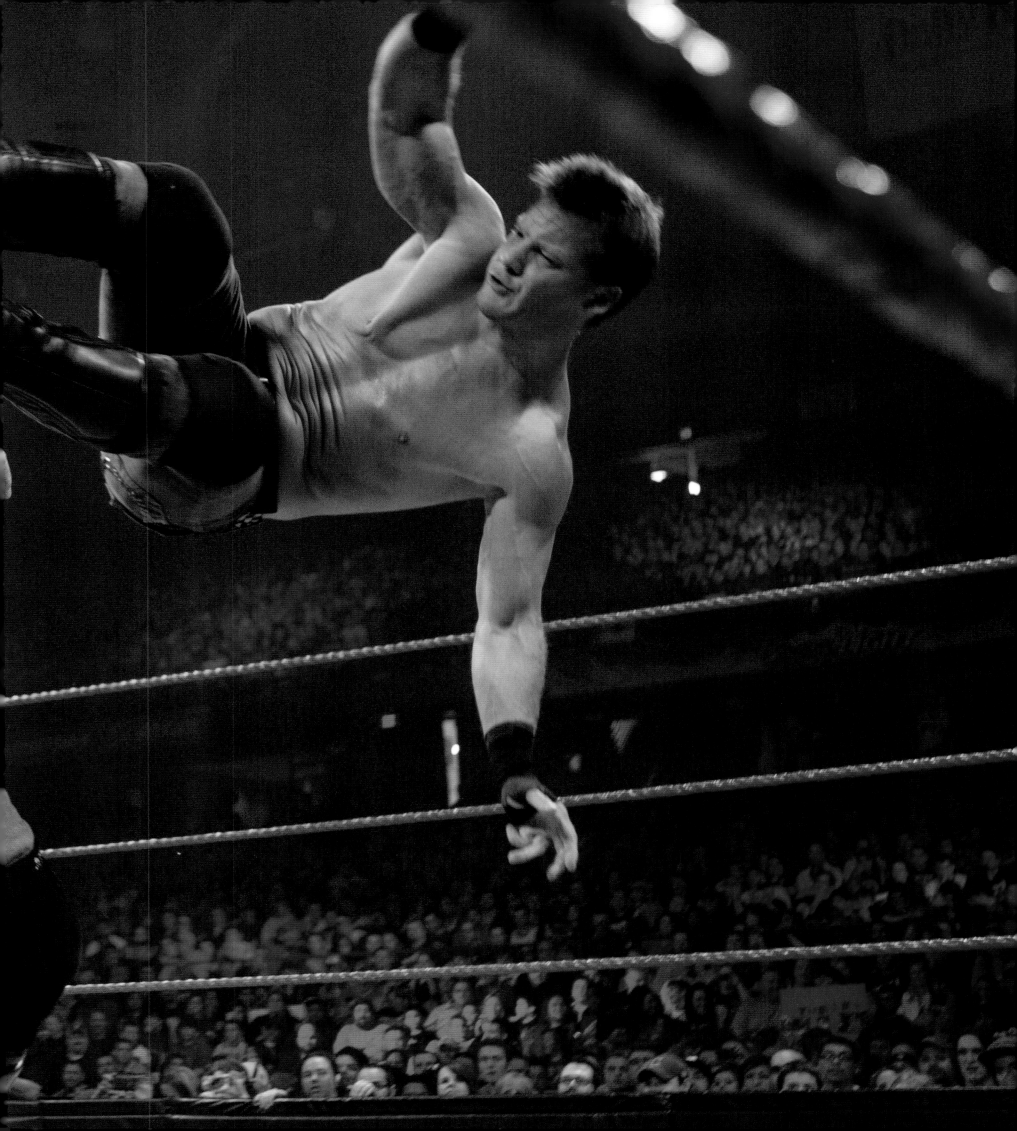

SUMMER SLAM

DANIEL BRYAN VS. JOHN CENA

IN THE SUMMER OF 2013, DANIEL BRYAN WAS inarguably the hottest Superstar in WWE. The WWE Universe was fully in his corner, and so was the defending champion, John Cena, who actually selected Bryan as his opponent, based on the response from the WWE Universe.

In the weeks leading up to *SummerSlam*, Mr. McMahon, who was decidedly not a fan of Bryan's, did everything he could to try and break Bryan's spirits, from putting him in Gauntlet Matches to having the commentators run him down. None of it worked, and Bryan came into *SummerSlam* hotter than ever. The chants of "YES! YES! YES!" as he walked to the ring echoed through the Staples Center and across Los Angeles.

Even though Cena had chosen Bryan to be his opponent, that didn't mean he was going to go easy on him. Adding to the drama, the match had Triple H acting as the guest referee. From the moment the bell rang, Cena drove hard at Bryan, sending him the message that, if he wanted the WWE Title, he was going to have to earn it. He threw everything from a suplex off the steps to a sitdown powerbomb at Bryan to put him out of commission. Bryan was not about to go down that easy, however, kicking out of an Attitude Adjustment and trapping Cena in a Yes! Lock.

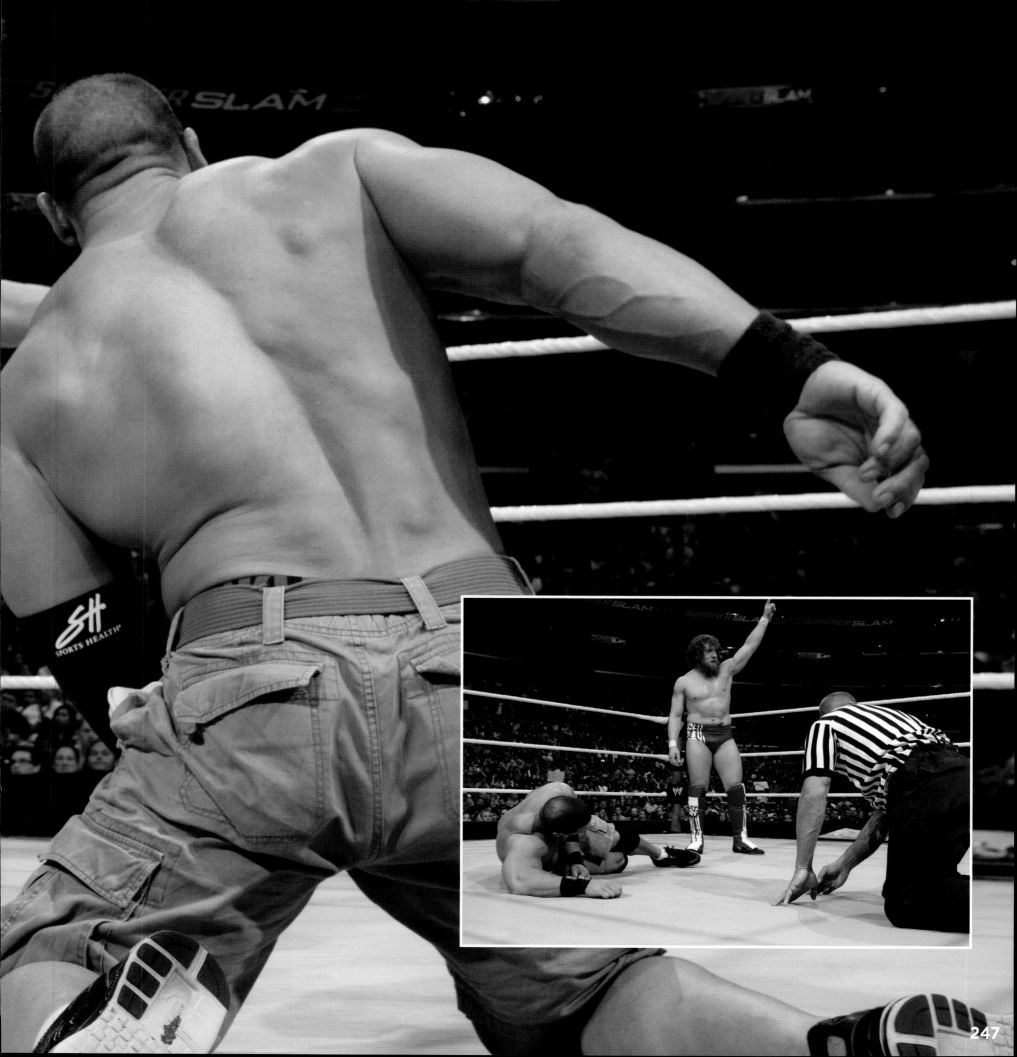

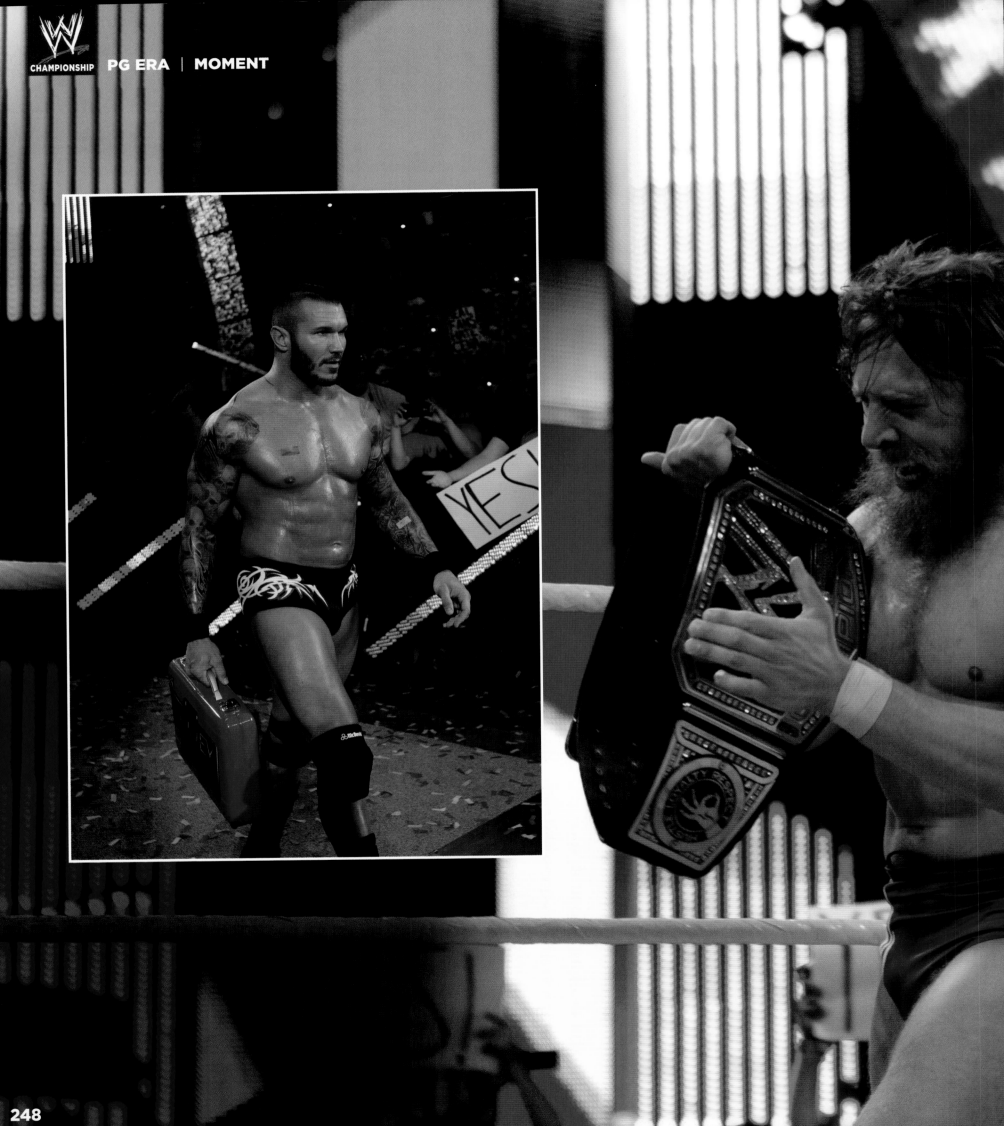

Finally, a flying knee took Cena down for the pinfall. Against all odds, Daniel Bryan had defied expectations and become the WWE Champion. That's when guest ref Triple H revealed his plan. Randy Orton came out to cash in his Money in the Bank contract and, in a shocking turn of events, The Game hit Bryan with a Pedigree, taking him out. Orton made a quick three-count and walked away with the title. The betrayal was so thick that everyone in the Staples Center could feel it. But it started a fire that even the powers that be could not contain, turning Bryan into WWE's biggest underdog.

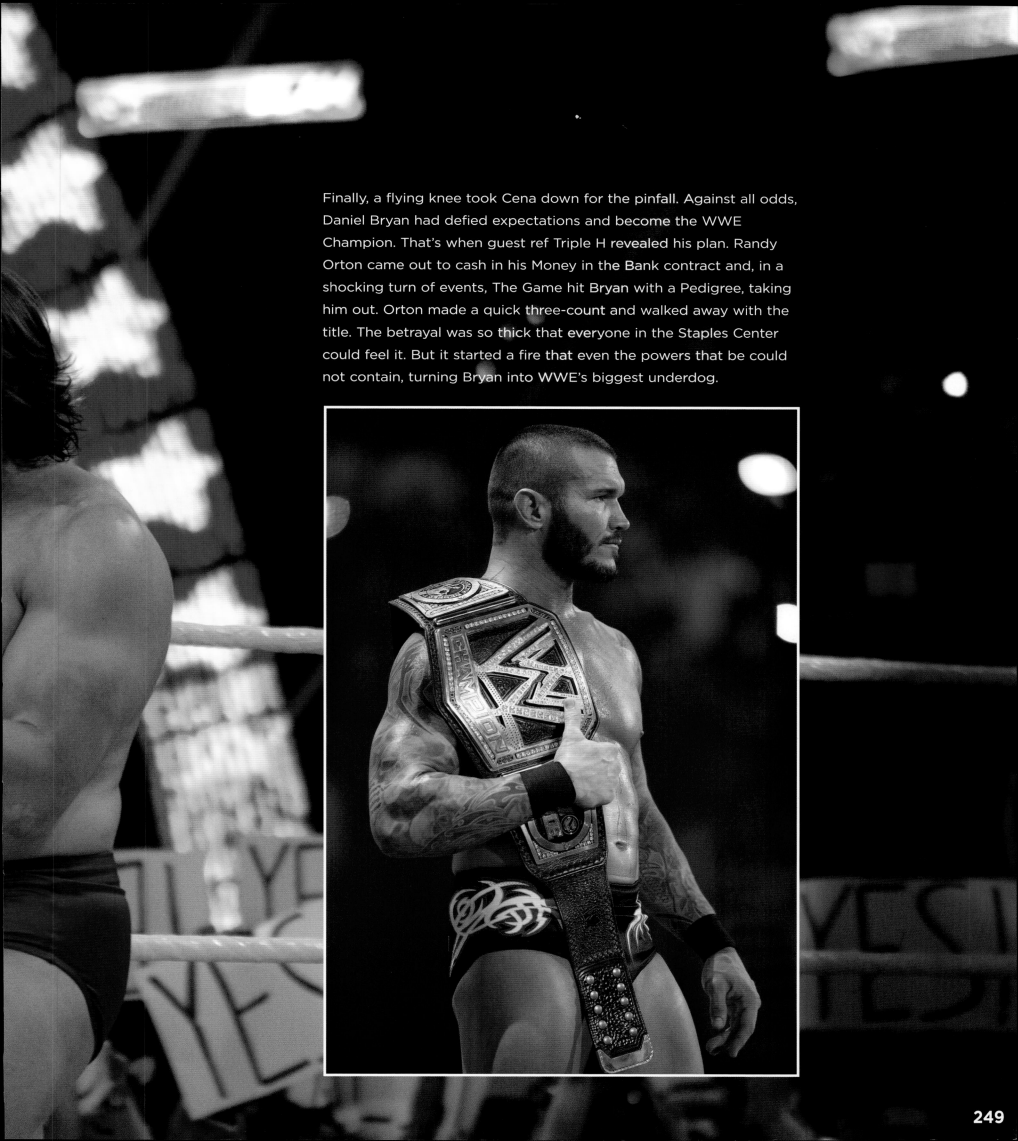

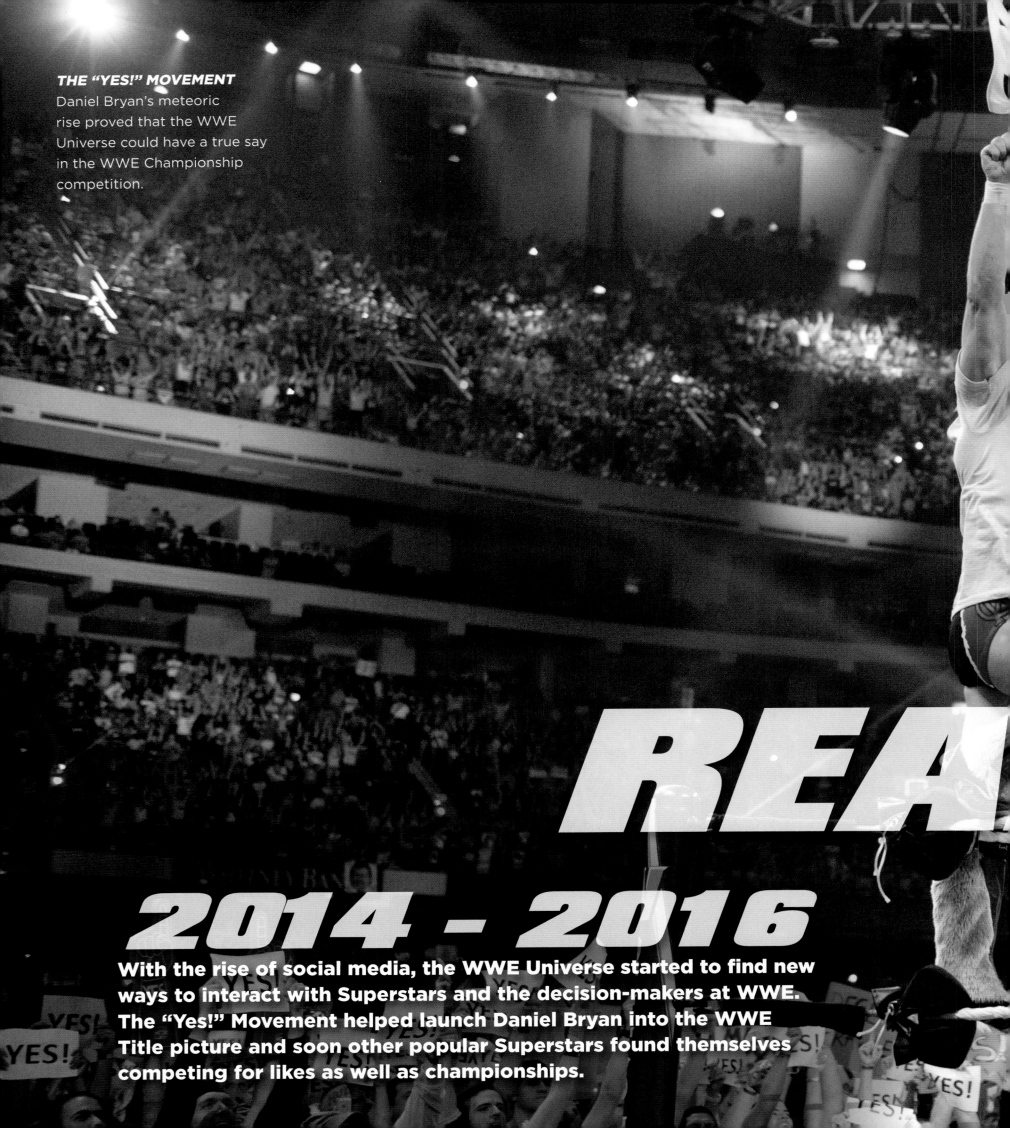

THE "YES!" MOVEMENT
Daniel Bryan's meteoric rise proved that the WWE Universe could have a true say in the WWE Championship competition.

REA

2014 - 2016

With the rise of social media, the WWE Universe started to find new ways to interact with Superstars and the decision-makers at WWE. The "Yes!" Movement helped launch Daniel Bryan into the WWE Title picture and soon other popular Superstars found themselves competing for likes as well as championships.

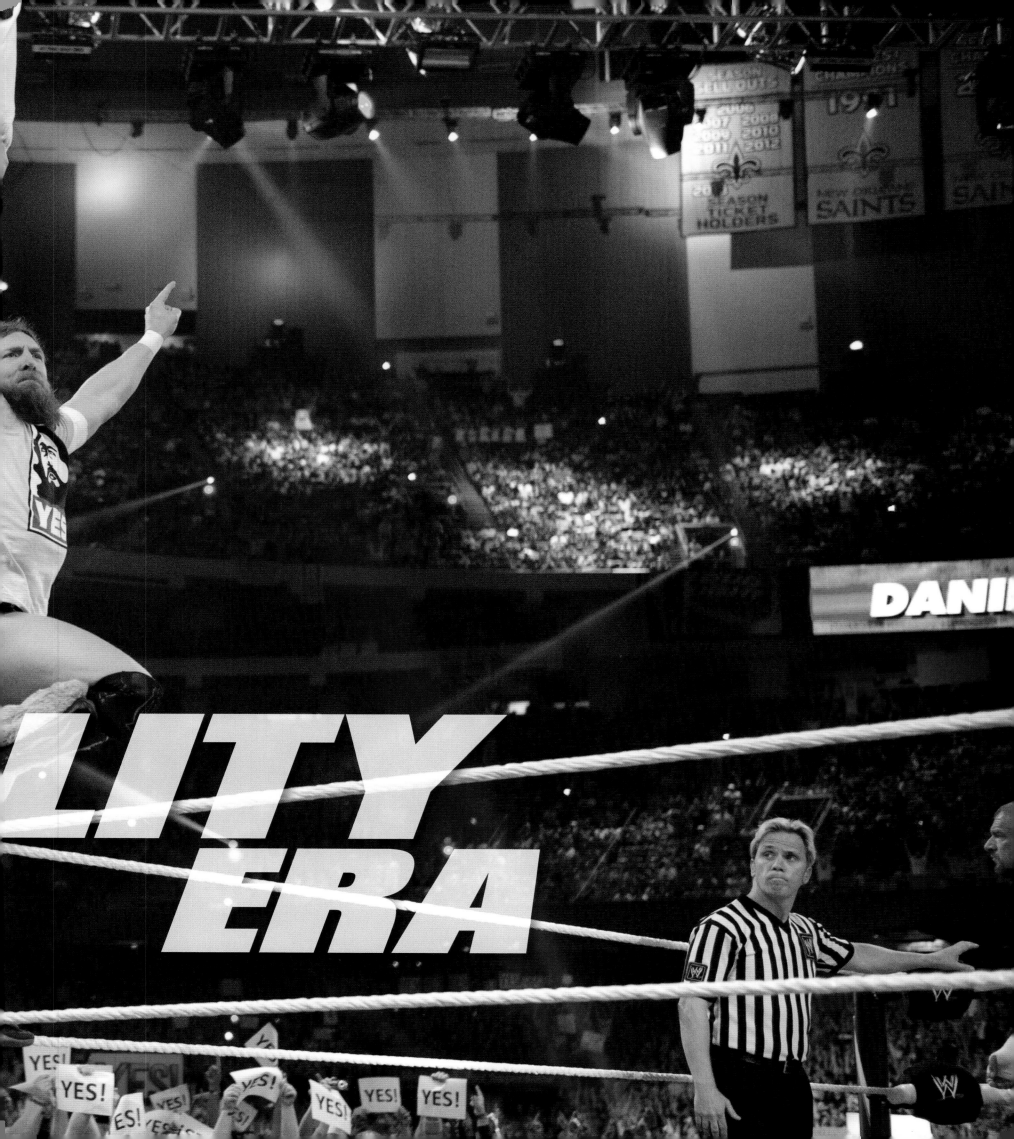

FOR YEARS, WWE HAD ALWAYS KNOWN

that one of its strongest assets was the WWE Universe. And, with the rise of social media, smart devices and streaming services, they now had the ability to get even closer to the action than ever before. This meant that, for the first time, the WWE Universe members had a way to voice their thoughts about Superstars, matches and outcomes beyond just cheers and boos in an arena. And they were prepared to use that voice.

The Reality Era had its beginnings in 2014, when Batista returned to WWE and won the Royal Rumble. While the Animal had long been a favorite among the WWE Universe, there was considerable outrage over the fact that Daniel Bryan, another beloved Superstar whose time the WWE Universe felt had come, was not even a part of the match. Bryan was being held in check by the ruling class of WWE, known as The Authority. Comprised of the most powerful people in the promotion, The Authority included Triple H, Stephanie McMahon, Mr. McMahon and a host of other Superstars. The Authority, and Triple H in particular, saw Bryan as a so-called "B-plus player," and were determined to do everything in their power to hold him down. But the WWE Universe wouldn't accept that.

The WWE Universe began to use their voices in earnest, speaking out loud across every available platform. The resentment created a ripple effect through the WWE Universe, culminating in a takeover on *Raw* in which the they stormed the ring, refusing to end the occupation until Bryan was given a shot at the title at *WrestleMania 30*. This match was for the WWE World Heavyweight Championship, as the WWE and World Heavyweight Titles had been unified by Randy Orton at *TLC: Tables, Ladders & Chairs* in December 2013.

In order to earn his shot at the gold, Daniel Bryan first had to defeat Triple H in the opening bout at *WrestleMania 30*. Having successfully completed that task, Bryan faced Batista and Randy Orton in a Triple Threat Match main event for the championship. In one of *WrestleMania*'s most iconic moments, Bryan managed to take down both competitors to hold the titles aloft and walk out of New Orleans as the WWE World Heavyweight Champion.

Bryan held the title until June 2014, when a neck injury forced him to vacate the gold. It was then picked up by John Cena in an eight-man Ladder Match at *Money in the Bank*. Cena's reign was short, as he lost the title to Brock Lesnar at the 2014 *SummerSlam*. At this time, the dual titles were fused into a single championship with a new design revealed by Triple H on *Raw*.

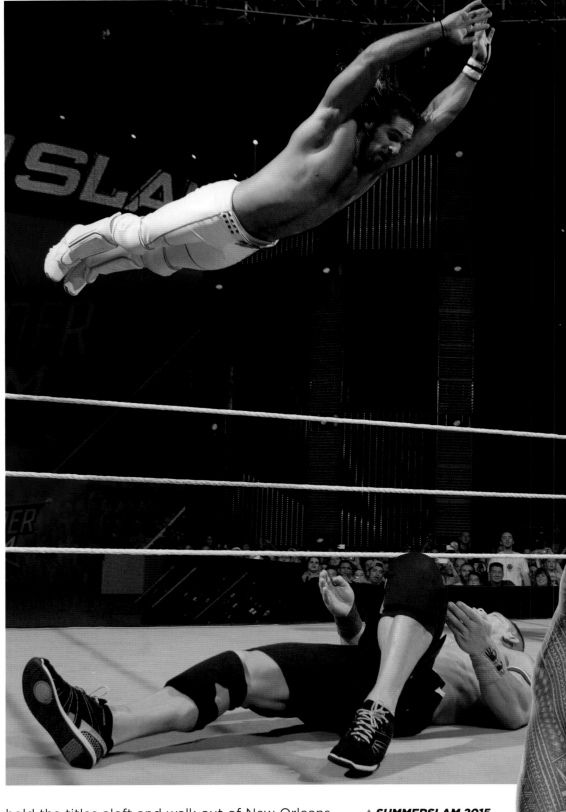

▲ *SUMMERSLAM 2015*
Seth Rollins defeated John Cena to become a double champion, holding both the WWE and United States Championships.

▶ *THE BIG DOG*
Roman Reigns, alongside his former partners in The Shield, would dominate the WWE Championship scene in 2015 and 2016.

Lesnar's *SummerSlam* victory kicked off a rampaging title run that lasted all the way to *WrestleMania 31*. On that night, Seth Rollins cashed in his Money in the Bank title shot on an exhausted Lesnar. History repeated itself that November, when Rollins was injured and forced to vacate the title. This led to his former Shield teammate Roman Reigns capturing the WWE Title at *Survivor Series*, only to lose it immediately to a cashing-in by Sheamus. Reigns continued his pursuit of WWE's biggest prize, winning it back on *Raw*, but surrendering it to Triple H at the 2016 *Royal Rumble*. This was the first Royal Rumble

"THE WWE UNIVERSE BEGAN TO SPEAK OUT."

since 1992 where the winner of the bout would also claim the WWE Title. Reigns was not about to take the loss lying down, however. He faced off against The Game at *WrestleMania 32* and defeated him to win his third WWE Championship.

At *Payback* that year, Roman Reigns successfully defended the title against AJ Styles, and The Authority officially disbanded with WWE announcing the start of "The New Era." What would come next was anyone's guess, but one thing was for certain. Competition for the WWE Championship was only going to get hotter.

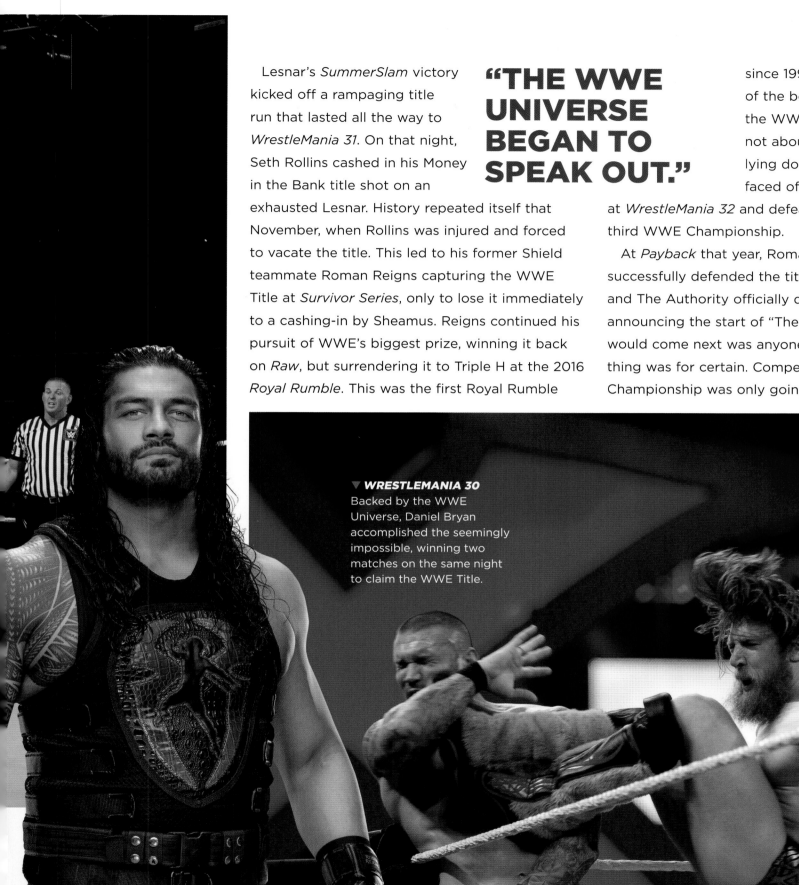

▼ **WRESTLEMANIA 30**
Backed by the WWE Universe, Daniel Bryan accomplished the seemingly impossible, winning two matches on the same night to claim the WWE Title.

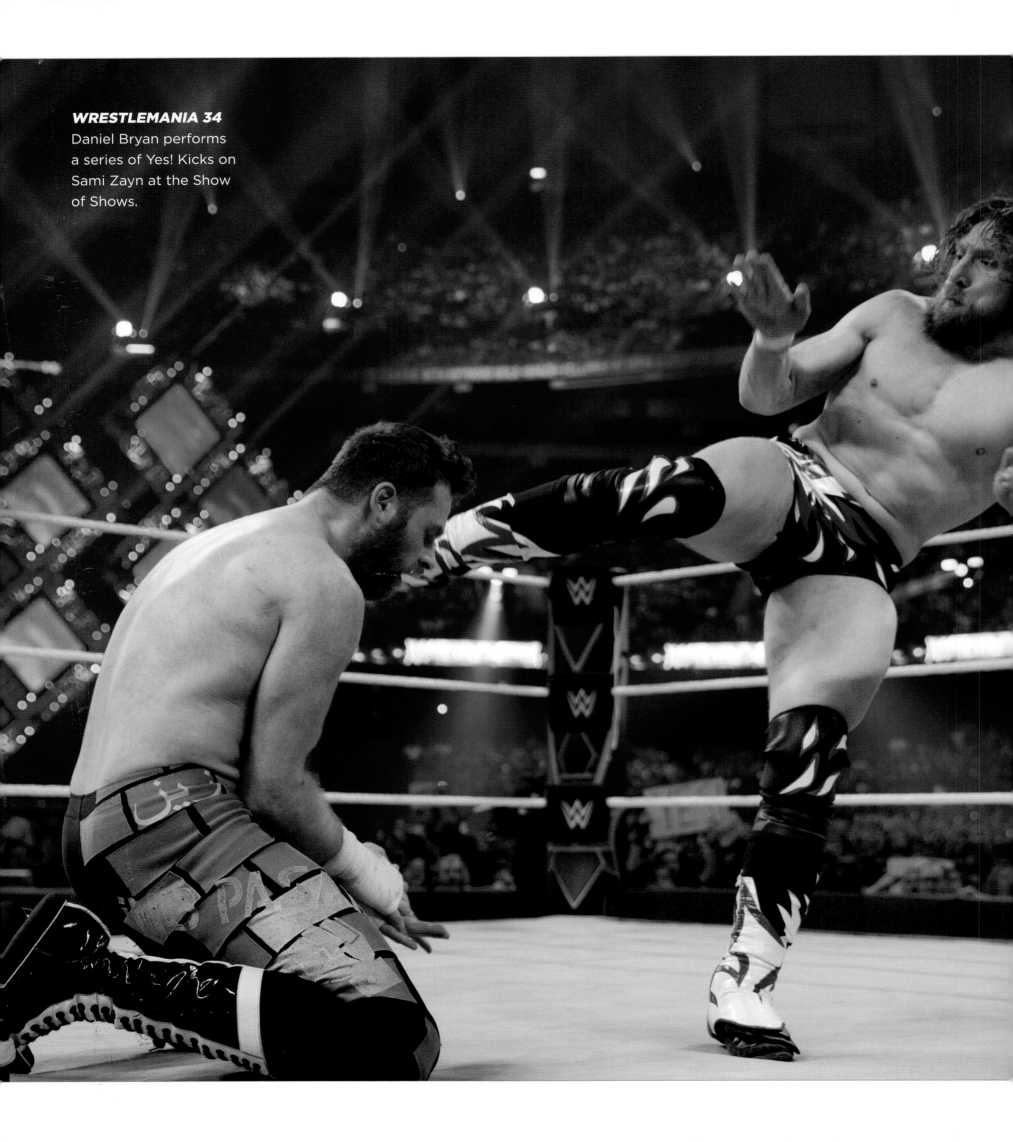

WRESTLEMANIA 34
Daniel Bryan performs a series of Yes! Kicks on Sami Zayn at the Show of Shows.

DANIEL BRYAN

HE DIDN'T FIT MR. MCMAHON'S VISION OF WHAT A WWE Superstar should look like, but Daniel Bryan defied expectations. Arriving in WWE in 2009, Bryan quickly proved to the WWE Universe that he was a force to be reckoned with, winning the United States Championship and World Heavyweight Championship.

At the 2013 *SummerSlam* that Bryan overcame John Cena to win his first WWE Championship. However, shockingly, guest referee Triple H then hit the Leader of the "Yes!" Movement with a Pedigree, allowing Randy Orton to cash in his Money in the Bank contract and win the title. A month later at *Night of Champions*, Bryan defeated Orton, proving The Authority wrong with their claim that Bryan was only a "B-plus player." The following night on *Raw*, WWE COO Triple H declared the WWE Title was to be held in abeyance due to a fast three-count, before Orton reclaimed the title at *Hell in a Cell*. With Orton uniting the WWE Title and World Heavyweight Championship, the stage was set for *WrestleMania 30*. Bryan heroically overcame Orton and Batista in a Triple Threat Match to claim the gold, leading the WWE Universe in chants of "Yes!" After losing the title to Cena and spending time as *SmackDown* GM (2016-18), Bryan returned to the ring in 2018. On an episode of *SmackDown,* he took down AJ Styles with a low blow and a Running Knee to win his fourth WWE Championship. "The New" Daniel Bryan retained and introduced a new WWE Title made from "entirely sustainable materials." But after 144 days, the WWE Universe got behind Kofi Kingston, who ended Bryan's fourth reign at *WrestleMania 35*.

"AT WRESTLEMANIA 30, BRYAN CLAIMED THE GOLD, LEADING THE WWE UNIVERSE IN CHANTS OF YES!"

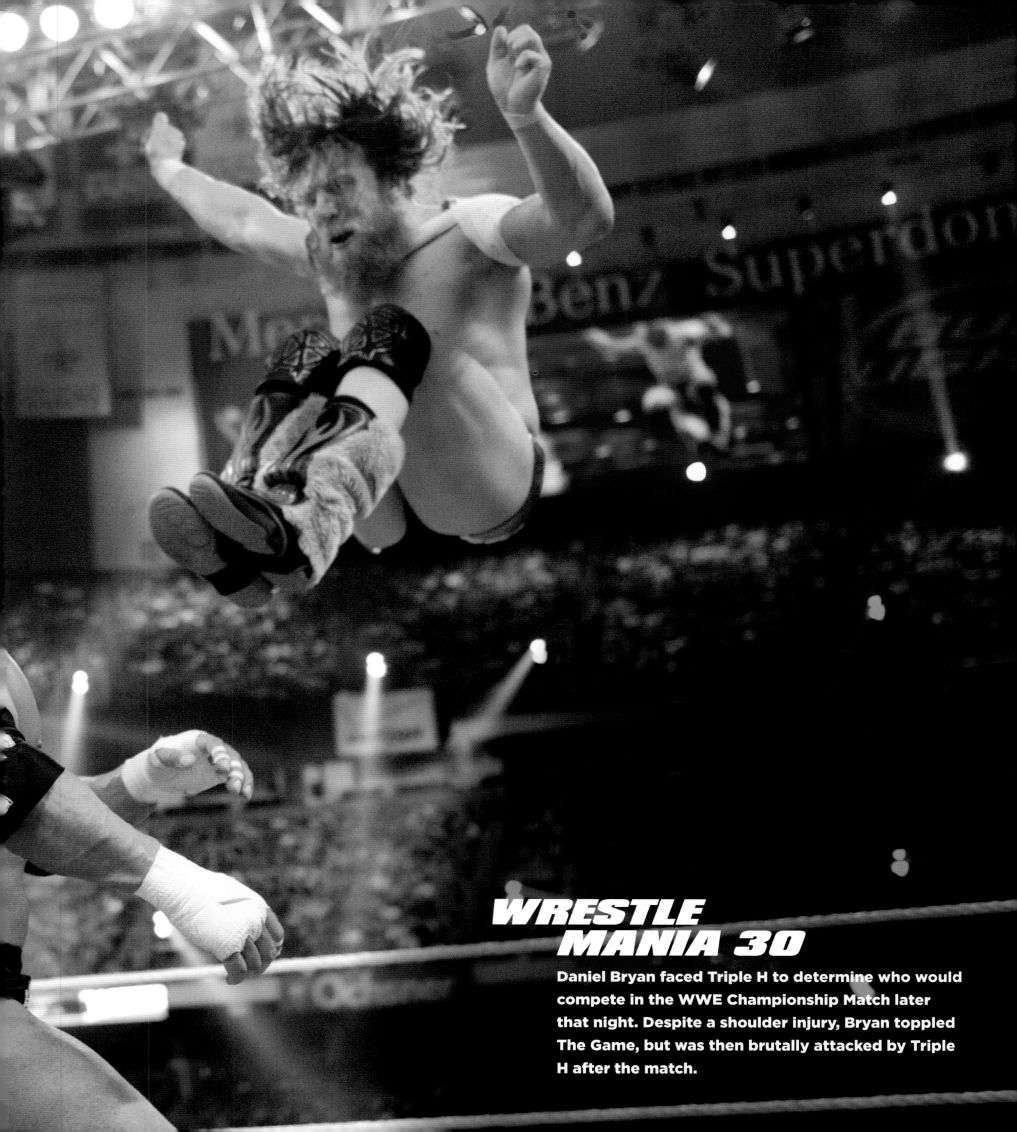

WRESTLE MANIA 30

Daniel Bryan faced Triple H to determine who would compete in the WWE Championship Match later that night. Despite a shoulder injury, Bryan toppled The Game, but was then brutally attacked by Triple H after the match.

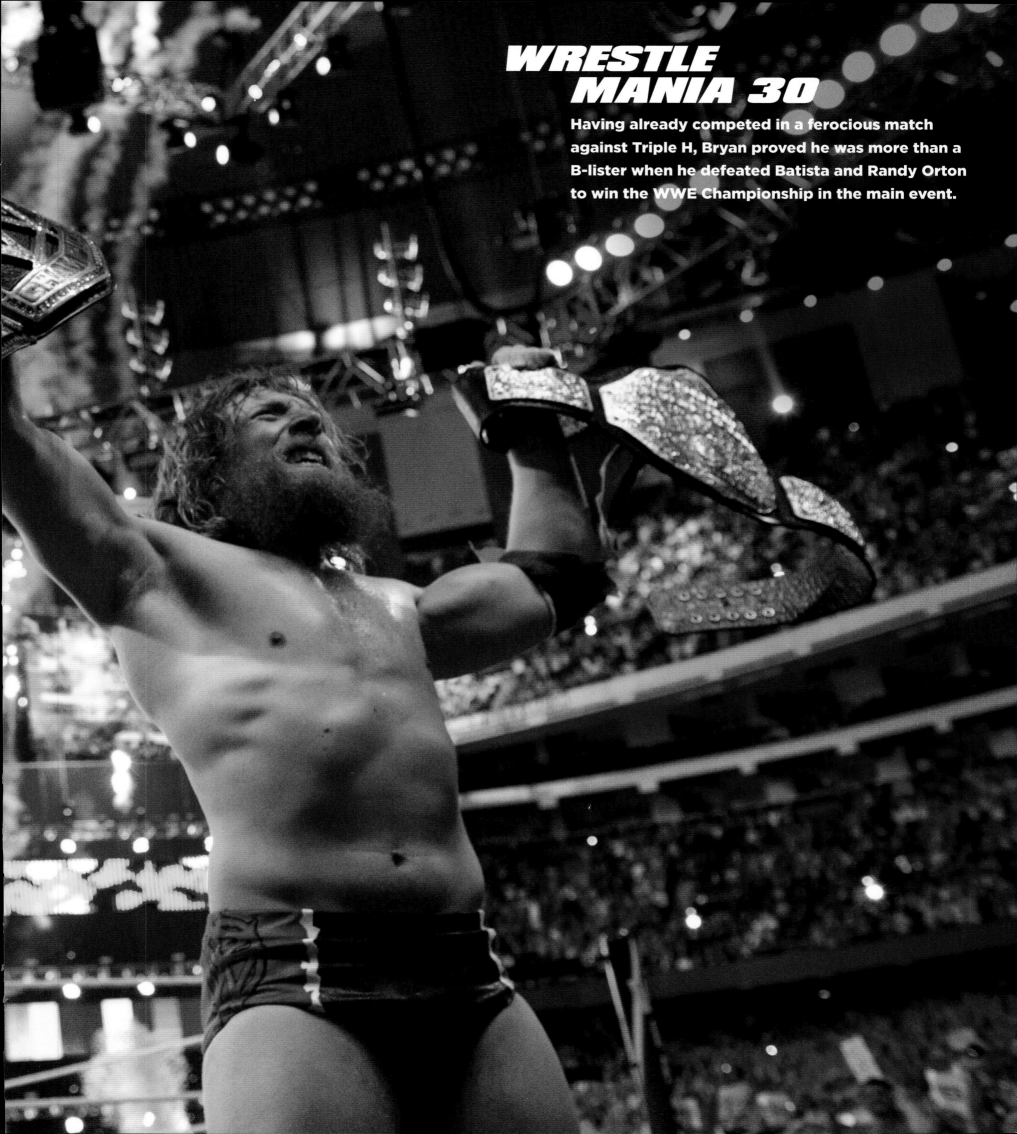

WRESTLE MANIA 30

Having already competed in a ferocious match against Triple H, Bryan proved he was more than a B-lister when he defeated Batista and Randy Orton to win the WWE Championship in the main event.

CASH AND GRAB

WHEN SETH ROLLINS WON THE contract for a championship opportunity at 2014's *Money in the Bank* pay-per-view it set up one of the most extraordinary and high-energy cash-ins in WWE history.

Having attempted to cash in the contract a few times prior to *WrestleMania 31*, and having each time been stopped by another WWE Superstar, Seth Rollins took no chances at the 31st Show of Shows. Waiting until Brock Lesnar and Roman Reigns had worn each other down, Rollins appeared during the end of the match, sprinting to the ring and turning the bout into a Triple Threat Match.

Attacking first Lesnar then Reigns, Seth managed to pin Roman to win his first WWE Championship, before sprinting back out of the ring. All in all, it took him just over two minutes! The stunning turn of events made Seth Rollins the first Superstar in WWE history to successfully cash in his Money in the Bank title opportunity at *WrestleMania*.

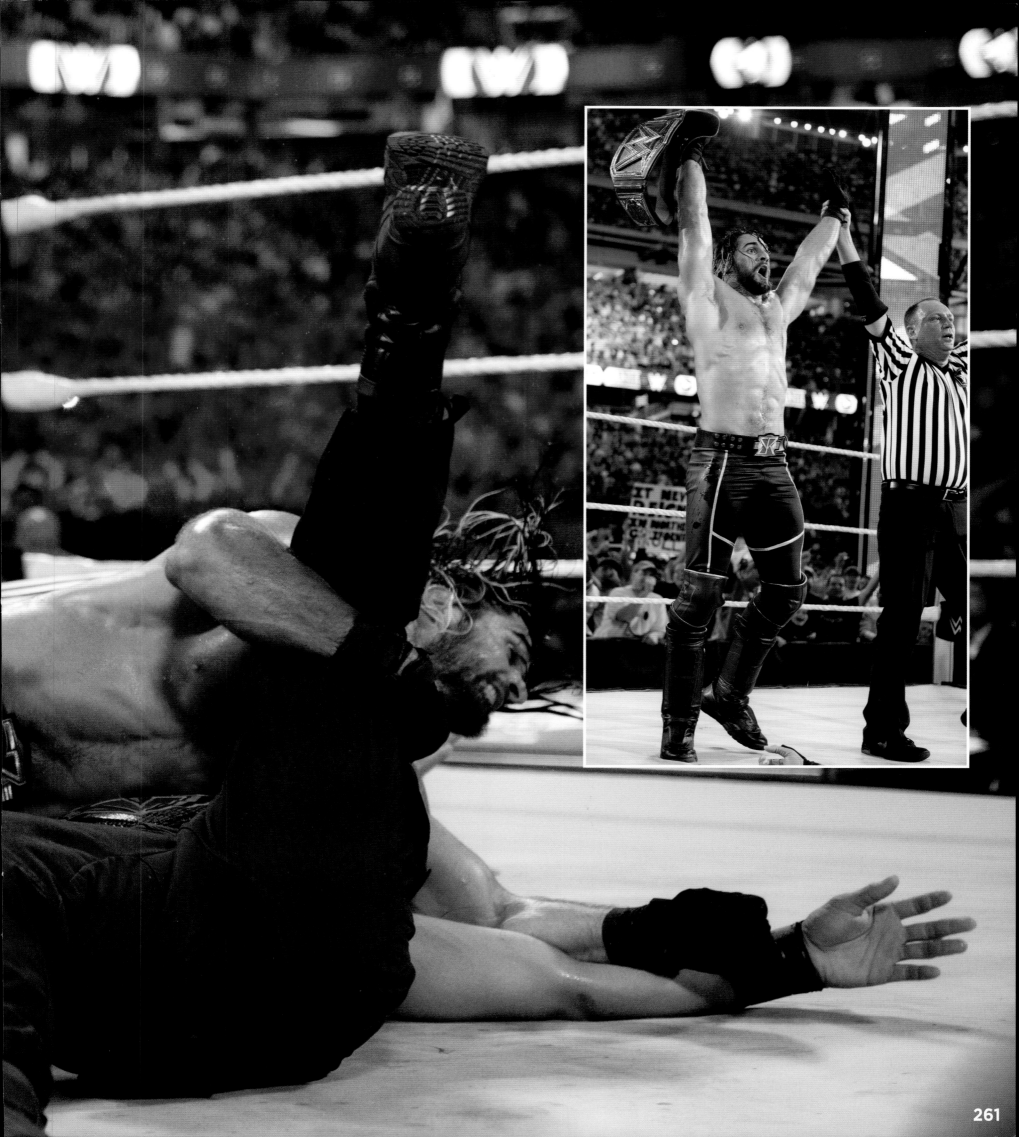

SETH ROLLINS

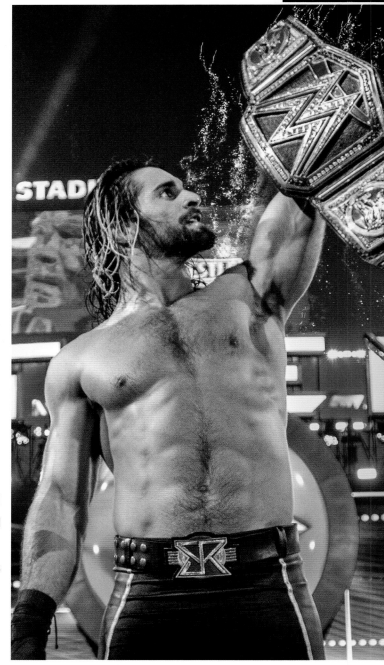

SETH ROLLINS IS SOMETIMES KNOWN AS THE ARCHITECT, and when you see the legacy he has constructed in WWE, it's pretty easy to understand why. From day one, Seth Rollins has been a man with a plan.

He debuted in 2012 as a member of the three-man stable known as The Shield, alongside Roman Reigns and Dean Ambrose. Although they denied having any affiliation with CM Punk, they seemed to initially target only Punk's rivals. However, their crusade against perceived injustice in WWE soon spread out, and they began to battle other opponents as well, eventually collecting a number of titles, including a WWE Tag Team Championship.

In June 2014, Rollins turned on The Shield and struck out on his own. At *WrestleMania 31*, during Roman's match against Brock Lesnar, Rollins cashed in his Money in the Bank contract, which he had won almost a year prior, and pinned Reigns to win the WWE Championship. He held the title for more than 200 days before having to vacate it due to an injury.

At the 2016 *Money in the Bank*, Rollins defeated Reigns in singles competition, becoming the first Superstar to do so, to win his second WWE Title. His reign was short-lived, as his former Shield partner, Dean Ambrose, cashed in the contract he had won earlier in the night, and in just nine seconds, took the gold for himself.

From beating Brock Lesnar for the Universal Title twice to being the only Superstar to hold both the WWE Championship and the United States Championship at once, Seth Rollins has one of the most impressive resumes of any WWE Superstar. Chances are that, before he hangs it up for good, he's looking at a few more runs with WWE gold.

"FROM DAY ONE, SETH ROLLINS HAS BEEN A MAN WITH A PLAN."

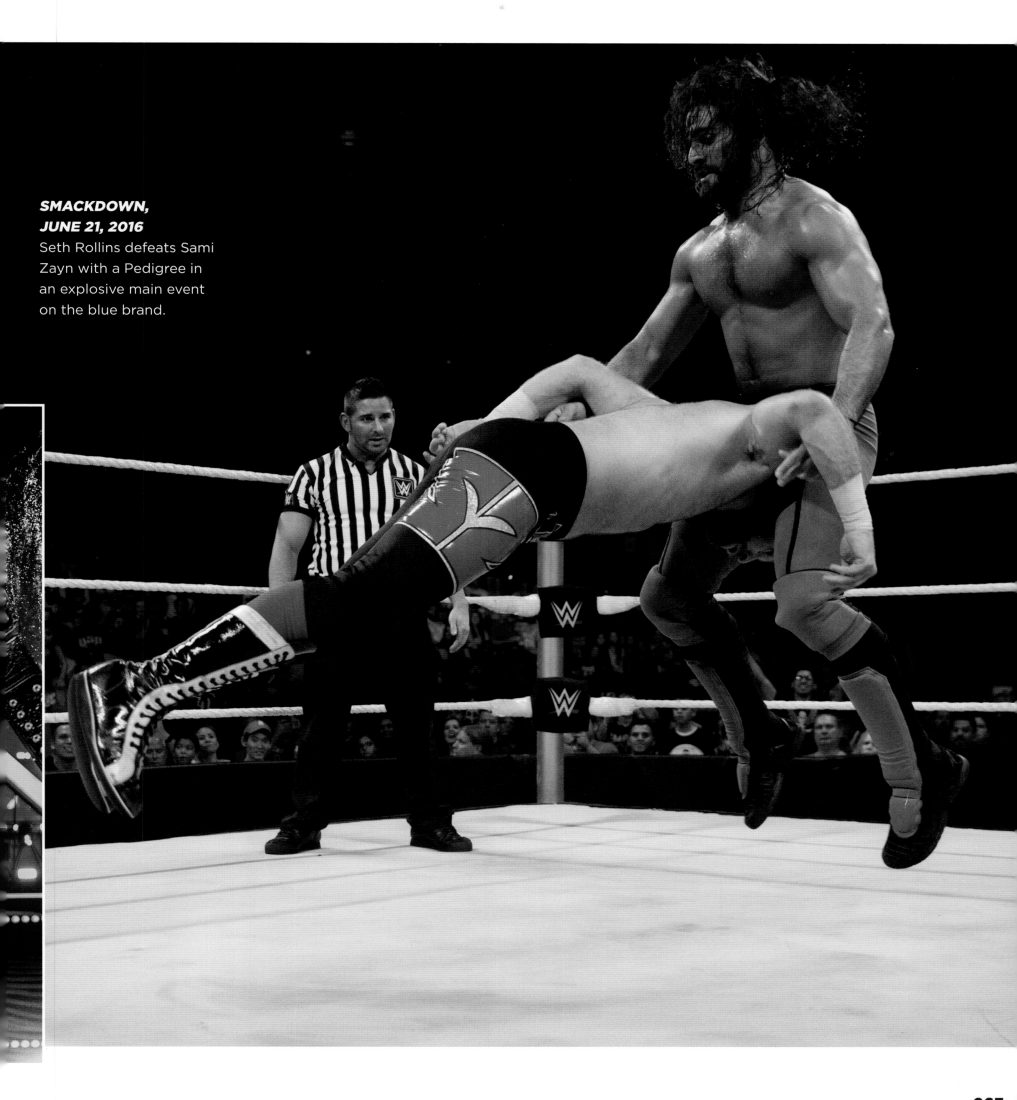

Seth Rollins defeats Sami Zayn with a Pedigree in an explosive main event on the blue brand.

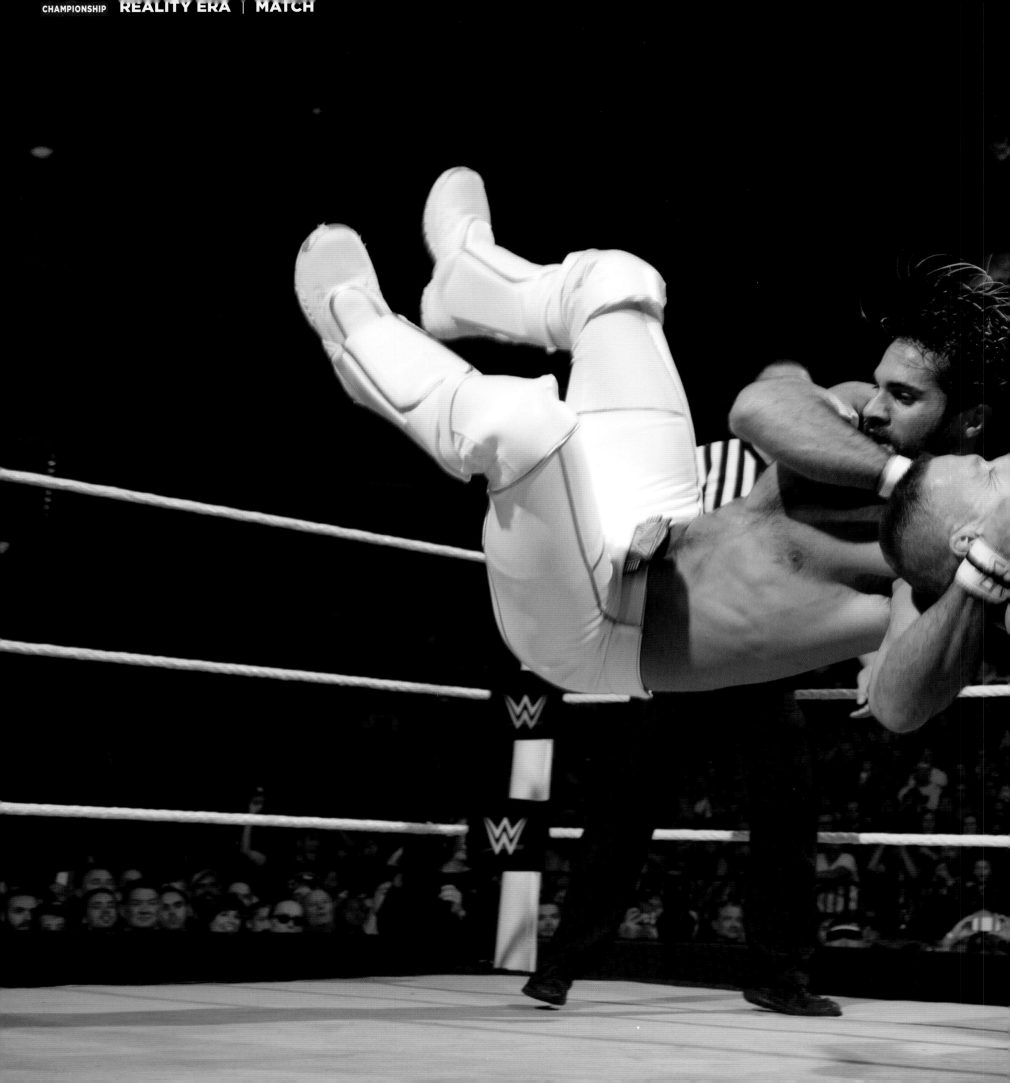

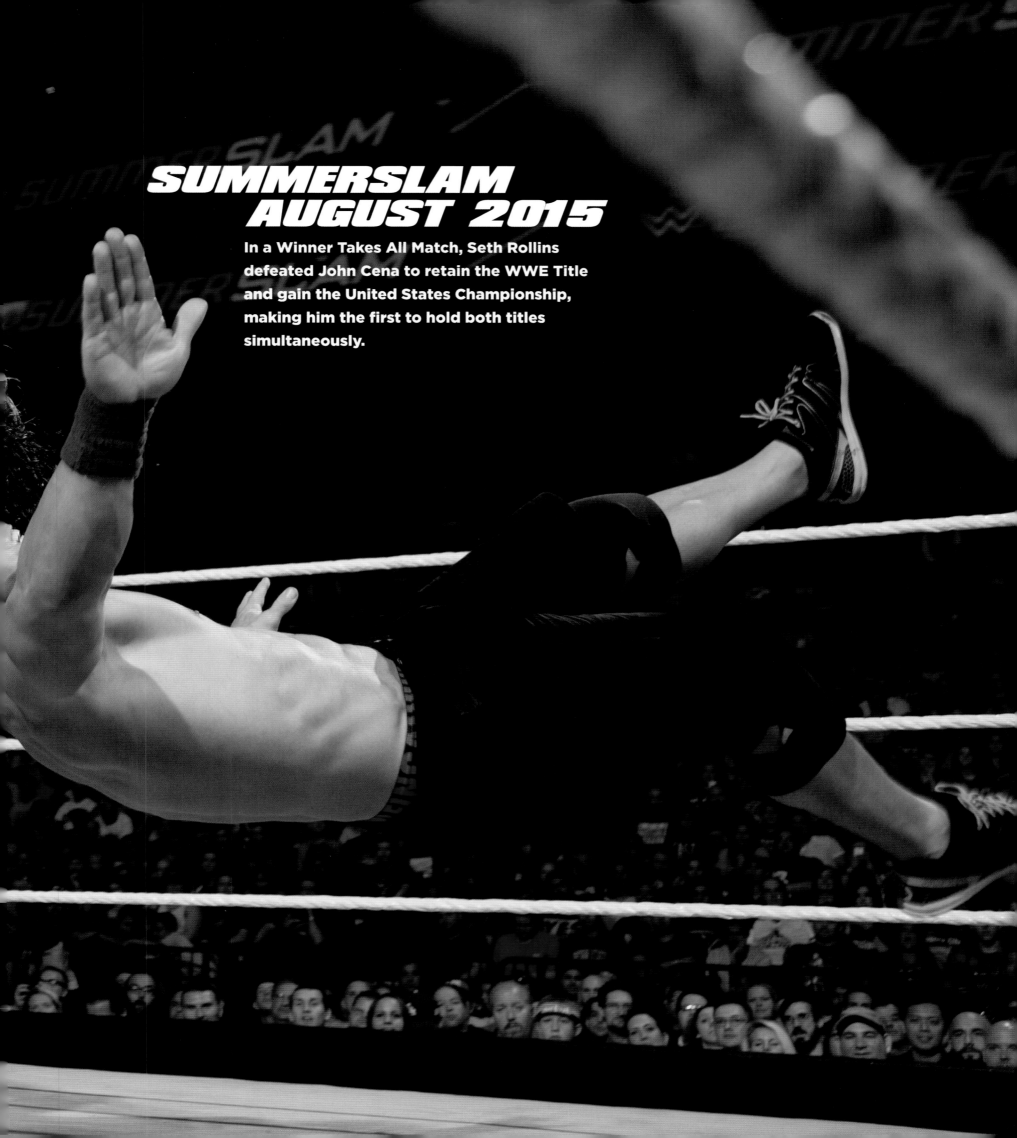

SUMMERSLAM
AUGUST 2015

In a Winner Takes All Match, Seth Rollins defeated John Cena to retain the WWE Title and gain the United States Championship, making him the first to hold both titles simultaneously.

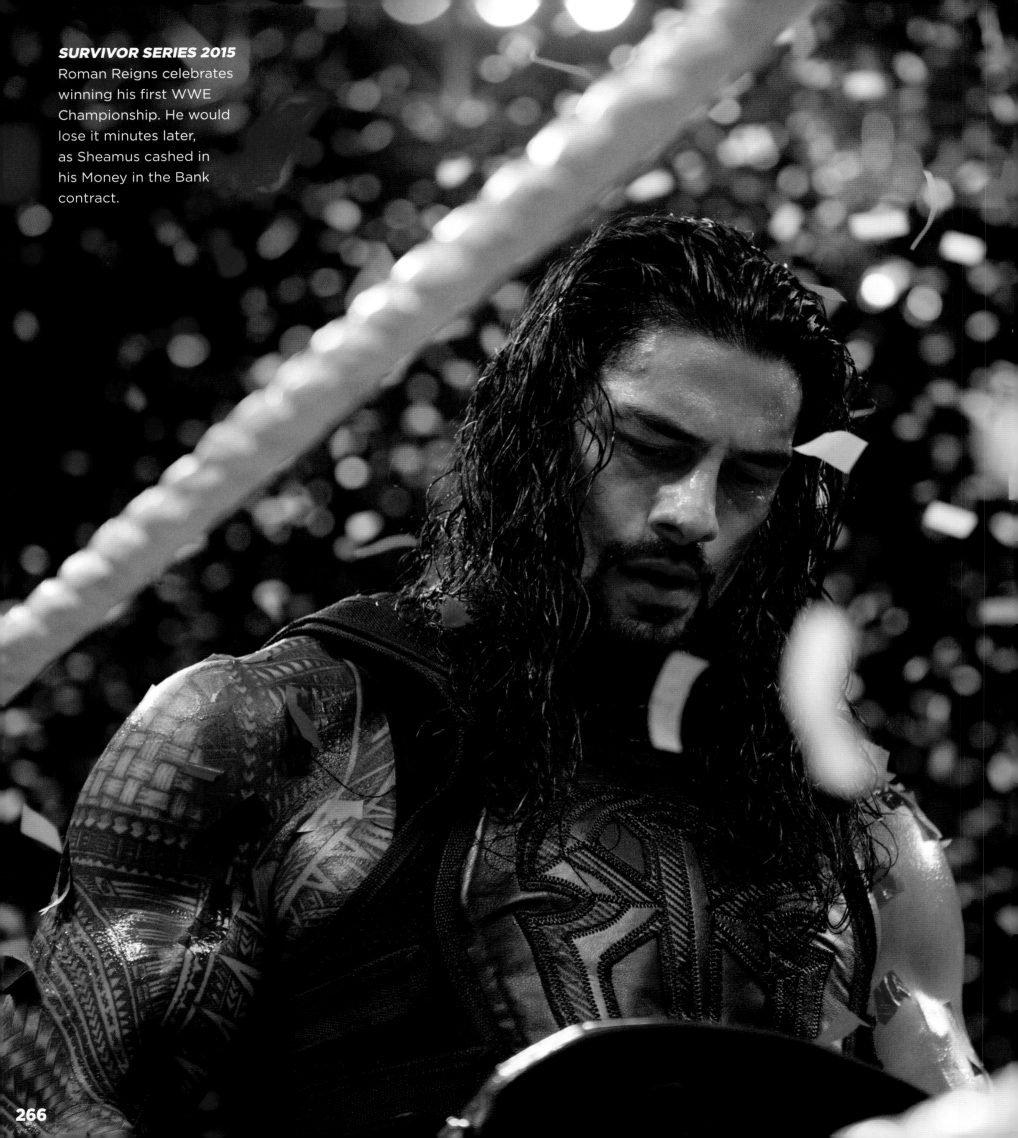

ROMAN REIGNS

"THE HEAD OF THE TABLE... ...REIGNS IS IN CHARGE."

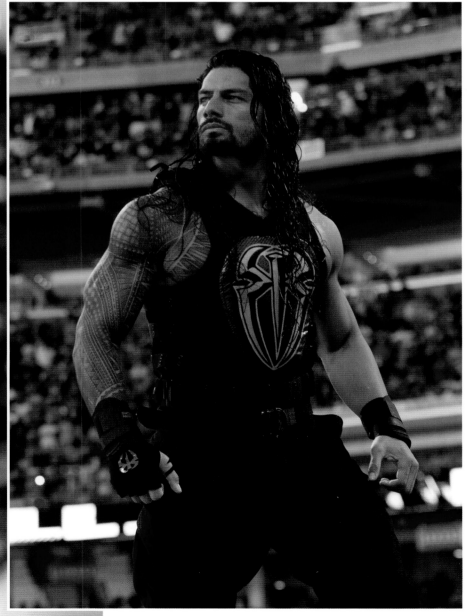

HE ALSO GOES BY THE name Big Dog, and it's a fitting moniker. In any yard, Roman Reigns is most definitely the king. Making his WWE debut in 2012 as one-third of the justice-seeking juggernaut The Shield, Reigns quickly made an impact as one of the most driven competitors ever to lace the boots. Alongside Seth Rollins and Dean Ambrose, Reigns won titles (namely the WWE Tag Team Championship alongside Rollins) and earned a reputation as a man who knew how to win.

When The Shield fell apart in 2014, Reigns embarked on the hunt for the WWE Championship. He won a battle royal, allowing him to compete for the vacant WWE Title at the 2014 *Money in the Bank*. He came up short, with the title going to John Cena, but soldiered on. He lost to Cena again in a Fatal 4-Way Match at *Battleground* but managed to win the Royal Rumble Match the following January. That victory put him in line for the title at *WrestleMania 31*. During the bout, Reigns had Brock Lesnar on the ropes, but Seth Rollins cashed in his Money in the Bank contract, pinning Reigns to win the WWE Title. It wouldn't be until *Survivor Series* of that year that Reigns was crowned WWE Champion, winning a tournament to capture the gold. That reign came to a swift end that same night thanks to another contract cash-in, this one by Sheamus.

Roman took back the title from Sheamus just a few weeks later on *Raw* in a Title vs. Career Match. The next month, Triple H took it from him when he eliminated him from the Royal Rumble Match. However, Reigns won a Triple Threat Match at *Fastlane* to earn a shot at the WWE Title against Triple H at *WrestleMania 32*. At that event, Reigns defeated The Game to become a three-time WWE Champion.

The Big Dog, The Head of the Table—whatever you want to call him, the meaning is clear. When he steps between the ropes, Roman Reigns is in charge.

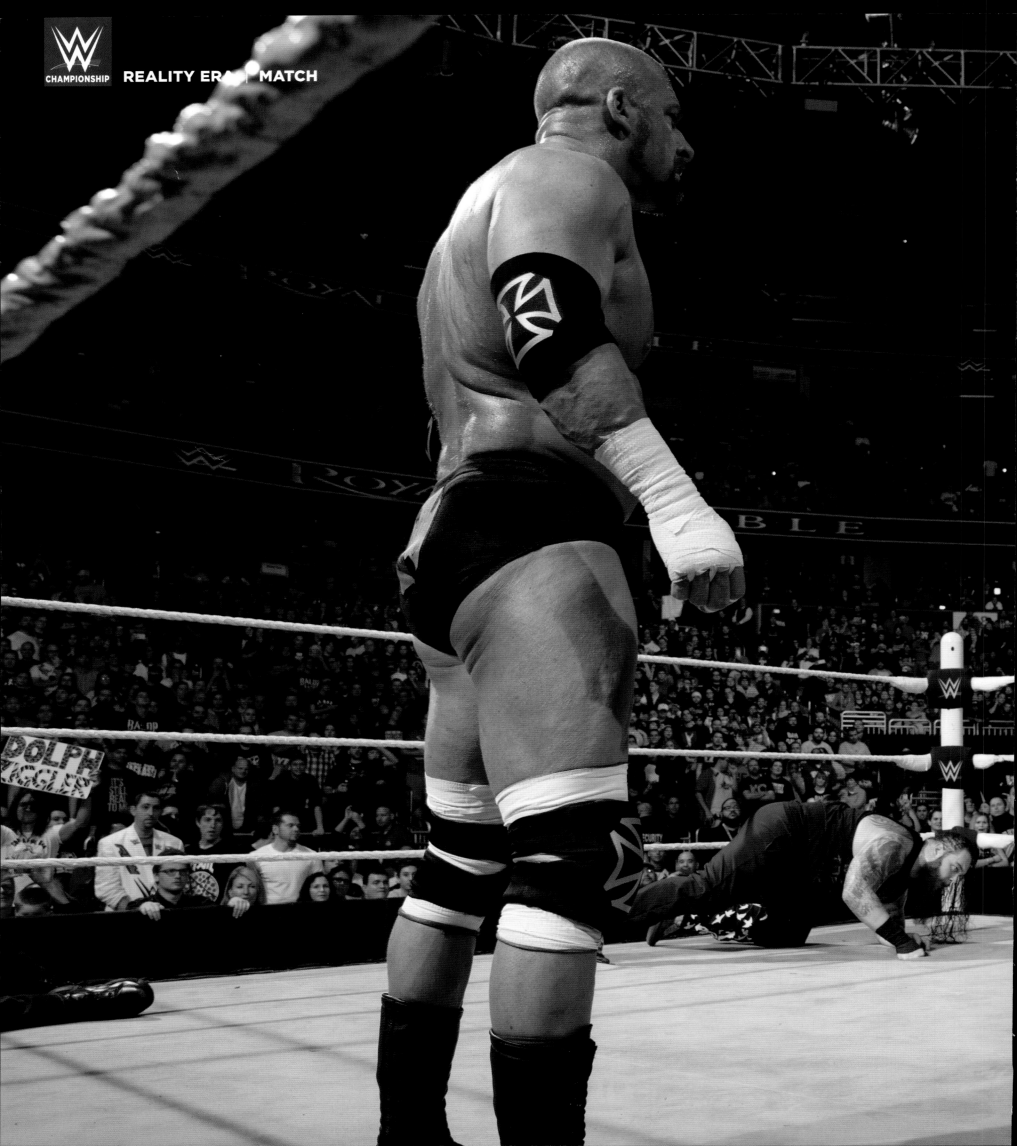

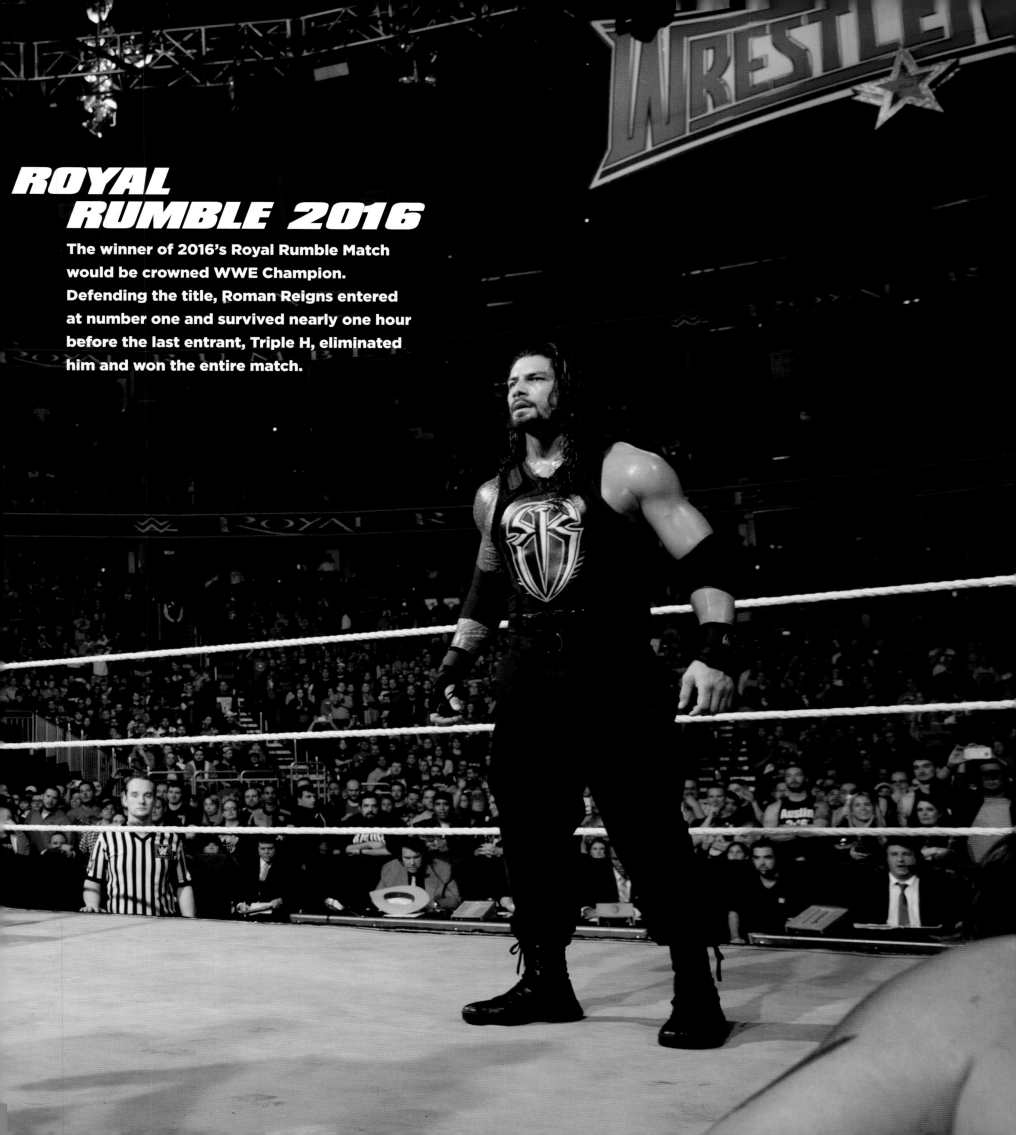

ROYAL RUMBLE 2016

The winner of 2016's Royal Rumble Match would be crowned WWE Champion. Defending the title, Roman Reigns entered at number one and survived nearly one hour before the last entrant, Triple H, eliminated him and won the entire match.

WRESTLEMANIA 36
In the midst of a global pandemic, Drew McIntyre defeats Brock Lesnar in the first *WrestleMania* to be held on two consecutive nights.

NEW ERA
2016 – PRESENT

One of WWE's greatest assets is its ability to adapt and remain relevant to the time it finds itself in. As the New Era launched, the WWE Universe witnessed some historic moments as Superstars from across the world became the first from their home countries to win the WWE Championship.

I N 2016, WWE ANNOUNCED THE START OF A New Era, in which WWE programming would strip itself down to deliver an even grittier, reality-driven product, with harder-hitting rivalries and, more importantly, harder-hitting Superstars. The proposed face of this New Era was Roman Reigns, a Superstar who had spent years earning his stripes and prepping for a bona fide run with the WWE Championship.

At *WrestleMania 32*, Reigns took home WWE's biggest prize when he defeated Triple H in the main event. That June, he surrendered the title to Seth Rollins in the main event at *Money in the Bank*. Rollins, however, had very little time to enjoy his victory, as his former Shield partner, Dean Ambrose, rushed the ring and cashed in his Money in the Bank contract immediately to defeat Rollins and win the title.

Ambrose's win was a significant one, as it resulted in some shake-ups in the championship picture. Following his victory, the WWE World Heavyweight Championship was renamed the WWE Championship and became a *SmackDown*-exclusive title. *Raw* would have its own title in the form of the WWE Universal Championship.

As a *SmackDown* title, the WWE Championship was first won by AJ Styles at *Backlash*, defeating Ambrose to win his first title in WWE. Styles managed to retain the championship for the remainder of 2016, before coming up against a returning John Cena. The Champ challenged for the gold at the 2017 *Royal Rumble*, defeating Styles to kick off a stunning thirteenth WWE Championship run.

At the 2017 *Elimination Chamber*, *SmackDown* commissioner Shane McMahon decreed that the WWE Championship be put up for grabs inside the Chamber. At the event, with AJ Styles, Cena, Baron Corbin, Dean Ambrose, Bray Wyatt and The Miz all competing for the gold, Wyatt was the Superstar who outlasted all the others to win his first WWE Championship.

Meanwhile, as Wyatt was basking in his first title win, the storm clouds were gathering. Randy Orton won the 2017 Royal Rumble, which put him on a direct path to the title at *WrestleMania 33*. Despite Wyatt's attempts at defeating the Viper with mind games, Orton managed to overpower the Eater of Worlds to

win his ninth WWE Championship and his first-ever at the Show of Shows.

Over the course of the next year, the title changed hands three more times, between first-time champ Jinder Mahal, AJ Styles and a returning Daniel Bryan. Bryan would face off against Kofi Kingston at *WrestleMania 35*, with Kingston winning the title to become the first-ever African-born WWE Champion.

Kingston's run lasted for 180 days, right up to

▲ **WRESTLEMANIA 35**
Kofi Kingston defeats the "New" Daniel Bryan in spectacular fashion to become WWE Champion.

▶ **THE MODERN DAY MAHARAJA**
Jinder Mahal defeated Randy Orton to become the first WWE Champion of Indian descent.

the *SmackDown* 20th-anniversary special, when the gold was won by Brock Lesnar, who entered his fifth WWE Title reign. After winning, Lesnar took the WWE Championship with him to *Raw*. His run ended the following spring when he lost to Royal Rumble winner Drew McIntyre at *WrestleMania 36*. This *WrestleMania* was a unique one, as it was held at the WWE Performance Center under controlled circumstances due to the COVID-19 pandemic. McIntyre and Randy Orton traded the gold during the fall of 2020 before McIntyre won it back in a No Disqualification No Count Out Match on *Raw*. 2021 saw both The Miz and Bobby Lashley take surprise title wins, showing that all Superstars have their eyes fixed on the ultimate prize of sports entertainment.

For close to 60 years, WWE Superstars have

"A GRITTIER, HARDER-HITTING ERA WAS BORN."

competed for the honor of walking out of the ring with WWE's greatest title around their waists. The WWE Championship has fractured partnerships, sparked rivalries and forged legends. The title has been held by some of the most iconic names the company has ever seen, and by a few unexpected challengers who shocked the WWE Universe by proving they too had what it took to stand alongside the greats. The history of the WWE Championship is like the history of WWE itself. Wild, unpredictable, full of unexpected twists and more than a few shocking surprises. No one knows what the next 60 years will hold for the WWE Championship, but you can guarantee that, somewhere out there, the next generation of would-be champions are already lacing their boots, eager for a shot at the gold.

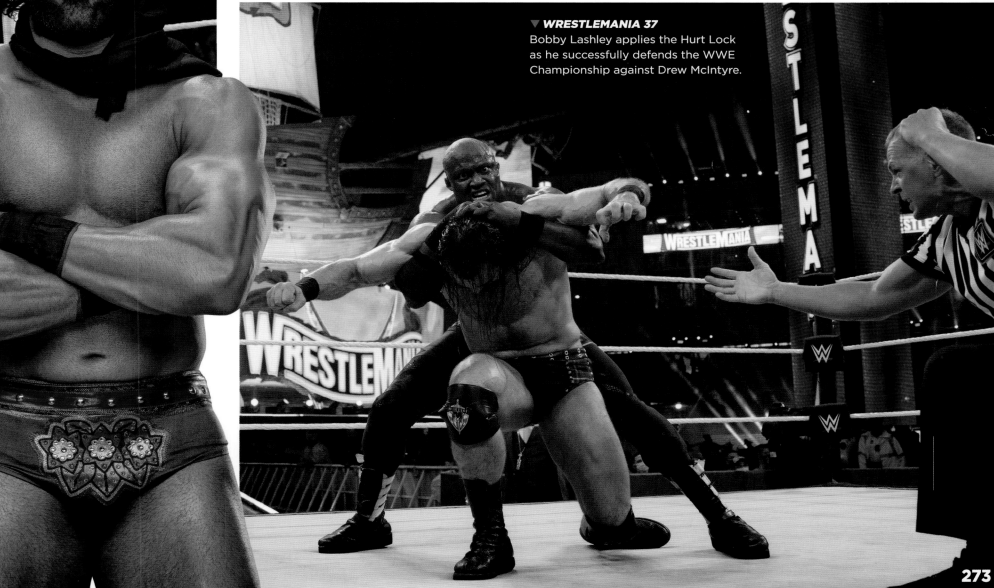

▼ **WRESTLEMANIA 37**
Bobby Lashley applies the Hurt Lock as he successfully defends the WWE Championship against Drew McIntyre.

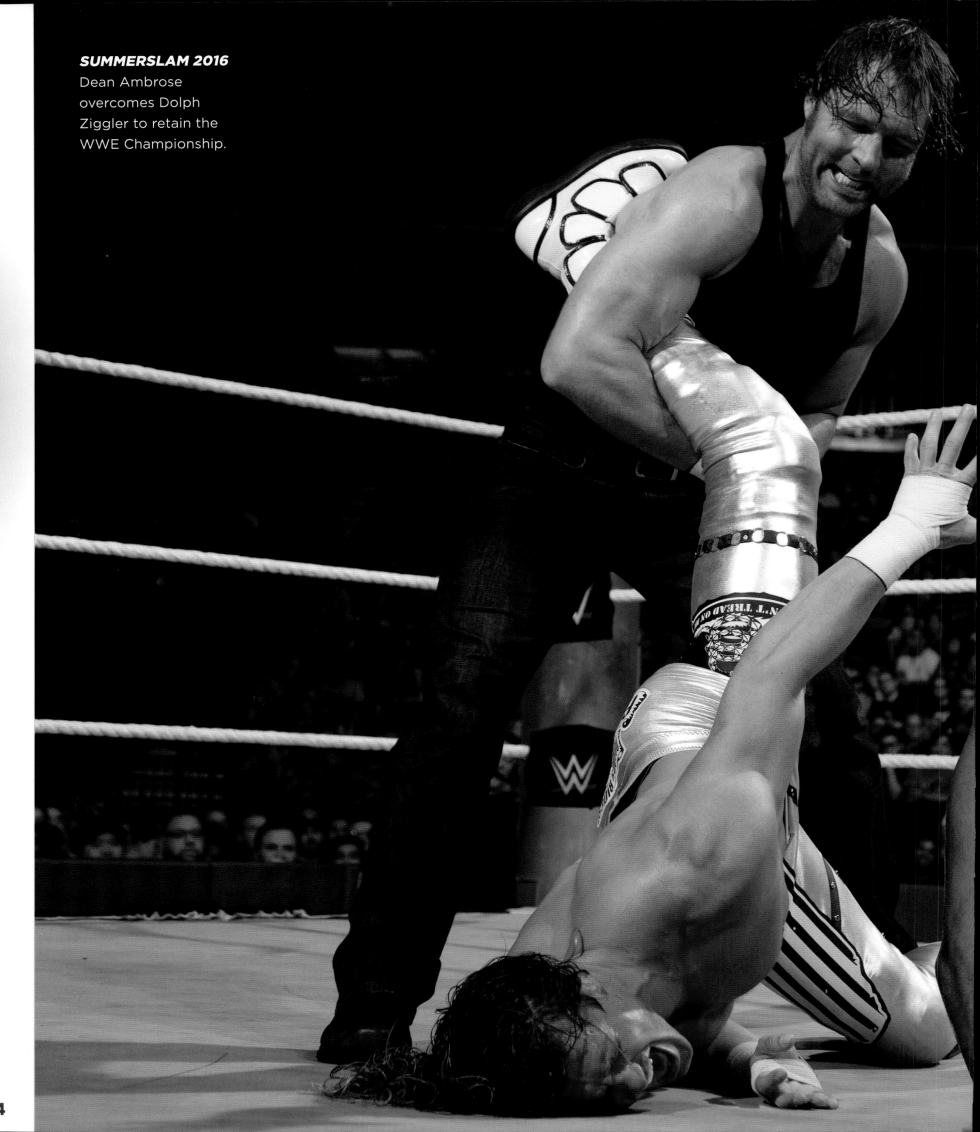

DEAN AMBROSE

DEAN AMBROSE IS A MAN who will do whatever it takes to win. He first came to WWE as one-third of The Shield, alongside Seth Rollins and Roman Reigns in a vicious group of vigilante enforcers who claimed they were on a mission for justice in WWE. The three Superstars quickly became a force to be reckoned with, as Ambrose won the United States Championship in 2013 and held it for a record 351 days.

When The Shield split in 2013, Ambrose proved to be just as fierce a competitor in the singles realm as he was when he was part of a trio. He battled his way through a host of challengers, including Bray Wyatt, Bad News Barrett and his former Shield teammate Seth Rollins. He went on to become Intercontinental Champion and a Money in the Bank Ladder Match winner at the 2016 *Money in the Bank*

event. That last victory was particularly impactful, as it paved the way for Ambrose to cash in his contract that same night, pinning Rollins to win the WWE Championship. He retained the title for the remainder of the summer before losing it to AJ Styles at *Backlash* that September.

Although Ambrose did not recapture the WWE Championship, he went on to win two more Intercontinental Titles and reformed with The Shield in 2017, winning the tag titles to become a Grand Slam Champion. In April 2019, he and The Shield took one final bow at a WWE event titled *The Shield's Final Chapter*. At that event, Ambrose, Reigns and Rollins had their last match together, defeating Baron Corbin, Bobby Lashley and Drew McIntyre.

For seven years, Dean Ambrose was one of WWE's most feared Superstars, and with good reason. Should he ever make a comeback and compete for the WWE Title again, there are not many who could stop him.

"ONE-THIRD OF A GROUP OF ENFORCERS WHO WERE ON A MISSION FOR JUSTICE."

A NEW ERA, A NEW TITLE

IN 2016, AFTER FIVE YEARS, WWE reintroduced the fabled brand extension, splitting *Raw* and *SmackDown* back into two distinct entities with their own separate rosters. To mark the official start of the split, *SmackDown* began officially broadcasting live on Tuesday nights, kicking off its first-ever show with a WWE Draft.

During that draft, Dean Ambrose, who was then the reigning WWE Champion, was selected for the *SmackDown* roster, taking the title with him. On July 24, at the *Battleground* pay-per-view event, Ambrose faced off against his former Shield teammates, Roman Reigns and Seth Rollins. Both Rollins and Reigns had been drafted to *Raw*, so the battle was on to determine which brand would possess the WWE Title. The WWE Universe had their answer when Ambrose hit Reigns with a Dirty Deeds to make the three-count and retain the gold.

With the WWE Championship now officially on *SmackDown*, *Raw* was left without a title to defend. On the first *Raw* after *Battleground*, Stephanie McMahon and *Raw* General Manager Mick Foley unveiled a new title, exclusive to *Raw*, dubbed the Universal Championship. The name of the title was chosen in tribute to the fans, collectively known as the WWE Universe.

After announcing the creation of the new title, McMahon and Foley then revealed that a pair of Fatal 4-Way Matches would be held on *Raw*, with the winners of those matches facing off in a singles bout to determine who would face Seth Rollins for the Universal Championship. The two matches were won by Finn Bálor and Roman Reigns. Bálor then beat Reigns in a singles match, earning the chance to face Rollins for the title.

At *SummerSlam*, the actual Universal Title itself was unveiled to the world and Bálor and Rollins faced off in a singles match to see who would claim it. In the end, it was Bálor who managed to take down Rollins with a Coup de Grâce to make the pinfall and become WWE's first-ever Universal Champion.

124

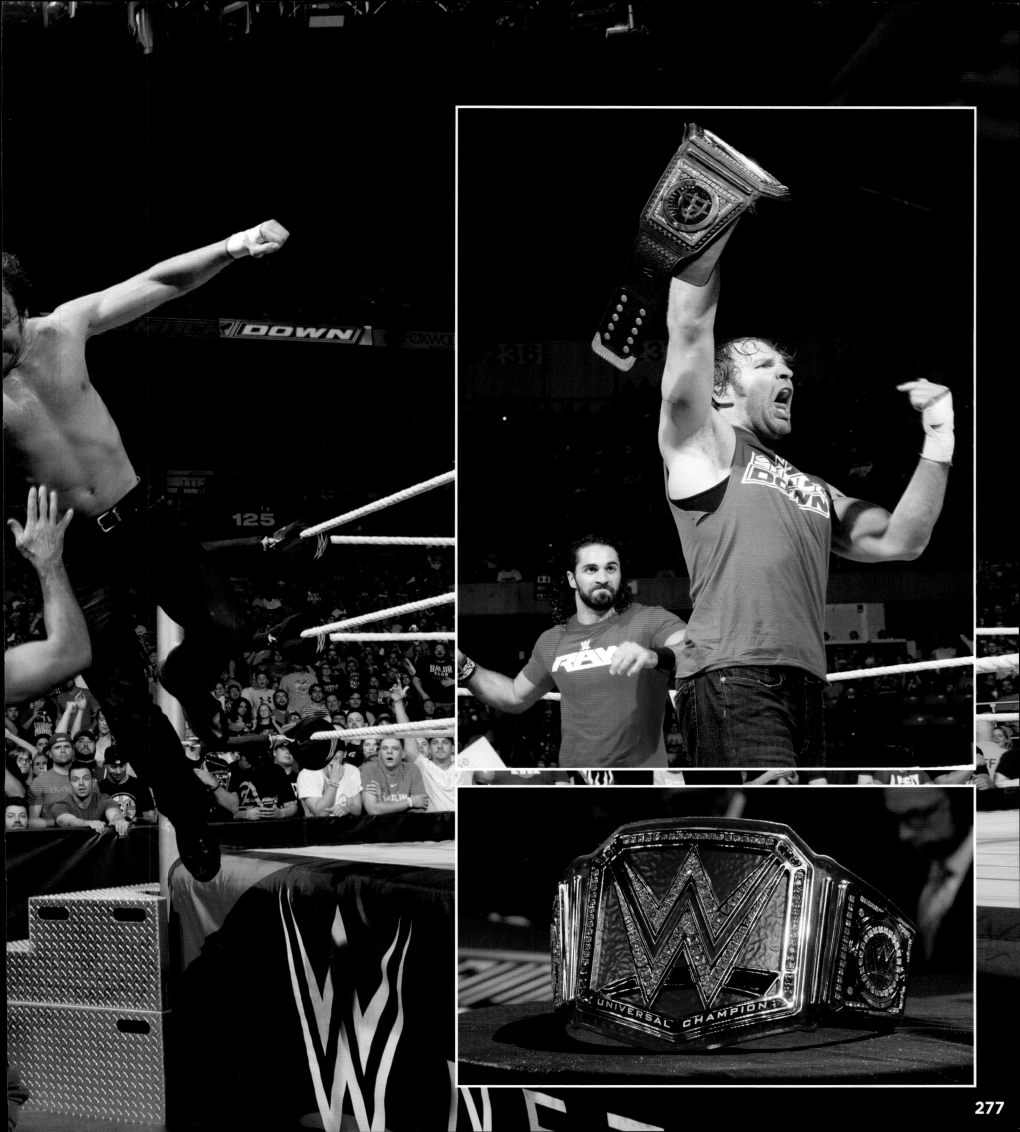

AJ STYLES

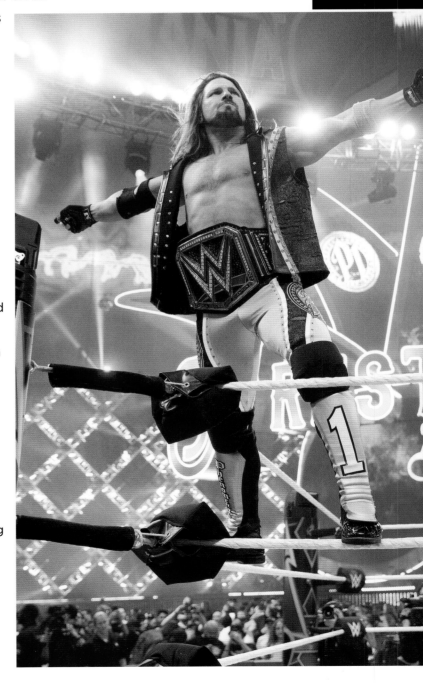

WITH HIS IN-RING PROWESS, CONFIDENCE AND jaw-dropping aerial maneuvers, there's a reason that AJ Styles is known as The Phenomenal One. Making his long-awaited WWE debut in 2016, he went on to claim his first WWE Championship just seven months later at *Backlash* by defeating Dean Ambrose. He held the WWE Title for 139 days, defeating Ambrose in rematches, and both Ambrose and John Cena in a Triple Threat Match at *No Mercy*. However, at *Royal Rumble 2017* he was finally felled by Cena in front of a crowd of 52,000 in San Antonio, Texas. Styles would go on to win the United States Championship twice in 2017, and then in November that year, he spectacularly won the WWE Championship again. Facing Jinder Mahal on *SmackDown* in Manchester, England, this victory marked the first time the WWE Championship had ever changed hands outside of North America. Styles went on to successfully defend the title against Kevin Owens and Sami Zayn in a Handicap Match at *Royal Rumble* 2018, followed by a Six-Pack Challenge win at *Fastlane*. He then retained the title against Shinsuke Nakamura at *WrestleMania 34*, *Greatest Royal Rumble*, *Backlash* and *Money in the Bank*. With his victory against Rusev at *Extreme Rules*, Styles became the longest-reigning WWE Champion in *SmackDown* history and the eighth longest-reigning WWE Champion ever (tied with Randy Savage). After defeating Samoa Joe at multiple events, Styles' stunning 371-day reign eventually came to an end against Daniel Bryan on *SmackDown*, but he'd backed up his claim that *SmackDown* was "The House that AJ Styles Built!"

"THE LONGEST REIGNING WWE CHAMPION IN *SMACKDOWN* HISTORY."

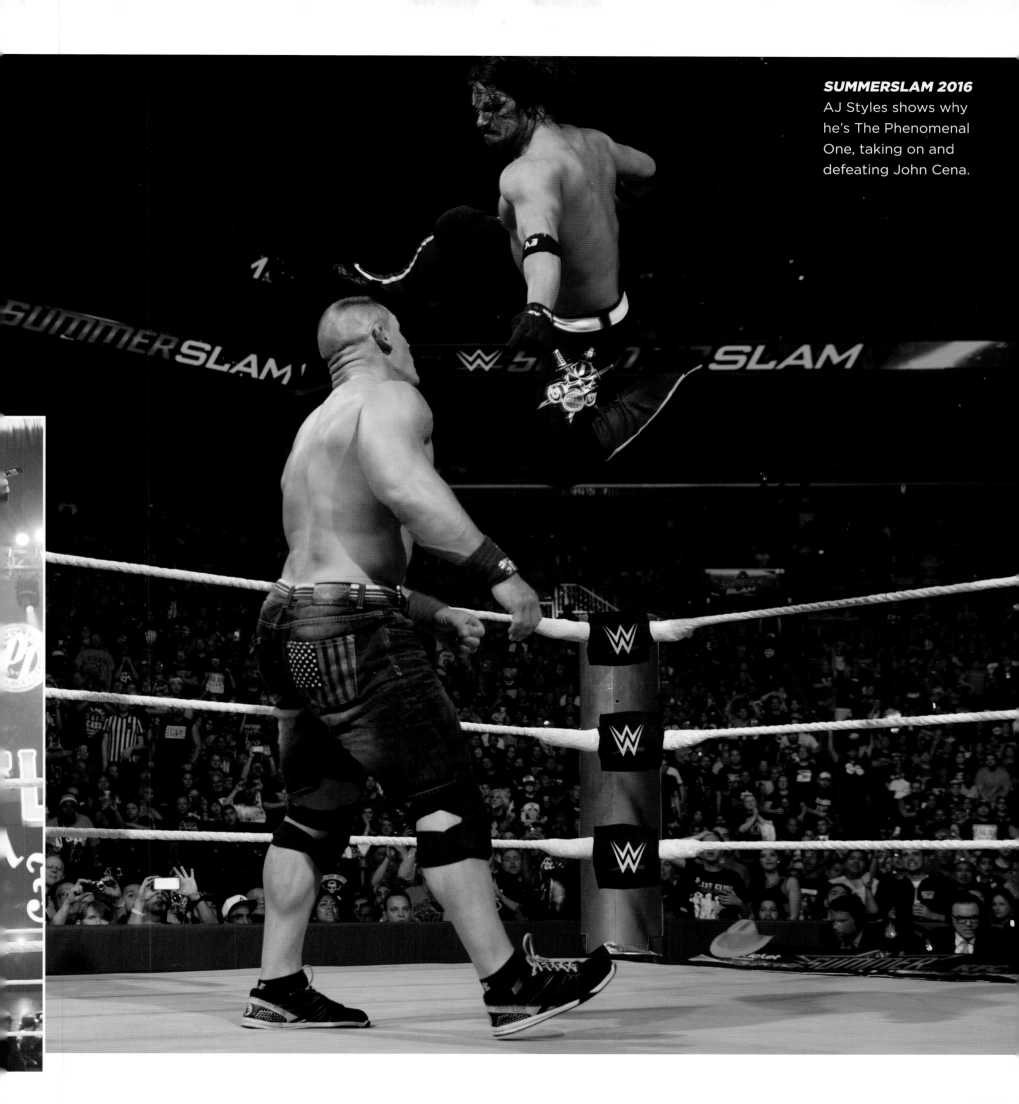

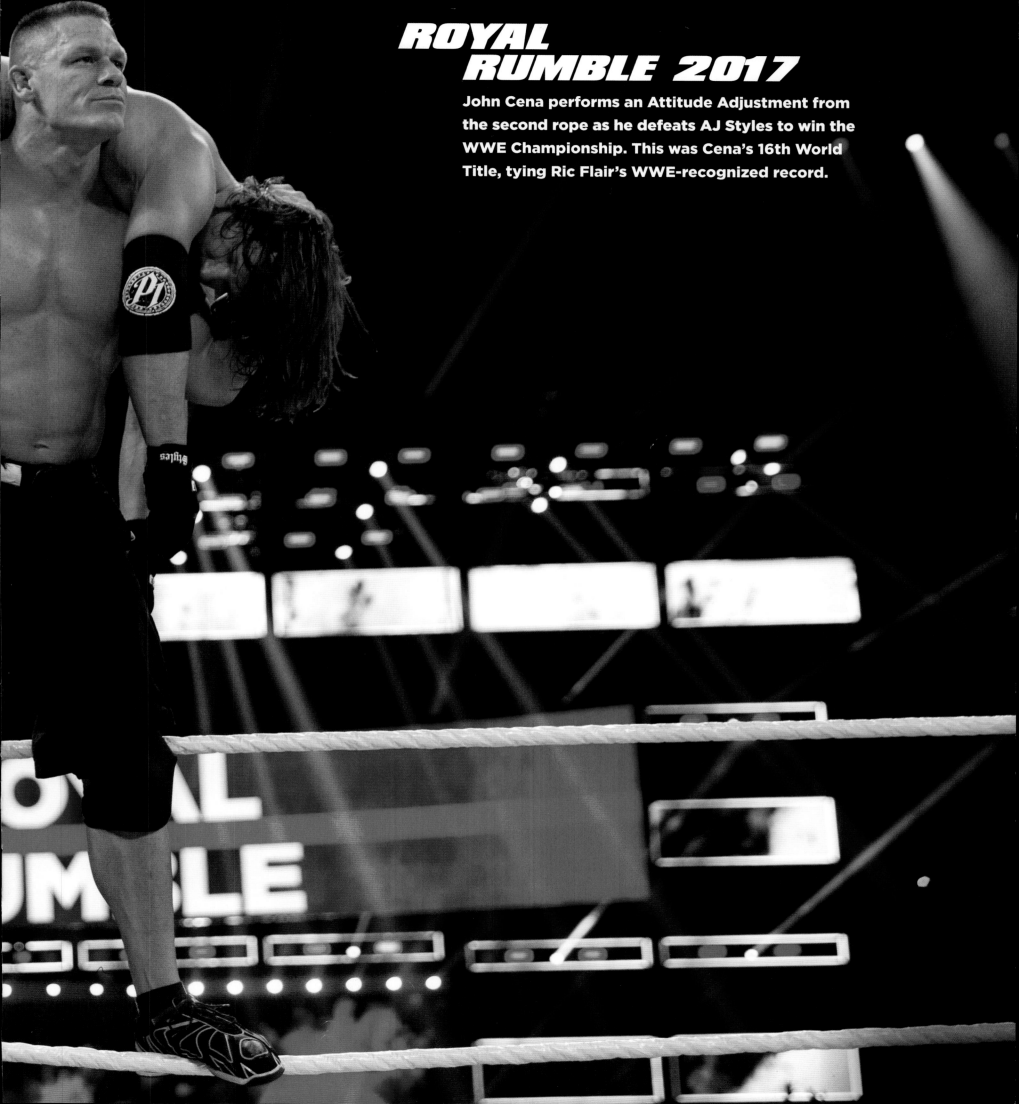

ROYAL RUMBLE 2017

John Cena performs an Attitude Adjustment from the second rope as he defeats AJ Styles to win the WWE Championship. This was Cena's 16th World Title, tying Ric Flair's WWE-recognized record.

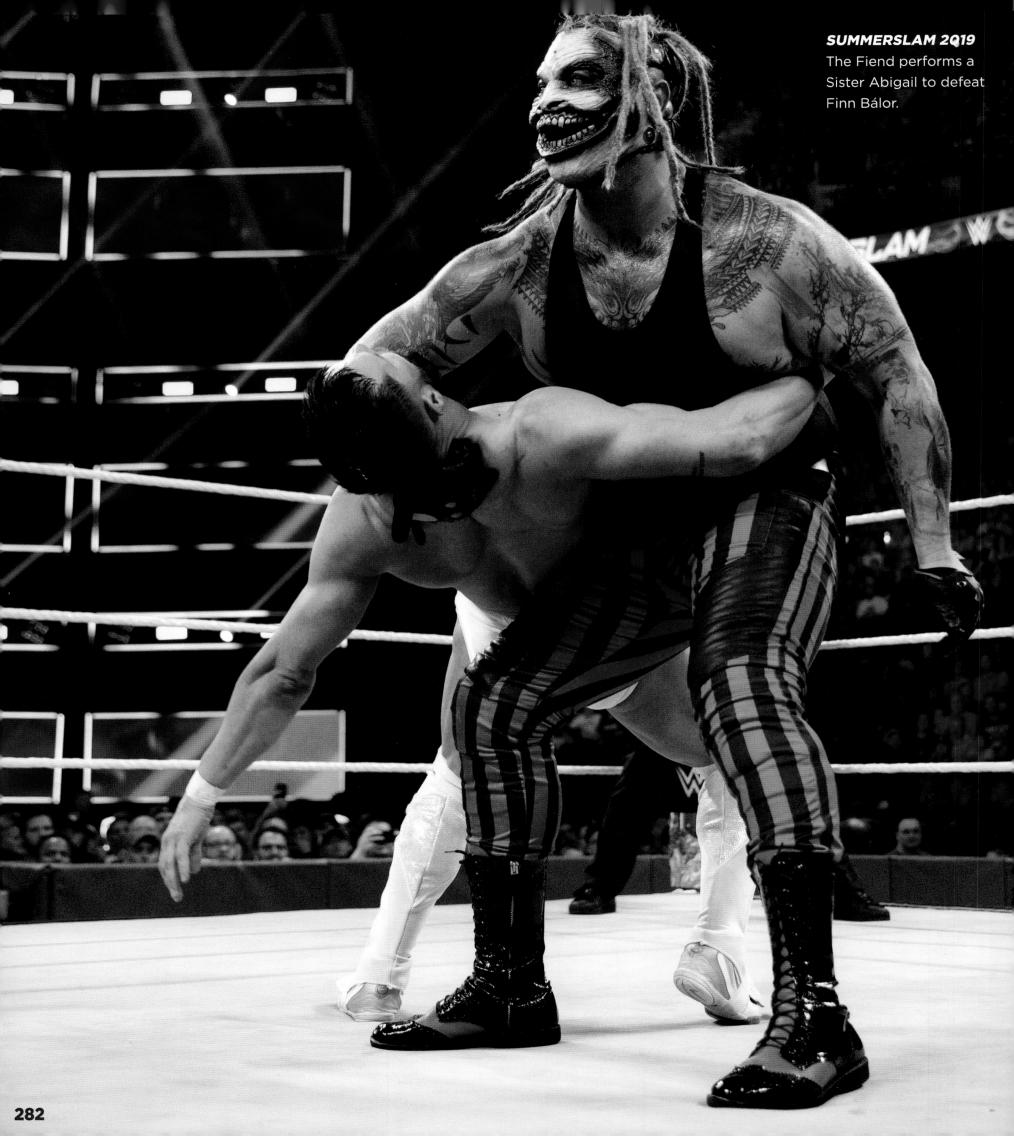

SUMMERSLAM 2019
The Fiend performs a
Sister Abigail to defeat
Finn Bálor.

BRAY WYATT

AFTER ESTABLISHING HIMSELF AS THE CULT LEADER OF the Wyatt Family and winning the WWE SmackDown Tag Team Titles with Randy Orton, Bray Wyatt also made his mark as a singles competitor. At *Elimination Chamber* 2017, Wyatt showed strength and resilience as he survived John Cena, Dean Ambrose, AJ Styles, The Miz and Baron Corbin in the Elimination Chamber Match to win his first WWE Championship. He eliminated Styles last with a Sister Abigail to claim the gold, before Orton emerged and briefly stared down his teammate before celebrating with him. The bearded Superstar then retained the title in a Triple Threat Match on *SmackDown* against John Cena and AJ Styles, after a pre-match attack on Wyatt from teammate Luke Harper. Despite Orton pledging his allegiance to Wyatt and refusing to face him at *WrestleMania 33*, he betrayed his teammate, destroying the Wyatt Family compound and Sister Abigail's grave. The bitter and twisted rivalry saw the two Superstars clash at the Show of Shows, with Wyatt using mind games on his opponent but falling to an RKO, his reign ending after 48 days. However, Bray Wyatt later returned as something much more sinister and terrifying—The Fiend.

As The Fiend, Wyatt found success pursuing the Universal Championship, winning it first at *Crown Jewel* 2019 and then a second time at 2020's *SummerSlam* event. With this dark alter ego and his unnerving Firefly Fun House, The Fiend seems to have unleashed Wyatt's true madness and depravity. His determination to break both the bodies and minds of WWE Superstars might prove his greatest motivation, but there can be no doubt that The Fiend is always ready to reclaim the gold.

"HE SHOWED STRENGTH AND RESILIENCE TO WIN HIS FIRST WWE CHAMPIONSHIP."

JINDER MAHAL

AGAINST THE ODDS AND OVERWHELMING CHALLENGES, Jinder Mahal achieved his dreams and climbed to the peak of the WWE mountain. After finishing as the runner-up in the André the Giant Memorial Battle Royal, Mahal defeated five *SmackDown* Superstars to earn a WWE Championship Match. With allies Sunil and Samir Singh by his side, Mahal defeated Randy Orton at 2017's *Backlash* to win the WWE Title, becoming the fiftieth WWE Champion and the first of Indian descent. After a Punjabi celebration was held, it wasn't long before Orton demanded a rematch, and Mahal successfully defended the title at *Money in the Bank 2017*. A furious Orton was granted another match on the condition that Mahal could choose the stipulation, resulting in a Punjabi Prison Match at *Battleground*. Mahal emerged victorious, thanks to the assistance of his "personal hero" the Great Khali, and retained the title again. As the reigning WWE Champion for an impressive 169 days, Mahal defeated a number of challengers, including Baron Corbin and Shinsuke Nakamura, proving he lived up to his reputation as the Modern Day Maharaja. Jinder Mahal finally lost the WWE Title to AJ Styles at a *SmackDown* show in Manchester, England. Mahal would continue his rivalry with Styles as he attempted to recapture the gold in several unsuccessful title matches.

Mahal would go on to win the United States Championship at *WrestleMania 34*, defeating Rusev, as well as holding the 24/7 Championship multiple times in 2019. Leading the charge for the new NXT India brand, it seems that Jinder Mahal is far from done being a WWE Champion and making history.

"THE FIRST WWE CHAMPION OF INDIAN DESCENT."

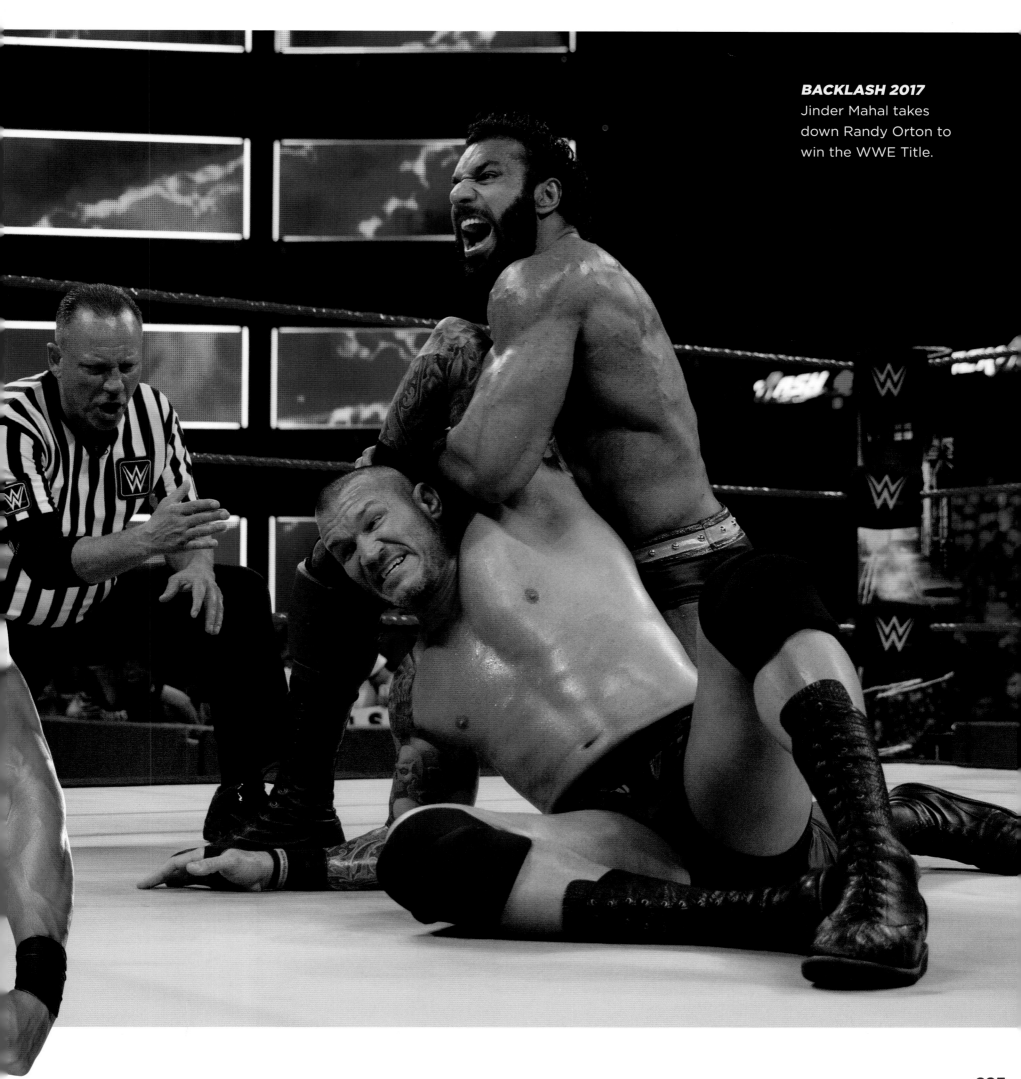

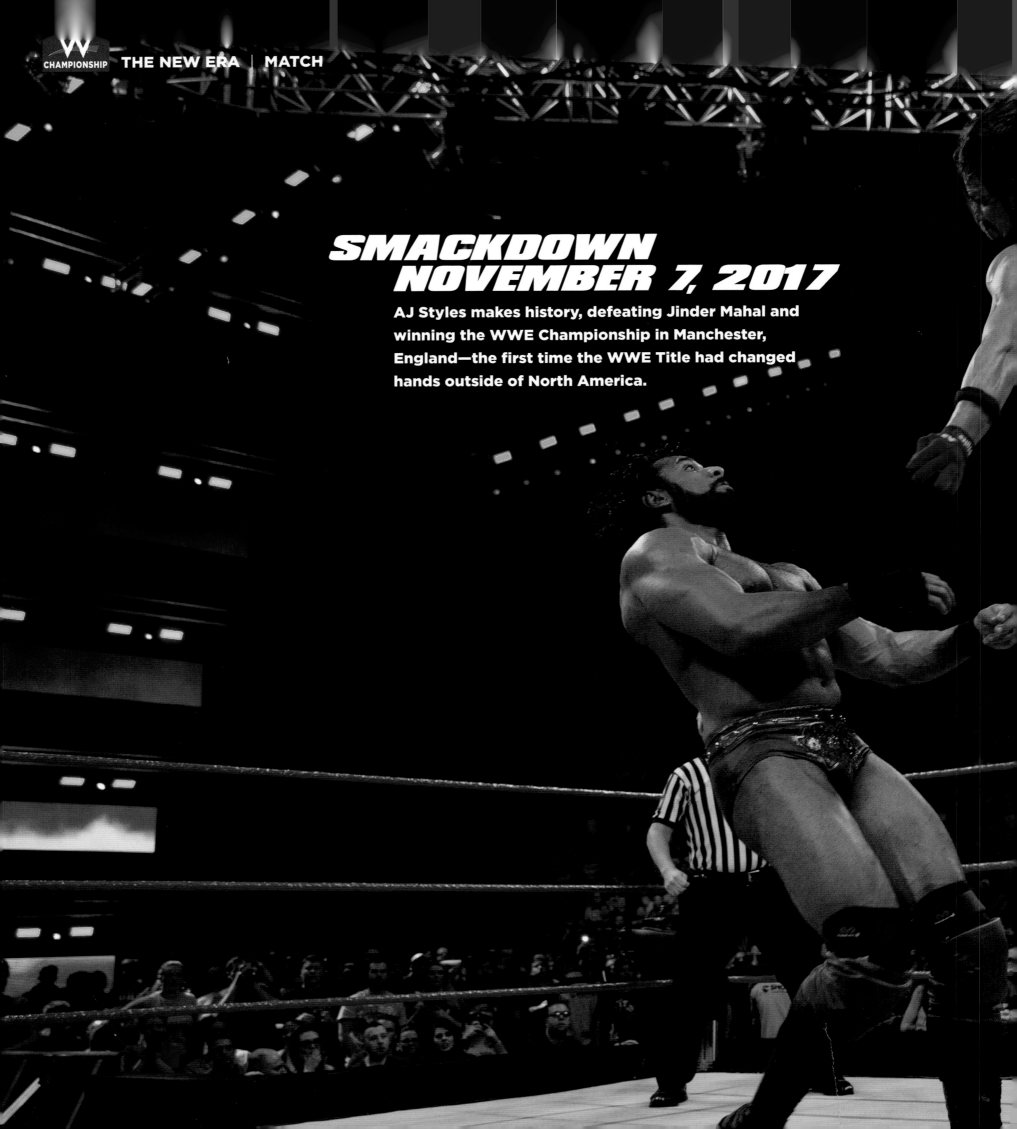

SMACKDOWN
NOVEMBER 7, 2017

AJ Styles makes history, defeating Jinder Mahal and winning the WWE Championship in Manchester, England—the first time the WWE Title had changed hands outside of North America.

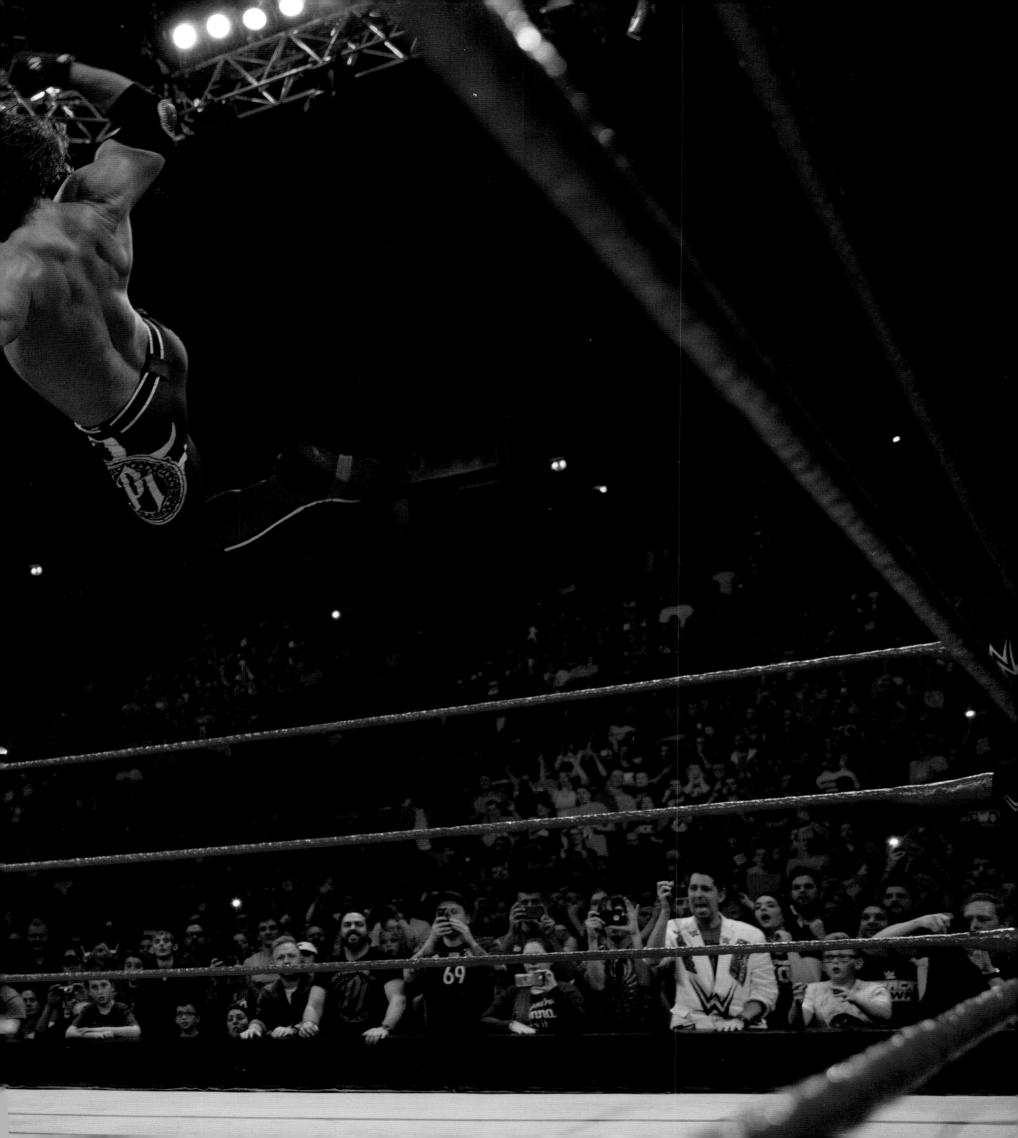

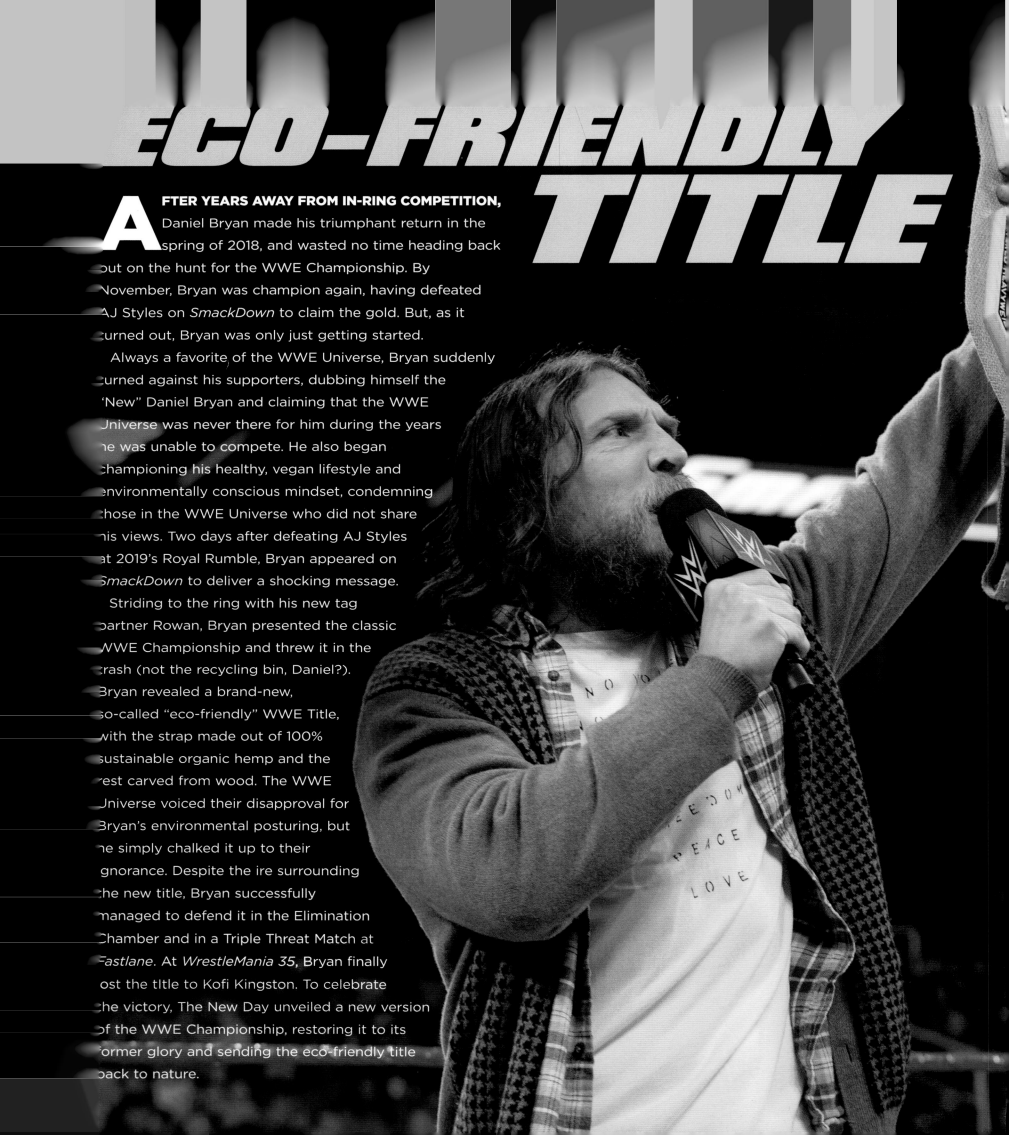

ECO-FRIENDLY TITLE

AFTER YEARS AWAY FROM IN-RING COMPETITION, Daniel Bryan made his triumphant return in the spring of 2018, and wasted no time heading back out on the hunt for the WWE Championship. By November, Bryan was champion again, having defeated AJ Styles on *SmackDown* to claim the gold. But, as it turned out, Bryan was only just getting started.

Always a favorite of the WWE Universe, Bryan suddenly turned against his supporters, dubbing himself the "New" Daniel Bryan and claiming that the WWE Universe was never there for him during the years he was unable to compete. He also began championing his healthy, vegan lifestyle and environmentally conscious mindset, condemning those in the WWE Universe who did not share his views. Two days after defeating AJ Styles at 2019's Royal Rumble, Bryan appeared on *SmackDown* to deliver a shocking message.

Striding to the ring with his new tag partner Rowan, Bryan presented the classic WWE Championship and threw it in the trash (not the recycling bin, Daniel?). Bryan revealed a brand-new, so-called "eco-friendly" WWE Title, with the strap made out of 100% sustainable organic hemp and the rest carved from wood. The WWE Universe voiced their disapproval for Bryan's environmental posturing, but he simply chalked it up to their ignorance. Despite the ire surrounding the new title, Bryan successfully managed to defend it in the Elimination Chamber and in a Triple Threat Match at *Fastlane*. At *WrestleMania 35*, Bryan finally lost the title to Kofi Kingston. To celebrate the victory, The New Day unveiled a new version of the WWE Championship, restoring it to its former glory and sending the eco-friendly title back to nature.

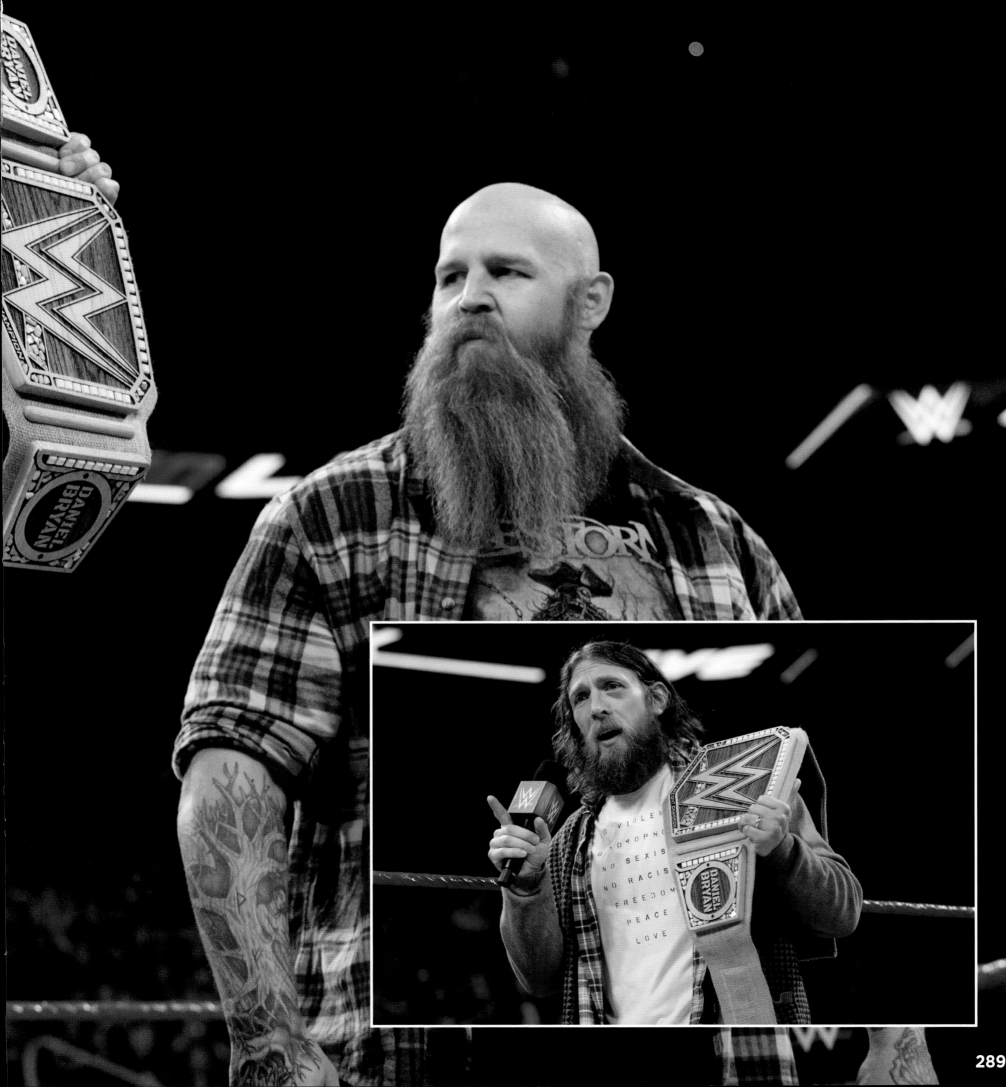

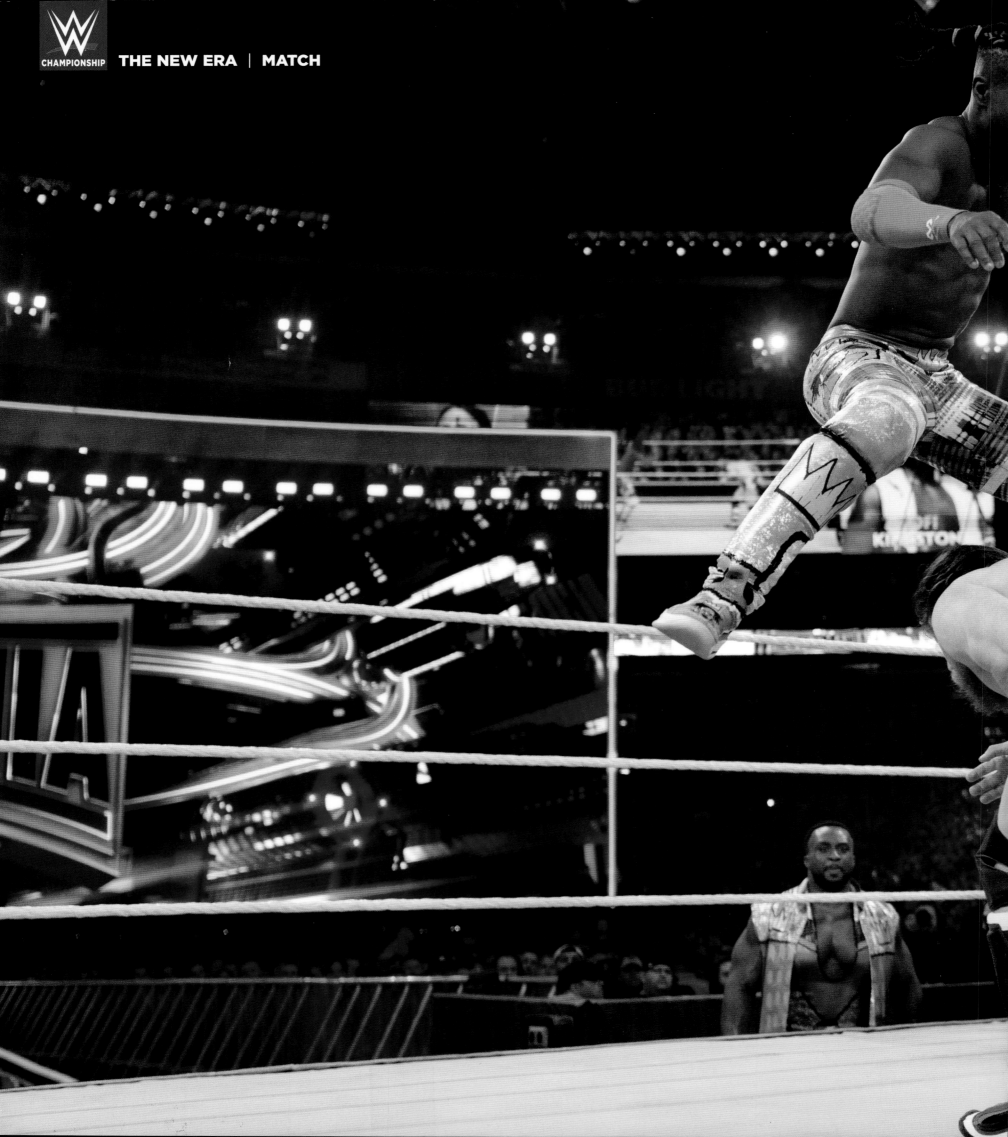

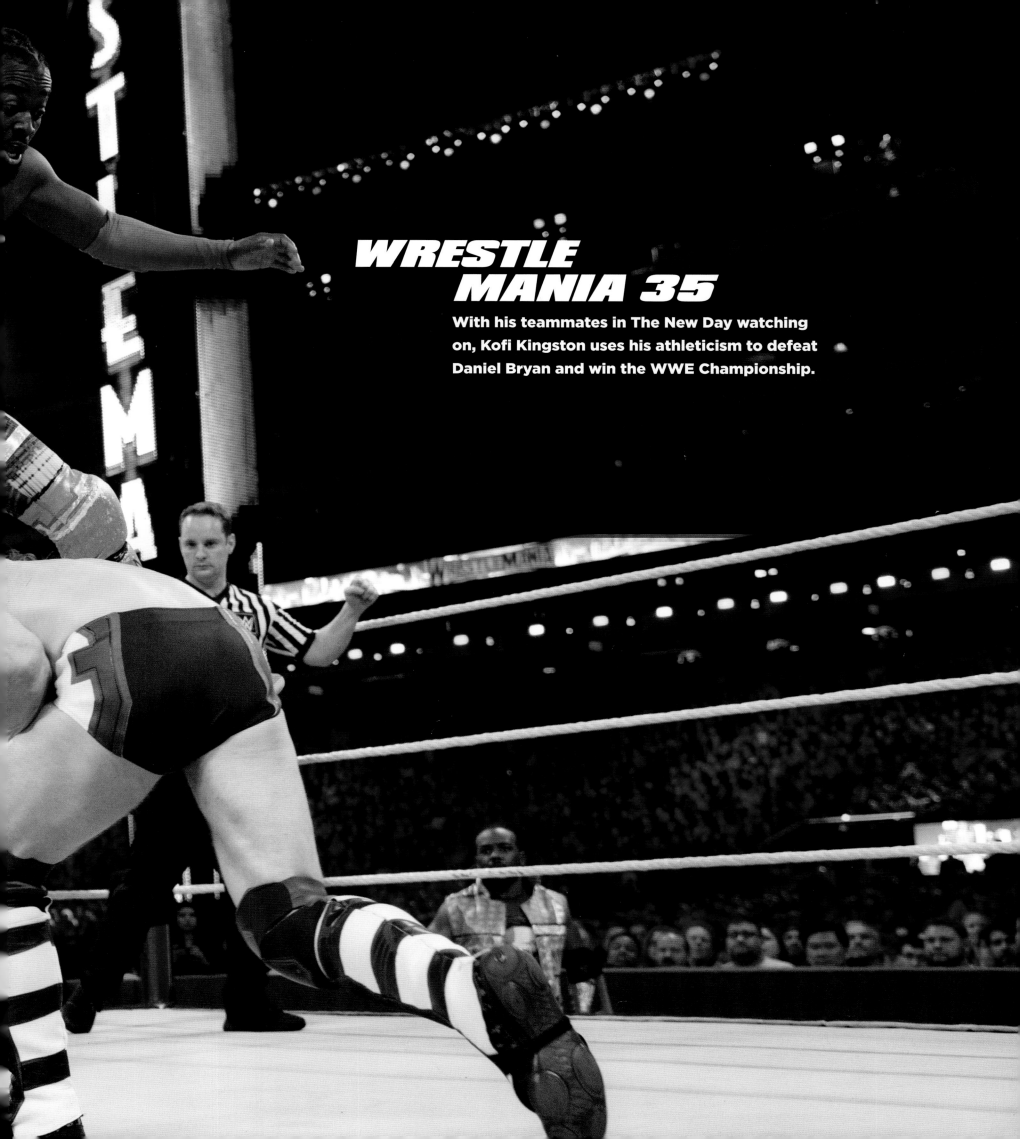

WRESTLE MANIA 35

With his teammates in The New Day watching on, Kofi Kingston uses his athleticism to defeat Daniel Bryan and win the WWE Championship.

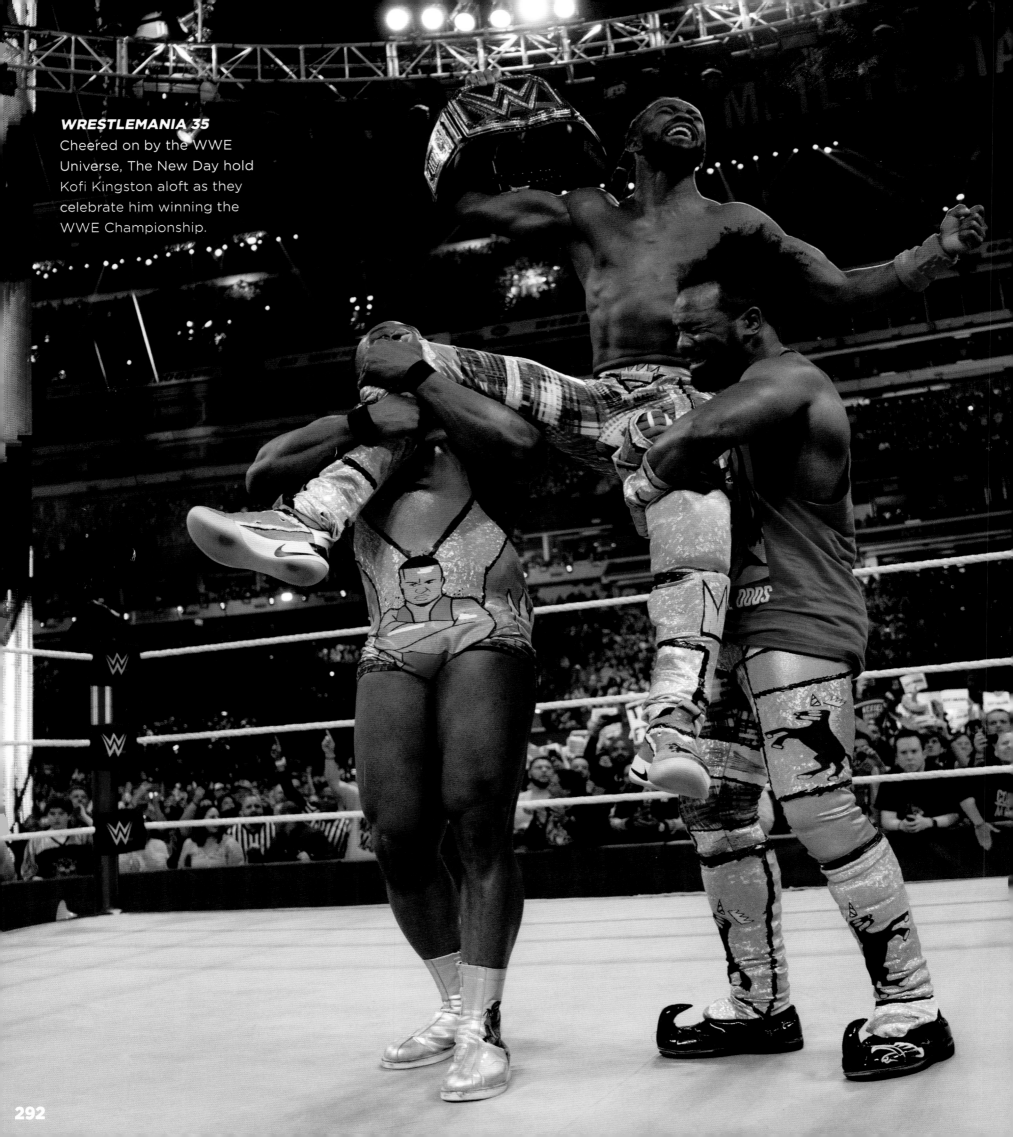

WRESTLEMANIA 35
Cheered on by the WWE Universe, The New Day hold Kofi Kingston aloft as they celebrate him winning the WWE Championship.

KOFI KINGSTON

A REMARKABLE STORY THAT SHOWS EXACTLY WHAT THE Power of Positivity can do, Kofi Kingston's rise to the top of the Tag Team Division and the WWE Championship, as well as winning Intercontinental and United States Titles, is inspiring. Between 2009 and 2013, Kingston became a four-time Intercontinental Champion and a three-time United States Champion. But in 2014 his career changed forever, when he teamed up with Big E and Xavier Woods to form the weird and wonderful tag team The New Day. The trio of Booty-O-chomping, unicorn-horn-wearing Superstars were initially

"THE FIRST AFRICAN-BORN WWE CHAMPION."

met with derision, but soon became one of the most loved factions in modern WWE. With Kofi as the veteran member, The New Day would win multiple Tag Team Championships and hold the record for the longest tag team reign in WWE history, at a stunning 483 days.

However, Kofi Kingston wasn't looking to stop with these astonishing achievements. With over a decade's experience, he finally took his chance at *WrestleMania 35*, challenging Daniel Bryan for the WWE Title. With the whole of the WWE Universe, not to mention his teammates in The New Day, completely behind him, Kingston hit Bryan with a Trouble in Paradise to win his first WWE Championship. Kofi Kingston made history on April 7, 2019, becoming the first African-born WWE Champion. Kingston held the WWE Championship for 180 days, in which time he successfully defended the title against Daniel Bryan, Dolph Ziggler, Samoa Joe and Randy Orton, before losing to Brock Lesnar in a match that lasted just eight seconds.

Beloved for his acrobatic skills and innovative techniques to avoid being eliminated from Royal Rumble and battle royal matches, it feels like Kingston is just getting started.

WRESTLE MANIA 36

THE THIRTY-SIXTH SHOW of Shows was a *WrestleMania* event like no other. As the COVID-19 pandemic shut down businesses, workplaces and sporting events around the world, WWE was forced to rethink its flagship event, spreading it out over the course of two nights and moving the majority of its action from Tampa's Raymond James Stadium to WWE's Performance Center in Orlando.

Brock Lesnar and Drew McIntyre's title match was scheduled as the main event of the second night, and had its origins in the 2020 Royal Rumble Match. After a dominant performance during the men's Royal Rumble, Lesnar eliminated 13 competitors and seemed poised to win it all. However, his plans were undone when Drew McIntyre eliminated him and went on to win the whole match.

The victory secured Drew a shot at the world title match of his choice, and he wasted no time putting the Beast in his crosshairs.

The bout itself was short by *WrestleMania* standards, lasting just under seven minutes. But, during that time, both Superstars managed to pack in ultimate brutality. Drew came out strong, taking down Lesnar with a Claymore Kick for a two-count. But Lesnar battled back hard, devastating his opponent with a series of F-5s that nearly took McIntyre out for good. Amazingly, however, Drew managed to push through the pain and launched a trio of Claymore Kicks at Lesnar to make the pinfall and win his first WWE Championship. The win was particularly historic, as McIntyre was WWE's first-ever British-born (and Scottish-born) World Champion.

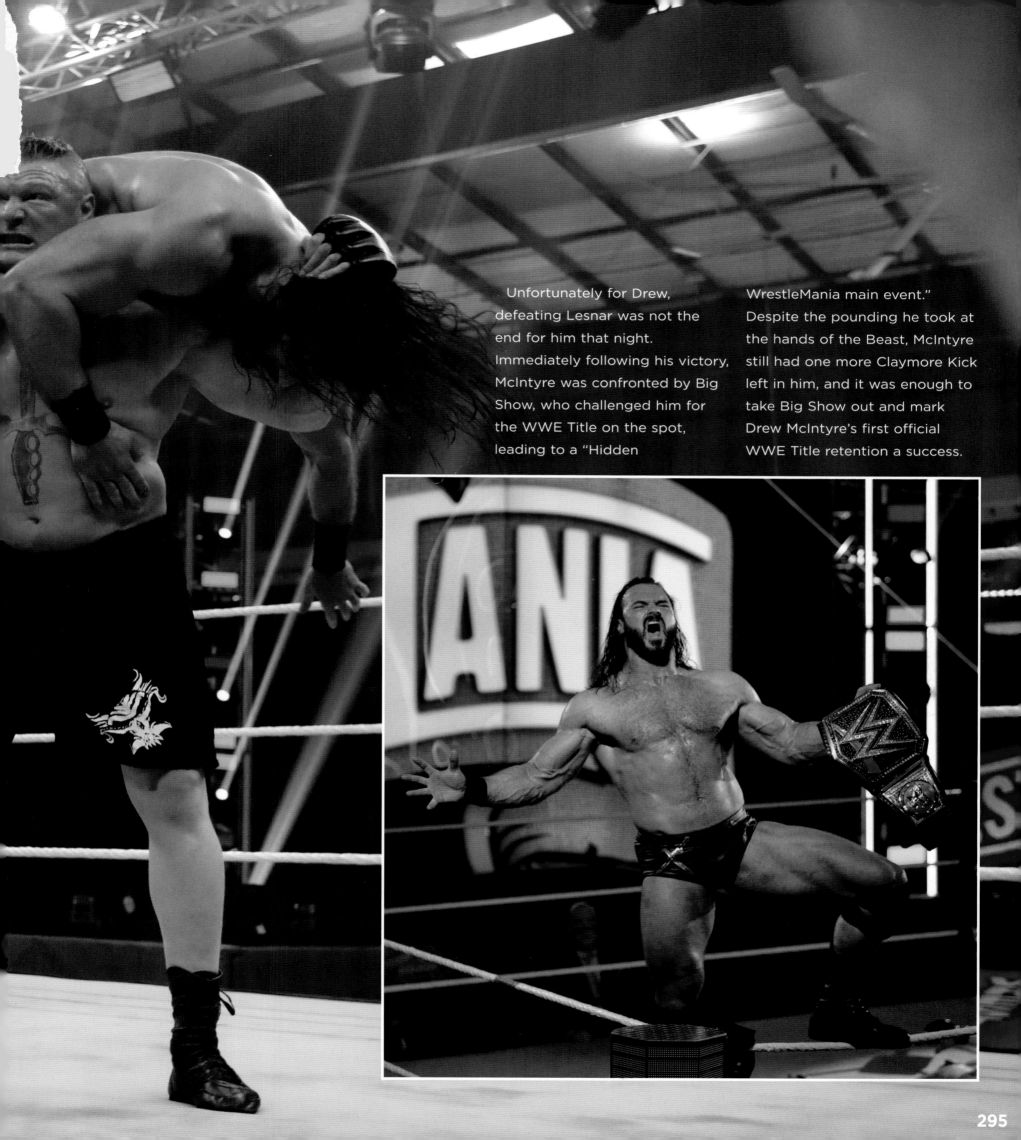

Unfortunately for Drew, defeating Lesnar was not the end for him that night. Immediately following his victory, McIntyre was confronted by Big Show, who challenged him for the WWE Title on the spot, leading to a "Hidden WrestleMania main event." Despite the pounding he took at the hands of the Beast, McIntyre still had one more Claymore Kick left in him, and it was enough to take Big Show out and mark Drew McIntyre's first official WWE Title retention a success.

DREW MCINTYRE

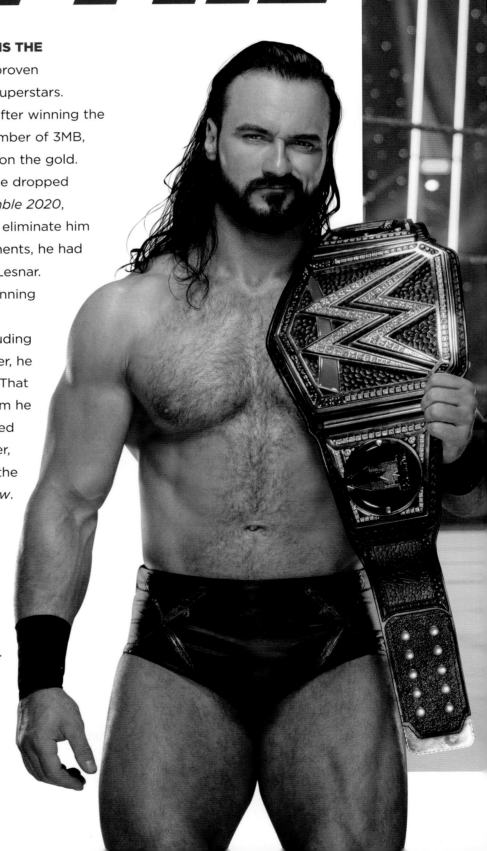

AT 6'5" AND 265 POUNDS, DREW MCINTYRE IS THE claymore-wielding Scottish Warrior who has proven himself in battle against the WWE's biggest Superstars. McIntyre's first run in WWE came to an end in 2014, after winning the Intercontinental Championship and competing as a member of 3MB, but he returned to the promotion in 2017 with his eyes on the gold.

After claiming the NXT Title, he continued to rise as he dropped opponents with his thundering Claymore. At *Royal Rumble 2020*, McIntyre landed his signature kick on Roman Reigns to eliminate him and win the Royal Rumble Match. Eliminating six opponents, he had earned his title shot at *WrestleMania 36* against Brock Lesnar. McIntyre felled the Beast with three Claymore Kicks, winning his first WWE Championship in spectacular style.

Successfully retaining against a list of Superstars including Big Show, Seth Rollins, Bobby Lashley and Dolph Ziggler, he issued an open challenge for the WWE Championship. That call was answered by the returning Robert Roode, whom he also defeated. McIntyre's first title reign was finally ended after 202 days by Randy Orton at *Hell in a Cell*. However, less than a month later the Scottish Warrior reclaimed the title in a No Disqualification Match against Orton on *Raw*. He went on to successfully defend the title in matches against AJ Styles, The Miz and Goldberg. Celebrating victory in an Elimination Chamber Match at *Elimination Chamber 2021*, he was immediately caught off guard by The Miz and Bobby Lashley after the bout. The Miz cashed in his Money in the Bank contract and performed a Skull Crushing Finale on McIntyre to end the Scotsman's second title reign.

Drew McIntyre's warrior quest for gold has only just begun...

> **"THE CLAYMORE-WIELDING SCOTTISH WARRIOR HAS PROVEN HIMSELF IN BATTLE."**

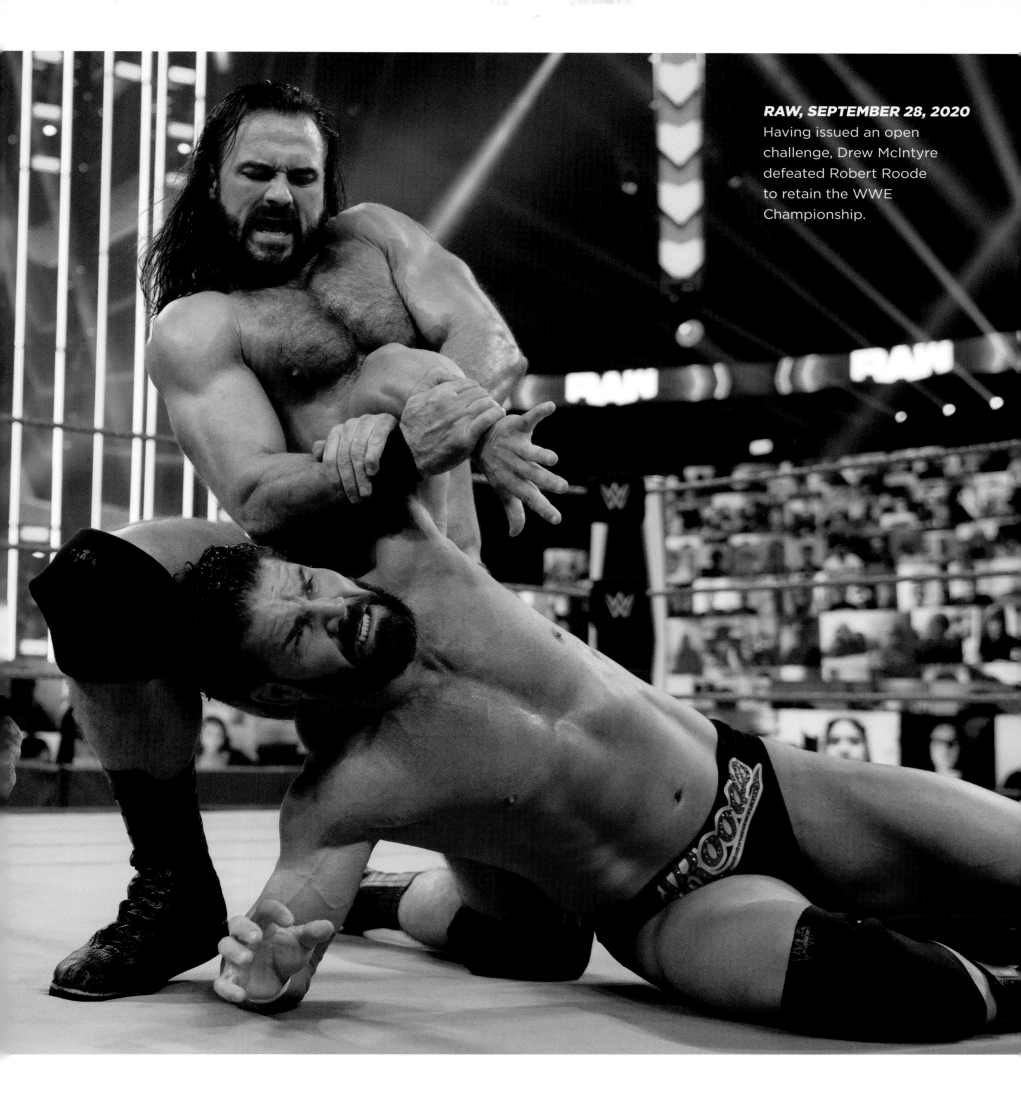

RAW, SEPTEMBER 28, 2020
Having issued an open challenge, Drew McIntyre defeated Robert Roode to retain the WWE Championship.

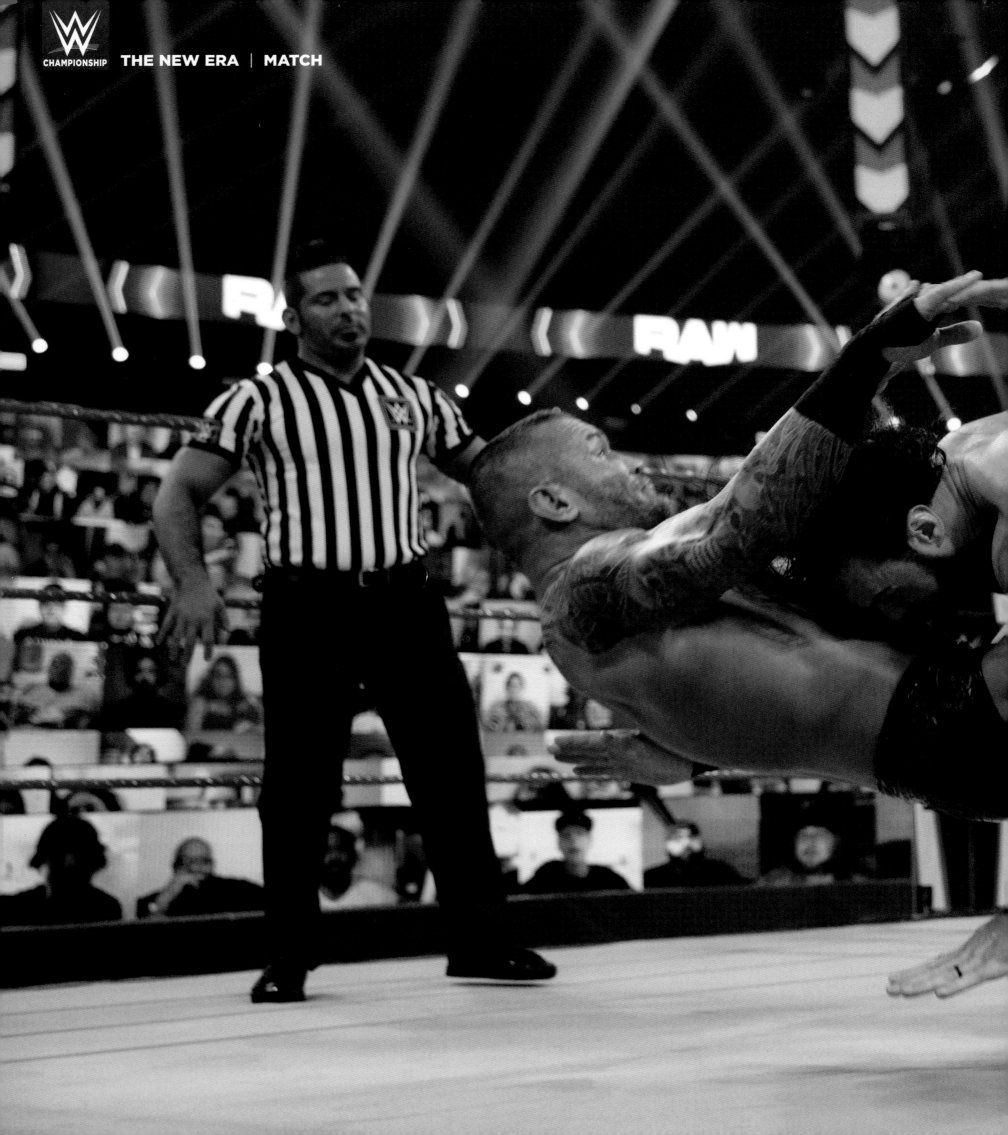

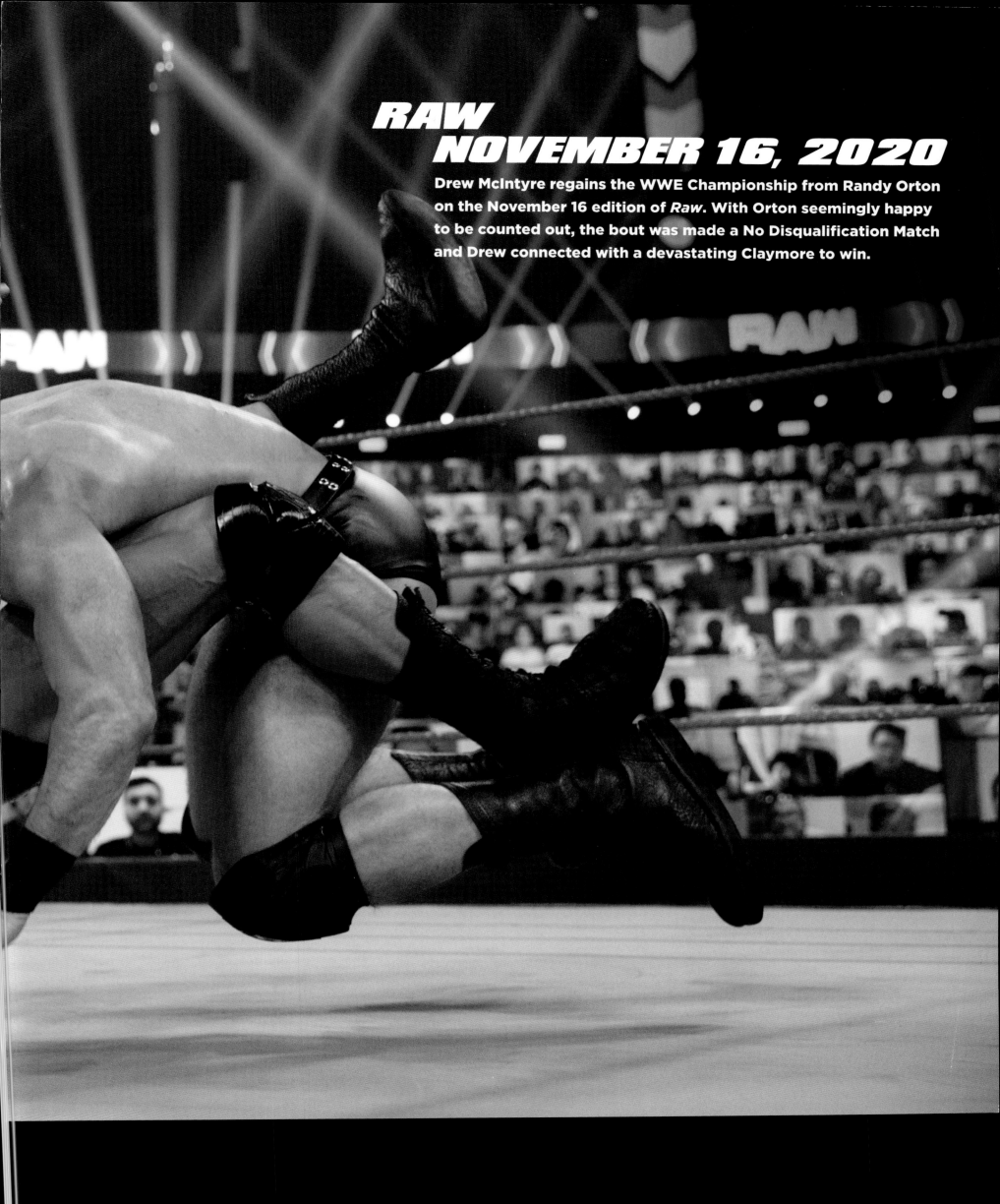

RAW
NOVEMBER 16, 2020

Drew McIntyre regains the WWE Championship from Randy Orton on the November 16 edition of *Raw*. With Orton seemingly happy to be counted out, the bout was made a No Disqualification Match and Drew connected with a devastating Claymore to win.

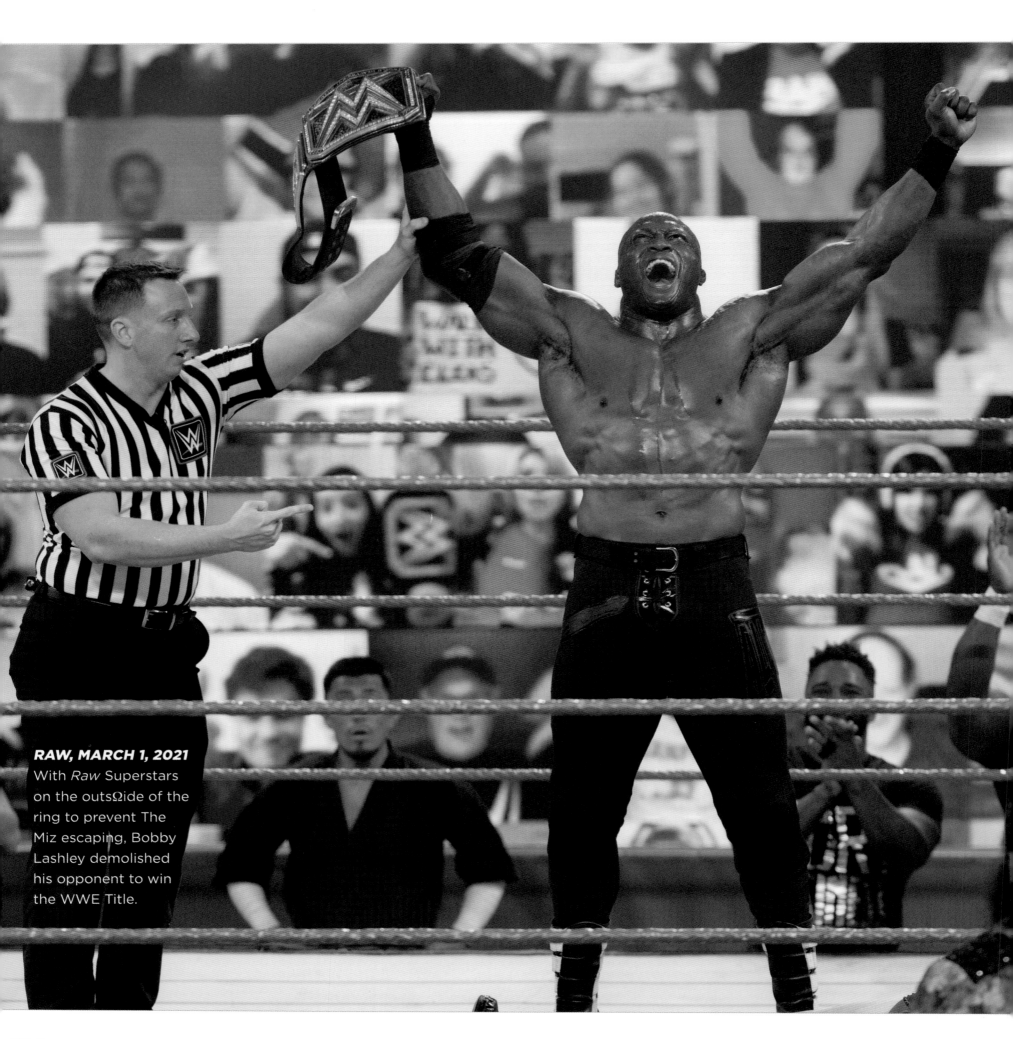

RAW, MARCH 1, 2021
With *Raw* Superstars on the outsΩide of the ring to prevent The Miz escaping, Bobby Lashley demolished his opponent to win the WWE Title.

BOBBY LASHLEY

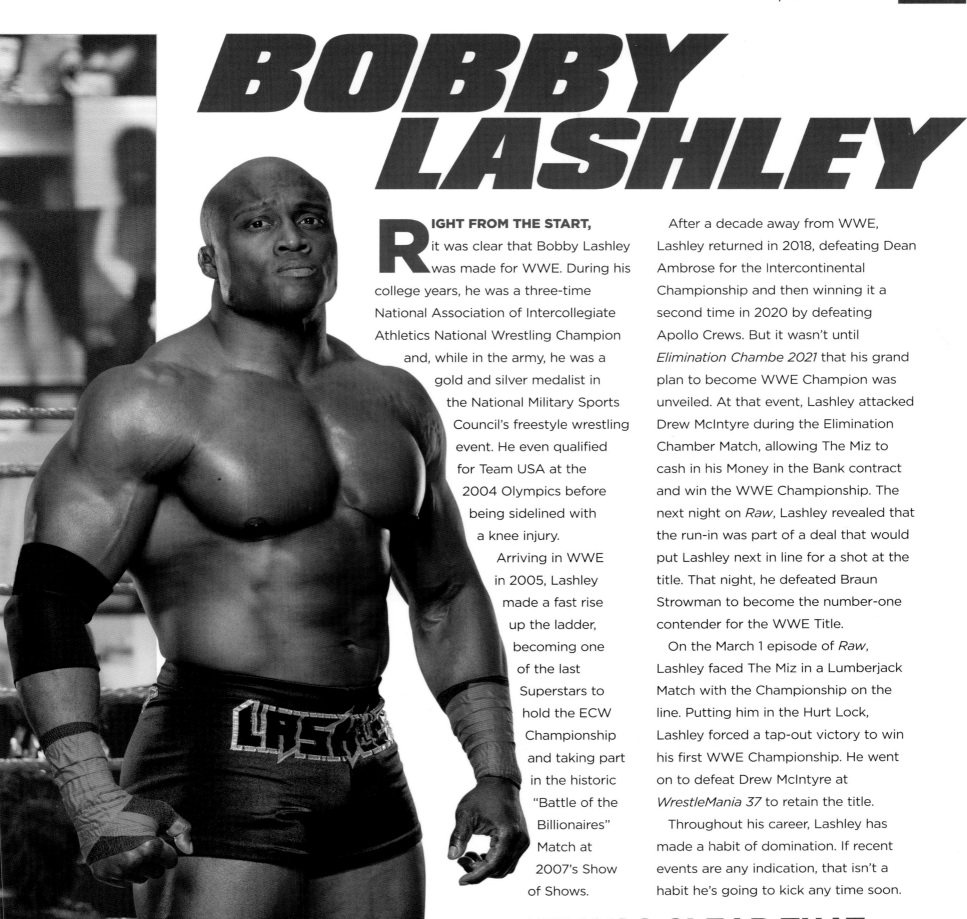

RIGHT FROM THE START, it was clear that Bobby Lashley was made for WWE. During his college years, he was a three-time National Association of Intercollegiate Athletics National Wrestling Champion and, while in the army, he was a gold and silver medalist in the National Military Sports Council's freestyle wrestling event. He even qualified for Team USA at the 2004 Olympics before being sidelined with a knee injury.

Arriving in WWE in 2005, Lashley made a fast rise up the ladder, becoming one of the last Superstars to hold the ECW Championship and taking part in the historic "Battle of the Billionaires" Match at 2007's Show of Shows.

After a decade away from WWE, Lashley returned in 2018, defeating Dean Ambrose for the Intercontinental Championship and then winning it a second time in 2020 by defeating Apollo Crews. But it wasn't until *Elimination Chambe 2021* that his grand plan to become WWE Champion was unveiled. At that event, Lashley attacked Drew McIntyre during the Elimination Chamber Match, allowing The Miz to cash in his Money in the Bank contract and win the WWE Championship. The next night on *Raw*, Lashley revealed that the run-in was part of a deal that would put Lashley next in line for a shot at the title. That night, he defeated Braun Strowman to become the number-one contender for the WWE Title.

On the March 1 episode of *Raw*, Lashley faced The Miz in a Lumberjack Match with the Championship on the line. Putting him in the Hurt Lock, Lashley forced a tap-out victory to win his first WWE Championship. He went on to defeat Drew McIntyre at *WrestleMania 37* to retain the title.

Throughout his career, Lashley has made a habit of domination. If recent events are any indication, that isn't a habit he's going to kick any time soon.

"IT WAS CLEAR THAT BOBBY LASHLEY WAS MADE FOR WWE."

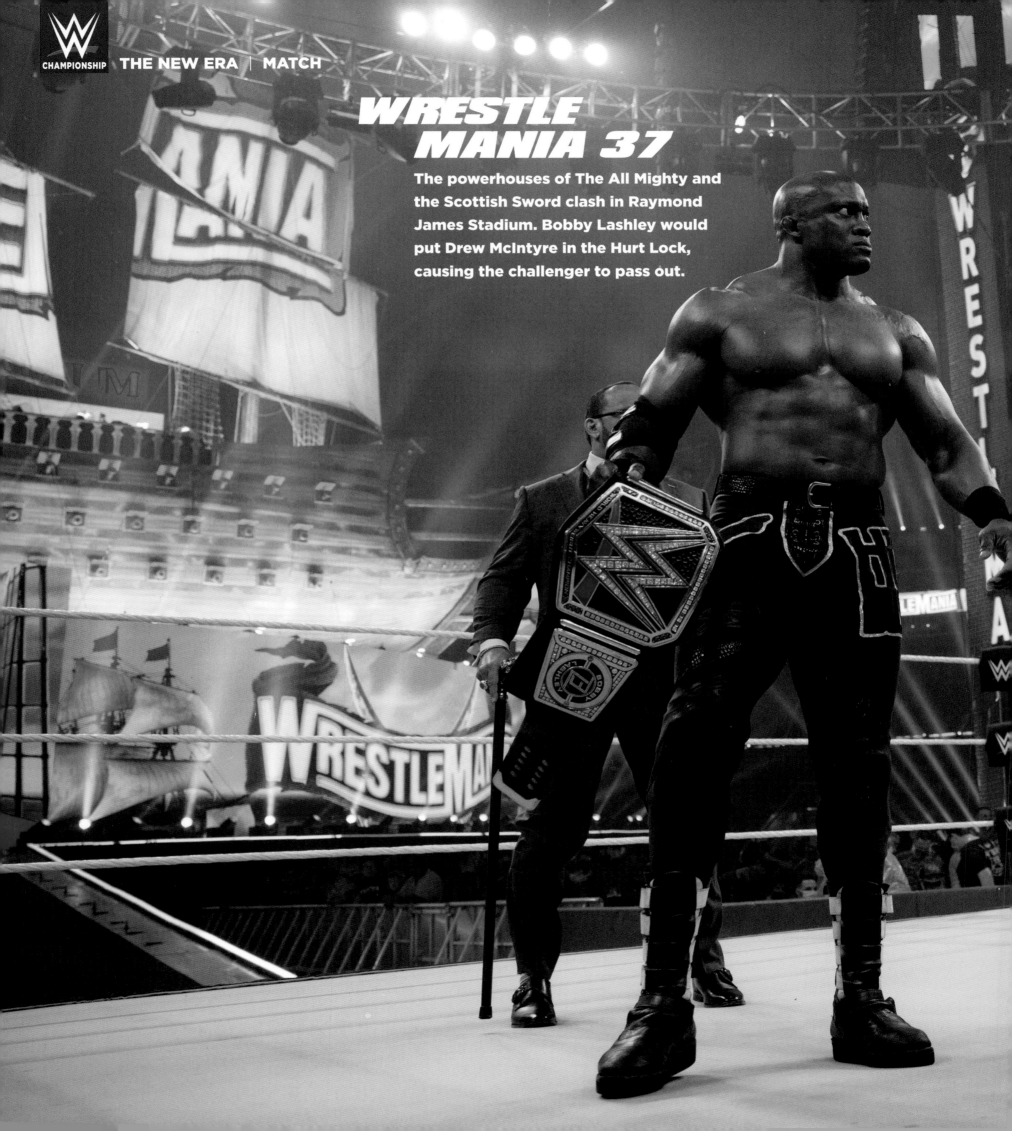

WRESTLE MANIA 37

The powerhouses of The All Mighty and the Scottish Sword clash in Raymond James Stadium. Bobby Lashley would put Drew McIntyre in the Hurt Lock, causing the challenger to pass out.

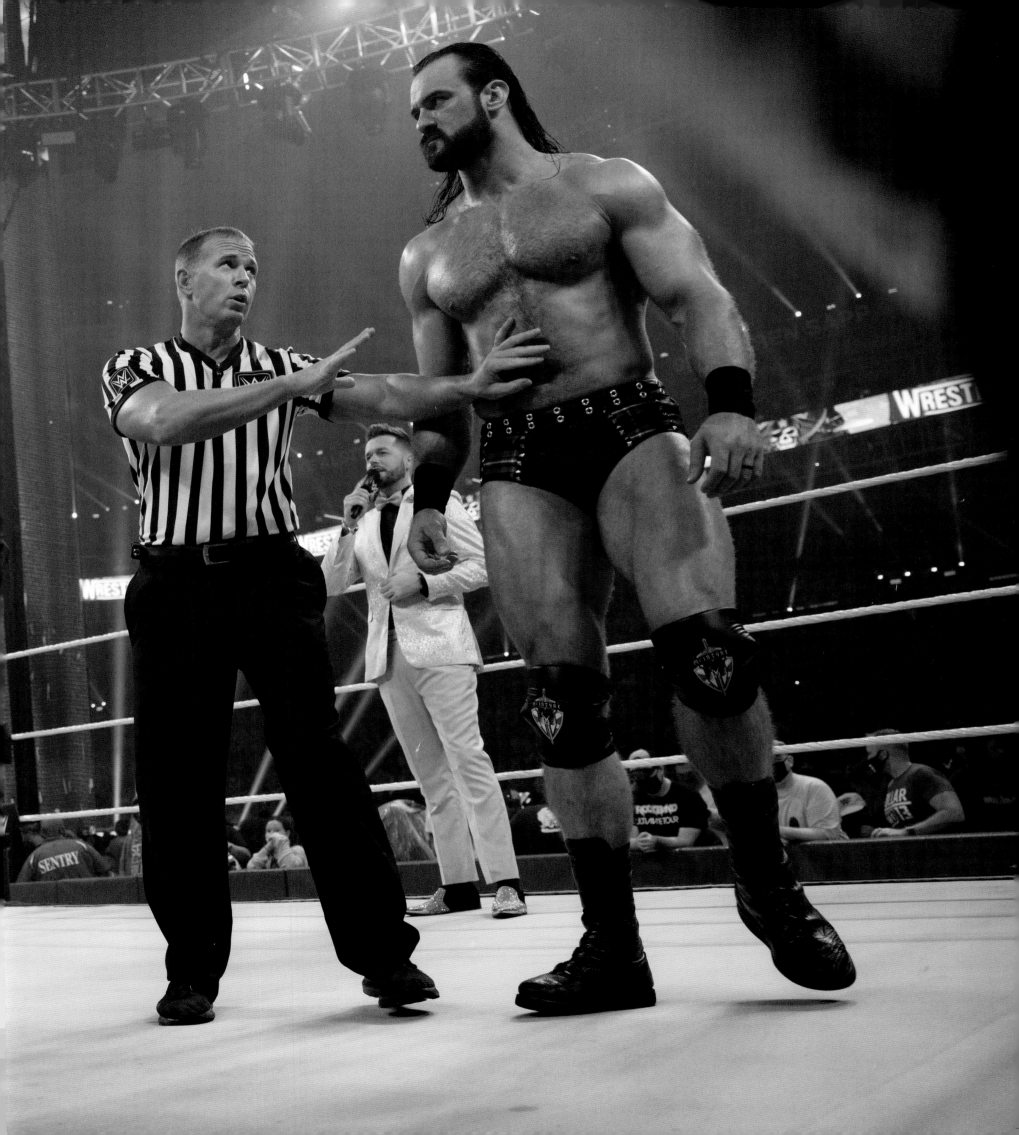

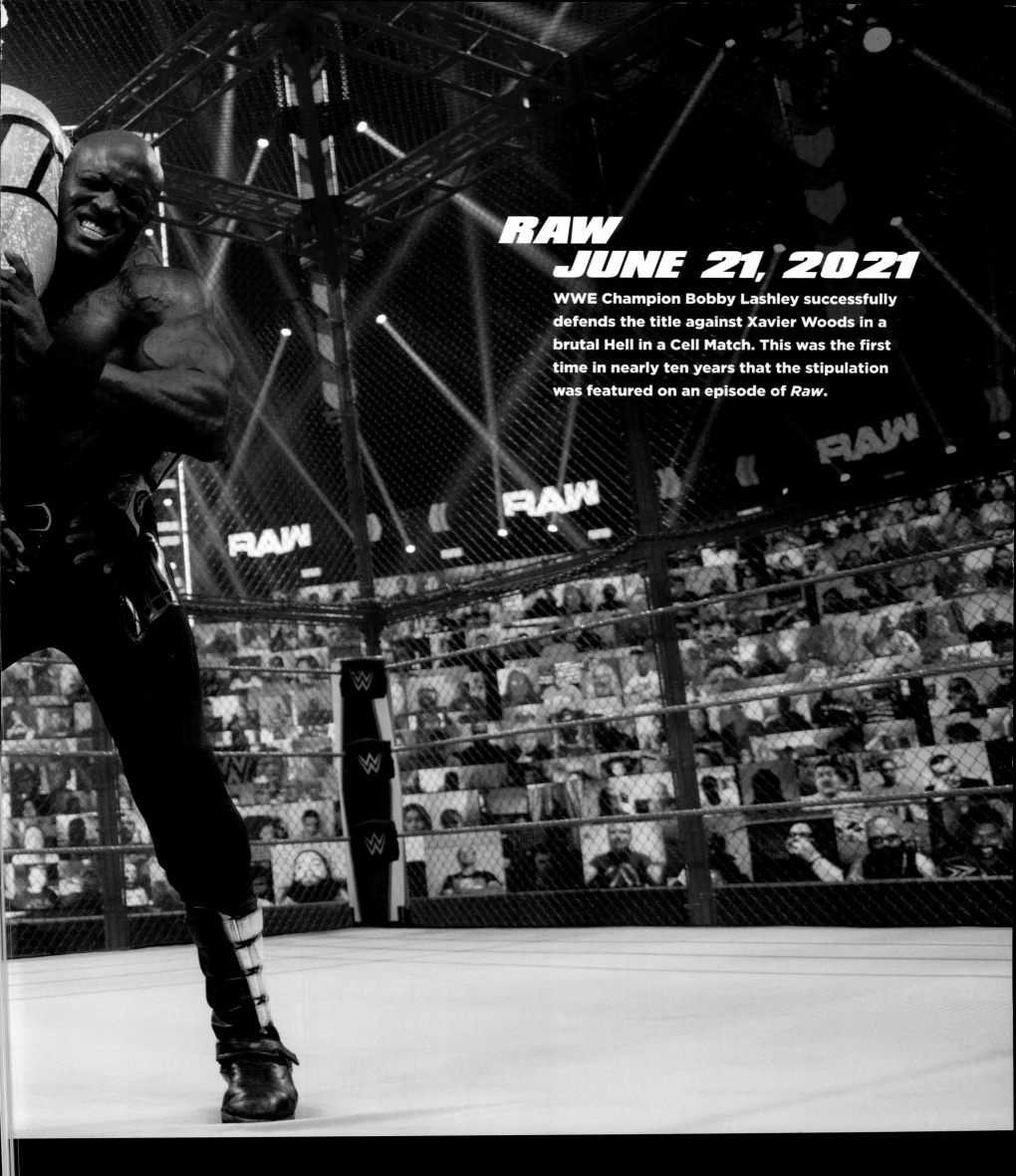

RAW
JUNE 21, 2021

WWE Champion Bobby Lashley successfully defends the title against Xavier Woods in a brutal Hell in a Cell Match. This was the first time in nearly ten years that the stipulation was featured on an episode of *Raw*.

CHAMPIONSHIP STATS & FACTS

RECORD HOLDERS

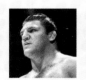

BRUNO SAMMARTINO
Longest Single Title Reign - 2,830 days

JOHN CENA
Most Title Reigns - 13

ANDRÉ THE GIANT
Shortest Single Title Reign - 108 seconds

Tallest Champion - 7' 4"

REY MYSTERIO
Shortest Champion - 5' 6"

Lightest Champion - 175 lbs

YOKOZUNA
Heaviest Champion - 589 lbs

BROCK LESNAR
Youngest Champion - 25 years, 1 month, 13 days

MR. MCMAHON
Oldest Champion - 54 years, 21 days

WINNING MOVES

The top five ways a new Champion has been crowned:

1. Pinfall- **109 Times**
2. Submission- **12 Times**
3. Iron Man Match- **3 Times**
4. Ladder Match- **3 Times**
5. Royal Rumble Match- **2 Times**

23 SUPERSTARS
With only one title reign to their name.

VACATED TITLE
The WWE Championship has been vacated 11 times with a total of 250 days without a Champion.

RANK	SUPERSTAR	NO. REIGNS	TOTAL REIGN DAYS
1	Bruno Sammartino	2	4,040
2	Hulk Hogan	6	2,188
3	Bob Backlund	2	2,138
4	John Cena	13	1,254
5	Pedro Morales	1	1,027
6	Brock Lesnar	5	761
7	Randy Orton	10	680
8	Bret Hart	5	654
9	Triple H	9	611
10	Steve Austin	6	529
11	Randy Savage	2	520
12	AJ Styles	2	511
13	CM Punk	2	462
14	Shawn Michaels	3	396
15	The Rock	8	378
16	Diesel	1	358
17	Drew McIntyre	2	300
18	Kurt Angle	4	299
19	Billy Graham	1	296
20	Ultimate Warrior	1	293
21	Yokozuna	2	280
22	JBL	1	280
23	Undertaker	4	238
24	Seth Rollins	2	220
25	Daniel Bryan	4	210
26	Sheamus	3	183

SIMULTANEOUS TITLES

Just nine Superstars have officially held another title at the same time as the WWE Championship—not including unifications or titles instantly vacated:

- **Bob Backlund** - World Tag Team Championship
- **Bruno Sammartino** - United States Tag Team Championhsip
- **Diesel** - World Tag Team Championship
- **Kofi Kingston** - SmackDown Tag Team Championship
- **Rob Van Dam** - ECW Championship
- **Seth Rollins** - United States Championship
- **Shawn Michaels** - European Championship
- **Stone Cold Steve Austin** - World Tag Team Championships (x2)
- **The Miz** - WWE Tag Team Championship

27	Kofi Kingston	1	180
28	Jinder Mahal	1	170
29	The Miz	2	168
30	Bobby Lashley+	1	140
31	Edge	4	139
32	Eddie Guerrero	1	133
33	Roman Reigns	3	118
34	Ric Flair	2	118
35	Chris Jericho	1	98
36	Sycho Sid	2	97
37	Alberto Del Rio	2	84
38	Dean Ambrose	1	84
39	Big Show	2	78
40	Sgt. Slaughter	1	64
41	Bray Wyatt	1	49
42	Mankind	3	36
43	Jeff Hardy	1	42
44	Batista	2	37
45	Buddy Rogers	1	22
46	The Iron Sheik	1	28
47	Rob Van Dam	1	22
48	Ivan Koloff	1	21
49	Stan Stasiak	1	9
50	Mr. McMahon	1	4
51	Kane	1	1
52	Rey Mysterio	1	<1
53	André the Giant	1	<1

+ Current Champion and reign as of print

TRIPLE THREAT MATCH

The WWE Championship has changed hands 12 times in Triple Threat Matches with the defending Champion losing the title without being pinned or submitting on 3 occassions.

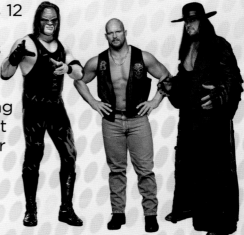

CASH IN

The Money in the Bank Contract has been successfully cashed in for the WWE Championship 9 times out of 11.

NEW YORK, NY

The title has been won here more than anywhere else with 13 new Champions.

TOP EVENTS

The top five programs that the WWE Championship has exchanged hands:

 24

 16

 12

 9

 8

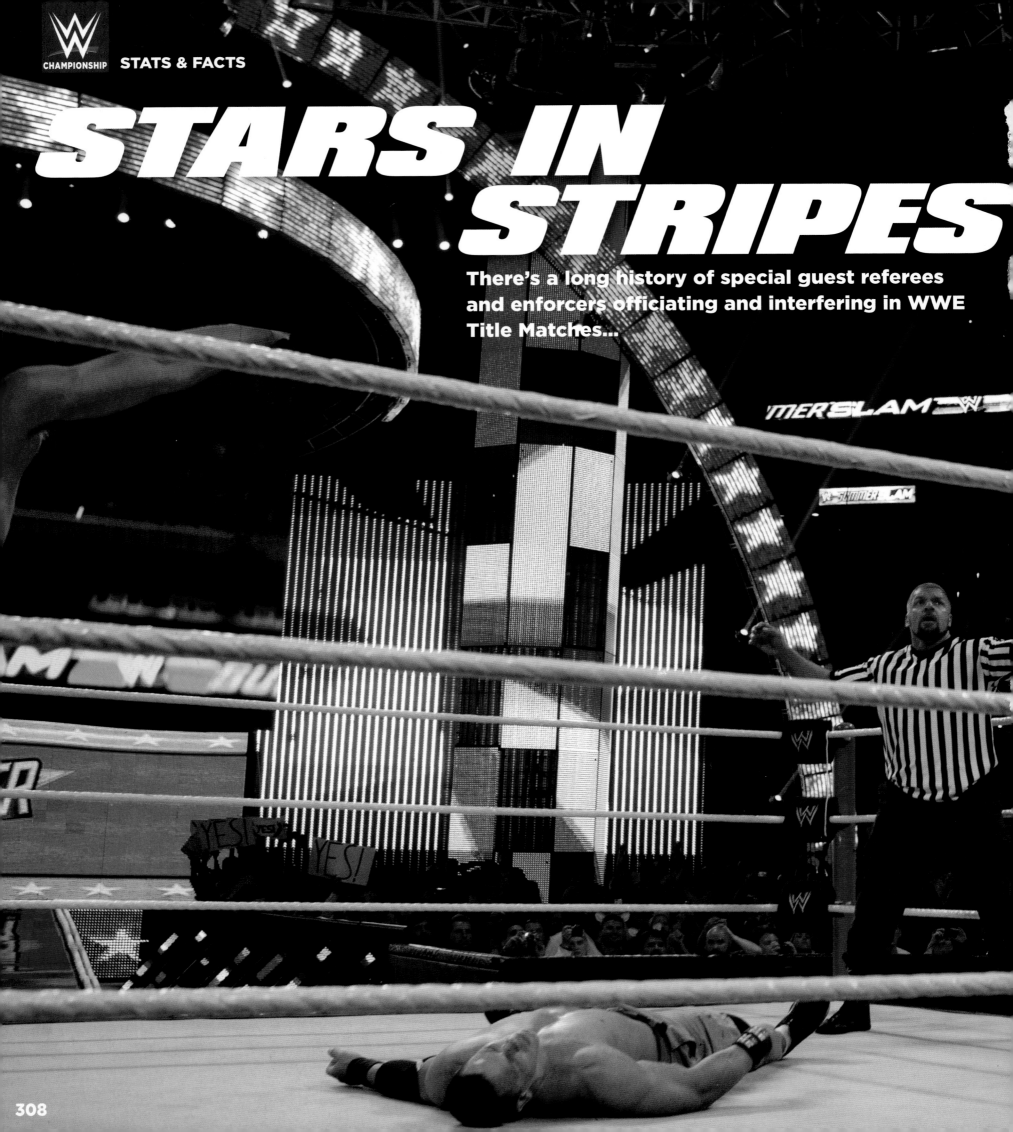

STARS IN STRIPES

There's a long history of special guest referees and enforcers officiating and interfering in WWE Title Matches...

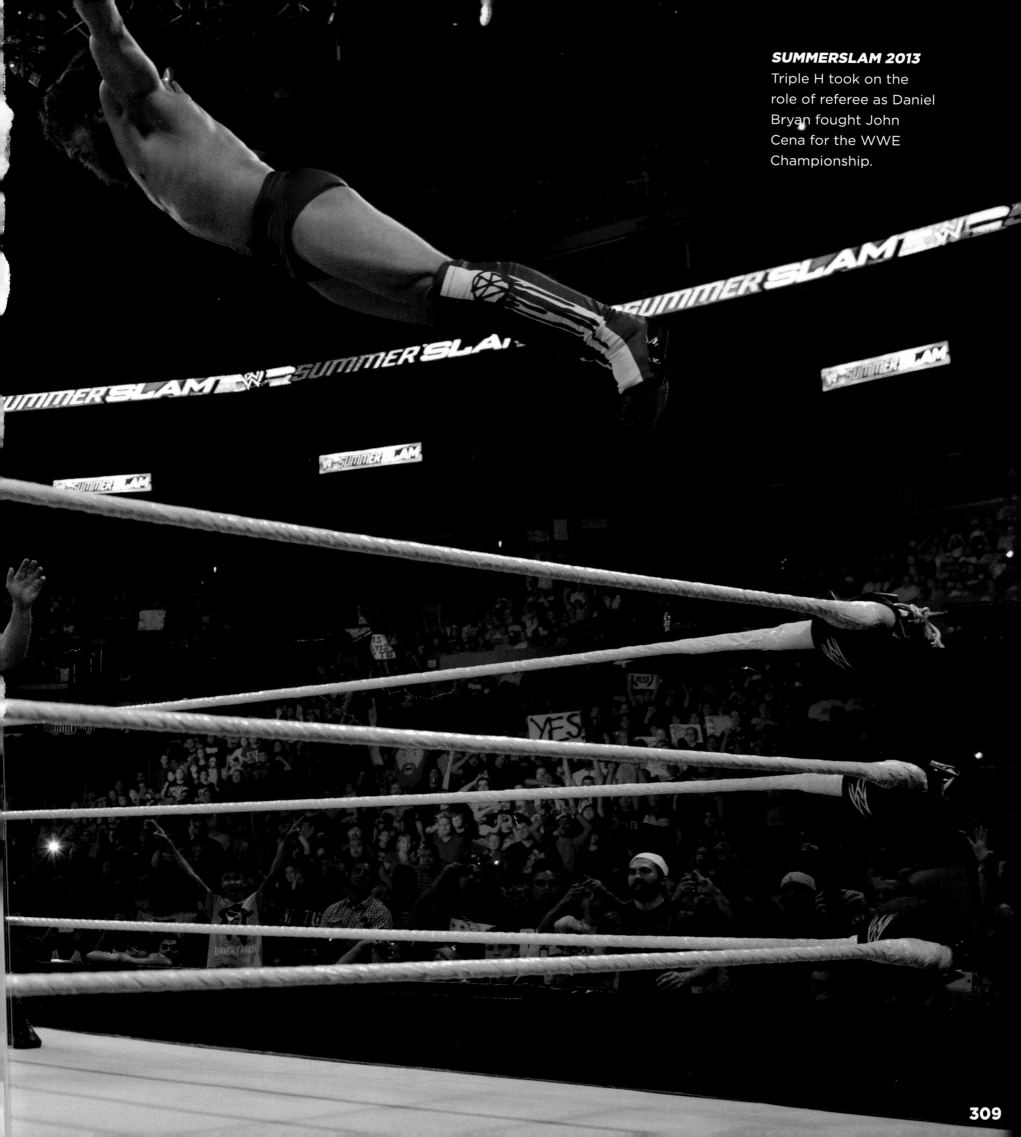

SPECIAL GUEST REFEREES AND ENFORCERS (who keep the rules from outside the ring) have added an unpredictable, disruptive dimension to title matches since the early days of WWE. The much-loved goliath Gorilla Monsoon officiated title matches between champion Bruno Sammartino and challengers like Ivan Koloff and "Superstar" Billy Graham in the mid '70s. In the decades that followed, special guest referees would become more personally involved in matches. In 1994, Mr. Perfect and "Rowdy" Roddy Piper both refereed WWE Title matches at *WrestleMania X*. Perfect disqualified his rival Lex Luger in his match against Yokozuna. Four years later, a boxer would make an era-shifting impact at the Show of Shows.

"Iron" Mike Tyson was the enforcer for Shawn Michaels' WWE Title defense against "Stone Cold" Steve Austin at *WrestleMania XIV*. Tyson turned on Michaels by entering the ring to make the quick three-count, making Austin the new WWE Champion. Confronted by Michaels over the betrayal, Tyson landed a punch that floored HBK. The Attitude Era had arrived. Stone Cold himself reluctantly took on the role of special guest referee at 1998's *Judgment Day: In Your House*, as Undertaker and Kane faced off over the vacated WWE Championship. Austin refused to count when 'Taker pinned Kane, before responding to Undertaker's complaints with a Stone Cold Stunner and a foreign object. Austin slapped the mat three times and declared himself the winner before Mr. McMahon fired him.

When the sunglasses-wearing The Rock mocked an entire title match as special guest referee on a 1999 edition of *SmackDown* between Triple H and British Bulldog, he delighted the WWE Universe. The People's Champ sarcastically clapped finishing moves, ignored low blows, and even joined the commentary team at times! When Bulldog went for the pinfall, The Rock counted: "one... two... it doesn't matter if The Rock counts to three!" With the match ending in a no contest, The Rock left carrying the WWE Title.

Sparks flew when AJ Lee officiated at 2012's *Money in the Bank*, as she had been romantically linked with both defending WWE Champion CM Punk and the challenger Daniel Bryan. She first assisted Bryan, but later prevented his attack, allowing Punk to retain. Other Superstars who have memorably interfered as referees during WWE Title matches have included Jesse Ventura, Mankind, Ric Flair, Kurt Angle, and John Cena. But some of the most consequential, manipulative special guest referees are also powerful figures running WWE, such as the McMahons and Triple H.

Both Mr. McMahon and his son Shane have donned the striped shirt to stop the rise of Superstars they deemed unworthy. They tried to cause the downfall of then WWE Champion "Stone Cold" Steve Austin in the late '90s. Shane also guest refereed a title match between Mr. McMahon and Triple H on *SmackDown* in 1999, with both father and son receiving a beating.

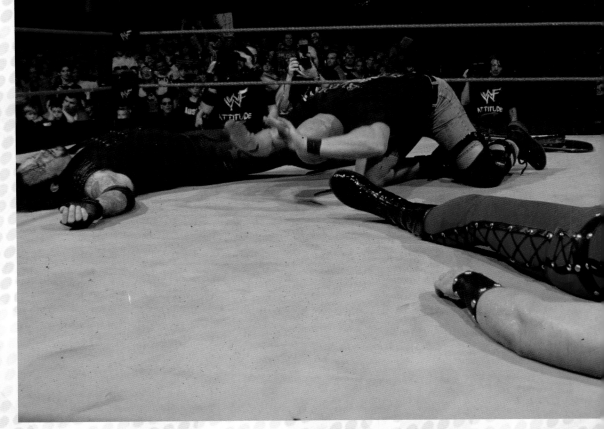

▼ JUDGMENT DAY 1998
Forced to referee Undertaker and Kane's Title Match, Steve Austin made sure both men were on the mat before counting to three and declaring himself the winner.

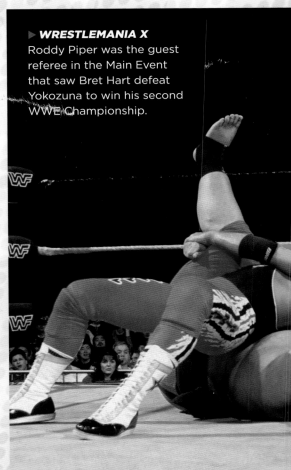

▶ WRESTLEMANIA X
Roddy Piper was the guest referee in the Main Event that saw Bret Hart defeat Yokozuna to win his second WWE Championship.

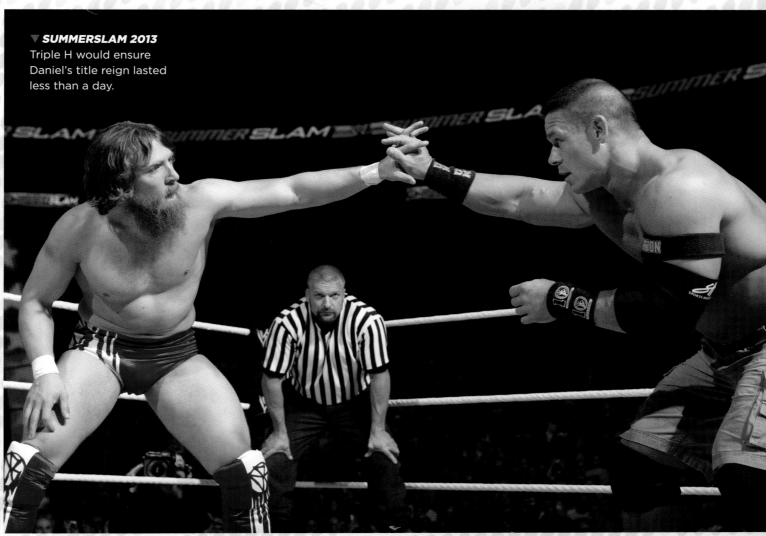

▼ **SUMMERSLAM 2013**
Triple H would ensure
Daniel's title reign lasted
less than a day.

As WWE's Chief Operating Officer, Triple H made himself a special guest referee at *SummerSlam 2011*, to prevent John Cena becoming the Undisputed WWE Champion, and again at *SummerSlam 2013*, taking down new WWE Champion Daniel Bryan immediately after his title win. The latter moment set Bryan on a course to win back the WWE Title from Randy Orton, with the support of the WWE Universe.

One Superstar stands out as the Showstopper of special guest referees. At 1997's *SummerSlam*, Undertaker defended the WWE Championship against Bret Hart, with Shawn Michaels refereeing for the first time. HBK swung a foreign object at Hart, who ducked, flooring Undertaker

instead. Reluctantly, Michaels was forced to award the WWE Title to his arch-nemesis. On the first-ever episode of *SmackDown* on August 26, 1999, then WWE Commissioner Michaels refereed a WWE Title match between his friend Triple H and The Rock. Michaels hit The Rock with Sweet Chin Music, allowing Triple H to retain the gold. HBK again prevented The Rock defeating Triple H by disqualifying him during an Iron Man Match for the title at 2000's *Judgment Day*.

At *Hell in a Cell 2013*, Triple H was in Randy Orton's corner against an outnumbered Daniel Bryan, and Michaels was referee. Although Bryan took down Orton and Triple H, he was met by Michaels performing Sweet Chin Music. Orton pinned Bryan and claimed the vacant WWE Championship.

Special guest referees and enforcers can have a huge influence on who will become the next WWE Champion, often using biased, physical and underhand tactics. With sports entertainment you should always expect the unexpected!

WWE CHAMPIONSHIPS

THE WWE TITLES PAST AND PRESENT THAT SUPERSTARS AND LEGENDS HAVE FOUGHT OVER.

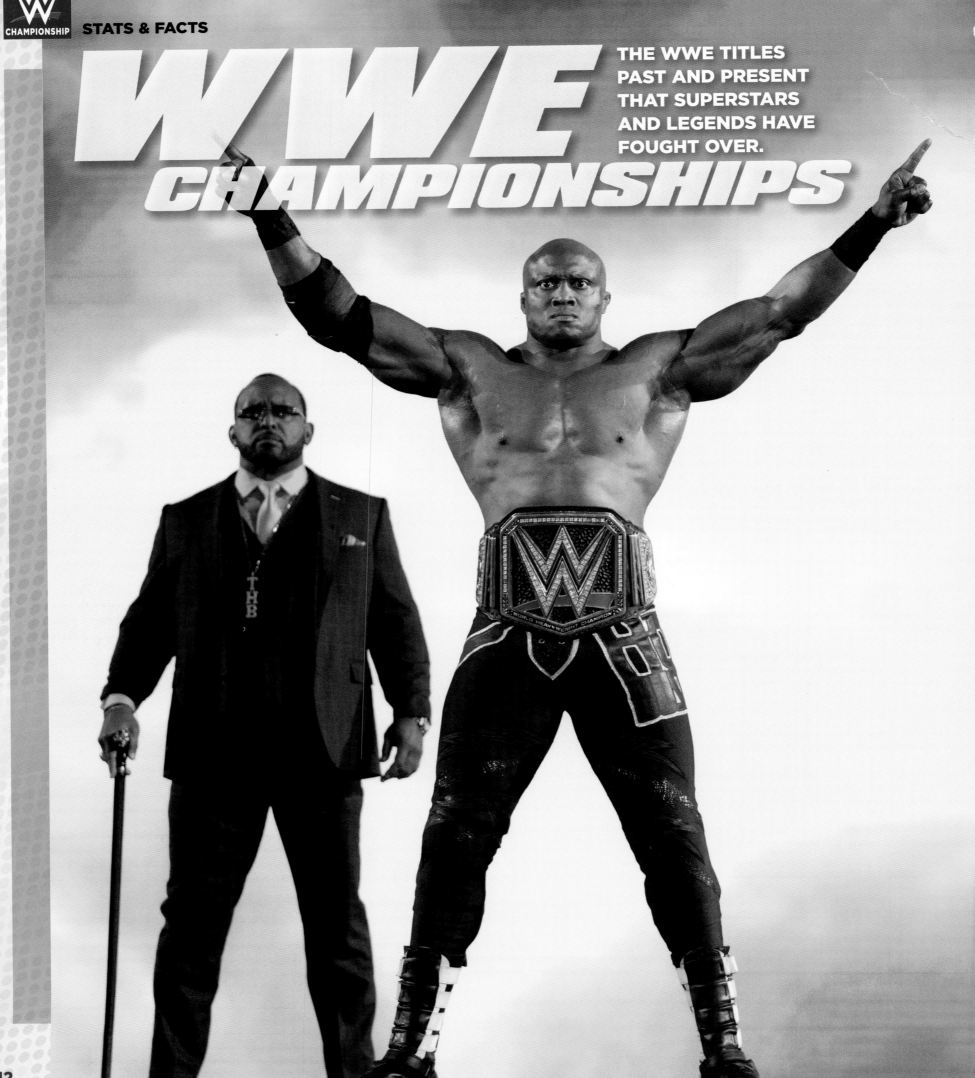

MEN'S CHAMPIONSHIPS CURRENT

WWE CHAMPIONSHIP

1963-Present

UNIVERSAL CHAMPIONSHIP

2016-Present

INTERCONTINENTAL CHAMPIONSHIP

1979-Present

UNITED STATES CHAMPIONSHIP

1975-Present

RAW TAG TEAM CHAMPIONSHIP

2002-Present

SMACKDOWN TAG TEAM CHAMPIONSHIP

2016-Present

NXT CHAMPIONSHIP

2012-Present

NXT NORTH AMERICAN CHAMPIONSHIP

2018-Present

NXT CRUISERWEIGHT CHAMPIONSHIP

2016-Present

NXT TAG TEAM CHAMPIONSHIP

2013-Present

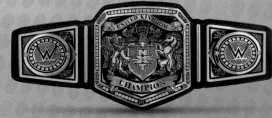

NXT UNITED KINGDOM CHAMPIONSHIP

2017-Present

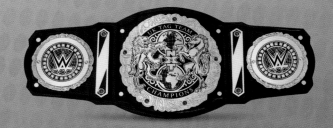

NXT UNITED KINGDOM TAG TEAM CHAMPIONSHIP

2019-Present

MENS CHAMPIONSHIPS DECOMMISSIONED

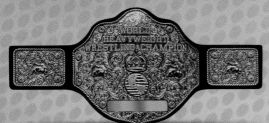

WCW WORLD CHAMPIONSHIP

1991-2001

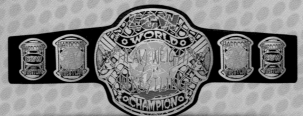

ECW CHAMPIONSHIP

1994-2010

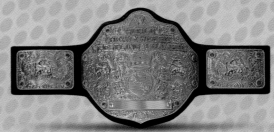

WORLD HEAVYWEIGHT CHAMPIONSHIP

2002-2013

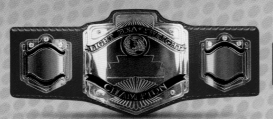

LIGHT HEAVYWEIGHT CHAMPIONSHIP

1997-2001

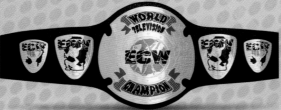

ECW WORLD TELEVISION CHAMPIONSHIP

1992-2001

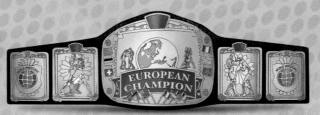

EUROPEAN CHAMPIONSHIP

1997-2002

CRUISERWEIGHT CHAMPIONSHIP

1991-2007

WCW WORLD TAG TEAM CHAMPIONSHIP

1975-2001

WORLD TAG TEAM CHAMPIONSHIP

1971-2010

WOMEN'S CHAMPIONSHIPS CURRENT

RAW WOMEN'S CHAMPIONSHIP

2016-Present

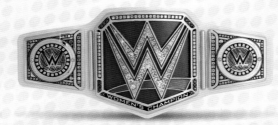

SMACKDOWN WOMEN'S CHAMPIONSHIP

2016-Present

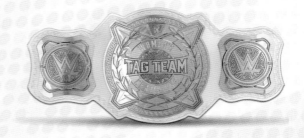

WWE WOMEN'S TAG TEAM CHAMPIONSHIP

2019-Present

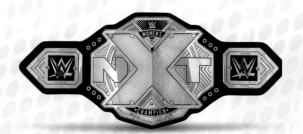

NXT WOMEN'S CHAMPIONSHIP

2013-Present

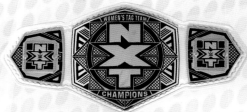

NXT WOMEN'S TAG TEAM CHAMPIONSHIP

2021-Present

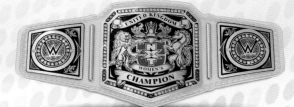

NXT UNITED KINGDOM WOMEN'S CHAMPIONSHIP

2018-Present

WOMEN'S CHAMPIONSHIPS DECOMMISSIONED

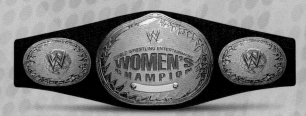

WOMEN'S CHAMPIONSHIP

1956-2010

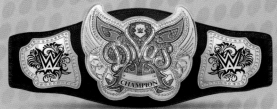

DIVA'S CHAMPIONSHIP

2008-2016

OTHER CHAMPIONSHIPS

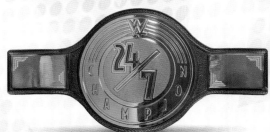

24/7 CHAMPIONSHIP

2019-Present

HARDCORE CHAMPIONSHIP

1998-2002

WWE GREATEST ROYAL RUMBLE CHAMPIONSHIP

2018

MILLON DOLLAR CHAMPIONSHIP

1989-Present

INTERNET CHAMPIONSHIP

2011-2012

Index

AUTHOR ACKNOWLEDGMENTS

This book has been a wonderful project to work on from the start, and I am very grateful to everyone who helped in its creation. Thanks to Steven Pantaleo at WWE Publishing and Richard Jackson at Eaglemoss for giving me the opportunity to be a part of this book. And much love and thanks to my wife, Alli, and my two boys, William and James, for their unwavering support and for being in my corner in victory and defeat. Being a husband and father has been the greatest championship run of my life.

EDITOR ACKNOWLEDGMENTS

Special Thanks to everyone at Eaglemoss Ltd who work tirelessly behind the scenes to ensure books like this can be published. Without the following people, this and many other books and collectibles would never see the light of day: Paul Ansell, Hayley Edwards, Chris Hayward, Siobhan Hennesey, Helen Hinds, Sandra Segade-Hermida, H, Priti Kothary, Alex Neal, Graham Smith, Georgina Tiltay, Emma Williamson, and many more unsung heroes.

We'd also like to thank two life-long WWE fans that have helped Eaglemoss with everything WWE related: Mike Kanik and Kosta Patapis. Whether working officially for Eaglemoss or as a consultant, their knowledge, expertise and enthusiasm has been invaluable.

Finally, we'd like to thank everyone in the editorial department at Hero Collector: John Ainsworth, Jo Bourne, Ian Chaddock, Adex Costa, Simon T. Diplock, Katy Everett, James King, Alice Peebles, Will Potter, Ben Robinson and Colin Williams.